MODERN PHOTOGRAPHIC PROCESSING

WILEY SERIES ON PHOTOGRAPHIC SCIENCE AND TECHNOLOGY AND THE GRAPHIC ARTS

WALTER CLARK, Editor

PHYSICAL AND PHOTOGRAPHIC PRINCIPLES OF MEDICAL RADIOGRAPHY
Herman E. Seemann

OPTICAL AND PHOTOGRAPHIC RECONNAISSANCE SYSTEMS
Niels Jensen

AERIAL DISCOVERY MANUAL
Carl H. Strandberg

PRINCIPLES OF COLOR REPRODUCTION
J. A. C. Yule

PHOTOMICROGRAPHY, Vols. 1 and 2
Roger P. Loveland

IN-WATER PHOTOGRAPHY
L. E. Mertens

SPSE HANDBOOK FOR PHOTOGRAPHIC SCIENTISTS AND ENGINEERS
Society of Photographic Scientists and Engineers
Edited by Woodlief Thomas, Jr.

PHOTOGRAPHIC SENSITOMETRY—A SELF-TEACHING TEXT
Hollis N. Todd

PHOTOGRAPHY BY INFRARED: ITS PRINCIPLES AND APPLICATIONS
A Third Edition of "Photography by Infrared," by Walter Clark
H. Lou Gibson

MODERN PHOTOGRAPHIC PROCESSING, Vols. 1 and 2
Grant Haist

Modern Photographic Processing

Volume 2

Grant Haist

A Wiley-Interscience Publication

JOHN WILEY AND SONS New York · Chichester · Brisbane · Toronto

Library of Congress Cataloging in Publication Data:

Haist, Grant Milford, 1922–
 Modern photographic processing.

 (Wiley series on photographic sciences and technology
and the graphic arts)
 "A Wiley-Interscience publication."
 Bibliography.
 Includes indexes.
 1. Photography—Processing. I. Title.

TR287.H28 770'.28 78-17559
ISBN 0-471-04285-4 (Vol. 2)
ISBN 0-471-04286-2 (SET)

Printed in the United States of America

10 9 8 7 6 5 4 3 2 1

To PHYLLIS and LYNNE

who suffered my neglect
during the 10 years
of the preparation of this book

Preface

The basic photographic process was discussed in detail in Volume 1. When properly processed and stored, the silver image is remarkably durable, yet its density may be intentionally decreased (reduction), increased (intensification), or changed in image tone (toning). Volume 2 deals with these silver image changes and with the modern systems that use silver salts to form either silver or dye images.

Modern photographic processing has sought to simplify the conventional develop–fix–wash procedure. The wash cycle may be eliminated (stabilization) or the develop-and-fix stages may be combined into one solution (monobath processing). Some of the processing chemicals may be added to the silver halide films or papers, thus simplifying and shortening the processing.

Reversal processing provides a positive image directly, eliminating the separate handling of a photographic negative. This procedure reaches a high degree of refinement in the diffusion transfer process, such as in the instant print camera, where only the desired black-and-white or color positive image is visible. Further applications of the dye transfer technique should do much to simplify and speed the production of both still and motion picture color photography.

Color photographs, though still dependent on silver images, make final use of a dye image. The increasing popularity of color pictures threatens to relegate the silver image to the status of an unseen intermediate or perhaps even to eliminate it from the photographic film or paper. The need to simplify color photographic processing and to increase color image stability may force a reevaluation of other color systems, such as dye bleach or the screen grid, that differ from the predominantly used chromogenic development route to a dye image. All color systems are discussed in Chapters 9 and 10.

Information contained in this book has been compiled from a variety of sources believed to be reliable and accurate but is not guaranteed to be so.

This material is published for information only, and nothing should be construed as recommending any product or practice in violation of any patent or of any law or regulation. It is the user's responsibility to determine the suitability of any material or composition and/or procedure for each purpose, and to adopt such safety precautions and safeguards against toxicity and pollution as may be necessary.

Every effort has been made to prevent errors of fact, but it is inevitable that certain mistakes will be contained in the first printing of a work of this size. I would be most interested to learn of any errors of omission or commission, or how this book might be made of greater value in the classroom, darkroom, laboratory, or other areas of use. A letter addressed to the publisher will be most carefully considered.

GRANT HAIST

Rochester, New York
July 1978

Contents

VOLUME TWO

CONTENTS: VOLUME ONE

MODERN PHOTOGRAPHIC PROCESSING

Chapter 1

Chemical Treatment of the Silver Image

INTENSIFICATION

Negatives underdeveloped or negatives lacking in contrast because of overexposure can be materially improved by intensification; it is also possible to get more out of an underexposed negative by intensification. Obviously no chemical treatment, however, can supply detail lacking through underexposure.

ROBERT TAFT[106]

When properly processed, the photographic image is remarkably long-lasting. Yet, in the presence of many chemical compounds, it may gain or lose density or change in tone. Unintended, uncontrolled changes must be prevented, but intentional alteration in the density or tone of the silver image has been an important part of photography since its inception.

The uncertainty of early photographic materials and equipment resulted in a high percentage of either underexposed or overexposed negatives. Harsh or flat lighting often produced negatives that gave unsatisfactory photographic prints. Incorrect development also produced inadequate negatives from properly exposed films and plates. In order to make practical

use of these imperfect silver images, the early photographers resorted to chemical aftertreatment. Weak silver images were built up (intensification) to resemble more closely the normal result of correct exposure and development; extremely dense silver images were lessened in density (reduction) by chemical removal of some of the excess image silver. Such chemical treatments may have a beneficial effect, but rarely does a treated image reach the quality of a correctly exposed and properly developed negative. To retake a negative is better than to attempt the sometimes hazardous chemical rescue of an inadequate silver image. Occasions do arise, however, even today, when chemical aftertreatment may be called for to save a negative that cannot be duplicated. And after an acceptable photographic print is obtained, the tone of the developed image may be changed (a process called toning) to a color that is more effective esthetically.

Intensification or reduction was commonly used in the early days of photography, because printing papers had limited ranges of reproduction. The much wider range of photographic papers available today allows printing most negatives, even imperfect ones, without any chemical modification of the negative image. Every attempt should be made to avoid intensification or reduction of the silver image of the original negative. This negative can be used to produce a positive transparency, upon which chemical reduction or intensification can be carried out. Printing this modified positive intermediate will then produce a duplicate negative. Making duplicate negatives furnishes a means to provide the desired negative characteristics without endangering the original camera negative.[1-2]

Chemical treatment of the silver image involves considerable danger to an original negative image, as staining or softening of the gelatin emulsion layer may occur. This staining may be related to the presence of retained silver thiosulfates. Henry W. Bennett[3] never found yellow staining to occur in the presence of thiosulfate. "Imperfect fixation," said Bennett, "not imperfect washing, is the cause of the staining of negatives." Thorough washing is to be recommended, however, in most cases as an added precaution. It has also been recommended[4] that, before reduction or intensification is attempted, the well-washed negative be first treated with a special formalin hardener, such as the Kodak SH-1 hardener.

Formalin Hardener (Kodak SH-1)

Formalin (37% formaldehyde solution)	10.0 ml
Sodium carbonate, desiccated	5.0 g
(If monohydrate is used, 6.0 g are required)	
Water to make	1.0 liter

A 3-min immersion in the SH-1 hardening solution is sufficient. The negative is then rinsed in water and treated for 5 min in a *fresh* acid fixing bath before washing thoroughly. The negative is then immediately intensified or reduced without any intermediate drying step. Only one negative should be treated at a time and should be agitated thoroughly during each of the chemical aftertreatments.

Most normally processed photographic papers are sufficiently hardened to withstand chemical aftertreatment. It is usually wiser to make another photographic print than to attempt extensive chemical treatment of an unsatisfactory print. A special supplementary hardener (Kodak SH-2) has been recommended for bromide prints that might have a tendency to stick to the cloth belt of a heated dryer.

Kodak Supplementary Hardener SH-2

Solution A

Water	1.0 liter
Sodium sulfite, desiccated	45.0 g
Acetic acid (28%)	64.0 ml
Potassium alum	135.0 g
Water to make	2.0 liters

Solution B

Hot water (about 160°F or 71°C)	500.0 ml
Borax	30.0 g
Cold water to make	2.0 liters

First cool solution B, then add slowly to solution A with continuous stirring. Failing to cool solution B will produce an insoluble white precipitate. Prints should be fixed and washed thoroughly before treating for 5 to 10 min in the SH-2 hardener solution. Wash thoroughly again. This hardening solution should not be used for prints that are to be toned by hypo-alum or redevelopment methods because the resulting image tone may not be satisfactory.

INTENSIFICATION PROCESSES

Intensification of a weak silver image of a negative is a means of strengthening that image so that a print of normal gradation of tone can be secured.

Weak negatives are usually the result of underexposure or underdevelopment. A normally exposed but underdeveloped negative lacks contrast, as the areas of greater exposure do not possess sufficient density. Details are usually visible even in the areas of least exposure. Underexposed negatives, though properly developed, have little or no detail in the shadow areas. Intensification has a beneficial effect on the underdeveloped image, as all the detail is present for strengthening. The badly underexposed image can be improved only slightly, as the intensifier cannot build up any detail that is not present in the image.

A weak silver image may be intensified in a number of ways: more silver may be deposited on the image; some metal, such as mercury or chromium, may be deposited on the silver image to produce a greater total density; all or part of the silver image may be converted into a colored compound that has greater lightstopping power than silver particles; dyes can be formed imagewise to reinforce the silver image—for example, pyrogallol development forms both a silver and a dye image. (See Figure 1.)

The weak silver image may be intensified so that the density increase is greatest in the area of the least image silver; so that the density increase is greatest in the areas of the higher image silver; or so that the density increase is proportional to the amount of silver in the image. Proportional intensifiers cause a density increase that is a percentage of the amount of image density, resulting in an increase of image contrast such as might have been obtained if the original image development had been prolonged. Superproportional intensifiers build up the higher densities but have little effect upon the lower (shadow) image densities, producing a considerable increase in image contrast. The solvent action of the superproportional intensifier may prevent the increase of the low densities. Subproportional intensifiers increase the lower densities (shadow detail) to a much greater degree than the higher densities representing subject highlights. This action may be caused by

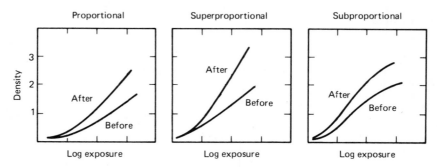

Figure 1. Types of intensification.

incomplete reactions that are not allowed to build up the higher densities to the maximum possible before the intensification treatment is stopped.

SILVER INTENSIFICATION

A solution of a soluble silver salt, such as silver nitrate, and a developing agent has long been known for the physical development of the latent image into visible and practical form. In such a solution finely divided silver is slowly deposited on any suitable site, such as the particles of the latent image, but also on surface nonimage areas as stains, scums, and so on. Physical developers may be used as well to intensify a weakly developed silver image. Silver intensifiers deposit the finely divided silver substantially in proportion to the amount of silver in the original image. Proportional intensification results. (See Figure 2.) The effect is the same as though the original development had been continued for a longer time or carried out at a higher temperature. The intensified image is permanent, consisting of silver of a neutral color. The silver intensifier is the only intensifying solution that does not result in a change in color of the image.

The proportional growth of the image is especially effective for improving underdeveloped negatives, and it helps build up the weakest parts of image detail of underexposed negatives. The degree of intensification may be controlled easily by discontinuing the silver deposition at any time. A chemical solution that is precipitating silver is very unstable and has a short effective life. A mixed silver-intensifying solution has a solution life of about 30 min. After 25 min it should be replaced by a fresh solution. In this way successive

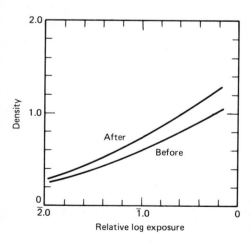

Figure 2. The effect of silver intensification, according to D. T. Copenhafer, *Photo Developments*, 25 (11): 33 (1950).

baths can be used to give increased degrees of intensification. Increases of density of 50 % in 10 min and an increase of contrast (measured by gamma) of 90 % in 30 min of intensification have been reported.[5]

A silver intensifying solution must be unstable enough to plate or deposit silver upon the silver of a photographic image but sufficiently stable that silver is not precipitated upon the nonsilver areas of the negative. Many formulations have been proposed,[6-9] but those of J. B. B. Wellington, Allan F. Odell, and J. I. Crabtree and L. E. Muehler are representative. The method of J. B. B. Wellington,[10-11] published in 1911, is generally credited with being the first practical silver-intensifying solution for dry emulsions, although Wellington proposed improved silver intensifiers as early as 1889.[12-14] A concise summary of the Wellington formula is given in the 1940 edition of *The Chemistry of Photography*[15] and the *British Journal Photographic Almanac* (1959).[16]

Intensification with the Wellington formula may be carried out as follows. Harden for 5 min in the following bath:

Formalin	1 part
Water	10 parts

Wash well in water and immerse for 1 min in

Potassium ferricyanide	2.3 g
Potassium bromide	2.3 g
Water to make	1.0 liter

Rinse well in water and intensify in solution made from these two solutions:

Stock Solution No. 1

Silver nitrate	91.5 g
Distilled water to make	1.0 liter

Stock Solution No. 2

Ammonium thiocyanate	160.0 g
Sodium thiosulfate	160.0 g
Water to make	1.0 liter

Prepare the intensifying bath by adding 100 ml of solution 1 slowly to 100 ml of solution 2 while stirring vigorously. The mixture should be clear.

Then add 25 ml of 10% pyrogallol solution containing 5 to 10% sodium sulfite and 50 ml of 10% ammonia water.

Pour intensifier over negative placed flat in a chemically clean nonmetal tray, such as one made of glass, porcelain, or plastic (stainless steel is acceptable). Metallic silver starts depositing on the silver image within a minute or two. When visual inspection shows that intensification is satisfactory, remove the negative and fix in an acid fixing bath. Wash well after fixation.

The negative is first hardened in the formalin bath to prevent softening of the gelatin emulsion layer during the other steps of the process. Then, after thorough washing in running water, it is immersed for not longer than 1 min in the potassium ferricyanide–potassium bromide solution. The 1-min immersion is apparently sufficient to oxidize nonimage silver, such as silver gelatin compounds, into silver ferrocyanide in order to avoid silver deposition upon undesirable sites. The 1-min limit should not be exceeded, or the silver image will also be attacked. The negative should be rinsed thoroughly in water after this treatment.

The Wellington intensifying solution consists of silver nitrate, ammonium thiocyanate, and sodium thisosulfate carefully balanced to be on the verge of precipitating silver. Pyrogallol-ammonia solution is added to trigger the silver deposition when the negative is to be intensified. Silver thiocyanate would be yielded as a white precipitate immediately upon the addition of the ammonium thiocyanate to the silver nitrate except for the presence of the sodium thiosulfate. This chemical ties up much of the silver but leaves some soluble silver thiocyanate in solution. The pyrogallol slowly converts the silver thiocyanate to silver metal, which is deposited on the silver image of the negative.

Allan F. Odell was active in the mid-1930s in promoting the physical development of camera negatives.[17–20] Such physical development produced very fine grained silver images, but the negative required from five to 10 times the normal exposure in order to produce usable images. Odell modified the formulation of his physical developing solution by increasing the amount of silver nitrate to produce a silver intensifying solution.[21] The negative to be intensified must have been thoroughly washed. If its past history leaves any doubt about its condition, the negative should be first immersed in an oxidizing bath to remove any silver compounds, such as those of thiosulfate. A 1-min immersion in either of the following bleach baths will eliminate these nonimage silver compounds.

Potassium ferricyanide	0.5 g
Potassium bromide	0.5 g
Water	250 ml

or

Potassium bichromate	0.5 g
Potassium bromide	1.0 g
Acetic acid	10 drops
Water	250 ml

Rinse in water briefly, then immerse immediately in an intensifying bath made just before use from stock solutions as described below.

A silver stock solution has the formula

Sodium thiosulfate, crystalline	80 g
Sodium sulfite, anhydrous	30 g
Silver nitrate, crystals	16 g
Water to make	500 ml

and is made by dissolving the sulfite in 150 ml of water (preferably distilled) and the silver nitrate separately in 50 ml of water. Add the silver nitrate solution to the sodium sulfite solution, stirring briefly until the white precipitate dissolves. Then add water to increase the volume of the mixed solution to 450 ml. The sodium thiosulfate crystals are added and the solution stirred until the thiosulfate dissolves. The solution volume should now be 500 ml.

To make the working intensifying solution, 120 ml of water is added to 30 ml of the silver stock solution. Then add, in order, just before use,

Metol	0.7 g
Ammonia, dilute	10 to 12 ml
(one part concentrated ammonia and nine parts water)	

A single negative, wet or dry, but preferably dry according to Odell, should be immersed, emulsion up, in a horizontal container (glass, plastic, or stainless steel) with at least 1 in. of solution above the emulsion surface. The immersion time should not exceed 45 min. As soon as the negative is sufficiently intensified, as determined visually, it is removed from the solution, washed in water briefly, and dried. Allan F. Odell concluded that "If one has a valuable negative underexposed and not capable of being satisfactorily printed he takes less chances with silver intensification methods for bringing out the desired features than with any other method the author [Odell] knows—and there are many good methods extant." It is an excellent policy to learn the techniques of physical development before risking a highly

valued negative, a familiarization that is necessary with any chemical after-treatment of the silver image of a negative.

Most silver intensifying solutions are too unstable, work too rapidly, or deposit an excess of silver on the clear portions of the negative, according to J. I. Crabtree and L. E. Muehler.[5] These research scientists devised a formula that "is reasonably stable and permits of intensification in any degree up to 90 percent without incipient precipitation of silver from the solution." Successive treatments were possible, and a total intensification of 140% was obtained in one case, using four separate solutions for 10, 20, 30, and 30 min. The intensification solutions should not be used for more than 30 min without being replaced by a fresh intensifying bath. Attempting to use the silver intensification solution for longer than 30 min may risk the deposition of metallic silver on areas of the negative other than the silver image. A 25-min treatment is recommended, as the normal degree of intensification is obtained in this time. A similar formulation of D. T. Copenhafer[22] has a time limit of 20 min.

The Crabtree–Muehler silver intensifier consists of four stock solutions. Although formulated in 1931, this intensifier is in current use today and may be found in most chemical formula listings under the name of Kodak Silver Intensifier In-5.

Stock Solution No. 1

Silver nitrate, crystals	60.0 g
Distilled water to make	1.0 liter

Stock Solution No. 2

Sodium sulfite, desiccated	60.0 g
Water to make	1.0 liter

Stock Solution No. 3

Sodium thiosulfate, crystals	105.0 g
Water to make	1.0 liter

Stock Solution No. 4

Sodium sulfite, desiccated	15.0 g
Metol	25.0 g
Water to make	3.0 liters

The intensifying solution is made from the stock solutions by adding one part of solution 2 to one part of solution 1. Thoroughly mix these two solutions by stirring or shaking. Then add one part of solution 3 to dissolve the white precipitate that was formed when solutions 1 and 2 were mixed. When the solution becomes clear, add, with stirring, three parts of solution 4.

The addition of sodium sulfite solution to the silver nitrate solution produces a precipitate of silver sulfite. This insoluble compound is dissolved by sodium thiosulfate (solution 3) to form silver thiosulfate. The proportions of sodium thiosulfate and silver sulfite are adjusted so that the solution is clear but on the verge of precipitation. Silver from the thiosulfate complex is slowly reduced to metallic silver by the developing agent in solution 4. This metallic silver is more readily deposited on the silver of the image than on nonsilver sites. This intensifying solution should be used immediately to treat the negative previously hardened in the SH-1 formalin solution. Only one negative should be treated at a time, and it should be agitated throughout the intensification period. After intensification, which may be followed visually and stopped at any time, the negative should be immersed and agitated for 2 min in a 30% solution of sodium thiosulfate, then washed thoroughly. Wipe the surface of the emulsion layer very carefully to remove any adhering scum before drying.

CHROMIUM INTENSIFICATION

The chromium intensifier consists of readily available, inexpensive, and relatively nontoxic chemicals. The intensifier is also available in commercially prepared packets. H. A. Miller and J. I. Crabtree[23] have stated, "In many cases where it is desired to produce an increase in density and contrast in a photographic image after the usual processing, chromium intensification has distinct advantages. It is easy to apply, gives a good degree of intensification, and the resulting image is comparatively permanent. The solutions are stable and have considerable exhaustion life. The operation and the results are quite reproducible. The process may be repeated several times on the same image giving increased intensification with each successive treatment." In his "critical resumé of all known methods" of intensification, E. J. Wall[24] concluded, "Summing up, one may say that the chromium intensifier is one of the most practical and least likely to go wrong in an amateur's hands." Someone else has wryly suggested that chromium intensification has not been justly publicized because most of the communications concerning intensification have been devoted to overcoming the difficulties connected with unstable, toxic, and difficult-to-use intensification processes.

Intensification with chromium consists of treating the silver image (first hardened in SH-1 hardener) with either a solution of potassium dichromate (same as potassium bichromate) with hydrochloric[25-26] or hydrobromic acid[27-28] or, alternatively, chromic acid with sodium or potassium chloride.[29-31] Chlorochromates (made by evaporating a dichromate salt with hydrochloric acid) may also be used.[32-33] The silver image is converted to silver chloride. At the same time a quantity of a chromium compound is deposited that is approximately proportional to the amount of silver that was converted to silver chloride. The silver chloride in the photographic material is exposed to light and redeveloped in a conventional developer. The intensified image consists of metallic silver from the development of the silver chloride plus the chromium compound deposited during the treatment with the dichromate solution or as modified during the development. The image is a warm black in color. The intensification by chromium is essentially proportional.

The exact chemical reactions during chromium intensification are not precisely known. Probably the first to use chromium salts in negative aftertreatment was J. M. Eder,[34] who in 1881 used potassium dichromate–hydrochloric acid to treat harsh negatives. The extensive investigation of chromium intensification by D. J. Carnegie and C. Welborne Piper[35-38] just after the turn of the century did much to stir interest in this method of treatment. Other investigators[39] attempted to determine the nature of the deposited chromium compound. Carnegie and Piper, and A. and L. Lumière and A. Seyewetz, felt that potassium chlorochromate was produced when the potassium dichromate and hydrochloric acid were mixed. The chlorochromate salt then reacted with the metallic silver of the image to produce silver chloride and a double chromite of silver and potassium. The equations of the reactions would be

$$K_2Cr_2O_7 + 2\,HCl \longrightarrow 2\left(CrO_2 \begin{smallmatrix} \diagup OK \\ \diagdown Cl \end{smallmatrix}\right) + H_2O$$

$$CrO_2 \begin{smallmatrix} \diagup OK \\ \diagdown Cl \end{smallmatrix} + 2\,Ag \longrightarrow CrO_2 \begin{smallmatrix} \diagup OK \\ \diagdown Ag \end{smallmatrix} + AgCl$$

During development the silver chloride is reduced to metallic silver but the chromite compound is not changed. This compound is of a brownish color, which, if the intensification is repeated, becomes more intense. After the first intensification treatment only one-half the image is metallic silver,

the rest being converted to the chromium compound. Each successive intensification treatment converts one-half the remaining silver to the chromium compound. After five intensifications, so little silver remains that the degree of intensification essentially is unchanged. This interpretation of chromium intensification was supported by Paul E. Boucher,[40] who found that "the first intensification produces the greatest increase in contrast. The increase in contrast seems to approach a limit after intensifying four times. In fact, all the curves for intensification repeated four times or more show slight increases in density for lower values and actual decreases for the higher densities. (See Figure 3.) This meant of course a decrease in the gamma factor and usually a degradation in tone values was to be noted; so that it is not worthwhile to repeat intensification more than about three times." The following increases in density have been given[41] for repeated intensification.

	Density
Chromium + development: once	1.25
Chromium + development: twice	1.6
Chromium + development: three times	2.0

These concepts of chromium intensification have been disputed particularly by R. E. Crowther.[27] Another reference indicates the final image is metallic silver, chromium, and possibly chromium chromate. Crabtree and Muehler[5] list the chemical reaction as

$$2\,Ag + K_2Cr_2O_7 + 2\,HCl \longrightarrow$$

silver potassium hydrochloric
bichromate acid

$$2\,AgCl + \text{a reduction product of the bichromate}$$

silver
chloride

During the redevelopment the silver chloride is reduced to metallic silver, and "a colored compound of chromium (probably a lower oxide) remains in the image thus increasing the density." C. B. Neblette[42] repeats the above equation but adds "a reduction product of the bichromate, sometimes assumed to be CrO_2 or $CrCl_2$." Chromic chromate has also been suggested[30,31] as the brown constituent that is formed.

The early research by Carnegie and Piper indicated that the degree of intensification depends upon the concentration of the potassium dichromate and the hydrochloric acid, especially of the acid. The greatest intensification was produced when the quantities of acid (2 ml/liter) and dichromate (10 g/liter) were small, the degree of intensification decreasing with increasing

Figure 3. The contrast variation produced by the chromium intensifier (Kodak In-4), as determined by Paul E. Boucher [*Am. Annual Phot.*, **49**: 60 (1935)]. Curves 1 and 2 (in the lower section of the above figure) are for 35mm pan film developed for $3\frac{3}{4}$ and 10 min in Kodak D-76 developer. Curves 1a, 1b, 1c and 2a, 2b, 2c show the increase in contrast for chromium intensification of the film strips repeated one, two, and three times. The upper part of the figure shows the increase in contrast (gamma) of the image for the different times of development.

quantities. The rate of reaction is slowed considerably as the acid concentration reaches a high value. Maximum concentrations were said to be 20 g/liter of the dichromate and 40 ml/liter of the acid. Incomplete reaction of the dichromate–hydrochloric acid solution with the metallic silver caused a greater intensification of the lower densities than of the higher densities, producing a subproportional action.

After treatment in the acidic dichromate solution, the negative should be washed for 5 min to remove all traces of the dichromate from the emulsion layer. Insufficient washing causes stains on the negative. The negative should then be exposed during the redevelopment to artificial light or diffused daylight but not sunlight. Too strong a light for exposure may prevent redevelopment, causing stains. The negative is then developed in a non-staining developer of low solvency for silver halide. Developers with a high concentration of sodium sulfite or other silver halide solvents cause a reduction in the lower densities and produce images of a brownish color. Most quick-acting, low-sulfite developers are satisfactory, especially those containing Amidol, *p*-aminophenol, Metol, Metol-hydroquinone, or Phenidone-hydroquinone. For example, Kodak developer D-72 or Du Pont developer 53-D, diluted one part of developer to three parts of water, has been recommended. It was reported by Crabtree and Muehler that the chromium-intensified images could be reduced by treating the image in 5 % hydrochloric acid or 2 % sulfuric acid solution. A 5-min treatment will decrease the amount of the addition product on the silver image, and 30 min will remove almost all of the intensification. Because chromium intensification, or any acid removal of the intensified image, involves strong acid treatment, the need for hardening the negative, as with SH-1, is essential before the chemical after-treatments.

Almost every photographic manufacturer has included a chromium intensifying solution among his published formulas. The solutions are remarkably similar to the Kodak chromium intensifier In-4 given here as an example.

Kodak Chromium Intensifier In-4: Stock Solution

Potassium dichromate (bichromate) (anhydrous)	90.0 g
Hydrochloric acid (concentrated)	64.0 ml
Water to make	1.0 liter

For use, take one part of the stock solution and 10 parts of water.

Harden the negative first in Kodak special hardener SH-1. Bleach the negative in the working solution, wash thoroughly for 5 min, then redevelop

in artificial light or diffused daylight in a rapid-acting, low-solvent developer, such as for 10 min, 68°F, in Kodak developer D-72, diluted one part of developer with three parts of water. Pyro-Metol developer has been suggested[43] for particular use with miniature negatives and so has Amidol.[44] Rinse in water, fix for 5 min, and wash thoroughly before drying. If a greater degree of intensification is desired, the bleach-and-redevelop process may be repeated once again.

When a silver image is intensified by using potassium dichromate–hydrochloric acid followed by redevelopment in D-72 developer, diluted 1:3, as recommended in the In-4 formula, a warmer-toned image results. The addition of various blue-black compounds to the redeveloping solution has been found[23] to be effective in producing more neutral black tones. Benzotriazole, 5-methylbenzotriazole, bromobenzotriazole, chlorobenzotriazole, and 6-nitrobenzimidazole nitrate were used in concentrations of 1:5000 to 1:30,000 in developers such as Kodak D-8 (1:2), D-72 (1:3), and D-19 (1:3). These agents improved the image tone and produced an increase in density and contrast. Cold black tones were obtained when D-72 (1:3) plus 0.1 g of benzotriazole per liter of solution was used as the redeveloper. Miller and Crabtree noted that the benzotriazole compounds affected the tone of the silver image only; they did not affect the chromium compound at all. They concluded that, as a result of intensification with chromium, "The warm tone produced is due primarily to a physical change in the redeveloped silver image rather than to the presence of a brown chromium compound." Only by several repetitions of the intensification procedure is it possible to build up enough of the brown chromium compound to affect the tone of the image.

Chromium intensification is usually thought of in reference to pictorial images, but a modern use has been to intensify weak line images on a spectroscopic plate.[45] A solution of 10% potassium dichromate (15 ml), 10% hydrochloric acid (5 ml), and distilled water (100 ml) was used as the first solution, followed by development in a rapid developer containing a moderate amount of sulfite. Illumination during the development was found to have an important effect, with diffused daylight or artificial light being preferred. It was recommended that chromium intensification can be used expediently when exhausted developer, too low a development temperature, insufficient exposure, or inadequate developing time has produced an image of a spectrum that cannot be rephotographed (rare or expensive sample).

MERCURY INTENSIFICATION

Mercuric bromide, mercuric chloride, or mercuric iodide will react with the metallic silver of a photographic image, forming water-insoluble silver halide

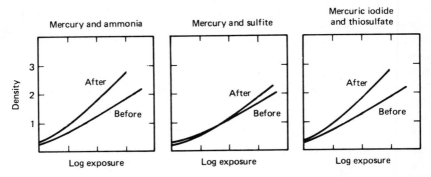

Figure 4. Action of various mercury intensifiers. [T. Thorne Baker, *Brit. J. Phot.*, 53: 264 (1906)]

and water-insoluble mercurous halide salt. The black metallic silver image is completely replaced by a white or light-colored image. No black silver image is visible when the negative is viewed from the back by transmitted light. This whitening of the black silver image is called bleaching. The bleached image is then blackened by treatment in a second solution, although combined bleaching-and-blackening is possible with some formulations of mercury intensifiers. The intensified image consists of metallic silver and mercury metal or a mercury compound of high light opacity. The printing density and contrast of this final image are increased so that an acceptable print can now be obtained. (See Figure 4.) The use of mercury to strengthen the photographic image is as old as photography itself. For silver halide–gelatin photographic materials, the degree of intensification by the silver intensifier has been estimated[46] to be 50%, that given by chromium intensifier to be 40%, but the mercury intensifiers may yield 80 to 100%. Henry W. Bennett[47] recommended chromium intensification for moderate strengthening of the image, suitable for 19 out of 20 cases, but "where it may be required to build up an image which is scarcely visible, mercury intensification is the only process possible." It is this great reinforcement of the image that has caused mercury intensification to be used, even though mercury compounds are dangerous and the intensified image often is not permanent.

Mercuric salts are poisonous. The *Merck Index*[48] contains the following warning concerning mercuric chloride: "*Danger! May Be Fatal If Swallowed.* Do not breathe dust. Keep away from feed or food products. Wash hands before eating or smoking." The *Index* also states: "*Human Toxicity*: Highly toxic. Corrosive to mucous membranes. Ingestion may cause severe nausea, vomiting, hematemesis, abdominal pain, diarrhea, melena, renal damage, prostration. 1 or 2 g is frequently fatal." Because of their poisonous nature, mercuric salts may be difficult to obtain as well as the poisonous potassium

or sodium cyanide that is also often used in mercury intensifiers. Solutions of mercuric compounds, or the cyanide compounds, should not be allowed to contact the human skin; impervious rubber gloves must be used. Acids should not be added to cyanide solutions because hydrogen cyanide, a deadly gas, is evolved. Intensification operations should be carried out in a well-ventilated work area. Mercury compounds attack not only human beings but also metals. Gold and silver jewelry or wrist watches should not be worn while handling mercury intensifying solutions. Glass or plastic trays are recommended for holding the solution during the treatment of the negative.

Highly colored stains have formed on negatives during treatment with mercuric chloride or bromide solutions when the negative is insufficiently fixed and washed. Treating the negative first with a fresh fixing bath, or refixing in an unused bath, washing very thoroughly, hardening in SH-1 hardener, and washing again very thoroughly will help avoid the staining and gelatin-softening difficulties that have been encountered frequently in the past with mercury intensification. In many cases the intensified image is not permanent; in some cases it fades and cannot be regenerated. Graininess of the intensified image is increased more than with the silver or chromium intensifications; for this reason some writers have advised against the use of mercury for the intensification of miniature negatives. H. D'Arcy Power[49] has stated that the mercury process is one which "a man who values his negatives will never employ." Yet, many photographers, including this writer, have found mercury intensification a needed means to rescue a valued negative and have managed to survive the fleeting contact with mercuric salt solutions.

Intensification with Mercuric Chloride or Mercuric Bromide

A plain water solution of mercuric chloride or mercuric bromide cannot be used, as the insoluble mercurous halide salts are precipitated from solution. Adding a small amount of sodium chloride, ammonium chloride, hydrochloric acid, or potassium bromide, in that order, increases the amount of mercuric chloride that can be dissolved in a given volume of water. One of these compounds is usually present in the mercury salt solution for solubility purposes, but the compounds have other beneficial effects. Chapman Jones[50] pointed out that "in practice it is found difficult if not impossible to prevent the mercury salt from combining with the gelatine, when it is employed in a plain solution, and to prevent this it is usual to add a little hydrochloric acid." The hydrochloric acid combines with the gelatin apparently and facilitates the removal of the mercury compound.[51–52] Even so, A. Haddon[53] reported that all the combined mercury salts were not removed by washing

with dilute hydrochloric acid, and the retention by the gelatin of the mercury salt was the cause of later fading of the intensified image. The use of the acid in the mercuric chloride solution is beneficial, however, and does not appear to take part in the intensification reactions.

The first use of mercuric chloride (or bichloride of mercury, as it was called) has been ascribed[54] to Frederick Scott Archer (1852) for use with collodion materials. Since that time a flood of suggestions has been offered to modify either the first bleaching solution or the second solution, used to blackened the whitened image. When mercuric chloride reacts with the metallic silver of the image, mercurous chloride and silver chloride are formed. (Metallic silver is oxidized, losing an electron to the mercuric ion, which is reduced to the mercurous ion.) Both chloride salts are white, have low solubility, and remain in the emulsion layer.

The bleaching action of mercuric chloride was explained by Cosmo I. Burton and Arthur P. Laurie[55] by the equation

$$HgCl_2 + Ag \longrightarrow HgCl + AgCl$$

Chapman Jones[56] felt that the result was not a mixture of the two chlorides but a definite double chloride.

$$HgCl_2 + Ag \longrightarrow HgAgCl_2$$

If mercuric bromide (or mercuric chloride and potassium bromide) was used to treat the silver image, a silver mercurous bromide was produced. The extent of the intensification by either the chloride or bromide mercuric salts was the same.

The white double silver-mercury salt is reduced during the redevelopment step to produce an amalgam of silver and mercury metals or silver and mercury compounds. The exact nature of the final image depends upon the specific action of the solution used to blacken the bleached image. The combined opacity of the diverse products composing the final image determines the degree of the intensification, but the solvency of the redeveloper influences the extent of the departure from proportional reinforcement of the original silver image. Some of the blackening solutions tend to dissolve weak silver image detail, yielding superproportional intensification. Mercury-intensified images are not permanent unless the final image is composed of metallic silver and mercury or converted to the sulfides.[57]

Bleach for Mercury Intensification
(Kodak Mercury Intensifier In-1)

Potassium bromide	22.5 g
Mercuric chloride	22.5 g
Water to make	1.0 liter

Immerse the negative in this solution until the image is completely white as viewed from the film base side of the negative. *Wash thoroughly.* Mercuric salts are difficult to remove from gelatin but must be eliminated in order to avoid staining of the negative. Soaking the negative in several baths of acidified water (one part of hydrochloric acid in 300 parts of water) has been suggested[58] for the removal of the mercury salts from the gelatin. Solubilization of the silver mercurous chloride from the image must be avoided, however, as fine image detail may be lost.[50] The In-1 bleach lists only a thorough water wash, probably the best choice for weak images where detail must be retained.

Blackening Solutions Following Image Bleaching

After the negative is bleached and washed, the image is blackened to produce the final image. Through the years many chemical treatments have been proposed for this purpose. As E. J. Wall[59] points out, "Almost every procedure now used was originally suggested for the older processes"—that is, the waxed paper, albumen, and collodion processes that preceded the gelatin–silver halide materials. The most-used blackening solutions include the following, listed in order of increasing intensifying action:

1. *Sodium sulfite.* Immersion of the well-washed bleached negative in 10% sodium sulfite (concentrations of 4 or 5% have also been suggested) until the image is completely darkened yields a slight increase in image density over the original density. A representation of the chemical action was given by Chapman Jones.[50,56]

$$4\,HgAgCl_2 \longrightarrow \underbrace{3\,HgCl_2 + 2\,AgCl} + Ag_2Hg$$

$$\text{dissolved by the}$$
$$\text{sodium sulfite}$$

Jones summarized this action as follows: "When sodium sulphite reacts upon mercurous silver chloride, the whole of the chlorine goes into the solution, three-fourths of the mercury and half the silver are also dissolved, and one-fourth of the mercury and half the silver remain in the metallic condition to form the image." For negatives that are slightly fogged, the solvent action of the sodium sulfite will clear out the shadow details. For negatives that have weak shadow detail, however, the sulfite blackener will result in a loss of shadow details. Only the higher densities will be increased slightly, and the lower densities may actually be lowered from the original density values. Successive treatments do not materially increase the slight degree of intensification.

2. *A photographic developer.* A photographic developing solution, such as Kodak developer D-72 (one part of developer diluted with two parts of water), can be used to blacken the bleached negative. Most modern developers contain sodium sulfite, often in appreciable quantities, so the solvent effect of the sulfite limits the degree of the intensification and may decrease image detail in the areas of least exposure. Thus, developing solutions must contain very little sulfite or none at all. Chapman Jones[60,61] tried Amidol, catechol, Eikonogen, Metol, Ortol, pyrogallol, and other reducing substances, but reported that none was as satisfactory as ferrous oxalate for blackening the silver mercurous chloride of the bleached image. Ferrous oxalate developers do not contain sodium sulfite, reducing the silver mercurous chloride quantitatively to the metals, that is, AgHg. This intensified image may then be intensified again in the same way as before (mercuric chloride followed by ferrous oxalate development).

$$AgHg + 2HgCl_2 \longrightarrow AgHg_3Cl_4 \xrightarrow[\text{oxalate}]{\text{ferrous}} AgHg_3 + \text{soluble products}$$

The intensification may be repeated many times, the image gaining as many atoms of mercury as there are atoms of silver and mercury in the image before the last treatment.

Original	First Intensification	Second Intensification	Third Intensification
Ag	AgHg	$AgHg_3$	$AgHg_7$

Summarizing the action of this type of intensification, Chapman Jones[62] said, "When a negative bleached with mercuric chloride is acted on by ferrous oxalate, the image that remains consists of an amalgam of silver, the metals being in the proportion of one atom of each, AgHg. If the process of intensification is repeated, each atom takes another atom of mercury and we get an amalgam in which the proportion of the metals is as in the formula $AgHg_3$." The factor for the increase in density was 1.45 for each treatment.[63] The intensification was exactly proportional. The all-metal image is permanent.

Ferrous oxalate is not soluble in water to any extent but may be prepared by mixing solutions of ferrous sulfate and potassium oxalate under slightly acidic conditions. The negative is first bleached in mercuric chloride intensifier solution, washed thoroughly (20 min) in running water; then the image is blackened in the following ferrous oxalate developing solution:[64]

Solution No. 1

Potassium oxalate (neutral)	240 g
Water (hot)	1 liter

(Cool this solution and use clear supernatant liquid.)

Solution No. 2

Ferrous sulfate	240 g
Sulfuric acid	3 ml
Water	1 liter

For use, pour one part of solution 2 into three parts of solution 1. Treat the bleached negative until completely blackened when viewed from the film base side. Wash the negative thoroughly.

3. *Dilute ammonia solution.* The blackening of mercury-bleached images with dilute ammonia was proposed as early as 1854. A complex silver–mercury–ammonium chloride compound of a black color is formed. Not more than a 5 % solution of ammonia is advisable, as the solvent action forms soluble silver ammonium chloride that is washed from the image. The loss of the solubilized silver may impair fine detail in shadow areas and alter the tone rendition of the intensified negative. Such intensifying action may prove to have some value in strengthening line-copy negatives, but generally ammonia blackening is not recommended for negatives with shadow details. The image is not permanent and apparently consists of silver, mercury, chlorine, and ammonia with the formulas $NH_2AgHgCl$ and $NHAgHg_2Cl$ suggested by Jones.[65–66] Once the image has faded, it cannot be regenerated. A dilute ammonia solution (one part 28 % ammonia and nine parts water) can be used only once before it must be discarded.

T. Thorne Baker[67] found that mercury bleaching followed by ammonia (10 %) blackening produced proportional intensification of all densities (as did mercury and acetone sulfite), but mercury and sodium sulfite caused the low densities to be reduced, and intensification occurred in the denser portions. Long times of treatment, however, in the sodium sulfite solutions did give intensification at all levels of image density.

4. *Monckhoven's intensifier.* The use of a potassium cyanide solution saturated with silver nitrate as a blackening solution for images bleached in mercuric chloride has been named after Désiré van Monckhoven, who

proposed it in 1879.[68] Monckhoven's Reducer, as listed in *The British Journal Photographic Almanac* of 1894, consisted of

Solution A

Potassium bromide	23 g
Mercury bichloride	23 g
Water	1 liter

Solution B

Potassium cyanide	23 g
Silver nitrate	23 g
Water	1 liter

Immerse the silver image in solution A until the image is whitened, then rinse in water and immerse in solution B. A weak solution of sodium thiosulfate was suggested for reduction of the image if the intensification was carried too far.

E. J. Wall[54] has pointed out that "as a matter of history it should be recorded that potassio-cyanide of silver was suggested by Ad. Martin as early as 1854." Certainly, Martin's description[69–70] of his intensification method is very similar to the one named after Monckhoven:

The plate, sensitized in the ordinary way, is exposed in the camera for a rather shorter time than when intended to be developed with pyrogallic acid, and the development is effected instead by means of sulfate of iron.

Silver thus reduced is white, and will only give grey shadows. How can we transform this white into black silver? By pouring on the developed and well-washed *but not fixed* image a saturated solution of non-acid bichloride of mercury: the reduced silver becomes black by the precipitation of metallic mercury. The proof is then carefully washed, and covered with a solution of cyanide of silver in cyanide of potassium.

This solution is obtained by dissolving forty-eight grains of cyanide of potassium in one ounce of water, and adding thereto a sufficiency of a fifty-grain solution of nitrate of silver, until the precipitated cyanide of silver which results ceases to be redissolved on shaking it up. The liquid, after filtration, is ready for use.

In 1873, six years before Monckhoven's publication, H. J. Burton[71] described in detail a process identical to that of Monckhoven except that ammonium chloride was used in place of potassium bromide in the mercuric chloride bleaching bath, a minor change chemically.

The method of mixing the blackening solution is important. A slight excess of silver must be used,[72] or the free potassium cyanide has a tendency

to act as a solvent for the finely divided silver particles of the image. Fine detail in the weakly exposed areas of the image may be dissolved away. The potassium cyanide–silver nitrate blackening solution is particularly suited for line images, as the heavier silver deposits of the image are greatly strengthened and the background silver is removed. Overexposed but under-developed negatives of full tone scale have weak detail in the low exposures that may be lost while the higher densities are greatly intensified. This action produces a considerable gain of image contrast.

When a potassium (or sodium) cyanide solution is combined with a silver nitrate solution, a precipitate of silver cyanide is formed. Part of this precipitate goes back into solution as the soluble potassium silver cyanide salt. This salt reacts with the bleached image. The exact chemical reaction is not completely known, but, according to J. I. Crabtree and L. E. Muehler,[5] "The final image probably consists of silver, silver chloride or bromide, silver cyanide and mercuric cyanide." C. E. K. Mees[73] lists the following reactions of potassium silver cyanide with the silver and mercurous chloride formed during the bleaching treatment:

(1) $$HgCl + KAg(CN)_2 \longrightarrow Ag + Hg(CN)_2 + KCl$$

(2) $$AgCl + KAg(CN)_2 \longrightarrow 2AgCN + KCl$$

If all the reactions were complete, one or two molecules of silver chloride or silver cyanide would be added for each atom of silver. This image is subject to change with time. If desired, treating the intensified image with 5% sodium thiosulfate for 5 min will reduce the image densities to values similar to the original unintensified image.[65] The thiosulfate treatment may also be used to remove staining that may have occurred.[74]

Kodak mercury intensifier In-1 uses the Monckhoven blackening solution for darkening the bleached image. The image is bleached in a solution of potassium bromide (22.5 g) and mercuric chloride (22.5 g) in a liter of water. The thoroughly washed negative is then treated in the blackening solution, which is made in the following manner:

Solution A

Water	500 ml
Sodium cyanide	15.0 g

Solution B

Water	500 ml
Silver nitrate, crystals	22.5 g

Add the silver nitrate (solution B) to the sodium cyanide (solution A) in small quantities. Vigorous agitation will dissolve the precipitate of silver cyanide that forms, but eventually a permanent precipitate forms that cannot be dissolved by stirring. The presence of the permanent precipitate indicates that all the cyanide has been combined with silver and the silver nitrate is in slight excess. After the solution has stood for a short time, filter off the precipitate and protect the solution from a strong light.

The bleached and washed negative must be blackened completely (as viewed from the film base side) because the reaction must go to completion.

5. *Sodium sulfide solution.* A 2% solution of sodium sulfide may be used for a blackening solution for hardened and bleached negatives. A 1% sulfide solution has also been suggested.[75-76] A brown image of the sulfides of mercury and silver is formed that produces a high degree of intensification. The image is permanent. Only one intensification treatment can be made. A mercury-sulfide intensifier has also been proposed.[77] Any sulfide solution will give off an unpleasant odor, and sodium sulfide has a detrimental effect upon photographic films and papers that it might reach. Sodium sulphantimoniate, $Na_3SbS_4 \cdot 9H_2O$, called Schlippe's salt, has also been suggested[78-79] as a blackener for mercury-bleached images, but this compound, too, has an unpleasant odor.

Mercuric Iodide Intensifier

Intensification based on mercuric chloride or mercuric bromide requires two solutions: one for bleaching and another for blackening the bleached image. Potassium iodide has been used in a separate solution following the mercuric chloride solution.[80] A solution containing both mercuric chloride and potassium iodide was mentioned[81] as early as 1861. But these solutions were only the bleaching step of a two-part intensifier that included a separate solution for blackening the image. In 1879 B. J. Edwards[82-86] proposed the simultaneous use of mercuric chloride, potassium iodide, and sodium thiosulfate to form a single-solution, self-blackening intensifier. A similar solution was proposed by A. J. Jarman,[87] causing some controversy,[88-90] but Edwards was acknowledged as its originator.[91] The solution composition was modified by others,[92-93] notably by J. M. Eder[94-95] and by Lumière Frères and Seyewetz,[96-99] and then largely forgotten. The history of Edwards' iodide intensifier has been recounted by W. B. Shaw,[100-101] who concluded that "Of no other photographic process can it be said that both the history and the technique are in such a chaotic state as they are in the case of the mercuric iodide intensifier. Almost every writer on the subject contradicts some other author."

Edwards' formula as revised by W. B. Shaw is given below (the composition is identical to Du Pont 2-I Mercuric Iodide Intensifier)[102]:

Mercuric Iodide Intensifier

Mercuric iodide	20 g
Potassium iodide	20 g
Sodium thiosulfate, crystals	20 g
Water to make	1 liter

After fixation, the negative need be washed only 5 min, as the intensifying solution contains thiosulfate. The negative is immersed in the iodide solution, and the degree of intensification may be followed visually. The intensification is proportional to the time of immersion, but treatment beyond 20 min produces little additional effect. After the desired intensification has been secured, the negative is washed for 20 min and dried. The image is not permanent. A permanent image may be secured by treating the negative in 1% sodium sulfide solution. Redevelopment in a nonstaining developer has also been suggested if increased stability of the intensified image is required.

The advantages of the improved Edwards' intensifier have been summarized by Shaw as the following:

The plates need not be washed free from hypo before intensification is commenced.

Intensification takes place, directly and visibly, in one step. It is therefore under constant control.

The intensification, if unsatisfactory, can be removed entirely by treating the plate with 20% hypo solution. (This must be done before any after-treatment is applied.)

Local intensification can be carried out under continual observation, and local density can be built up to a required strength with ease and certainty. Moreover, errors are remediable. (If *very* exact matching of density is essential, sulphiding should be omitted. If the plates are only of temporary importance, no after-treatment is necessary. No alteration in density occurs if the negatives are treated with M.-Q. developer, and their stability is thereby greatly increased, although they cannot be regarded as being absolutely permanent.)

The intensified images, if sulphided, are absolutely permanent.

Stains and failures are almost unknown.

Mercuric iodide reacts with the metallic silver of the image to produce mercury and silver iodide. The reaction, according to Mees,[103] is

$$2\,Ag + HgI_2 \longrightarrow 2\,AgI + Hg$$

Treatment with sodium sulfide produces the sulfides of silver and mercury without much change in density. The intensification is greater with the lower than with the higher densities. The lowest densities are about doubled by the intensification, but the higher densities are increased about 1.4 times.[104]

In a 1970 U. S. patent[105] a proposal was made to enhance the density of the silver image produced by the very fine-grained emulsions (Lippmann type) by replacing the silver image with one consisting only of metallic mercury. The processed metallic silver image is treated with a solution consisting of one mole of mercuric iodide and six moles of potassium iodide. The treatment period was "only one hour." Smaller quantities may take up to 20 hr. The mercuric ion reacts with metallic silver to give silver ion and mercurous ion. The silver ions first form insoluble silver iodide, which, in excess iodide of the solution, dissolves to form soluble $(Ag_2I_4)^-$. This is removed from the gelatin layer. The mercurous ion first reacts with iodide to form the insoluble Hg_2I_2, which reacts further with iodide ions

$$Hg_2I_2 + 2I^- \longrightarrow (HgI_4)^- + Hg^0\downarrow$$

The grains and filaments of the original image are completely replaced by spherical metallic mercury particles. The water-soluble salts are removed, and the end product was said to be both enhanced and stable.

URANIUM INTENSIFICATION

Uranium intensifier has great power in building up faint, almost invisible, detail in an extremely thin negative. (See Figure 5.) It has been called "the best builder of detail of any intensifier; detail that is scarcely perceptible to the eye in an underexposed negative can be built up, by its use, into printable densities."[106] The intensification was found[104] to be approximately proportional in the low and mid negative densities, giving about 250 % increase in photographic density over the original negative density. The intensification is less at higher densities, though still around a 200 % increase. This very great increase in photographic density of the negative is achieved because the uranium intensifier converts the black silver image to a highly colored image, ranging from reddish brown to bright red. This colored image filters the light used to make a print exposure, resulting in a much greater photographic effect than can be determined by visual examination of the intensified negative.

Uranium intensifier is difficult to use, as the visual evaluation of image density is less than the photographic effect of the colored image. It is often recommended[107] that the negative be removed from the intensifier while the image is still brown, and before a red color is obtained, in order to

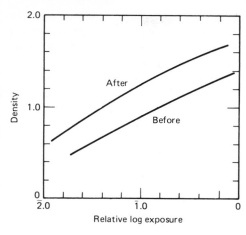

Figure 5. The effect of uranium intensification. [D. T. Copenhafer, *Photo Developments*, 25 (11): 33 (1950)]

shorten the printing time. The image, which is not permanent, has been said to contain uranium, iron, silver, and a small amount of potassium.[108] Matthew Wilson[109] suggested silver ferrocyanide, $Ag_4Fe(CN)_6$, and uranium ferrocyanide $[UFe(CN)_6]$, as constituting the image. The brown image, formed when the uranium is in excess, is said to have the formula $(UO_2)_3K_2[Fe(CN)_6]_2$; the red image (with the ferricyanide in excess) is supposed to be $K_6(UO_2)_4[Fe(CN)_6]_4$.[110–114] Fortunately, should the photographic density of the intensified negative become too great, the intensification may be removed by washing the negative in dilute ammonia or sodium carbonate solution. The negative may then be reintensified, but any alkalinity remaining in it must be first neutralized with a weak solution of acetic acid.

A two-bath uranium intensifier has been suggested.[30,31]

<div align="center">

Solution A

</div>

Potassium ferricyanide	50 g
Water	1 liter

<div align="center">

Solution B

</div>

Uranium nitrate	59 g
Potassium bromide	20 g
Water	1 liter

The well-washed negative is treated in solution A until completely bleached, then washed very thoroughly and immersed in solution B until no further action can be observed. The negative is bathed in dilute baths of acetic acid, then in distilled water (never hard water), and dried.

A single-solution uranium intensifier is made from two stock solutions.

<div align="center">

Ilford Uranium Intensifier In-5

</div>

<div align="center">

Stock Solution A

</div>

Uranium nitrate	22.0 g
Water to make	1.0 liter

<div align="center">

Stock Solution B

</div>

Potassium ferricyanide	22.0 g
Water to make	1.0 liter

To make working solution:

Solution A	4 parts
Solution B	4 parts
Glacial acetic acid	1 part

After intensification, wash the negative in several changes of water made acid with a few drops of glacial acetic acid.

In each of the formulations given, washing of the negative is specified to be in acidified water. This is important. Uranium ferrocyanide is formed during the intensification, and this compound is soluble in alkaline solution. Washing in hard water is sufficient to remove the uranium ferrocyanide. Actually, washing an overintensified negative in hard water is one way to remove the intensification before intensifying again.

OTHER METAL INTENSIFIERS

Lead-Ferricyanide Intensifier

Like uranium, lead forms a ferrocyanide that is less soluble than the ferricyanide. Thus, lead can be used to prepare a powerful intensifier suitable for negatives with very faint image detail. The lead nitrate–potassium ferricyanide intensifying solution was first utilized by J. M. Eder and V.

Toth[115-118] in 1876 for collodion plates, but essentially the same composition with the addition of glacial acetic acid has been used for gelatin–silver halide materials. The silver of the image is converted to silver ferrocyanide and potassium ferrocyanide. In the presence of the lead salt, the soluble potassium ferrocyanide is converted to the insoluble lead ferrocyanide.[103] After washing, the image is treated with sodium sulfide, depositing one and one-half molecules of lead sulfide on each atom of silver.

The formula of a lead intensifier is compounded as follows[119-120]:

Potassium ferricyanide	40 g
Lead nitrate	60 g
Glacial acetic acid	20 ml
Water to make	1 liter

This stock solution keeps for a long time if stored in the dark. After bleaching, the negative is placed in three successive baths of 3% hydrochloric acid, allowing 5 min in each. (Alternatively, one brief immersion in 10% nitric acid has also been suggested,[121] but the gelatin may become very tender.) The negative is then carefully but thoroughly washed until all the yellow color has been removed. The image is blackened in a 5% solution of sodium or ammonium sulfide.

A very high degree of intensification, essentially proportional but with greater effect upon the low densities, is obtained with lead. This intensifier has never been overly popular, possibly because, as E. J. Wall notes,[122] "The smell of the sulphide (this delightful substance is familiarly but vulgarly known as 'stinko') is extremely objectionable."

Copper Intensification

Cupric chloride and bromide were used in intensifiers for collodion plates,[123] and later formulas were perfected for silver halide material.[124-125] A copper-silver intensifier, said by André Callier[119,126] to have been first used by M. Fery for gelatin materials, gave great intensification with only moderate increase in graininess. The image intensification could be repeated several times. The well-washed negative was placed in the copper bleach bath:

Copper sulfate	25 g
Potassium bromide	25 g
Water	1 liter

This solution acts as though it were copper bromide, bleaching the image:

$$Ag + CuBr_2 \longrightarrow AgBr + CuBr$$

The soluble potassium sulfate is removed by immersing the bleached negative for 5 min in each of three or four baths of 2% glacial acetic, then washed in distilled water to remove most of the acetic acid from the gelatin. Blacken the negative in a 2% solution of silver nitrate. The cuprous bromide reacts further to form

$$CuBr + 2AgNO_3 \longrightarrow Cu(NO_3)_2 + Ag + AgBr$$

The net result is to produce two molecules of silver bromide for each atom of silver of the image.

The negative is again washed in distilled water, then immersed in a weak solution of sodium chloride (salt). The salt precipitates the excess of silver nitrate, which may produce fog in a later step. The silver chloride produced is dissolved by placing the negative in 10% sodium sulfite solution. The negative is finally developed in daylight, preferably with an Amidol developer. This converts the silver bromide to metallic silver. The image is silver–stable and capable of reintensification.

A copper-tin intensifier was proposed by J. Desalme[127] to produce dense black intensified images. The negative is first bleached in

Cupric chloride	25 g
Hydrochloric acid	4 ml
Water to make	1 liter

(Or use 47 g copper sulfate and 11 g sodium chloride to form the cupric chloride.)

The following blackening solution is prepared and filtered just before use:

Stannous chloride	28.5 g
Water	250 ml

Separately, dissolve

Sodium hydroxide	22 g
Water	750 ml

and add to the stannous chloride solution until a clear solution is obtained. The bleached-and-washed negative is treated with the stannous chloride-sodium hydroxide solution until quickly blackened, then rinsed with water, treated with 2% sodium bisulfite solution, and finally washed in water before drying.

L. P. Clerc[128] studied the intensification factor—that is, the density of intensified image divided by the density of the image before intensification—of the copper-tin intensifier of Desalme. He found that "the factor is remarkably constant, the measured values do not depart more than 1 in 100 from their average 1.66, and thus the intensifier must be classed among the most regular in action and most suitable for the intensification of very weak negatives. It may also be said that it is one of the most energetic of those applicable to halftone negatives, considering that the density factor of the intensifier prepared with mercuric chloride and ferrous oxalate developer is, according to Mr. Chapman Jones, only 1.45."

QUINONE THIOSULFURIC ACID INTENSIFIER

Quinone or sodium quinone sulfonate with potassium bromide were used by A. and L. Lumière and A. Seyewetz[129–131] in 1910 to produce a bath that changed the color of the image resulting in a small degree of intensification. The image becomes reddish brown with the quinone intensifier or yellow brown with the quinone sulfonate intensifier. The presence of sodium thiosulfate in the negative was undesirable, as a reddish fog is produced. In 1939 K. C. D. Hickman and J. C. Hecker[132–134] patented a toning-and-intensifying solution containing quinone thiosulfuric acid or hydroquinone thiosulfuric acid with an oxidizing agent (potassium dichromate) that produced an intensification of three to five times. Sodium thiosulfate was one of the ingredients of the intensifier, so that the sensitivity to thiosulfate remaining in the negative was greatly diminished. This formula was improved by L. E. Muehler and J. I. Crabtree[135] in 1945. The improved formulation became known as Kodak Quinone-Thiosulfate Intensifier In-6. (See Figure 6.)

"The following quinone-thiosulfate type of intensifier produces a greater degree of intensification than any other known single-solution intensifier, particularly when used with high-speed negative materials," was the claim of Muehler and Crabtree.[136] For a coarse-grained roll film, the intensification resulted in an increase of approximately 900% in the effective photographic density. Very fine-grained film materials were merely toned or intensified to a negligible degree. The quinone-thiosulfate toner-intensifier is thus most effective with medium- and high-speed photographic materials, and another intensifier should be used for fine-grained films.

The intensified image is brownish, not indefinitely stable, and considered to have a useful life similar to that of uranium-intensified images (estimated to be at least five years at 75°F and 60% R.H.). The quinone-thiosulfate intensifier is believed to cause an oxidation of the silver image followed by

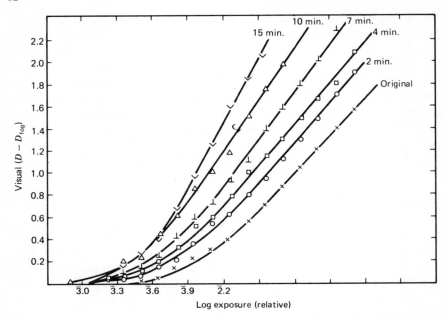

Figure 6. Effect of time of treatment in the quinone-thiosulfate intensifier at 68°F (20°C). [L. E. Muehler and J. I. Crabtree, *J. PSA*, **11** (2): 120 (1945)]

the immediate formation and deposition of a silver salt or complex of a hydroquinone- or quinone-thiosulfuric acid. These compounds are dark brown salts, and the intensified image may be a mixture of

The quinone-thiosulfate intensifier is made by adding hydroquinone to potassium dichromate solution to oxidize the hydroquinone to quinone. The quinone is then allowed to react with sodium thiosulfate to produce hydroquinone thiosulfuric acid. A further amount of the dichromate solution is then added to oxidize the hydroquinone thiosulfuric acid to quinone thiosulfuric acid. This compound converts the silver of the image to silver ion. The silver ion forms a dark brown salt that precipitates because of its low solubility in water. The dark brown precipitate is more soluble than

silver chloride, however, so the presence of chloride ion must be avoided. If chloride ion is present in the water used to prepare the intensifier, or there is other chloride or bromide contamination, the degree of intensification will be greatly lessened. Water containing more than 15 ppm chloride ion (25 ppm sodium chloride) should not be used. Distilled water or uncontaminated rain water have been recommended. Avoid touching the surface of the emulsion layer either before or during intensification in order to avoid surface markings.

Photographic films may be intensified immediately after fixing or after they have been thoroughly washed and dried normally. In either case, wash the film for 5 min in running water, harden for 5 min in SH-1 hardener, and wash again for 5 min. Each negative is intensified individually in a minimum amount of solution in the Kodak In-6 Intensifier that is prepared from three stock solutions. A definite order of addition of the stock solutions is important and should be followed.

Kodak In-6 Intensifier

Stock Solution A

Water (about 70°F)	750.0 ml
Sulfuric acid (concentrated)	30.0 ml
Potassium dichromate	22.5 g
Water to make	1.0 liter

Stock Solution B

Water (about 70°F)	750.0 ml
Sodium bisulfite	3.8 g
Hydroquinone	15.0 g
Kodak Photo-Flo Solution	3.8 ml
Water to make	1.0 liter

Stock Solution C

Water (about 70°F)	750.0 ml
Sodium thiosulfate (crystals)	22.5 g
Water to make	1.0 liter

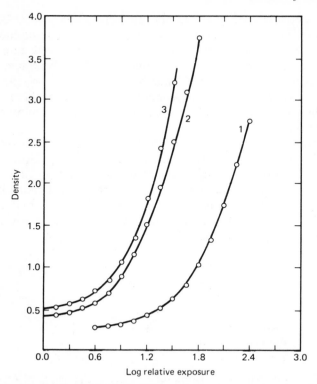

Figure 7. **Characteristic curves of Kodak Industrial X-ray film, Type K, for (1) normal processing and (2) 5-min and (3) 10-min treatment in Kodak Intensifier In-6. [G. M. Corney and H. R. Splettstosser,** *Non-Destructive Testing,* **10 (1): 29 (1951)]**

For making the working intensifying solution, mix the stock solutions in the following way, while stirring:

1. Add two parts of solution B to one part of solution A.
2. Then add two parts of solution C.
3. Finally, add one part of solution A.

 Intensification of the individual negative may be carried out for 10 min for maximum effect (5 min for high density intensification) or for less time if such a high degree is not needed. The film should be agitated frequently

during the intensification treatment. The film is then washed for 20 to 30 min and dried normally. The intensified negative should not be placed in a fixing bath or in wash water contaminated with fixing bath. Acid fixing baths remove practically the entire image. Negatives that have received maximum intensification are appreciably grainy. The In-6 treatment is, however, particularly useful for greatly underexposed photographic materials. For example, underexposures as large as a factor of 5 on industrial radiographs have been intensified to give adequate radiographic quality.[137-138] (See Figure 7.)

If the image is overintensified, all intensification may be removed by bleaching the negative in an acid permanganate solution and then re-developing the image.[139] Kodak Stain Remover S-6 may be used as the bleaching solution, then treating the image in 1% sodium bisulfite. Expose the negative to strong light, then develop in any rapid, nonstaining developer, such as Kodak D-72 developer, diluted one part of developer with two parts of water. Developers with silver halide solvents, such as high concentrations of sodium sulfite, should be avoided. After the image has been developed, rinse 1 min in dilute acetic acid solution, wash thoroughly, and dry.

DYE INTENSIFICATION

In alkaline solutions of low sodium sulfite content, the benzene-derived developing agents (except Glycin) produce a secondary stain image resulting from the oxidation of the developing agent during development of a photographic image.[140] The intensity of the stain diminishes as the sulfite content increases. With pyrogallol, the secondary stain image failed to appear above 10% sodium sulfite, but 2% of the sulfite was sufficient to inhibit stain formation with the other developing agents. The yellowish stain that was formed imagewise when a low-sulfite pyrogallol developer was used had long been observed and credited by some photographers with the excellence of pyro-developed negatives. A system of intensification by redevelopment was proposed by J. M. Eder[141] and later by R. B. Wilsey.[142-143] The silver of an image was bleached, exposed, then developed in a low-sulfite pyrogallol developer. Wilsey claimed that when an Elon-hydroquinone developed negative was bleached, then developed in the pyro developer, "any intensification up to double the original photographic contrast can be secured." Nearly as much intensification was said to result when a pyro-developed negative was bleached and redeveloped in pyro again. Pyrogallol was also suggested by Negatak in 1925 for treating faulty negatives.[144]

The Wilsey redevelopment technique for intensification consisted of bleaching the negative in a ferricyanide bleach having this composition:

Potassium bromide	10.0 g
Potassium ferricyanide	30.0 g
Water to make	1.0 liter

The negative was then developed, after exposure to a strong light, in a solution of pyrogallol (5 g/l) and sodium carbonate (10 g/l) for 5 min.

The image is permanent, and the intensification is proportional to the original silver in the image. The image may be bleached and redeveloped several times with some gain in intensification, but the gain is not as much as during the initial redevelopment.

Another form of dye reinforcement of the silver image was proposed as early as 1865 by M. Carey Lea.[145-147] He proposed using chemical substances, called mordants, that would enable dyes to adhere to the metallic silver of the image. Dye toning is the name given to this type of image intensification, and such a technique has been of interest ever since, because the image graininess is not increased. Dye toning is thus a form of intensification that can be used to advantage on small negatives. Generally, an attempt is made to add a mixture of dyes that approximate a black color, so that the amount of image reinforcement is visually apparent. In practice, however, the photographic effect may be unequal to the visual estimation of the degree of the intensification. In some cases a yellow-green dye is used, as this has high photographic effect, but it is somewhat difficult to evaluate visually.

During the 1920s F. E. Ives[148] and A. L. Lumière and A. Seyewetz[149] proposed methods to intensify silver images by adding dye to reinforce the image. In 1956 the Leitz formula for dye intensification, based on the Lumière and Seyewetz method, was described.[150] The negative is placed in a copper sulfate bleach bath, where the following reaction occurs:

$$Cu(CNS)_2 + Ag^\circ \longrightarrow CuCNS + AgCNS$$

The bleach bath has the following composition:

Water	1.0 liter	
Copper sulfate	33	g
Potassium citrate	60	g
Glacial acetic acid	30	ml
Ammonium thiocyanate	28	g

The clean negatives, one at a time, are treated in the bleach bath for 2 min, during which time the surface of the silver image is converted to cuprous

thiocyanate and silver thiocyanate. These compounds will allow the dye to adhere to the surface of the image silver. After bleaching, the negative is given a rinse in water, then placed in a dye bath of the composition

Methylene blue (1 % solution)	287 ml
Rhodamine S (1 % solution)	380 ml
Neophosphine (1 % solution)	333 ml

During this dye bath the negative should be swabbed with a wad of cotton. The dye treatment can take from 5 to 15 min, depending upon the degree of intensification required. During this time the negative may be removed from the dye solution, rinsed in water, and inspected. Overintensification may be reduced by prolonged washing in water. A 5-min treatment in the dye bath doubled the emulsion speed of the image, increased contrast from 0.7 to 1.35, and increased fog from 0.21 to 0.46. (See Figure 8.)

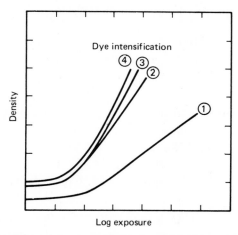

Figure 8. Effectiveness of dye intensification using the Leitz formula.

Curve No.	Time in Dye Bath (min)	Fog Level	Gain in Emulsion Speed	Gamma
1	Untreated	0.21	—	0.7
2	5	0.46	2 times	1.35
3	10	0.48	2 times	1.45
4	15	0.49	$2\frac{1}{6}$ times	1.60

[*Leica Fotografie*, English Edition, p. 67 (March–April 1956)]

A bleaching solution containing the same compounds as the Leitz (and the Lumières and Seyewetz) was also used by C. Van Duijn, Jr.,[46] but with stock dye solutions. The dye solution for intensification is prepared from three stock solutions:

Stock Solution A (Red)

Rhodamine B	1 g
Glacial acetic acid	2 ml
Water to make	100 ml

Stock Solution B (Yellow)

Auramine	1 g
Glacial acetic acid	2 ml
Water to make	100 ml

Stock Solution C (Blue)

Methylene blue	1 g
Glacial acetic acid	2 ml
Water to make	100 ml

The dye intensification bath consists of

Solution A	38 ml
Solution B	33 ml
Solution C	29 ml

The Kodak Dye Toning Solution T-17, utilizing a uranium nitrate–potassium ferricyanide bleaching solution, has also been proposed[151] for dye intensification.

Kodak Mordant Bath T-17: Stock Solution

Uranium nitrate	8.0 g
Oxalic acid	4.0 g
Potassium ferricyanide	4.0 g
Water to make	1.0 liter

Dissolve each ingredient in a small amount of water. Add the oxalic acid solution to the uranyl nitrate solution, then add the solution of potassium ferricyanide. Add water to make one liter of clear, yellow solution. Mix in the recommended order to avoid formation of low-solubility precipitates. Store solution in the dark as the solution is light-sensitive. For use, one part of stock solution is mixed with four parts of water.

Treat the negative until a very light brown tone is evident. In a fresh solution this will require about $1\frac{1}{2}$ to 2 min. Then wash 15 min in water to remove yellow stain from the negative. Do not wash longer than this, for uranium ferrocyanide of the image is slightly soluble in water.

A yellow-green dye solution was suggested by E. G. Ashton[151] for dyeing the negative.

Dye Bath

Malachite green	0.13 g
Auramine	0.06 g
Acetic acid (glacial)	4 drops
Water to make	590 ml

Dissolve the dyes in hot water and then filter. When the solution has cooled, add the acetic acid. Immerse the washed negative from 2 to 10 min in the dye bath, depending on the degree of intensification required. Wash thoroughly in water. If the time of immersion was less than 10 min, the washed negative may be returned to the dye bath. Wash again. The whole procedure of mordanting and dye treatments may be repeated for additional intensification. If too much dye has been taken up, some may be removed by immersion in 0.2% ammonia solution. Washing in warm water may be used to remove some of the dye from the negative.

RESTORATION OF FADED PHOTOGRAPHIC PRINTS

Intensification may be used to rejuvenate faded photographic prints. It is possible that the use of filters, air brushing, spotting, and other suitable techniques may restore the print to a condition from which a suitable copy negative can be made. This procedure is recommended first for a valued print. If the old print was correctly processed, but the image has faded from oxidative factors (peroxides, sulfides, ammonia), the yellowish toned image, often of low density, may be improved by chemical methods of intensification. (See Figure 9.)

Figure 9. Restoration of faded photograph through the use of sodium borohydride solution. Only the left half of this old photograph, mounted on card, was swabbed with the borohydride solution to show darkening of the image. (From the author's collection)

The treatment of a faded print, even a mounted one, is possible if sodium borohydride is used. This compound decomposes to hydrogen, sodium hydroxide, and boric acid.

$$NaBH_4 + H_2O \longrightarrow BH_3 + NaOH + H_2$$

$$\quad\quad\quad\quad\quad\quad\quad\quad\quad\quad |\; +\,HOH$$

$$\quad\quad\quad\quad\quad\quad\quad\quad\quad\quad \longrightarrow H_3BO_3$$

These by-products of a borohydride treatment may be removed sufficiently by a water treatment of the print surface.

A solution containing 1 or 2 g of sodium borohydride in a liter of distilled water is suitable. The solution begins to decompose immediately, liberating hydrogen gas, so that it remains effective only about 30 to 60 min. The borohydride treatment is followed by a water rinse applied by a swab and then blotted. Excessive surface rubbing is to be avoided.

Prints faded from excessive thiosulfate retention (but not excessive silver thiosulfates) may be restored. Brown-toned prints are restored to a black image, but selenium-toned prints are not rejuvenated. Once restored, the prints appear to resist later image instability, even though a mounted print may have had only a brief water treatment following the borohydride application.

SUMMARY OF INTENSIFICATION METHODS

Intensification is often less than successful because the procedures are being used for the first time to rescue a failure from conventional processing. Success is more likely if one uses intensification sufficiently often to gain familiarity and experience in image enhancement. Even the selection of the most suitable intensifier is a problem. The intensifiers listed in the previous sections represent only a cross section of the great number of formulations that have been proposed from the beginning of photography. It is most difficult to find scientific comparisons of the characteristics given by the various intensifying procedures, but a few have been published. Table 1 gives characteristics of the more important intensification methods.[46]

The visual effect of intensification is the enhancement of the image as seen by the eye—usually a guide to controlling the degree of intensification. The photographic effect of the intensification determines the characteristics of the final printed image, as the photographic emulsion responds differently to the image than the human eye would view it. The differences in the visual and photographic response to the added density of the image were plotted by A. H. Nietz and K. Huse[104] for a number of the intensification procedures. (See Figure 10.) In the two graphs the base line represents the densities of original silver image. Any line above this line, and parallel to it, would represent strictly proportional development. The height of the lines above the base represents the percentage of density increase, showing the great effectiveness of lead or uranium intensification. Very few intensifiers produce proportional intensification, although a few approximate it.

A given type of intensifier acts differently on different types of photographic materials and on images of different size. Four intensifiers

- Mercuric chloride–ammonia (Modified Kodak In-1)
- Chromium intensifier (Kodak In-4)
- Silver intensifier (Kodak In-5)
- Quinone-thiosulfate intensifier (Kodak In-6)

Table 1. Comparison of Intensification Methods

Type of Intensifier	Average Degree of Intensification	Increase in Graininess	Especially Suited for
Silver	25% in 10 min 50% in 20 min	Little	Underdeveloped, normally exposed negatives; first treatment of much under-exposed negatives
Chromium	40%	Little	Negatives that must be increased more in density than in contrast
Mercury	80 to 100%; after hardening, 45%	More	Normally exposed, under-developed negatives; under-exposed, normally developed negatives
Monckhoven	80 to 100%	More	Fogged negatives
Dye	No exact figures available; may be about 30 to 60%	None	Miniature film
Quinone-thiosulphate (Kodak In-6)	Up to 900%; with fine-grain negatives, below 100%	Much	Very much underexposed, coarse-grain negatives

Source: From C. Van Duijn, Jr., *Amer. Phot.*, **42**: 146 (1948).

Figure 10. Percent increase in visual and photographic density produced by various methods of intensification.

No.	Bleaching Solution	Blackening Solution
I	Mercuric chloride	Ammonia
VI	Potassium dichromate and hydrochloric acid	Amidol developer
VII	Mercuric bromide	Amidol developer
X	Mercuric iodide	p-Aminophenol developer
XII	Uranium	Brit. J. Phot. Almanac formula
XIII	Lead ferricyanide	Sodium sulfide
XVI	Mercuric iodide	Schlippe's salt
XVII	Potassium ferricyanide and potassium bromide	Sodium sulfide

[A. H. Nietz and K. Huse, *J. Frank. Inst.*, 185: 393, 401 (1918)]

were used by Fred H. Perrin and J. H. Altman[152] to intensify three types of photographic materials:

- High-speed negative
- Fine-grain negative
- High-contrast positive

The effect of intensification was studied on the resolving power of low, medium, and high densities on the three photographic films. Although

intensifiers do not follow a general rule, the following conclusions were
given:

Intensifiers vary in the amount of damage they do to the resolving power of the image,
and some do none whatever. Speaking generally, the silver intensifier is the least deleter-
ious, although it is also the least potent on two of the three emulsions studied. At high
densities, however, intensifiers improve resolution, so this is a way of increasing
resolving power at high densities. The probable increase in graininess may make this
procedure impracticable, however, and in addition, the resolution is usually injured at
low densities.

With the mercury, chromium, and quinone-thiosulfate intensifiers it was
better to give the proper exposure in the camera than to underexpose-and-
intensify the image if high resolving power is required at low values of the
final image density. The silver intensifier increased the resolving power for
the useful density range of the two negative films but the optimum density
of the positive emulsion was so high that the resolving power was almost
unaffected.

REFERENCES

1. J. G. Capstaff and M. W. Seymour, "The Duplication of Motion Picture Negatives,"
 Trans. SMPE, **10**: 223 (1926).
2. C. E. Ives and E. Huse, "Notes on Making Duplicate Negatives," *Trans. SMPE*, **12**: 382
 (1928).
3. H. W. Bennett, "Intensification and Reduction," *Phot. J.*, **53**: 214 (1913).
4. J. I. Crabtree and G. E. Matthews, *Photographic Chemicals and Solutions*, Am. Phot. Pub.
 Co., Boston, 1938, pp. 314–315.
5. J. I. Crabtree and L. E. Muehler, "Reducing and Intensifying Solutions for Motion
 Picture Film, *J. SMPE*, **17**: 1001 (1931).
6. G. Balagny, "Silver Intensification," *Brit. J. Phot.*, **44**: 552 (1897).
7. R. E. Blake-Smith, "The Silver Intensification of Dry-Plate Negatives," *Brit. J. Phot.*,
 56: 82 (1909).
8. R. E. Blake-Smith, "Further Notes on Silver Intensification," *Brit. J. Phot.*, **57**: 43 (1910).
9. R. E. Blake-Smith, "Intensification of Dry Plates with Silver," *Brit. J. Phot.*, **63**: 20 (1916).
10. J. B. B. Wellington, "A New Silver Intensifier," *Brit. J. Phot.*, **58**: 551 (1911).
11. J. B. B. Wellington, "Silver Intensification," *Brit. J. Phot. Almanac*, p. 604 (1912).
12. J. B. B. Wellington, "An Improved Silver Intensifier for Gelatine Plates, Etc.," *Brit. J.
 Phot. Almanac*, p. 575 (1889).
13. J. B. B. Wellington, "Silver Intensification," *Brit. J. Phot. Almanac*, p. 588 (1890).
14. "The Wellington Silver Intensifier," *Camera*, **48** (4): 264 (1934).
15. *The Chemistry of Photography*, 6th Edition Revised, Mallinckrodt Chemical Works,
 St. Louis, 1940, p. 63.
16. "Wellington's Silver Intensifier," *Brit. J. Phot. Almanac*, p. 322 (1959).

17. Allan F. Odell, "An Improved and Simplified Process," *Camera*, **46** (4): 217 (1933).

18. Allan F. Odell, "New Process of Physical Development," *Brit. J. Phot.*, **80**: 286 (1933).

19. Allan F. Odell, "Physical Development," *Camera*, **48** (2): 73 (1934).

20. Franz Baur and Gottl. Imhof, "A New and Efficient Method of Fine Grain Development," *Camera*, **48**: 256 (1934).

21. Allan F. Odell, "Intensification by the Physical Method," *Camera*, **49** (2): 73 (1934).

22. D. T. Copenhafer, "Correction of Negatives," *Photo Developments*, **25** (11): 32(1950).

23. H. A. Miller and J. I. Crabtree, "Chromium Intensification of Positive Transparencies," *J. PSA*, **9** (7): 300 (1943).

24. E. J. Wall, *Intensification and Reduction*, Am. Phot. Pub. Co., Boston, 1927, p. 11.

25. J. S. Teape, "Intensification without Metallic Salts," *Brit. J. Phot.*, **51**: 272 (1904).

26. Sellors, "Intensification by Bleaching," *Brit. J. Phot.*, **51**: 1074 (1904).

27. Raymond E. Crowther, "A Modified Bleacher in Chromium Intensification," *Brit. J. Phot.*, **66**: 709 (1919).

28. Raymond E. Crowther, "Chromium Intensification with Chlorochromate," *Brit. J. Phot. Almanac*, p. 368 (1921).

29. C. H. Bothamley, "Chromium Intensification," *Brit. J. Phot. Almanac*, p. 278 (1919).

30. C. H. Bothamley, "Some Minor Processes of Photography," *Phot. J.*, **58**: 48 (1918).

31. C. H. Bothamley, "Some Minor Processes of Photography," *Brit. J. Phot.*, **65**: 111 (1918).

32. A. and L. Lumière and A. Seyewetz, "Chromium Intensification with Chlorochromates," *Brit. J. Phot.*, **66**: 451 (1919).

33. A. and L. Lumière and A. Seyewetz, "Chromium Intensification with Chlorochromate," *Brit. J. Phot. Almanac*, p. 369 (1920).

34. J. M. Eder, "Changing the Colour of Gelatine Images," *Phot. News*, **25**: 262 (1881).

35. C. Welborne Piper and D. J. Carnegie, "Intensification by Redevelopment: A New Process," *Amat. Phot.*, **40**: 336, 397, 435, 473, 505 (1904–1905).

36. C. Welborne Piper and D. J. Carnegie, "Intensification with Chromium," *Brit. J. Phot. Almanac*, p. 794 (1906).

37. C. Welborne Piper, "Chromium Intensification," *Brit. J. Phot.*, **54**: 3 (1907).

38. W. T. P. Cunningham, "Intensification," *Phot. J.*, **56**: 2 (1916).

39. R. E. Crowther, "A Note on the Chromium Intensification Process," *J. Soc. Chem. Ind.*, **35**: 817 (1916).

40. Paul E. Boucher, "A Study of Contrast Variation Obtained with the Chromium Intensifier," *Am. Annual Phot.*, **49**: 59 (1935).

41. H. W. Bennett, "Intensification and Reduction," *Phot. J.*, **53**: 214 (1913).

42. C. B. Neblette, *Photography, Its Principles and Practice*, 4th Edition, Van Nostrand, New York, 1944, p. 574.

43. David Charles, "Intensifying Miniature Negatives," *Min. Cam. Mag.*, **1** (6): 346 (1937).

44. Philip Johnson, "Reducing and Intensifying Miniature Negatives," *Min. Cam. Mag.*, **10**: 451 (1946).

45. A. Petrakev and G. Dimitrov, "Application of Chrome Intensifier for Intensifying Photographic Images on Spectroscopic Plates," *Zhur. Nauch. Prikl. Fot. Kinemat.*, **14** (4): 259 (1969) (in Russian).

46. C. Van Duijn, Jr., "Intensification of Negatives," *Am. Phot.*, **42**: 144 (1948).

47. Henry W. Bennett, "Intensification of a Very Weak Image," *Brit. J. Phot.*, **78**: 405 (1931).

48. "Mercuric Chloride," *The Merck Index*, 8th Edition, edited by Paul G. Stecher, Merck and Co., Rahway, N.J., 1968, p. 659.

49. H. D'Arcy Power, "Chromium and Sulphur Intensification of Negatives and Prints," *Camera Craft*, **38** (2): 73 (1931).

50. Chapman Jones, "A Chemical Study of Mercurial Intensification," *Phot. J.*, **17**: 95 (1893).

51. H. Lloyd Hind, "Mercury Solutions," *Brit. J. Phot. Almanac*, p. 637 (1908).

52. "Intensification with Mercury," *Brit. J. Phot.*, **44**: 402 (1907).

53. A. Haddon, *Eder's Jahrbuch*, **18**: 469 (1904).

54. E. J. Wall, "Some Historical Notes," *Brit. J. Phot.*, **68**: 197 (1921).

55. Cosmo I. Burton and Arthur P. Laurie, "A New Mercury Intensifier," *Phot. News*, **25**: 269 (1881).

56. Chapman Jones, "On Control in the Density of Negatives," *Phot. J.*, **14**: 40 (1890).

57. C. E. Kenneth Mees, *The Theory of the Photographic Process*, Revised Edition, Macmillan, New York, 1954, p. 748.

58. E. J. Wall and Franklin I. Jordan, *Photographic Facts and Formulas*, Am. Phot. Pub. Co., Boston, 1947, p. 127.

59. E. J. Wall, *Intensification and Reduction*, Am. Phot. Pub. Co., Boston, 1927, p. 5.

60. Chapman Jones, "A System of Intensification," *Phot. News*, **32**: 18 (1888).

61. Chapman Jones, "On the Proposed Substitutes for Ferrous Oxalate in Mercurial Intensification," *Phot. J.*, **50**: 241 (1910).

62. Chapman Jones, "Intensification by Mercuric Chloride and Ferrous Oxalate," *Phot. J.*, **50**: 238 (1910).

63. Chapman Jones, "The Optical Effects of Intensification," *Phot. J.*, **21**: 233 (1897).

64. D. T. Copenhafer, "Correction of Negatives," *Photo Developments*, **25** (10): 36 (1950).

65. Chapman Jones, "On the Product of the Action of Mercuric Chloride upon Metallic Silver," *J. Soc. Chem. Ind.*, **12**: 983 (1893).

66. Chapman Jones, "On the Product of the Action of Mercuric Chloride upon Metallic Silver," *Phot. News*, **38**: 166 (1894).

67. T. Thorne Baker, "The Theory and Practice of Intensification," *Brit. J. Phot.*, **53**: 264 (1906).

68. D. van Monckhoven, "Die Bromsilber-Gelatine," *Phot. Corr.*, **16**: 208 (1879).

69. Ad. Martin, "Transparent Positives," *Phot. News*, **5**: 339 (1861).

70. Ad. Martin, "On the Production of Transparent Positives and on the Transferrence of Collodion," *Brit. J. Phot.*, **8**: 270 (1861).

71. H. J. Burton, "On the Production of Negatives of Line Subjects for Photo-Lithography, Etc.," *Year-Book of Photography*, p. 97 (1873).

72. H. J. Channon, "A Hint Regarding the Cyanide of Silver Intensifier," *Brit. J. Phot. Almanac*, p. 825 (1898).

73. C. E. Kenneth Mees, *The Theory of the Photographic Process*, Revised Edition, Macmillan, New York, 1954, p. 749.

74. F. J. Fogliano and Carlo Gordo, "Modified Mercuric Chloride Intensification of Miniature Negatives," *Am. Phot.*, **31**: 677 (1937).

75. C. Harold Smith, "Mercury-Sulphide Intensifier," *Brit. J. Phot. Almanac*, p. 760 (1907).

76. C. Harold Smith, "Mercury-Sulphide Intensifier," *Brit. J. Phot.*, **63**: 20 (1916).

77. H. Mennenga, "A Mercury-Sulphide Intensifier," *Brit. J. Phot.*, **73**: 703 (1926).

78. W. E. Debenham, "Intensifying Gelatine Negatives," *Brit. J. Phot.*, **28**, 566 (1881).

79. W. E. Debenham, "Permanent Intensification with Mercury," *Brit. J. Phot.*, **34**: 585 (1887).

80. F. Maxwell Lyte, *J. Phot. Soc.*, **1**: 128 (1853).

81. "Visiting Card Portraits," *Phot. News*, **5**: 13 (1861).

82. "Mercurial Intensification for Gelatine Plates," *Brit. J. Phot.*, **26**: 467 (1879).

83. "The Mercury and Hyposulphite Developer," *Brit. J. Phot.*, **26**: 552 (1879).

84. B. J. Edwards, "Intensifying Gelatine Negatives," *Brit. J. Phot.*, **26**: 561 (1879).

85. B. J. Edwards, "Intensifying Gelatine Negatives," *Phot. News*, **23**: 609 (1879).

86. B. J. Edwards, "Intensifying Gelatine Negatives," *Brit. J. Phot. Almanac*, p. 56 (1880).

87. A. J. Jarman, "The Gelatine Negative Process," *Phot. News*, **23**: 595 (1879).

88. William Cobb, "Photographic Plagiarism," *Brit. J. Phot.*, **27**: 11 (1880).

89. A. J. Jarman, "The Hypo Mercurial Intensifier," *Brit. J. Phot.*, **27**: 23 (1880).

90. A. J. Jarman, "Photographic Plagiarism, Etc.," *Brit. J. Phot.*, **27**: 35 (1880).

91. A. J. Jarman, "Intensifying Gelatine Negatives," *Phot. News*, **23**: 617 (1879).

92. "Mercurial Intensifiers," *Brit. J. Phot.*, **27**: 218 (1880).

93. G. Watmough Webster, "Mercurial Intensification for Gelatine Negatives," *Brit. J. Phot.*, **26**: 469 (1879).

94. J. M. Eder, "A New Mercuro-Cyanide Intensifying Process for Gelatino-Bromide Plates," *Phot. News*, **26**: 274 (1882).

95. J. M. Eder, *Modern Dry Plates*, E. and H. T. Anthony, New York, 1881, p. 79.

96. Lumière Frères and Seyewetz, "On the Use of Mercuric Iodide for Intensification," *Brit. J. Phot.*, **46**: 827 (1899).

97. "Iodide of Mercury Intensifiers," *Brit. J. Phot.*, **47**: 274 (1900).

98. J. M. Eder, "Modern Intensifiers for Gelatino-Bromide Plates and Their Effect," *Brit. J. Phot.*, **47**: 68 (1900).

99. Henry F. Raess, "Mercuric Iodide Intensifier," *Am. Annual Phot.*, **24**: 25 (1910).

100. W. B. Shaw, "Edwards' Iodide Intensifier Rediscovered," *Brit. J. Phot.*, **80**: 327 (1933).

101. H. D'Arcy Power, "Iodide Intensifier," *Camera Craft*, **41**: 248 (1934).

102. "2-I Mercuric Iodide Intensifier," Chemicals and Formulas for Du Pont Graphic Arts Films, E. I. du Pont de Nemours and Co., Wilmington, Delaware.

103. C. E. Kenneth Mees, *The Theory of the Photographic Process*, Revised Edition, Macmillan, New York, 1954, p. 749.

104. A. H. Nietz and K. Huse, "The Sensitometry of Photographic Intensification," *J. Frank. Inst.*, **185**: 389 (1918).

105. Allen W. Grobin, Jr., "Enhanced and Stable Photographic Images," U.S. Pat. 3,523,790 (1970).

106. Robert Taft, "Intensification," *The Complete Photographer*, Vol. 6, National Educational Alliance, New York, 1943, p. 2127.

107. Paul N. Hasluck, *The Book of Photography*, Cassell and Co., London, 1907, p. 134.

108. A. and L. Lumière and A. Seyewetz, "On the Composition of the Silver Image Toned with Various Metals," *Brit. J. Phot.*, **52**: 68 (1905).

109. Matthew Wilson, "The Theory and Practice of Intensification," *Brit. J. Phot.*, **49**: 614 (1902).

110. G. Hauberrisser, *Eder's Jahrbuch*, **16**: 560 (1902).

111. Georg Hauberrisser, "Intensification," *Process Photogram*, **9**: 41 (1902).

112. Georg Hauberrisser, "Misserfolge beim Verstärken mit Uran," *Eder's Jahrbuch*, **18**: 79 (1904).

113. E. J. Wall, "The Colour of Uranium-toned Images," *Brit. J. Phot.*, **53**: 418 (1906).

114. L. P. Clerc, "Toning with Ferrocyanides," *Brit. J. Phot.*, **47**: 249 (1900).

115. Josef Maria Eder and Victor Tóth, "Die Bleiverstärkung, eine neue Verstärkungsmethode," *Phot. Corr.*, **13**: 10 (1876).

116. Josef Maria Eder and Victor Tóth, "New Experiments in Intensification with Lead," *Brit. J. Phot.*, **23**: 580 (1876).

117. Josef Maria Eder and Victor Tóth, "Intensification with Lead: A New Method," *Brit. J. Phot.*, **23**: 104 (1876).

118. Josef Maria Eder, "The Reaction of Red Prussiate of Potash Upon Metallic Silver and the Conversion of Silver Negatives," *Brit. J. Phot.*, **23**: 140 (1876).

119. André Callier, "Powerful Intensification of Gelatine Plates," *Brit. J. Phot.*, **58**: 152 (1911).

120. A. Callier, "Lead Intensifier," *Brit. J. Phot. Almanac*, p. 603 (1912).

121. "Lead Intensifier," *Brit. J. Phot. Almanac*, p. 322 (1959).

122. E. J. Wall, *Intensification and Reduction*, Am. Phot. Pub. Co., Boston, 1927, p. 15.

123. M. Carey Lea, "Remarks on a Process for Strengthening Negatives," *Phila. Phot.*, **2**: 72 (1865).

124. W. Abney, "On a Neglected Method of Intensification," *Phot. News*, **21**: 171 (1877).

125. Harold Jeffreys, "The Intensification of Negatives," *Brit. J. Phot.*, **57**: 541 (1910).

126. A. Callier, "Renforcements intensifs pour Plaques au Gélatino-bromure," *Bull. Belge Assn. Phot.*, **38**: 165 (1911).

127. J. Desalme, "Intensification with Copper and Tin," *Brit. J. Phot.*, **59**: 215 (1912).

128. L. P. Clerc, "Some Tests of the Copper-Tin Intensifier," *Brit. J. Phot.*, **59**: 215 (1912).

129. A. and L. Lumière and A. Seyewetz, "Quinone and Quinone Compounds for Intensification and Colour Toning," *Brit. J. Phot.*, **57**: 949 (1910).

130. A. and L. Lumière and A. Seyewetz, "Quinone Intensifier," *Brit. J. Phot. Almanac*, p. 606 (1912).

131. A. and L. Lumière and A. Seyewetz, "Quinone Compounds in Intensification and Toning," *Brit. J. Phot.*, **69**: 784 (1922).

132. Kenneth C. D. Hickman and John C. Hecker, "Toning and Intensifying Solutions," U. S. Pat. 2,158,184 (1939).

133. Kenneth C. D. Hickman and John C. Hecker, "Toning and Intensifying Solutions," U. S. Pat. 2,158,185 (1939).

134. Kenneth C. D. Hickman and John C. Hecker, "Toning and Intensifying Solutions," U. S. Pat. 2,158,186 (1939).

135. L. E. Muehler and J. I. Crabtree, "A Single-Solution Intensifier for Very Weak Negatives," *J. PSA*, **11** (2): 81 (1945).

136. L. E. Muehler and J. I. Crabtree, "A Single-Solution Intensifier for Very Weak Negatives," *Phot. J.*, **86B**: 32 (1946).

137. G. M. Corney and H. R. Splettstosser, "Intensification of Underexposed Industrial Radiographs," *Non-Destructive Testing*, **10** (1): 29 (1951).

138. G. I. P. Levenson, "Thick or Clear?," *Funct. Phot.*, **4** (3): 5 (1952).

139. Ellie Haburton and Ralph Haburton, "Accentuate the Negative," *Minicam Phot.*, **8** (10): 34 (1945).

140. A. and L. Lumière and A. Seyewetz, "The Colour of Developed Silver Images," *Brit. J. Phot.*, **75**: 172 (1928).

141. Josef Maria Eder, "Correctur von zu harten oder gelbschleierigen Negativen durch Überführen in Chlor- oder Bromsilber und Wiederentwickeln," *Eder's Handbuch*, 5th Edition, Vol. 3, p. 561 (1903).

142. R. B. Wilsey, "Intensification and Reduction with Pyro Developers," *Phot. J. Am.*, **56**: 558 (1919).

143. R. B. Wilsey, "Intensification and Reduction with Pyro Developers," *Brit. J. Phot.*, **66**: 721 (1919).

144. Negatak, "Pyro and the Treatment of Faulty Negatives," *Brit. J. Phot.*, **72**: 216 (1925).

145. M. Carey Lea, "Dyeing Negatives," *Brit. J. Phot.*, **12**: 162 (1865).

146. M. Carey Lea, "Dyeing Negatives," *Phila. Phot.*, **2**: 55 (1865).

147. "Dye-Toning in 1865," *Brit. J. Phot.*, **71**: 161 (1924).

148. F. E. Ives, "The Mordant Dye Process for Negative Intensification," *Brit. J. Phot.*, **68**: 187 (1921).

149. A. and L. Lumière and A. Seyewetz, "Intensification by Dye-Toning," *Brit. J. Phot.*, **73**: 147 (1926).

150. "Dye Intensification of Leica Negatives," *Leica Fotografie*, English Edition, p. 66 (March–April 1956).

151. E. G. Ashton, "Dye Intensification," *Brit. J. Phot.*, **91**: 330 (1944).

152. Fred H. Perrin and J. H. Altman, "Studies in the Resolving Power of Photographic Emulsions. V. The Effect of Reduction and Intensification," *J. Opt. Soc. Am.*, **42**: 462 (1952).

Chapter 2

Chemical Treatment of the Silver Image

REDUCTION

*Negatives are quickly ruined by over-reduction—
never by under-reduction!*

ADOLF FASSBENDER[13]

Either overexposure or overdevelopment may produce negatives that have too much silver in the image. Too much exposure produces a negative that is flat in appearance (lacking a full range of silver deposits from the almost-clear shadow areas to highlight silver deposits that can just still pass light), often foggy, and lacking contrast. Too much development produces an overly contrasty negative with dense silver deposits that are almost incapable of letting light pass. Overdevelopment and overexposure produce negatives that require an unusually long exposure to make prints, especially when small negatives must make enlarged prints. The tone scale obtained in the prints is distorted and unacceptable for most normal purposes. Correcting such negatives is the purpose of photographic reduction, a chemical aftertreatment that removes enough of the excess silver of the image so that an acceptable print may be made from the negative.

The first step in the intensification of photographic images using metal-ion intensifying solutions is the conversion of the metallic silver image

(Ag0) to low-solubility silver compounds. The first step in photographic reduction is the conversion of a very small amount of the metallic silver of the image to soluble silver compounds or a silver compound that can be solubilized and removed by a silver solvent, such as thiosulfate ions. Both intensification with metal ions and photographic reduction involve the chemical oxidation (the loss of electrons) of the metallic silver image. Photographic reduction is a chemical oxidation process, a somewhat confusing situation, because chemical reduction is not the principal reaction when the term "reduction" is used. Reduction refers to the lessening of the amount of metallic silver in the image, not the chemical reaction involved in the solubilization of the image silver.

The action of photographic reducing solutions has been classified into types depending on the way in which silver is removed from the original silver deposits of the image. (See Figure 1.) A photographic reducer may lessen the image density by

1. Removing image silver so that equal density increments are subtracted from the low to the highest densities of the image. Subtractive or cutting reducers are of this type. Subtractive reducers are useful in correcting the veiled negatives produced by overexposure but without a change in image contrast.
2. Removing image silver so that the density is lessened proportionally to the original density, resulting in a lowering of the image contrast. Proportional reducers are effective in correcting the densities given by over-development.
3. Removing image silver so that the denser parts of the image lose more silver than the areas of less density. Superproportional reducers act to remove more silver from the areas of greater density. This type of reducer lowers or flattens contrast, so the name "flattening reducer" is sometimes used. This name leads to confusion, as proportional reducers also lower or flatten contrast. Superproportional reducers are used to correct overdevelopment.

The name "subproportional reducer," sometimes used[1] for one that removes more silver at lower densities, has been superseded by "subtractive" or "cutting reducer." Most subproportional reducers approach the action of the subtractive type as a limit. Subtractive reducers, when used to reduce fine-grained images of essentially the same particle size, remove silver so that the image density is lessened in equal increments from both high and low densities. They tend to remove more silver from the denser portions when the image is composed of a wide range of silver particle sizes. Dilution of a subtractive reducer, or lowering of the concentration of its ingredients, can convert it into a reducer giving proportional reduction. It is thus unwise

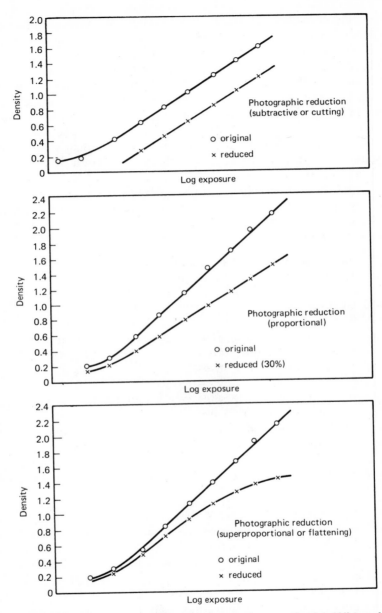

Figure 1. The effect on image density of subtractive (top), proportional (middle), and super-proportional (bottom) reducers. [J. I. Crabtree and L. E. Muehler, *J. SMPE*, 17: 1020–1022 (1931)]

to associate a specific chemical with one of the types ·of reducing action. Reducing solutions should be chosen for their action to correct overexposure or overdevelopment, or both.

Reduction can be a valuable technique for improving the photographic images on film or paper prints. The necessary skill is derived from experience, however, so practice with an unfamiliar solution on an important negative is to be guarded against, as once fine image detail is lost, it may not be regained.

The following suggestions should help minimize some of the difficulties sometimes encountered with reducing solutions:

- A completely fixed and thoroughly washed negative or print will avoid the formation of stains.
- A hardened photographic negative, such as one treated in Kodak SH-1 or other formaldehyde hardener, can better withstand those highly acid or gelatin-softening reducing solutions.
- Treat only one negative or print at a time.
- After a brief immersion in the reducing solution, plunge the negative or print into running water, then evaluate the extent of reduction after the reducing action has been stopped. (Do not attempt to evaluate the extent of reduction during treatment in the reducing solution, as a rapid-acting reducer may remove image detail before the action can be stopped.)
- Thoroughly wash the treated image to remove retained chemicals in the emulsion layer, which may cause staining with the passage of time.

REDUCERS FOR CORRECTING OVEREXPOSURE

Overexposed images need to be reduced subtractively. Accidental fogging of the negative, resulting from unintended light exposure or from chemical action during development, can also be treated effectively with a subtractive reducing solution. Sharpening the edges of lines or dot images is possible with a cutting (subtractive) reducing solution. This type of reducer can also remove the fog given by over-age photographic paper. Some print makers make regular use of a subtractive reducing solution to "brighten" photographic prints, applying it either locally to lighten dark areas or over the entire print area.

Farmer's Reducer

When E. Howard Farmer[2] proposed "A Convenient Reducing Agent" with an eight-sentence description in the *Year-Book of Photography* in

1884, he could not have foreseen the universal acceptance that his solution of potassium ferricyanide and sodium thiosulfate would achieve. Farmer's reducer is the most widely used of all reducing solutions. This interest has occasioned a flood of published variations. As E. J. Wall[3] said (in 1927): "The notes on this are legion, in many cases they are utterly contradictory and certainly far too voluminous to permit of abstraction, even if they were worth it." The action of Farmer's reducer, however, has been well documented by several modern scientific studies.

Farmer's reducer consists of a solution of potassium ferricyanide and sodium thiosulfate in water. The ferricyanide converts the metallic silver of the image to silver ferrocyanide, an insoluble compound. Silver ferrocyanide, however, is solubilized by the sodium thiosulfate and removed. The image silver is lessened in quantity by the combined action of the two compounds. The chemical reactions were represented by J. I. Crabtree and L. E. Muehler[4] as follows:

$$4\,Ag \ + 4\,K_3Fe(CN)_6 \longrightarrow Ag_4Fe(CN)_6 + 3\,K_4Fe(CN)_6$$

silver	potassium	silver	potassium
(metallic)	ferricyanide	ferrocyanide	ferrocyanide

$$3\,Ag_4Fe(CN)_6 + 16\,Na_2S_2O_3 \longrightarrow$$

silver	sodium
ferrocyanide	thiosulfate

$$4\,Na_5Ag_3(S_2O_3)_4 + 3\,Na_4Fe(CN)_6$$

sodium silver	sodium
thiosulfate	ferrocyanide

The work of Crabtree and Muehler helped to resolve some of the controversy concerning the nature of the reducing action. The type of reduction achieved is influenced by the concentration of the ferricyanide and thiosulfate in the solution as well as by the distribution of sizes of silver particles in the photographic image. When the reducing solution consisted of 1% of potassium ferricyanide and 10% of sodium thiosulfate, the effect was that of a pure subtractive reducer with both negative and positive films. (See Figure 2.) With a lower concentration of the ferricyanide (0.4%) and thiosulfate (5%), the action was nearly subtractive with the positive film, but the effect on the negative film was to remove more silver from the higher than from the lower densities of the image, approaching proportional reduction. Small silver particles are more easily dissolved than larger ones, so the distribution of particle sizes in the image, as well as the strength of the chemical ingredients of the reducing solution, influence the final effect upon the image.

Every photographic manufacturer lists a ferricyanide-thiosulfate reducer; all are similar in chemical composition, differing mainly in the dilution of

Figure 2. The subtractive or cutting reducing action as shown by Farmer's reducer: 1.0% potassium ferricyanide and 10% sodium thiosulfate. [J. I. Crabtree and L. E. Muehler, *J. SMPE*, 17: 1023 (1931)]

the stock solution. The Kodak Farmer's Reducer R-4a[5] is representative of this subtractive type of reducing solution.

Kodak Farmer's Reducer R-4a

Stock Solution A

Potassium ferricyanide	37.5 g
Water to make	500.0 ml

Stock Solution B

Sodium thiosulfate (crystals)	480.0 g
Water to make	2.0 liters

Combine the solutions just before use, in the proportions listed below, as the mixed solution has a short useful life.

Add	Solution A	30 ml
To	Solution B	120 ml
Then dd	Water to	1 liter

For less rapid action

Add	Solution A	15 ml
To	Solution B	120 ml
Then add	Water to	1 liter

Pour mixed reducing solution over the clear, wet negative (soaked 10 min in water at 70°F) in a white tray and rock the tray continuously. Remove the negative and wash in running water, then evaluate the extent of reduction after the action has been stopped.[6] The immersion in the reducing solution, then in the water, can be repeated until the desired effect is achieved. If an attempt is made to evaluate the reducing effect in the reducing solution, remove the negative somewhat before the desired effect is achieved. The reducing action continues in the water, so an allowance must be made for this additional reduction of image detail. Wash thoroughly to remove all of the reducing chemicals, then dry.

As soon as the ferricyanide and thiosulfate are mixed, the thiosulfate begins to reduce the ferricyanide to ferrocyanide, destroying the reducing action. The mixed solution must be prepared just before use and discarded when the yellow color is lost. It is possible to extend its life once by adding more potassium ferricyanide solution, but freshly mixed Farmer's reducer is to be preferred. Solution stability, according to Crabtree and Muehler,[4] can be increased by the addition of 10 ml of ammonia or 10 g of desiccated sodium carbonate per liter of reducing solution.

The limited life of a mixed Farmer's reducer was suggested by Alexander Murray[7] as a basis for a chemical retouching solution for securing optimal halftone dots on screen negatives and positives. A mixed solution of 100 ml of 53.3% sodium thiosulfate crystals and 5 ml of 30% potassium ferricyanide has an active life of 63 sec at 75°F. By adjusting the concentration of ferricyanide, thiosulfate, and water as well as the operating temperature, it was possible to make self-limiting reducing solutions that automatically stopped acting. The photographic emulsion layers treated should be wet; dry layers may show little effect because of slow diffusion rates.

With some photographic materials, removal of a considerable part of the silver image by Farmer's reducer may reveal a brown stain in the remaining image. This stain, believed to be sodium sulfide, may be prevented by the presence of potassium iodide in the fixing bath used to process the image initially.[8] From 0.1 to 1.0% potassium iodide in the fixing bath was suggested by Crabtree and Muehler.[4] To eliminate staining in the low-density areas of photographic prints that are reduced with Farmer's solution, Don

D. Nibbelink[9] suggested the addition of potassium cyanide,* an extremely toxic chemical, to the solution, as follows:

Sodium thiosulfate (crystals), 20%	150 ml
Potassium ferricyanide, 10%	50 ml
Potassium cyanide, 2%	10 ml

Dilute one part of this solution with 20 parts of water for use.

The residual brown stain of sodium sulfide left around the edges of image silver, such as line or dot images, can be prevented from forming by using a ferricyanide-thiosulfate reducing solution that contains thiourea as an added silver-solubilizing agent.

Kodak Non-Staining Reducer R-14

Stock Solution A

Water (125 to 140°F)	2 liters
Thiourea	60 g
Sodium thiosulfate (crystals)	2800 g
Cold water to make	4 liters

Stock Solution B

Water (125°F)	750 ml
Potassium ferricyanide	300 g
Cold water to make	1 liter

For dot etching:

To solution A	5 parts
Add water	14 parts
Before use add solution B	1 part

For line clearing:

To solution A	5 parts
Add water	100 parts
Before use add solution B	1 part

After reduction, wash the negatives for 5 min, then dry normally.

* A reducer consisting of iodine crystals (1 g) and sodium cyanide (5 g) in a liter of water can be used to remove image silver without leaving a brown stain.

The presence of potassium bromide in Farmer's reducer has been said to increase the length of the activity by about 30%.[10-13] The rapidity of action is decreased by the presence of the bromide, but the slower action is beneficial for the treatment of photographic prints. One such solution contains ferricyanide, thiosulfate, and bromide, and is prepared as follows:[13]

Stock Solution A

Water	444 ml
Sodium thiosulfate (crystals)	85 g

Stock Solution B

Water	177 ml
Potassium ferricyanide	28 g
Potassium bromide	14 g

Mix 148 ml of solution A and 15 ml of solution B and use immediately, as the mixed solution does not remain active more than 5 to 10 min.

A number of modifications of Farmer's reducer have been suggested. As early as 1891 the addition of ammonia to the potassium ferricyanide–sodium thiosulfate was reported to prevent yellowing.[14] Later, A. Edwards[15] said that "the addition of ammonia to the reducer accelerates its action, prevents the tendency to yellow stain, and modifies the character of the reduction, which, instead of increasing contrast, seems to slightly reduce it, but not to a pronounced extent." Prolonging the action of the reducer as much as four times was the claim of B. Brougham[16] when ammonium thiocyanate was present in the solution. John Bartlett[17-18] proposed to transfer the unwashed film, immediately after fixing, to a 10% solution of acetic or citric acid, then to a 5% solution of potassium ferricyanide. Shadow detail was said to be preserved by this technique.

Haddon's Reducer

Potassium ferricyanide converts the metallic silver of the image to silver ferrocyanide, a compound with low solubility in water. In Farmer's reducer the silver from the ferrocyanide salt is solubilized by the reaction with sodium thiosulfate to form a water-soluble silver complex. But any compound capable of combining with the silver to form a soluble salt might be used. A. Haddon[19-20] and others have proposed to use ammonium thiocyanate in place of the sodium thiosulfate. Haddon's formula is a single solution of

potassium ferricyanide and ammonium thiocyanate in water that retains activity over five days. The unused mixed solution will keep for weeks in the dark.[13] The average exhaustion life of Farmer's reducer, according to J. I. Crabtree and L. E. Muehler,[21] is less than 24 hr unless ammonia or sodium carbonate is added to improve the stability.

	Haddon's Reducer	Modified Haddon's Reducer
Potassium ferricyanide	10 g	5 g
Ammonium thiocyanate	20 g	10 g
Water to make	1 liter	1 liter

The modified Haddon's reducer was proposed by Crabtree and Muehler, who suggested that the reducing action followed the reaction:

$$Ag_4Fe(CN)_6 + (x + 4) NH_4CNS \longrightarrow$$

silver ferrocyanide ammonium thiocyanate

$$x\, NH_4CNS \cdot 4\, AgCNS + (NH_4)_4Fe(CN)_6$$

ammonium silver thiocyanate ammonium ferrocyanide

The action is essentially subtractive, similar to that of Farmer's reducer.

A small amount of a white compound, apparently silver thiocyanate, may be deposited on the surface of the film. This white deposit, often in the form of a scum that is streaked or showing finger marks, may be removed by immersion in a fixing bath, then washed in water. Crabtree and Muehler noted that sodium cyanide solution was also effective in removing the surface deposit. The sodium cyanide, a poisonous compound, may be added to the reducing solution as follows:

Potassium ferricyanide	2.5 g
Ammonium thiocyanate	2.5 g
Sodium cyanide	2.5 g
Water to make	1.0 liter

This forms a very stable reducing solution that has a subtractive action. Actually, elimination of the ammonium thiocyanate from the formula does not significantly change its properties. Negatives should be hardened previously, as cyanide has a softening effect upon the gelatin.

Reducers Containing Manganese, Chromium, and Other Metallic Elements

Acidic solutions containing compounds having metallic elements of variable valence can be used to oxidize the metallic silver image to water-soluble silver salts. No silver-solubilizing compound, such as thiosulfate, thiocyanate, or thiourea, need be present in the reducing solution. Acidic permanganate reducing solutions were first proposed by R. Namias[22-24] at the turn of the century. Sulfuric acid was initially used, but glacial acetic acid was later proposed to reduce the precipitate of manganese dioxide in the gelatin.[25-28] According to Crabtree and Muehler, potassium permanganate dissolves the silver image by the reaction

$$10\,Ag \ + \ 2\,KMnO_4 \ + 8\,H_2SO_4 \ \longrightarrow$$

silver potassium sulfuric
(metallic) permanganate acid

$$5\,Ag_2SO_4 + 2\,MnSO_4 + 8\,H_2O + \ K_2SO_4$$

silver manganese water potassium
sulfate sulfate sulfate

A suitable formula consists of potassium permanganate (1 g) and concentrated sulfuric acid (5 ml) in a liter of water, although Namias used only 0.5 g potassium permanganate and 1 ml sulfuric acid in a liter of water. The solution is not stable, and a brown precipitate of manganese dioxide will eventually form because of the presence of air. After reduction, to remove any coloration, the negative should be treated for 1 min in 1% sodium bisulfite before thoroughly washing in water. The action of the acidic formulation is subtractive, but reducing the sulfuric acid concentration or using neutral permanganate solution gives proportional reduction. The replacement of the sulfuric acid with nitric acid increases the activity of the reducing solution because of the greater solubility of the silver nitrate that is formed from the silver of the image.

Kodak permanganate reducer R-2 is a modern formulation suitable for correcting overexposed negatives.

Kodak Permanganate Reducer R-2

Stock Solution A

Water	1.0 liter
Potassium permanganate	52.5 g

(To dissolve the permanganate, add the crystals to a small amount of water at about 180°F, then stir until dissolved. Dilute to 1.0 liter with cold water.)

Stock Solution B

Water	1.0 liter
Sulfuric acid (concentrated)	32.0 ml

For use, add

Solution A	1 part
Solution B	2 parts
Water	64 parts

The negative must be free of all traces of thiosulfate before treating with the permanganate reducer. Mix the working solution just before use, as this solution has a short life. After the negative has been reduced, place it in a fresh acid fixing bath for a short time to remove the yellow stains, then wash thoroughly.

Potassium dichromate (2.5 g) and concentrated sulfuric acid (2.5 ml) in a liter of water subtractively reduced metallic silver to water-soluble silver chromate and silver sulfate. In the Crabtree and Muehler experiments a residual stain was produced, and they were unable to remove it completely.

Another compound, ceric ammonium sulfate (ceric salts were originally studied by A. and L. Lumière and A. Seyewetz[29] in 1900), was found to give reduction intermediate between subtractive and proportional. A solution consisting of ceric ammonium sulfate (15 g) and concentrated sulfuric acid (10 ml) in a liter of water precipitated basic cerium compounds from the solution on standing. Ceric ammonium nitrate (20 g/liter of water) was a rapid reducing agent but also precipitated a basic nitrate compound.

According to W. J. Smith,[30] the potassium ferricyanide of Farmer's reducer may be replaced by copper sulfate without changing the characteristics of the reducer. The solution is also more stable, having an active life of 14 hr. The formula for the Smith reducer contains

Stock Solution A

Water	250 ml
Copper sulfate	10 g
Sodium chloride	10 g

Add the chemicals in the order given, then ammonium hydroxide until the cloudy precipitate is completely dissolved, leaving a clear ultramarine-colored solution.

<div align="center">

Stock Solution B

Sodium thiosulfate (crystals)	50 g
Water	250 ml

For use:

Solution A	1 part
Solution B	1 part

</div>

The solution keeps well in well-stoppered containers. Loss of the ammonia from solution A will cause the precipitate to return. The addition of more ammonium hydroxide will dissolve the precipitate so that the solution is usable again.

As with Farmer's reducer, the negative must be well washed and free of thiosulfates. Richard B. Willcock[31–32] felt that better control of the reduction was achieved if the A and B solutions were combined with one or two parts of water. The reduction is slightly less subtractive than Farmer's reducer, especially with the higher-speed films. The Smith reducer may be used for any purpose for which Farmer's was used: cutting fog, sharpening screen dots or lines, or treating overexposed negatives or prints, either locally or completely.

A single-solution reducing formula containing

<div align="center">

Copper sulfate	56.7 g
Sodium chloride	56.7 g
Hydrochloric acid (concentrated)	14.2 ml
Water	591.0 ml

</div>

was proposed recently by George L. Wakefield.[33] The image is converted to silver chloride, which is then removed in a fixing bath followed by thorough washing. Water may be used to dilute the reducer so that the action is slowed.

REDUCERS FOR CORRECTING OVERDEVELOPMENT

An overdeveloped photographic image has excessively high contrast. The negative image is also so dense that long exposures are required to make

photographic prints. A proportional reducer will help correct these faults by removing silver in proportion to the amount of the silver in the developed image. A subtractive reducer, such as the single-solution Farmer's reducer, would not correct for overdevelopment. A two-solution version of Farmer's reducer, however, is proportional in action and has been effectively used to overcome the contrast-density problems resulting from overdevelopment.

The two-solution technique for proportional reduction by Farmer's reducer was recommended by F. F. Renwick[34] in 1908. Some time later, Richard Lluellyn[35] summarized in three sentences the technique for two-solution reduction:

The negative is immersed for a given time in a generous quantity of 1 percent potassium ferricyanide solution, it is then washed for at least ten minutes in running water, fixed in normal hypo, and finally washed again.

The time of immersion in the ferricyanide should be about thirty seconds for slight, one minute for medium, and two for very considerable action. Results may vary slightly, according to the temperature of the solution, but in no case will any shadow detail be destroyed, and in all there will be appreciable softening.

The two-solution method of reduction with Farmer's reducer has been condemned by some because the extent of reduction is not known until the silver ferrocyanide is removed in the thiosulfate solution. Control of the reduction is more difficult than if the lessening of the image could be followed visually. The concentration of the potassium ferricyanide is important, as is the agitation during treatment in the ferricyanide solution. According to Crabtree and Muehler, the concentration of the ferricyanide must not be less than 7.5 g/liter of solution for use with panchromatic negative film. The concentration of the sodium thiosulfate in the second solution, however, is not critical and may vary from 50 to 300 g/liter. The following formulation incorporates these concentrations:

Two-Solution Farmer's Reducer (Kodak R-4B)

Solution A	
Potassium ferricyanide	7.5 g
Water to make	1.0 liter

Solution B	
Sodium thiosulfate, crystals	200.0 g
Water to make	1.0 liter

Figure 3. Proportional reduction as given by two-bath Farmer's reducer containing in (A) 0.75%
potassium ferricyanide and (B) 30% sodium thiosulfate. [J. I. Crabtree and L. E. Muehler, *J.
SMPE*, **17**: 1027 (1931)]

The negatives or prints are treated in solution A with uniform agitation
for 1 to 4 min at 65 to 70°F, then immersed in solution B for 5 min. Wash
thoroughly. The process may be repeated several times, if desired, but it is
important to wash thoroughly after each thiosulfate treatment. Failure to
remove all of the thiosulfate from the negative will result in contamination
of the ferricyanide bath and a shortened useful life. In addition, the ferri-
cyanide bath will take on some of the characteristics of the one-solution
Farmer's reducer. The resulting reduction will be approximately subtractive
rather than the proportional reduction of a normal two-solution Farmer's
reducer. (See Figure 3.)

Permanganate-Persulfate Reducer

In 1916 Norman C. Deck[36] from the Solomon Islands proposed a propor-
tional reducer consisting of potassium permanganate and ammonium

persulfate in water (such a reducer had been studied in 1910 by A. Schuller[37,38]). Deck claimed that after the use of the permanganate-persulfate solution with an overdeveloped negative, the result obtained was the same as if the development had been stopped at the correct time. He listed the following advantages:

1. The action starts right away, and is quite regular, not hurrying up like persulphate alone.
2. It is not sensitive at all, like persulphate, to small traces of hypo from imperfect washing. In fact, with it I reduced with perfect ease a negative in which I could still just taste the hypo.
3. A hardening bath on the film does not interfere with its subsequent reduction in this reducer, the action being regular, though somewhat slowed.
4. As yet, in my hands, it has never shown the slightest erratic action.
5. During reduction it is clearer in its action than the acid permanganate reducer, thus the degree of reduction can be more perfectly estimated.
6. The solution, when in use, appears to keep in working order longer than the acid permanganate solution.
7. It is a proportional reducer (as far as the eye can see).

The permanganate-persulfate reducer of Deck was immediately studied by Kenneth Huse and Adolph H. Nietz.[39] They verified that the formulation gave more proportional reduction than the potassium permanganate or potassium dichromate reducers. The addition of a small amount of sulfuric acid improved the activity of the reducer and reduced staining. Various proportions of permanganate and persulfate were tried to secure the most effective combination in the presence of the acid. This modified version of Deck's reducer with additional persulfate is now Kodak acid permanganate-persulfate reducer R-5.

Acid Permanganate-Persulfate Reducer

	Stock Solution A	
	Kodak R-5	Huse and Nietz
Water	1.0 liter	1.0 liter
Potassium permanganate	0.3 g	0.25 g
Sulfuric acid (10% solution)	16.0 ml	15.0 ml

Stock Solution B

	Kodak R-5	Huse and Nietz
Water	3.0 liters	1.0 liter
Ammonium persulfate	90.0 g	25.0 g

For use:

| Solution A | 1 part |
| Solution B | 3 parts |

The stock solutions keep well, but the reducer should not be mixed until just before use. Crabtree and Muehler reported that the reducer did not have sufficient stability for motion picture work. One to three minutes, depending on the extent of reduction desired, was recommended by Huse and Nietz. Greater control over the reducing action may be obtained by dilution of the mixed reducer with an equal volume of water. After reduction is completed, the photographic material must be immersed in a solution of potassium metabisulfite (1 %) for 5 min or, as recommended for R-5, cleared in 1 % bisulfite. Thorough washing before drying completes the treatment. R. C. Cardinal[40] warns that acetic acid should not be used for aftertreatment of the film.

A water solution of potassium permanganate is a slow-acting reducer of the subtractive type. Such a solution has been used to remove the green (reflected light) or red (transmitted light) surface layer of silver that is called dichroic fog. Adding sulfuric acid increases the oxidizing power of the permanganate, converting image silver into soluble silver sulfates that are removed from the image.[41]

The action of ammonium persulfate in sulfuric acid solution appears to be complex, possibly involving the formation of an unstable silver persulfate that decomposes to form silver peroxide before finally yielding silver sulfate. The action is greater in the denser portions of the image than in the less dense areas; that is, the reduction is superproportional.[42] The combined action of the acid permanganate-persulfate reducer is the sum of the subtractive action of the permanganate and the superproportional action of the persulfate. The resulting reduction is essentially proportional. (See Figure 4.)

Reduction with Iron Compounds

Ferric chloride was commonly used to reduce the silver image during the wet collodion era of photography. The silver chloride formed in the reaction

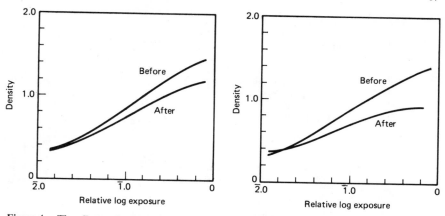

Figure 4. The effect on image density of the persulfate (left) and permanganate-persulfate (right) reducers. [D. T. Copenhafer, *Photo Developments*, 25 (9): 32 (1950)]

was not soluble in the reducing solution but had to be removed by a separate treatment in a sodium thiosulfate or potassium cyanide solution.[43] Combining the thiosulfate with the ferric salt in a single solution produced an active but unstable solution. Ferric sulfate or nitrate as indicated by the Lumière Brothers and A. Seyewetz were suitable for reducing the silver image, but an insoluble iron salt was precipitated in the gelatin. In 1883 L. Belitski[44–49] proposed a stable single solution consisting of ferric potassium oxalate and sodium thiosulfate, but the relative scarcity of ferric potassium oxalate hampered the acceptance of Belitski's reducer.

Ferric ammonium sulfate (ferric alum) is a much more readily available iron compound. In 1919 Hugo Krause[50–51] found that an acidic solution of this compound had proportional reducing properties.[52] The reducing reaction may be represented as:

$$2\,Ag \;+\; Fe_2(SO_4)_3 \cdot (NH_4)_2SO_4 \;\longrightarrow$$

silver ferric ammonium
(metallic) sulfate

$$Ag_2SO_4 \;+\; FeSO_4 \;+\; FeSO_4 \cdot (NH_4)_2SO_4$$

silver ferrous ferrous ammonium
sulfate sulfate sulfate

The Krause reducing formula consisted of ferric ammonium sulfate (20 g), concentrated sulfuric acid (10 ml), and cold water to make one liter. A

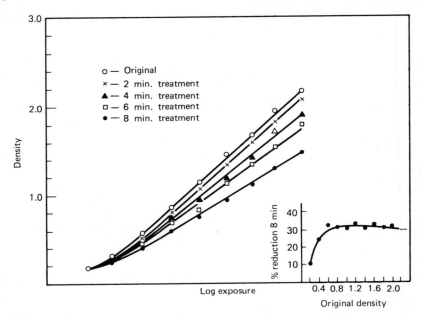

Figure 5. Type and degree of reduction produced by modified Krauss formula containing 15 g/liter of ferric ammonium sulfate and 10 ml/l sulfuric acid (conc). [J. I. Crabtree and L. E. Muehler, *J. SMPE*, 17: 1034 (1931)]

modification of this formula, with 15 instead of 20 g of the ferric salt, was evaluated by Crabtree and Muehler in 1931. This is the composition of Kodak ferric alum reducer R-7. Treatment times of about 6 min or less produced practically proportional reduction of the silver image, but longer times caused a loss of some of the lower densities. (See Figure 5.)

Photographic films to be treated in the ferric ammonium sulfate reducer must be free of all traces of thiosulfate and silver salts. To avoid the softening of the emulsion layer by the acid solution or the stains from residual thiosulfates, the negative should first be hardened in an alkaline formalin hardener, such as Kodak SH-1, and then fixed in a fresh fixing bath followed by thorough washing in water. During or after treatment in the reducer, the film should not be allowed to come into contact with the air for any appreciable length of time. Brown stains may result from excessive exposure to air. Wash the treated negative thoroughly after the reduction. The reducing

solution has almost an indefinite life, provided the solution is not contaminated with traces of sodium thiosulfate, which react and shorten the useful life of the reducer.

REDUCER FOR CORRECTING OVEREXPOSURE AND OVERDEVELOPMENT

A dense, contrasty negative can result from overexposure and overdevelopment. Such a negative can be corrected by a reducer having an action that lies between subtractive and proportional reduction of the silver image. Iron salts were used as reducing compounds from almost the beginning of photography, as the ferric ion converts metallic image silver to a silver salt. The silver salt is not sufficiently soluble in the reducing solution, so immersion in a second solution containing sodium thiosulfate was necessary. A single solution of the ferric salt and sodium thiosulfate was unstable. In 1883 L. Belitski[44–45] found that a single-solution iron reducer could be made if ferric potassium oxalate was combined with the sodium thiosulfate. Ferric potassium oxalate was not a common photographic chemical, so J. M. Eder proposed replacing it with ferric chloride and potassium oxalate, which were combined with the sodium thiosulfate in solution.

In 1890 Belitski[46–48] made his ferric potassium oxalate–sodium thiosulfate solution acidic by adding oxalic acid, requiring also the addition of sodium sulfite to prevent the sulfurization of the thiosulfate in the acidic solution. Besides the potassium ferric oxalate (10 parts), Belitski's modified reducer contained sodium sulfite (8 parts), oxalic acid (2.5 to 3 parts), and sodium thiosulfate (50 parts) in 200 parts of water. The green solution was said to be stable for months in a closed container in the dark. The reducing solution could be used until it turned yellow, indicating exhaustion. O. Iarecki[49] (1894) then proposed the use of oxalic acid and sodium sulfite with Eder's ferric chloride–potassium oxalate substitution for ferric potassium oxalate.

Very little use was made of the neutral and acidic ferric potassium oxalate reducer of Belitski or the modifications that were suggested, possibly because of the popularity of Farmer's reducer. A solid mixture of pulverized potassium ferric oxalate and anhydrous sodium thiosulfate was patented and sold by Agfa for many years.[99] Another modification of the Belitski reducer was proposed by J. I. Crabtree and L. E. Muehler[4] in 1931. (See Figure 6.) This modification, however, should really be considered a totally new formulation, because the oxalate was eliminated from the formulation.

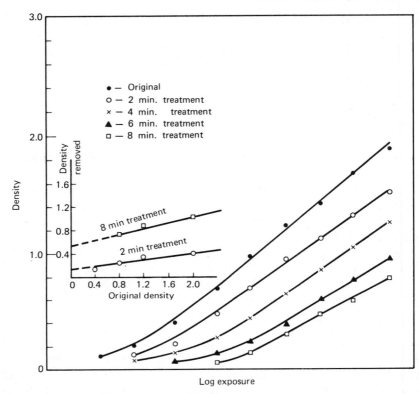

Figure 6. The type and degree of reduction produced by the modified Belitski reducer. [J. I. Crabtree and L. E. Muehler, *J. SMPE*, 17: 1033 (1931)]

Oxalate and oxalic acid are poisonous compounds. In addition, oxalates react with the calcium and magnesium salts found in hard water, precipitating an insoluble white deposit on the surface of the emulsion layer. A ferric chloride solution was buffered with citric acid–potassium citrate in place of the oxalates. If formed, calcium and magnesium citrate would not precipitate, as these salts were soluble in water. Sodium sulfite was also added to protect the sodium thiosulfate from sulfurization in the acidic solution.

The Crabtree and Muehler formulation was called Modified Belitski Reducer (Kodak R-8). A later modification of the modified formula substituted Krause's[50–51] ferric ammonium sulfate for the ferric chloride. This revised formulation was called Modified Belitski Reducer (Kodak R-8a). The compositions of these two iron reducing solutions are as follows:

Modified Belitski Reducer

	Formula R-8	Formula R-8a
Water (125°F)	750.0 ml	750.0 ml
Ferric chloride (crystals)	25.0 g	—
Ferric ammonium sulfate	—	45.0 g
Potassium citrate	75.0 g	75.0 g
Sodium sulfite (desiccated)	30.0 g	30.0 g
Citric acid	20.0 g	22.5 g
Sodium thiosulfate (crystals)	200.0 g	200.0 g
Water to make	1.0 liter	1.0 liter

Either reducer is used at full strength for the maximum rate of reduction. For a slower rate, dilute one part of the reducing solution with one part of water. About 1 to 10 min at 68°F should provide sufficient reduction as desired. Then wash thoroughly.

REDUCING ACTION OF FIXING BATHS

Any photographer who has inadvertently forgotten a photographic print immersed in a fixing bath is aware that the fixing bath acts as a reducer to decrease the density of the image. The reduction of image density by a fixing bath was evident to the early workers in photography.[53-54] Sodium thiosulfate in the presence of the oxygen of the air was shown by A. Haddon and F. B. Grundy in 1896 to decrease image silver.[55] Alum is also known to reduce image density.[56] Acid fixing baths were an early recommended means for image reduction, but Paul Hasluck[57] (1907) noted that a long time of immersion in fixing baths may require a longer time than usually necessary for washing.

The reduction of silver images by fixing baths was extensively investigated by H. D. Russell and J. I. Crabtree.[58] They concluded that "for a given fixing bath containing alum, sulfite, acid, and hypo, (1) the rate of reduction increased rapidly if the pH value of the bath was reduced below 4.0, (2) for pH values greater than 4.0 the degree of reduction was of a much lower order of magnitude, (3) for a given hypo concentration and a pH value less than 4.0, an increase in the sulfite concentration increased the rate of reduction, (4) for a given sulfite concentration and a pH value less than 4.0 an increase in the hypo concentration up to 300 grams per liter increased the

rate of reduction but with concentrations of hypo greater than 300 grams per liter, the rate of reduction decreased."

Silver images of fine particles are attacked much more than coarser-grained images. Increasing the temperature or the agitation markedly increased the amount of reduction. Agitation is believed to increase the amount of air introduced into the fixing bath, and oxygen may then attack the metallic silver. The reduction of the metallic silver image in an acid fixing bath may be represented, according to Russell and Crabtree, by the following chemical reaction:

$$2\,Ag \;+\; H_2S_2O_3 \;+\; O \longrightarrow Ag_2S_2O_3 \;+\; H_2O$$

| silver (metallic) | thiosulfuric acid | oxygen | silver thiosulfate | water |

The silver thiosulfate dissolves in the excess thiosulfate of the solution, forming a soluble silver salt that is removed from the image. In an acid fixing bath, the reaction between thiosulfuric acid and sulfurous acid may form $H_2S_2O_3 \cdot SO_2$, a compound which may be the active oxidizing agent.

Figure 7. Curves obtained by a series of increasing times of reduction of silver images on Kodak Plus-X film, 35mm, developed in Kodak DK-60a for 7 min, 68°F. Kodak Rapid Liquid Fixer with 30 g of citric acid added per liter was used to treat the film images for 0, 4, 8, 16, and 32 min at 68°F (curves 1, 2, 3, 4, and 5, respectively). Note that the curves for an increasing time-of-reduction series resemble the reverse of an increasing time-of-development series. [R. W. Henn, J. I. Crabtree, and H. D. Russell, *Phot. Sci. and Tech., PSA J.*, 17B (11): 111 (1951)]

The reduction of the silver image in a solution of only sodium thiosulfate is believed to involve the conversion of the silver image into silver oxide by the attack of oxygen.

$$4\,Ag + O_2 \longrightarrow 2\,Ag_2O$$

silver oxygen silver
oxide

$$Ag_2O + Na_2S_2O_3 + H_2O \longrightarrow 2\,NaOH + Ag_2S_2O_3$$

silver sodium water sodium silver
oxide thiosulfate hydroxide thiosulfate

The silver thiosulfate dissolves in the excess thiosulfate of the fixing bath. The reduction of the image is said to be "almost strictly proportional." (See Figure 7.)

The use of a fixing bath as a reducing solution would be an advantage to photographers who could use an available solution rather than deal with a special solution, often containing dangerous chemicals. The rapid, liquid fixing baths, so useful in modern photographic processing, contain ammonium thiosulfate. Ammonium thiosulfate in acid fixing solutions has an even more rapid reducing action than that of sodium thiosulfate. Such a fixing bath would have reducing action on photographic images, particularly those of photographic prints. It has been proposed[59] to add citric acid

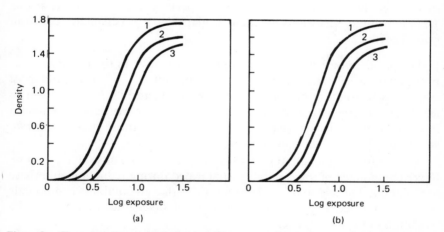

Figure 8. Characteristic curves of photographic papers reduced in Kodak Rapid Liquid Fixer with 15 g/l of citric acid added. (a) Kodak Royal Bromide Paper, F-3, untreated (1) and reduced for 4 min (2) and 8 min (3) at 68°F. (b) Kodak Velox Paper, F-3, untreated (1) and reduced for 2 min (2) and 4 min (3) at 68°F. [R. W. Henn, J. I. Crabtree, and H. D. Russell, *Phot. Sci. and Tech.*, *PSA J.*, 17B (11): 111 (1951)]

to an ammonium thiosulfate fixing bath to form an acid reducing bath that slowly causes a proportional reduction of the image silver. A uniform reduction of contrast without loss of shadow detail is produced, almost as if the image-forming process of development had been reversed. The addition of 15 to 30 g of citric acid per liter of ammonium thiosulfate fixing bath produced a 20% loss in image density after a 10- to 20-min treatment of the negative. (See Figure 8.)

REDUCER FOR CORRECTING EXTREMELY HIGH CONTRAST

Very contrasty images, such as might be given by overdevelopment of under-exposed negatives, can be corrected by a superproportional reducer. A. and L. Lumière and A. Seyewetz,[60-64] in 1898, were the first to find that ammonium persulfate in aqueous solution attacked silver images so that the densest deposits of silver were substantially reduced while the thinner parts of the image were almost untouched. Beyond the known fact of its origin, the early story of persulfate reduction is a published series of conflicting results dealing with the erratic behavior of persulfate solutions, and the theories devised to explain this action. A history of these early studies up to 1921 has been detailed by G. I. Higson.[65]

Ammonium persulfate, or potassium persulfate,[66-67] are both capable of converting the metallic silver of the photographic image into a silver salt that is soluble in the reducing solution, expecially if the solution is acidic. The following observations on the irregular action of persulfate reduction were reported:

1. The presence of a small amount of dissolved silver in the reducing solution greatly accelerates the action of the persulfate.[68-69] The buildup of silver ions in solution during reduction would cause the rate of action to accelerate enormously. A used solution would act more vigorously than a fresh solution, so it was suggested that a small quantity of silver nitrate should be added to the solution of persulfate.

2. The acidity of the solution also influences the rapidity of the action. Silver compounds of low solubility are formed during reduction, and these are solubilized in acid solution. The removal of the low-solubility compounds results in an increase of the concentration of silver ions, accelerating the oxidation of the image silver.[70]

3. The presence of chlorides, either from impurities in the chemicals or from the water, influences the reducing action. Very small amounts of chloride ion aid in the reduction of the densest silver deposits without loss of fine image detail, but subtractive reduction could result from excess

chloride. A proposal was made by E. Stenger and H. Heller[71–72] to add from 0.15 to 0.25 g of sodium chloride to a reducing solution containing 20 g of ammonium persulfate in a liter of water free of chloride.

4. Although the reducing action is limited at first to an attack on the densest part of the silver image, reduction may start to take place in the thinnest parts of the image after the reducing action has proceeded for a time. Variability from subtractive to superproportional may mark the action of persulfate. Stopping the reducing action by washing in water when an attack on fine detail was observed was suggested by Henry W. Bennett.[73–75]

Reducing solutions containing ammonium persulfate were uncertain in action and often produced stains. To overcome these difficulties, Henry W. Bennett[73] proposed an acid reducing solution containing sodium sulfite:

<div align="center">

Bennett Persulfate Reducer

Ammonium persulfate	28.4 g
Sodium sulfite	5.5 g
Sulfuric acid	5.0 ml
Water to make	273.0 ml

</div>

The Bennett formula was reported[76] to offer no advantages in reducing action and "it is distinctly less permanent than the simple solution." Simple solutions of $2\frac{1}{2}$ or 5% ammonium persulfate, made acid with ammonium bisulfite, were used in the comparison.

The effect of impurities on the reducing power of ammonium persulfate solutions interested S. E. Sheppard.[77,78] He found that "The small variable amount of iron salt present as an impurity in ammonium persulfate is thus the cause of its variability, and iron, however introduced is a powerful catalyzer of the action of persulphate on metallic silver. The chemical reactions involved show that we have here a case where a side-reaction supplies more rapidly the autocatalyst for the main reaction, while the main reagent re-energises the side reagent or catalyst. Iron, as a ferric salt, e.g., ferric sulphate, rapidly attacks metallic silver, forming silver sulphate and ferrous sulphate:

(4) $$Fe_2(SO_4)_3 + 2\,Ag = Ag_2SO_4 + 2\,FeSO_4$$

and the *ferrous sulphate* is rapidly re-oxidized to *ferric* by persulphate

(5) $$2\,FeSO_4 + (NH_4)_2S_2O_8 = Fe_2(SO_4)_3 + (NH_4)_2SO_4$$

so that the concentration of ferric iron tends to be kept up to the initial level. Further, the silver salt (or silver ions) supplied by reaction (4) give the necessary acceleration to the persulphate reaction proper. . . ."

One to two parts of iron per thousand parts of solid ammonium persulphate were found by Sheppard to be the upper permissible limit for this impurity. The effect of ferric ions was not found to be essential for the reducing action of persulfate solutions, according to A. and L. Lumière and A. Seyewetz.[79,80] Sheppard[81] maintained that "both silver ions and ferric ions have an accelerating action on persulphate reduction, provided the acidity is not too high." However, "At an acidity of about 0.5 percent sulphuric acid, the acceleration becomes negligible."

Silver ions and acid accelerate the attack of persulfate upon the metallic silver of the image. Both of these are produced during the reduction as the persulfate acts upon the silver. The action accelerates with time, the greatest acceleration being in the areas of greatest image silver. A superproportional reduction results.

Impurities in the form of chloride or copper also influence the reduction reaction. A small amount of chloride removes free silver ions, forming silver chloride. This effect is most significant in the areas of least silver. In the areas of the densest silver deposits, all of the silver ions cannot be tied up as silver chloride, so the free silver ions result in an ever-accelerating attack by the persulfate on the silver image. The effect of small amounts of chloride is to promote superproportional reduction. Excessive amounts of chloride, however, would reduce the availability of the silver ions in the dense parts of the image, causing the reduction to become more proportional in nature.

A comparison of the reactions of persulfate reduction as concluded by either Sheppard or Higson was listed by C. E. K. Mees:[82]

Sheppard	Higson
1. $S_2O_8^{2-} + H_2O \rightarrow 2HSO_4^- + O$	$S_2O_8^{2-} + H_2O \rightarrow 2HSO_4^- + O$
2. Atomic oxygen from (1) forms oxides, Ag_2O_2, Ag_2O.	Nascent oxygen from (1) forms peroxide, probably Ag_3O_4.
3. —	Silver peroxide oxidizes gelatin and is reduced to Ag_2O.
4. Oxides, Ag_2O, etc., react with acid: $Ag_2O + 2H^+ \rightarrow 2Ag^+ + H_2O$ $2HSO_4^- \rightleftharpoons 2H^+ + 2SO_4^{2-}$	Ag_2O reacts with acidic ion HSO_4^-: $Ag_2O + 2HSO_4^- \rightarrow 2Ag^+ + 2SO_4^{2-} + H_2O$

The persulfate reducer may be made as a single solution ready for use, or prepared just before use by mixing two stock solutions.

Kodak Persulfate Reducer R-1

Water	1.0 liter
Ammonium persulfate	60.0 g
Sulfuric acid (concentrated)	3.0 ml

For use:

Stock solution	1 part
Water	2 parts

Kodak Persulfate Reducer R-15

Stock Solution A

Water	1.0 liter
Potassium persulfate	30.0 g

Stock Solution B

Water	250 ml
Sulfuric acid (10% solution)	15 ml
Water to make	500 ml

For use:

Solution A	2 parts
Solution B	1 part

Mix and use the solutions only in nonmetal containers or in impervious and unchipped enameled containers.

The negative should be hardened in a formalin hardener (Kodak SH-1) and thoroughly washed. Immerse the negative in the reducing solution, agitate continuously, and observe carefully the reducing action, which increases in rate with time. Stop the reduction a little before the desired result is obtained by removing the negative from the persulfate reducing solution and immersing, without rinsing, in an acid fixing bath for a few minutes. Wash the negative thoroughly before drying. Discard the used reducing solution.

Microscopic examination of the effect of various reducing solutions upon the silver particles of the photographic image was used by J. I. Pigg[83] to differentiate between the action of persulfate and other types of reduction.

Reducing solutions of potassium ferricyanide–sodium thiosulfate or potassium cyanide–iodine removed the silver particles from the edge of image dots but had little effect on the dense silver deposit in the center of each dot. Reduction with ammonium persulfate caused a considerable loss of silver from the center of each dot and, although the silver particles surrounding the dot were smaller after reduction, the number of particles of silver was not reduced.

Cross sections of reduced silver images were studied by W. Scheffer[84–85] in order to understand the differences between reduction by Farmer's reducer and reduction by ammonium persulfate. From his microscopical research, Scheffer concluded that

The difference in the action of the two reducers lies in the fact that the Farmer reduces the grains according to their position in the film; the nearer the grains lie to the free surface the earlier they are dissolved, and the upper have entirely disappeared before the lower show any change. In a manner of speaking, the persulphate of ammonia works inversely. It is a matter of indifference to this reducer whether the grains lie on the surface or on the lower parts of the film near the glass. It reduces all grains approximately at the same time no matter if they are located in the uppermost or lowest parts of the film.

It is to be seen from this that the Farmer reducer penetrates the film rather slowly, and dissolves the grains relatively quickly, whilst the persulphate reducer penetrates very quickly and dissolves the grains very slowly. The relation of the time taken by the reducer to penetrate the gelatine to that taken to dissolve the grains determines the harsh or soft action of the same.

An alkaline solution of Farmer's Reducer was said[86] to act more delicately than the regular formula. Scheffer[87] found, however, that the action upon image silver was identical in both cases. The addition of ammonium thiocyanate to a persulfate reducing solution causes the solution to give the harsh results characteristic of Farmer's reducer. Potassium permanganate reducing solutions also give the strong reducing action upon fine image details that Farmer's reducer produces. It was concluded that the attack upon fine image details will be greatest for a reducing agent that has a strong solvent action that is rapid in proportion to the diffusibility of the agent through the gelatin.

REDUCTION BY REDEVELOPMENT

Contrasty photographic images resulting from overdevelopment may be corrected by converting the metallic silver into a silver salt, then redeveloping to a lower contrast than that possessed by the original silver image. This

technique, called harmonizing, appears to have been originated by J. M. Eder[88-89] in 1881. The silver image was treated in a solution containing potassium dichromate (10 g), hydrochloric acid (50 ml), and alum (50 g) in a liter of water. When the negative was completely whitened, it was thoroughly washed, then redeveloped in a slow-acting developer. The lesser deposits of silver were allowed to develop until completely blackened, but the negative was removed from the developer when the densest part of the image was still white as viewed from the base side. The negative was fixed to remove the undeveloped silver salt from the image, then washed. The lower image densities were little changed from the original silver image but the highest densities had had silver removed, giving essentially super-proportional reduction of the image.

Experience with the technique of reforming the silver halide, then re-developing, is necessary, because there is a considerable loss of density in the fixing bath. This loss must be taken into account when estimating when to stop the redevelopment. Many investigators have suggested techniques and solutions to make the reduction less critical and to obtain consistent results. Most of the treatments used potassium ferricyanide with a soluble halide (bromide or chloride, preferably) to change the metallic silver to a silver halide.[90] A solution containing 1% potassium ferricyanide and 1% potassium bromide may be used.[91] George E. Brown[92] and, later, C. Welborne Piper[93] suggested developing the well-washed rehalogenated image in 2% Rodinal and 1% potassium bromide. The developer is very slow acting, and the selection of the time to end the development is not as critical as with more rapid-acting solutions. A physical developer was used by James R. Carter.[94] Bernard Wakeman[95] proposed adding a small amount of sodium thiosulfate to the standard MQ developers. Redevelopment and image reduction then took place simultaneously.

A reduction procedure proposed by W. J. Hickman[96] involved bleaching in the ferricyanide-bromide solution, washing from 3 to 5 min, redeveloping completely in an MQ or nonstaining developer, rinsing in water, and then immersing the negative briefly in a weak solution of sodium thiosulfate (28 g in 591 ml of water). Reduction occurs because, although the ferricyanide has been washed out of the thinner portions of the image, some ferricyanide is retained in the heavy silver deposits. The ferricyanide and sodium thio-sulfate form Farmer's reducing solution but act only on the areas of greatest exposure without undue harm on the thin silver areas. Careful attention must be given to the negative when immersed in the thiosulfate solution. When the desired level of reduction has been reached, the negative is washed and dried.

Correctly exposed negatives that are overdeveloped may be too high in contrast and excessively grainy. Both the contrast and grain are claimed to

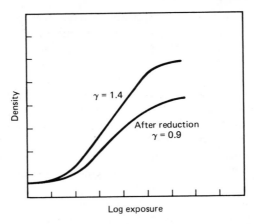

Figure 9. Superproportional reduction of image density as given by treatment with Heymer's reducer. Note that the greatest loss of density has occurred in the region of highest density. [C. van Duijn, Jr., *Am. Phot.*, 41 (5): 31 (1947)]

be reduced by the Heymer reducer, which acts superproportionally. (See Figure 9.) Contrast is said[97] to be decreased more than with the ammonium persulfate reducer. The negative is treated in the following solution, which may be stored indefinitely:

Copper sulfate	10 g
Sodium chloride	10 g
Water	500 ml
When in solution, add	
Sulfuric acid (concentrated)	25 ml
Water to make	1 liter

The negative is treated until all the metallic silver is converted into white silver chloride, then washed for about 10 min. The image is redeveloped in a fine-grain developer. One such developer that has been proposed contains 1.6 g *p*-phenylenediamine (free base) and 10 g sodium sulfite in a liter of water.[98] Redevelopment is continued until the negative has just a little more contrast than desired. The negative is then rinsed in water and fixed in a regular fixing bath, which removes the remaining undeveloped silver chloride. Wash thoroughly and dry.

The harmonizing method of reduction was also evaluated by Crabtree and Muehler.[4] The silver image was whitened in modified chromium intensifier bleaching solution (Kodak In-4a):

Potassium dichromate	8 g
Hydrochloric acid (concentrated)	6 ml
Potassium bromide	5 g
Water to make	1 liter

The bleached image was then developed in

Metol	2 g
Sodium sulfite (desiccated)	10 g
Sodium carbonate (anhydrous)	10 g
Water to make	1 liter

After development, the negatives were rinsed, fixed for 5 min in an acid fixing bath, washed thoroughly, and dried. Redevelopment times of 1 and 2 min gave superproportional reduction for the high densities, although proportional intensification was obtained for the low densities. This method was recommended for the reduction of underexposed, overdeveloped negatives.

SPECIAL REDUCING SOLUTIONS

Iodine Reducers

Iodine in water can convert the metallic silver image into silver iodide, which can then be solubilized in a thiosulfate fixing bath.[100] Iodine is not very soluble in water but dissolves readily in a water solution of potassium iodide, such as

Iodine	5 g
Potassium iodide	15 g
Water to make	100 ml

The treated image is cleared in an acid fixing bath.

The combination of iodine and potassium cyanide makes a rapid-acting, nonstaining reducer that does not change image tone in the treated areas.[101] Such a reducing solution is extremely poisonous, however. In 1926 T. H. Greenall[102] replaced the poisonous cyanide with thiourea. Three stock solutions are needed.[103]

Solution A

Iodine	2.3 g
Methyl alcohol	50.0 ml

Solution B

Thiourea	4.6 g
Water	50.0 ml

Solution C

Methyl alcohol	50.0 ml

For use, mix one part each of solutions A, B, and C. For vigorous action, use equal parts of A and B only. The iodine reducing solution is applied locally to the dry image with a moistened brush, then wetted immediately with a larger brush containing methyl alcohol. The excess alcohol is blotted, then the procedure repeated until the desired image density is obtained. The treated print, without washing, is immersed in a fixing bath for a few minutes and then washed in water as usual. This iodine-thiourea reducer for dry prints is excellent for removing black spots or for local reduction of small area.

Iodine is only slowly soluble in the methyl alcohol of Greenall's formula, so Richard B. Willcock[104] proposed solubilizing the iodine as in formula 1 or formula 2:

Formula 1

Iodine	10 g
Potassium iodide	30 g
Water to make	100 ml

Dissolve potassium iodide in about 25 ml water, add iodine, stir rapidly until dissolved, then add the rest of the water.

Formula 2

Iodine	10 g
Potassium iodide	6 g
Water	10 ml
Isopropyl alcohol	100 ml

Dissolve the potassium iodide in the 10 ml of water, add the iodine, then the isopropyl alcohol, and stir until a solution is obtained. A spotting solution is then made as follows:

Spotting Solution

Iodine solution (either formula 1 or 2)	1 part
Thiourea solution (10% in water)	2 parts

The action of the spotting solution is almost instantaneous. The treated print should be washed briefly in water before clearing in a fixing bath.

Overall reduction of the silver image, such as an overexposed bromide photographic print, may also be accomplished by an iodine-thiourea solution. The action is essentially subtractive. A suitable formulation consists of

Print Reducing Solution

Iodine solution (either formula 1 or 2)	10 ml
Thiourea solution (10% in water)	20 ml
Water to make	150 ml

The mixed iodine reducing solutions do not keep and should be discarded after use.

Quinone Reducers

In alkaline solution, hydroquinone is oxidized to quinone when silver halide is converted to metallic silver. In sulfuric acid solution containing halide ions, quinone will change metallic silver to silver halide and, in the process, hydroquinone is formed from the quinone. This curious reversal of the development process was first reported by A. and L. Lumière and A. Seyewetz.[105,106] Both quinone and sodium quinone monosulfonate acted as oxidizing agents in sulfuric acid solution. Five grams of quinone and 20 ml of sulfuric acid added to one liter, according to E. Stenger and H. Heller,[107]

"gives proportional reduction throughout a scale of densities as does the persulphate reducer when likewise made up with distilled water."

Stenger and Heller also investigated the effect of the chloride ions upon the reduction mechanism. The very pronounced effect of chloride (quantities as little as 0.02%) caused the reducing solution to act similar to that of Farmer's reducer. The Lumières and Seyewetz[108] formulated quinone reducing solutions of the following composition:

Quinone	5 g	5 g
Sodium chloride	6 g	—
Potassium bromide	—	11 g
Sulfuric acid	3 ml	3 ml
Water	1 liter	1 liter

The bromide-containing solution was said to work more rapidly than the chloride, and without staining the gelatin. Pierre Glafkides[109] suggested that a print treated in a quinone–sulfuric acid solution should be immersed in a 10% sodium sulfite or 20% sodium bisulfite solution before being washed.

REFERENCES

1. C. E. Kenneth Mees, *The Theory of the Photographic Process*, Revised Edition, Macmillan Company, New York, 1954, pp. 738–739.
2. E. Howard Farmer, "A Convenient Reducing Agent," *Year-Book of Photography*, p. 59 (1884).
3. E. J. Wall, *Intensification and Reduction*, Am. Phot. Pub. Co., Boston, 1927, p. 30.
4. J. I. Crabtree and L. E. Muehler, "Reducing and Intensifying Solutions for Motion Picture Film," *J. SMPE*, **17**: 1023 (1931).
5. "Processing Chemicals and Formulas for Black-and-White Photography," Kodak Publication No. J-1, 6th Edition, 1963, 1st 1970 Printing, p. 58.
6. Derek Watkins, "Printing," *SLR Camera*, **2** (6): 11 (1968).
7. Alexander Murray, "New Control Methods in Chemical Retouching," *Brit. J. Phot.*, **77**: 121 (1930).
8. Alexander Murray credits Ross and Crabtree with the suggestion for the use of potassium iodide in the fixing bath.
9. Don D. Nibbelink, "Reduction of Prints," *Photo. Tech.*, **3** (2): 38 (1941).
10. John H. Gear, "A Discussion on Negative-Making," *Phot. J.*, **56**: 177 (1916).
11. John H. Gear, "Farmer's Reducer," *Brit. J. Phot. Almanac*, p. 357 (1917).
12. C. Welborne Piper, "Sulphide Toning and a New Reducer," *Brit. J. Phot.*, **55**: 319 (1908).
13. Adolf Fassbender, "Reduction Methods and Media," *Camera*, **46** (3): 171 (1933).

14. Arthur Ernest Whiting, "Reducing Bromide Opals," *Year-Book of Photography*, p. 130 (1891).

15. A. Edwards, *Brit. J. Phot.*, **55**: 350 (1908).

16. B. Brougham, "Farmer's Reducer," *Brit. J. Phot.*, **63**: 399 (1916).

17. John Bartlett, "On the Application of Farmer's Method of Reduction, by which the Shadows are Preserved and only the High Lights Reduced," *Phot. News*, **49**: 570 (1905).

18. John Bartlett, "Persulphate Effects with Farmer's Reducer," *Brit. J. Phot.*, **52**: 625 (1905).

19. A. Haddon, "Potassium Ferricyanide and Ammonium Sulphocyanide Reducer," *Brit. J. Phot.*, **39**: 49, 60 (1892).

20. A. Haddon, "A New Reducing Solution," *Brit. J. Phot. Almanac*, p. 710 (1893).

21. J. I. Crabtree and L. E. Muehler, "Reducing and Intensifying Solutions for Motion-Picture Film," *Brit. J. Phot.*, **79**: 106 (1932).

22. R. Namais, "Übermangansaures Kali zur Abschwächung zu harter Negative and die Herstellung direkter Positive in der Camera," *Phot. Mitt.*, **36**: 366 (1899).

23. "The Permanganate Reducer," *Brit. J. Phot.*, **48**: 675 (1901).

24. A. and L. Lumière and A. Seyewetz, "Reducers," *Brit. J. Phot.*, **47**: 805 (1900).

25. R. Namias, "Über die Harmonisierung harter Negative ohne Abschwächungsmittel," *Atelier*, **14**: 50 (1907).

26. R. Namias, "Permanganate Reducer," *Brit. J. Phot. Almanac*, p. 638 (1908).

27. R. Namias, "L'armonizzazione delle negative per dissoluzione dell'argento sottostante mediante soluzione acetica di permanganato," *Il Prog. Fot.*, **32**: 185 (1925).

28. R. Namias, "Reduction of Negatives by Means of Permanganate with Acetic Acid," *Kodak Monthly Abstract Bull.*, **11**: 511 (1925).

29. A. and L. Lumière and A. Seyewetz, "Sur l'emploi des sels au maximum comme affaiblisseurs de l'image photographique aux sels d'argent," *Bull. soc. franc. phot.*, (2) **16**: 103 (1900).

30. W. J. Smith, "A Substitute for Potass. Ferricyanide in the Reducer," *Brit. J. Phot.*, **63**: 574 (1916).

31. Richard B. Willcock, "Copper Sulphate in Bleachers and Reducers," *Brit. J. Phot.*, **90**: 457 (1943).

32. Richard B. Willcock, "Copper Sulfate in Bleachers and Reducers," *Am. Phot.*, **38** (8): 12 (1944).

33. George L. Wakefield, "Chemical Retouching," *Amat. Phot.*, **142** (14): 60 (1970).

34. F. F. Renwick, "The Ferricyanide-Bromide-Hypo Reducer," *Brit. J. Phot.*, **55**: 349 (1908).

35. Richard Lluellyn, "Proportional Reduction with Ferricyanide," *Brit. J. Phot.*, **87**: 432 (1940).

36. Norman C. Deck, "A Combined Permanganate-Persulphate Reducer for Negatives," *Brit. J. Phot.*, **63**: 391 (1916).

37. Aladár Schuller, "Zur Theorie und Praxis der Abschwächung," *Phot. Rund.*, **24**: 113 (1910).

38. Aladár Schuller, "Die chemischen Vorgänge beim Abschwächen mit Ammoniumpersulfat," *Phot. Rund.*, **24**: 161 (1910).

39. Kenneth Huse and Adolph H. Nietz, "Proportional Reducers," *Brit. J. Phot.*, **63**: 580 (1916).

40. R. C. Cardinal, "A Reliable Reducer for Over-Dense Cine Reversal Film Positives," *Brit. J. Phot.*, **85**: 131 (1938).

41. H. D'Arcy Power, "Permanganate Reducer," *Camera Craft*, **40** (6): 257 (1933).

42. A. Schuller, "Zur Persulfatfrage," *Phot. Rund.*, **49**: 235 (1912).

43. Richard B. Willcock, "Ferric Salts as Negative Reducers," *Brit. J. Phot.*, **91**: 258 (1944).

44. L. Belitski, "Abschwächung zu stark entwickelter Gelatine-Negative," *Deutsche Phot.-Zeit.*, **7**: 315 (1883).

45. L. Belitski, "Abschwächung zu stark entwickelter Gelatine-Negative," *Phot. Woch.*, **10**: 14 (1884).

46. L. Belitski, "Der grüne haltbare Abschwächer," *Phot. Woch.*, **16**: 71 (1890).

47. L. Belitski, "Reduction," *Phot. Annual*, p. 89 (1891).

48. L. Belitski, "Ein haltbarer Abschwächer," *Eder's Jahrbuch*, **5**: 41 (1891).

49. Ollomar Iarecki, "Belitzki Permanent Reducer," *Brit. J. Phot. Almanac*, p. 804 (1895).

50. Hugo Krause, "Abschwächung photographischer Platten mit Ferriammoniumsulfat," *Z. für wiss. Phot.*, **18**: 192 (1919).

51. Hugo Krause, *Eder's Jahrbuch*, **29**: 405 (1915).

52. R. Luther, "The Under-Exposure Period of the Characteristic Curve," *Trans. Fara. Soc.*, **19**: 340 (1923).

53. Alexander Lainer, "Ueber Abschwächung von Negativen und Positiven und weitere Eigenschaften des sauren Fixirbades," *Phot. Corr.*, **27**: 16 (1890).

54. E. Stenger and R. Kern, "Die abschwächende Wirkung der Fixierbäder," *Atelier*, **19**: 96 (1912).

55. A. Haddon and F. B. Grundy, "Solubility of Silver in Hyposulphite of Soda," *Brit. J. Phot.*, **43**: 7 (1896).

56. Valentine Blanchard, "On the Prolonged Action of Alum for Reducing Density," *Phot. News*, **25**: 20 (1881).

57. Paul N. Hasluck, *The Book of Photography*, Cassell and Company, London, 1907, p. 142.

58. H. D. Russell and J. I. Crabtree, "The Reducing Action of Fixing Baths on the Silver Image," *J. SMPE*, **18**: 371 (1932).

59. R. W. Henn, J. I. Crabtree, and H. D. Russell, "An Ammonium Hypo Reducer," *PSA J., Phot., Sci. and Tech.*, **17B** (11): 110 (1951).

60. A. and L. Lumière and A. Seyewetz, "Action of Persulphate of Ammonia on Metallic Silver," *Brit. J. Phot.*, **45**: 473 (1898).

61. A. and L. Lumière and A. Seyewetz, "Action curieuse du persulfate d'ammoniaque sur l'argent des phototypes et utilisation de cette action," *Bull. soc. franc. phot.*, (2) **14**: 395 (1898).

62. A. and L. Lumière and A. Seyewetz, "Merkwürdige Einwirkung von Ammoniumpersulfat auf photographische Silberbilder und die Verwerthung dieser Reaction," *Phot. Corr.*, **35**: 466 (1898).

63. Auguste and Louis Lumière, "Sur la théorie relative a l'action du persulfate d'ammoniaque sur l'argent des phototypes," *Bull. soc. franc. phot.*, (2) **15**: 226 (1899).

64. Rodolfo Namias, "Il Persolfato D'Ammonio," *Bull. Soc. Fot. Italiana*, **10**: 296 (1898).

65. G. I. Higson, "The History of Persulphate Reduction," *Phot. J.*, **61**: 237 (1921).

66. G. I. Higson, "Potassium Persulphate as a Reducer," *Phot. J.*, **62**: 98 (1922).

67. Geoffrey Isherwood Higson, "The Reaction between Persulphates and Silver," *J. Chem. Soc.*, **119**: 2048 (1921).

68. Hugh Marshall, "The Manufacture and Industrial Uses of Persulphates," *J. Soc. Chem. Ind.*, **16**: 396 (1897).

69. Hugh Marshall, "The Action of Silver Salts on Solution of Ammonium Persulphate," *Phot. J.*, **41**: 340 (1901).

70. G. Watmough Webster, "The Persulphate of Ammonia Reducer," *Brit. J. Phot.*, **50**: 924 (1903).

71. E. Stenger and H. Heller, "Über die Abschwächung mit Persulfat," *Z. für wiss. Phot.*, **9**: 73 (1910).

72. E. Stenger and H. Heller, "Persulphate Reducer," *Brit. J. Phot. Almanac*, p. 607 (1912).

73. Henry W. Bennett, "Ammonium Persulphate," *Phot. J.*, **47**: 328 (1907).

74. H. W. Bennett, "The Persulphate Reducer," *Brit. J. Phot. Almanac*, p. 628 (1913).

75. Henry W. Bennett, "Reduction with Ammonium Persulphate," *Phot. News*, **51**: 317 (1907).

76. R. Namias and Adolph Baschieri, "The Keeping Qualities of Persulphate Reducers," *Brit. J. Phot.*, **54**: 940 (1907).

77. S. E. Sheppard, "The Effect of the Iron Content of Ammonium Persulphate on its Photographic Reducing Power," *Brit. J. Phot.*, **65**: 314 (1918).

78. S. E. Sheppard, "The Effect of the Iron Content of Ammonium Persulphate on its Photographic Reducing Power," *Phot. J. Am.*, **55**: 297 (1918).

79. A. and L. Lumière and A. Seyewetz, "On Irregularities in the Action of the Persulphate Reducer," *Brit. J. Phot.*, **68**: 124 (1921).

80. A. and L. Lumière and A. Seyewetz, "On the Causes of the Variation in Reducing Power Found in Various Samples of Commercial Persulphate of Ammonia," *Phot. J.*, **61**: 144 (1921).

81. S. E. Sheppard, "Persulphate Reduction," *Phot. J.*, **61**: 450 (1921).

82. C. E. Kenneth Mees, *The Theory of the Photographic Process*, Revised Edition, Macmillan Company, New York, 1954, p. 744.

83. J. I. Pigg, "The Action of Ammonium Persulphate on the Photographic Image," *Brit. J. Phot.*, **50**: 706 (1903).

84. W. Scheffer, "Microscopical Researches on the Effect of the Persulphate and Ferricyanide Reducers," *Brit. J. Phot.*, **53**: 964 (1906).

85. W. Scheffer, "Theory of the Persulphate Reducer," *Brit. J. Phot. Almanac.*, p. 639 (1908).

86. C. Stürenburg, "Anwendung der Photographie zur Herstellung eingebrannter Bilder," *Deut. Phot.-Zeit.*, **7**: 254 (1883).

87. W. Scheffer, "Further Researches in the Action of Reducers," *Brit. J. Phot.*, **55**: 472 (1908).

88. J. M. Eder, *Phot. Corr.*, **18**: 111 (1881).

89. J. M. Eder, "Correctur von zu harten oder gelbschleierigen Negativen durch Ueberführen in Chlor- oder Bromsilber und Wiederentwickeln," *Eder's Handbuch*, 5th Edition, Vol. III, Part 3, p. 561 (1903).

90. Practicus, "Reducing Negatives," *Brit. J. Phot.*, **60**: 118 (1913).

91. Alphonse Seyewetz, "Sur les divers Procédés d'Affaiblissement des Négatifs permettant d'harmoniser les Clichés fortement contrastés," *IX^e Congress International de Photographie Scientifique & Appliquée*, Paris, 1935, Revue d'Optique theorique et instrumentale, Paris, 1936, p. 365.

92. George E. Brown, "Reduction by Re-Development," *Brit. J. Phot.*, **58**: 890 (1911).

93. C. Welborne Piper, "Two Neglected Processes of Reduction and Intensification," *Brit. J. Phot.*, **63**: 167 (1916).

94. James R. Carter, "Negative Reduction by Physical Re-Halogenization," *Camera*, **49** (6): 376 (1934).

95. Bernard Wakeman, "Reduction to Order," *Brit. J. Phot.*, **92**: 23 (1945).

96. W. J. Hickman, "A New Method for Reducing Hard Negatives," *Brit. J. Phot.*, **80**: 59 (1933).

97. C. van Duijn, Jr., "The Reduction of Negatives," *Am. Phot.*, **41** (5): 30 (1947).

98. Lew Gust and Ray Cole, "Reduction of Negatives," *Am. Phot.*, **34** (6): 404 (1940).

99. "Improved Manufacture of a Photographic Reducer," *Brit. J. Phot. Almanac*, p. 907 (1902).

100. Pierre Glafkides, *Photographic Chemistry*, Vol. 1, Fountain Press, London, 1958, p. 177.

101. "Iodine-Cyanide," *Brit. J. Phot. Almanac*, p. 326 (1959).

102. T. H. Greenall, "A New Local Reducer on Dry Prints," *Brit. J. Phot.*, **73**: 383 (1926).

103. "Local 'Dry' Reducer for Prints," *Brit. J. Phot. Almanac*, p. 305 (1950).

104. Richard B. Willcock, "The Iodine-Thiocarbamide Reducer," *Brit. J. Phot.*, **97**: 477 (1950).

105. A. and L. Lumière and A. Seyewetz, "Sur l'emploi des quinones pour l'affaiblissement des images photographiques aux sels d'argent," *Bull. soc. franc. phot.*, (3) **1**: 392 (1910).

106. A. and L. Lumière and A. Seyewetz, "Quinone Compounds as Reducers of Silver Images," *Brit. J. Phot.*, **57**: 625 (1910).

107. E. Stenger and H. Heller, "The Lumière Quinone Reducer," *Brit. J. Phot.*, **58**: 988 (1911).

108. A. and L. Lumière and A. Seyewetz, "Quinone and other Oxidizing Agents for the Conversion of Silver Images into Bromide or Chloride," *Brit. J. Phot.*, **68**: 6 (1921).

109. Pierre Glafkides, *Photographic Chemistry*, Vol. 1, Fountain Press, London, 1958, pp. 182–183.

Chapter 3

Chemical Treatment of the Silver Image

TONING

The idea of changing the color of a black-and-white print is almost as old as the process of making a black-and-white print itself. The number of chemicals used for this purpose and combinations of these chemicals into toning formulas are countless.

FRED P. PEEL[22]

In the broadest sense, toning is the production of colored photographic images on black-and-white paper or film materials. Toning is a technique that enhances the visual effectiveness of an image by better recreating the mood or impression that the photographer wishes to convey. Brown tones suggest a feeling of friendliness or sunshine; blue tones enhance the brilliance of marine scenes or convey the crisp cold feeling of winter. Images toned green, red, or other colors attract attention more readily than the original black or nearly black color. Toning may be simple, such as soaking a contrasty photographic portrait in cold coffee (not hot coffee!) to produce the yellowed look of age.[1] Most toning methods, however, involve chemical reactions, ranging from the formation of colored silver images during

development to the changing of the color of the normal silver image once it has been formed. Early color photographs were made by combining three separate toned images.

Depending upon the type of chemical reaction involved, toning processes may be divided into several categories:

1. Toning during image development, by which the color of the silver image is determined by the nature of the photographic emulsion and by the composition and use of the developer.
2. Toning by conversion of the metallic silver image into a colored silver compound, such as the formation of brown silver sulfide from the metallic silver of the image.
3. Toning by deposition on, or by partial or complete substitution for, the silver image of an insoluble metal compound, or compounds, that are colored. This method of toning is probably the most commonly used for changing the tone of a silver image, formed either by developing or by printing out the image.
4. Toning by replacing the silver metal of the image by a colored dye which is permanently attached to a metal salt that has replaced the image silver.
5. Toning by color development during which the oxidized developing agent (produced from the development of the image silver) reacts with a chemical compound contained in the developing solution, to deposit a dye image in the same areas as the silver image.

TONING BY DEVELOPMENT OF THE SILVER IMAGE

The silver image commonly formed during normal development is black, although some silver may appear grayish by reflected light. The possible differences in image color, according to C. E. K. Mees,[2] are due to a difference in the size of the metallic silver particles. Colored silver images may be obtained if the silver particles are small when compared to the wavelength of the incident light. The finest silver particles first appear yellow; then, as the particles increase in size, their color changes from yellow to orange, pink, reddish-brown, brown to gray. Other factors, such as the condition of the silver surface, also influence the color of the developed silver. The use of restrained, often very dilute, developers favors the formation of finely divided silver, as does a photographic material that has fine silver halide crystals in the emulsion. Chlorobromide photographic papers generally yield warmer-toned images than bromide papers, but in these days of proprietary products, many photographic papers contain all three halides, and their ratio may differ from grade to grade of the same brand. In addition,

organic compounds added to the emulsion influence image tone. Photographic papers or films, regardless of their chloride, bromide, or iodide content, may be satisfactorily toned by one of the many methods of toning.

The gamut of image tones given by direct development ranges from blue to red but depends upon the photographic material as well. Hydroquinone, used alone in restrained developing solutions, tends to give warm-toned images; Metol alone in a developing solution produces black or blue-black images. Kodak D-32 developer (hydroquinone alone) produced warm-black tones on lantern slides; Kodak D-34 developer (Metol only) produced cold-black images on lantern slides. A hydroquinone developer for photographic prints was said by John H. Waddell[3] to give image tones ranging from black to red depending upon the dilution. This developing solution had the following formula:

Hydroquinone Developer (Waddell)

Sodium sulfite, desiccated	35 g
Hydroquinone	10 g
Sodium carbonate, anhydrous	30 g
Ammonium bromide	2 g
Potassium bromide	3 g
Water to make	1 liter

For black tones, do not dilute. For red tones, add 10 parts of water to each part of developer and overexpose the print.

Generally, Amidol is used to compound developers that give blue-black tones, Glycin for brown tones, and chlorohydroquinone for red to brown tones on photographic prints. Amidol print developers have been a favorite of many printmakers for producing rich cold-black tones, even though the solution deteriorates rapidly after mixing and easily can stain the fingers and clothing. Many Amidol formulations have been proposed, and most work satisfactorily, as the composition of an Amidol developer is not critical. One developer for photographic paper has the composition:[4]

Kodak Amidol Developer D-51

Stock Solution

Water	750.0 ml
Sodium sulfite, desiccated	120.0 g
Amidol (diaminophenol hydrochloride)	37.5 g
Water to make	1.0 liter

For use:

Stock solution	180 ml
Potassium bromide (10% solution)	3 ml
Water	750 ml

Develop from $1\frac{1}{2}$ to 3 minutes at 70°F. Use at once after mixing and discard after use.

The rich black image of the prints of Edward Weston has been much admired. Weston's Amidol developer, according to Ansel Adams,[5] was composed of

Water	800.0 ml
Sodium sulfite, desiccated	35.0 g
Amidol	11.0 g
Potassium bromide (10% solution)	7.5 ml
BB compound (antifoggant stock solution)	60.0 ml
Water to make	1200.0 ml

Citric acid may be added as a preservative.

Ansel Adams notes that Ansco Developer 113 (desiccated sodium sulfite, 44 g; Amidol, 6.6 g; 10% potassium bromide solution, 5.5 ml; in a liter of water) may be diluted with up to 20 parts of water to give softer tones with good image color. Long times of development—10 min or more—may be necessary with the higher dilutions.

Chlorohydroquinone developing solutions can produce image tones ranging from warm-black to red,[6] and Glycin developing solutions can form image tones from black to reddish-brown. Undiluted, the chloro-hydroquinone and Glycin developers give warm-black images. With dilution, additional quantities of potassium bromide, and prolonged developing times, combined with increased print exposure, these developers shift the image tone to reddish-brown or red. Hydroquinone is often used with either chlorohydroquinone or Glycin to produce warm-toned prints.[7] Glycin-hydroquinone and chlorohydroquinone-hydroquinone developing solutions, formulated by Ilford Limited, were modified slightly by Donald Burchan and Ira Current[8] so that a range of image tones could be produced on most photographic papers by changes in exposure time, developer dilution, and potassium bromide content, as well as variations in developing time. (See Tables 1, 2, and 3.)

Table 1. Glycin-Hydroquinone and Chlorohydroquinone Developing Solutions

	Chlorohydroquinone Formula	Glycin Formula
Chlorohydroquinone	6.8 g	—
Hydroquinone	6.8 g	6.8 g
Glycin	—	6.8 g
Sodium sulfite, anhydrous	62.4 g	62.4 g
Sodium carbonate, monohydrated	54.4 g	88.4 g
Potassium bromide	0.7 g	0.7 g
Water to make	1.0 liter	1.0 liter

Table 2. Conditions of Use for Chlorohydroquinone Formula

Image Tone	Dilution	Milliliters of 10% Potassium Bromide to Be Added to One Liter of Solution	Relative Exposure Time	Approximate Developing Time (min)
Warm black	1:0	0	1	$1\frac{1}{2}$
Warm sepia	1:10	40	4 to 5	9
Red-brown	1:15	120	6 to 8	14
Bright red	1:30	240	9 to 15	30

Table 3. Conditions of Use of Glycin Formula

Image Tone	Dilution	Milliliters of 10% Potassium Bromide to Be Added to One Liter of Solution	Relative Exposure Time	Approximate Developing Time (min)
Black	1:0	0	1	$1\frac{1}{2}$
Warm black	1:2	20	$1\frac{1}{2}$ to $2\frac{1}{2}$	3 to 6
Warm black to sepia	1:4	40	2 to 4	5 to 15
Sepia to red-brown	1:8	80	4 to 8	12 to 30

The color of the image of a normally processed photographic print may be changed by redevelopment. Such a technique was proposed by André Page,[9] who bleached the silver image of the print, after fixing and washing, in

Potassium dichromate	21 g
Hydrochloric acid (concentrated)	10 ml
Water to make	2366 ml

until the black-and-white image was whitened. (A faint buff image may remain, but this may be disregarded.) This print is washed in running water for 5 min, then redeveloped to finality in

Sodium sulfite, desiccated	14.2 g
Amidol	5.2 g
Water to make	591.4 ml

The print is then rinsed in water, given normal fixation, and washed thoroughly. "Beautiful blue-grey" image tones were said to be produced on bromide photographic papers and "delightful brown-black" tones on chlorobromide papers. Amidol (0.26 g) and sodium sulfite (2.6 g) in 30 ml of water has also been suggested as the basis of a developer.[10]

The same bleach-and-redevelop technique was used by Edward T. Howell,[11] who adapted the catechol redeveloper that was used by Cuisinier in 1933. A normally exposed and processed print was first immersed in

Solution A

Water	1 liter
Potassium ferricyanide	8 g
Potassium bromide	12 g

until only a faint brown image was visible. The print was washed in running water for 5 min, then immersed in solution B at 70°F.

Solution B

Water	1 liter
Catechol	2 g
Sodium carbonate	10 g

The image tone went from red through sepia to brown and finally dark brown. The final tone was darker after the print dried. After redevelopment, the toned print was washed 1 hr in running water and then dried. Most photographic papers were said to produce essentially the same image tones.

In British Patent 1,186,315, hydroquinone or hydroquinone-Phenidone developers for paper prints are said to produce brown image tones when the solution contains a 3,4-diaminopyridine or a related pyridine derivative. A suitable formulation for silver chloride paper contained

Sodium sulfite	15 g
Sodium carbonate	23 g
Potassium bromide	0.6 g
Hydroquinone	4 g
1-Phenyl-3-pyrazolidone	0.2 g
2-Hydroxyethylamino-5-aminopyridine	1 g
Distilled water to make	1 liter

The print was developed for 90 sec, fixed and washed. "A neutral-brown toned silver print" was said to be obtained. A yellowish-brown print on a silver bromide paper was produced when a similar developing solution contained 1 g of Metol in addition and with 1 g of 3,4-diaminopyridine replacing the above 5-aminopyridine compound.

CHEMICAL TONING

"Toning" refers usually to changing the image tone of the developed silver image by chemical modification. The final color of the image formed by toning depends upon the size and surface condition of the silver particles in the black-and-white image. Finely divided silver particles, produced by bromided developers and fine-grained photographic papers, form warmer image colors when chemically toned than do the larger image particles of coarser-grained photographic papers developed in more active developing solutions. The tone of the black-and-white print is not always a good indication of the warmth of the image tone of the toned print.[12] Proper density of the image should be secured by adequate exposure and full development. Generally, over- or underdevelopment should be avoided, although full development may be needed in some cases to offset the density-reducing effect of some toning baths. The uniformity and brilliance of the image tone are adversely affected by deviation from the recommended development

conditions. Such conditions may vary from toning solution to toning solution, so the development conditions must be coordinated with the type of toning solution to be used.

After development, the print should be treated in an acid stop bath, followed by fixation in an acid hardening fixing bath. Some toning methods soften the emulsion layer so that a fixed but unhardened emulsion layer may have to be hardened with a hardening solution, such as diluted Kodak hardener F-5a. Prints intended for toning should be fixed in a fresh fixing bath with agitation during the immersion. Extending the fixing beyond the recommended times is to be avoided, so that there is no loss of fine image details or increased retention of the thiosulfate in the print. As a general rule, washing must be thorough, as retained thiosulfate in the gelatin layer may react with intermediate compounds formed in some two-step toning processes. Loss of the intermediate compound by reaction with the retained thiosulfate will result in less density in the final toned image, sometimes evident as blotchiness. Retained silver thiosulfates may produce stained whites in the toned image.

Some toning solutions contain thiosulfate as an ingredient. For these, a complete removal of the fixing-bath ingredients is not essential, so that a water rinse between fixing and toning is sufficient. However, it is good practice to wash all black-and-white prints thoroughly, so that any toning process may be selected. Incomplete fixation and inadequate washing are without doubt the greatest causes of failure during chemical toning.

Sulfide Toning

The conversion of the silver image into silver sulfide produces a brown-colored image of low solubility and great stability. Sulfide toning may be a single-step treatment, or it may be done in two steps, first forming a silver halide from the metallic silver image and then changing the halide into silver sulfide. Conversion of the metallic silver image into the brown silver sulfide results in a loss of visual density and a softening of the image contrast. For sulfide toning, R. R. Rawkins[13] suggested adding 20% to the correct exposure for a normal black-and-white print. According to Kodak,[14] however, compensation for some photographic papers may be achieved by determining the correct exposure time for a 2-min development, then using the same exposure to make a print for sulfide toning that is developed for $3\frac{1}{2}$ min at 68°F. Increasing exposure is said to produce a contrast loss and undesirable (yellowish) image tone. Increasing the development time increases both contrast and density, off-setting the bleaching effect of the sulfide toning solution.

Direct Sulfur Toning

Toning with Polysulfides

Liver of sulfur is available as yellowish-brown lumps which, when broken, expose a liver-brown surface. According to the *Merck Index*,[15] the lumps contain a "mixture of potassium polysulfides, chiefly trisulfide, and potassium thiosulfate, containing not less than 12.8% sulfur as sulfide." This indefinite mixture, containing other impurities as well, has the characteristic rotten-egg odor of hydrogen sulfide. The sulfur that is formed from this mixture converts the metallic silver image of a photograph to silver sulfide of a sepia tone. The sulfiding of the silver probably proceeds according to these reactions, suggested by A. and L. Lumière and A. Seyewetz[16]:

$$S + H_2O \longrightarrow H_2S + O$$

$$2Ag + O \longrightarrow Ag_2O$$

$$Ag_2O + H_2S \longrightarrow Ag_2S + H_2O$$

In 1912 R. R. Woodman[17] proposed adding "a piece of the liver of sulphur the size of a pea" in 180 to 240 ml of water for use at 100°F. Treating the prints for 5 min in a 10% solution of liver of sulfur at room temperature, followed by 2 hr washing in water at 60 to 65°F, was suggested by the Lumières and Seyewetz.[16] Gordon Douglas[18] used 1.7 g of liver of sulfur in a liter of water for toning at 100°F. Ira B. Current[19] dissolved 2 g of liver of sulfur in a liter of water, obtaining the more rapid and satisfactory toning if the solution temperature was around 140°F. E. Fenske[20] patented the addition of sodium thiosulfate to a liver of sulfur toning solution for use at 60°F. From the varied proposals, it is evident that toning may be secured with a range of concentration of the liver of sulfur at different temperatures of the solution.

A modern toning solution[21] using liver of sulfur (polysulfide) has the composition

Kodak Polysulfide Toner T-8

Water	750.0 ml
Liver of sulfur	7.5 g
Sodium carbonate, monohydrated	2.5 g
Water to make	1.0 liter

The well-washed, hardened print is immersed for 15 to 20 min in the T-8 toning bath at a temperature of 68°F. If the solution temperature is raised to 100°F, the time for toning is 3 to 4 min. After toning, it is recommended that the print be rinsed in running water for a few seconds, then treated for about 1 min to 3% sodium bisulfite solution. The print is then immersed for about 2 to 5 min in diluted Kodak hardener F-5a (two parts of the hardener and 16 parts of water).

Kodak Hardener F-5a: Stock Solution

Water, about 125°F	600 ml
Sodium sulfite, desiccated	75.0 g
Acetic acid, 28% solution	235.0 ml
Boric acid, crystals	37.5 g
Potassium alum	75.0 g
Cold water to make	1.0 liter

After hardening, the print surface should be swabbed with a sponge if any sediment is present. Wash the print at least 30 min in 68°F water before drying.

Toning with liver of sulfur is direct (single solution) and inexpensive, but the toning is slow if the toning bath is at room temperature. The toning time is considerably shortened if the toning solution is heated. Heating the solution, however, increases the escape of hydrogen sulfide gas with its most unpleasant odor. "Smells like something crawled into the darkroom and died," said Fred P. Peel.[22] Hydrogen sulfide is a flammable, poisonous gas. About human toxicity, the *Merck Index*[23] states, "Extremely hazardous. Collapse, coma, and death from respiratory failure may come within a few seconds after one or two inspirations. Insidious poison, since sense of smell may be fatigued and fail to give warning of high concns. Low concns produce irritation of conjunctive and mucous membranes. Headache, dizziness, nausea, lassitude may appear after exposure." Hydrogen sulfide also has a detrimental effect on photographic materials, causing photographic film and paper to be fogged.[24] Any toning solution that emits hydrogen sulfide should obviously be used in well-ventilated areas but not in darkrooms. Someone has suggested an open garage. By taking the necessary precautions, workers have used the liver of sulfur toner effectively through the years.

Liver of sulfur is a mixture of potassium polysulfide and potassium sulfate with probably some potassium carbonate and potassium thiosulfate present as well. Only the potassium polysulfide is the effective toning agent, according

to E. R. Bullock.[25] The effectiveness of polysulfide for toning was recognized as early as 1913 by J. Desalme, [26-28] who prepared a sodium polysulfide solution by adding, slowly, 6 g of sulfur to 50 ml of boiling water containing 50 g of sodium sulfide. When the sulfur is dissolved, dilute to one liter for the toning bath (30 min immersion is required, followed by thorough washing in water). Desalme also noted that sodium sulfide may be converted to a polysulfide by adding hydrogen peroxide or some per-salt, such as ammonium persulfate. Sodium polysulfide toning baths, according to H. Cuisinier,[29-30] are caustic, may cause deterioration of the paper base, sometimes stain the whites of the paper, and may attack the skin and nails. Potassium polysulfide (liver of sulfur) is much more free of these disadvantages. Ammonium sulfide, "an evil-smelling liquid," was added to water (three or four drops to a pint of water) to form a toning bath in 1899.[31] Ammonium polysulfide (made by dissolving sulfur in ammonium sulfide) was the toning agent preferred by G. Underberg.[32] Direct sulfide toning has also been carried out in 1% potassium ethyl xanthate,[33] but this compound is as malodorous as the polysulfides.

Toning with Thiosulfate Solutions

A fixed but unwashed photographic silver image, especially if left in a moist atmosphere, will turn brown because sulfur, freed from the thiosulfate, converts the metallic silver into silver sulfide. For permanence of black-and-white images, this sulfiding of the image must be avoided, usually by thorough washing and the use of hypo eliminators. This reaction, however, may be used to tone silver images uniformly to a brown color. In 1847 Blanquart-Evrard patented the use of thiosulfate acidified with acetic acid to brown-tone silver printout paper.[34] An early method of toning,[35] not much in use at present, was to place a photographic print, after fixing in 20% sodium thiosulfate or a regular fixing bath, and without washing or after a brief water rinse, in a weak acid solution, such as 1 to 5% hydrochloric acid. The acid decomposes the thiosulfate, forming colloidal sulfur that remains as an insoluble deposit in the emulsion layer but is capable of slowly sulfiding the image silver. A treatment in 1% hydrochloric acid must last from 3 to 4 min at 60 to 63°F, followed by washing in water for $1\frac{1}{2}$ hr.

For brown toning of bromide prints, A. and L. Lumière and A. Seyewetz[36] proposed making a toning bath consisting of sodium thiosulfate (125 g) and 50% dextrine solution (250 ml) in a liter of water. Just before use, 50 ml of concentrated hydrochloric acid was added to decompose the thiosulfate and liberate sulfur. The dextrine prevented the sulfur from precipitating and

held it in an extremely fine state of division in the solution. The prints were immersed in the acidified thiosulfate solution for 20 to 25 min, then washed for about $1\frac{1}{2}$ hr. The brown tone does not appear until after some time in the wash water. It was proposed that the sulfur retained in the emulsion layer acted on the metallic silver of the image by

$$2\,Ag + S + H_2O \longrightarrow Ag_2O + H_2S$$

$$Ag_2O + H_2S \longrightarrow Ag_2S + H_2O$$

The use of the "messy dextrine solution" could be avoided, Henry Soar[37-40] suggested, if the acidic content of the bath were carefully adjusted to disintegrate the thiosulfate slowly. His toning bath consisted of sodium thiosulfate (14.2 g) and water (591 ml); and, just before use, he added concentrated sulfuric acid (1.2 ml). The toning procedure was essentially the same as suggested by the Lumières and Seyewetz.

Hypo-Alum Toners

Almost everyone, including Leo Baekeland, has agreed that Leo Baekeland in 1888 was the first to suggest the use of the action of a mixture of sodium thiosulfate and alum (potassium aluminum sulfate) to brown-tone the image of silver halide prints.[41-44] Baekeland[45] found that "the toning action of the above mixture can be looked upon as a process of slow sulphurication under the influence of sulphur in a nascent state." He noted that "mixtures of thiosulphate and alum will act in a different way on different kinds of silver prints." The exact nature of the reactions involved in thiosulphate-alum toning is unknown, as numerous interactions are possible.[46-47] The aluminum sulfate from the alum may be considered to form acid, which decomposes the thiosulfate.[46]

$$Al_2(SO_4)_3 + 3\,H_2O \longrightarrow Al_2(OH)_3 + 3\,H_2SO_4$$

$$Na_2S_2O_3 + H_2SO_4 \longrightarrow Na_2SO_3 + SO_2 + S$$

The aluminum sulfate can also react with the sodium thiosulfate, forming aluminum thiosulfate, which then spontaneously decomposes.[46]

$$Al_2(SO_4)_3 + 3\,Na_2S_2O_3 \longrightarrow Al_2(S_2O_3)_3 + 3\,Na_2SO_4$$

$$Al_2(S_2O_3)_3 + 3\,H_2O \longrightarrow Al_2(OH)_3 + 3\,SO_2 + 3\,S$$

It has also been suggested[48-49] that aluminum thiosulfate may decompose according to the following reaction:

$$Al_2(S_2O_3)_3 + 3H_2O \longrightarrow 3H_2S + Al_2(SO_4)_3$$

followed by a reaction of the hydrogen sulfide with the thiosulfate:

$$Na_2S_2O_3 + H_2S \longrightarrow NaHSO_3 + NaHS + S$$

Two toning reactions, one due to colloidal sulfur, the other to hydrogen sulfide, may be occurring.[50] The end reaction involves sulfiding of the image, regardless of the exact route of the intermediate reactions

$$2Ag + S \longrightarrow Ag_2S$$

Hypo-alum sepia toning has been described[51] as "Essentially an old fixing bath which liberates sulfur so that prints may be toned in it in about 30 minutes at 110°F. The sulfur is not liberated from a fresh bath—it must be artificially aged, or ripened, either by allowing unexposed paper to remain in it, or by adding silver nitrate and potassium bromide." In making the hypo-alum toner, either potassium alum is added to a solution of sodium thiosulfate, then boiled to precipitate the free sulfur,[52] or a hot solution of the potassium alum is added to a cold solution of sodium thiosulfate to accomplish the same purpose. The solution becomes cloudy, or sometimes is heated until cloudy, because of the freeing of the loosely held sulfur of the thiosulfate ion.

A toning bath consisting of only thiosulfate and alum has a tendency to attack and dissolve the fine silver details of the print. To protect the silver image, a silver salt, such as silver chloride, silver bromide, or silver iodide, is added to the toning bath. Some of the solvent action of the thiosulfate is expended in solubilizing the silver salt, forming a buffer action, but the action of the thiosulfate still removes image silver. Prints for hypo-alum toning are given more exposure than normal (up to 15%) and the development time is also extended (up to 50%) to compensate in some degree for the losses during the toning, but the exact increases vary with each paper. Almost every writer on hypo-alum toning recommends the saving of the used toning bath, as the ripened solution yields fine tones with less attack upon the fine image detail.

Almost every manufacturer of photographic materials has recommended a hypo-alum toning bath for his products.[53] All of the formulations are essentially the same: Sodium thiosulfate and potassium alum are first combined in a solution to which a solution of silver nitrate and sodium chloride, bromide, or iodide is then added. The order of addition of the compounds is important. The silver nitrate should be added to water and completely dissolved before the sodium chloride is added. Then this solution with its

milky white precipitate of silver chloride is added to the thiosulfate-alum solution. The Kodak hypo alum sepia toner T-1a [54-55] has a formulation typical of the many thiosulfate-alum formulations that have been proposed.

Kodak Hypo Alum Sepia Toner T-1a

Cold water	2800 ml
Sodium thiosulfate, pentahydrated	480.0 g

Dissolve completely, then add the following solution:

Hot water (about 160°F)	640 ml
Potassium alum, dodecahydrated	120.0 g

Then add the milky solution, including the white precipitate, slowly with rapid stirring, to the thiosulfate-alum solution:

Cold water	64.0 ml
Silver nitrate, crystals	4.2 g
Sodium chloride	4.2 g

Finally, add water to the combined solution to make a total of 4.0 liters.

For use: Pour solution into a tray in a water bath[56] and heat to 120°F but not above 125°F. Prints well fixed,[57] washed, and wet should be toned for about 12 to 15 min. Do not tone longer than 20 min at a temperature greater than 120°F, as the print may blister or stain at the extreme conditions. Hypo-alum toning baths may be used cold, but the time of toning may take up to 24 hr and the tones may be purplish and uneven.

Because the toning bath contains silver salts, some writers have advised that the toned print should be fixed in order to avoid a slow yellowing of the whites of the print image. The directions for the Kodak T-1a toner do not specify a fixing bath after toning, and probably one is not needed if the image has been completely converted to silver sulfide and thoroughly washed. After the print has been toned, the surface of the print is swabbed with a sponge or cotton soaked in warm water. The surface is swabbed to remove any sulfur sediment. This sediment is not too evident when wet, but is apparent, but difficult to remove, when the print is dry. Wash toned prints for 1 hr in running water before drying.

Many modifications of thiosulfate-alum toning baths have been suggested. Less than 1 % sulfuric acid added to thiosulfate solution was used following fixing of the prints in a thiosulfate-alum solution. The prints were not washed

before being immersed in the sulfurized thiosulfate bath. According to W. E. A. Drinkwater,[58] toning was said to be completed in a few seconds at 100 to 110°F. Another modification by M. B. Punnett[59] involved the use of ammonium thiocyanate. The use of potassium iodide rather than sodium chloride was part of early recommendations by Eastman Kodak Company[60] and Defender Photo Supply Company.[61] After fixing, the prints were rinsed in water, hardened (a saturated solution of alum was used for 10 min), then toned in a bath made in the following manner:

Sodium thiosulfate, pentahydrate	180 g
Hot water	1.0 liter
Alum	44 g

Stir the ingredients, then boil the solution for 2 to 3 min. Cool to 150°F before adding the solution

Silver nitrate	0.5 g
Water	12.0 ml
Ammonia	until solution clears

Then add

Potassium iodide	1.0 g
Water	12.0 ml

This solution was heated for use at 140°F. After toning, the surface of the print was swabbed to remove any sediment.

Thiosulfate-Gold Toners

The first photographic toner ever used was a heated solution of gold chloride and sodium thiosulfate, by which Hippolyte Louis Fizeau in 1841 improved both the color and permanence of the early daguerreotypes. Gold toning became the standard method for improving the unpleasant color of images on printout papers, particularly the use of alkaline gold toning baths, first suggested by Waterhouse in 1855.[62] It is not surprising, therefore, that the first important modification of hypo-alum toning baths was to add gold chloride or gold sodium chloride to a bath that had been made alkaline. A richer brown-toned image was secured. The image consisted of silver sulfide and a small amount of metallic gold. Because the bath was alkaline, the gold was deposited in a form that had cold-toned particles. The combined tone

of the silver sulfide and the bluish gold produced a very desirable image color that created a sensation in 1911.[63]

A hypo-alum toning solution with gold chloride (T-13)[64] consisted of

Stock Solution No. 1

Sodium thiosulfate, pentahydrate	120 g
Boiling water	1 liter

Dissolve and add

Potassium alum (powdered)	15 g

Boil 2 min, cool, then add

Sodium phosphate, dibasic	15 g

Next, prepare

Silver nitrate, crystals	1 g
Water	7.5 ml

and

Potassium bromide	3.1 g
Water	7.5 ml

Pour the potassium bromide solution into the silver solution and then add the mixture with the precipitate to the cool thiosulfate-alum solution.

Stock Solution No. 2

Gold chloride	1.0 g
Water	60 ml

For use:

Solution No. 1	400 ml
Solution No. 2	3 ml

Heat the toning bath to a temperature of 120 to 125°F (49 to 52°C). Place all the prints in the bath that are to be toned but keep separated. Toning time is about 20 min.

In 1932 Walter C. Nelson[65] patented a gold toning bath that has carried his name. Nelson's Gold Toner (Kodak gold toner T-21) produced a variety of excellent brown tones, the prints being removed from the bath when the desired color was achieved. The beauty of the color has made this toner a favorite of countless photographers, including this writer who has used it for all types of photographic paper.

Walter Nelson claimed his solution would produce more reproducible tones of a wider range of color and the bath would have a higher degree of stability than previous hypo-alum solutions. He stated,

I have been able to accomplish these objects by preparing a toning bath similar in many respects to the older "hypo-alum" toning baths, but one in which for the alum I substitute ammonium persulphate. The action of the ammonium persulphate in my toning formula is not perfectly understood, as this substance has never been previously used for this purpose. Its use in photographic reduction is of course well known. It is thought, however, that in this case the persulphate attacks or etches the surface of the silver particles in the image, after which they are then more easily converted to silver sulphide. It is, of course, understood that toning of the kind under consideration consists of a conversion of the silver image to silver sulphide, which is brown. Whatever the explanation of the action may be, I am able to secure a very pleasing variety of tones and colors by means of the method I will now describe.

Nelson's Gold Toning bath[66] is made by preparing first

Solution No. 1

Warm water (about 125°F or 50°C)	4.0 liters
Sodium thiosulfate, pentahydrated	960.0 g
Potassium persulfate	120.0 g

Dissolve the sodium thiosulfate before adding the ammonium persulfate. Stir the bath vigorously while adding the persulfate. If the solution does not turn milky, raise the temperature until it does, thus indicating sulfurization of the thiosulfate.

Cool this solution to 80°F (27°C), then add the following solution, including the precipitated silver chloride, slowly and with stirring to the cool, milky solution already prepared:

Cold water	64.0 ml
Silver nitrate, crystals	5.0 g
Sodium chloride	5.0 g

Dissolve the silver nitrate before adding the sodium chloride. Then prepare

Stock Solution No. 2

Water	250.0 ml
Gold chloride	1.0 gram

For use:

Add	stock solution 2	125 ml
To	stock solution 1	entire quantity

After stirring, it is recommended that the combined solution be allowed to stand for about 8 hr. The clear solution is poured off and the yellow precipitate discarded. The toner is used at a temperature of 110°F (43°C). When the desired tone is reached, after about 5 to 20 min, remove the print and swab off the surface with a wet sponge to remove the sediment. Wash all prints in running water for 1 hr and sponge off the surface water before drying.

Dry prints to be toned should be soaked in water first. If prints have just been fixed, wash for a few minutes in running water before toning. Hard-to-tone photo papers, such as Kodabromide, for which the Kodak T-21 bath has not been recommended, may be toned, according to this writer's experience, by raising the temperature of the bath to 130°F and extending the time to about 30 min to secure a very rich brown tone.

Indirect Sulfur Toning

The formation of brown image tones at normal temperatures may be accomplished by the two-solution sulfur toning process.

The originator of indirect sulfur toning is unknown, but this procedure was practiced about the turn of this century.[67] Since then, as E. J. Wall[68] comments, the literature "is as the sands on the seashore." An oxidizing agent, such as potassium ferricyanide, may be used to extract electrons from the metallic silver of the image. The silver ions that are formed then are reacted with halide ions, such as those from potassium bromide, to form a whitened image (bleached) of silver bromide. "The silver bromide so produced," said Edwin E. Jelley,[69] "does not occupy exactly the same position as the original silver; this is because the silver, after giving up its valency electron to the ferricyanide ion, is really in solution, and the deposition of silver bromide commences only when the silver ion concentration becomes greater than that which corresponds to a saturated solution of silver bromide.

The relative degree of spreading is appreciable in the case of fine grained photographic deposits. The second stage in the sepia toning is to convert the silver bromide to silver sulphide by the action of a soluble sulphide, such as sodium sulphide. The reaction in this case is:

$$2\,AgBr + S^{--} = AgS + 2\,Br^{-}$$

It must be remembered that it is necessary for the silver bromide to go into solution in order that it may combine with the sulphide ions." Jelley observed microscopically that the silver sulphide spread rapidly for a fraction of a second before congealing. The silver sulphide particles were larger than the silver particles from which they were produced.

Image Bleaching or Oxidizing Solutions

Many oxidizing compounds other than potassium ferricyanide have been used to bleach the metallic silver image:

- Chlorine or bromine water[70,71]
- Hypochlorites or hypobromites[71]
- Ferric chloride or bromide[70,71]
- Ceric chloride or bromide[71]
- Copper chloride or bromide[70,71]
- Mercuric chloride or bromide[70,71]
- Potassium chlorochromate[71,72]
- Potassium dichromate, chromic acid[70,71,73]
- Potassium permanganate[71,74-77]
- Ammonium persulfate[71]
- Iodine[67]

Chlorine and bromine water are unpleasant to use and the solutions deteriorate rapidly. Metallic salts, such as the cupric and mercuric halides, are generally unsuitable because they intensify the image.[78] Acidic solutions of potassium dichromate have been recommended for toning, but the dichromate is difficult to free from the gelatin. Sulfuric acid cannot be used with the dichromate, as image reduction will occur, but hydrochloric acid has been satisfactory, especially in the presence of potassium bromide.[52] Potassium permanganate or iodine causes stains to form with photographic prints. Removal of these stains requires treatment with an additional solution, such as a 5% sodium sulfite solution for iodine or a 1% sodium bisulfite solution for the permanganate bleach. Additional solutions must be used with care so as not to dissolve any of the silver salts formed by the bleaching action.

Of the many possible image bleaching solutions, the most successful—and the most commonly used—is the combination of potassium ferricyanide and potassium bromide. This bath shows no reducing action, does not stain, and has a long, useful life. The reactions involved in indirect sulfur toning with this bleaching solution are as follows.

1. Oxidation of the metallic silver image:

$$4\,Ag \ + 4\,K_3Fe(CN)_6 \longrightarrow \ 3\,K_4Fe(CN)_6 + Ag_4Fe(CN)_6$$

silver (metallic)	potassium ferricyanide	potassium ferrocyanide	silver ferrocyanide

2. Conversion of the silver into a bromide salt:

$$Ag_4Fe(CN)_6 + \ 4\,KBr \longrightarrow \ K_4Fe(CN)_6 + 4\,AgBr$$

silver ferrocyanide	potassium bromide	potassium ferrocyanide	silver bromide

3. Sulfiding the silver bromide:

$$2\,AgBr + \ Na_2S \longrightarrow \ 2\,NaBr + Ag_2S$$

silver bromide	sodium sulfide	sodium bromide	silver sulfide

The use of ferricyanide alone, or with potassium chloride, in the bleaching bath tends to form yellowish image tones. Dry sodium bromide or ammonium bromide may be substituted in equal weight in place of the potassium bromide, according to E. R. Bullock,[25] but for continued use of the bleaching solution, 12 g of the potassium bromide were suggested for every 10 g of the other two bromide compounds. Bullock calculated that a bath containing about three times as much potassium ferricyanide as the potassium bromide would be the best bleaching formulation. With more than 3% ferricyanide the tone of the image shifted toward yellow.

The proportion of ferricyanide to bromide, however, has varied widely in practical formulations.[79] Kodak sulfide toner T-10 for lantern slides contained 30 g of potassium ferricyanide and 15 g of potassium bromide in a liter of water for the bleaching bath. The T-10a sulfide toner for motion picture film contained 20 g of the ferricyanide and 5.0 g of the bromide in a liter of water. Fifteen grams of each of these compounds in a liter of water is the formulation for the bleaching solution of Gevaert G.411 toning bath.[80]

The addition of anhydrous sodium carbonate (15 g) or ammonia (20 ml) to the bleaching bath has been reported to give darker and colder image

tones. L. P. Clerc[78] said that the following bleaching bath "gives sepia tones with much greater certainty":

Potassium ferricyanide	30 g
Potassium iodide	10 g
Ammonia	20 ml
Water to make	1 liter

H. Nitze[81] found that "The composition of the bleaching bath, as regards the proportions of potass ferricyanide and potass bromide, has a distinct effect on the size of the grain of the bleached image, which change is plainly shown in the subsequent toning in a sulphide bath by the production of tones ranging from purplish-brown to yellowish-brown." Nitze reported that

If the sulphide of silver in the toned print is in a condition of coarse grain the tone is of purplish-brown hue, whilst it is of yellowish-brown colour in the case of a fine-grain image of silver sulphide. A size of grain which is intermediate gives rise to a print of chestnut-brown colour. There is a direct connection between the brown tone obtained by the process and the size of the grain of the original bromide or other print. If the print is of coarse grain, which, as a rule, corresponds to a cold black tone of the original print, the paper tends to yield sulphide tones of cool purplish-brown colour. But if the grain of the original print is fine, as it usually is in the case of a print of warm-black colour, the paper tends to give warm-brown tones by the sulphide-toning process. Prints of pronounced brown tone (extra fine grain) by development are not suitable for the two-bath method of sulphide toning, since the resulting tones are of unpleasant yellowish-brown colour.

Nitze proposed a "coarse-grain bleach" with more bromide than ferricyanide, producing tones that tend toward purplish-brown. A "fine-grain bleach" containing considerably more ferricyanide than bromide produced fine grain images that toned toward a yellowish-brown. The coarse grain bleach consisted of 89 ml of 10% potassium ferricyanide and 148 ml of 10% solution of potassium bromide with water to make 296 ml. The fine-grain bleach contained 222 ml of 10% ferricyanide and 15 ml of 10% bromide with water to make 370 ml.

The results of Nitze were challenged by Henry W. Bennett,[82] who felt that the variation in the tone of the toned image was determined by the development, not by the composition of the bleaching bath of the toning solutions. This viewpoint was supported by O. J. Morris,[83] provided that

the proportion of potassium or ammonium bromide was above a certain value. Nitze[84] still maintained that the composition of the bleaching bath did affect the tone obtained by sulfide toning.

This controversy was investigated by Helmer Backström and Artur Boström.[85] The effect of the composition of the bleaching bath upon tone depends upon the nature of the photographic paper. For some papers the image tone was largely independent of the composition of the bleaching bath; for other papers, lowering the bromide concentration produced a more and more yellow tone down to a certain limiting point below which the image tone became more neutral. It would appear that the final image tone is related to the type of photographic paper, its development, and the composition of the toning baths.[86]

Prints to be toned should be correctly exposed and fully developed if yellowish-brown tones are to be avoided. The prints must be free of sodium thiosulfate, as this compound in combination with the potassium ferricyanide of the bleaching bath will act as Farmer's reducer. Loss of image detail will be evident in the low or intermediate silver deposits if residual thiosulfate was present during bleaching. Inadequately washed prints containing silver thiosulfates may have stained highlights because of the formation of silver sulfide from the silver thiosulfates. Iron contamination, if present, from chipped enameled-iron trays or impure chemicals, will produce blue specks on the print surface. But even if all these precautions are successfully followed, an unpleasant yellow color, often in patches or streaks, was sometimes obtained with the two-step bleach-and-sulfide method of toning.[87-88]

Prevention of this yellowness has been the subject of considerable study, but contradictions in the published results have been common. E. E. Jelley[89] found that if the bleached print is washed completely free of the ferricyanide, the presence of thiosulfate in the sulfide toning bath can be tolerated without detriment to the image tone of the print. If the ferricyanide is present in the print, however, the thiosulfate retained from inadequate washing or thiosulfate formed by aerial oxidation of the sulfiding solution does not react rapidly with the ferricyanide, but the ferricyanide does react rapidly with the sulfide. The thiosulfate is thus available to solubilize some of the silver halide of the bleached image before the silver can be sulfided. The size of the silver halide is reduced, so that when sulfiding does begin, the silver sulfide particles formed are colloidal and yellowish. A suitable bleaching bath for sulfide toning, suggested by Jelley, contained potassium ferricyanide (35 g), potassium bromide (15 g), and sodium carbonate crystals (15 g) with water to make one liter. Immersion of the bleached print for 10 sec in a 1 % sodium carbonate solution had been found beneficial by E. R. Bullock,[25] but Jelley added 1.5 % of the carbonate directly to the bleaching solution to hasten the washing operation of the bleached print.

The bleaching solution need not be alkaline, however, as shown by the acidic bleaching solution of Kodak sulfide sepia toner T-7a. The stock bleaching solution consists of

Stock Bleaching Solution A

Potassium ferricyanide	75.0 g
Potassium bromide	75.0 g
Potassium oxalate	195.0 g
Acetic acid, 28 %	40.0 ml
Water to make	2.0 liter

For use:

Stock solution A	500 ml
Water	500 ml

The well-washed print is immersed in the bleaching solution (stock bleaching solution A diluted 1 : 1 with water) until only a faint yellowish-brown image remains. About 1 min is required for the bleaching to occur. The print should then be thoroughly rinsed in cold running water for at least 2 min, but excessively long wash times should be avoided.

The print is then toned brown in a toning bath made from

Stock Toning Solution B

Sodium sulfide	45 g
Water to make	500 ml

For use:

Stock toning solution B	125 ml
Water to make	1 liter

The print will be sulfided in about 30 sec. Immediately after toning, rinse the print thoroughly in water, then treat in a hardening bath (two parts of Kodak hardener F-5a stock solution and 10 parts of water) for 2 to 5 min. The print is then washed for at least 30 min in running water.

Image Darkening or Toning Solutions

Sodium sulfide, an inexpensive and ready source of sulfide, is commonly used to form silver sulfide from the bleached image. Ammonium sulfide and liver of sulfur have also been used for the sulfiding bath. Barium sulfide[90–91] has less odor than these sulfides, but insoluble barium sulfate or barium carbonate may form in the gelatin layer.[92] Sodium formaldehyde sulfoxylate and sodium hydrosulfite have also been suggested[93–94] for blackening bleached images. Sodium sulfantimoniate (Schlippe's Salt) has been proposed and successfully used, probably producing an image consisting of silver sulfide and some antimony sulfide.[52] Sepia tones are claimed in a patent to result after treatment in 1 % sodium thiostannate,[95] and other thio compounds have been used.[96–101]

In 1950 H. J. Walls[102] commented that "No photographer who has ever used sodium sulphide can pretend that it is anything but a most unpleasant chemical—it stinks, it is deliquescent and difficult to weigh out, and its solutions do not keep. But there is no reason on earth why any photographer should ever use it: it can be replaced for all photographic purposes by a thiocarbamide–sodium hydroxide solution, which is odourless and is readily prepared as required from two stable and easily made up stock solutions." An alkaline solution of thiocarbamide (or thiourea, as it is now commonly called) is indeed an odorless darkener of bleached photographic images,[103,104,105] but one reason for its limited use may be this: thiourea can cause fogging of photographic materials such as films or papers stored in the darkroom.[106] Contamination of the darkroom, the processing equipment, and the hands of the human processor must be avoided. Once contamination does occur, it is difficult to eliminate its fogging effects, as this writer can testify.

The exact tone given by alkaline thiourea solutions depends upon the amount of alkali present. Colder image tones are produced as the alkali increases above the equal proportions of thiourea and alkali. A 1-min treatment was suggested by Walls in the following sulfiding bath:

Thiourea, 5 % solution	1 part
Sodium hydroxide, 5 % solution	4 parts
Water	45 parts

At a ratio of 4 : 1 of hydroxide to thiourea, the coldest tones are obtained, the image becoming warmer again as the hydroxide is increased beyond this ratio. The most useful ratios were said to lie between 1 : 1 and 2 : 1.[107]

A modern odorless darkening bath for toning bleached prints, suggested by George L. Wakefield[108] "for the sake of domestic peace," contains

Thiourea	5 g
Potassium bromide	40 g
Sodium hydroxide	3 g
Water to make	1 liter

Bleached prints are darkened in this solution, then washed in running water for 15 min before drying. At 15 g/liter of sodium hydroxide, the bath is said to produce prints that are almost violet in color.

Thiourea dioxide was also used by George L. Wakefield[109] as a darkener for bleached photographic prints. Wakefield suggested, "For warm sepias and browns, one slightly heaped teaspoonful of the dioxide is dissolved in 500 ml of just tepid water. Six similar teaspoonsful of potassium carbonate should be added for initial trials and the solution stirred until the alkali has dissolved. The darkener is used undiluted but it must be allowed to stand for an hour at room temperature to allow it to attain its full activity. Thereafter it remains active for about 12 hours but the color of image obtained becomes slowly warmer as the hours pass." The bleached and washed print is treated in the bath, with frequent agitation to keep the print covered, until the darkening action has reached its maximum. The prints should be washed for 15 min, then dried carefully as the gelatin is softened.

A multitude of variations exist for the two-solution indirect sulfur toning process. One procedure[110-112] involves the combination of developed silver and silver sulfide. After bleaching and exposure to strong light, the image may be immersed in a weak, slow-acting developer such as a greatly diluted print developer (one part developer to 40 parts water). Part of the bleached image, consisting of exposed silver bromide or silver chloride, is developed to form black metallic silver. This development is then interrupted and the image immersed in a sulfiding bath to convert the remaining silver halide to brown silver sulfide. The longer the first development to form black metallic silver, the darker and colder the tone of the final silver–silver sulfide image.

Another toning variation[113-115] (said to have been originated by Henry W. Bennett), giving cold-brown or brown-black image tones, consists of adding mercuric chloride to the bleaching bath. The presence of the mercuric salt in the bleaching solution produces a toned print that has been intensified. The greater the amount of the mercuric salt, the greater is the degree of the intensification. Weak photographic images may be toned by this intensifying-toning method, or such prints may be intentionally prepared, not by shortening development, but by reducing the print exposure. Bennett advised drying

the prints after washing following fixing before toning with this technique. After bleaching, the prints are sulfided, producing an image consisting essentially of the sulfides of silver and mercury.

The bleaching solution is made from two stock solutions[116]:

Stock Solution A

Potassium ferricyanide	50 g
Potassium bromide	75 g
Water	500 ml

Stock Solution B

Mercuric chloride	12.5 g
Potassium bromide	12.5 g
Water	500.0 ml

By changing the amount of mercuric chloride in the bleaching solution, as shown below, the tone of the image may be changed.

Composition of Bleaching Bath

Tone of Image	Solution A	Solution B	Water
Sepia	40 ml	—	480 ml
Cool sepia	40 ml	20 ml	480 ml
Cooler sepia	30 ml	30 ml	480 ml
Brown-black	30 ml	50 ml	480 ml
Engraving black	30 ml	90 ml	480 ml

The well-washed print (thiosulfate-free) is treated in the desired bleaching solution until the image is a faint brown. The bleached print is then washed in water, treated in two or three baths of 1 % hydrochloric acid, then washed in water for 30 min. The print is then blackened in a fresh solution of 5 g of sodium sulfide in a liter of water. The toned print is washed for 1 hr in running water before being dried.

In 1911 Wilhelm Triepel[117] patented a claim that the two solutions—bleaching bath and thiourea toning bath—could be combined into a single bath to produce cold sulfur toning. The well-washed print was treated in

Potassium ferricyanide	15 g
Potassium bromide	10 g
Sodium sulfite	4 g
Thiourea	2 g
Sodium hydroxide	2 g
Water to make	1 liter

Although little has been heard of such a combined solution, possibly indicating some deficiencies, the odorless single-solution approach to sulfur toning is commendable. Sodium sulfide cannot be used in the presence of potassium ferricyanide because of the instant destruction of the ferricyanide.[118] This led W. B. Shaw[119] to combine barium sulfide with sodium meta-nitrobenzene sulfonate to form a single-solution brown toner. A single-solution toner formulated by Fritz Kropf,[120] using ammonium sulfide, ammonium bicarbonate, and potassium permanganate, was said to have low odor. Sulfide may be eliminated from the toning solution, as sepia tones are produced in benzoquinone solutions,[121–126] such as benzoquinone (5 g), potassium bromide (20 g) and 1% acetic acid (25 ml) in water to make one liter of solution. Benzoquinone has a pungent odor and toners containing this compound may stain the highlights of the print.

Sometimes the color of sulfided prints is unpleasant. A silver sulfide image may be rebleached[127,128,129] in

Copper bromide	20 g
Sodium bromide	150 g
Water to make	1 liter

then washed and redeveloped in any MQ print developer. Alternatively, the sulfided print may be bleached in a potassium permanganate-hydrochloric acid bath of the following composition:

Permanganate Bleaching Bath

Stock Solution A

Potassium permanganate	5 g
Water	1 liter

Stock Solution B

Hydrochloric acid	80 ml
Water	1 liter

For use:

Stock solution A	1 part
Stock solution B	1 part
Water	6 parts

The copper bromide or the permanganate bleaching bath is used to bleach the silver sulfide image of the toned print of undesirable color. After bleaching, the excess solution is removed by a water rinse. Then, the bleached print is redeveloped in the light with a standard print developer. This technique of rebleaching and redeveloping sometimes finds application for restoring old photographic prints that have faded because of inadequate washing (decomposition of residual thiosulfate) or because of contact with sulfurous gases in the atmosphere.

Red Toning of Sulfide-Toned Images

When the metallic silver image has been converted to silver sulfide by toning, this brown silver sulfide image can be converted to a red-chalk color by toning the silver sulfide image with a solution of gold chloride containing some thiourea, thiosinamine, or ammonium thiocyanate. The silver sulfide image is treated in the following solution until the image is converted to a red-chalk color:

Thiourea	120 g
Gold chloride (1% solution)	150 ml
Water to make	1 liter

The toned image is then well washed to eliminate all the soluble compounds.

A. and L. Lumière and A. Seyewetz[130] noted that "if the gold toning bath be applied to prints of colour closely resembling that of silver sulphide but containing no sulphur, there is no transformation of the images into the red tone." Sulfur appears to be necessary in both the toned image and in the toning bath. The red-toned image, according to the Lumières and Seyewetz, consisted of a double sulfide of silver and gold.

Selenium and Tellurium Toning

Sulfur, selenium, and tellurium are members of the same family of elements. Selenium and tellurium, as does sulfur, combine with silver to form brown-colored deposits of great stability. The use of sulfur (hydrogen sulfide) for brown-toning the photographic image was mentioned by W. H. Fox Talbot in 1849.[131] On the other hand, tellurium, which forms a reddish-brown color with silver, is of more recent origin for toning silver images, having been first used by T. Thorne Baker[132-134] in 1901. And toning of the silver image with selenium was first disclosed in a patent[135] in 1910 (German Patent 238,513 of Rheinische Emulsions-Papier-Fabrik Akt.-Ges. in Dresden).

Selenium and tellurium are difficult to solubilize. The early patents,[136-141] as reviewed by Karl Kieser,[142] are concerned with methods of preparing suitable solutions of selenium or tellurium. The first patent (German Patent 238,513) on a selenium toning bath formed the toning solution by dissolving 10 g of metallic selenium in 100 g of sodium sulfide in 500 ml of water, then making the solution to a volume of one liter. Ammonium sulfide, other sulfides, or polysulfide may be used in place of the sodium sulfide. If the highlight areas of the image were tinted with stain, the coloration could be removed by treating the image with a solution of 10% sodium bisulfite.

As A. Sedlaczek[143-144] has pointed out, however, "The known solution of selenium or selenium compounds in alkali sulphide is, however, subject to certain disadvantages, in that it attacks the skin, smells unpleasantly, and quickly deteriorates on diluting. These disadvantages are claimed to be removed by sulphite. The sulphite-containing solution has no odour, has little action on the skin, and is stable upon exposure to air. The following example is specified: 1 gm. (9 grs.) of metallic selenium is dissolved by boiling in a solution of 10 gms. (88 grs.) of sodium sulphide in 50 gms. (1 oz.) of water and the resulting solution is poured into 1,000 c.c.s. (20 ozs.) of a 20 percent solution of sodium sulphite (German Patent No. 335,627 by the Chem. Fabrik auf Aktien, vorm. E. Schering, of Berlin)." Reddish-brown image tones were obtained when fixed and well-washed prints were treated in the bath. Stained highlights may occur, requiring immersion in potassium metabisulfite solution to clear the stain.

Other methods were quickly patented for forming selenium toning baths. (Generally, the same techniques were applied to solubilizing tellurium, but the solutions were not as satisfactory.) Sodium selenosulfate in combination with sodium sulfite and sodium thiosulfate formed the toning bath disclosed in 1912 (German Patent 280,679). Selenious acid in hydrochloric acid solution was also patented (German Patent 283,205) as a toning bath. Following

a study of various selenium toning solutions, Jaroslav Milbauer[145] expressed a preference for the use of sodium sulfide and selenious acid.

Many of the methods for preparing toning baths with selenium (or tellurium) involve the use of sodium sulfide or sodium sulfite. Selenium, for example, undergoes many of the same reactions of sulfur, such as

$$Na_2S + S \longrightarrow Na_2S_2$$

sodium sulfur sodium
sulfide polysulfide

$$Na_2S + Se \longrightarrow NaSeS$$

sodium selenium sodium
sulfide selenosulfide

or

sodium sulfite + sulfur → sodium thiosulfate

sodium sulfite + selenium → sodium selenosulfate

Sodium selenosulfide, NaSeS, or sodium selenosulfate, $NaSeSO_3$, are believed to be the active toning agents in many selenium toning solutions. When sodium selenite is dissolved in sodium sulfite–sodium thiosulfate solutions, the selenosulfate is probably the toning agent.

A. Seyewetz[146] has commented as follows upon the two types of selenium toning solutions:

Selenium which has been dissolved in a solution of sulphide or in one of an alkaline sulphite forms solutions which allow of changing the colour of the image on chlorobromide development papers from its original black gradually to warm brown and thence to sepia.

These two kinds of solutions modify the colour of silver images in the same way, although they contain very different selenium compounds. That prepared with sulphite is colourless and probably consists of a solution of sodium selenosulphate

dissolved in excess of alkaline sulphite.* That made with sulphide is of brownish red colour and has the composition of an alkaline selenosulphide, analogous to a bisulphide. These two methods of selenium toning exhibit, however, marked differences in their action.

While both of them behave similarly in modifying the colour of prints on chloro-bromide papers, the solution of seleno-sulphide is for toning prints *on bromide papers* by the two-bath method, viz., by bleaching the image to silver bromide by a mixture of ferricyanide and bromide before treating it with alkaline sulphite or seleno-sulphide. Moreover the two kinds of solutions, when in a diluted condition, have very different keeping qualities. The seleno-sulphate solution is stable but the seleno-sulphide, when diluted, undergoes hydrolysis very rapidly, selenium being precipitated."

It is thought[146] that the toning action of selenosulfate (formed by the reaction of selenium in sodium sulfite solution) with silver of the image involves the reaction

$$
\underset{\substack{\text{sodium} \\ \text{selenosulfate}}}{\overset{\text{O}}{\underset{\text{O}}{\overset{\|}{\underset{\text{S}}{\diagdown}}}}\overset{\text{ONa}}{\underset{\text{SeNa}}{\diagup}}} + \underset{\text{silver}}{2\,\text{Ag}} \longrightarrow \underset{\substack{\text{silver} \\ \text{selenide}}}{\text{Ag}_2\text{Se}} + \underset{\substack{\text{sodium} \\ \text{sulfite}}}{\overset{\text{O}}{\underset{\text{O}}{\overset{\|}{\underset{\text{S}}{\diagdown}}}}\overset{\text{ONa}}{\underset{\text{Na}}{\diagup}}}
$$

Sodium selenosulfide (formed when selenium is solubilized in sodium sulfide solution) reacts with the silver of the image to form silver selenide as well.

$$
\underset{\substack{\text{sodium} \\ \text{selenosulfide}}}{\text{Na}_2\text{SeS}} + \underset{\text{silver}}{2\,\text{Ag}} \longrightarrow \underset{\substack{\text{silver} \\ \text{selenide}}}{\text{Ag}_2\text{Se}} + \underset{\substack{\text{sodium} \\ \text{sulfide}}}{\text{Na}_2\text{S}}
$$

Either of the two primary selenium toning solutions produces the same silver compound. The absence of silver in used selenium toning baths would indicate that there is no passage of silver into solution. Seyewetz analyzed the toned silver images formed by using either sodium selenosulfide or sodium selenosulfate. He concluded, "The quantity of selenium corresponding with 100 gms. silver in silver selenide Ag_2Se is 36.6 gms., and it is therefore evident that the composition of the toned image is very near to that of this silver selenide and is practically the same in the two different methods of toning." The ratio of silver to selenium in the final toned image is higher for chloride papers than for bromide papers. It has been suggested[147] "that silver selenide (as obtained on bromide papers) is black, and that any reddish-brown tone produced on other papers is due to the deposition of elemental red selenium in the image in addition to the black silver selenide."

* A. and L. Lumière and A. Seyewetz, *Proceedings of The Congress of Industrial Chemistry at Barcelona* (1929).

Present-day selenium toners do not differ greatly from the early formulations. The actual toning agent is not available as a separate chemical but may be prepared by dissolving selenium metal in sodium sulfite or sodium sulfide solution. (Note: Powdered selenium metal is very poisonous, and breathing the powder must be avoided. Contamination of breaks in the skin with either the powder or solution should also be avoided.)[148] Two formulations for selenium toning are the Selenium Toner T-55 and the sulfide-selenium toner T-56 of Kodak, Limited (London).[149] The Kodak T-55 toner may be used for chlorobromide and bromide photographic papers; the T-56 toner, which involves a two-step, bleach-and-tone procedure, is recommended for chloride and other photographic papers that do not tone satisfactorily in the T-55 toner.

Kodak Selenium Toner T-55: Stock Solution

Hot water	700 ml
Sodium sulfite, desiccated	150 g
Selenium metal, powdered	6 g
Ammonium chloride	190 g
Cold water to make	1 liter

Dissolve the sodium sulfite in about 700 ml of hot water, add the selenium, and boil for about 30 min. If the solution still has some residue, filter the solution to remove any residue. The solution is allowed to cool before adding the ammonium chloride. Add cold water to make one liter of toning stock solution.

For use, add five parts of water to one part of the stock solution.

Prints should be thoroughly washed after fixing; preferably, two-bath fixation should be used to remove all silver thiosulfates as well as the thiosulfate. Immerse the print in the toning bath for 10 to 15 min, 68°F (20°C). Wash thoroughly before drying the print.

The T-55 toner, according to the Photo-Lab Index,[150] is available in the United States as Kodak rapid selenium toner and in England as Kodak selenium toner. Commercial preparations of selenium toners often involve sodium selenite, rather than metallic selenium, combined with sodium sulfite and a thiosulfate, particularly the ammonium salt, because the solution is less hazardous to prepare and more rapidly mixed.

The Kodak sulfide-selenium toner T-56 is a toning bath for difficult-to-tone photographic papers, involving a first solution to bleach the silver image followed by a selenium toning bath. These solutions have the following composition:

Kodak Sulfide-Selenium Toner T-56

Solution A: Bleaching Bath

Potassium ferricyanide	50.0 g
Potassium bromide	50.0 g
Cold water to make	1.0 liter

Solution B: Toner Stock Solution

Warm water (125°F or 52°C)	750.0 ml
Sodium sulfide, pure crystals	250.0 g
Selenium powder	5.7 g
Cold water to make	1.0 liter

The thoroughly washed print is bleached in solution A, then washed in running water until the yellow stain is removed. The print is then placed in a toning solution consisting of one part of solution B and 20 parts of water. When the image is completely formed again, wash the print in running water and then dry without heating.

The selenium toner, says Ansel Adams,[151] is "the only toner I use." The Adams selenium toner has the following composition:

Selenium Toner (Ansel Adams)

Solution A

Boiling water	250.0 ml
Sodium sulfide, crystals	60.0 g
Selenium metal, powdered	5.5 g

Solution B

Water (125°F)	3000.0 ml
Sodium thiosulfate, crystals	660.0 g

Add solution A to solution B. Then

Dissolve sodium bisulfite	210.0 g
Add water to make	4000.0 ml

Cool to 75°F before use.

Ansel Adams offers some practical suggestions that might be applied to all selenium toning operations. Develop the print fully, fix in at least two fixing baths, and wash thoroughly. The print, wet or dry, should then be immersed for 15 to 30 sec in a 2% Kodalk solution, a procedure that this writer also has followed for some years. The print is then rinsed with water and put in a separate tray of water for holding until ready for toning. Tone with constant agitation, carrying the shade of the wet print a little beyond the desired point. Rinse the toned print with water and then wash for at least 1 hr. Dry the print naturally, without heat, if possible.

As with sulfur toning, there has been a considerable quantity of research on selenium toning, resulting in a number of variations in the toning solution or procedure.[152-158] An extensive review of selenium toning methods has been written by E. Asloglou.[159] Felix Formstecher[160] has written on the history and theory of the process. Many of the improvements in selenium toning have been the result of industrial research, resulting in a number of patents.[161-163]

Blue Toning with Gold

Gold, palladium, and platinum were commonly used for toning baths, particularly during the last half of the nineteenth century.[164-171] Palladium and platinum toning baths, possibly because of their cost, have not continued in use, but gold toning solutions are used today for producing both brown and blue tones that are highly prized. Nelson's Gold Toner T-21, giving rich brown tones, has already been described. But gold toning solutions may also be compounded to convert the normal black of the silver image to a very desirable blue. Such blue tones enhance the brilliance of the image to portray more strikingly snow scenes, seascapes, glassware, and other compatible subject matter. Although blue image tones can be achieved by several toning solutions, blue toning with gold is the common method for toning large prints designed for public exhibition.

Blue toning with gold solutions results in a replacement of part of the metallic silver image by metallic gold. About three times as much gold is deposited for a given amount of silver when the gold is in the colorless aurous state as when it is in the yellow auric condition. This difference in the amount of gold deposited, suggested Felix Formstecher,[172] was the result of the two oxidation states of gold:

$$3\,Ag + Au^{3+} \longrightarrow Au + 3\,Ag^+$$

metallic silver — auric gold — metallic gold — silver ions

$$Ag + Au^+ \longrightarrow Au + Ag^+$$

metallic silver — aurous gold — metallic gold — silver ion

The nature of the silver of the print image is as important with gold toning as it is with other toning baths. Prints on chloride and warm-toned chlorobromide paper generally produce more satisfactory blue tones than do bromide papers. Some bromide papers may not tone at all. The brilliance of the blue tone depends upon the size of the silver particles of the image. Overexposure of the print followed by slight underdevelopment favors improved quality of tone. The developed print should be slightly lighter in tone than a normal black-and-white print, as blue toning slightly intensifies the image.

Because of the size of the silver particles of the print image affects the color of the blue tone, the composition of the developer is an important factor. Developers containing chlorohydroquinone have been found to produce developed images that blue-tone particularly well. D. J. Ruzicka[173-174] has proposed a developer that would be a suitable multiple of (dilute 1 : 9)

Chlorohydroquinone	0.13 g
Sodium sulfite, desiccated	0.52 g
Sodium carbonate, anhydrous	0.52 g
Potassium bromide	0.01 g
Water to make	30.0 ml

Print development should be complete in about 2 min. Hydroquinone-chlorohydroquinone[175] or Metol-chlorohydroquinone developers have also been suggested as has Metol-hydroquinone developer.[176] Amidol developers are said to be undesirable.

A great deal of control over the blue tones can be achieved by the use of special developers. A glycin-hydroquinone developer, Edwal 106, has been recommended[177] for use with gold toning.

Edwal 106

Hot water (125°F)	750.0 ml
Sodium sulfite, anhydrous	85.0 g
Sodium carbonate, monohydrate	170.0 g
Glycin	28.0 g
Hydroquinone	9.0 g
Potassium bromide	4.0 g
Water to make	1.0 liter

By varying the dilution of the stock solution of this paper developer and the time of processing, a wide range of blue tones was said to result after gold-toning in an acidic gold chloride solution. Table 4 was prepared by Philip Phyllides.[177]

Table 4. Blue Tones Produced by Gold Toning

Glycin Development				Gold Toning	
Glycin Stock Parts to Water	Developing Time (min)	Tone	Contrast	Toning Time (min, approx.)	Blue Tone[a]
1 to 4	4	Warm black	Normal	3	Dark gray blue
				8	Normal blue
				15	Blue-black
1 to 7	5	Brown black	Medium Soft	3	Gray blue
				8	Warm blue
				15	Deep blue
1 to 10	6	Brown	Soft	3	Light gray blue
				8	Warm purplish-blue
				15	Purplish blue-black
1 to 15	8	Reddish brown	Very Soft	3	Purplish gray
				8	Brilliant purplish-blue
				15	Purple

[a] For greenish-blues for marines, add 25 grains of ammonium sulphocyanate to the toning solution.

Gold toning baths were extensively used for treating prints made during the era of printout papers. A gold chloride–ammonium thiocyanate toning bath was used as early as 1868 by P. E. Liesegang.[178] Today, the gold chloride–ammonium thiocyanate solution has been used for increasing the permanence of silver images of black-and-white prints. Such a gold protective solution is Kodak GP-1.

Kodak Gold Protective Solution GP-1

Water	750.0 ml
Gold chloride (1 % stock solution)	10.0 ml
Sodium thiocyanate	10.0 g
Water to make	1.0 liter

Dissolve the sodium thiocyanate separately in 125 ml of water, then add this solution slowly with stirring to the solution of the gold chloride in the 750 ml of water.

Normally, the well-washed print is treated for about 10 min or until the silver image of the print changes to slightly bluish-black. When only image permanence is desired, toning is normally stopped at this point. If the toning is extended to about one hour, however, good blue tones without staining of the white areas are obtained. Wash the print at least 10 min before drying.

The slow toning action of the gold protective solution is due to the low concentration of the reactants. Increasing the quantities of gold chloride and ammonium thiocyanate will greatly shorten the toning time. It is important that a large excess of thiocyanate be present. Yellow stains on the print may result from the deposition of gold thiocyanate if insufficient thiocyanate is present or if the gold is in the yellow auric state. Certain gold chloride–ammonium thiocyanate toning baths in the past have given stains that were the result of insufficient thiocyanate.

A gold toning bath, proposed by A. J. Jarman,[179] was said to give unstained prints. The bath was suggested for converting unsatisfactory print images (greenish or olive black in color) to an acceptable blue-black color. Prints, well fixed and thoroughly washed[180] and then dried, were placed in the toning bath made from two stock solutions:

Stock Solution A

Water	150 ml
Ammonium thiocyanate	15 g

Stock Solution B

Water, distilled	450 ml
Gold chloride	1 g

For use:

Stock solution A	22 ml
Water	1050 ml
Stock solution B	90 ml

Immerse each print in the solution quickly to insure that the solution completely covers the print surface. Remove when a blue-black or blue color is reached. Wash 20 min in water before drying.

The commonly—and deservedly—esteemed blue toning bath is the acidic solution of gold chloride and thiourea. The use of thiourea in toning

baths was not new when discussed by A. Helain[181–182] in 1902. Acid gold chloride solutions containing thiourea act, according to E. Valenta,[183]

$$\left(\begin{array}{c} NH_2 \\ / \\ C=S \\ \backslash \\ NH_2 \end{array}\right)_2 AuCl + Ag \longrightarrow \left(\begin{array}{c} NH_2 \\ / \\ C=S \\ \backslash \\ NH_2 \end{array}\right)_2 AgCl + Au$$

to replace image silver with metallic gold.

In the 1930s a gold toner became very popular for blue toning. Attributed to D. J. Ruzicka, it often is called the Ruzicka toner.[174] The toning solution was made from two stock solutions, using distilled water, if possible.

Stock Solution 1

Water (distilled)	225 ml
Gold chloride	1 g

Stock Solution 2

Water (distilled)	225 ml
Thiourea	4 g

For use:

Water	480 ml
Solution 2 (add with stirring)	60 ml
Solution 1 (add slowly, constant stirring)	60 ml
Add water to make	960 ml

Then add (drop by drop with stirring):

Concentrated sulfuric acid	10 drops

Toning time for black-and-white images is from 5 to 15 min at 70°F. After toning, wash for 15 min in running water and then dry, preferably by hanging in air. If a sulfide-toned print (preferably on bromide paper) is treated in the Ruzicka toner for 20 to 30 min, the brown image is changed to a red with a brown overtone. Ruzicka adds "a warning that all the ingredients are highly poisonous and should be dealt with as such."

The dangers of the Ruzicka toner were lessened when citric acid was substituted for the sulfuric acid. Such a formula modification is generally

credited to Zeiss, but Alvin W. Lohnes[176] says that Wellington and Ward Company Ltd. of England demonstrated such a toner in about 1920. Regardless of its exact origin, the gold chloride–thiourea–citric acid formula has become the best toner for blue toning, for, as Lohnes states, "As yet no one has ever improved upon it, or made one equally as good." A number of minor variations[184] do exist, however, and the following formula is representative

<div align="center">

Solution 1

Gold chloride	1 g
Water	250 ml

Solution 2

Thiourea	3 g
Water	250 ml

Solution 3

Citric acid	3 g
Water	250 ml

</div>

For use: Add one part of solution 2 to one part of solution 1, then add one part of solution 3. Add 10 parts water to form the toning bath. This bath will tone three 11 × 14 prints.

Toning with Metallic Ferrocyanides

The finely divided silver of the photographic image is an excellent reducing agent. In the reduction process the metallic silver of the image may be converted to an image composed of silver salts if a suitable supply of negative ions is available to form insoluble silver compounds. These silver compounds may then be converted into insoluble salts of metals other than silver. Many of the salts of heavy metals are highly colored, so this chemical procedure serves as a method of converting a black-and-white silver image into a highly colored nonsilver image. In some cases it is necessary to react the insoluble metal salt with another compound to produce the color of image that is desired.

The common method to convert a metallic silver image into an insoluble silver salt is to treat the silver in a solution of potassium ferricyanide, such as used in indirect toning methods.

$$4\,Ag\ +4\,K_3Fe(CN)_6\ \longrightarrow\ Ag_4Fe(CN)_6 + 3\,K_4Fe(CN)_6$$

| metallic silver | potassium ferricyanide | silver ferrocyanide | potassium ferrocyanide |

Four atoms of silver react with four molecules of potassium ferricyanide to form a molecule of silver ferrocyanide that is retained in place as the image. The three molecules of potassium ferrocyanide are soluble and go into the bleaching solution. Four ferrocyanide groups were formed, and these could have been reacted with a metal other than silver to form colored metal ferrocyanides for the image. The silver ferrocyanide is still available in place, but three-fourths of the ferrocyanide have been lost for any further reaction.

If a soluble metal salt is present in the same solution as the potassium ferricyanide, one ferrocyanide group is still used to form silver ferrocyanide but the other three will be precipitated as insoluble colored metal ferrocyanides. All of the ferrocyanide is precipitated, but the color of the image will be due to the three metal ferrocyanides formed. Three-fourths of the ferrocyanide formed is being used to produce the colored image, the silver ferrocyanide not being effectively used for color formation.

All the ferrocyanide groups may be used to form colored metal ferrocyanides if, during the reaction of the ferricyanide with the metallic silver image, an ion is present that forms a silver compound less soluble than silver ferrocyanide. The following order of preferential formation of silver compounds is known:[185] sulfide, iodide, bromide, ferrocyanide, chloride, ferricyanide. If a solution containing all these ions could be made, silver sulfide would form before any other silver compound. When all the sulfide ions were removed as silver sulfide, silver iodide would form as an insoluble silver salt, and so on down the list of preferred salt formation. It should be noticed that in a solution containing only ferrocyanide and bromide ions, as well as silver ions, silver bromide would be formed, not silver ferrocyanide. This means that all four ferrocyanides formed in the oxidation of four atoms of image silver—that is, every ferrocyanide formed—would be available to form colored metal ferrocyanides, provided bromide ions were present in sufficient number. Usually, the bromide salt of the metal is added to the potassium ferricyanide solution to insure complete conversion of the silver image to the metal ferrocyanide and silver bromide.

Metal ferrocyanides are insoluble but, unfortunately, so are many metal ferricyanides. If the toning solution consisted only of the potassium ferricyanide and a soluble metal salt, such as a copper or nickel compound, the insoluble metal ferricyanide would be precipitated immediately. Adding

citrates, oxalates, or tartrates to the solution, however, will prevent the precipitation. The combination of a citrate, oxalate, tartrate, or lactate ion with the metal ion forms a combination that removes most of the metal ion from active participation in forming the insoluble metal ferricyanide. The few metal ions in solution are not sufficient to exceed the solubility of the metal ferricyanide, so there is no precipitation of an insoluble metal ferricyanide. The lower solubility of the metal ferrocyanide means that sufficient metal ions are available to cause its precipitation whenever ferrocyanide ions are formed during the toning operation. The metal ions removed by forming metal ferrocyanide are immediately replaced by the release of an equal number of metal ions from the citrate, oxalate, or tartrate complexes with the metal ion. Sometimes organic sequestering agents, such as ethylenediamine tetraacetic acid, may be used to control the metal-ion concentration, so that unwanted precipitates are not formed or that the reaction proceeds in the desired direction.

A considerable number of image colors are possible when toning is carried out by the deposition of metal ferrocyanides.[186]

Metal	Color of Ferrocyanide
Cadmium	White
Cobalt (single bath)	Violet-red
Cobalt (two baths)	Cyan
Copper	Reddish brown-red
Iron	Prussian blue
Lead	White
Molybdenum	Brown
Nickel	Reddish brown
Titanium	Yellow
Uranium	Reddish brown-red
Vanadium	Yellow-orange

In addition, the metal ferrocyanide may be reacted with another compound to produce a colored image. The white ferrocyanide of cadmium is treated with sodium sulfide to form cadmium sulfide,[187] a yellow pigment called cadmium yellow. When the white lead ferrocyanide is treated with an alkaline potassium dichromate solution, the chrome yellow pigment (lead chromate) is produced.[188] Nickel ferrocyanide has been converted to a pinkish-red color by treatment with an alkaline alcoholic solution of dimethylglyoxime.[189]

Blue Toning with Iron Ferrocyanide

In 1842 Sir John Herschel invented what we call the blueprint process.[190] Herschel found that when a paper coated with ferric ammonium citrate and potassium ferricyanide was exposed, a blue color formed where the light exposure had reduced the ferric iron to ferrous state. The blue color was insoluble ferric ferrocyanide, often called Prussian blue. This deposition of blue iron ferrocyanide has been used extensively for blue-toning silver images. Josef Maria Eder claims to be the first (1876) to use Prussian blue for toning.[191-192] An acid, such as acetic, hydrochloric, nitric, or oxalic, is added to the bath both to prevent stains from the precipitation of basic iron salts and to improve the blue color. The presence of citrate or oxalate ions also helps to prevent the iron from reacting with the gelatin and to regulate the reaction rate.

A simple toner[193] producing blue tones (Prussian blue) consists in treating a well-washed print in

Ferric ammonium citrate (10% solution)	1 part
Potassium ferricyanide (10% solution)	1 part
Acetic acid (10% solution)	10 parts

Rinse thoroughly in pure water but do not wash too long, as the dye is soluble in weakly alkaline water. Extended washing may be used, if necessary, to remove blue coloration from the whites of the print.

The Ansco 241 iron blue toner[194] is similar, having the following formula:

Ansco 241 Iron Blue Toner

Water (distilled, if possible, at 125°F or 52°C)	500 ml
Ferric ammonium citrate	8 g
Potassium ferricyanide	8 g
Acetic acid, 28%	265 ml
Water to make	1 liter

The solution should be used in plastic trays or in unchipped enameled iron trays. Prints fixed in a plain, nonhardening fixing bath are preferred. When fully toned, the print image will appear greenish, but a clear blue color will result when the print is washed. Wash water slightly acidified with acetic acid may be required to prevent solubilization of the blue tone in alkaline wash water. The washed print may be bathed in a 0.5% (5 g/liter) of borax to produce a softer, blue-gray color, depending upon the time of immersion in the weakly alkaline borax bath.

Many variations[195] exist on the basic toning solution. Kodak iron toner T-12[196] uses oxalic acid crystals (4 g) with the ferric ammonium citrate (4 g) and potassium ferricyanide (4 g) in a liter of water, dissolving each chemical separately in a portion of the water before adding the three solutions together. Another procedure consists in bleaching the print in

Water	300 ml
Potassium ferricyanide	7 g
Ammonia water	6 ml

washing it after bleaching, and then toning in

Water	300 ml
Ferrous sulfate	7 g
Hydrochloric acid	3 ml

Wash the print until free of stain in the whites and fix in a plain fixing bath, such as

Water	600 ml
Sodium thiosulfate, crystals	120 g
Sodium bisulfite	15 g

Recently, Johnsons of Hendon Ltd. published the formula for the Johnsons Pactum Blue Toner,[197] which consists of two stock solutions mixed just before use:

Johnsons Pactum Blue Toner

Stock Solution A	
Potassium ferrioxalate	0.7 g
Tartaric acid	10.3 g
Water	500.0 ml

Stock Solution B	
Potassium nitrate	3.7 g
Potassium ferricyanide	0.9 g
Water	500.0 ml

Reddish-Brown Toning with Copper Ferrocyanide

In 1876 Josef Maria Eder and Hauptmann Victor Tóth[192] mentioned that red tones could be obtained by converting the silver image to copper (cuprous) ferrocyanide. The exact tone of the image depends upon the time of immersion, as the image color goes from black through brown, then reddish-brown, to red. When cupric sulfate is used in the copper toning bath, the following reaction probably occurs[198]:

$$4\,Ag \ + \ 4\,K_3Fe(CN)_6 \ + \ 6\,CuSO_4 \ \longrightarrow$$

metallic potassium copper
silver ferricyanide sulfate

$$Ag_4Fe(CN)_6 \ + \ 3\,Cu_2Fe(CN)_6 \ + \ 6\,K_2SO_4$$

silver copper potassium
ferrocyanide ferrocyanide sulfate

The toned image consists of red copper ferrocyanide and white silver ferrocyanide. C. B. Neblette[199] lists silver sulfate, copper ferrocyanide, and potassium ferrocyanide as the products formed during toning.

The thoroughly washed black-and-white print is toned in a solution made from two stock solutions.[200]

Stock Solution 1

Cupric sulfate	6.25 g
Potassium citrate	25.0 g
Water to make	1.0 liter

Stock Solution 2

Potassium ferricyanide	5.2 g
Potassium citrate	25.0 g
Water to make	1.0 liter

For use: Take equal parts of solution 1 and solution 2 for toning solution. Namias[201] suggested increasing the amount of potassium citrate in either of the stock solutions if a purplish stain is present in the whites of the print.

When four atoms of silver reacted with four molecules of ferricyanide, three of the ferrocyanides produced were deposited as red copper ferrocyanide. The other ferrocyanide was combined with the four silver ions. Silver ferrocyanide is white and contributes very little to the color of the image. If a print after copper toning is weak, the color may be increased a

little by treating the silver ferrocyanide with potassium bromide to form silver bromide and then reacting the released ferrocyanide with copper. Arthur Hammond[202] recommended treating the weak print in the following intensifying solution for the toned print:

Copper sulfate	30 g
Potassium bromide	15 g
Acetic acid (28%)	30 ml
Water to make	750 ml

Hammond suggested only washing the print after toning.

Single-solution copper toners must be mixed just before use, as they do not keep well. Cherry-red tones were said[195] to be produced when the well-washed print was immersed in

Ammonium oxalate (10% solution)	200 ml
Copper sulfate (10% solution)	40 ml
Ammonium carbonate (10% solution)	10 ml
Potassium ferricyanide (10% solution)	30 ml
Water	800 ml

Wash the print after toning, but the whites of the image may still be tinged.

Green Toning with Vanadium or Iron

R. Namias[203] is credited with being the first (1901) to show that vanadium would tone silver. The silver image was bleached in a ferricyanide solution, then treated in a second solution containing vanadium chloride. Vanadium ferrocyanide was yellow. Namias[204] then devised another toner that produced green tones. The silver ferrocyanide image, formed by bleaching the silver image in 5% potassium ferricyanide, was treated with

Ferric chloride	4.8 g
Vanadium chloride	4.0 g
Ammonium chloride	10.0 g
Hydrochloric acid, conc.	10.0 ml
Water to make	1.0 liter

The silver chloride was then removed by fixing. Namias explained that because "the ferriferrocyanide is blue and the vanadium ferrocyanide yellow, there is obtained by mixing the two chloride compounds, the desired green."

Namias[205-206] and others[207] studied the use of vanadium salts for toners.
An improved green toning solution was claimed by Henry E. Smith.[208]
This consisted of two stock solutions.

Stock Solution 1

Potassium ferricyanide	2 g
Water (distilled)	100 ml

Stock Solution 2

Vanadium chloride	2 g
Ferric ammonium citrate	1 g
Sodium citrate (neutral)	25 g
Ammonium chloride	2 g
Hydrochloric acid, concentrated	14 ml
Water (distilled)	100 ml

For use: Dilute one part of stock solution 1 with four parts water. Dilute
one part of stock solution 2 with four parts of water. Add the first solution
to the second. Prints should be toned for 4 to 8 min, or longer, washed 10 min
in water, then treated in 2% hydrochloric acid for 2 min. Wash 15 min in
water before drying.

"My objection," said E. J. Wall,[209] "to all these baths is that they contain
a chloride and hydrochloric acid, which must form some silver chloride
which dulls the transparency of the resultant images." Fixing was required
to remove the silver chloride. Wall then formulated a green toner without
the objectionable chlorides (and not requiring fixation) by making a stock
solution of vanadium oxalate from ammonium metavanadate.

Vanadium oxalate stock solution (20%)	50 ml
Oxalic acid, saturated solution	50 ml
Ammonium alum, saturated solution	50 ml
Ferric oxalate, 20% solution	10 ml
Glycerin	50 ml
Potassium ferricyanide, 10% solution	10 ml
Water	1 liter

Add the oxalic acid solution to the vanadium oxalate solution and 500 ml
of the water, then add the alum and the ferric oxalate. Mix the glycerin and
the ferricyanide in the remaining 500 ml of water. Mix the two solutions

together. The exact green of the color may be varied by changing the quantity of the ferric oxalate solution added. When 10 ml are used, the color produced is a bright emerald green. Bluer shades are obtained with increased quantities of the ferric oxalate, greener shades with increased amounts of the vanadium oxalate. Toning requires an immersion in the bath for 10 to 15 min followed by a 5 min treatment in a 10% solution of sodium sulfate, a short wash in water, and drying.

Brown-to-Red Toning with Uranium

Herman Selle[210-213] in 1865 proposed a uranium intensifier for collodion images. Selle's intensifier was made by mixing two solutions: (1) 22 g of uranium sulfate in a liter of water and (2) 22 g of potassium ferricyanide in a liter of water. The reddish-brown deposit of uranium ferrocyanide greatly intensified the original silver image. The amount of the intensification depends upon the length of the treatment, with the maximum being given by a bright red color. Exactly the same type of image color change can be used to tone a photographic print. The image intensification is not as great when viewing prints by reflected light as when viewing negatives by transmitted light.[214] The toned image of uranium ferrocyanide is limited in stability and is dissolved even in weakly alkaline solutions. To prevent unwanted loss of the toned image, the toning bath[215-216] and the wash water[217] are usually made acid by the addition of acetic acid to each.

Objections were made that the proportions of the Selle intensifier and the acidified toning baths based on it were incorrect.[218] E. Sedlaczek[219] proposed using $2\frac{1}{2}$ times as much uranium nitrate as potassium ferricyanide. Even a uranium toning bath of those proportions caused the whites of the print to be stained and the image intensified. Uranium salts, like alum, harden gelatin and impart a stain. To eliminate the hardening action, Sedlaczek used alum to combine with the gelatin and prevent the formation of uranyl gelatinate. The presence of an organic acid capable of forming complexes, such as citric or oxalic acid, or their salts, and hydrochloric acid, was also found to minimize the staining problem with uranium toning baths. Such a bath has the composition

Uranyl nitrate	5 g
Potassium citrate	5 g
Potassium ferricyanide	2 g
Ammonia alum	10 g
Hydrochloric acid, concentrated	0.3 ml
Water	1.0 liter

Prints to be uranium toned must be free of thiosulfate in any form, as stains will be produced. The well-fixed, thoroughly washed print slowly turns brown, then reddish-brown. Removal of the uranium and ferrocyanide compounds from the gelatin is difficult, and Sedlaczek suggested the following procedure:

1. Three minutes immersion in 0.1% acetic acid to remove most of the adsorbed toning bath.
2. Three or four immersions in different solutions of the following bath:

Potassium citrate	5 g
Sodium sulfate	25 g
Water	1 liter

3. Brief water rinse.
4. Fixation for a short time in 0.5% sodium thiosulfate.
5. Brief washing in acidified water, such as 0.1% acetic acid.

The formula and treatment as proposed by Sedlaczek was found to be the most preferable, according to Lüppo-Cramer, for the toning of prints.[220] The Kodak uranium toner T-9 contains the same ingredients, except that potassium oxalate is used in place of potassium citrate:

Uranium nitrate	9.4 g
Potassium oxalate	9.4 g
Potassium ferricyanide	3.7 g
Ammonium alum	22.7 g
Hydrochloric acid (10%)	19.0 ml
Water to make	3785.0 ml

At 70°F the time of toning is $1\frac{1}{2}$ to 3 min, depending on the depth of the tone desired. A 10-min wash of the toned film[221] or print is sufficient, as excess washing may solubilize the uranium ferrocyanide, which is soluble in water that is at all alkaline. L. Bune[222] suggested a separate bleaching bath, followed by a uranium toning bath, so that the image tone could be varied by the time of treatment in the bleaching bath.

Dye Toning

Dyes are highly colored substances, usually organic molecules, that can impart a long-lasting color to the material to which they are applied. Dyes used for toning may be either acidic or basic. Acid dyes are so called because they contain acid groups ($-OH$, $-COOH$, $-SO_3H$) that form negatively

charged ions in water. Basic dyes contain basic groups, such as $-NH_2$, which form positively charged ions in water. Acid or basic dyes are usually in the form of soluble salts when added to water, but in solution, negatively or positively charged dye ions exist as large agglomerated particles whose electrical condition keeps them suspended in the solution. The negatively charged dye particles repel each other, keeping them separated and suspended in the solution.

A positively charged dye particle will be attracted by a negatively charged particle. If the electrical condition of the dye particle is sufficiently neutralized, the dye particle will be precipitated as insoluble colored matter. Thus, to color a silver image requires that the silver image acquire electrical charge opposite to that of the dye particle. This may be accomplished by converting the silver image to a compound that will attract and precipitate the dye particle from solution. Metallic silver is easily converted to a compound such as silver iodide that will adsorb negatively charged iodide ions. Metallic silver may also be converted to a ferrocyanide, exactly in the same fashion as during the toning of the image with metal ferrocyanides, whose negative charges will attract and deposit a dye. In both these examples the uncharged metallic silver image has been converted to a negatively charged condition. Such an image will attract the positively charged dyes, that is, basic dyes. The image would have to be converted to a positively charged particle in order to attract the acid dyes (negatively charged). Gelatin is normally positively charged, so acid dyes are attracted and stain gelatin. Such overall staining may be used to tint motion picture film but is generally undesirable to tone photographic prints. Much of the gelatin staining by acid dyes may be removed by treatment with an alkaline solution, thereby making the gelatin more negatively charged. In general, basic dyes are used primarily for dye toning, particularly photographic prints.

When a photographic emulsion layer containing gelatin is fixed in a bath containing thiosulfate and chrome or aluminum alum, some of the chromium or aluminum ions unite with the gelatin to form stable complexes. All of the positive charge of the metal ions probably is not completely satisfied in the gelatin-metal complex.[223] This residual charge attracts negatively charged ions or particles. Thus, aluminum or chromium ions can be used to fix negatively charged acid dyes to the gelatin, an action called *mordanting* the dye. Conversion of the metallic silver image to a form that will also mordant dyes often involves positively charged metallic ions. As Joseph S. Friedman[224] notes, "Almost every metal has been suggested for mordant purposes."

Mordanting of dyes began, not with silver halide, but with light-sensitive chromium compounds during the 1850s. This early history has been reviewed in detail by J. S. Friedman,[224] who credited E. Kopp[225] with the first clear

understanding of dye toning of light-sensitive chromium systems. In 1865 Carey Lea[226] suggested that the metallic silver image be treated with mercuric chloride so that murexide, a dye, would mordant to the bleached image. Lea's purpose was to reinforce, or intensify, the image. Georges Richard was said [227–228] to be the first to describe the concept of the substitution of an organic color for the metallic image silver, although he failed to reduce the concept to practice. C. E. K. Mees[229] also said that A. Richard "originated the modern method of dye toning when he showed that a developed silver image can be converted to an insoluble salt having a mordanting power or affinity for dyestuffs." There is little question, however, that Arthur Traube was the first to propose[230–234] and patent[235] a satisfactory system of dye toning for the purpose of a three-color printing process (Diachrome). Traube's iodide process converted the silver image to silver iodide, using an iodine or iodine-ferricyanide bleach, followed by washing and immersion in a slightly acidic basic-dye solution.[236–238] Basic dyes would adhere to the image but could be removed from the gelatin by washing with water. From this beginning, Traube[239–242] moved on to the use of dye-toned copper ferrocyanide images in his Uvachrome process (uva is the Latin equivalent of Traube [grape]), probably the most successful[243–244] of the three-color mordant processes.[245–248] Collodion stripping papers or Carbro tissues were later suggested as most suitable for making color prints by dye toning.[249–251]

A considerable number of metallic ferri- and ferrocyanides were found[252–253] to be effective mordants for basic organic dyestuffs. In practice, however, the choice is limited. Ideally, the mordant should be colorless so that the image color is due solely to the absorbed dye. Copper ferrocyanide mordant was used by A. Traube, J. I. Crabtree,[254–255] F. E. Ives,[256] and others.[257–258] Copper ferrocyanide has a slight color, but the copper may be removed. If copper thiocyanate is used for the mordant, the image is usually a dirty gray, but J. S. Friedman[259] found that the mordant can be invisible if the thiocyanate is increased to 10% from the value given in the formula below (devised by Lyman Chalkley):

Copper sulfate	40 g
Potassium citrate	250 g
Acetic acid	30 ml
Ammonium thiocyanate	25 g
Water to make	1 liter

A mordanted image that is colorless was listed by L. P. Clerc[260] as having the following composition (partial or complete bleaching of the image is possible):

Potassium ferricyanide	5 g
Ammonium dichromate, 10% sol	15 ml.
Sulfuric acid, 10% sol	30 ml
Water to make	1 liter

The uranium toning bath T-17 may also be used to mordant an image[261]:

Stock Solution

Uranium nitrate	8.0 g
Oxalic acid, crystals	4.0 g
Potassium ferricyanide	4.0 g
Water to make	1.0 liter

Dissolve the uranium nitrate in a small volume of water at about 125°F (52°C). Dissolve the oxalic acid in a small portion of the water and filter the solution. Then add the oxalic acid solution to the uranium nitrate solution. Dissolve the potassium ferricyanide separately in a small portion of water; if not clear, filter; then add to the solution containing the other two compounds.

For toning, this bath is diluted with two parts of water; for use as a mordant for dye toning, one part of the stock solution is diluted with four parts of water. The well-washed print is treated for only about 2 min in the toning bath or until the image turns a pale brown in color. Wash the print for 10 min (70 to 75°F) to remove the yellow stain from the highlights of the image. The image is ready then for dye toning.

After the silver image has been treated to form an image that will bind basic dyes, the mordanted image is then treated for 10 to 15 min in a second solution of the dye. The dye bath (T-17B) for papers is composed of

Dye (1 : 1000 solution)	100 ml
Acetic acid, 1% solution	25 ml
Water to make	1 liter

Dyes are selected to yield the desired tone colors.

Tone Color	Dye
Red	Safranine A
Yellow	Auramine
Blue Green	Victoria green
Blue	Methylene blue BB
Violet	Methyl violet

(Use only 20 ml of methyl violet solution in the T-17B bath.) Other colors may be formed by mixing solutions of the dyes or using other basic dyes.[262] After toning, wash in running water until the dye is washed from the highlights of the print image. The dye may be difficult to remove from paper prints, so the following solution may be used for 1 to 2 min to remove the last traces of the dye in the highlights.

Potassium permanganate	4 g
Sulfuric acid	1.5 ml
Water to make	1.0 liter

In the T-17 uranium toning and mordanting bath, the uranyl ferrocyanide is used as a visual measure of the extent of the conversion of the silver image. Actually, the silver ferrocyanide formed at the same time is the more powerful mordant, but this compound is not colored. The T-17 mordanting bath then may be used without the uranium nitrate, thus eliminating the color contamination given by the brown uranyl ferrocyanide. A 3-min immersion at 70°F in the modified T-17 (no uranium salt) followed by a 10-min, 70°F wash should produce purer colors after dye toning, although the highlights may have slightly more stain. Compounding the dye toner in any other order may result in the precipitation of the dye.

The number of basic dyes suitable for use in the single solution is limited, but the following dyes were found useful:

Dye	Optimum Dye Concentration
Safranine base	0.01 %
Safranine 6B	0.02
Chrysoidine 3R	0.02
Tannin heliotrope	0.02
Thioflavine T	0.02
Auramine	0.04
Victoria green	0.04
Rhodamine B	0.04

Toning should be carried out at 65 to 70°F for a time sufficient to give the desired depth of color. In some cases this time should not be extended beyond 18 min, because degradation of tones can occur. Washing for 10 to 15 min after toning is usually sufficient to remove most or all of any dye stain in the gelatin layer. As with most dye toning processes, results are more satisfactory with film images than with prints on photographic paper.

The dye toning processes consist of two steps: (1) converting the silver image to a compound that will mordant dyes and (2) then treating this image with a dilute, weakly acidic dye bath. Attempts were made early to combine these two operations into a single bath for dye toning. The basic dye invariably precipitated from the single solution after standing for a short time. When the uranium nitrate is omitted from the T-17 mordant solution and a basic dye added, there is less tendency for the dye to precipitate than if the uranium salt was present. J. I. Crabtree and C. E. Ives[263-264] found that by omitting the usual heavy metal salt (such as copper or uranium), by the use of a weaker organic acid, and by the presence of an organic solvent such as acetone, a single-solution dye toning bath could be formulated which would not precipitate the dye from the solution.

The formula of the single-solution dye tone consisted of

Basic dye	0.01 to 0.04%
Acetone	100.0 ml
Potassium ferricyanide	1.0 g
Glacial acetic acid	5.0 ml
Water to make	1.0 ml

First dissolve the dye in a small amount of hot water before adding to the acetone. Dilute the acetone-dye solution to 750 ml with cool water. Then dissolve the potassium ferricyanide in a small amount of hot water and add to the acetic acid. Add this mixture to the dye solution with stirring and bring the volume of the toner solution to one liter with cold water.

Toning by Dye Coupling

When the latent image is developed, silver ions are reduced to metallic silver and the developing agent is oxidized. In the case of low sulfite development with pyrogallol, the oxidized developer stains the gelatin in those areas where development occurred. The oxidation products need not be colored, however, as these compounds can be made to react with other compounds, called couplers, to precipitate a dye image in direct proportion to the amount of silver that was developed. The silver image formed originally then can be bleached and removed, leaving an image consisting only of dye particles. Depending on the nature of the coupler used to react with the oxidized developing agent, a wide range of brilliant colors can be formed.

The forming of dye images by reacting the oxidized form of the developing agent with a coupler was the invention of Rudolf Fischer (1912).[265-267] This dye-forming reaction is the basis of most of the present-day color photographic processes. The developing agent is usually a derivative of

p-phenylenediamine, whose oxidation product is highly reactive. Many thousands of coupling compounds have been studied for the dyes produced when these compounds react with oxidized *p*-phenylenediamine. Coupling compounds may be used singly in the developer or combined for a wide range of image colors. The dye may be formed directly when the exposed photographic paper is developed in the color developer. A black-and-white print may be bleached and redeveloped in the color developer. The metallic silver may be left in the print to add density to the image, or the metallic silver image may be removed by a ferricyanide bleach, leaving a pure dye image.

The following represent the general reactions of the dye coupling reaction.[268]

coupler	developing agent	exposed silver halide	

dye image	metallic silver image	acid

Various solutions for toning prints by dye coupling have been suggested.[269-273] The following solutions and procedure for toning by color development are from the *British Journal Photographic Almanac*.[274] All the compounds are readily available from chemical supply houses. The color developer is made in two stock solutions to increase the life of the solutions. Mixing occurs just before use. The couplers are dissolved in separate solutions and the desired coupler or couplers added to the color developer before use.

Color Developer for Print Toning

Stock Solution A	
Sodium metabisulfite	5 g
p-Diethylaminoaniline sulfate	10 g
Water	100 ml

Stock Solution B

Calgon (Calgon Corp.)	2 g
Sodium carbonate, anhydrous	17 g
Sodium formaldehyde sulfoxylate	5 g
Potassium bromide	1 g
Water to make	1 liter

Coupler Solutions

Magenta:	p-Nitrobenzyl cyanide	0.5 g
	Alcohol	100 ml
Yellow:	Acetoacet-2, 5-dichloroanilide	2.0 g
	Alcohol	100.0 ml
Blue-green:	2, 4-Dichloro-1-naphthol	1.0 g
	Alcohol	100.0 ml
Blue:	1-Naphthol	1.0 g
	Alcohol	100.0 ml

Keep all solutions in well-stoppered brown bottles filled to the neck.
For use:

Stock solution A	3 parts
Stock solution B	100 parts
Coupler solution	10 parts

Coupler solutions may be made by mixing the listed four coupler solutions. A green toner may be made by using equal quantities of the yellow and blue-green coupling solutions; a scarlet toner by using equal quantities of the magenta and yellow coupling solutions. A fixing bath and two bleach baths are also required. The second bleach (Farmer's reducer) should be mixed just before use, as it has a very short life.

Fixing Bath

Sodium thiosulfate, crystals	200 g
Water to make	1 liter

First Bleach

Potassium ferricyanide	50 g
Potassium bromide	20 g
Water to make	1 liter

Second Bleach

First Bleach	30 ml
Fixing Bath	70 ml

Best results are obtained if the black-and-white print has been processed normally, including fixing and washing, then the silver image converted to silver bromide by the first bleach, exposed to light, and redeveloped in the color developer. Vigorous agitation during the color development is essential. The image silver may be left in the image or removed by the second bleach. The following procedure is recommended:

Processing Step	Time of Processing (68°F or 20°C)
1. First developer	2 min
2. Stop bath	1 min
3. Fixing bath (fresh)	10 min
4. Water wash	30 min
5. First bleach	To remove the black silver deposit
6. Water wash	15 min
7. Light exposure (1 ft from 100-W lamp)	1 min
8. Color developer	5 min

If the silver is allowed to remain:

9. Water wash	5 min
10. Fixing bath	5 min
11. Water wash	20 min

If the silver image is to be removed

9. Water wash	20 min
10. Second bleach	Until black silver deposit is removed
11. Water wash	20 min

Wash time after color development may need to be extended, as color staining of the highlights is often encountered with dye-coupling toning. Keep acids away from the dye image. As with most dyes, exposure to strong light, such as direct sunlight, may cause fading of the dye image.

Because of the widespread interest in color photography, many couplers are available for toning by dye coupling. The combination of several developing agents with several coupling agents permits the selection of a wide range of colors. Some of these possibilities have been suggested by Ernest Gehret[275] and Howard C. Colton.[276] These possibilities caused Colton to predict, possibly prematurely, in 1939 that "The common black silver picture image rather seems to be nearing that age when it is only a by-product in the formation of a colored image."

REFERENCES

1. A. J. Hand, "Instant 1910," *Camera 35*, **15** (4): 39 (1971).
2. C. E. Kenneth Mees, *The Theory of the Photographic Process*, Revised Edition, Macmillan, New York, 1954, pp. 753–755.
3. John H. Waddell, "Toning Prints and Transparencies," *Photo Technique*, **1** (1): 35 (1939).
4. J. I. Crabtree and G. E. Matthews, *Photographic Chemicals and Solutions*, Am. Phot. Pub. Co., Boston, 1938, pp. 289–290.
5. Ansel Adams, *The Print*, Morgan and Lester, New York, 1950, p. 114.
6. Adolph Nietz and Kenneth Huse, "The Production of Sepia Tones by Direct Development," *Brit. J. Phot.*, **64**: 497 (1917).
7. A. Jackson and W. A. Potts, "Colour with Chloro-Bromide Papers," *Brit. J. Phot.*, **77**: 195 (1930).
8. Donald Burchan and Ira Current, "Toning," in *Handbook of Photography*, edited by Keith Henney and Beverly Dudley, McGraw-Hill Book Co., New York, 1939, pp. 453–455.
9. André Page, "Getting Away from Black-and-White," *Brit. J. Phot.*, **100**: 623 (1953).
10. W. T. P. Cunningham, "Intensification," *Brit. J. Phot.*, **62**: 818 (1915).
11. Edward T. Howell, "Brown Blacks: 1—Catechol Redevelopment," *J. PSA*, **9** (7): 312 (1943).
12. Ira B. Current, "Some Factors Effecting Sepia Tone," *PSA J.*, **15** (11): 684 (1950).
13. R. R. Rawkins, "Pure Whites in Sulphide Toning," *Brit. J. Phot.*, **78**: 207 (1931).
14. "The ABC's of Toning," Kodak Pamphlet No. G-23 (8-66 Minor Revision), Eastman Kodak Co., Rochester, p. 7.
15. Paul G. Stecher, Editor, *The Merck Index*, 8th Edition, Merck and Co., Rahway, N.J., 1968, p. 851.
16. A. and L. Lumière and A. Seyewetz, "Studies in Sepia Toning," *Brit. J. Phot.*, **70**: 732 (1923).
17. R. R. Woodman, "Sulphide Toning," *Brit. J. Phot.*, **59**: 546 (1912).
18. Gordon Douglas, "Toning Prints," *Amat. Phot.*, **106**: 515 (1953).

19. Ira B. Current, "Toning," in *The Complete Photographer*, edited by Willard D. Morgan, National Educational Alliance, New York, 1943, Vol. 9, p. 3414.

20. E. Fenske, "Single-Solution Sulphide Toning," *Brit. J. Phot. Almanac*, p. 660 (1914).

21. "The ABC's of Toning," Kodak Pamphlet No. G-23 (8-66 Minor Revision,) Eastman Kodak Co., Rochester, p. 10.

22. Fred P. Peel, "Tone Your Prints," *Camera*, **65** (4): 67 (1943).

23. Paul G. Stecher, Editor, *The Merck Index*, 8th Edition, Merck and Co., Rahway, N.J., 1968, pp. 545–546.

24. J. B. B. Wellington, "On the Deterioration of Plates, Papers, and Films," *Brit. J. Phot.*, **52**: 443 (1905).

25. E. R. Bullock, "Experiments on Sulphide Toning," *Brit. J. Phot.*, **68**: 447 (1921).

26. J. Desalme, "Toning by Sulphuration," *Brit. J. Phot.*, **60**: 157 (1913).

27. J. Desalme, "Direct Sulphide Toning," *Brit. J. Phot. Almanac*, p. 661 (1914).

28. J. Desalme, "Sur le virage par sulfuration," *Bull. soc. franc. phot.*, (3) **4**: 56 (1913).

29. H. Cuisinier, "Les emplois photographiques du polysulfure de sodium," *Rev. franc. phot.*, **17**: 190 (1936).

30. H. Cuisinier, "The Photographic Uses of Sodium Polysulphide," *Brit. J. Phot.*, **83**: 471 (1936).

31. "Sulphide Toning," *Phot. News*, **43**: 568 (1899).

32. G. Underberg, "Experiments in Sulphur Toning," *Brit. J. Phot.*, **71**: 50 (1924).

33. Ivor Bassett, "Print Toning with Potassium Ethyl Xanthate," *The Camera*, **54**: 217 (1937).

34. E. J. Wall, "Sulphide Toning," *Am. Phot.*, **21**: 620 (1927).

35. A. and L. Lumière and A. Seyewetz, "Notes on Sepia Toning with Colloid Sulphur," *Brit. J. Phot.*, **60**: 672 (1913).

36. A. and L. Lumière and A. Seyewetz, "A New Method of Sepia Toning of Bromides by Colloid Sulphur," *Brit. J. Phot.*, **59**: 972 (1912).

37. Henry Soar, "Sepia Toning of Bromides by Acid Hypo, without Heat," *Brit. J. Phot.*, **60**: 156 (1913).

38. Henry Soar, "Sepia Toning with Acid Hypo," *Brit. J. Phot. Almanac*, p. 662 (1914).

39. "Recent Progress in Sulphide Toning," *Brit. J. Phot.*, **60**: 155 (1913).

40. Henry Soar, "Recent Progress in Sulphide Toning," *Brit. J. Phot.*, **60**: 185 (1913).

41. Leo Backelandt, *Assn. Belge Phot. Bull.*, (2) **16**: 5 (1889).

42. Detaille Frères, "A propos du virage des diapositives au moyen de l'alun et de l'hyposulfite sodique," *Assn. Belge Phot. Bull.*, (2) **17**: 336 (1890).

43. Leo Baekeland, "Sepia Tones on Developed Prints," *Wilson's Phot. Mag.*, **35**: 518 (1898).

44. Leo Baekeland, "Tons sépia pour Épreuves sur Papier," *Assn. Belge Phot. Bull.*, (3) **25**: 716 (1898).

45. Leo Baekeland, "On the Toning Action of a Mixture of Thiosulphate of Sodium and Alum," *Phot. News*, **47**: 724 (1903).

46. S. E. Sheppard, "The Theory of Photographic Processes and Methods," in *Photography as a Scientific Instrument*, Blackie and Son, London, 1923, p. 167.

47. A. and L. Lumière and A. Seyewetz, "Sur les réactions qui se produisent dans les solutions utilisées pour le virage et le fixage combinés des épreuves sur papier au chlorocitrate d'argent et sur la théorie de cette opération," *Bull. Soc. Chim. (Paris)*, (3) **27**: 137 (1902).

48. A. Seyewetz and G. Chicandard, "Sur les réactions engendrées par la décomposition de l'hyposulfite de soude dans le fixage des images photographiques," *Bull. Soc. Chim. (Paris)*, (3) **13**: 11 (1895).

49. A. Seyewetz and G. Chicandard, *Eder's Jahrbuch*, **10**: 488 (1896).

50. S. O. Rawling, "Sepia Toning with Colloidal Sulphur," *Phot. J.*, **69**: 3 (1922).

51. S. A. C., "Modern Methods of Toning Prints," *Photo Technique*, **2** (10): 42 (1940).

52. P. Wiegleb, "Methods of Sulphide Toning," *Brit. J. Phot.*, **76**: 344 (1929).

53. *The Chemistry of Photography*, 6th Edition, Revised, Mallinckrodt Chemical Works, St. Louis, 1940, pp. 30–38.

54. *Elementary Photographic Chemistry*, Eastman Kodak Co., Rochester, 1923, p. 52.

55. "A Study of the Factors Controlling the Tones Obtained with a Hypo Alum Toning Bath on Artura Iris Paper," Report No. 1746, *Kodak Monthly Abstract Bulletin*, **9**: 322 (1923).

56. H. A. Robinson, "The Virtues of Hypo-Alum," *Amat. Phot.*, **96**: 617 (1946).

57. A. and L. Lumière and A. Seyewetz, "Discoloration of the Whites in Sepia Toning," *Brit. J. Phot.*, **70**: 732 (1923).

58. W. E. A. Drinkwater, "Sulphur Toning," *Brit. J. Phot.*, **70**: 204 (1923).

59. Milton B. Punnett, "Original Methods of Toning Developed Photographic Prints," *Am. Phot.*, **1**: 25 (1907).

60. "Hypo-Alum Toning," *Brit. J. Phot.*, **68**: 773 (1921).

61. "Variations in Hypo-Alum Toning," *Brit. J. Phot.*, **70**: 570 (1923).

62. W. Jerome Harrison, *The Chemistry of Photography*, Scovill and Adams Company, New York, 1892, p. 340.

63. "Artura-Method Sepias," *Photo-Era*, **27**: 258 (1911).

64. Sigismund Blumann, *Photographic Workroom Handbook*, 3rd Edition, Camera Craft Pub. Co., San Francisco, 1930, p. 36.

65. Walter C. Nelson, "Toning Bath for Photographic Prints," U. S. Pat. 1,849,245 (1932).

66. "The ABC's of Toning," Kodak Pamphlet No. G-23 (1-72 Major Revision), Eastman Kodak Co., Rochester, p. 6.

67. Ons (E. A. Robins), "Bromide Toning," *Brit. J. Phot. Almanac*, p. 769 (1902).

68. E. J. Wall, "Sulphide Toning II," *Am. Phot.*, **22**: 22 (1928).

69. Edwin E. Jelley, "A Cause of Yellowness in Sepia Toning," *Phot. J.*, **72**: 480 (1932).

70. Ons (E. A. Robins), "Toning Bromide Prints," *Brit. J. Phot. Almanac*, p. 733 (1905).

71. A. and L. Lumière and A. Seyewetz, "Sur l'emploi des oxydants et notamment des quinones dans la chloruration et la bromuration de l'argent des images argentiques," *Bull. soc. franc. phot.*, (3) **7**: 267 (1920).

72. A. and L. Lumière and A. Seyewetz, "Chromium Intensification with Chlorochromates," *Brit. J. Phot.*, **66**: 451 (1919).

73. L. P. T., "The Acid Bichromate Bleaching Bath for Sulphide Toning," *Brit. J. Phot.*, **58**: 672 (1911).

74. David M. Webster, "The Permanganate Process of Sulphide Toning," *Brit. J. Phot.*, **62**: 353 (1915).

75. T. H. Greenall, "Permanganate Bleach for Sulphide Toning at Almost One Twentieth Cost of Ferricyanide Bromide," *Brit. J. Phot.*, **63**: 106 (1916).

76. T. H. Greenall, "The Permanganate Bleacher for Sulphide Toning," *Brit. J. Phot.*, **63**: 203 (1916).

77. Horace C. Inskeep, "Permanganate Formulae," *Brit. J. Phot.*, **68**: 339 (1921).

78. L. P. Clerc, *Photography, Theory and Practice*, 2nd Edition, Pitman Pub. Corp., New York, 1946, p. 379.

79. J. I. Crabtree and G. E. Matthews, *Photographic Chemicals and Solutions*, Am. Phot. Pub. Co., Boston, 1938, p. 325.

80. A. H. S. Craeybeckx, *Gevaert Manual of Photography*, 5th Edition, Revised, Fountain Press, London, 1962, p. 390.

81. H. Nitze, "Paper, Developer and Bleach in Sulphide-Toning," *Brit. J. Phot.*, **79**: 486 (1932).

82. Henry W. Bennett, "Sulphide Toning," *Brit. J. Phot.*, **79**: 527 (1932).

83. O. J. Morris, "Sulphide Toning," *Brit. J. Phot.*, **79**: 538 (1932).

84. H. Nitze, "Paper, Developer and Bleach in Sulphide Toning," *Brit. J. Phot.*, **79**: 602 (1932).

85. Helmer Bäckström and Artur Boström, "The Influence of the Bleaching Bath on the Colour Obtained in the Indirect Sulphide-Toning Process," *Phot. J.*, **76**: 607 (1936).

86. D. B., "Notes on Sulphide Toning," *Brit. J. Phot.*, **54**: 523 (1907).

87. Douglas Carnegie, "The Chemistry of Sulphide Toning," *Brit. J. Phot.*, **56**: 664 (1909).

88. O. J. Morris, "Stains in Sulphide Toning," *Brit. J. Phot.*, **80**: 127 (1933).

89. E. E. Jelley, "A Cause of Yellowness in Sepia Toning," *Brit. J. Phot.*, **79**: 200 (1932).

90. R. Namias, "Sulphide Toning with Barium Sulphide," *Brit. J. Phot.*, **58**: 324 (1911).

91. Rudolfo Namias, "Wie erhält man bei Bromsilberkopien mit Schwefeltonbad die besten und haltbarsten Brauntöne?," *Phot. Mitt.*, **48**: 100 (1911).

92. T. H. Greenall, "Barium Sulphide and Sulphide Toning—A Warning," *Brit. J. Phot.*, **66**: 655 (1919).

93. Alfred Miller, "Rongalit C in der Photographie," *Phot. Ind.*, p. 1064 (1925).

94. A. Miller, "Emplois photographiques du sulfoxylate formaldéhyde de sodium," *Sci. et Ind. Phot.*, **5R**: 199 (1925).

95. Henry Solomon Wellcome, Arthur Gerald Bates, and Frank Clement Starnes, "Sulphide Toning with Thiostannate," *Brit. J. Phot.*, **55**: 44 (1908).

96. Auguste Lumière and Henri Lumière, "Procédé d'utilization des sulfoxyphosphates dans les virages des papiers photographiques," French Pat. 507,332 (1920).

97. C. Welborne Piper, "Some Experiences with New Methods of Sulphide Toning," *Brit. J. Phot.*, **55**: 136 (1908).

98. Harry E. Smith, "Notes on Compound Thio Salts for Toning the Bleached Silver Image and also for Toning P.O.P. Prints," *Phot. J.*, **48**: 267 (1908).

99. Bertha E. Woolley and Charles W. Gamble, "On the Toning of Silver Images by Means of the So-Called Colloidal Silver Method," *Brit. J. Phot.*, **60**: 987 (1913).

100. Arthur Hammond, "Colloid Silver Toning with Tin Salts," *Brit. J. Phot.*, **68**: 759 (1921).

101. J. G. F. Druce, "Toning with Tin Salts," *Brit. J. Phot.*, **69**: 433 (1922).

102. H. J. Walls, "More Controlled Toning," *Brit. J. Phot.*, **97**: 606 (1950).

103. P. K. Turner, "Bromide Exposure Latitude for Sulphide Toning," *Brit. J. Phot.*, **85**: 439 (1938).

104. Louis Houben, "Emploi de la sulfo-urée en photographie," *Photo-Revue*, **45**: 179 (1933).

105. George L. Wakefield, "Toning is Fun," *Amat. Phot.*, **145** (1): 58 (1972).

106. Neville Maude, "After Treatment—The Modern Way," *Amat. Phot.*, **142** (24): 73 (1970).

107. Hugh Corry, "Thiocarbamide Toning," *Brit. J. Phot.*, **98**: 290 (1951).

108. George L. Wakefield, "The Lost Art of Toning," *Amat. Phot.*, **140** (9): 62 (1969).

109. George L. Wakefield, "Colloidal Silver Toning," *Amat. Phot.*, **145** (3): 60 (1972).

110. J. Vincent Lewis, "Controllable Sepia-Tones by Re-Development," *Am. Phot.*, **29** (1): 30 (1935).

111. Edward T. Howell, "Brown Blacks: 5—Modified Sulfide Toning," *J. PSA*, **11** (1): 12 (1945).

112. Hugh Corry, "Controlled Toning," *Brit. J. Phot.*, **97**: 543 (1950).

113. D. Sedlaczek, "Mercurial Toning of Gaslight Prints," *Brit. J. Phot.*, **72**: 635 (1925).

114. H. W. Bennett, "The Positive Processes: VII. Sulphide Toning," *Phot. J.*, **69**: 392 (1929).

115. Henry W. Bennett, "Uniformity in Sulphide Toning," *Am. Phot.*, **26**: 132 (1932).

116. Edward T. Howell, "Brown Blacks: 6—Sulfide Mercury Toning," *J. PSA*, **11** (3): 113 (1945).

117. Wilhelm Triepel, "Cold Single-Solution Sulphide Toning," *Brit. J. Phot.*, **58**: 657 (1911).

118. W. B. Shaw, "A New Direct Method of Cold Sulphide Toning," *Brit. J. Phot.*, **70**: 267 (1923).

119. W. B. Shaw, "An Improved Method of Nitro-Sulphide Toning," *Brit. J. Phot.*, **70**: 759 (1923).

120. Fritz Kropf, "A New Single-Solution Method of Sulphide Toning," *Brit. J. Phot.*, **57**: 836 (1910).

121. A. and L. Lumière and A. Seyewetz, "Sur l'emploi des quinones et de leurs dérivés sul-foniques pour renforcer les images argentiques et pour les virer en différentes couleurs," *Bull. soc. franc. phot.*, (3) **1**: 360 (1910).

122. A. and L. Lumière and A. Seyewetz, "Sur l'emploi des produits substitution de la benzo-quinone et ses homologues supérieurs pour le renforcement et le virage des plaques et papiers photographiques," *Bull. soc. franc. phot.*, (3) **9**: 331 (1922).

123. A. Seyewetz, "Virage direct en tons sépia des images argentiques positives par l'emploi de la benzoquinone," *Bull. soc. franc. phot.*, (4) **1**: 101 (1939).

124. A. Seyewetz, "Virage direct en sépia a la benzoquinone," *Photo-Revue*, **51**: 193 (1939).

125. A. Seyewetz, "Direct Sepia Toning of Positive Silver Images by Means of Benzoquinone," *Brit. J. Phot.*, **86**: 642 (1939).

126. "Toning with Benzoquinone," *Photo Technique*, **2** (9): 72 (1940).

127. Harry E. Smith, "Reagents for Reducing Bromide Prints Toned Sepia by the Sulphide Process," *Phot. J.*, **47**: 281 (1907).

128. Practicus, "The Sulphide Toning of Bromide Prints," *Brit. J. Phot.*, **60**: 158 (1913).

129. Harry E. Smith, "A Note on Reducers for Sepia-Toned Bromides," *Brit. J. Phot.*, **55**: 137 (1908).

130. A. and L. Lumière and A. Seyewetz, "The Chemistry of the Red Toning of Sulphide-Toned Prints," *Trans. Fara. Soc.*, **19**: 391 (1923).

131. Historicus, "Fox Talbot's Patenting," *Brit. J. Phot.*, **52**: 985 (1905).

132. T. Thorne Baker, "The Sensitive Compounds of the Chromium Family," *Phot. J.*, **41**: 333 (1901).

133. T. Thorne Baker, "The Sensitive Compounds of the Chromium Family," *Brit. J. Phot.*, **48**: 555 (1901).

134. T. Thorne Baker, "Andere Tonbader," *Eder's Jahrbuch*, **16**: 585 (1902).

135. Rheinische Emulsions-Papier-Fabrik Akt.-Ges. in Dresden, "Verfahren zur Herstellung braun getonter Bromsilber-, Chlorbromsilber- oder Chlorsilber-Bilder," German Pat. 238,513 (1910).

136. E. Schering, "Tellur-Tonbad für photographische Silberbilder," German Pat. 271,041 (1912).

137. Paul Rehländer, "Toning-Bath for Photographic Silver-Prints," U. S. Pat. 1,064,379 (1913).

138. E. Schering, "Selen-Tonbad für photographische Silberbilder," German Pat. 280,679 (1912).

139. E. Schering, "Tellur-Tonbad für photographische Silberbilder," German Pat. 290,720 (1915).

140. A. Spitzer and L. Wilhelm, "Verfahren zum gleichzeitigen Tonen und Fixieren von photographischen Silberbildern," German Pat. 292, 352 (1914).

141. E. Schering, "Selen-Tonbad für photographische Silberbilder," German Pat. 296,009 (1914).

142. Karl Kieser, "Die Tonung mit Selen- und Tellurverbindungen," *Phot. Korr.*, **55**: 9 (1918).

143. A. Sedlaczek, "Die Tonung mit Selenverbindungen," *Phot. Ind.*, **26**: 1190 (1928).

144. A. Sedlaczek, "Selenium Toning Processes," *Brit. J. Phot.*, **76**: 4 (1929).

145. Jaroslav Milbauer, "Über Selentonung," *Phot. Korr.*, **65**: 10 (1929).

146. A. Seyewetz, "The Chemistry of Selenium Toning," *Brit. J. Phot.*, **77**: 718 (1930).

147. Edward T. Howell, "Brown Blacks: 2—Selenium Toning," *J. PSA.*, **9** (9): 580 (1943).

148. Paul G. Stecher, Editor, *The Merck Index*, 8th Edition, Merck and Co., Rahway, N.J., 1968, p. 940.

149. B. L. Twinn, "Some Enlarging Papers and Developers for Miniature Work," *Phot. J.*, **78**: 483 (1938).

150. Ernest Pittaro, Editor, *Photo-Lab Index*, 28th Edition, Morgan and Morgan, Inc., Hastings-on-Hudson, N.Y., 1969, p. 22–07.

151. Ansel Adams, *The Print*, Morgan and Lester, New York, 1950, pp. 78, 116.

152. E. Valenta, "Zur Selentonung von Bromsilberpapierbildern," *Phot. Korr.*, **49**: 169 (1912).

153. E. Valenta, "Single-Solution Selenium Toning of Bromide Prints," *Brit. J. Phot.*, **59**: 313 (1912).

154. A. Steigmann, "Tonen und Verstärken selengetonter Bromsilberdrucke und Negative," *Phot. Ind.*, **26**: 902 (1928).

155. F. Bürki, "Über eine neue Methode der Tonung mit Selen," *Phot. Korr.*, **65**: 254 (1929).

156. George L. Wakefield, "A New Treatment for Contrasty Negatives," *Min. Cam. World*, **3**: 800 (1939).

157. S. Rahmatullah, "A New Way in Selenium Toning," *Brit. J. Phot.*, **91**: 75 (1944).

158. Jack Levinson, "Selenium Toner Credited to George D. Greene," *Am. Phot.*, **42** (1): 4 (1948).

159. E. Asloglou, "Selenium Toning Methods for Prints," *Brit. J. Phot.*, **85**: 599 (1938).

160. Felix Formstecher, "Zur Geschichte und Theorie der Selentonung," *Phot. Ind.*, **34**: 1014 (1936).

161. Paul Rehländer, "Compound for Making Photographic Toning Baths," U. S. Pat. 1,491,313 (1924).

162. Paul Rehländer, "Composition for Toning Photographic Silver Images," U. S. Pat. 1,499,749 (1924).

163. Mimosa Akt.-Ges. in Dresden, "Verfahren zur Tonung photographischer Silberbilder," German Pat. 301,019 (1917).

164. Hardwich, "Gold Toning Applied to Albuminized Paper," *J. Phot. Soc.*, **5**: 95 (1858).

165. M. Jeanrenaud, "New Toning Process," *Brit. J. Phot.*, **10**: 50 (1863).

166. Alexander Watt, "Toning with Platinum," *Phot. News*, **2**: 205 (1859).

167. "Toning," *Year Book of Photography*, p. 213 (1900).

168. T. Thorne Baker, "The Transitional Elements in Photography," *Brit. J. Phot.*, **48**: 827 (1901).

169. G. Hauberrisser, "A Simplified Method of Toning C. C. Prints with Gold and Platinum," *Brit. J. Phot.*, **56**: 667 (1909).

170. A. and L. Lumière and A. Seyewetz, "The Chemistry of Platinum Toning," *Brit. J. Phot.*, **60**: 159 (1913).

171. W. Jerome Harrison, *The Chemistry of Photography*, Scovill and Adams, New York, 1892, pp. 334–374.

172. Felix Formstecher, "Die Principien der Edelmetalltonung," *Camera (Luzern)*, **3** (1): 100 (1924).

173. D. J. Ruzicka, *Am. Phot.*, **28**: 779 (1934).

174. D. J. Ruzicka, "Gold Toning," *Photo Art Monthly*, **5**: 379 (1937).

175. *Am. Phot.*, **32** (5): 371 (1938).

176. Alvin W. Lohnes, "Blue Toning De Luxe," *Am. Phot.*, **36** (6): 38 (1942).

177. Philip Phyllides, "Gold Toning with Glycin Development," *Am. Phot.*, **37** (3): 22 (1943).

178. P. E. Liesegang, "Toning and Fixing in One Bath," *Brit. J. Phot.*, **15**: 232 (1868).

179. A. J. Jarman, "Improving the Color of Prints by Toning with Gold," *Am. Phot.*, **24**: 584 (1930).

180. Carlyle F. Trevelyan, "Commonsense Toning," *J. PSA*, **7**: 149 (1941).

181. A. Hélain, "Virage a la sulfo-urée," *Bull. soc. franc. phot.*, (2) **15**: 224 (1902).

182. A. Hélain, "A New Toning Bath," *Brit. J. Phot.*, **49**: 402 (1902).

183. E. Valenta, "Saure Goldtonbäder mit Thiocarbamidzusatz," *Phot. Corr.*, **39**: 650 (1902).

184. C. B. Neblette, *Photography, Its Principles and Practice*, 4th Edition, D. Van Nostrand, New York, 1946, p. 653.

185. C. H. Bothamley, "Some Minor Processes of Photography," *Phot. J.*, **58**: 48 (1918).

186. Rex Hayman, "Metallic Toning of Prints," *Amat. Phot.*, **137** (10): 56 (1969).

187. B. Tolmachoff, "A Cadmium Yellow Toner," *Am. Phot.*, **31** (12): 907 (1937).

188. Josef Maria Eder and Hauptmann Victor Tóth, "Neue Untersuchungen über die Bleiverstärkung," *Phot. Corr.*, **13**: 221 (1876).

189. Harold Swahn, "A Practical Method of Tricolor Toning," *Am. Phot.*, **31** (5): 316 (1937).

190. Bernard E. Jones, Editor, *Cassell's Cyclopaedia of Photography*, Cassel and Company, London, 1912, pp. 67–69.

191. Josef Maria Eder, "Die Reaction von rothem Blutlaugensalz auf metallisches Silber und die Unwandlung von Silbernegativen," *Phot. Corr.*, **13**: 26 (1876).

192. J. M. Eder, "Kupfer-Tonbad und Verstärker für Bromsilbergelatinebilder," *Phot. Corr.*, **36**: 537 (1900).

193. *The Chemistry of Photography*, 6th Edition, Revised, Mallinckrodt Chemical Works, St. Louis, 1940, p. 45.

194. "Ansco Formulas for Black and White Photography," Ansco, Binghamton, N.Y., 1948, p. 27.

195. E. Sedlaczek, "The Toning of Bromide Prints," *Brit. J. Phot.*, **53**: 624 (1906).

196. Ernest M. Pittaro, Editor, *Photo-Lab Index*, 28th Edition, Morgan and Morgan, Inc., Hastings-on-Hudson, N.Y., 1969, p. 6–114.

197. A. R. Pippard, "Johnson Blue Toner," *Brit. J. Phot.*, **113**: 1067 (1966).

198. C. E. Kenneth Mees, *The Theory of the Photographic Process*, Revised Edition, Macmillan, New York, 1954, p. 763.

199. C. B. Neblette, *Photography, Its Principles and Practice*, 6th Edition, Van Nostrand, New York, 1962, p. 366.

200. *The Chemistry of Photography*, 6th Edition, Revised, Mallinckrodt Chemical Works, St. Louis, 1940, p. 44.

201. R. Namias, "Nouvelle méthode de virage brun des épreuves au bromure," *Bull. soc. franc. phot.*, (3) **9**: 26 (1922).

202. Arthur Hammond, "Practical Methods for Toning Prints," *Am. Phot.*, **40** (6): 14; (7): 16; (8): 14 (1946).

203. Rodolfo Namias, "Herstellung einfarbiger und mehrfarbiger Bilder auf chemischem Wege," *Eder's Jahrbuch*, **15**: 170 (1901).

204. R. Namias, "Ueber die grüne Tonung auf Bromsilber papier," *Eder's Jahrbuch*, **17**: 158 (1903).

205. Rodolfo Namias, "Green Toning on Silver Bromide Paper," *Chem. Abstracts*, p. 2039 (1915).

206. Rodolfo Namias, "Virage jaune au vanadium et Virage vert au fer et au vanadium," *Rev. franc. phot.*, **5**: 76 (1924).

207. C. W. Somerville, "Green, Purple and Sepia Tones," *Phot. News*, **48**: 650 (1904).

208. Harry E. Smith, "A Practical Green Toner for Bromide Prints, a Blue Toner, and Two-Colour Toning," *Brit. J. Phot.*, **60**: 416 (1913).

209. E. J. Wall, "Vanadium Toning," *Phot. J. Am.*, **58**: 96 (1921).

210. Hermann Selle, "New Intensifier of Cyanide of Iron and Uranium," *Humphrey's Journal*, **17**: 223 (1865).

211. John Towler, "Selle's New Intensifier," *Humphrey's Journal*, **17**: 150 (1865).

212. Hermann Selle, "Ein neuer Verstärker," *Phot. Arch.*, **6**: 326 (1865).

213. "Selle's neuer Verstärker," *Phot. Arch.*, **6**: 393 (1865).

214. J. Vincent Elsden, "Review of the Theory and Use of Uranium Compounds in Photography," *Brit. J. Phot.*, **41**: 102 (1894).

215. E. Vogel, "Uranium Intensification," *Brit. J. Phot.*, **35**: 586 (1888).

216. E. Vogel, "Uran- und Bleiverstärkung für Trockenplatten," *Phot. Mitt.*, **25**: 34 (1888).

217. A. J. Jarman, "Employing the Salts of Uranium for Toning Purposes," *Phot. J. Am.*, **59**: 368 (1922).

218. A. Haddon, *Phot. News*, **36**: 62 (1892).

219. E. Sedlaczek, "Toning with Ferricyanides," *Am. Phot.*, **19**: 4 (1925).

220. Lüppo-Cramer, "Intensifying and Toning with Ferricyanide," *Brit. J. Phot.*, **54**: 392 (1907).

221. J. M. Nickolaus, "Toning Positive Film by Machine Methods," *J. SMPE*, **29**: 65 (1937).

222. L. Bune, "Le Virage à l'Urane," *Assn. Belge Phot. Bull.*, **28**: 627 (1901).

223. E. R. Bullock, "The Theory of Photographic Dye Mordanting," *Trans. Fara. Soc.*, **19**: 396 (1923).

224. Joseph S. Friedman, "Dye Toning," *Am. Phot.*, **35** (2): 145 (1941).

225. E. Kopp, "New Photographic Agent: The Double Chromate of Potassa and Ammonia," *Phot. News*, **8**: 147 (1864).

226. M. Carey Lea, "Dyeing Negatives," *Brit. J. Phot.*, **12**: 162 (1865).

227. E. J. Wall, "Positives in Colors," *Am. Phot.*, **5**: 160 (1911).

228. E. J. Wall, "Warm Tones by Means of Dyes in Transparencies," *Brit. J. Phot.*, **58**: 607 (1911).

229. C. E. Kenneth Mees, *The Theory of the Photographic Process*, Revised Edition, Macmillan, New York, 1954, p. 764.

230. "A New Three-Colour Printing Process," *Brit. J. Phot.*, **53**: 944 (1906).

231. A. Traube, "Coloured Tones by the Traube Iodide Process," *Brit. J. Phot.*, **54**: 196 (1907).

232. A. Traube, "Ein neues Dreifarben-Kopierverfahren," *Atelier*, **14**: 23 (1907).

233. A. Traube, "Ein neues Dreifarben-Kopierverfahren," *Eder's Jahrbuch*, **21**: 103 (1907).

234. "Diachromie," *Eder's Jahrbuch*, **25**: 365 (1911).

235. Arthur Traube, "Process of Converting Photographic Silver-Prints into Colored Prints," U. S. Pat. 1,093,503 (1914).

236. Arthur Traube, "Verfahren zur Umwandlung von Silberbildern in reine Farbstoffbilder unter Anlagerung von organischen Farbstoffen an die das Bild bildenden Metallverbindungen," German Pat. 187,289 (1905).

237. Arthur Traube, "Verfahren zur Umwandlung von Silberbildern in reine Farbstoffbilder unter Anlagerung von organischen Farbstoffen an die das Bild bildenden Metallverbindungen," German Pat. 188,164 (1906).

238. E. J. Wall, *Practical Color Photography*, Am. Phot. Pub. Co., Boston, 1922, p. 95.

239. Arthur Traube, "Process for Making Coloured Pictures," Brit. Pat. 147,005 (1921).

240. Arthur Traube, "Process for Making Coloured Pictures," Brit. Pat. 147,103 (1921).

241. Arthur Traube, "Process for Making Coloured Pictures," Brit. Pat. 163,337 (1921).

242. Arthur Traube, "Process for Making Coloured Pictures," Brit. Pat. 163,336 (1921).

243. Arthur Traube, "Process for Making Coloured Pictures," Brit. Pat. 163,337 (1921).

244. Uvachrom-Akt.-Ges. für Farbenphotographie, "Verfahren zur Herstellung von Farbstoffbildern aus Kupferbildern," German Pat. 403,428 (1918).

245. "Photographische Beizfarbenprozesse. — Uvachromie. — Bromsilberfarbstoffdruck," *Eder's Jahrbuch*, **29**: 170 (1921).

246. Joseph S. Friedman, "The Mordant Processes," *Am. Phot.*, **32**: 209 (1938).

247. Joseph S. Friedman, "Toning Processes," *Am. Phot.*, **34**: 926 (1940).

248. Joseph S. Friedman, "Toning Processes," *Am. Phot.*, **35**: 50, 145, 210, 302 (1941).

249. George L. Wakefield, "Color Prints by Dye Toning," *Photo Art Monthly*, **7** (4): 198 (1939).

250. George L. Wakefield, "Two-Colour Photography," *Brit. J. Phot.*, **86**: 229 (1939).

251. George L. Wakefield, "Colour Prints by Dye Toning," *Brit. J. Phot.*, **85**: 259 (1938)

252. A. B. Clark, "The Mordanting Action of Metallic Ferri- and Ferrocyanides," *Abridged Scientific Publications*, Vol. 2, Eastman Kodak Co., Rochester, 1915–1916, p. 130.

253. Arthur B. Clark, "The Mordanting Action of Metallic Ferro- and Ferricyanides," *J. Phys. Chem.*, **21**: 776 (1917).

254. J. I. Crabtree, "A New Method of Obtaining Dyetoned Images by the Use of Copper Ferrocyanide as a Mordant," *Phot. J. Amer.*, **55**: 338 (1918).

255. John I. Crabtree, "Colored Image and Process of Producing the Same," U. S. Pat. 1,305,962 (1919).

256. F. E. Ives, "The Mordant Dye Process for Colour Toning," *Brit. J. Phot.*, **68**: 186 (1921).

257. Fritz Kropff, "Farbtonungen mit Anilinfarben in einem Bade," *Phot. Ind.*, **22**: 1143 (1924).

258. A. Gleichmar, "Vereinfachte Farbstoff-Tonungen," *Phot. Ind.*, **24**: 1304 (1926).

259. Joseph S. Friedman, *History of Color Photography*, Am. Phot. Pub. Co., Boston, 1947, pp. 338–339.

260. L. P. Clerc, *Photography, Theory and Practice*, 2nd Edition, Pitman Pub. Co., New York, 1946, p. 388.

261. J. I. Crabtree and G. E. Matthews, *Photographic Chemicals and Solutions*, Am. Phot. Pub. Co., Boston, 1938, pp. 334–335.

262. A. Seyewetz, "A Review of Dye-Toning Processes," *Brit. J. Phot.*, **71**: 611 (1924).

263. J. I. Crabtree and C. E. Ives, "Dye Toning with Single Solutions," *Am. Phot.*, **22**: 656 (1928).

264. J. I. Crabtree and C. E. Ives, "Dye Toning with Single Solutions," *Trans. SMPE*, **12** (36): 967 (1928).

265. Rudolf Fischer, "Verfahren zur Herstellung farbiger photographischer Bilder," German Pat. 253,335 (1912).

266. Rudolf Fischer, "Process of Making Colored Photographs," U. S. Pat. 1,102,028 (1914).

267. R. Fischer and H. Siegrist, Über die Bildung von Farbstoffen durch Oxydation mittels belichteten Halogensilbers," *Phot. Korr.*, **51**: 18 (1914).

268. Edwin Mutter, "The Chemistry and Technology of Colour Photography," *Leica Foto-grafie*, No. 2: 72 (1971).

269. Edward D. Wilson, "Coupler Developers for Color Photography," *Am. Phot.*, **33**: 161 (1939).

270. F. L. Bingaman, "Color Prints by Color Coupling," *Am. Phot.*, **35** (1): 8 (1941).

271. J. B. Stansfield, "Print Toning by Dye-Coupled Development and by a Special Sulphide Toning Bath," *Phot. J.*, **83**: 55 (1943).

272. Ira B. Current, in *The Complete Photographer*, edited by Willard D. Morgan, National Educational Alliance, New York, 1943, pp. 3420–3421.

273. Leonard Wells, "Toning by Dye-Coupling," *Australasian Photo-Review*, **57** (9): 546 (1950).

274. "Toning by Colour Development," *Brit. J. Phot. Almanac*, pp. 340–342 (1956).

275. Ernest Ch. Gehret, "Chromatic Variations," *Brit. J. Phot.*, **117**: 914 (1970).

276. Howard C. Colton, "Dye Coupling for Color and Monochrome," *Photo Technique*, **1** (4): 16 (1939).

Chapter 4

Monobath Processing

*The proposal of adding hypo (sodium thiosulphate)
to a photographic developing solution so that
developing and fixing can be carried out at the
same time and in the same bath is an old one—
and rather appealing, because it eliminates
separate acid rinsing, hardening, and fixing
solutions.*

H. A. MILLER AND J. I. CRABTREE[32]

Simultaneous developing and fixing of photographic materials can occur in a single processing solution called a monobath, which is essentially a developing solution to which has been added a sufficient amount of a silver halide solvent to remove the unused silver salts from the photographic material. Long-time treatment in a solvent developer had early been observed to clear or partially clear photographic plates or film. It was probably this observation that prompted the early photographers, skilled in practical photographic chemistry, to increase the amount of silver-solubilizing compound to secure more rapid clearing during the normal time of development of their plates or films.

Combined development-and-fixation would be a considerable simplification of the tedious develop-stop-fix cycle of conventional photographic processing. The counterbalancing actions of simultaneous development and fixation tend to some degree to offset each other, thus minimizing the

155

effect of temperature and agitation variations upon image formation. Less concern need be given to these processing conditions. Processing in a suitable monobath could have a self-limiting action; that is, image development would stop automatically because the fixing agent had combined with the silver halide not already reduced to metallic silver by the developing agent. These and other attractive advantages have been the spur to overcome the difficulties in perfecting practical monobaths for photographic uses.

The story of combined developing-and-fixing is a classic example of the slowness of the advances of photographic chemistry throughout the history of photography. To interpret the sudden surges of monobath activity, followed by disuse, that have occurred periodically through the present century, one must understand the difficulties and the efforts of the early makers of monobaths. This historical perspective is also essential for evaluating monobath compositions, whose true merit has often been buried under unrealistic claims of commercial promoters.

Single-solution processing would provide considerable simplification of the conventional three-step processing cycle. The first recorded attempt to combine developing and fixing was made by W. D. Richmond in 1889.[1] Sodium thiosulfate and ammonium thiocyanate were added to a pyrogallol–ammonia–silver nitrate solution. A faint trace of a developed image was obtained. No image was present when the silver nitrate was absent, indicating that physical development was primarily responsible for the formation of the weak silver image.

The presence of fixing agents, such as sodium thiosulfate, according to S. E. Sheppard and C. E. K. Mees,[2] retarded the rate of development in alkaline solutions. The loss of image density was the result of the silver-complexing action of the thiosulfate before reduction of all the exposed silver halide could occur. This loss of potential image density was suggested to be at a maximum near the emulsion surface, with more normal development occurring in the depths of the emulsion layer. This suggestion was later confirmed by microscopic studies for developers containing Amidol, Metol, or Metol-hydroquinone with thiosulfate present.[3]

The inability of the developing agent to reduce exposed silver halide before the silver was complexed by the thiosulfate caused great losses in emulsion speed. Many investigators spent many years studying many developing agents, or combinations of developing agents, in the quest to find one that was suitably rapid in the presence of the thiosulfate to produce normal emulsion speed with a single plate or film material. At the turn of the century many developing agents were carefully tested: Ortol (1897, Vogel and Hannecke,[4] and 1898, Punnett[5]), catechol (1899, Hannecke[6]), Edinol and hydroquinone (1904, Baker[7,8]), Metol-hydroquinone (1909, Raymond[9]), Amidol (1910, Crémier[10]), and pyrogallol (1914, Valenta[11]).

These early monobaths often produced images that were low in density, foggy, and excessive in contrast, with a serious loss in emulsion speed. Sometimes the emulsion layer was coated with metallic silver that was deposited during the exceedingly long processing times. It was found that some of these difficulties could be minimized by carefully balancing a high level of solution alkalinity against a high level of thiosulfate to give a rapid-acting monobath. Some of these improved monobaths contained Metoquinone (that is, two molecules of Metol combined with one molecule of hydroquinone) (1914, Otsuki and Sudzuki[12-14]), Chloranol (two molecules of Metol with one molecule of chlorohydroquinone) with trisodium phosphate (1920, A. and L. Lumière and A. Seyewetz[15]), Amidol with acetone (1921, L. J. Bunel[16,17]), and Amidol with trisodium phosphate (1925, A. and L. Lumière and A. Seyewetz[18,19]). In 1924 H. Hashimoto[20] patented Metoquinone with sodium hydroxide or Metol-hydroquinone with sodium hydroxide monobaths that could be adapted to process plates, film, or paper by simply balancing the hydroxide-to-thiosulfate ratio.

The modern era of monobath formulation began with World War II. The German Navy sponsored research for the rapid processing of aerial films; the U. S. Air Force contracted for a systematic study of single-solution processing for films of a similar nature. In Germany the investigations were carried on by J. M. Keller, K. Maetzig, and F. Möglich[21]; in the United States, Hutson K. Howell,[22,23] Arthur Fentin,[24] and, later, Harry S. Keelan[25,26] formulated monobaths at the Optical Research Laboratory of Boston University.

Both groups attempted to overcome the still existing shortcomings of single-solution processing. The highly alkaline solution needed to secure rapid development without it causing the excessive softening and swelling of the gelatin emulsion layer. In addition, such highly alkaline baths had a short working life. Both groups tried to apply a published and patented claim by James R. Alburger.[27,28] Alburger had reported that a developer containing certain metal salts, such as potassium aluminum sulfate (alum), would act as a buffer to maintain the solution alkalinity essentially constant as well as "to provide an improved method of hardening emulsion material."

Some of the more rapid-acting monobath compositions formulated by the German workers were based on potassium alum and sodium hydroxide. These compounds were also used in the United States by Harry S. Keelan,[29] who carefully balanced developing-agent concentration against that of sodium thiosulfate to produce a solution with an adequate exhaustion life in use.

Variation of the potassium alum–sodium thiosulfate composition could meet the specific requirements of each photographic film or paper material. Monobath formulations were introduced commercially in considerable

numbers in the early 1960s, but their success in the marketplace was limited. The commercial compromises made in the monobath formulation to process a number of film products, rather than an optimum composition to use with a single product, produced solutions that offered little advantage over conventional processing. The lack of acceptance was due in part to the excessive swelling of the film emulsion layers, often degrading image quality and lengthening the time required to dry the processed film. Potassium alum, unfortunately for the monobath maker, has very limited emulsion hardening action above a pH of 6. The unhardened, swollen emulsion layer after processing was exceedingly susceptible to abrasion damage. The intense interest of the 1960s was quickly dissipated, and monobaths seemed to disappear from sight, as after similar cycles of commercialization in the past.

MECHANISM OF MONOBATH REACTION

A small amount of sodium thiosulfate may have beneficial effects in a developer, as reported by J. M. Eder[30] in 1896. Larger quantities of thiosulfate, however, act as a development retarder.[31] Unfortunately, considerable quantities of the fixing agent are necessary if the monobath is to clear the film during a practical time of processing. The early work on the mechanism of monobaths by H. A. Miller and J. I. Crabtree[32] indicated that the results given by a monobath are what might be expected from a developing solution with a large amount of restraint from the fixing agent. Some of the loss of image density and emulsion speed could be recovered by suitable formulation of a combined developer-fixer that favored the developing reaction— that is, higher solution pH, higher concentration of the developing agents, more active developing agents or combination of developing agents, and less concentration of the fixing agent.

The loss of emulsion speed with thiosulfate monobath processing was commonly attributed to the loss of the exposed silver halide to the fixing agent before image development could occur. It was something of a surprise, therefore, when R. G. Clarke, C. E. Milner, Jr., and J. Gomez-Ibanez[33] found that a monobath-produced image, although equal or lower in density than a conventionally processed image, may actually contain more silver, particularly at the low exposure levels. The phenomenon of more image silver producing less image density was attributed to a more compact grain structure, especially at the lower exposure levels, where the monobath acted as a fine-grain developer with a strong physical developing action.

In the presence of solvents for silver halide, the main part of development

has been attributed to an intensification of the chemically developed silver filaments by the deposition of silver by physical development.[34] With developers containing rapid-acting solvents, such as thiosulfate ions, T. H. James and W. Vanselow[35] found that "silver from a grain which does not contain latent-image nuclei may physically develop onto the silver of an adjacent developed grain and cause a significant increase in the amount of silver in the developed grain." G. W. W. Stevens, in a private communication, has suggested that "silver might be deposited by physical development on a chemically developed grain without even producing an increase in the over-all size of that grain, since the physically developed silver may simply fill in the spaces which exist in the original porous structure. Even if the size of the grain increased, density would not increase proportionally to the increase in the amount of silver."

According to G. M. Haist, J. R. King, and L. H. Bassage,[36] the continued growth of image silver in a thiosulfate monobath is "the result of physical development of the dissolved silver salt upon filamentary silver of the image and other nuclei. Such growth results in the silver particles becoming more massive without a material increase in their projection area. This growth in silver without a like increase in optical density is evidenced in the steadily declining covering power with increasing time of action of the thiosulfate monobath. It is likewise evident that continued immersion of a silver image in a solution containing silver salt, as in a used thiosulfate monobath, will not be without effect, and will probably result in an increase of graininess of the silver image."

From their model thiosulfate monobath experiments, Hermann Eggenschwiller and Walther Jaenicke[37] concluded that only silver halide, but not silver-thiosulfate complex, was reducible in a monobath. Physical development, then, would be of little importance. Recently, however, Jaenicke[38] is said to entertain the opinion that although the direct reduction of silver–sodium thiosulfate complexes in a solution containing a large excess of thiosulfate is thermodynamically impossible, the localized conditions near dissolving grains may make physical development possible. This concession would make it nearly unanimous that physical development is indeed an important factor in the mechanism of thiosulfate monobath processing.

A. A. Newman,[39] after reviewing 70 years of progress in formulating monobaths, concluded that the lowering of density and contrast was due to "the ability of the fixer to dissolve out *exposed* silver halide from the emulsion before the light-struck particles have had a chance to undergo development. Most of the speed reduction is due, however, to the proportionally more severe silver halide losses in the areas of underexposure corresponding to the toe region of the characteristic curve."

The solvent action of the thiosulfate dissolves both exposed and unexposed grains, increasing the amount of image silver without proportionate increases in image density. The suggestion by G. W. W. Stevens that the mass of a developed silver grain could be increased several times without increasing the size has been verified by J. C. Barnes.[40] After studying electron micrographs of images processed in thiosulfate monobaths, Barnes reported that "the effect of thiosulfate is primarily to thicken the dendrites making up the fibrous grain structure. Thus, considerable silver may be introduced into the grain without any increase in the density."

Barnes concluded:

With regard to combined developer-fixers compounded with thiosulfate, the concept that the developer and fixer compete for exposed silver halide is not entirely correct. There is a related competition, but it is actually between two different types of develop-

Figure 1. Comparison of silver particles formed in the low- and high-exposure areas. Note the more massive silver in the low-exposure area, indicating the presence of physical development with both the developer and monobath. Developer D-76 contains Metol-hydroquinone with 100 g of sodium sulfite per liter, giving the solution a high level of solvency. Monobath MM-5 is a Phenidone-hydroquinone-ascorbic acid solution with 132 g of sodium thiosulfate pentahydrate per liter. The bath also contained glutaraldehyde as a hardener and *o*-mercaptobenzoic acid as an antisilvering agent. [G. M. Haist and D. A. Pupo, from "The Inhibition of Silvering in Thiosulfate Monobaths," presented at the 28th Annual Conference of the Society of Photographic Scientists and Engineers, Denver, Colorado, May 11–16, 1975. See also *Phot. Sci. and Eng.*, **20**: 224 (1976)].

ment, since both chemical and physical development are involved, and there is in a sense competition between these means of development. More physical development relative to chemical development would be produced by increasing thiosulfate concentration, resulting in lower covering power, more compact silver structure, and a tendency towards the development of additional silver from surrounding grains. On the other hand, more chemical relative to physical development would produce higher covering power, because the fibrous structure of the chemically developed silver would tend to predominate over the more amorphous structure of physically developed silver.

In a thiosulfate monobath two types of development compete to form two types of image silver. For Phenidone-thiosulfate monobaths used to process three types of iodobromide photographic films, Margarete Ehrlich[41] found that in fog grains and in the weakly exposed grains, physical development was easily recognizable, producing silver aggregates that were large, smooth, and compact. At high exposures, the values for silver mass of the grain and its covering power were similar to those obtained by conventional development, where chemical reduction plays an important part. The silver particles were small and filamentary, and there was little evidence, if any, of thickening of the filaments. Chemical development is primarily the mechanism of silver image formation at intermediate and high image densities in a thiosulfate monobath. (See Figure 1.)

HIGH EXPOSURE AREA

D-76 MM-5

Figure 1 (*continued*)



solubilized from adjacent but unexposed grains that are near exposed, developing grains. The thiosulfate complex with the silver is a stable combination until it is near the freshly formed silver of a developing silver halide crystal. This metallic image silver catalyzes the reduction of the complexed silver from the thiosulfate complex, causing the reduced silver to deposit upon the edges of the exposed image details that are developing. A considerable increase in density may result from this solvent-induced edge enhancement, apparently by an increase in both the size of the silver filaments and the grain area. Sometimes the enhancement of edge silver by monobaths is so substantial as to cause a monobath image to have greater sharpness, even though the graininess is increased, than a conventionally developed image of finer grain.

Summary of the Mechanism of Monobath Processing

Image formation in a thiosulfate monobath represents the interaction of two types of development: physical development, prevailing at low exposure levels, and chemical development, the primary type at high exposure levels. At fog and low exposure levels, the reduced silver is composed of massive, compact particles; at higher exposure levels, the silver image is filamentary, and the filaments are similar in size to the particles produced by conventional development. Monobath processing thus represents, not a loss of exposed and unexposed silver halide to the fixing agent, but a competitive situation in which physical development forms large silver particles of low light-stopping ability, and chemical development forms filamentary clusters of high light-stopping power. This combined chemical-and-physical development often deposits more image silver than conventional development of an image of the same density.

Silver ions released from thiosulfate complexes are deposited on suitable sites, such as fog nuclei, where chemical reduction of the silver halide is slow but long-time processing may coat all silver particles of the image. In high-speed emulsions, with their coarser silver halide crystals, the physically developed silver is deposited primarily within the silver grain structure and does not increase its diameter appreciably. Because of the solvent action of the thiosulfate upon the silver halide crystals, coarser-grained emulsions may have finer silver images when monobath processed. Fine-grained emulsions, however, may have increased grain size because the physically developed silver cannot find sufficient sites within the silver grain structure and the silver is deposited so that the grain diameter is enlarged.

Silver thiosulfate complexes, formed by dissolving exposed or unexposed silver halide crystals, are relatively unstable in the presence of a suitable site for the catalytic reduction of the silver contained in the complex. The silver

thiosulfate complex will decompose when the complex passes near a silver filament formed by chemical development of the exposed silver halide. The first opportunity for the deposition to occur arises when the complex passes from an area of little or no exposure to one undergoing active chemical development. Metallic silver is deposited at the interface between the two areas. Considerable metallic silver will be deposited, increasing the edge density by as much as 25% and sometimes much more. The enhancement of the very edge with added silver makes the details of the silver image appear sharper to the eye, even though the granularity of the silver particles may be slightly increased.

PRACTICAL CONSIDERATIONS IN THE FORMULATION OF MONOBATHS

The chemistry of the combined developer-fixer must be matched to the nature of the light-sensitive photographic material and the conditions of processing such as temperature, agitation, and time of treatment. Much has been learned in recent years concerning the optimization of the chemical composition of monobaths to provide high-quality results in the minimum time. The following sections discuss the major factors involved in the formulation of modern monobaths.

The Developing Agent

The developing agents must be rapid acting—that is, have a very short time delay before starting to reduce the exposed silver halide. Two of the most rapid-acting, practical developing agents at moderate solution alkalinity are Metol and Phenidone. Either of these agents is usually combined with hydroquinone to form a superadditive combination. Phenidone, however, has generally proven to be more effective than Metol in most modern monobaths. Marilyn Levy[44] ran a direct comparison of the two in a monobath, using either Phenidone (3 g/liter) or Metol (10 g/liter) in a sodium thiosulfate (150 g/liter) solution of moderate pH. As shown in Figure 2, the Phenidone-thiosulfate monobath produced marked increases in speed, contrast, and maximum density over the results given by the Metol-thiosulfate solution of similar composition.

Marilyn Levy formulated a Phenidone-hydroquinone-sodium thiosulfate monobath (USASEL monobath 24-2) that was free of added development restrainers, such as potassium bromide or antifoggants. This bath was said to give "no loss in film speed for representative films tested, e.g., Eastman Tri-X Panchromatic Negative Safety Film, Type 5233 (35mm), Exposure

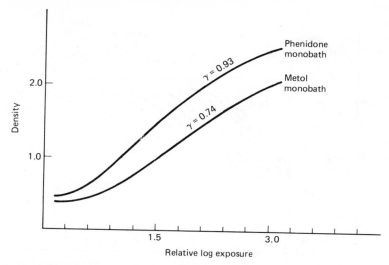

Figure 2. Comparison of Phenidone and Metol in thiosulfate monobaths; Eastman Tri-X panchromatic negative film, Type 5233 (35mm), tray processed for 3 min at 68 F. [Marilyn Levy, *Phot. Sci. and Eng.*, 2: 138 (1958)].

Index 320; Kodak Super-XX Aerial Recon. Reconnaissance Base Film, Exposure Index 100; Kodak Tri-X Aerial Recon. Reconnaissance Base Film, Exposure Index 200." The formula of the USASEL monobath is as follows.

<div align="center">

USASEL Monobath 24-2

Water (90 to 100°F)	750 ml
Sodium sulfite (anhydrous)	60 g
Hydroquinone	30 g
Sodium hydroxide	25 g
Phenidone	0.8 to 5.0 g
Sodium thiosulfate (crystals)	75 to 250 g
Ice water to make	1 liter
Formaldehyde (38%)	10 ml

</div>

Excessive oxidation can be prevented if ice water is used to cool the solution before the formaldehyde is added.

The gamma varied from 0.65 to 1.05 when the thiosulfate ranged from 250 to 150 g/liter. These results compared favorably to those when the 35mm

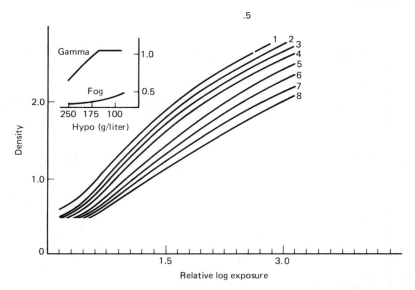

Figure 3a. Effect of hypo variation on monobath; Eastman Tri-X Film (35mm), tray processed at 68°F. [Marilyn Levy, *Phot. Sci. and Eng.*, 2: 138 (1958)].

Curve No.	Hypo (g/liter)	Processing Times (min at 68°F)
1	75	4
2	100	$3\frac{1}{2}$
3	125	$3\frac{1}{4}$
4	150	3
5	175	$2\frac{3}{4}$
6	200	$2\frac{1}{2}$
7	225	$2\frac{1}{4}$
8	250	2

Eastman Tri-X film was processed in Kodak developer D-76 for 6 to 20 min. (see Figures 3a and 3b.)

Phenidone-hydroquinone solutions may be unstable under alkaline conditions, thus limiting the shelf life of monobath or of solid developer-fixer formulations containing an alkaline substance. Liquid monobaths may deteriorate upon storage, especially at higher temperatures. The decrease in developing activity has been attributed by V. L. Abritalin and K. K. Markhilevich[45] to a large drop in the hydroquinone concentration and some loss of Phenidone. It has been claimed[46] that this disadvantage may

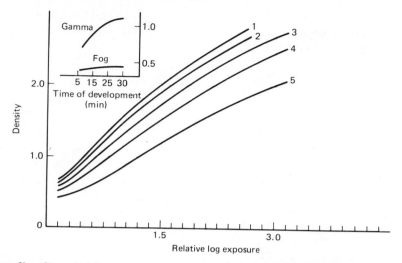

Figure 3b. Characteristic curves of Eastman Tri-X Film (35mm) developed in Kodak Developer D-76. [Marilyn Levy, *Phot. Sci. and Eng.*, 2: 139 (1958)].

Curve No.	Min at 68°F
1	20
2	15
3	12
4	10
5	6

be overcome through the use of 1-phenyl-4-methyl-3-pyrazolidone in place of 1-phenyl-3-pyrazolidone. Higher contrast, or a given contrast at a lower solution alkalinity, resulted from the use of the 4-methyl derivative of Phenidone. An example of such an improved monobath (pH = 11.3) is

1-Phenyl-4-methyl-3-pyrazolidone	1.5 g
Hydroquinone	7.5 g
Sodium thiosulfate (anhydrous)	66.0 g
Tribasic sodium phosphate (12 H$_2$O)	60.0 g
Sodium carbonate (anhydrous)	25.0 g
Sodium sulfite (anhydrous)	21.0 g
Water to make	1.0 liter

Even greater advantages in respect to speed and contrast were produced[47] by the use of 1-phenyl-4-methyl-3-pyrazolidones that have a phenyl group substituted in the 4-position. Examples of such compounds are

or

1-*p*-tolyl-4-methyl-3-pyrazolidone

1-*p*-methoxyphenyl-4-methyl-3-pyrazolidone

Improved monobath compositions (pH = 12.0) containing these developing agents were given in 1966 British Patent 1,039,875:

Sodium sulfite (anhydrous)	25.0 g
Hydroquinone	10.0 g
Sodium metaborate (8 H_2O)	37.5 g
Sodium hydroxide	7.0 g
Sodium thiosulfate (anhydrous)	105.0 g
1-*p*-Methoxyphenyl-4-methyl-3-pyrazolidone, *or*	2.0 g
1-*p*-Tolyl-4-methyl-3-pyrazolidone	2.0 g
Water to make	1.0 liter

A 7-min, 68°F, processing of Ilford Pan F and HP 3 films produced higher speed and contrast in monobaths containing 3-pyrazolidones with the substituted phenyl group as compared with a monobath with the unsubstituted phenyl group on the 3-pyrazolidone.

In the earlier U. S. Patent 2,875,048 (1959) of G. M. Haist and J. R. King[48] other derivatives of Phenidone, such as

1. 1-phenyl-4,4-dimethyl-3-pyrazolidone
2. 1-*p*-tolyl-4,4-dimethyl-3-pyrazolidone
3. 1-*p*-methoxy-4,4-dimethyl-3-pyrazolidone

were used in monobaths. These compounds also have superior stability in alkaline solution over solutions containing 1-phenyl-3-pyrazolidone.

In some cases the speed at which the silver image is formed is still inadequate even with two superadditive developing agents. A third developing agent may then be used. L-Ascorbic acid or isoascorbic acid has been used as the third developing compound. Glycin has also been added as the third compound with hydroquinone-Phenidone monobaths containing sodium thiosulfate. Amidol has been combined with hydroquinone-Glycin in thiosulfate monobaths.[49] An example of a Glycin-Phenidone-hydroquinone monobath with sodium thiosulfate is given in British Patent 906,034:

Water (120°F)	700.0 ml
Hydroquinone	40.0 g
Sodium sulfite	50.0 g
1-Phenyl-3-pyrazolidone	1.3 g
Glycin	15.0 g
Potassium alum	5.0 g
Sodium hydroxide	30.6 g
Sodium thiosulfate	90.0 g
Water to make	1.0 liter

Exposed Ansco Telerecord film was treated in this bath for 5 sec at 90°F, giving a gamma of 0.89, suitable for copying of records.

The combination of hydroquinone–ascorbic acid–Phenidone as developing agents in a thiosulfate monobath has been claimed to produce fine-grain, good-quality images with a short processing time. In U. S. Patent 3,806,344 (1974) Daniel Earle Speers stated that the preferred composite developer contains one developing agent with two negative charges, one developing agent having one negative charge, and one having no negative charge. An example of such a monobath is contained in the U. S. Patent 3,806,344 of Speers:

Water	2.0 liters
Sodium sulfite, anhydrous	210.0 g
Hydroquinone	30.0 g
Sodium carbonate	6.8 g
Ascorbic acid	3.36 g
Sodium hydroxide	14.4 g
Phenidone	4.0 g
Potassium bromide	1.47 g
Sodium thiosulfate	200 to 300 g

Films should be developed 6 min at approximately 75°F. This monobath was said to be "usable with films such as those commercially available under the trademarks Kodak Plus-X, Tri-X, and Panatomic-X, Ansco Super Hypan, Ilford HP3, and Agfa ISU, ISS, and IFF."

Four developing agents—preferably, Phenidone, Amidol, hydroquinone, and ascorbic acid—were combined with sodium, potassium, or ammonium thiosulfate or thiocyanate to form the monobaths in the U. S. Patent 3,867,151 of Jerome Katz. Such compositions were claimed to be "effective in producing satisfactory images on all film emulsions without film speed loss." The following monobath composition (pH = 10.15) was given as an example that was effective on Tri-X, Plus-X, Verichrome Pan, and Pan-X emulsions.

Phenidone	3 g
Hydroquinone	10 g
Amidol	1 g
Ascorbic acid	5 g
Sodium hydroxide	5.7 g
Sodium sulfite	30 g
Sodium bromide	1 g
Sodium thiosulfate ($5\,H_2O$)	80 g
Sodium hexametaphosphate	2 g
Water to make	1 liter

According to the patent, "Plus-X (35mm) exhibited an E.I. of about 275 when processed by the monobath of this Example [formula above] at 66°–69°F for 6 minutes with agitation for the first 15 seconds and thereafter for 5 seconds out of every 30 seconds."

The Fixing Agent

Sodium thiosulfate was used in the first monobath made by W. D. Richmond in 1889. This compound is commonly used today because it is readily available, inexpensive, and has low toxicity and odor. Ammonium thiosulfate has been used to reduce the salt content of the solution and thus shorten processing time.[49,50] At temperatures above 85°F loss of ammonia might seriously affect the monobath consistency.

In addition to thiosulfate, Richmond had thiocyanate in his monobath. Ammonium thiocyanate (140 g) has been used[51] with sodium thiosulfate crystals (280 g) and potassium sulfite (80 g) to make one liter of a rapid-acting fixing bath (10 sec, 80°F), indicating that the thiocyanate-thiosulfate

combination might be also suitable for modern monobath processing. The effect of thiocyanate was studied by Akira Sasai and Nobuo Mii.[42] The presence of potassium thiocyanate in a thiosulfate monobath reduced the processing time by shortening the clearing time of the film as well as accelerating the development rate.

A practical monobath was formulated for processing Fuji Neopan F Panchromatic Negative Film (35mm) by Sasai and Mii. A 40-sec, 20°C, treatment of this film produced a gamma of 0.68. This monobath (pH = 10.05) contained

Monobath Formula for Neopan F Film

Sodium sulfite, desiccated	40 g
Phenidone	2 g
Hydroquinone	15 g
Sodium carbonate, desiccated	40 g
Potassium thiocyanate	90 g
Sodium thiosulfate	25 g
2-Mercaptobenzothiazole	0.1 g
Water to make	1.0 liter

Sasai and Mii concluded that "When thiocyanate is used with sodium thiosulfate (hypo) in a suitable mixing ratio and total concentration, it is possible to obtain suitable monobaths for rapid processing of a variety of sensitive materials without loss of gamma and effective emulsion speed. These monobaths lead to a finer grain image having a bluish tone. The color is not objectionable for negative or television films, but might be for some positive films."

An example of a thiocyanate monobath is contained in German Patent 1,422,864 (1972). An oscillographic recording paper was treated for 30 sec, 20°C, in the following formulation and then dried.

Metol	2.2 g
Sodium sulfite (anhydrous)	72.0 g
Hydroquinone	8.8 g
Sodium carbonate (anhydrous)	48.0 g
Potassium thiocyanate	150.0 g
Potassium bromide	4.0 g
Water to make	1.0 liter

Thiosulfates and thiocyanates, however, tend to release silver ions in the monobath solution, resulting in the formation of a silver sludge that is especially objectionable in high-temperature, rapid-access monobath processing. A considerable number of organic sulfur-containing compounds have been proposed as monobath solvents, as many of these compounds do not easily release the complexed silver ions, thus minimizing the difficulty with silver sludging. Many of the organic sulfur compounds, containing a —SH, =S, or —S— group and an alkali solubilizing function in the molecule, do not produce a high concentration of salt as does thiosulfate and are more rapid acting; thus they are more adaptable for rapid-acting monobaths.[52]

Mercaptosuccinic acid $\left(\begin{array}{c} \text{HS—CHCOOH} \\ | \\ \text{CH}_2\text{COOH} \end{array}\right)$ was found by G. M. Haist, J. R. King, A. A. Rasch, and J. I. Crabtree[53] to be effective in acid monobaths containing titanium trichloride as the developing agent. Monothioglycerol $(\text{HOCH}_2\text{CH(OH)CH}_2\text{SH})$, thioglycol $(\text{HOCH}_2\text{CH}_2\text{SH})$, β-mercapto ethylamine $(\text{H}_2\text{NCH}_2\text{CH}_2\text{SH})$, N,N-diethyl-β-mercaptoethylamine

$$(\text{CH}_3\text{CH}_2)_2\text{NCH}_2\text{CH}_2\text{SH}),$$

and 2-thiobarbituric acid $\left(\begin{array}{c} \overset{S}{\overset{\|}{\text{HNC}}}\text{—NHC}\overset{O}{\overset{\|}{}}\text{—CH}_2\text{C}=\text{O} \end{array}\right)$ have been proposed by G. M. Haist and J. R. King[54] for use in combined alkaline developer-fixers, although these compounds are probably too toxic or odorous for general use. (See Figure 4.) The temperature and pH dependence of a number of organic sulfur-containing compounds was determined by G. M. Haist, J. R. King, and .L. H. Bassage.[55] In addition to monothioglycerol and N,N-diethyl-β-mercaptoethylamine, mercaptoacetic acid $(\text{HSCH}_2\text{COOH})$, cysteine hydrochloride $\left(\begin{array}{c} \text{HSCH}_2\text{CHCOOH}\cdot\text{HCl} \\ | \\ \text{NH}_2 \end{array}\right)$, o-mercaptobenzoic acid

$\left(\begin{array}{c}\text{SH}\\ \bigcirc\text{—COOH}\end{array}\right)$, and thiourea $\left(\text{H}_2\text{NC}\overset{S}{\overset{\|}{}}\text{—NH}_2\right)$ were studied.

A 6-min, 75°F, monobath for processing Kodak Verichrome pan film was formulated with mercaptoacetic acid as the fixing agent. This solution had the following composition (pH = 10.7):

Mercaptoacetic Acid Monobath

Water	750 ml
1-Phenyl-3-pyrazolidone	5.0 g
Sodium isoascorbate	24.0 g
Sodium sulfite (anhydrous)	48.0 g
Mercaptoacetic acid, sodium salt	24.0 g
2-Diethylaminoethanol	80.0 ml
Mucic acid	1.2 g
Potassium hydroxide	12.0 g
2-Anthraquinonesulfonate, sodium salt	0.25 g
Water to make	1.0 liter

In comparing a mercaptoacetic acid monobath and a thiosulfate monobath of the same image-producing activity, Haist, King, and Bassage found that

This organic agent was more rapid-acting than its inorganic counterpart, requiring a more potent developing action to give an equal density response. The presence of the rest of the salts of the monobath considerably slowed the action of the thiosulfate but this salt effect was not of appreciable importance with the organic compound in a monobath.

There does appear to be a very marked difference in the mechanism of action of the two types of monobaths. After a sharp initial rise, the growth of both image density and image silver is stopped in the monobath containing mercaptoacetic acid, but there is a continued growth of both of these with the thiosulfate bath, even after the film has been shown to have cleared.

The greater stability of the silver complexes of certain sulfur-containing organic compounds reduces the tendency of a used monobath to deposit silver sludge. The rapid action of many of the organic agents also suppresses the formation of fog, especially the high fog densities that are often encountered at high temperatures with thiosulfate monobaths. A properly compounded mercapto monobath does not need development restrainers, such as potassium bromide or a benzotriazole, as the rapid action of the organic compound is usually sufficient to restrain nonimage development. Mercapto compounds act as a preservative for developing agents, especially those agents derived from benzene, appearing to be much better inhibitors of oxidation than sodium sulfite. These mercapto compounds act in much

Figure 4. Filamentary silver produced by Developer D-76 (a) compared to silver given by a mercaptoacetic acid monobath (b). The anti-physical-developing activity of the potassium hydroxide–mercaptoacetic acid monobath has produced finer silver filaments than those given by the high-sulfite D-76 developer (10,000 ×). (Grant Haist and James King, Eastman Kodak Company).

Figure 4 (*continued*)

the same way as sodium sulfite in reacting with the oxidized forms of the developing agents.[56]

In modern monobaths a mercapto silver complexing agent is often used with Phenidone-hydroquinone developing agents. Aerial oxidation of such solutions can cause the complexing activity to be impaired by the reaction between the quinone from the oxidized developing agent and the mercapto compound.[57] Quinone has been reported[58] to react with mercaptoacetic acid to yield a hydroquinone with four —SCH$_2$COOH groups attached to the ring:

Once the ring has been completely filled, the compond may react further with oxygen, and the resulting quinone will cause the formation of the inactive disulfide, HOOCCH$_2$S—SCH$_2$COOH, from two molecules of the active mercapto acid, HSCH$_2$COOH. Either the addition of the mercapto compound to the quinone ring or the formation of the disulfide can cause a mercapto monobath to lose fixing activity if air and hydroquinone, or substituted hydroquinones, are present.

The presence of a high level of sodium sulfite will significantly increase the life of a mercapto monobath. The oxidized forms of hydroquinone and chlorohydroquinone are more reactive with sulfite ions (in large concentration) than with the lesser quantities of the mercapto compound. Once the monosulfonate is formed, the addition of the mercapto compound to the same molecule is inhibited. The ease of addition of mercapto compounds to various hydroquinones varies with the structure. Thus, Truman R. McMurtray[59] in U. S. Patent 3,542,544, proposed to use in mercapto monobaths hydroquinone derivatives that had already been reacted with one molecule of the mercapto acid. Examples of such modified hydroquinones have the structures

2,5-dihydroxyphenyl thioacetic acid	2,5-dihydroxyphenyl thiosuccinic acid	o-(2,5-dihydroxy phenyl thio) benzoic acid

The mercapto-substituted hydroquinone developing agent is still about as active as hydroquinone in monobaths. The use of 2,5-dihydroxyphenyl thiosuccinic acid in place of hydroquinone in a mercaptosuccinic acid monobath, according to McMurtray, showed that "after 24 hours of exposure to air, the stabilizing activity of the hydroquinone monobath is markedly decreased, while the second, i.e., a monobath of the invention with the modified hydroquinone, shows no evidence of significantly decreasing stabilizing activity."

Sludge-free monobaths may be obtained, according to German Patent 1,163,142 (1964), when 2-mercaptopyrimidines are used as the solvent for the silver halide. A bath suitable for processing black-and-white enlarging paper had the following composition:

Sodium sulfite, anhydrous	30 g
Hydroquinone	14 g
Sodium carbonate, anhydrous	30 g
Potassium bromide	5 g
2-Mercapto-4-methyl-5-(1′-morpholylmethyl)-6-hydroxypyrimidine	8 g
1-Phenyl-3-pyrazolidone	0.5 g
Water to make	1 liter

Ammonia and Amine Compounds

Ammonia was used as the alkali in the first monobath made by W. D. Richmond in 1889. In 1933 Merle L. Dundon[60] patented the use of certain organic ammonia compounds, such as mono-, di-, and triethanolamine, as alkali substitutes for photographic developers. In 1945 John N. Boberg[61] patented triethanolamine as the sole activating alkali, or with trisodium phosphate, in thiosulfate monobaths containing Metol-hydroquinone or Metol-catechol as the developing agents. In modern monobaths ammonium compounds or ammonia derivatives have found increasing use, not necessarily as alkalies, but as accelerators of development and fixation. Generally, organic amines are especially beneficial to increase the rate of image formation, probably by a reduction of any barrier that might lengthen the time before the developing agent can begin to act. Because the fixing rate is controlled by the diffusion time, the fixing action, though accelerated, is benefited less than the development. Higher fog density usually results when an organic amine is present in a monobath. (See Figure 5.)

In an early patent, Garnet P. Ham[62] found guanidine anthranilate to be of value in thiosulfate monobaths. In British Patent 1,207,583[63] the ammonium compound is combined with sulfite, bisulfite, or pyrosulfite to eliminate the need for a separate preservative. The general formulas of suitable compounds are

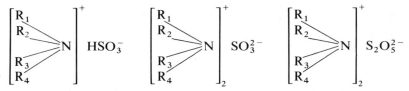

An example of a thiosulfate monobath containing such a tetra alkyl ammonium salt has the following composition.

Water	600 ml
Ethylenediamine tetraacetic acid	2.0 g
Tetramethyl ammonium bisulfite (55 % solution)	30.0 g
Hydroquinone	10.0 g
1-Phenyl-3-pyrazolidone	2.5 g
Sodium thiosulfate (anhydrous)	50.0 g
1-Phenyl-5-mercapto-tetrazole	0.01 g
Sodium hydroxide	10.0 g
Water to make	1000 ml

This monobath was said to process film similar to Kodak Plus-X pan in 8 min at 68°F, with "excellent image quality."

Just as the addition of organic amines has been beneficial for obtaining rapid-acting developing solutions, so organic amines have been of significant value for securing adequate emulsion speed and image density with

monobaths. Primary $(R—NH_2)$, secondary $\left(\begin{array}{c}R_1\\ R_2\end{array}\!\!>NH\right)$, and tertiary

$\left(\begin{array}{c}R_1\\ R_2—N\\ R_3\end{array}\right)$ amines may be used. Generally, the primary amines are more

active, giving higher fog and more softening of the gelatin. The tertiary amines are less active but promote less fog and exhibit lessened gelatin softening. In many cases hydroxyalkyl amines are preferable.

Alkaline solutions containing ammonium salts, such as ammonium thiosulfate, show a high development rate and produce fine-grain images. Such solutions may lose both developing and fixing activity by the slow loss of ammonia if the monobath is used in shallow trays or stored in poorly sealed bottles, or if the processing is carried out at elevated temperatures. These difficulties could be minimized, according to J. S. Goldhammer,[64] by using the lower volatilization of an organic amine in a sodium thiosulfate monobath. Ethanolamine or ethylenediamine, both primary amines, accelerated developing and fixing action of a sodium thiosulfate monobath in a manner similar to that produced by the ammonium ion of the ammonium thiosulfate. A Goldhammer monobath for the 2-sec, 85°F, processing of a prehardened motion picture film had the following composition (pH = 10.5):

Water (90°F)	750 ml
Sodium sulfite, desiccated	50 g
Sodium bisulfite	20 g
Amidol	15 g
Hydroquinone	5 g
Glycin	10 g
6-Nitrobenzimidazole ($\frac{1}{2}$%)	80 ml
Sodium thiosulfate (anhydrous)	54 g
Ethylenediamine (85 to 88%)	60 ml
Water to make	1000 ml

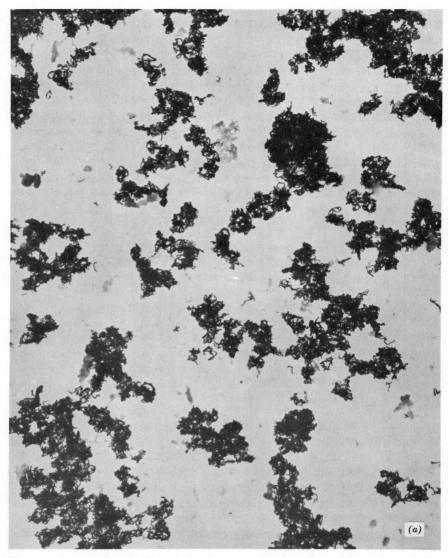

Figure 5. An organic amine affects the structure of the silver given by a thiosulfate monobath. The filamentary silver is less thickened by a thiosulfate monobath using potassium hydroxide as the alkali (a) than when the monobath of a similar composition has an organic amine replacing the hydroxide (b) (10,000 ×). (Grant Haist and James King, Eastman Kodak Company).

(b)

Figure 5 (*continued*)

Ammonia and water-soluble substituted amines have been reacted with acidic mercapto compounds to form fixing agents for developer-fixer solutions.[65] Suitable amine salts are those derived from monomethylamine, dimethylamine, diisopropylamine, diethylamine, monoisopropanolamine, diisopropanolamine, and triethanolamine. Alternatively, "The photographic developing and fixing solutions may also be prepared from dry compositions using a thioglycolate or other acid salts, such as sodium thioglycolate and as a source of thioglycolate ion when preparing the working solution and an ammonium salt, such as ammonium chloride or an amine, as a source of the ammonium or substituted ammonium ion."

Combined developer-and-fixers containing amines may be split into two solutions, the first, an inactive developing solution, and the second, an alkaline bath containing a fixing agent.[66] Advantages of the two-bath system were claimed to be long standing life in tray or tank, a lessened sensitivity to temperature changes, and a tendency for self-correction of over- and underexposure. An example of such a processing technique involves an inactive developing composition:

Isoascorbic acid	80 g
1-Phenyl-3-pyrazolidone	3 g
Sodium sulfite, anhydrous	25 g
Water to make	1 liter

Adjust pH to 5.0 with potassium hydroxide. After the emulsion layer has imbibed the developing solution, the film is immersed in a fixing activator (fixavator).

Thioglycolic acid	22 ml
Monoethanolamine	40 ml
Water to make	1 liter

Adjust pH to 12.5 with potassium hydroxide.

Gelatin Hardening Agents

Combined developing and fixing solutions are usually alkaline, sometimes very caustic. Most general-purpose photographic films do not possess sufficient hardening to be processed in a monobath without additional

hardener in the solution. Without the hardener, the gelatin layer on the film will be softened and easily abraded during processing. Even more serious, the emulsion layer may swell irreversibly, causing reticulation of the gelatin layer. In some cases the reticulation may not be easily visible but will still cause image degradation. Excessive swelling of the emulsion layer is often evidenced by a great increase in time required to dry it after processing.

Alums containing chromium or aluminum have been added as hardening agents to alkaline monobaths, apparently as a result of the claims of James R. Alburger,[27] who used alums as hardeners in developing solutions. The hardening action of alums, however, has been inadequate for most solutions of alkaline monobaths. As F. W. H. Mueller[67] has reported, "Above pH 6.0–6.5 hardening with chromium or aluminum is ineffective, whereas organic hardening agents increase in hardening efficiency as the pH is raised above the isoelectric point of gelatin." Most of the aldehydic hardeners are effective in alkaline solution, forming intermolecular bridges that modify the swelling and water uptake of the gelatin molecules.

A suitable organic hardening agent must be selected with great care, as most hardening agents, by their very nature, are highly reactive compounds that may promote high fog and seriously shorten the useful life of the developer-fixer solution. Most aldehydes, halogen-substituted aldehydes, diketones, and related gelatin-hardening compounds are unsuitable for inclusion in a monobath. In spite of its instability in alkaline solution, formaldehyde has been used in monobaths by Levy,[44] Sasai and Mii,[42] Ehrlich,[41] and others. Glutaraldehyde is said by D. H. O. John and G. T. J. Field[68] to become ineffective if the pH rises significantly above 10. The sodium bisulfite derivatives of various dialdehydes have been claimed to have advantages over the use of free aldehyde in alkaline solutions.[69] Formaldehyde is known to react with an amino developing agent, such as Metol, in a developing solution, but certain dialdehydes do not, yet are claimed to be effective gelatin hardeners. At pH values between 8.5 and 12.0, β-methyl glutaric dialdehyde bis(sodium bisulfite) has proven in practice to be an efficient hardener for both developing and developer-fixer solutions. The addition of glutaraldehyde bis(sodium bisulfite) to most monobaths without a hardening compound may be necessary if the solutions are to be used with any film materials other than the highly hardened thin-emulsion film products.

Antifoggants

By accelerating both chemical and physical development, organic amines in monobaths tend to produce considerable nonimage silver. Aldehyde hardening agents also promote the nonselective reduction of silver halide.

In such monobaths antifoggants are usually required to keep the fog density within acceptable limits, as the fixing agent alone may not provide sufficient restraint. This needed restraint is also required for rapid-acting monobaths, which contain highly activated developing agents that are often used at high temperatures.

Potassium bromide is a common restrainer in combined developer-fixers, but organic antifoggants are often more effective. Benzotriazoles, benzoxazoles, benzimidazoles, and benzothiazoles have been used. The compound, 1-phenyl-5-mercaptotetrazole, is a powerful antifoggant and is often found in modern monobaths. The sodium salt of 2-anthraquinone sulfonate has been used to control fog in a very active mercaptoacetic acid monobath.

Surprisingly, antifoggants forming silver compounds of less solubility than silver bromide may be employed to secure more image density and emulsion speed than in the absence of the antifoggants. The presence of silver compounds of low solubility at the surface of the silver halide grain interferes with the fixing action more than the developing action when the antifoggant is present in a suitable concentration. The net effect is to produce more image, not less, when very small quantities of the antifoggant are added to the solution. Increasing the quantity of the antifoggant will eventually result in severe image loss, as the restraint of development becomes appreciable at the higher antifoggant levels. Considerable quantities of the antifoggant in the solution will greatly lengthen the time required to clear the emulsion layer and, indeed, may prevent a thiosulfate monobath from clearing the emulsion in reasonable times of processing. Judicious use of small quantities of antifoggants, however, has proven to be valuable in photographic research in adjusting image characteristics to a desired sensitometric aim point.

Potassium iodide has been shown to be unusually effective in thiosulfate monobaths, probably because it is difficult for thiosulfate ions to complex and solubilize silver iodide. As early as 1946 R. J. King[70] recognized and patented the beneficial effect of iodide in monobaths. Suitable concentrations were said to range from 0.05 to 1.0 g of potassium (or sodium) iodide per liter of monobath. Greater quantities interfered with the clearing of the emulsion layer; lesser quantities produced dichroic fog. A quantity of potassium iodide around 0.5 g/liter caused an increase in image density and a decrease in fog density. King found that "The amount of potassium iodide is quite independent of whether potassium bromide is or is not used in the solutions. That is, the potassium iodide used is in no way a substitute, in part or in whole, for potassium bromide, and the important functions which it performs in the specified quantities in these solutions cannot be performed by replacement of part or all of the potassium iodide by bromide."

Antisilvering Agents

Photographic developing solutions containing silver halide solvents often deposit an argentic sediment after the solution has been used. Thiosulfate monobaths, and even some solutions containing certain organic fixing agents, become cloudy after use and soon start to precipitate a silver sludge. In a developing solution the quantity of sediment is quite small, but a used monobath, because of its higher solvency, deposits considerable sludge. Silver sludging from a used monobath starts rapidly; at high processing temperatures, silver deposition after 10 sec may make the equipment unusable for further processing. Metallic silver depositing upon photographic equipment, such as machine transport rollers, or upon the surface of the photographic material, has limited the practicality of single-solution machine processing.[71]

The makers of monobaths for darkroom use have usually treated their silvering action as if it were of little consequence, suggesting that the precipitate may be removed by filtration or the clear solution decanted after the precipitate has completely settled. The sludging of silver from a monobath is not a trivial annoyance, however, but a symptom of a serious chemical problem. Probably its deeper significance was first recognized by H. A. Miller and J. I. Crabtree[32] in 1948. They pointed out that "A combined developer and fixer exhausted more rapidly than a conventional developer of similar composition without hypo because the developing agent is depleted not only by virtue of development and image silver, but also by reaction with the silver halide dissolved out by the hypo. This secondary reaction usually requires several hours for completion, and more than doubles the average amount of development per film processed."

The reduction of the silver ions held by the thiosulfate results in the regeneration of the thiosulfate ions. These ions are then available for further reaction with the silver halide of the photographic emulsion. A high concentration of unreacted thiosulfate is maintained at the very time that the developing agents are being exhausted by having to develop both the exposed silver halide and much of the remaining unexposed but solubilized silver halide. The delicate chemical balance of the monobath is quickly upset, and the fixing action soon overwhelms the developing action, thus limiting the solution's practical life.

A used monobath contains small particles or nuclei that serve as preferred sites for the deposition of silver formed by the reduction of the silver ions from the silver thiosulfate complex. Detached latent image specks, silver sulfide, colloidal silver, or other suitable nuclei leached from the emulsion layer may serve as a catalytic site for the silver to be deposited from the used monobath solution. As the silver deposition is continued, the small particles

grow, then may agglomerate until their size causes them to fall to the bottom of the solution. A strongly adhering layer of metallic silver may plate on suitable surfaces that are in contact with the used monobath solution. The silvering action of the solution is greatly accelerated by temperature; at high temperatures even the light-sensitive photographic material may be coated during its brief contact with the solution.

Silver sludging has often prevented the practical use of monobaths. Carl Orlando,[72] for example, compounded the following formula that gave satisfactory image quality with low fog at 140°F and only 1.3 sec processing time:

High-Speed Monobath Processing Solution

Water (125°F)	750 ml
Metol	12.9 g
Sodium sulfite	70.9 g
Hydroquinone	25.7 g
Sodium hydroxide	25.7 g
Benzotriazole	10.0 g
Sodium thiosulfate	180.0 g
Water to make	1.0 liter

However, Orlando found "a serious difficulty was encountered which made the technique impractical. The monobath solution forms a silver compound which precipitates and adheres to the surface of the developing chamber and its liquid ports. Since ports are very narrow—approximately 0.005-inch wide—any foreign deposition causes restriction to the liquid flow sufficient to make the equipment inoperative after a very short time." Two-solution processing had to be used so that photographic data could be projected 0.2 sec after exposure.

Silver sludging may be avoided through the use of suitable organic sulfur compounds to replace silver complexing agents, such as thiosulfate, that release the complexed silver ions to form the silver sediment. The film-clearing action of a number of mercapto compounds was given by G. M. Haist, J. R. King, and L. H. Bassage.[36] Sulfur-containing sugars were used in monobaths by W. J. Humphlett, G. M. Haist, and J. R. King.[73] Organic silver complexing agents are thought to have been used by E. D. Seymour[74] for side-looking radar mapping and by H. S. Keelan and W. B. Sievers[75] for monobath processing of X-ray film.

One approach to avoid the difficulties of silver precipitation from thio-sulfate monobaths is possible when the solution is thickened and applied to the emulsion surface, then washed off when the processing period is completed. Physical development nuclei, such as colloidal silver or the colloidal sulfides or selenides of zinc, cadmium, nickel, or silver, are added in a quantity of from 0.05 to 2.0 g/liter of monobath. According to British Patent 1,066,993,[76] "The function of the physical development nuclei in the processing solution is to provide centres on which complexed silver halide from unexposed areas of the emulsion layer being processed may be developed. Such physical development releases the thiosulphate from the silver complex and thus allows a lower thiosulphate concentration to be used in the solution for a given rate of development. The tendency for the nuclei with the silver developed on them to adhere to the surface of the film and the processing vessel is reduced by the thickener. The amine increases the rate of development of the image and is prevented from causing excessive fog by the physical development nuclei."

An example of such a thickened monobath is given in British Patent 1,066,993 or U. S. Patent 3,392,019.[77]

(Methylaminoethanol)-sulfur dioxide addition product (17.8 % SO_2)	75.0 g
1-Phenyl-4,4-dimethyl-3-pyrazolidone	2.0 g
Hydroquinone	10.0 g
Sodium thiosulphate crystals (5 H_2O)	50.0 g
Potassium iodide	0.5 g
pH	10.5
Water to make	1.0 liter
Colloidal silver (Carey Lea Silver)	0.2 g
Natrosol (hydroxyethylcellulose) (Hercules, Inc.)	0.2 g

This thickened solution was applied to the surface of a silver bromoiodide emulsion layer and allowed to stand 10 min at 70°F before being washed away. The effective speed of the film was maintained, with the image contrast, granularity, and acutance being as satisfactory as those obtained by developing the film in Kodak developer D-76.

Marilyn Levy[78] prepared monobaths thickened with sodium polyacrylate. Polyvinylpyrrolidone, in concentrations of from 5 to 15 g/liter of the mono-bath, did not dissolve in the solution but was suspended as microscopic droplets. These droplets kept the depositing silver in transparent colloidal

suspension, thus preventing any silvering from the solution, even at temperatures of 130°F.

Prevention of silver sludging from used thiosulfate monobaths has been sought by many in the form of a single chemical antisludging agent to be added to the solution. Such an antisilvering compound should form a silver compound with the silver ions as they are released from the silver thiosulfate complex or poison nuclei so as to inhibit their activity as sites for physical development. The silver compound formed by the antisilvering addendum should bind silver ions more strongly than the silver held by thiosulfate. This silver compound should not be reduced to metallic silver by the action of developing agents, even in strongly alkaline solution. An obvious antisilvering compound would be potassium cyanide, as the cyanide ion attracts and holds silver ions tenaciously. Unfortunately, potassium cyanide is too poisonous to be considered.

Many antisludgants form silver salts of low solubility. The silver salt, however, must be soluble, because a silver salt of low solubility will precipitate from solution just as does metallic silver. Mercapto-containing compounds, particularly those with groups that give the compound good solubility in alkaline solution, have proven to be effective in delaying the deposition of silver from the solution of used thiosulfate monobaths. As little as 50 mg of a 2-mercapto-1,3,4-thiadiazole derivative in a liter of solution was found by A. von König and R. Pfeiffenschneider[79] to be sufficient to maintain a solution free of silver staining even after considerable use of the solution. Other heterocyclic mercapto compounds were patented by J. R. King and J. R. Moran[80] as antisilvering compounds for monobath processing of silver chloride photographic paper used for document copying. Suitable compounds included 1-phenyl-5-mercaptotetrazole and various 2-mercapto-1,3,4-oxadiazoles and 2-mercapto-1,3,4-thiadiazoles. The following monobath composition (pH = 10.2) is from the King and Moran patent:

4-Methyl-1-phenyl-3-pyrazolidone	4.0 g
Hydroquinone	12.0 g
Sodium sulfite, desiccated	70.0 g
Sodium hydroxide	3.0 g
Sodium metaborate, octahydrate	40.0 g
Sodium thiosulfate, crystalline	100.0 g
1-Phenyl-5-mercaptotetrazole	0.2 g
Water to make	1.0 liter

When each of 20 sheets of exposed silver chloride document-copying photographic paper, 8 × 11½ in., was processed for 10 sec at room temperature in the monobath, no silver sludge appeared for a period longer than 24 hr. When the same test was made with the 1-phenyl-5-mercaptotetrazole not present in the solution, a heavy gray to black precipitate formed within 1 hr. Image characteristics produced by the antisilvering monobath were equal or better than those produced by the monobath without the mercaptotetrazole. King and Moran found another advantage:

In commercial processing, it has frequently been found that useful capacity of separate developers and fixers seldom exceeds 10,000 square inches per gallon of either developer or fixer. Contrasted with the foregoing, we have found that the useful tray capacity of the monobath compositions of our invention is extended to 70,000 square inches of paper per gallon for a period exceeding two weeks. This increased processing capacity is realized without deleterious changes in photographic quality during this period. The normal reduction in developing activity due to aerial oxidation and exhaustion is counter balanced in our system by withholding a part of the thiosulfate content in the form of silver thiosulfate complex. When the complex is eventually destroyed, re-entry of the thiosulfate causes severe degradation of the developed image. This effect does not occur when processed with our novel monobath composition.

The organic mercapto compounds that are effective for paper-processing solutions have limited use for film processing. Of the compounds mentioned so far, 1-phenyl-5-mercaptotetrazole is probably the most useful, because monobaths containing this compound exhibit a delay in silvering. Unfortunately, this mercaptotetrazole is a powerful antifoggant, and only limited quantities can be used without causing serious losses in image density and emulsion speed. The selection of an antisilvering compound to delay sludging involves a critical combination of minimum antifogging properties, good solubility of silver compounds, and strong adsorption to nuclei to inhibit their growth.

o-Mercaptobenzoic acid, often called thiosalicyclic acid, has been patented by Grant M. Haist and David A. Pupo[81] for use in thiosulfate monobaths designed for high-speed negative films. Quantities from 1 to 10 g of *o*-mercaptobenzoic acid were claimed to be effective against silvering, although only 0.3 g of the compound per liter reduced fog of the image without depressing the densities of higher exposure. At a level of 3 g/liter, the compound did reduce slightly the image density and emulsion speed. To overcome this restraint, a more active monobath would have to be compounded with the *o*-mercaptobenzoic acid as an integral component and not added just as an afterthought to an existing thiosulfate monobath. (See Figure 6.)

Later, in French Patent 2,002,685,[82] Grant M. Haist and David A. Pupo indicated that a class of organic mercapto acids, especially with branched chains

Figure 6. The effect of *o*-mercaptobenzoic acid upon the edge of a monobath-processed 2000 μ line. The microdensitometer tracing (left) was made from a line processed in MM-4 monobath (MM-1 with glutaraldehyde bis sodium bisulfite). The tracing at right was made after processing in MM-4 containing *o*-mercaptobenzoic acid. [G. M. Haist and D. A. Pupo, from "The Inhibition of Silvering in Thiosulfate Monobaths," presented at the 28th Annual Conference of the Society of Photographic Scientists and Engineers, Denver, Colorado, May 11–16, 1975. See also *Phot. Sci. and Eng.*, 20: 223 (1976)].

and of fairly low molecular weight, were superior to any antisilvering compounds that had been tested. Effective compounds included thiolactic acid,

$$CH_3-\underset{\underset{H}{\overset{|}{S}}}{CH}-COOH, \text{ and 2-mercaptoisobutyric acid, } HS-\underset{\underset{CH_3}{\overset{CH_3}{|}}}{\overset{|}{C}}-COOH,$$

although related compounds, such as cysteine, $HS-CH_2-\underset{\underset{NH_2}{|}}{CH}-COOH,$

were not without some beneficial effect. Thiosulfate monobaths containing 2-mercaptoisobutyric acid had great resistance to silver sludging, although the baths had to be carefully compounded to overcome the strong anti-physical-developing restraint of the mercapto acid.

Other mercapto compounds, usually acids for use with alkaline thiosulfate monobaths, have been proposed to delay the silvering action of used solutions. Thioctic acid, often referred to as DL-6,8-dithio octanoic acid,

$$\underset{\underset{S-\!\!-\!\!S}{|\quad\quad|}}{H_2C\overset{CH_2}{\diagup}\diagdown CHCH_2CH_2CH_2CH_2COOH}$$

has been patented by Leo D. Corben[83] for delaying the appearance of sludge. Six to twelve times as much photographic film is said to be processable in the presence of the antisludging compound as in the monobath that did not contain the compound. A dimercapto compound, $HCH-CH-CH_2SO_3Na$,

$$\begin{array}{cc} | & | \\ S & S \\ H & H \end{array}$$

dimercaptopropane sulfonate, called Unithiol in Russia, has been patented[84] there for use in monobaths. When used in thiosulfate monobaths, Unithiol was said to enhance the stability of the solution. When the thiosulfate was completely replaced with the sodium dimercapto propane sulfonate, solutions were formed which did not precipitate silver.

L-Thiazolidine-4-carboxylic acid,

$$\begin{array}{c} CH_2 \\ S \diagup \quad \diagdown NH \\ | \qquad\quad | \\ H_2C \rule{1cm}{0.4pt} CH-COOH \end{array}$$

has been claimed as a fixing accelerator[85] and as an antisludging agent that gives prolonged life to thiosulfate monobaths. This compound was added in a 0.4% sodium hydroxide solution. Under these conditions it is possible that the compound may exist as cysteine resulting from ring cleavage, as suggested by the following equilibrium from the work of Sarah Ratner and H. T. Clarke:[86]

$$\begin{array}{c} CH_2 \\ S \diagup \quad \diagdown NH \\ | \qquad\quad | \\ H_2C \rule{0.8cm}{0.4pt} CH-COOH \end{array} \;+\; H_2O \;\rightleftharpoons\; \begin{array}{c} NH_2 \\ | \\ HSCH_2CH-COOH \end{array} \;+\; CH_2O$$

Any compound that is strongly adsorbed to silver, forms soluble silver compounds, and does not repress image formation too seriously, appears to exhibit some antisilvering action. In practice, suitable compounds represent a unique blend of these properties. In thiosulfate monobaths there is insufficient antisilvering compound to react as a primary silver solvent and tie up all the available silver ions in solution. To be effective the antisilvering compound must be strongly adsorbed to the silver and silver sulfide nuclei in the thiosulfate solution. This surface layer acts as a barrier to the deposition of silver by physical development from the used monobath. Complete inhibition of physical development would be the result of a monomolecular layer of the antisilvering compound on the surface of each physical development nucleus.[87]

The development centers on an exposed silver halide grain contain metallic silver and silver sulfide. Other physical-developing nucleating metals, such

as gold, may also be present. The antisilvering compounds are strongly adsorbed to these latent image centers. In addition, the strongly adsorbed compound may form silver salts on the surface of the silver halide crystal. According to R. B. Pontius, R. M. Cole, and R. J. Newmiller,[88] "When used in alkaline solution in sufficient quantity, this substance [1-phenyl-5-mercaptotetrazole] lays down a layer of the silver salt on the silver bromide crystal and ejects the bromide ion into the solution. The grains covered by this layer are nearly impervious to the solvent action of moderate silver halide solvent, hence the material may be termed an 'anti solvent.'" In lesser quantities, the antisilvering compound only covers part of the surface and only reduces the solvent action of the thiosulfate of a monobath.

The adsorption of antisilvering agents on metallic silver of the latent image and the surface of the silver halide crystal slows the rate of development of an exposed crystal. Thus, the effective anti-physical-developing agents used to reduce silver sludging also tend to repress development by typical antifoggant action. The antisilvering compound may also form a silver compound with free silver ions that are present within the body of the solution. If the salt is of sufficient solubility, there will be no detrimental effect. If the salt has low solubility, however, the combination of the silver ion and the antisilvering compound may precipitate, causing a sludge to form. Although this precipitate is different than the normal silver sludge and usually does not adhere as strongly, it is still objectionable. Antisilvering compounds must therefore be chosen to give strong adsorption to physical-developing nuclei but not so strong as to interfere seriously with developing action on the silver halide crystal, and to avoid silver compounds of such low solubility that may promote the deposition of a precipitate from the monobath solution itself.

Sludge and sediment in a used thiosulfate monobath may be restricted according to the U. S. Patent 3,857,710 of Daniel E. Speers, by adding ethylenediamine tetraacetic acid tetrasodium salt to the solution. One example of such a bath contained

Water	1.0 liter
Sodium sulfite, anhydrous	25.0 g
Hydroquinone	13.0 g
Sodium hydroxide	5.0 g
Sodium carbonate, anhydrous	6.0 g
Phenidone	0.5 g
Benzotriazole	0.5 g
Ethylenediamine tetraacetic acid tetrasodium salt	1.5 g
Sodium thiosulfate	110.0 g

With fresh solution the preferred development time was 4 to 5 min at from 25 to 40°C for Kodak Plus-X and Kodak Tri-X film as well as high-contrast copy films. The solution was said to be "resistant to the formation of sludge and sediment."

Silver sludging can be avoided by using a nonthiosulfate fixing agent in a monobath, as already indicated. Such a monobath "which, even after extended use, is substantially free from silver sludge" was claimed in U. S. Patent 3,240,603 by Horst Schüler, Herbert Grabhöfer, and Hans Ulrich. These monobaths contained 2-mercapto-6-hydroxypyrimidine derivatives in quantities from 8 to 20 g/liter of solution.

Modification of the Activity of a Monobath Formulation

The monobath involves a competitive balance between developing-agent velocity and fixing-agent velocity. The relationship between them was summarized by Harry S. Keelan[89] as follows:

If two developing solutions are adjusted to have equal developing activity when used in the conventional manner, they will develop to the same gamma and density when mixed with identical concentrations of hypo to form a monobath. An increase in developer activity with the fixing activity kept constant increases gamma and density. The reverse takes place when fixing activity is increased and developer kept constant. But a simultaneous increase in both developer and fixing activity at equal rates yields the same gamma and density, but increases emulsion speed and shortens processing time. In other words, the more active the developer, the higher is the concentration of hypo required to maintain a given gamma and density, and the greater will be the emulsion speed. This use of more active developers and higher hypo concentrations also gives better exhaustion characteristics.

The most commonly recurrent problem in formulating monobaths is the necessary precision of balance between developing and fixing reactions existing for various emulsion speeds to obtain optimum performance for any particular monobath. This ratio has been found to be a function of both the physical and chemical properties of the emulsion to be processed. For example, variations of emulsion thickness and grain size require different ratios. Silver chloride fixes faster than silver bromide, and even the presence of small amounts of silver iodide has an enormous retarding effect upon the fixing process.

These observations of Keelan are in accord with and are essentially a restatement of the earlier published findings of H. A. Miller and J. I. Crabtree.[32]

The competitive balance between developing and fixing velocity in a monobath controls the contrast and the emulsion speed of the processed image. This writer in his book, *Monobath Manual*, suggested chemical

changes that would allow adjustment of these two photographic properties:[90]

To increase Contrast and Emulsion Speed

1. Make the solution more alkaline.
2. Increase the quantity or use more active developing agents or superadditive combination of agents.
3. If more contrast is needed, increase the quantity of hydroquinone or ascorbic acid present in the solution. If more emulsion speed is required, increase the concentration of Phenidone or Metol in the monobath.
4. Raise the processing temperature, if possible, because the gain in the rate of development is greater than the gain in the rate of fixation with higher temperatures.
5. Reduce the amount of fixing agent present, if possible, although the minimum amount of the fixer must be sufficient to clear the film in the desired time of processing.

To Lower Contrast and Reduce Emulsion Speed

1. Increase the quantity of the fixing compound or utilize more active fixing agents.
2. Lower the alkalinity of the solution, as the developing action will be decreased significantly, but the fixing rate of many compounds will be relatively unchanged.
3. More vigorous agitation increases both the rates of development and fixation, but the clearing rate will be accelerated more than development.

The concentration of the fixing agent is probably the most important factor, with the solution alkalinity rating second, in determining image characteristics in an active monobath. Changing the alkalinity of the monobath solution may be used to adjust the image contrast and emulsion speed. The *Monobath Manual* describes an attempt to use a modern monobath, called MM-1, to process a number of Kodak film products.

Monobath MM-1

Water	750.0 ml
Sodium sulfite, desiccated	50.0 g
Phenidone	4.0 g
Hydroquinone	12.0 g
Sodium hydroxide	4.0 g
Sodium thiosulfate, pentahydrate	110.0 g
Glutataldehyde (25% in water)	8.0 ml
Water to make	1.0 liter

Processing time is 7 min, 75°F. Agitate 5 sec initially, then 5 sec every minute.

This formula was originally made to process Kodak Verichrome pan film to give the same contrast and film speed as when it is processed in D-76 developer for the recommended time. The same formula without the glutaraldehyde has been used to process a dental X-ray film.[91] Changing the pH of the solution was only partially successful for processing other negative films, because, when the image contrast was normal, there was usually a loss in film speed. The main reason that solution alkalinity adjustments cannot be used to balance the developing and fixing actions is the varying composition of modern film products. The kind and the amount of silver halide and the relative proportions of the halides, the crystal size, the emulsion layer thickness, various emulsion addenda, and other factors make it possible to balance a monobath composition for only one photographic product or for only very similar photographic materials. Adjustment of the solution alkalinity is usually insufficient to adapt an otherwise satisfactory monobath for use with another photographic film or paper without serious loss of photographic quality of the image as shown in Table 1.

The developing and fixing actions of a monobath are in direct competition for the silver halide of the emulsion layer. Variation in the concentration of the fixing agent should influence the characteristics of the final silver

Table 1. Effect of Adjustment of Monobath Alkalinity

Film	Size	Addition to 1 liter of monobath	Contrast	Speed
Kodak Verichrome pan	Rolls	None	Same	Same
Kodak Royal-X pan	Rolls	None	Similar	1 Stop loss
Kodak Tri-X pan	Rolls	4 ml Glacial acetic acid	Similar	$\frac{1}{2}$ Stop loss
Kodak Tri-X pan	35mm	1 ml Glacial acetic acid	Higher	$\frac{1}{4}$ Stop loss
Kodak Plus-X pan professional	120–620	3 ml Glacial acetic acid	Similar	$\frac{1}{3}$ Stop gain
Kodak Plus-X pan	35mm	1.5 ml Glacial acetic acid	Same	$\frac{1}{2}$ Stop loss
Kodak Panatomic-X	Rolls	2.5 g Sodium hydroxide	Similar	Same
Kodak Panatomic-X	35mm	2.5 g Sodium hydroxide	Same	$\frac{2}{3}$ Stop loss

image, and this procedure was also tried to influence the results so that one monobath might offer optimum results with more than one photographic material. A two-part stock solution of Monobath MM-2 was compounded, having all of the fixing agent (sodium thiosulfate) in the second solution.

Monobath MM-2

Part I (pH = 10.2)

Phenidone	8 g
Hydroquinone	24 g
Sodium sulfite, anhydrous	100 g
Sodium hydroxide	6 g
Water to make	1 liter

Part II

Sodium thiosulfate pentahydrate	400 g
Water to make	1 liter

In use, the proportions of part I, part II, and water are varied for each photographic film. In this case the films ranged from the lowest-silver, finest-grain Kodak Panatomic-X to the highest-silver, medium-grain Kodak Tri-X pan. The proportions of the monobath solutions and water for each of four films are listed below. Processing was for 8 min, 75°F, with 5-sec agitation every minute. For comparison purposes the four films were developed in Kodak developer D-76 for 8 min, 68°F, using agitation of 5 sec at 30-sec intervals. The D-76 was undiluted except for the 1 : 1 dilution with water for use with the Plus-X film. The working monobath solutions are used only once, then discarded.

	Panatomic-X	Verichrome Pan	Plus-X Pan	Tri-X Pan
Part I	500 ml	500 ml	250 ml	240 ml
Part II	180 ml	255 ml	275 ml	225 ml
Water	320 ml	245 ml	475 ml	535 ml

If film hardening is needed to prevent reticulation, add 8.0 ml of 25% glutaraldehyde to each liter of the working solution of the monobath.

The divided-stock-solution technique can greatly reduce the specificity of monobath processing, although small variations from conventional D-76 processing will exist. Image densities of the four films were similar to those given by the D-76 development, but slight differences (not necessarily detrimental) did exist in the shadow and highlight areas of the silver image. Image silver formed by the monobath treatment was greater than for D-76 development, varying from only slightly more at the higher densities for Panatomic-X to considerably more at all exposures for the Tri-X pan film. Better acutance values were obtained for the monobath-processed films with somewhat higher granularity.

Monobaths that produce the normal emulsion speed of the film often tend to produce increased contrast over conventionally developed images. Contrast control at normal film speed was promised by Monobath FX 6a, a formulation of Geoffrey Crawley that was published in the *British Journal of Photography Annual* for 1964.[92]

Monobath FX 6a

Sodium sulfite (anhydrous)	50 g
Hydroquinone	12 g
Phenidone	1 g
Sodium hydroxide	10 g
Sodium thiosulfate	90 g
Water to make	1 liter

Continuous agitation is recommended for the first 30 sec with 15 to 20 twists of the tank agitator at 1-min intervals. All films will be processed in 6 min, and thin-emulsion films may be completely processed in only 4 min.

Contrast control may be achieved by varying the thiosulfate between 70 and 125 g/liter. With 90 g/liter of sodium thiosulfate, the bath was said to be adjusted to mean contrast. Increasing the thiosulfate content will gradually lower the contrast; decreasing the thiosulfate will increase the image contrast. At the 90-g concentration, a test (reported in the *Monobath Manual*) showed that a 6-min, 68°F, treatment of Panatomic-X film 120 size produced an image contrast very similar to that given by the recommended development of this film in D-76 developer. The film speed, however, was reduced to one-half.

Variation of the fixing agent in a monobath composition is a very useful technique to adapt a given formula for use with more than one photographic material. This variation of the thiosulfate concentration was a feature of a commercial monobath (Simprol, a product of May and Baker, Ltd.).[93]

Because of the wide variability in composition of different film or paper products, however, any simple technique of varying monobath composition usually has failed to provide optimum image quality with each possible photographic film or paper.

Variation of the thiosulfate content of a monobath is an attempt to overcome the single image contrast that is given by a given monobath formulation. At a given temperature, changing the time of processing, or the dilution of the solution, does not appreciably affect the gamma of the processed image. A wider range of image contrast may be secured without sacrificing film speed by changing the concentration of the thiosulfate in the monobath. The effect of such thiosulfate variation has been shown by Marilyn Levy with USASEL monobath 24-2.[44]

The inability of most monobaths to allow an adjustment of contrast without change in effective film speed has limited the use of single-solution processing for those who wish to relate camera exposure to film development (Zone System). Charles D. Gold of Indiana University has compounded a monobath for this purpose.

Monobath SG-4

Solution A

Water (90°F)	600 ml
Sodium sulfite, anhydrous	45 g
Phenidone	4 g
Hydroquinone	3 g
Sodium hydroxide	4 g
Sodium thiosulfate	100 g
Glutaraldehyde (25% in water)	6 to 10 ml*
Water to make	1 liter

Solution B

To each liter of solution A add	
Sodium sulfite, anhydrous	15 g
Hydroquinone	9 g

* If the temperature of the wash water is 60 F or less, use 6 ml of glutaraldehyde; if the water is warmer, use 10 ml per liter.

The two solutions can be combined for three types of development:

- Solution A only is for "compression."
- Solution A (two parts) : solution B (one part) is "normal."
- Solution B only is for "expansion."

Normal development is said to be comparable to normal development in D-76 developer. Normal SG-4 is balanced for Kodak Tri-X 35mm and 120 roll film. Processing in all baths of SG-4 is for 9 min, 75°F, with any normal agitation, followed by a wash in cold tap water for 5 min. After a treatment in a wetting agent for 30 sec, the film is hung to dry without being squeegeed.

SPECIAL PURPOSE MONOBATHS

Monobaths for Rapid Processing

The modern monobath has become part of many systems that are designed for rapid processing. Such systems consist of a special photographic film or paper, the monobath, and a processing machine, all components being carefully designed to give optimum image quality in a minimum amount of time. Christopher Lucas has described[94] and patented[95] a 4-sec monobath for processing Kodak Plus-X reversal film, SO-273, a hardened thin-emulsion film expecially adapted to rapid high-temperature processing. To accomplish the 4-sec, 120°F, processing of this film, Lucas compounded the following monobath:

Thioglycolic acid	50 ml
Potassium hydroxide	145 g
1-Phenyl-3-pyrazolidone	5 g
Hydroquinone	50 g
Potassium arsenite	20 g
Water to make	1.0 liter

This monobath contains toxic materials and should be handled accordingly. The film processed in this solution had an exposure index of 50, a gamma of 0.84, a base-plus-fog density of 0.28, and a resolution of 70 lines per millimeter. No silver plating occurred on the film.

Kodak timing negative film, a thin-emulsion, hardened panchromatic film of ASA Exposure Index 80, was used by L. Corben, A. Shepp, and C.

Bloom[96] in a 5-sec, 140°F, monobath process. A maximum density of 1.97 with a fog of 0.40 was given by monobath RM-79C, which had the following composition:

Hydroquinone	25.0 g
Phenidone	4.0 g
Sodium sulfite, desiccated	35.0 g
Sodium hydroxide	20.0 g
Sodium thiosulfate	200.0 g
L-Thiazolidine-4-carboxylic acid (5% in 0.4% sodium hydroxide)	25.0 g
Water to make	1.0 liter

These same investigators with D. Willoughby[97] also compounded an ultra-rapid monobath for processing Kodak Plus-X reversal film, SO-273, in 2.5 sec at 120°F, yielding emulsion speed and high-contrast resolution values comparable to those given when this film was processed in Kodak developer D-19. This monobath, OM-8, had the following formulation:

Potassium sulfite	20.0 g
Antimony potassium tartrate	40.0 g
Phenidone	3.0 g
Hydroquinone	60.0 g
α-Thioglycerol	150.0 g
Potassium hydroxide to pH 12.65	
Water to make	1.0 liter

The antimony potassium tartrate was added to stabilize the activity of the monobath. No noticeable sludge formation was found during processing with the thioglycerol monobath.

Monobaths of Paper Stabilization

After processing, photographic paper prints may curl objectionably. Such curl may be reduced by means of a monobath formulation disclosed by William J. Cain and Paul E. Crough.[98] In addition to the usual developing agent, silver halide solvent, and alkali, the solution contained sorbitol and diethanolamine to act as solvents for a polyethylene oxide (molecular weight of 400). A monobath suitable for a silver chloride emulsion layer coated on a

photographic paper required 10 sec immersion at 20°C and had the following formula (pH 10.45 ± 0.05):

Water	700 ml
Diaminopropanol tetraacetic acid	1.0 g
Sodium sulfite, desiccated	110.0 g
Sodium hydroxide (vary to obtain pH)	4.5 g
Hydroquinone	18.0 g
1-Phenyl-5-mercaptotetrazole	0.4 g
Sodium thiosulfate pentahydrate	120.0 g
Sorbitol	50.0 g
Diethanolamine	50.0 ml
Polyethylene oxide (mol wt 400)	50.0 ml
Water to make	1.0 liter

Many photographic papers designed for processing without washing contain the developing agent coated within the photographic material. Dorothy Johnson Beavers and James Robert Moran[99] have described such a photographic system:

A photographic paper containing incorporated 3-pyrazolidone developer was prepared as follows:

A fine grain gelatino silver chloride emulsion was coated at 70 mgs. silver per sq. ft. and 0.1 gram gelatin per sq. ft. on a gelatin layer containing 0.017 gram per sq. ft. of 1-phenyl-3-pyrazolidone and 0.3 gram sq. ft. of gelatin. The gelatin layer was coated on a stain-resistant paper adapted to resist hydroquinone stain upon aging. A suitable monobath for processing this paper according to the invention has the following composition (pH 10.45):

Ethylenediamine tetraacetic acid, tetrasodium salt	0.7 g
Sodium metaborate · 8 H₂O	25.0 g
Sodium hydroxide	5.0 g
Sodium sulphite, anhydrous	120.0 g
Hydroquinone	18.0 g
Sodium thiosulphate · 5 H₂O	105.0 g
1-Phenyl-5-mercaptotetrazole	0.4 g
Water to make	1.0 liter

Exhaustion tests using the above paper and monobath solution were carried out by processing at 72°F for 6 sec, 20 prints per day for two weeks. All the test papers were prepared and exposed under identical conditions. Maximum reflection density in the first print obtained was 1.40. At the end of the two-week test the density had fallen only slightly to 1.34.

Direct-print oscillographic recording paper may be processed without washing in a monobath patented by Alan D. O'Neill and Edward A. Sutherns.[100] After the initial exposure and a 1-sec postexposure latensification, the paper was processed for 4 sec in a monobath of the composition

1-Phenyl-3-pyrazolidone	1.0 g
Sodium sulfite, anhydrous	50.0 g
L-Ascorbic acid	20.0 g
Sodium carbonate	35.0 g
Potassium thiocyanate	400.0 g
Alkylene oxide	1.0 g
Water to make	1.0 liter

The alkylene oxide is not specifically identified, but the claims of the patent indicate that it is "a polymeric material having a molecular weight from about 300 to about 6000."

Monobath Producing Silver-and-Dye Images

The presence of the silver halide solvent in a monobath may cause a loss of image density and a decrease in the sensitivity of the photographic material. The use of a self-coupling developing agent has been patented[101] as a means of reinforcing the silver image with a dye image, yielding a brown-black to black image. The gain in image density by the formation of the additional dye image is said to be "far greater than the loss in density and sensitivity observed in the optimum fixing-developing in the absence of self-coupling developing compounds." Specific examples of such compounds are

A suitable monobath formulation for processing X-ray film (98.3% AgBr and 1.7% AgI with a coating weight corresponding to 60 mg of $AgNO_3$ per dm^2) was as follows (pH 12.3):

N-(2'-Hydroxy-5'-aminobenzyl)-3-hydroxyaniline sulfate	20 g
1-Phenyl-3-pyrazolidone	1 g
Sodium metaborate ($4H_2O$)	150 g
Sodium sulfite, anhydrous	50 g
Potassium hydroxide	14 g
Sodium thiosulfate pentahydrate	40 g
Ethylenediamine teraacetic acid, disodium salt	1 g
Potassium bromide	3 g
Thiosalicylic acid	0.1 g
Water to make	1.0 liter

Processed results were compared with those given by a conventional hydroquinone-Phenidone developer of pH of 11.0. The relative sensitivity of the film rose from 1.0 for the conventional development to 1.3 for the monobath-processed film. The monobath gave a maximum density of 2.4 as compared with 1.3 for conventional processing, the gradation remaining the same for both processing methods.

WASHING OF MONOBATH-PROCESSED FILM

Photographic film fixed in alkaline solution is known to wash more quickly than film fixed in an acid fixing bath. Monobaths are usually alkaline and contain ingredients that act as hypo clearing agents. Thus, it is to be expected that monobath-processed film would require only a short wash in water to free the emulsion layer from residual chemicals. According to A. Green and M. G. Rumens,[102] it was necessary to wash monobath-processed films only 40 sec in tap water at 12°C to remove the thiosulfate to the level required for archival permanence. It was found necessary, however, to wash 60 sec at 12°C in order to remove residual hydroquinone to prevent staining. The shortest time of washing of monobath-processed film is the minimum time needed to remove, not the thiosulfate, but rather the staining residual chemicals from the monobath. (See Figure 7.)

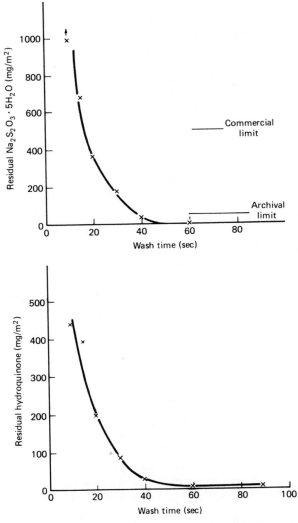

Figure 7. Washing of monobath-processed film in cold tap water (12°C) removes residual thiosulfate to an archival level in 38.5 sec (above), but a 60-sec washing is needed to remove residual hydroquinone to prevent staining (below). [A. Green and M. G. Rumens, *J. Phot. Sci.*, 19: 149–150 (1971)].

REFERENCES

1. W. D. Richmond, "Concurrent Development and Fixation," *Brit. J. Phot.*, **36**: 827 (1889).

2. S. E. Sheppard and C. E. K. Mees, *Investigations on the Theory of the Photographic Process*, Longmans, Green and Co., London, 1907, p. 135.

3. H. D. Murray and D. A. Spencer, "The Addition of Sodium Thiosulphate to Organic Developing Solutions," *Phot. J.*, **77**: 330 (1937).

4. H. W. Vogel and P. Hanneke, "Weiteres über den Ortol-Entwickler," *Phot. Mitt.*, **34**: 267 (1897).

5. Milton B. Punnett, "Simultaneous Developing and Fixing," *Brit. J. Phot.*, **45**: 126 (1898).

6. P. Hannecke, "Developing and Fixing of Bromide of Silver Dry Plates in One Solution," *Anthony's Phot. Bull.*, **30**: 203 (1899).

7. T. Thorne Baker, "Combined Development and Fixing," *Phot. J.*, **44**: 1 (1904).

8. T. Thorne Baker, "On Simultaneous Development and Fixing," *Brit. J. Phot.*, **51**: 128 (1904).

9. R. Raymond, "Le Développement-Fixage," *Photo-Revue.*, No. 39: 99 (1909).

10. V. Crémier, "A Solution for Combined Development and Fixation," *Brit. J. Phot.*, **57**: 358 (1910).

11. E. Valenta, "Über das Entwickeln und Fixieren von Trockenplatten in einer Operation," *Phot. Korr.*, **51**: 347 (1914).

12. Chiri Otsuki and Takashi Sudzuki, "Gleichzeitiges Entwickeln und Fixieren der Bromsilbergelatineplatten," *Phot. Korr.*, **51**: 214 (1914).

13. Chiri Otsuki and Takashi Sudzuki, "Silver Bromide-Gelatin Plates; The Simultaneous Development and Fixation of—," *J. Soc. Chem. Ind.*, **33**: 668 (1914).

14. Chiri Otsuki and Takashi Sudzuki, "Combined Development and Fixing," *Brit. J. Phot.*, **61**: 541 (1914).

15. A. and L. Lumière and A. Seyewetz, "Perfectionnements dans le méthodes de développement et de fixage combinés des images photographiques," *Bull. soc. franc. phot.*, **7**: 234 (1920).

16. L. J. Bunel, "Recherches sur le développement-fixage," *Bull. soc. franc. phot.*, (3) **8**: 193 (1921).

17. L. J. Bunel, "Combined Development and Fixing," *Brit. J. Phot.*, **68**: 359 (1921).

18. A. and L. Lumière and A. Seyewetz, "Improvements in the Simultaneous Development and Fixing of Plates," *Brit. J. Phot.*, **67**: 747 (1920).

19. A. and L. Lumière and A. Seyewetz, "Combined Development and Fixation," *Brit. J. Phot.*, **72**: 44 (1925).

20. Hatsutaro Hashimoto, "Combined Development and Fixation," *Brit. J. Phot.*, **71**: 768 (1924).

21. J. M. Keller, K. Maetzig, and F. Möglich, "Développement et fixage simultanés," *Sci. et Ind. Phot.*, (2) **19**: 68 (1948).

22. Hutson K. Howell, "Progress Report on Monobath—Sensitometric Study," Boston University Optical Research Laboratory Technical Note No. 24, April 1948.

23. Hutson K. Howell, "Sensitometric and Resolution Studies on the Monobath M-52," Boston University Optical Research Laboratory Technical Note No. 39, September 30, 1948.

24. Arthur Fentin, "Photographic Monobath," Boston University Optical Research Laboratory Technical Note No. 23, April 1948.
25. Harry S. Keelan, "Photographic Monobaths for Rapid Processing," Boston University Optical Research Laboratory Technical Note No. 94, January 15, 1953.
26. Harry S. Keelan, "Photographic Monobaths for Rapid Processing, Part II," Boston University Optical Research Laboratory Technical Note No. 126, March 1956.
27. James R. Alburger, "Process of Photographic Development," U. S. Pat. 2,199,903 (1940).
28. James R. Alburger, "RCA Aluminate Developers," *J. SMPE*, **33**: 296 (1939).
29. Harry S. Keelan, "Photographic Monobaths for Rapid Processing," *Phot. Eng.*, **4**: 157 (1953).
30. J. M. Eder, "The Influence of Hypo in the Metol Developer," *Wilson's Phot. Mag.*, **33**: 324 (1896).
31. C. W. Kendall, "Effect of Adding Hypo to Developer," *Am. Phot.*, **41**(4): 15 (1947).
32. H. A. Miller and J. I. Crabtree, "Combined Developing and Fixing Solutions," *Am. Phot.*, **42**: 76 (1948).
33. R. G. Clarke, C. E. Milner, Jr., and J. Gomez-Ibanez, "Some Properties of Monobath Developers," *Phot. Eng.*, **4**: 231 (1953).
34. Roger P. Loveland, cited in C. E. Kenneth Mees, *The Theory of the Photographic Process*, Revised Edition, Macmillan Co., New York, 1954, p. 504.
35. T. H. James and W. Vanselow, "The Rate of Solution of Silver Halide Grains in a Developer," *Phot. Sci. and Tech.*, (2) **2**: 135 (1955).
36. G. M. Haist, J. R. King, and L. H. Bassage, "Organic Silver-Complexing Agents for Photographic Monobaths," *Phot. Sci. and Eng.*, **5**: 198 (1961).
37. Hermann Eggenschwiller and Walther Jaenicke, "Catalytic Activity of Photographically Developed Silver for the Reduction of Silver Complexes," *Z. Electrochem.*, **64**: 391 (1960) (in German).
38. Walther Jaenicke, cited in Margarete Ehrlich, "Characteristics of Dosimeter Films Processed in Phenidone-Thiosulfate Monobaths," *Phot. Sci. and Eng.*, **9**: 9 (1965).
39. A. A. Newman, "Seventy Years of Progress in Photographic Monobaths," *Brit. J. Phot.*, **106**: 44, 66 (1959).
40. J. C. Barnes, "Mechanism of Development in Monobaths Containing Thiosulfate Ion," *Phot. Sci. and Eng.*, **5**: 204 (1961).
41. Margarete Ehrlich, "Characteristics of Dosimeter Films Processed in Phenidone-Thiosulfate Monobaths," *Phot. Sci. and Eng.*, **9**: 1 (1965).
42. Akira Sasai and Nobuo Mii, "Studies on Photographic Monobaths Containing Potassium Thiocyanate," *Phot. Sci. and Eng.*, **8**: 270 (1964).
43. J. C. Barnes, G. J. Johnston, and W. J. Moretti, "The Chemistry of Monobaths: Effect of Thiosulfate Ion upon Image Structure," *Phot. Sci. and Eng.*, **8**: 312 (1964).
44. Marilyn Levy, "Combined Development and Fixation of Photographic Images with Monobaths," *Phot. Sci. and Eng.*, **2**: 136 (1958).
45. V. L. Abritalin and K. K. Markhilevich, "Keeping Quality of Phenidone in Developers in Storage," *Tekh. Kino Tele.*, **10**: 19 (1966) (in Russian).
46. Leslie Frederick Alfred Mason and Abraham Mark Sinclair, "Combined Developer and Fixer Compositions," British Pat. 954,453 (1964).
47. Leslie Frederick Alfred Mason, Brian George Sanderson, and Geoffrey Ernest Ficken, "Photographic 3-Pyrazolidinone Developing Agents," British Pat. 1,039,875 (1966).

48. Grant M. Haist and James R. King, "Combined Photographic Developing and Stabilizing Solution," U. S. Pat. 2,875,048 (1959).

49. Jerome Stewart Goldhammer, "Combined Developer and Fixer," U. S. Pat. 2,782,121 (1957).

50. Jerome Stewart Goldhammer and John Andrew Maurer, Jr., "Combined Developer and Fixer," U. S. Pat. 2,782,120 (1957).

51. John R. Kane and Harry G. Morse, "Fixer Composition," U. S. Pat. 3,582,341 (1971).

52. L. A. Khrapkova and N. S. Spasokukotskii, "Investigation of the Rate of Fixing of Silver Halide Films with Various Solvents," *Zhur. Nauch. Prikl. Foto. Kinemat.*, **12**: 291 (1967) (in Russian).

53. G. M. Haist, J. R. King, A. A. Rasch, and J. I. Crabtree, "Photographic Processing in Metal-Ion–Chelate Systems," *Phot. Eng.*, **7**: 182 (1956).

54. G. M. Haist and J. R. King, "Combined Photographic Developing and Stabilizing Solution," U. S. Pat. 2,875,048 (1959).

55. G. M. Haist, J. R. King, and L. H. Bassage, "Organic Silver-Complexing Agents for Photographic Monobaths," *Phot. Sci. and Eng.*, **5**: 198 (1961).

56. T. H. James and A. Weissberger, "Oxidation Processes. XIII. The Inhibitory Action of Sulfite and Other Compounds in the Autoxidation of Hydroquinone and Its Homologs," *J. Am. Chem. Soc.*, **61**: 442 (1939).

57. J. M. Snell and A. Weissberger, "The Reaction of Thiol Compounds with Quinones," *J. Am. Chem. Soc.*, **61**: 450 (1939).

58. Maxwell Schubert, "The Interaction of Thiols and Quinones," *J. Am. Chem. Soc.*, **69**: 712 (1947).

59. Truman R. McMurtray, "Mercapto-Substituted Hydroquinone Developing Agents," U. S. Pat. 3,542, 554 (1970).

60. Merle L. Dundon, "Photographic Developer with Alkali Substitute," U. S. Pat. 1,925,557 (1933).

61. John Norman Boberg, "Improved Composition or Solution for Use in Developing and Fixing Photographic Films, Plates and the Like," British Pat. 571,389 (1945).

62. Garnet Philip Ham, "Single Solution Photographic Developing and Fixing Bath," U. S. Pat. 2,230,977 (1941).

63. Philip A. Hunt Chemical Corporation, "Processing of Photographic Silver Halide," Brit. Pat. 1,207,583 (1970).

64. Jerome Stewart Goldhammer, "Combined Developers and Fixers," U. S. Pat. 2,901,350 (1959).

65. William J. Tefft, "Photographic Processing Compositions," U. S. Pat. 3,255,008 (1966).

66. Fairchild Camera and Instrument Corporation, "Photographic Process," British Pat. 1,102,392 (1968).

67. F. W. H. Mueller, "Additives which Influence the Physical Properties of the Emulsion Layers," *Photographic Theory*, A. Hautot, editor, Focal Press, London, 1963, p. 69.

68. D. H. O. John and G. T. J. Field, "The Developer Controlled," *Photographic Chemistry*, Reinhold Publishing Corp., New York, 1963, p. 121.

69. C. F. H. Allen and D. M. Burness, "Improvements in Hardening Gelatin," British Pat. 825,544 (1959).

70. Robert Joshua King, "Combined Developer and Fixer," U. S. Pat. 2,397,016 (1946).

71. William M. Drumm, "A Sensitometric Study of Film and Rapid Processing Solution Combinations," *Phot. Sci. and Eng.*, 1: 147 (1958).

72. Carl Orlando, "Projection of Photographic Data Recording Two-Tenths Second after Exposure," *Phot. Sci. and Eng.*, 2: 142 (1958).

73. Wilbert Jeptha Humphlett, Grant Milford Haist, and James Reber King, "Thiosugar Silver Halide Solubilizing Agents," British Pat. 1,063,777 (1967).

74. Edgar D. Seymour, "A Continuous Rapid-Processing System for Side-Looking Radar Mapping," *Phot. Sci. and Eng.*, 2: 91 (1958).

75. Harry S. Keelan and Warren B. Sievers, "The Simultaneous Developing and Fixing of X-ray Film," *SPSE News*, 7 (4): 6 (1964).

76. John Carleton Barnes and Gerald John Johnston, "Photographic Processing Solutions," British Pat. 1,066,993 (1967).

77. John C. Barnes and Gerald J. Johnston, "Viscous Silver Halide Photographic Monobath Solutions," U. S. Pat. 3,392,019 (1968).

78. Marilyn Levy, "Monobaths Containing Sodium Polyacrylate and Polyvinyl-Pyrrolidone," U. S. Pat. 3,167,429 (1965).

79. Anita von König and Raymond Pfeiffenschneider, "A Process for Preventing Darkening and Precipitates in Photographic Developers," British Pat. 940,169 (1963).

80. James R. King and James R. Moran, "Method and Composition for Inhibiting Silver Sludge in Thiosulfate Monobaths," U. S. Pat. 3,173,789 (1965); "Photographic Monobath Compositions," British Pat. 1,030,442 (1966).

81. Grant M. Haist and David A. Pupo, "Bain unique de développement et de fixage stabilisé contre la formation de boues," French Pat. 1,497,980 (1967); "Photographic Processing Solutions," Canada Pat. 802,144 (1968); "Processing Photographic Materials," British Pat. 1,144,481 (1969).

82. Grant Milford Haist and David Alan Pupo, "Nouveaux bains de traitement photographique présentant une bonne stabilité," French Pat. 2,002,685 (1969).

83. Leo D. Corben, "Photographic Monobaths Containing a DL 6-8 Dithio-Octanoic Acid Antisludging Agent," U. S. Pat. 3,318,701 (1967).

84. T. N. Gerasimova, A. B. Bromberg, N. S. Spasokukotskii, T. N. Baykalova, and B. B. Berkengeyn, "A Method of Enhancing the Stability of Developing and Fixing Solutions," Russia Pat. 203,481 (1967) (in Russian).

85. L. Corben, A. Shepp, and C. Bloom, "Very Rapid Monobath Processing," *J. Phot. Sci.*, 13: 233 (1965).

86. Sarah Ratner and H. T. Clarke, "The Action of Formaldehyde Upon Cysteine," *J. Am. Chem. Soc.*, 59: 200 (1937).

87. Thomas R. Thompson, "Action of Organic Stabilizers on a Photographic Emulsion," *Phot. Sci. and Eng.*, 3: 272 (1959).

88. R. B. Pontius, R. M. Cole, and R. J. Newmiller, "Comparison of Development Kinetics of a *p*-Phenylenediamine-Type Developer and a Metol-Hydroquinone Developer," *Phot. Sci. and Eng.*, 4: 23 (1960).

89. Harry S. Keelan, "The Simultaneous Developing and Fixing of Photographic Emulsions," *J. Phot. Sci.*, 5: 144 (1957).

90. Grant Haist, *Monobath Manual*, Morgan and Morgan, Hastings-on-Hudson, New York, 1966, p. 46.

91. Raphael Escoe and Dorcas Escoe, "Chairside X-ray Processing in Broad Daylight," *New York State Dental Journal*, **33**: 207 (1967).

92. Geoffrey Crawley, *Brit. J. Phot. Annual—1964*, Henry Greenwood and Co., Ltd., London, 1964, p. 249.

93. Geoffrey W. Crawley, "May and Baker Simprol—A Variable Contrast Monobath," *Brit. J. Phot.*, **110**: 135 (1963).

94. Christopher Lucas, "A Four Second Monobath," *Phot. Sci. and Eng.*, **10**: 259 (1966).

95. Christopher Lucas, "Monobaths for Photographic Processing," U. S. Pat. 3,512,980 (1970).

96. L. Corben, A. Shepp, and C. Bloom, "Very Rapid Monobath Processing," *J. Phot. Sci.*, **13**: 233 (1965).

97. L. Corben, C. Bloom, D. Willoughby, and A. Shepp, "Ultra-Rapid Monobath Processing," *J. Phot. Sci.*, **14**: 297 (1966).

98. William J. Cain and Paul E. Crough, "Photographic Monobaths," U. S. Pat. 3,684,512 (1972).

99. Dorothy Johnson Beavers and James Robert Moran, "Photographic Monobath Processing of Silver Halide Emulsions," British Pat. 1,063,844 (1967).

100. Alan D. O'Neill and Edward A. Sutherns, "Photographic Compositions and Processes for Stabilizing or Developing Silver Halide Image Records," Canadian Pat. 904,645 (1972).

101. E. I. du Pont de Nemours, "Photographic Silver Halide Fixer-Developer Solution," British Pat. 1,273,081 (1972).

102. A. Green and M. G. Rumens, "Washing Monobathed Film," *J. Phot. Sci.*, **19**: 149 (1971).

Chapter 5

Stabilization Processing

*By eliminating the normal processing operations
of fixing and washing and, after development,
treating the films or prints in a so-called
"stabilizer," images of reasonable permanence
to heat, light, and moisture can be obtained
with a minimum of effort and equipment.*

HAROLD D. RUSSELL[51]

Conventional photographic processing consists of five separate operations: (1) development, (2) stopping development, (3) fixation, (4) washing, and (5) drying. Normal darkroom procedure for making a photographic print requires a 90-sec development, a 30-sec stop-bath treatment, a 10-min fixation, and (4) a 1-hr washing. This wet-processing cycle consumes 72 min, of which 70 min (97%) is required for fixing and washing; the drying period adds considerable extra time. When properly carried out, although it is lengthy, wet photographic processing produces a photographic image of a permanent nature.

Photographic film records may be produced in as little as 15 sec from reception of information to projection, but hot processing solutions must be applied with elaborate automated equipment.[1] The processing equipment may be greatly simplified if only a developing solution is applied to a photographic paper, which is then heated.[2-4] A drum heated to about 110°C is sufficient to dry the paper in 15 sec so that it may be handled in the light.

A developer of the following composition was said to be the most satisfactory for this purpose.[5] The Datarite Processor of Consolidated Electro-

HD-2

Elon	15 g
Sodium sulfite, anhydrous	25 g
Trisodium phosphate hydrate	40 g
Kodak anti-fog powder	5 g
Teepol*	20 ml
Water to make	1 liter

* Mixture of the sodium salts of sulfated fatty acids, manufactured by Shell Chemical Co.

dynamics Corp. was an adaptation of the develop-out system.[6] About 0.0002 in. of developing solution was spread on a recording paper, which was then contacted with a hot platen at about 250°F. Development took place in 50 to 100 msec. Heat-dried developed images are not completely stable, of course, especially if wetted, but have a useful temporary life.

For some applications a temporary photographic image is sufficient. Rapid access to the image is more important than its long life. For these requirements a special form of rapid processing has been devised that shortens the processing time, particularly by the elimination of the long washing period. This type of production of nonpermanent photographic images is called stabilization processing. The photographic image has been made temporarily more resistant to change by light, heat, or humidity.[7] The stabilizing agents, often the same as the silver complexing compounds used in fixing baths, should not be confused with the stabilizers that are added to the emulsion during manufacture to minimize fog and lengthen the useful lifetime of the light-sensitive material.

Stabilization processing shortens the processing time by saving time during each part of the operation. (See Table 1.) One, two, or three solutions may be used during the wet cycle. Development can be shortened and simplified considerably by the inclusion of a developing agent in the light-sensitive material, requiring only an alkaline solution to form the image. The stop bath is often eliminated. The stabilizing bath that inactivates the unexposed, undeveloped silver salts in the emulsion layer contains quick-acting silver complexing compounds that are largely unaffected by the carryover from the alkaline activator. The light-sensitive film or paper is highly hardened, so no slow-acting hardening compounds, which might be sensitive to pH change, are needed in the stabilizing solution.

Table 1. Comparison of Conventional and Stabilization Processing

Conventional Processing			Stabilization Processing		
	Silver Halide			Silver Halide	
Step of Process	Exposed	Unexposed	Step of Process	Exposed	Unexposed
Develop	Silver image	Silver halide	Activate	Silver image	Silver halide
Stop	Silver image	Silver halide			
(developer neutralized)					
Fixing	Silver image	Silver halide solubilized			
Wash	Silver image	Unused silver halide washed out	Stabilize	Silver image	Inactivated silver halide and residual chemicals
Image Stability			Image Stability		
Can be archival			Limited Can be improved by conventional fixing and washing		

The brief solution treatment of stabilization processing is often carried out in an automatic but simple processing machine which insures that the photographic material does not get very wet.[8-9] In some cases the stabilizing solution is applied only to the emulsion side, and not at all to the paper base, to limit the absorption of liquid by the paper fibers. The controlled application of a limited amount of solution, and the use of squeegee rollers at the end of the processing cycle, provides an almost-dry stabilized image. This moist print does not need to be dried but is usable immediately.

Because stabilized photographic film or paper has not been washed, the photographic material still contains most of the silver from the undeveloped silver salts as well as retained developing agents and the chemical con-

stituents of the stabilizing bath. These excess developing and stabilizing agents have a detrimental effect upon the photographic image. Under the continued effect of heat, light, and humidity, or destructive atmospheric gases, the silver image may change tone from a black to a brown, or even fade completely. The background may turn brown, especially under conditions of high humidity. Yet, stabilized images have a remarkably long useful life. This writer has a stabilized paper print, now over 20 years old, that has retained its legibility, although the background has colored.

By eliminating the washing and drying stages of conventional processing, the stabilization technique achieves a considerable shortening of the time before the photographic image can be viewed. Conservation of water supplies has promoted the use of "no wash" processing. The primary value of stabilization processing, however, remains in its shortening of the time before the image may be interpreted. Since World War II, rapid-access processing has been urgently needed to reveal photorecorded data for industrial, military, and scientific applications. In addition, there are many uses in advertising, document reproduction, newspaper, and a multitude of other applications, where rapid viewing is more important than the permanence of the image.[10] As a result of these needs, stabilization processing of photographic materials has had a widespread gain in usage in very recent years. The future goal is to provide an image without the use of solutions, as a rapid dry process would extend the usefulness of stabilized images to other areas where solutions are now objectionable.

CHEMICAL AGENTS FOR STABILIZATION PROCESSING

The conventional developing agents, especially those with low staining properties normally used for developing solutions, are also used for stabilization processing. When a three-solution stabilization process is used, the first bath is a rapid-acting developing solution. In a two-solution process, the first bath may only be an alkaline solution for activating the developing agents contained within the light-sensitive material.[11] Such incorporated-developer films or papers may allow different developing characteristics in the same activator, provided the activating solution does not become contaminated with the developing agents diffusing from the emulsion layers. Incorporated developing agents in the photosensitive material may also be activated in a single-solution alkaline fixing activator—called a fixavator—without subsequent washing. Conventional photographic films and papers may be processed in a monobath containing both the developing and stabilizing compounds. Catechol, surprisingly, has been patented for use in a monobath for stabilization.[12]

Simple alkaline solutions are usually sufficient for causing image development in stabilization systems. Arginine has been patented[13] as a development accelerator in an activator for a silver chlorobromide emulsion that contained catechol and 1-phenyl-3-pyrazolidone as developing agents:

Sodium hydroxide	58 g
Sodium sulfite, anhydrous	23 g
Potassium bromide	0.4 g
Arginine (20% solution)	10.0 ml
Water to make	1.0 liter

Heterocyclic triazole compounds have also been added to the activator, as these compounds are more soluble in the alkaline solution than in the emulsion layer or the acidic stabilizing solution.[14] They are said to increase the stability of the silver image upon prolonged storage.

Because the processing chemicals are retained in the photographic material, the choice of suitable developing and stabilizing compounds is critical if the stabilized image is to have a useful life of any duration. The choice of developing agents does not appear to be as limited as the choice of stabilizing compounds. Sulfur-containing compounds, such as those present in fixing baths, usually must be used as stabilizing agents, yet these same compounds have been shown to limit the life of a photographic image. Even thorough washing may not insure permanence of a conventionally processed image. Thus, the selection of silver inactivating compounds for use without the washing step has been the subject of intensive investigation in order to give the best possible image stability.

The fading of the very early photographic negatives and prints indicates that a form of stabilization processing was practiced, unintentionally, since the beginning of photography. The first publication concerning unwashed photographic images is generally credited to A. Bogisch,[15,16] who, in 1893, was studying an acidic thiourea fixing solution. He noted that thiourea at a concentration of 10 g/liter of water acidified with 10 g of citric acid caused a precipitation of a silver compound that was not completely removed from the emulsion layer by washing. If the emulsion layer was made alkaline, the silver thiourea compound, composed of two thiourea molecules to one silver chloride, decomposed into silver sulfide, causing the image to turn brown. Bogisch found that "If it [the precipitated silver thiourea compound] is exposed to direct sunlight, the layer does not change within a few days; but, after several weeks, depending on the circumstances, spot formation and the browning of the whole plate takes place, a proof of the fact that the silver compound is not as insensitive to light as has been assumed."

This study of Bogisch was concerned with fixing with acidic thiourea solutions. Apparently, he never recognized the potential practical significance that "no wash" processing might offer. Nathan Sulzberger[17] in 1920 suggested that silver chloride photographic paper need only be treated after development in a 15% solution of potassium ferricyanide before drying. Ammonium chloropallidate was used for X-ray negatives. According to Sulzberger's U. S. Patent 1,361,352,[18] "The fixing of the print or the like may be accomplished in cases with a solution containing as little as even one part of palladium-ammonium proto-chloride in five hundred parts of water." Not until just after World War II did the demands for rapid viewing of a photographic record cause serious consideration of a less-than-permanent image in order to minimize the time and effort of photographic processing. Fixation without washing, to make the unexposed and undeveloped silver halides relatively inert to heat, light, humidity, and atmospheric gases, was defined as "stabilization" by H. D. Russell, E. C. Yackel, and J. S. Bruce in 1950.[19] These investigators did extensive work on the selection of suitable stabilizers for unwashed photographic images.

The chemical—that is, the stabilizing agent—that reacts with the unused silver halides should, ideally,

1. be stable in the alkaline or acid processing solution,
2. be odorless, nontoxic, nondeliquescent, noncorrosive, and low in cost,
3. react rapidly with all the silver halides of the emulsion layer, but not the gelatin,
4. form a colorless compound with silver ions, preferably transparent so film products may be treated,
5. form a compound with silver ions that is resistant to change, especially in hot, humid conditions or in the presence of gases such as hydrogen sulfide,
6. and have a minimum reactivity with the metallic silver of the photographic image.

The effectiveness of the stabilizing agent, according to Russell, Yackel, and Bruce, may be tested by subjecting the stabilized image to storage for one to four weeks at 90% humidity and 100°F; by exposure to sunlight, daylight, or arc light for several hours or weeks; and by storage in an atmosphere of hydrogen sulfide at 70°F and 95% relative humidity using one part of the sulfide gas in 500 parts of air. How well the stabilized material resists the bleaching and toning of the silver image or the coloring of the background is a measure of how well the stabilizing agent approaches the ideal properties for such a compound. No compound, unfortunately, has yet satisfied all the requirements.

Stabilizing agents have been classified by Russell et al.[19] and others,[20,21] into two types: silver complexes formed by Type I compounds are soluble and those formed by Type II are not. The thiosulfates, thiocyanates, thiosemicarbazides, and thiourea were listed as examples of Type I; thiohydroquinone, thioglycolic acid, and thiosalicylic acid were examples of Type II. Such an arbitrary classification is much too simplified. The concentration of the stabilizing agent and the pH of the stabilizing bath determine in many cases if the silver compound formed will be soluble or insoluble. A stabilizing agent such as sodium thiosulfate produces silver complexes that are soluble in both acid or alkaline solution, provided the thiosulfate is present in sufficient concentration.

Mercaptoacetic acid (thioglycolic acid) gave soluble silver compounds in alkaline solution, clearing Kodak fine-grain positive film in 65 sec at 70°F in a solution at pH 10.5 and requiring only 43 sec at 70°F when the solution pH was 12.0. The film was not cleared at a solution pH of 6.5, indicating a low solubility of the silver mercaptide in acid solution. A generalization that organic compounds with —SH groups fail to yield soluble silver compounds must not be made, however. An organic mercapto compound with a suitable solubilizing group, such as —NH$_2$, may actually clear film in acid faster than in alkaline solution. For example, 2-diethylaminoethanethiol hydrochloride causes film to clear in 24 sec in a solution at 70°F and a pH of 6.5 but requires 34 sec at 70°F when the solution pH is 10.5. These clearing times for acidic and alkaline conditions were taken from a publication by G. M. Haist, J. R. King, and L. H. Bassage.[22]

As good a general characterization of stabilizing agents as probably is possible was contained in a 1949 British patent,[23] which is quoted here:

Stabilizing agents which may be employed are organic compounds containing double-bonded sulphur or an —SH linkage, and include alkali metal and ammonium thiosulphates and thiocyanates, thioureas, and thioglycollic acid. Compounds containing a quaternary nitrogen atom, such as α-picolinium-β-phenylethobromide, may also be employed. These agents are generally used in lower concentration than they would be in normal fixing procedures, where the emulsion is washed after fixing.

Specific stabilizing agents which may be used, together with the useful concentrations (by weight) in aqueous solution, are as follows:

Potassium thiocyanate	10%
Ammonium thiocyanate	5%
Sodium thiosulphate (crystalline)	10%
Potassium thiosulphate	10%
Ammonium thiosulphate	10%
Thiourea	2%

Ethylene thiourea	2%
Propylene thiourea	2%
Thioglycollic acid (sodium salt)	10%
α-Picolinium-β-phenylethobromide	10%

Other stabilizing compounds which may be used in various concentrations are the following:

Thiobarbituric acid

Ammonium dithiocarbamate

2-Mercapto-4-methyl-5-nitrothiazole

2-Mercapto-4-methyl-thiazole

Dithiobiurea

4-Aminomethyl-2-mercapto imidazole

5-Amino-2-mercapto-1,3,4-thiodiazole

2-Mercapto-5-amino-benzimidazole

6-Amino-2-thio-4-hydroxy-pyrimidine

Dithiooxamide

Thiotrimethyl acetamide

Cysteine hydrochloride

Thioacetamide

Thiopropionamide

Thioglycollic hydrazide

The concentrations given above are based on a treatment or immersion time of about 30 seconds. Lower concentrations might be used with longer application or immersion times. The upper limit of concentration is defined by the solubility of the reagent and the general tendency toward crystallization in the photographic material when very high concentrations are used.

The time of treatment will vary with the nature of the film (that is, the grain size and chemical composition), the temperature of treatment and the manner of application of the stabilizing solution. The time necessary for the application of a given stabilizing solution may be readily judged by inspection of the emulsion layer. It is necessary that the silver halide shall have disappeared from the emulsion and the disappearance of the halide, which indicates the formation of a complex with the stabilizing compound, may be determined by inspection of the emulsion layer. When the silver halide has just disappeared from the emulsion, stabilization is complete.

The thiosulphates and thioureas are used in acid solution, the thioglycollic acid in alkaline solution, and the thiocyanates in either acid or alkaline solution.

Development and stabilization can occur simultaneously in a single bath. For such monobath use, mercaptopyridines and mercaptopyrimidines have

been proposed[24] for the stabilizing agents. Examples of suitable compounds are

4-amino-6-hydroxy-2-
mercaptopyrimidine

6-amino-4-hydroxy-2-
mercaptopyrimidine

4-amino-6-hydroxy-2-
mercaptopyridine

For combined photographic developing-and-stabilizing solutions, Grant Haist and James R. King[25] proposed the following sulfur compounds:

monothioglycerol

thioglycol

β-mercaptoethylamine

N,N-diethyl-β-mercaptoethylamine

2-thiobarbituric acid

Sulfur compounds that have a low molecular weight often have a distinct odor, are toxic, or have other objectionable properties. U. S. patent 3,220,838[26] stated that "thiosugars do not have the strong characteristic odors which characterize many of the conventional sulfur-containing fixing agents, such as thioglycerol, mercaptoacetic acid, diethylaminoethanethiol

and others." The 2-oxazolidinethione derivatives of various sugars were used in concentrations of at least 3 g/liter in alkaline processing solutions.

The number of silver halide complexing agents capable of use for stabilization processing is very great. Only a few of the more common—and inexpensive—compounds have actually been of practical importance. Thiocyanates, thiosulfates, and thioureas have been those of greatest usage. Certain organic sulfur compounds may offer potential advantages over these three classes of compounds but other factors, such as cost or toxicity, may limit their future use.

Thiourea Stabilizing Solutions

Thiourea was the first silver complexing agent to be used for "no wash" photographic processing. This first use is generally credited to A. Bogisch in 1893, but in his review of the chemistry of stabilization processing A. A. Newman[27] points out that J. Volhard[28] in 1874 may have a claim to this distinction. Thiourea had been used by J. Waterhouse[29,30] in 1890 in a developer to form a positive image in the low-exposure areas of a photographic plate. In acid developing solutions and acid fixing baths the developing and fixing actions are accelerated, owing apparently to the lowering of the negative charge barrier.[31-36] Negatively charged ions can then more easily approach the surface of the silver halide crystal. A good review of the many applications of thiourea in photographic processes has been given by V. N. Sintsov[37] with particular reference to the use of thiourea for stabilizing photographic films and papers.

Thiourea is particularly useful for rapid stabilization processing. One or two molecules of thiourea combine with a single molecule of silver bromide or silver iodide, but only two or five molecules of thiourea combine with a single molecule of silver chloride.[38] The silver thioureas are transparent or white, with their solubility in water increasing as the thiourea content increases. Thiourea is believed to be adsorbed irreversibly on the surface of a

silver bromide crystal, forming first $AgBr \cdot NH_2C\overset{\displaystyle S}{\overset{\|}{-}}NH_2$, which is then

converted to $AgBr \cdot 2(NH_2C\overset{\displaystyle S}{\overset{\|}{-}}NH_2)$. Initially, upon adsorption, the $=S$ of the thiourea is converted to the $-SH$ form:

$$
\begin{array}{ccc}
NH_2 & & NH \\
| & & \| \\
C{=}S & \longrightarrow & C{-}SH \\
| & & | \\
NH_2 & & NH_2
\end{array}
$$

In the presence of a silver ion the guanyl mercaptide reacts to form the $1:1$ silver thiourea compound:

$$
\begin{array}{ccc}
\overset{\displaystyle NH}{\underset{\displaystyle \|}{}} & & \overset{\displaystyle NH}{\underset{\displaystyle \|}{}} \\
C-S-H + Ag^+ & \longrightarrow & C-S-Ag \\
| & & | \\
NH_2 & & NH_2
\end{array}
$$

In the presence of another silver ion and hydroxyl ions from an alkaline environment, the silver thiourea compound will decompose to form silver sulfide:

$$
\begin{array}{c}
NH \\
\| \\
C-S-Ag \xrightarrow[OH^-]{Ag^+} Ag_2S + H_2N-C\equiv N + HOH \\
| \\
NH_2
\end{array}
$$

Thiourea-silver compounds should not be subjected to any alkaline environment, such as given by contamination of the stabilizing solution by carryover from the developing solution. If excess thiourea from stabilized images contacts normally processed emulsion layers, dark stains may form on the otherwise stable washed prints. Attempting to wash a stabilized image removes the excess thiourea present and may precipitate a quantity of the silver compound in the gelatin. This poorly soluble silver compound will then decompose readily in the presence of light and moisture, producing a discoloration that may obscure the image.

The instability of the silver thiourea compound can be decreased by measures to minimize the availability of silver ions. The concentration of the thiourea may be increased or an antifoggant used to tie up the silver ions. The increase in thiourea also decreases the concentration of the unstable $1:1$ thiourea-silver ion, the starting point for the formation of silver sulfide, by forming ions which contain more than one thiourea per silver ion.

In alkaline solution the hydroxyl ion (OH^-) strips a hydrogen ion (H^+)

from $\quad \begin{array}{c} HN \\ \diagdown \\ \diagup \\ H_2N \end{array} C-S-Ag$ to start the formation of silver sulfide, with water

and cyanamide as the other products. Substitution of electron-donating groups, such as methyl, on thiourea should minimize the H^+ release and make the thiourea-silver compound less susceptible to the presence of hydroxyl ions from alkaline contamination of the stabilizing bath. The stability of the silver complexes of a number of thiourea derivatives was determined by Rolf Bruenner.[39] The stability of the silver complexes increased with the increasing number of methyl groups attached to the nitrogen

atoms. Substitution of the nitrogen with alkyl groups did indeed increase the stability of the thiourea-silver complex, but the stabilizing time was increased. The silver complex of ethylene thiourea was stable in alkaline solution and nearly without effect upon images on photographic paper. The image silver was bleached more rapidly, however, by the ethylene thiourea than by the unsubstituted thiourea.

Thiourea Stabilization Systems

Because the thiourea-silver complexes may break down to silver sulfide above pH 7, the stabilizing solution must be acidic. A developer of low alkalinity, such as one with Amidol, would minimize the problem of the carryover of the alkaline solution. Thiourea tends to soften the gelatin of the emulsion layer, so that an acid bath containing a hardening compound often follows the developing solution. Photographic films or papers that have been highly hardened in manufacture have been suggested by most investigators of thiourea stabilization.

A three-solution thiourea stabilization process has been described[40] and patented[41] by Steven Levinos and Willard C. Burner.

Solution 1

Developer for Film and Waterproof Paper

Sodium carboxymethyl cellulose, medium viscosity	1.0 g
Ammonium sulfite	75.0 g
Amidol	6.8 g
Ammonium bromide	2.0 g
Water to make	1.0 liter

Wet sodium carboxymethyl cellulose with 10 ml methyl alcohol, then add to the solution while stirring rapidly. Development time (at 68°F): sheet film, 3 min; roll film, $2\frac{3}{4}$ min; paper, 1 to $1\frac{1}{2}$ min.

Solution 2

Film: Stop Hardener

Chromium ammonium sulfate	30.0 g
Water to make	1.0 liter
Time, 68°F	1 to 2 min

Waterproof Paper: Stop Bath

Sodium bisulfite	30.0 g
Water to make	1.0 liter
Time, 68°F	1 to 3 min

Solution 3: Stabilizing Bath

	Film	Waterproof Paper
Thiourea	30 g	15 g
Glycerine	20 g	20 g
Water to make	1 liter	1 liter
Time, 68°F	2 to 3 min	2 min

The developer is a pH 7.0 Amidol solution that yields development similar to that of Kodak Microdol developer. Ammonium sulfite, instead of the usual sodium sulfite, and the viscosity-enhancing carboxymethyl cellulose help to increase the resistance of the developing solution against aerial oxidation. The chromium ammonium sulfate hardener is necessary for film products, requiring the 2-min treatment when high humidities are encountered. The simple sodium bisulfite stop bath is adequate for hardened photographic papers. The concentration of thiourea (1.5%) in the paper stabilizing bath is just half that needed for a film stabilizing solution. The amount of glycerine is that recommended for cold weather use and should be reduced in the print stabilizing bath when humid conditions prevail. Sea water may be used to prepare the processing solutions for stabilization.[42] Constant and uniform agitation is required for all steps of the processing. Photographic films will not be transparent when removed from the stabilizing bath but will become transparent during drying. Films and papers should be squeegeed before drying to avoid surface crystallization of the chemicals in the emulsion layer. Perforated films must be wiped along the perforation on the base side, using a slightly moistened wad of cotton to absorb the chemicals still trapped in the perforations. The stabilized images should not be rinsed in water after thiourea stabilization unless they are next treated in a fixing bath and then thoroughly washed.

The developer used in the stabilization process proposed by Levinos and Burner contained Amidol and ammonium sulfite. Amidol is not now a common photographic chemical. Ammonium sulfite, like many ammonium

salts, decomposes during storage unless very thoroughly dried and carefully packaged. To eliminate these difficulties, Christopher Lucas and Harvey Hodes[43] proposed to use Armed Forces Developer No. 25 (AFD-25 is the equivalent of Kodak developer D-72) to replace the Amidol developer for the stabilization of variable-contrast, water-resistant paper. The pH of the developer is 10.4, so an acetic acid stop bath (pH 2.8) was used before the thiourea stabilizing solution (pH 7.8). Better availability of chemicals, longer shelf life of the packaged chemicals, longer useful life of the developing solution, and improved print resistance to temperature and humidity were claimed for the improved system. The formulas for the AFD-25 system are:

Developing Bath

Metol	3.0 g
Sodium sulfite	45.0 g
Hydroquinone	12.0 g
Sodium carbonate	80.0 g
Potassium bromide	2.0 g
Water to make	1.0 liter

Stop Bath

Acetic acid, glacial	32.0 ml
Water to make	1.0 liter

Stabilizing Bath

Thiourea	15.8 g
Glycerol	5.3 ml
Water to make	1.0 liter

On a processor maintaining the solutions at 100°F, the paper was immersed for 8 sec in the developer, 8 sec in the stop bath, and 16 sec in the stabilizing solution.

According to K. I. Markhilevich,[44] N. M. Zyuskin was the first to formulate thiourea stabilizing solutions in the USSR (1954). Photographic papers

were processed 3 min and photographic film and plates 6 min in the following stabilizing solutions:

	Stabilizing Solution for		
	Photographic Papers	Photographic Plates	Photographic Films
Thiourea	20 g	20 g	20 g
Acetic acid, glacial	10 ml	10 ml	10 ml
Chrome alum	—	10 g	10 g
Glycerol	—	—	60 ml
Water to make	1 liter	1 liter	1 liter

U. S. Patent 2,930,692 proposes a bath containing thiourea for the stabilization of printout images to prevent the further action of actinic light.[45] The stabilizing solution is composed of

Thiourea	40 g
Ammonium thiosulfate	40 g
Ammonium chloride	15 g
Sodium sulfite, desiccated	15 g
Potassium bromide or chloride	40 g
Sodium salt of a condensate of a fatty acid with a protein hydrolysate (such as lysalbinic acid), 10% solution	8 ml
Monodiethylaminoethyldodecenyl succinate, 10% solution	2 ml
Water to make	500 ml

This viscous solution is first imbibed into a porous sheet of paper and then dried. This stabilizing sheet is then thoroughly wetted with water and pressed against the emulsion side of the developed image. Good contact is essential. After a contact time of from 1 to 5 min, the stabilizing paper is removed and the photographic print is dried.

Thiourea can be used in a combined developing-and-stabilizing bath, provided the solution is acid. Such a stabilizing monobath was proposed by Kurt Wenske and Anna Warnke.[46]

Water	100 ml
Titanous chloride, 10%	5 ml
Potassium oxalate (or sodium citrate)	10 g
Thiourea	2 to 3 g

A strong brown image is formed in about 30 sec on a fine-grain silver chloro-bromide emulsion, which is stable even if exposed immediately to daylight.

Silver images stabilized with thiourea solutions tend to fade when stored under conditions of high temperature and humidity. To improve the resistance of the stabilized silver image to bleaching, Harold D. Russell[47] patented the addition of metals such as palladium, platinum, gold, iridium, and rhodium to the thiourea stabilizing bath or to the emulsion before coating. Compounds such as gold chloride, palladium chloride, iridium sesquichloride, and chloroplatinic acid may be added to the stabilizing bath in amounts from 0.01 to 10 g/liter of solution. Typical thiourea stabilizing solutions had the following compositions:

Thiourea Stabilizing Baths

	Solution 1	or	Solution 2
Thiourea	40 g		40 g
Acetic acid	60 ml		—
Gold chloride	1 g		5 g
Citric acid	—		15 g
Sodium citrate	—		10 g
Water to make	1 liter		1 liter

Of a number of different methods tried by Rolf S. Bruenner[39] to inhibit the fading of thiourea-stabilized images the most effective were those that involved adding gold or selenium toning additives to the stabilizing bath.

Thiosulfate Stabilizing Solutions

Thiosulfates are the commonly used silver complexing agents of fixing baths. They are inexpensive and have acceptable odor and toxicity characteristics. Unlike thiourea, thiosulfates do not fog silver halide under alkaline conditions or attack the gelatin of the emulsion layer. Sodium, potassium, and

magnesium thiosulfate have been reported[19] to produce more stable silver complexes than the ammonium or amine thiosulfates, which should not be used with sodium thiosulfate, as the silver complexes will be less stable than when sodium thiosulfate is used alone.

The chemistry of a sodium thiosulfate stabilizing bath is essentially that of a fixing bath. A variety of silver thiosulfates have been reported to exist in solution, but it is generally agreed[48,49] that only four double salts are capable of stable existence at 25°C:

Silver Thiosulfate Complex	Ratio of Silver to Thiosulfate	Water Solubility of Silver Thiosulfate
$Na_3Ag(S_2O_3)_2 \cdot 2HOH$	1 : 2	Readily soluble
$Na_5Ag_3(S_2O_3)_4 \cdot 2HOH$	3 : 4	Readily soluble
$NaAg(S_2O_3) \cdot HOH$	1 : 1	Sparingly soluble
$NaAg_3(S_2O_3)_2 \cdot HOH$	3 : 2	Very slightly soluble

It was concluded[19] that "no salt richer in silver than $Na_3Ag(S_2O_3)_2 \cdot 2H_2O$ exists in thiosulfate solutions. The ratio of silver to sodium thiosulfate $(Na_2S_2O_3 \cdot 5H_2O)$ in this salt is approximately 1 gram of silver to 4.6 grams of $Na_2S_2O_3 \cdot 5H_2O$ and tests have indicated that the ratio of silver to thiosulfate in a stabilized print should be at least 1 : 5. Therefore, in order to obtain a high degree of stability, it is evident that all of the silver should exist as a thiosulfate complex relatively richer in thiosulfate than silver and sufficient time should be allowed in the stabilization process for these complexes to form."

For print stability an excess of thiosulfate should be present in the dried print. If this excess is removed by washing a stabilized print in water, silver thiosulfate complexes may be formed that readily decompose on exposure to light, heat, or humidity. As pointed out by L. F. A. Mason,[50] an excess of the complexing agent keeps the silver complex from dissociating into its component ions. It is very important to keep the free silver-ion concentration very low, as it is the presence of these ions that is responsible for the instability of the stabilized image. If a thiosulfate-stabilized image is washed in water, some $NaAg(S_2O_3) \cdot H_2O$ is eventually formed. This complex is poorly soluble in water and probably decomposes as suggested by Henry Bassett and John T. Lemon:[49]

$$NaAg(S_2O_3) \cdot H_2O \longrightarrow NaAg_3(S_2O_3)_2 \cdot H_2O \longrightarrow$$

$$Ag_2S_2O_3 \longrightarrow Ag_2S$$

The silver compounds become richer and richer in silver until the silver thiosulfate decomposes to form the brownish-black silver sulfide. (See Figure 1.)

The amount of thiosulfate remaining in the stabilized image is a critical factor in image stability. Too much thiosulfate will cause the image silver to bleach during moist storage; too little will cause the silver thiosulfates to decompose and stain the background. Photographic films and waterproof paper may have to be rinsed with water briefly after stabilization in order to prevent crystallization of chemicals on the emulsion surface. A 10-sec rinse in water or 10% Kodalk solution after stabilization improves the storage life of the image, because some of the thiosulfate and silver complexes are removed, and less stain is produced under moist conditions. Increasing the alkalinity of the emulsion layer with the Kodalk treatment further decreases image bleaching and staining. Short rinses are beneficial, but thorough washing should not be attempted unless the stabilized images are treated first in a regular fixing bath.

Thiosulfate Stabilizing Systems

For the rapid stabilization of conventional photographic papers, H. D. Russell[51] used a stabilizing solution consisting of 5% sodium bisulfite and from 15 to 45% sodium thiosulfate crystals. Each solution must be adapted to each photographic paper emulsion and to each processing machine. Russell suggested the solutions and conditions in Table 1 for the stabilization of photographic papers in small processing machines.

Machine processing is recommended because precise timing to insure minimum pickup of solution is necessary for the best print stability. The quantity of developer absorbed influences the rate of stabilization of paper prints. Stabilization is most rapid if the paper print can be withdrawn quickly from the developing solution or the solution applied only to the emulsion surface to limit the volume of developing solution absorbed by the print. If the paper becomes saturated with developing solution, this solution must be displaced before stabilization can occur. Immersion or application times of less than 10 sec have been recommended to prevent excessive absorption by the paper. Two baths of stabilizer are suggested to reduce the concentration of the silver thiosulfates in the stabilized print. Minimum absorption of the processing solutions by the prints means that the stabilized images may be dried more quickly than regularly washed prints. Drying equipment using canvas belts should not be employed, as the stabilizing solution will cause rapid belt deterioration.

Although the carefully controlled stabilization cycle is best performed by a machine, paper prints may be stabilized by hand, using trays. A suggested

Fig. 7. Machine for rapid processing of paper in rolls.

Fig. 8. Sectional view of machine illustrated in Figure 7.
A. Unprocessed paper compartment. B. Developer tank.
C. Hypo tank. D. Wash tank. E. Drying section. F. Roll
of unprocessed paper. G. Guide rollers. H. Wringer rollers
and drive rollers. I. Take-up roller. J. Drain. K. Rubber
squeegee and light-trap. L. Rubber squeegee. M. Water
inlet. N. Heater lamps; 250-watt 12-inch tubular lamps.

The use of a prehardener is entirely satisfactory, permitting subsequent development of high-speed negative films at temperatures up to 125° F., but the hardening procedure requires time and some softening of the gelatin may occur before adequate hardening is accomplished. For moderately rapid processing, however, this procedure is the most satisfactory since it is applicable to all existing photographic materials.

Some degree of success has been obtained by incorporating a hardening agent, such as formaldehyde, in the developer and, although such hardening developers work satisfactorily at temperatures up to 90° F., at higher temperatures the rate of hardening is frequently insufficient to prevent some softening or reticulation, while the formaldehyde tends to combine chemically with the developing agent so that the hardening properties fall off with age of the solution.

A semirapid procedure for processing negative sheet and roll films at 90° F., consists in adding 5% sodium sulfate to the developer and controlling fog, if necessary, by the addition of benzotriazole or 6-nitrobenzimidazole. After development for 1 minute, the film is immersed for 1 minute in a stop bath consisting of 5% chrome alum plus 5% sodium sulfate (anhydrous), then fixed for 2 minutes in the Kodak Liquid Fixer with Hardener (1:3), and finally washed for 2 minutes at 90° F.

Combined Development and Fixation

Although at first thought it would appear that a combined developing and fixing solution would be most suitable for rapid processing purposes by virtue of omission of one of the processing stages, little or no time is saved by the combined solutions since the concentration of the fixing constituents must be restricted so as to permit almost full development before fixation commences.

By incorporating formaldehyde in a pyrocatechol developer, however, it has been possible to process emulsions of medium speed satisfactorily at a temperature of 90° F. in from 15 to 30 seconds. Such baths have a tendency to give dichroic fog which could be offset by the addition of a little sodium cyanide, while with use, the baths accumulate a sludge of metallic silver and their exhaustion lives are relatively short.

For many years the Eastman Kodak Company has supplied Ophthalmographic Film for use in the Ophthalmograph, an instrument for recording the movement of the pupil of the eye while reading. As the film leaves the camera, it is pushed into a U-tube containing the combined developing and fixing solution consisting essentially of Kodak D-19 with the addition of sodium thiosulfate. After remaining for about 1 minute at room temperature, it is then passed through squeegee rollers and is ready for viewing, the entire operation taking place in daylight. Rapid processing methods are particularly advantageous for rendering such records immediately available.

Rapid Reversal Processing

The introduction of hardened emulsions has made possible the rapid production of positive images by reversal. For example, at modern race tracks, motion pictures are taken of a race from different viewpoints covering the entire track, and the judges may require the projection of the dry strip of positive image within a period of from 60 to 90 seconds after exposure. With the following procedure, Eastman Type 5275 with hardening (Super-X Blue Base Reversal Film) may be reversed to a positive in about 90 seconds:

Stage of Process	Bath	Time (Sec.)	Temperature, °F.
1st Developer	Kodak D-8 + 0.1 gram per liter 6-nitrobenzimidazole nitrate	15	125
Rinse	Water	5	125
Bleach	Kodak TC-1 (1:3)	10	125
Clear	Kodak CB-1	10	125
Redevelop	Kodak FD-68	15	125
Rinse	Water	2	125
Fix	Kodak Rapid Liquid Fixer with Hardener (1:2)	10	125
Wash	Water	10	125
Dry	Hot Air	15	125

The bleach bath contains dichromate and sulfuric acid and the clearing bath, sodium sulfite, while the redeveloper contains hydrazine sulfate, which permits redevelopment without exposure to light.

Rapid Processing of Paper Emulsions

The principles and factors which apply to the processing of films may, in general, be applied satisfactorily to

134

Figure 1. This example of a twenty-year-old stabilized print has turned tan on both the face and back side, has a roller pattern in the clear areas, but has not lost appreciable density or legibility. (Harold D. Russell, Eastman Kodak Company)

Table 1. Stabilization of Photographic Papers (Bisulfite-Hypo)

Kodak Paper	Temp. (°F)	Developer	Time (sec)	Bisulfite-Hypo Bath		Time (sec)	Water Rinse (sec)
				Sodium Bisulfite (g/liter)	Sodium Thiosulfate (g/liter)		
Kodabromide	100	D-72(1:2)	10	50	300	20	—
Resisto Rapid N	100	D-72(1:2)	10	50	300	20	3
Velox Unicontrast	100	D-72(1:2)	10	50	240	20	—
Kodak fast projection	100	D-72(1:2)	10	50	240	20	—
Kodagraph Autopositive	100	D-72(1:2)	5	50	150	10	3

procedure[19] for "Kodagraph type" paper prints for photocopying involves the following:

Development:	Kodak D-72 (1:2)	4 to 10 sec, 100°F
Stop bath:	Acetic acid, 5%	2 sec, 100°F
Stabilizing solution:	Sodium sulfite, 15 g	4 to 10 sec, 100°F
	Sodium bisulfite, 45 g	
	Sodium thiosulfate, 100 to 600 g	
	Water to make, 1 liter	

The prints are squeegeed after each solution treatment and then dried between blotters. Once used for this purpose, the blotters must only be used for other stabilized prints, then discarded.

Immersion processing of paper prints results in a greater absorption of the processing solution and a longer drying period than if the solution is applied only to the emulsion surface. Stabilization of photographic paper, such as Kodagraph Autopositive paper, can be done in ordinary room light by using a simple technique described by R. Gilliam Rudd.[52] The solutions are applied with sponges to the emulsion surface while the paper is held in contact with a porous platen made of plaster of Paris. The first sponge, wetted with full-strength Kodak Dektol or Kodagraph developer, is brushed on the emulsion for about 20 sec. Then the second sponge, moistened with the stabilizing solution, is brushed on the print surface for about 20 sec.

The following stabilizing formula for use with the papers was recommended:

Kodak Stabilizing Bath for Photographic Paper, S-2

Water	750.0 ml
Sodium sulfite, desiccated	15.0 g
Sodium bisulfite	45.0 g
Sodium thiosulfate (hypo)*	240.0 g
Water to make	1.0 liter

* The concentration of hypo may be varied from 120 to 480 g/liter of solution according to the conditions of use.

Stabilizing systems for Autopositive paper were also studied by E. T. Smith.[53] At room temperature an acid sodium thiosulfate stabilizing solution required only 15 sec to stabilize the Autopositive paper. Only 7 to 10 sec was required by an ammonium thiosulfate stabilizing solution. A monobath with a 10- to 15-sec treatment time was formulated to meet the requirements for office copying. This monobath had the formula

Sodium sulfite (anhydrous)	100 g
Sodium hydroxide	45 g
Sodium thiosulphate (crystal)	200 g
Sequestrol N.A.4 liquid*	6 ml
(Maher Color and Chemical Co., Chicago, Ill.)	
Water to make	1 liter
Hydroxylamine hydrochloride (add just before use)	12 g

Smith concluded that

Monobaths based on the use of hydroxylamine as developing agent, and sodium thiosulphate as the silver complexing agent, came nearest to meeting these requirements. Caustic alkali is needed to give adequate development rate and hydroxylamine has the advantage that the rate of atmospheric oxidation is not markedly increased in high pH solutions. A monobath based on hydroxylamine has been formulated and gave good results with a processing time of 10 seconds. The solution could be kept in a suitable processing machine for six days, with a processing capacity of about one hundred 8-in. × 10-in. prints in 500 cubic centimeters of solution.

Unfortunately the freedom from toxicity of hydroxylamine solutions is open to question, and there is evidence that blistering and other skin conditions can occur as a result of contact with hydroxylamine solutions. For this reason this system was never marketed.

* Forty percent (weight/weight) of sodium salt of ethylenediamine tetraacetic acid in water.

The developing agent for use in a stabilization system need not be contained in a solution but may be incorporated in the emulsion layer of the light-sensitive paper. Developing agents of low water solubility, such as 3,4-dihydroxydiphenyl, 2,5-dihydroxydiphenyl, 2,3-dihydroxydiphenyl, and 5,6,7,8-tetrahydronaphthohydroquinone, have been claimed[54] to be preferable to more soluble developing agents (hydroquinone, catechol, or Metol) for this purpose. The developing agents may be incorporated into paper emulsions of the usual types as well as the direct positive type. The exposed photographic paper containing developing agent is first treated, preferably by surface application, for 30 to 60 sec in the following solution:

Sodium carbonate	50 g
Sodium hydroxide	5 g
Sodium thiosulfate (crystal)	2 g
Potassium bromide	8 to 16 g
Water to make	1 liter

Both the thiosulfate and sufficient bromide are required to prevent fog during activation of the exposed image. The developed image is then treated for 30 to 60 sec by applying on the surface the following stabilizing solution and then letting the print dry.

Sodium sulfite, desiccated	15 g
Sodium bisulfite	45 g
Sodium thiosulate	150 g
Water to make	1 liter

The stabilization processing of photographic films has not been as widespread as for photographic paper prints. A thiosulfate stabilizing solution reported[19] for film contains 5% sodium bisulfite and 30 to 60% sodium thiosulfate crystals. A brief water rinse must follow the stabilizing bath to remove the chemicals from the surfaces of the film to avoid crystallization of the chemicals. The addition of certain hydroxy-substituted aliphatic amines, for example, mono-, di-, or triethanolamine, to the stabilizing solution has been claimed to prevent chemical crystallization on the surface of the emulsion.

Silver images stabilized with thiosulfates may bleach, especially under conditions of high humidity and temperature. One method to increase the storage life of the stabilized image has been to include a metal salt in the stabilizing solution. The metal from this salt was deposited upon the silver image, making it much more resistant to attack by the residual chemicals

retained in the emulsion layer. As with thiourea-stabilized images, gold chloride, palladium chloride, iridium sesquichloride, and chloroplatinic acid have beneficial effects when included in the stabilizing bath or added to a silver halide emulsion just before coating.[23] Examples of suitable stabilizing solutions are

Sodium thiosulfate	150 g	—
Ammonium thiosulfate	—	100 g
Sodium bisulfite	15 g	15 g
Acetic acid	—	10 ml
Gold chloride	1 g	0.25 to 1.0 g
Water to make	1 liter	1 liter

Improved image stability may be obtained if the stabilized print is immersed in a separate rinsing solution as the final processing step. Such a rinse bath, according to U. S. Patent 3,271,153,[55] should contain about 15 to 40% of the mono- and dibasic salts of phosphoric acid and about 2 to 20% of a sulfite salt. Apparently, the sulfite prevents the thiosulfate from decomposing into sulfides, but the rinse bath is also effective in thiocyanate stabilizing baths, where stickiness of the print surface is also reduced. The useful life of the sulfite bath is limited to a few days' use. Antioxidants have been proposed[56] to lengthen the useful life of the sulfite rinse bath. Developing agents, such as chlorohydroquinone or *p*-aminophenol, were found effective as antioxidants. For example, a rinsing solution of the following composition was used for 20 sec at 25°C:

Sodium acetate	14 g
Boric acid	6 g
Sodium bisulfite	180 g
p-Aminophenol	0.07 g
Water to make	1 liter

Stabilized prints stored for 20 hr at 80% relative humidity and 50°C maintained image density without any increase in background density.

Thiocyanate Stabilizing Solutions

Ammonium thiocyanate ("the sulfocyanide of ammonium") was proposed as a fixing agent in 1863 by M. Meynier.[57] The high cost of the compound, and some question of its effectiveness, limited its immediate use.[58–59] Two successive baths of 30 to 40% ammonium thiocyanate were found by

Davanne and Girard[60] to produce the practical conditions for the formation of stable silver complexes. The stability of the silver complexes with ammonium, potassium, and sodium thiocyanate has been studied by Vincent J. Occleshaw.[61] At 25°C the following double salts were found to exist:

$$NaNCS \cdot AgNCS \cdot 2H_2O \quad and \quad 3\,NaNCS \cdot AgNCS$$

$$KNCS \cdot AgNCS \quad and \quad 2\,KNCS \cdot AgNCS$$

$$NH_4NCS \cdot AgNCS \quad and \quad 5\,NH_4NCS \cdot AgNCS$$

Of these double salts, only the last is stable in contact with its saturated solution. Generally, in practice, only the ammonium thiocyanate is used for stabilization and in sufficient concentration to insure the formation of the stable double salt containing the higher proportion of thiocyanate.

The colorless silver thiocyanate complexes are much more stable than the silver complexes with thiosulfate. These silver thiocyanates do not easily break down into silver sulfide. Ammonium thiocyanate is very rapid acting and readily adaptable for use in simple two-solution stabilization processing machines.[62,63] Against these advantages must be balanced, according to British Patent 936,177,[64]

a certain number of disadvantages as concerns the quality of the prints obtained.

A first disadvantage is that a large excess of complex-forming agent is required to ensure good stability upon exposure to light.

This excess of a product which is often hygroscopic does not favour the drying of the prints and renders the surface of the paper tacky.

Another disadvantage which is even more serious is that nearly all the complexing agents of the silver halides attack the metallic silver, that is, the photographic image, by converting it into a complex or non-complex silver salt. This is manifested by a disappearance of the silver image or by merely a yellowing of the blacks during storage of the print. This is particularly so in a moist atmosphere, the hygroscopic nature of the stabilizing product in this case accelerating this reaction.

Although the silver complex formed with ammonium thiocyanate can be very stable, the necessary excess of the thiocyanate results in the bleaching of the image. This bleaching is accelerated by the moisture that the stabilizing compound attracts. The increased moisture content also makes the gelatin tacky, and sometimes it is softened by the thiocyanate attack. To overcome these practical difficulties, a great number of patents have proposed to introduce organic and inorganic additives in the thiocyanate stabilizing solution.[65–68] Other approaches, such as reducing the concentration of the thiocyanate needed, also have been patented. A selection of the patented systems will be reviewed to show the great diversity of approaches for solving the problems of stabilization with thiocyanate.

The excess thiocyanate present in the stabilized material gradually oxidizes the metallic silver of the image, converting the silver to a complex that causes the image to change color, decrease in density, or completely fade away. One method to reduce the bleaching of the silver image is to replace some of the silver atoms of the surface image with metallic atoms that are less likely to combine with the thiocyanate. This may be accomplished by including compounds containing gold, iridium, platinum, palladium, or rhodium in the stabilizing bath. According to William L. Brice,[69] the compounds may be included in the emulsion ("0.4 gram per liter of wet emulsion") or in the stabilizing bath ("0.1 to 10 grams per liter of solution"). The following is a representative solution using gold chloride as given by Brice:

Water	750 ml
Auric chloride	0.24 g
Ammonium thiocyanate	60 g
Glacial acetic acid	10 ml
Water to make	1 liter

As pointed out in British Patent 875,878,[70] "The quantities of such precious metal compounds which are required to achieve a marked improvement are too great to make their use an economical proposition."

Georges Bonjour[71] added salts of less-expensive bi- or trivalent metals, such as the salts of chromium, cobalt, nickel, zinc, cadmium, and copper. Presumably, these metal ions reduce the level of excess thiocyanate in the stabilized image by forming stable complexes. Concentrations of 2 to 8 g of metal ions per liter were used in stabilizing baths with pH of 1.8 to 3.0 given by the addition of citric or acetic acid. An example of this process involved activating a silver chloride paper containing hydroquinone for 1 sec in

Sodium hydroxide	30 g
Sodium carbonate (anhydrous)	40 g
Sodium sulfite, desiccated	20 g
Water to make	1 liter

This print is then stabilized for 1 sec in the following bath:

Ammonium thiocyanate	150 g
Acetic acid	15 g
Nickel sulfate (crystalline)	30 g
Water to make	1 liter

It was claimed that after washing 0.15 hr and exposing to sunlight for 2 hr, the print did not exhibit the coloration given by a similarly treated print that was not treated with nickel sulfate.

Organic compounds containing —SH groups are known to adhere strongly to metallic silver, protecting the silver from oxidative attack. Such organic thiols are often effective in minute quantities, making their use an economic possibility. Proposals have been made to add organic mercapto compounds to either the emulsion or the stabilizing solution. In British Patent 1,004,301 of David Harold Cole and Douglas James Fry,[72] a 5-mercaptotetrazole was added to the stabilizing solution to reduce the fading of the image density upon storage of the thiocyanate-stabilized print. The introduction of such a compound into the emulsion layer would result in a severe speed loss. This loss may be avoided, according to British Patents 1,004,302 and 1,079,061,[73] if the 5-mercaptotetrazole is introduced as a water-insoluble salt, preferably the silver zinc or lead salt, into an emulsion layer containing a hydroquinone developing agent. After activation the ammonium thiocyanate stabilizer then releases the active 5-mercapto-tetrazole from the inactive salt during the stabilization step. Other sulfur-containing compounds, such as thiadiazoles blocked with acyl or carboxyl groups, have also been incorporated in the light-sensitive material.[74]

Other mercapto compounds have been used by Cole and Fry[75] to produce cold-toned images that are resistant to attack during storage. Dimercapto-triazoles and dimercaptothiadiazoles were added to the stabilizing solution to yield images that are less susceptible to bleaching. An example of such a process involves treating a silver chloride paper (containing hydroquinone) in an activator consisting of 60 g of sodium hydroxide and 50 g of crystalline sodium sulfite per liter of water. This activator may also contain 10 g of sodium carboxymethyl cellulose to increase the solution viscosity. A stabilized print of a bluer-black image tone and superior stability upon keeping is said to be produced when the activated image is immersed in the following solution:

Ammonium thiocyanate	200 g
Sodium metabisulfite	32 g
Sodium sulfite (anhydrous)	5 g
Ethyl alcohol	200 ml
Acetone	50 ml
Water to make	1 liter
4-Methyl-3,5-dimercapto-1,2,4-triazole	1 g

The dimercaptotriazoles and the dimercaptothiadiazoles cannot be added directly to the emulsion because they cause a speed loss. Such dimercapto

compounds may be added as water-insoluble salts of silver, cadmium, copper, lead, or zinc that form soluble salts in aqueous thiocyanate solutions.[76]

Various derivatives of 1,2,3-triazole-3-thiol were claimed[77] to be "effective in preventing fading on storage of rapidly processed photographic prints in a humid, high-temperature environment." The silver-image-preserving compounds could be used in the developing solution, the stabilizing solution, in a separate bath, or incorporated in the light-sensitive layer. Examples given included processing of a silver chloride paper and of a silver chloride paper that contained 3,4-dihydroxydiphenyl as a developing agent in the emulsion layer.

Ingredients	Silver Chloride Paper	Silver Chloride Paper with Developing Agent
Developing Solution		
Sodium hydroxide	22.5 g	5.0 g
Sodium sulfite (anhydrous)	80.0 g	—
Sodium carbonate	—	50.0 g
Hydroquinone	36.0 g	—
Phenidone	2.0 g	—
Potassium bromide	0.5 g	12.0 g
Sodium thiosulfate (crystalline)	—	2.0 g
Water to make	1.0 liter	1.0 liter
2',3'-Dihydrobenzothiazolo-2',3',5,4-triazole(1,2,4)-3-thiol	1.0 g	—
Stabilizing Solution		
Ammonium thiocyanate	300.0 g	300.0 g
Acetic acid (glacial)	40.0 ml	40.0 ml
2',3'-Dihydrobenzothiazolo-2',3',5,4-triazole(1,2,4)-3-thiol	—	1.0 g
Water to make	1.0 liter	1.0 liter

The paper prints were processed in a machine running at 10 fpm for about 2 sec in the developer or activator and about 3 sec in the stabilizing solution. They were then subjected to 7 days incubation at 120°F and 75% relative humidity. The images that had been treated with the triazole-3-thiol compound were more resistant to bleaching than those of a print that had not.

Many heterocyclic thiols have been patented for use in thiocyanate stabilizing solutions. These include mercaptobenzimidazoles, 2-mercaptobenzoxazoles and many others,[78] heterocyclic thioxo compounds,[79] and heterocyclic carboxyl alkyl mercapto compounds,[80] to name but a few.

Stabilized images produced on silver chloride paper containing 3,4-dihydroxydiphenyl are claimed to have increased resistance to fading if the paper contains sodium formaldehyde bisulfite or if the thiocyanate-stabilized image is moistened with a 4% formaldehyde and 5% sodium metabisulfite solution. A silver chloride paper containing 3,4-dihydroxydiphenyl was exposed and activated in the same carbonate-hydroxide solution as above[77] described. The squeegeed print was then swabbed for 60 sec with the following stabilizing solution:[81]

Ammonium thiocyanate	320 g
Sodium fluoride	4 g
Chrome alum (2% solution)	100 ml
Acetic acid (99.5%)	40 ml
Sodium metabisulfite	50 g
Water to make	1 liter

After stabilization various strips of the processed paper were treated with a variety of reducing agents, then stored at 120°F and 98% relative humidity with the following test results:

Treatment after Stabilization	Image Stability (120°F, 98% RH)
No aftertreatment	Image lasted 2 hours
5% Hydroquinone solution	Image lasted 4 hours
5% Sodium metabisulfite solution	Image lasted 7 hours
5% Ascorbic acid solution	Image lasted 5 days
4% Formaldehyde solution	Image lasted 3 days
4% Formaldehyde and 5% sodium metabisulfite	Image lasted more than 8 days

Improved image stability was claimed when the thiocyanate-processed silver image was treated with the solution containing both the formaldehyde and the sodium metabisulfite.

A cyclic ketone bisulfite, such as cyclohexanone bisulfite, was said[82] to improve the stability of silver images produced by first treating a silver chloride paper (containing hydroquinone) in an activator

Sodium hydroxide	60 g
Sodium sulfite (anhydrous)	50 g
Potassium bromide	2 g
Water to make	1 liter

and then in the stabilizing solution

Ammonium thiocyanate	250 g
Potassium metabisulfite	80 g
Acetic acid (60% in water)	20 ml
Cyclohexanone bisulfite	50 g
1-Phenyl-5-mercaptotetrazole	1 g
Water to make	1 liter

Formaldehyde bisulfite,[83] potassium pyrosulfite with borax-boric acid,[84] and adipic or succinic acid[85] have been proposed for use in stabilization baths to increase print image stability. To prevent deterioration of stabilizing solutions containing sulfite compounds, small amounts of developing agents in conjunction with mercapto compounds have been proposed.[86]

Ascorbic acid has often been included in patented stabilizing solutions containing ammonium thiocyanate.[70] A 4-aryl-2-hydroxytetronic acid or imide, such as 5% 2-hydroxy-4-*o*-sulfophenyl tetronimide (sodium salt), has also been suggested.[87] The use of ascorbic acid with an ammonium salt in an ammonium thiocyanate stabilizer has been proposed.[88] A silver chloride paper containing hydroquinone is first activated in 5% sodium hydroxide, then treated with (pH 4.5)

Ammonium thiocyanate	180 g
Ammonium chloride	180 g
Ascorbic acid	20 g
Water to	1 liter
Ammonia	6 ml

The use of ammonium chloride permitted the use of a lower level than the 200 to 400 g/liter of ammonium thiocyanate usually present in the rapid-acting thiocyanate stabilizing solution. In another patent, a neutral am-

monium thiocyanate stabilizing solution is claimed to be better for rapid processing.[89]

Stabilizing photographic papers is a less difficult processing problem than treating photographic films. Most photographic films require light-absorbing dyes, such as a triphenylmethane dye contained in the anticurl layer on the back of the film, to prevent serious halation effects. These antihalation dyes are usually decolorized by the sodium sulfite in the processing solution and then washed out. The stabilizing solutions can decolorize the antihalation dye successfully, but the colorless dye is still retained on the back of the film. Upon exposure to air, the colorless dye may be changed back to a colored stain that limits the usefulness of the stabilized film. In British Patent 1,138,087[90] a colloidal dispersion of manganese dioxide was used in the antihalation layer to replace the organic dye. The manganese dioxide is an effective absorber of blue light, but its effectiveness decreases as the wavelength of the light increases. Such a silver chloride film containing hydroquinone was, after exposure, passed through a bath of

Sodium hydroxide	60 g
Sodium sulfite (anhydrous)	25 g
Potassium bromide	0.25 g
Water to make	2500 ml

and then through a second bath containing

Ammonium thiocyanate	400 g
Ammonium chloride	20 g
Sodium sulfite, anhydrous	120 g
Ascorbic acid	60 g
Glacial acetic acid	40 ml
Water to make	2000 ml

This stabilizing solution is said to have a number of functions:

The ammonium thiocyanate, which is in large excess in said solution, converts the unused silver halide into an inert silver salt complex which does not readily print out on exposure to light. The ammonium thiocyanate also serves to neutralize to some extent the alkalinity of the activator solution. The ascorbic acid in the solution delays attack on the developed silver image by excess salts and products of development, and reduces adverse effects of excessive humidity as disclosed in British Patent No. 875878.[70] The acid and sulphite content of the stabilizing solution serves to convert the manganese dioxide in the backing layer of the film into colourless manganese compounds and also to complete the neutralisation of the alkalinity of the activator solution.

This quotation summarizes some of the complex chemical actions necessary to make practical the simple and rapid stabilization with thiocyanate solutions.[91,92]

Besides the problem of dye stains, photographic films have a great tendency for the crystallization of the processing chemicals on the emulsion surface when the stabilized image has been dried. Photographic paper with its porous base is less likely to show this objectionable tendency. When incorporated in the emulsion layer, photographically inert material, such as finely divided silica in a medium of gelatin and polyvinyl alcohol, was claimed[93] to avoid the crystallization difficulty. Zinc oxide particles have also been said[94,95] to prevent tackiness of the stabilized layer of light-sensitive products that are coated on film base or on water-resistant paper support.

The tackiness of thiocyanate-stabilized silver images is due in part to the presence of excess thiocyanate. Salts of aluminum, cadmium, cobalt, chromium, lead, nickel, and zinc have been added to the stabilizing solution for minimizing tackiness and image instability. Zinc nitrate is commonly used, but this compound lowers the efficiency of the solution, because of the precipitation of zinc hydroxide. It has been proposed to avoid this difficulty by incorporating the zinc salts in the emulsion layer of the photographic material.[96] Aluminum sulfate may be used as a hardener in the solution but may precipitate if the pH of the bath rises when contaminated with developer. A mixed hardener complex, $ZrO_2 \cdot Al_2O_3 \cdot Cr_2O_3$, has been patented as an improved hardener.[97] Aluminum sulfate, or other metal-ion hardeners, cause corrosion. This action is claimed to be inhibited by the presence of polyethylene glycols.[98]

Reduction of the tackiness of the stabilized image and improved resistance of the silver image against fading are claimed when a silver chloride paper containing hydroquinone is exposed, developed, and then stabilized in water-soluble borates.[99] An example of such a stabilizing solution is

Water	500 ml
Ammonium thiocyanate	250 g
Potassium pyrosulfite	120 g
Boric acid	15 g
Borax	19 g
Cobalt sulfate	0.3 g
2-Mercaptopropionic acid (1 % alcoholic solution)	60 ml
Water to make	1 liter

The borates buffer the solution, preventing a lowering of the stabilizing activity caused by a rise in pH when the developing solution is carried over into the stabilizing solution. The metal salts of nickel, cobalt, cadmium, zinc, and gold form a salt with the thiocyanate, reducing the concentration of the excess complexing agent available to attack the image. The mercapto organic compound helps protect the silver of the image by adsorbing to the surface of the silver.

Reducing the excess amount of the thiocyanate retained in the stabilized image has helped to improve image stability. The use of waterproof paper has been suggested.[100] Another method was outlined in British Patent 936,117[64]: "The amount of complexing agent theoretically necessary is relatively very small and the only purpose in the great amount of excess actually used is to accelerate the stabilization process so that it is complete within a very short stay in the stabilization bath. By adding to this bath a silver halide desensitizing agent it is possible to allow the stabilization reaction to proceed outside this bath without risk to the whites or high lights of the photographic image. In this way it is possible notably to reduce the amount of complexing agent without damage." It is claimed that a lower level of ammonium thiocyanate may be used when the solution also contains a desensitizing agent such as mercuric chloride or picric acid. Such a stabilizing bath has the composition

Ammonium thiocyanate	150 g
Mercuric chloride	2 g
Borax	4 g
Isopropyl alcohol	250 ml
Water to make	1 liter

Prints stabilized with ammonium thiocyanate solutions may form a red stain in the processed image. Any traces of ferric iron in the processing system react to form the vividly red ferric ferrithiocyanate complex. The ferric ion may also accelerate the bleaching of the silver image. These adverse effects can be prevented by the inclusion of phosphoric acid or its sodium, potassium, or ammonium salts in the stabilizing solution or in a separate bath. Sodium dihydrogen phosphate, disodium hydrogen phosphate, and trisodium phosphate are examples of useful compounds for use in the stabilizing solution. For ordinary purposes, 10 to 30 g of the phosphate compound were said to be sufficient.[101-2] The inclusion of zinc oxide particles in the light-sensitive material is also said[94] to prevent discoloration due to the formation of red ferrithiocyanates. Image stability was improved in all examples which also had an incorporated developing agent, such as norborane hydroquinone, in the emulsion layer.

Sometimes it is desirable to prevent further change in images produced by printout, such as the records produced on oscillographic recording machines. A method has been proposed[103] to stabilize the printed-out images by a 5-sec treatment in a solution containing

Ammonium thiocyanate	100 g
Sodium sulfite, desiccated	20 g
1,8-Dihydroxy-3,6-dithiaoctane	100 g
Water to make	1 liter

Printed-out images may also be treated in a monobath of the following composition for 30 sec at 20°C, squeegeed and dried[104]:

Phenidone	1 g
Sodium sulfite (anhydrous)	50 g
Ascorbic acid	10 g
Sodium carbonate (anhydrous)	20 g
Potassium thiocyanate	150 g
Water to make	1 liter

Ultrarapid processing of prehardened films can be accomplished by using solutions at high temperatures. A concentrated (50%) solution of ammonium thiocyanate with 3% magnesium sulfate can be used as a stabilizing bath to be followed by a rapid rinse in water. The processing cycle, as worked out by A. R. Burkin,[105] of a prehardened high-speed panchromatic film included:

1. Development for 2 sec at 130°F (54°C) in

ID-51 Ilford Rapid Oscillograph Developer

Sodium sulfite (crystals)	160 g
Potassium bromide	26.0 g
Sodium hydroxide	40.0 g
Metol	26.7 g
Hydroquinone	26.7 g
Water to make	1.0 liter

2. A 120°F (49°C) treatment for 1 sec in

Acid Stop Bath

Sodium metabisulfite	14.0 g
Sodium acetate (crystals)	29.0 g
Water to make	1.0 liter

3. Stabilization for 10 sec at 130°F (54°C) in

IF 14 Ilford Rapid Oscillograph Fixing Bath

Ammonium thiocyanate	500.0 g
Magnesium sulfate (crystals)	30.0 g
Water to make	1.0 liter

Dissolve the thiocyanate in 200 ml warm water; dissolve the magnesium sulfate in 100 ml warm water. Add the two solutions together and make up to one liter with water.

4. If the negatives are needed for only temporary use, a brief rinse in water is all that is required. Negatives which are to be stored should be immersed in a 5% sodium thiosulfate solution for 5 min or less at room temperature, then washed and dried in the normal fashion.

Rinse Baths after Thiocyanate Stabilization

After stabilization the print still contains all the processing chemicals and cannot be ferrotyped to produce a glazed surface. The glazed surface can be obtained, however, if after the normal stabilization treatment the print is immersed for 3 to 5 min in a second stabilizing bath consisting of either 3.5% ammonium thiocyanate or a 4% potassium thiocyanate solution.[106] Another process[107] used four solutions with a 5% ammonium thiocyanate solution as the final rinse-wash solution. A proposal has also been made to subject "the light-sensitive material to a washing bath treatment wherein the washing fluid comprises water as the sole component which is utilized to remove stabilizing agents, the washing bath being conducted for a period of time shorter than sixty seconds after exposing, developing and stabilizing said light-sensitive material."[108] Ferrotyping was possible after the water rinse, and the image was claimed to be more resistant to bleaching and free from discoloration. Lamination of a transparent sheet (4-mil polyester film base) to the surface of a stabilized print was said[109] to yield a glossy surface without the need for the water rinse bath.

Thiol Stabilizing Solutions

Organic compounds with —SH groups, or double-bonded sulfur that can be converted into a thiol group, have a strong affinity for silver ions and can be used for the stabilization of photographic films and papers. Thiourea is one such, but the great diversity of organic chemistry provides numerous possible compounds. Many of them lack solubility, are extremely expensive, form colored compounds with silver, have pungent odors, are toxic to human beings, or possess other undesirable properties. A number of organic thiols, even those with some of these disadvantages, have found use as practical stabilizing agents because of certain properties that are not inherent in the other more common stabilizing compounds. Organic thiols often are present in a single-solution, combined activator-and-stabilizer solution.

In the early work Harold D. Russell[110] patented the use of thiophenols in acid stabilizing solutions following 5- to 60-sec treatment in a Metol-hydroquinone developing solution and a 5-sec immersion in an acetic acid stop bath. Prints treated from 15 sec to 15 min were claimed to be "stable to sunlight, heat and humidity without printing-out or fading." Solutions containing thiohydroquinone produced a bright yellow silver salt, while thiosalicylic acid produced a colorless silver salt.

More often, organic thiols are incorporated in a combined developing-and-stabilizing solution, as was done by Roman P. Dreywood.[111] 2-Mercaptopyrimidines or a 2-mercaptopyridine were found useful for a single-solution stabilizing bath, as in the following example:

Monomethyl-*p*-aminophenol sulfate	0.83 g
Sodium sulfite, desiccated	12.4 g
Hydroquinone	3.3 g
Sodium carbonate	30.0 g
Potassium bromide	0.5 g
6-Amino-4-hydroxy-2-mercaptopyrimidine	5.0 g
Water to make	500.0 ml

The exposed photographic material was immersed for 90 sec in this solution, rinsed for 30 sec in a 10% acetic acid solution, then squeegeed to remove the excess liquid and the print dried.

Stabilizing monobaths need not be always alkaline. Kodagraph Auto-positive paper, a material that can be handled under room-light illumination,

required 2 min for stabilization in a titanium monobath compounded by G. M. Haist et al.[112] (pH = 0.8):

Titanium trichloride (20%)	20.0 ml
Hydrochloric acid (conc.)	10.0 ml
Ethylenediamine tetraacetic acid, tetrasodium salt	12.0 g
Mercaptosuccinic acid	60.0 g
Water to make	1.0 liter

A bath at pH 1.5 with the chelating agent Cheelox B-14 (GAF Corp.) required only 30 sec stabilization time, but both monobaths had a short aeration life because of the instability of the titanium. Stabilized prints often yellowed upon standing. This was prevented by a 30-sec afterrinse in 5% sodium metaborate. The alkaline treatment also helped reduce the extreme brittleness of paper fibers of the print if left in the extreme acid condition produced by the monobath.

To avoid this embrittlement of the paper fibers, most monobaths with organic thiols are alkaline. For simultaneous development and stabilization of Kodak Autopositive paper, a 30-sec treatment in a 2-thiobarbituric acid monobath (pH = 12.5) has been proposed[113]:

Hydroxylamine sulfate (95%)	10.0 g
Sodium sulfite, desiccated	50.0 g
2-Thiobarbituric acid	32.0 g
Sodium hydroxide	30.0 g
Water to make	1.0 liter

This same silver complexing agent was also used to compound a monobath for stabilizing high-speed printout papers. Two stock solutions were used to prepare the working monobath:

Solution A

Hydroxylamine sulfate (95%)	20.0 g
Sodium sulfite, desiccated	100.0 g
Sodium hydroxide	13.0 g
Water to make	1.0 liter

Solution B

2-Thiobarbituric acid	60.0 g
Sodium hydroxide	39.0 g
Water to make	1.0 liter

The pH of each solution was 12.4. From 0.5 to 2.0 parts of A per part of B were used, depending upon the particular emulsion to be stabilized, with a treatment time of 30 sec to 2 min. Other monobaths using monothioglycerol or N,N-diethyl-β-mercaptoethylamine hydrochloride were also illustrated in the patent by Grant Haist and James King. 2-Thiobarbituric acid has also been used to render undevelopable certain layers of a multilayer film.[114]

A 4-sec monobath for use at 120°F has been described[116] and patented[115] by Christopher Lucas. A hardened thin-emulsion film (Kodak Plus-X reversal film, SO-273) was processed with continuous agitation in a monobath containing thioglycolic acid:

Thioglycolic acid	50 ml
Potassium hydroxide	145 g
1-Phenyl-3-pyrazolidone	5 g
Hydroquinone	50 g
Potassium arsenite	20 g
Water to make	1 liter

The potassium arsenite was said to make the solution resistant to aerial oxidation and so have a high exhaustion capacity. A brief (0.5 sec) water rinse may be used to insure that chemical crystallization does not occur on the surface of the film. A film resolution of 70 lines per millimeter was obtained without any silver plating on the film surface as is often obtained with the high-temperature use of thiosulfate monobaths.

Stabilized prints that are ferrotyped may change color and lose contrast. These undesirable changes are said[117] to be prevented when a stabilizing bath contains an alkali rhodanide, such as ammonium rhodanide, and a rhodanide substituted at the 3 or 5 position. The ammonium rhodanide is used in a concentration of from 100 to 300 g/liter and the substituted rhodanide from 0.5 to 10.0 g/liter of stabilizing solution. Three examples of stabilizing solutions used to treat prints developed in a separate solution are the following from British Patent 1,063,134:

Solution Composition 1

Ammonium rhodanide	175 g
Borax	5 g
Acetic acid	5 ml
Water to make	1 liter
3-Acetylaminorhodanide	10 g

Solution Composition 2

Ammonium rhodanide	160 g
Sodium metabisulfite	50 g
Picric acid	1.5 g
Ascorbic acid	2 g
Ammonia (25% NH_3)	1 ml
Water to make	1 liter
3-Aminorhodanine	5 g

Solution Composition 3

Ammonium rhodanide	200 g
Thiobenzanilide	1 g
Acetic acid	5 ml
Ethanol	250 ml
Water to make	1 liter
3-Ethylrhodanide	8 g

Stabilizing baths containing 1,3,5-triazine-2-thione derivatives have been claimed to overcome many of the deficiencies of prints processed in thiosulfate, thiocyanate, or thiourea solutions. According to Canadian Patent 883,754,[118]

The stabilising time is very short, 30 seconds to 3 minutes generally being sufficient. The photographic images which have been stabilised with the baths prepared according to the invention show practically no discoloration even after prolonged storage. The finished silver image is very stable even without the presence of stabilisers such as phenylmercaptotetrazole which are usually added, and bleaching occurs only to a very small extent even after prolonged storage under tropical conditions.

In contrast to the most commonly used stabilisers, ammonium thiocyanate and sodium thiocyanate, which result in sticky layers, the substances according to the invention in no

way influence the mechanical properties of the layer. In particular, no odors are produced by the baths according to the invention nor are they found in the stabilised photographs.

A silver chloride photographic emulsion containing hydroquinone and formaldehyde sodium bisulfite was coated on baryta paper. The exposed paper was processed in the following solutions in an automatic machine such that a photographic print 30 × 40 cm took 60 to 80 sec to run through the apparatus:

Activator Bath

Sodium hydroxide	54 g
Sodium sulfite, anhydrous	45 g
Potassium bromide	18 g
Water to make	1 liter

Stabilizing Bath

5-Hydroxyethyl-1,3,5-triazine-2-thione	200 g
Potassium metabisulfite	85 g
Monopotassium phosphate	25 g
Disodium phosphate	25 g
Formamide	50 ml
Phenylmercaptotetrazole	4 g
Water to make	1 liter

Rinse Bath

Water	900 ml
Isopropanol	100 ml

The rinse bath may be omitted when an acid short stop bath at pH 2 is used after the activator solution. The final rinse bath is advantageous when film base or water-resistant light-sensitive materials are stabilized.

Water-soluble 2-mercapto-1,3,5-triazines are said[119] to be harmless physiologically, without unpleasant odor, and not to cause sticky emulsion layers on prints. When used in fixing baths, the silver salts of 2-mercapto-1,3,5-triazines were easily removable with water washing. Silver images of superior resistance to changes in image tone and density were also pro-

duced[120] when thio- or mercapto-substituted compounds of tetrahydro-pyrimidine, tetrazine and thiazines were used as stabilizing agents.

Iodide Stabilizing Solutions

It has been known for many years that the treatment of a photographic film or paper after development with a solution of potassium iodide greatly lessens the light sensitivity of the photographic emulsion layers. The iodide replaces both the chloride and bromide ions of the silver halide in the emulsion. The light sensitivity of silver iodide is very low under these conditions, so a photographic image may be effectively rendered insensitive by an iodizing bath. The first monobath that this writer ever formulated contained potassium iodide as the stabilizing agent, producing a print with a yellow background that was resistant to change in the light. Generally, iodide stabilization is used as a part of a rapid process to produce light-stable images. In 1946 hydroquinone and a water-soluble or a water-insoluble amine were incorporated in a silver bromoiodide emulsion and coated on paper, glass, or film.[121] After exposure the light-sensitive material was activated by heating in a stream of steam. The image was then stabilized by a 1- to 2-min treatment in a 10% solution of potassium iodide, or in a 10% potassium iodide solution containing 3% sodium bisulfite. An alcoholic solution of hexamethylenetetramine allyl iodide was also introduced into the steam to eliminate the need for solution stabilization. An alternative proposal was to disperse the iodide in the emulsion or contiguous layer. *N*-Butyl, ethyl, secondary butyl, tertiary butyl, or other alkyl iodides could be used for making dispersions with butyl phthalate by passing the mixture three times through a colloid mill. One example of such a dispersion may be made as follows:

n-Butyl iodide	10.0 g
Butyl phthalate	20.0 g
Gelatin (10% solution)	40.0 ml
Water	30.0 ml
Alkanol B (E. I. du Pont de Nemours and Co.)	0.3 g

Upon heating with steam, the iodide is extracted from the suspended particles in the coated layer and the iodide then reacts with the silver halide to stabilize the emulsion layer.

A self-processing camera using fast 35mm film was devised by E. W. Jackson[122] to provide a photographic image for inspection within 10 sec

after exposure. The exposed film was developed in a rapid-acting developer of the following composition:

Metol	3.5 g
Hydroquinone	5.7 g
Sodium hydroxide	17.2 g
Sodium sulfite, anhydrous	75.0 g
Water to make	250.0 ml

Rapid fixation of the developed image was more difficult to accomplish. Comparative testing of the fixing times of different silver complexing agents indicated the following results:

Fixing Agent	Temperature	Concentration	Time for Complete Clearing
Sodium thiosulfate	70°F	35%	2.7 min
Ammonium thiosulfate	70°F	35%	1.4 min
Sodium cyanide	70°F	10%	15.0 sec

Sodium cyanide could not be used because of its highly poisonous nature. Ammonium thiocyanate required about 20 sec but at a risk of softening the emulsion layer. Because the clearing times of the thiosulfates were too slow, it was decided to use the hot developing solution in combination with an iodide stabilizing solution. An image of black developed silver against a yellowish background of silver iodide which did not darken when exposed to daylight was produced within 10 sec. The iodizing solution, which was not heated, was of the following composition:

Potassium iodide	130 g
Hydrochloric acid (conc)	100 ml
Water	1000 ml

The shortening of the processing time for photographic materials to a few seconds was also the object of a system proposed in U. S. Patent 2,706,157.[123] The emulsion-coated, water-resistant photographic materials incorporated a development accelerator such as cadmium chloride or a desensitizing dye such as pinakryptol yellow or green. The exposed material was processed for not more than 2 or 3 sec. Two examples of a suitable developer are

Hydroxylamine hydrochloride	20 g	—
Hydrazine hydrochloride	—	20 g
Sodium hydroxide	22 g	22 g
Sodium sulfite (anhydrous)	50 g	50 g
Water to make	1 liter	1 liter

The image was then stabilized by treatment with "an acid-reacting aqueous solution of a water-soluble salt of an inorganic halogen or halogenoid acid selected from a group consisting of iodic acid, fluoric acid and thiocyanic acid. With the salt is preferably used an organic acid such as acetic acid, tartaric acid, citric acid or some other organic acid of comparable hydrogen-ion concentration the action of which is to terminate development." Examples of these solutions for stabilizing the image included

Potassium iodide	100 g	—
Potassium fluoride	—	100 g
Acetic acid (glacial)	100 ml	—
Citric acid	—	75 g
Water to make	1 liter	1 liter

These baths were used for a few seconds at room temperature.

In Canadian Patent 764,918, Marilyn Levy[124] proposed the ultrafast processing of photographic films and prints by a technique that involved "the use of a fast developing solution to achieve maximum speed in combination with a concentrated solution of Potassium Iodide as a fixing agent." Developed film was not washed but had to be treated, after iodide stabilization, with a dilute aqueous solution of thiourea to eliminate surface crystallization of retained chemicals. A clear negative was said to be produced that had high resolution and accurate gradation. Exposed Kodak Plus-X Aerocon film was first developed for 2 sec at 50°C in a developer such as follows:

Water	800 ml
Sodium sulfite, desiccated	80 g
Hydroquinone	80 g
Sodium hydroxide	40 g
1-Phenyl-3-pyrazolidone	12 g

then stabilized for 4.5 sec at 50°C in the following solution:

Water	500 ml
Potassium iodide	420 g

and then swabbed about $\frac{1}{4}$ sec with a thiourea solution:

Water	100 ml
Thiourea	2 g

The processed film was said to have a crystalline-free clear emulsion and "neither the silver image or emulsion will suffer deterioration."

STABILIZATION PROCESSING OF MATERIALS CONTAINING DEVELOPING AND COMPLEXING AGENTS

Most modern light-sensitive films and papers designed for stabilization processing have the developing agent or agents in the photographic material. As stated[125] in the disclosure of U. S. Patent 3,140,178, "It would be convenient to have the fixing agent incorporated directly in the emulsion. However, usual fixing agents are not suitable for incorporation directly in emulsions as they form complexes with silver halide regardless of the acidity of the environment. Also many fixing agents would cause substantial desensitization of the emulsion if incorporated therein. It is thus desirable to have fixing materials that are sufficiently compatible with silver halide emulsions so that they can be utilized therein." Starting in the early 1960s there have been efforts to find suitable compounds that in an inactive form could be included in the emulsion layer without deleterious effect but could be activated when desired to produce a silver complex that did not change on storage or exposure to light.

Solutions for Stabilization

Fixing or stabilizing agents to be incorporated in photographic films or papers are often organic compounds having the $-\overset{|}{\underset{|}{C}}-S-\overset{|}{\underset{|}{C}}-$ which effectively lessens the activity of the sulfur atom to combine with silver ion. The bonding between the sulfur and the carbon atoms of the organic molecule is weakened by the inclusion of electron-withdrawing radicals attached to the groups that connect to the carbons. Such radicals that attract electrons may be, for example, amino, carboxy, hydroxyl, keto, morpholino, nitrilo, or sulfonyl. When such an organic compound is placed in a strongly alkaline solution, such as given by sodium hydroxide or tetramethylammonium hydroxide, the hydroxyl ion is able to displace the sulfur-containing end from the rest of the molecule. The sulfur-containing end of the molecule that

is released is an active mercapto compound capable of combining with silver ions to form light-insensitive silver mercaptides. A general mechanism for the formation of a mercapto compound from an isothiuronium salt has been given by Ralph Connor[126]:

$$\left[R-S-C \underset{NH_2}{\overset{NH_2}{<}} \right]^{+} X^- + NaOH \longrightarrow$$

$$RSH + NaX + H_2O + (H_2NCN)_n$$

where X^- is a negative ion, such as chloride, bromide, or *p*-toluene sulfonate, and R represents alkyl, substituted alkyl, or other groups. The decomposition of S-substituted thioureas in alkaline solution has also been studied by M. Fedoroňko and P. Zuman.[127]

There is not complete agreement on the number of steps necessary to produce the mercapto compound from the isothiuronium compound in the presence of hydroxyl ions. A recent proposal by D. G. Dickerson[128] involves three steps: (1) addition of the —OH to the carbon attached to the sulfur (hydration), (2) loss of the H from the —OH (ionization), and (3) release of the mercapto end of the molecule (elimination). For an isothiuronium inner salt that exists in the ionic form

$$\underset{H_2N}{\overset{NH}{>}} C-S-CH_2CH_2CH_2SO_3H \longrightarrow$$

$$\underset{H_2N}{\overset{H_2N^{\oplus}}{>}} C-S-CH_2CH_2\overset{..}{C}H_2 \cdots SO_3^{\ominus}$$

the Dickerson mechanism of hydrolysis would involve the following three steps:

1. Hydration:

$$\underset{H_2N}{\overset{H_2N^{\oplus}}{>}} C-S-CH_2CH_2CH_2SO_3^{\ominus} + OH^- \longrightarrow$$

$$\underset{H_2N}{\overset{H_2N}{>}} \underset{}{\overset{OH}{<}} C-S-CH_2CH_2CH_2SO_3^{\ominus}$$

2. Ionization:

$$
\begin{array}{c}
H_2N \\
\diagdown OH \\
C\!-\!S\!-\!CH_2CH_2CH_2SO_3^{\ominus} + OH^- \longrightarrow \\
H_2N \diagup
\end{array}
$$

$$
\begin{array}{c}
H_2N \\
\diagdown O^{\ominus} \\
C\!-\!S\!-\!CH_2CH_2CH_2SO_3^{\ominus} + HOH \\
H_2N \diagup
\end{array}
$$

3. Elimination:

$$
\begin{array}{c}
H_2N \\
\diagdown O^{\ominus} \\
C\!-\!S\!-\!CH_2CH_2CH_2SO_3^{\ominus} \longrightarrow \\
H_2N \diagup
\end{array}
$$

$$
\begin{array}{c}
H_2N \\
\diagdown \\
C\!=\!O + {}^{\ominus}S\!-\!CH_2CH_2CH_2SO_3^{\ominus} \\
H_2N \diagup
\end{array}
$$

If the 3-S-thiuroniumpropane sulfonate were incorporated in a silver halide emulsion layer, as has been proposed,[129] a fourth step would ensue:

4. Complexation of silver ions:

$$AgCl + {}^-SCH_2CH_2CH_2SO_3^{\ominus} \longrightarrow Ag\!-\!SCH_2CH_2CH_2SO_3^{\ominus} + Cl^-$$

The silver complex is clear, colorless, odorless, and water soluble, owing largely to the presence of the sulfonic acid group in the molecule. The kind of functional group in the mercapto end of the isothiuronium compound and its nearness to the sulfur determine in large measure how easily the mercapto compound is split off by the hydroxide during the hydrolysis step. These same groups also determine the color, odor, and solubility of the silver compound that will be formed by the liberated mercapto compound.

Compounds such as β-aminosulfides and Michael adducts,[125] and thiazoline derivatives,[130] have been proposed for incorporation as blocked stabilizing agents as well as the isothiuronium salts. An example[129] of a self-developing-and-stabilizing coating consisted of adding 20 ml of a 10% solution of 3-S-thiuroniumpropane sulfonate to 20 ml of 10% pigskin gelatin. To this mixture was added 0.25 g of 1-phenyl-3-pyrazolidone and 3.5 ml of a "concentrated negative-type medium speed gelatino silver bromoiodide emulsion." This emulsion composition was then coated on a

photographic paper stock having a water-resistant backing. After exposure, the coated paper was immersed in a solution of 10% tetramethylammonium hydroxide containing 1% L-ascorbic acid. The resultant image was described as of good quality and light stable. In another example the L-ascorbic acid (4 ml of a 10% solution) was incorporated in the coated layer, and activation required only 15 sec in the same alkaline solution. An activator consisting of a 2.5% sodium hydroxide and 10% sodium sulfate was also used to produce light-stable images without washing.

A photographic material containing o-mercaptobenzoic acid and developing agents has been patented[131] for rapid stabilization processing. The photographic paper consisted of two layers: (1) an underlayer containing the processing chemicals and (2) a silver chloride emulsion layer that was coated over the dry underlayer. The underlayer consisted of adding at 50°C

<div align="center">Solution 1</div>

o-Mercaptobenzoic acid	9.0 g
Ethanol	72.0 ml

slowly with stirring to

<div align="center">Solution 2</div>

Gelatin	36.0 g
Ascorbic acid	3.0 g
1-Phenyl-3-pyrazolidone	0.5 g
Sodium formaldehyde bisulfite	1.0 g
Disodium hydrogen phosphate	1.0 g
Potassium dihydrogen phosphate	1.0 g
Saponin ($7\frac{1}{2}$% in water)	24.0 ml
Formaldehyde (20% in water)	5.0 ml
Water	360.0 ml

The contact-speed silver chloride emulsion was coated over the dry underlayer of the above composition on baryta-coated paper base. Coating weight of the o-mercaptobenzoic acid was 3.2 gr/ft^2 and the silver-coated weight was 2.6 gr of equivalent silver nitrate per square foot. The exposed dry paper was machine processed by surface application using a 5% potassium hydroxide solution. A 2-sec surface application of the alkali to the paper produced a developed and stabilized print. No storage data on the coated photographic material or the processed print were given in the patent.

No prestabilization after accelerated aging for 7 days at 120°F and 35% relative humidity was found for a silver halide coating containing a 1,1-bis-sulfonyl alkane stabilizing compound and developing agents. In Example 1 of U. S. Patent 3,647,453, Grant M. Haist, James R. King, and David A. Pupo described the preparation of this coating with incorporated developing and stabilizing agents:[132]

The following coating composition is prepared and coated at 0.004 inch wet thickness on a baryta-coated paper base:

Water	40.0 ml
Gelatin, 15% solution	40.0 ml
Bis(methylsulfonyl)-methane	3.0 g
1-Phenyl-2-carbohexyloxy-3-pyrazolidone	0.8 g
Hydroquinone	2.0 g
Negative type, medium-speed gelatino–silver chloride–gelatin emulsion containing 40 mg silver/ml	5.0 ml

This composition contains approximately 8 moles of stabilizer compound per mole of silver. After drying, the resulting photographic element is then exposed to an image and then immersed for 10 seconds in a solution at 75°F containing 5 percent sodium hydroxide, 5 percent sodium sulfite, and 5 percent sodium sulfate. The element is then washed in water. A blue-black image of excellent density and emulsion speed is obtained with a white background that is stable to the continued effect of light.

The water rinse should be "for about 1 second to about 5 minutes."

Dry Stabilization

The activation of silver halide emulsion layers containing developing agents or stabilizing agents, or both, usually requires an alkaline solution.[133] Often, for rapid processing, caustic alkalies are needed. Caustic solutions are both inconvenient and dangerous to handle. Any wet solution could be eliminated if heat could be used as the sole agent to activate the incorporated chemical coating. Heat-activated stabilization would make the dry process more acceptable in a wider range of applications than a wet stabilization process. At the beginning of this chapter a wet stabilization method was described that consisted of applying a developer to a photographic paper, then flash-drying the paper on a heated drum. Adding the constituents of the developer directly to the photographic material would eliminate the need for the single solution. And this is what Paul H. Stewart, George E. Fallesen, and John W. Reeves, Jr. did.[134] They added 48 g of a 20% gelatin solution to 500 ml of the following solution:

Sodium sulfite, anhydrous	45.0 g
Ascorbic acid	13.5 g
Potassium bromide	1.0 g
Sodium metaborate	45.0 g
5-Methylbenzotriazole	0.02 g
Water to make	1.0 liter

Eight grams of solution per square foot was then coated on a baryta-coated paper base. This layer was then overcoated with a silver bromoiodide emulsion (94.5 mole percent silver bromide and 5.5 mole percent silver iodide) containing 50 g of 1-phenyl-3-pyrazolidone and 320 g of sucrose per mole of silver at a coverage of about 475 square feet per mole of silver. The exposed paper was processed at 20 fpm by passing the paper over a metal surface heated at 200°C in a closed chamber processor. The maximum density was 1.65. Eight days' incubation at 120°F and 35% relative humidity had negligible effect (maximum density 1.60) on the coated paper.

Such an incorporated developer photographic material provides a heat-processed image that has a limited life when subjected to light or humid conditions. The photographic material should also contain a suitable stabilizing agent so the processed image will have a longer useful life. Precursors of stabilizing agents, suitable for emulsion incorporation, were patented by Wilbert J. Humphlett, Dee Lynn Johnson, and Grant Haist[135] for use in a heat-activated stabilization process. These inventors claimed "A substantially dry stabilization method which comprises heating, at a temperature in the range of about 200°F to about 400°F, an exposed photographic element comprising a photographic silver halide emulsion, and contiguous to said silver halide, at least about one mole per mole of said silver halide of a sulfur-containing compound which upon said heating forms a compound that combines with unexposed silver halide to form a silver mercaptide which is more stable to light than said silver halide." (See Figure 2.)

Suitable precursors for the stabilizing agents in this process included a number of isothiuronium salts having amino or substituted amino, carboxy, or hydroxy radicals on one end of the molecule containing the sulfur atom. Examples of such compounds have the following structures:

$$\overset{O}{\underset{\ominus O}{\diagdown}}C-R-S-C\overset{\overset{\oplus}{N}H_2}{\underset{NH_2}{\diagup}} \quad \text{or} \quad \left[HO-R-S-C\overset{\overset{\oplus}{N}H_2}{\underset{NH_2}{\diagup}}\right]X^-$$

In these general formulas R stands for a carbon chain of from one to five atoms, and X is a negatively charged ion, such as trichloroacetate. Suitable

Figure 2. Contact print made on an experimental paper containing both developing and stabilizing compounds in the emulsion layer. The exposed paper was thermally processed by contacting the back of the print for 30 sec on a metal platen heated to 180°C. The stabilized print has not changed in 15 years of room storage. (Grant Haist, Eastman Kodak Company)

precursors also include Michael adducts. An example of a compound of this type has the structure

Heating this last compound to about 200°F would cause the rupture of the sulfur-to-carbon bond to liberate mercapto acetic acid, a silver complexing agent.

A photographic paper support was coated with 3.5 ml of a concentrated medium-speed, gelatino-bromide emulsion in 20 ml of 10% pigskin gelatin combined with 2 g of betaine, and 2 g of 2-hydroxyethylisothiuronium trichloroacetate dissolved in 16 ml of water and 4 ml of acetic acid. Heating the back of the exposed light-sensitive paper for about 15 sec on a metal surface heated to 275°F produced an image that was insensitive to room light without further treatment.

In a continuation of the above approach, Haist, Humphlett, and Johnson next proposed that "the time required for stabilization could be improved when such stabilizers are used in combination with stabilization activator precursors of the invention."[136] The term "stabilization activator precursor" referred to compounds which are heat-cleavable above 90°C and which aid in the liberation of the active silver complexing agent from its precursor in order to form silver mercaptides to stabilize the image. Stabilization activator precursors are stable at temperatures normally encountered during storage of the photographic material but upon heating during processing provide a suitable environment, probably weakly alkaline, for rapid development and stabilization to occur.

Stabilization activator precursors include compounds such as guanidine salts—for example, diguanidinium glutarate, malonate, or succinate, amino acids (6-aminocaproic acid), and certain heat-cleavable hydrazide compounds such as isonicotinic acid hydrazide. In an example, a photographic paper support was coated at the coverage of 10 g/sq ft of the following composition:

Polyvinyl alcohol	48.0 g
Tertiary-butyl hydroquinone	3.1 g
4-Methyl-4-hydroxymethyl-1-phenyl-3-pyrazolidone	3.1 g
3-S-Thiuroniumpropane sulfonate	31.0 g
Diguanidinium oxalate	52.0 g
Ethyl alcohol	100.0 g
Water to make	1.0 liter

Over this layer was coated a silver chlorobromide emulsion with a coverage of 40 mg of silver per square foot and 120 mg of gelatin per square foot. After exposure, this two-layer coating was developed and stabilized in 2 sec when the coating was heated to 220°C.

The stabilization precursor, 3-S-thiuroniumpropane sulfonate, was claimed[137] as being superior to the precursors listed in the U. S. Patent 3 301,678. These precursors were said to "have not been found entirely satisfactory due to their obnoxious odor." However, compounds containing the sulfonate group, after heating, released odorless stabilizing mercapto compounds that formed clear, colorless silver complexes.

$$\overset{\oplus}{N}H_2 \diagdown$$
$$\qquad\qquad C-S-CH_2CH_2CH_2SO_3^- \xrightarrow{\text{heat}}$$
$$NH_2 \diagup$$
$$\qquad\qquad\qquad\qquad\qquad\qquad HSCH_2CH_2CH_2SO_3H + \text{other products}$$

$$HSCH_2CH_2CH_2SO_3H \xrightarrow[\substack{\text{activator} \\ \text{precursor}}]{} {}^-SCH_2CH_2CH_2SO_3H + H^+$$

$$Ag^\pm + {}^-SCH_2CH_2CH_2SO_3H \longrightarrow AgSCH_2CH_2CH_2SO_3H$$

Because of the acidic character of the sulfonic acid group, the stabilization activator precursors of U. S. Patent 3,531,285 were necessary to insure that the image was completely resistant to the aftereffects of heat, light, and moisture. In addition, three, five, sometimes 10 times the molar quantity of the stabilization precursor was required to stabilize one mole of silver halide.

Dry processing of silver halide may be carried out using a nonaqueous substance which is a solid at room temperature but, upon heating, forms a liquid solvent for incorporated developing agents.[138] Compounds such as acetamide, formamide, succinimide, and urea, or their mixtures, are examples of such solids that have melting points below 150°C. The developing agent and the silver halide emulsion may be coated with the nonaqueous compound and a film-forming binder (gelatin, polyvinyl alcohol, or ethyl cellulose). The following developing dispersion is first made:

1-Phenyl-3-pyrazolidone	120 g
n-Butylacetanilide	480 ml
Ascorbic acid	40 g
Potassium bromide	5 g
Gelatin (10% in water)	1860 g

The coating composition is prepared by making

Silver chloride–gelatin emulsion	37 g
Developing dispersion	50 g
Succinimide	13 g

A coating of this composition on film base (polyethylene terephthalate) was exposed and then heated on a hot shoe at about 300°F to develop the image.

A coating of this type is not completely inert to continued light exposure. Joseph Samuel Yudelson and Randall Edward Mack[139] found that organic halides can serve as a fixing bath, especially when heated in the presence of a nonaqueous solvent, such as succinimide. According to these inventors,

The organic halides are incorporated in a nonaqueous solvent which is solid at room temperature and has a melting point below 150°C. and a polymeric binder through which the melted solvent can diffuse. This mixture is coated as an image stabilization layer upon a light-sensitive photographic silver halide emulsion layer. The amount of organic halide used is preferably at least 0.5 mole per mole of silver halide in the material. The solvent is solid at room temperature and the complexing agents contained therein are inactive. Upon heating, the solvent melts and allows diffusion of the complexing agent into the photographic emulsion layer where it reacts with unexposed silver halide to cause stabilization.

The combination of succinimide and tetraethylammonium bromide or tetraethylphosphonium bromide when used as a stabilizing composition has an exceptionally low tendency toward bleaching the silver image. Succinimide forms a clathrate which is non-deliquescent with tetraethylammonium bromide or tetraethylphosphonium bromide, and thus fading is inhibited. Images stabilized with this composition do not fade as quickly as those fixed with alkali metal thiosulphates.

An example of this type of composition is

Succinimide	15.0 g
1-Phenyl-3-pyrazolidone	1.5 g
Sodium isoascorbate	2.5 g
Tetraethylammonium bromide	6.5 g
Water	15.0 g

This solution, dispersed in 93 g of 7% ethylcellulose in toluene, was coated over the gelatino–silver chloride emulsion layer of a photographic paper. The dried coating was exposed, then heated for 3 sec on a mandrel at 155°C. The developed image was unaffected by continued light exposure.

Other Dry Silver Stabilization Processes

The need for dry methods for photographic reproduction has spurred efforts in directions considerably different from the conventional stabilization of silver halide materials. In 1967 the Minnesota Mining and Manufacturing

Company (3M) introduced commercially the 3M Brand Dry Silver Paper, Types 771 and 777. The exact composition of Dry Silver Paper is not known nor is the mechanism of action understood, but the development of the product has been the subject of a number of patents.[140-146] Exposed Dry Silver Paper produces a good-quality print with a black image on an off-white background after heating for 5 sec at 135°C. The processed print is not completely resistant to environmental conditions but has a good practical life. The storage stability of the current paper before use is also limited, especially under conditions of high temperatures. 3M Dry Silver Films, Types 7842, 7889 and 7969, have been introduced.[147] They have good contrast with gamma 1.2 to 2.8 and maximum density between 1.6 and 2.0.

The light-sensitive element of Dry Silver Papers is silver bromide in intimate contact with silver behenate. Silver behenate is the silver salt of the 22-carbon saturated acid. Other silver salts of 18- and 20-carbon saturated acids may be present as well. This light-sensitive element might be considered to consist of a very minute quantity of the light detector, silver bromide, imbedded in a large particle of silver behenate that serves as a silver source. Upon exposure, the latent image formed by the silver bromide serves as a site for the deposition of silver from the silver behenate. To reduce the silver ions to metallic silver, a weak developing agent such as 2,2'-methylene-bis(4-methyl-6-*t*-butylphenol) is included in the coating. Another compound, 1(2H)-phthalazinone, is also required for obtaining blue-black images. Apparently, the phthalazinone acts as an electron-transfer agent between the hindered developing agent and the latent image site. Although not essential to the process, a considerable amount of behenic acid is also present, resulting in better image quality and lessened printout after processing. This chemical mixture, as well as a sensitizing dye, is coated in a polyvinylbutyral binder on the support, and a cellulose acetate overcoat is then added.

Modifications of the original dry silver composition have been proposed. Mary J. Youngquist[148] has patented the use of anhydro amino hexose reductone or anhydro dihydro amino hexose reductones for developing agents for this process. A bis-β-naphthol, such as

2,2'-dihydroxy-1,1'-binaphthyl

was proposed for use with a phthalimide toner

phthalimide

by Charles A. Goffe.[149] It was reported, "A combination of a bis-β-naphthol reducing agent, a gelatino silver halide emulsion, an alkylene oxide polymer and/or a mercaptotetrazole derivative in conjunction with a stable source of silver for physical development is useful in photosensitive elements for dry processing with heat." Heating was said to produce a stable developed image.

Another dry silver system has been disclosed that involves benzotriazolyl silver salts rather than conventional silver halides, although silver halides are used as the light-formed catalytic centers.[150–152] A patent assigned to Fuji Shashin Film Kabushi Kaisha[151] states that

Stable photographic images can be obtained by a dry process after exposure to an image, without the necessity of wet development and wet fixing, by employing a thermally developable light-sensitive element having at least one layer containing at least (a) silver benzotriazole, which is a light-sensitive and reducible organic silver salt, (b) a small amount of an inorganic halide capable of forming a light-sensitive silver halide by reaction with the silver benzotriazole, (c) a reducing agent, and (d) an organic acid or a salt thereof, which may also serve as the reducing agent. The photographic image formed by thermal development of such an element is stable and can be stored for a long period at a normal temperature even under white light without further processing such as fixing or stabilizing, but if the image formed by thermal development is stored under the severe conditions of a high temperature and a high humidity, the development proceeds gradually even though it is very slight and hence the background turns brown gradually.

This Fuji process consists of silver iodide as the light-sensitive element in intimate contact with silver benzotriazole, a source of reducible silver ions. The developing agent, such as L-ascorbyl palmitate, is capable of reducing silver ions from the silver benzotriazole upon the nuclei provided by the latent image of the exposed silver iodide. It is also claimed that the L-ascorbyl palmitate is destroyed by the action of ultraviolet light. A saturated straight-chain monocarboxylic acid having from 12 to 22 carbon atoms, or a dicarboxylic straight-chain acid having from 4 to 10 carbon atoms, was also present, presumably to react with any excess silver ions to form light-insensitive silver salts, improving both image quality and image stability.

After exposure of such a coating to visible light, the coating is heated from 1 to 10 sec at 110 to 160°C. The image is then subjected to ultraviolet radiation to destroy the developing agent and form the print.

In British Patent 1,191,919 a proposal is made to treat the thermally developed print in a solution containing an organic mercapto or thione compound. The stabilizing compound reacts with the small amount of silver halide remaining in the unexposed portions of the print, making the silver stable to light and ineffective as a catalyst for the reduction of silver ions from the silver benzotriazole. A permanently stable image was claimed to be provided by the stabilizing treatment. A 2-sec immersion in a 2.5% solution of 5-mercapto-1-phenyltetrazole in methanol was said to produce stable images, even though the print was again heated to the thermal development temperature originally used to form the image.

FIXING STABILIZATION PRINTS

Small stabilization processors make possible the rapid production of large numbers of high-quality photographic prints. Stabilized prints, however, may have an objectionable odor or touch to the fingers and are, of course, not permanent. Such stabilized prints should not be stored in contact with conventionally processed photographic materials, as chemical contamination can reduce the storage life of the permanent photo materials.

The rapid access to high-quality photographic prints has made the stabilization processor a valuable tool for the print maker. In fact, a surprisingly large number of users stabilize their prints first, then fix, wash, and often gloss to produce prints of conventional appearance and permanence. A suitable hardening, rapid fixing bath must be chosen, according to Lester Salerno,[153] to avoid sticking of the stabilized-then-fixed print to the dryer. He used a rapid fixing bath (Edwal Quick-Fix was his choice) for 2 min, a hypo eliminator bath for 3 min, and a 20-min water wash for double-weight prints before gloss drying. Other users of stabilization papers have indicated that fixing and washing of selected stabilized prints is a desirable method to insure greater image stability upon storage.

REFERENCES

1. F. M. Brown, L. L. Blackmer, and C. J. Kunz, "A System for Rapid Production of Photographic Records," *J. Frank. Inst.*, **242**: 203 (1946).
2. G. I. P. Levenson, "A Machine for Rapidly Processing Photographic Trace Recordings," *J. Sci. Instr.*, **27**: 170 (1950).

3. G. I. P. Levenson, "The Rapid Processing of Trace Recordings," *Funct. Phot.*, **1** (11): 10 (1950).

4. Alan Batley, Edward Roy Davies, and Gerald Isaac Pasternak Levenson, "Improvements in or relating to Processing Photographic Light-Sensitive Material," Brit. Pat. 647,922 (1950).

5. A. V. Holden, G. I. P. Levenson, and N. Wells, "Developers for Hot-Drum Processing Machines," *J. Sci. Instr.*, **28** (10): 318 (1951).

6. John H. Jacobs, "Stabilization," *Photo Methods for Industry (PMI)*, **4** (10): 41 (1961).

7. Grant Haist, "Stabilization," an article in *The Encyclopedia of Photography*, Vol. 19, Greystoke Press, New York, 1964, pp. 3511–3517.

8. "Stabilization," *Photo Methods for Industry (PMI)*, **8** (6): 49 (1965).

9. Eric Thomas Smith, "Improvements in or relating to Wringers," Brit. Pat. 800, 266 (1958).

10. Arthur H. Rosien, "Stabilization: A Time and Money Saver," *Ind. Phot.*, **14** (8): 40 (1965).

11. Hal Denstman, "Stabilization Processing," *Ind. Phot.*, **14** (8): 38 (1965).

12. Eric Thomas Smith, "Improvements in Photographic Processing Solutions," Brit. Pat. 776,082 (1957).

13. Tatsuya Tajima and Katsumi Hayaski, "Rapid Developing Photographic Materials Containing Arginine," U. S. Pat. 3,615,529 (1971).

14. Werner Berthold, Anita von König, and Helmut Timmler, "Stabilising Developed Photographic Silver Images," Brit. Pat. 1,293,622 (1972).

15. A. Bogisch, "Fixiren mit Sulfoharnstoff," *Phot. Arch.*, **34**: 310 (1893).

16. Josef Maria Eder, *Eder's Jahrbuch*, **8**: 413 (1894).

17. Nathan Sulzberger, "Process of Reducing the Sensitiveness of Silver Compounds and Products," U. S. Pat. 1,356,236 (1920).

18. Nathan Sulzberger, "Process of Desensitizing Photo-Sensitive Silver Compounds," U. S. Pat. 1,361,352 (1920).

19. H. D. Russell, E. C. Yackel, and J. S. Bruce, "Stabilization Processing of Films and Papers," *PSA J.*, **16B**: 59 (1950).

20. Lloyd E. Varden, "The Chemistry of Stabilization: A Review of Some Fundamentals," *Photo Methods for Industry (PMI)*, **8** (6): 28 (1965).

21. G. I. P. Levenson, "Stabilisation Processing," *Funct. Phot.*, **2** (3): 6 (1950).

22. G. M. Haist, J. R. King, and L. H. Bassage, "Organic Silver-Complexing Agents for Photographic Monobaths," *Phot. Sci. and Eng.*, **5**: 198 (1961).

23. William Lawrence Brice, Harold Daniel Russell, and Edward Carl Yackel, "Improvements in the Processing of Photographic Materials," Brit. Pat. 631,184 (1949).

24. Roman P. Dreywood, "Simultaneously Developing and Fixing Photographic Images," U. S. Pat. 2,525,532 (1950).

25. Grant M. Haist and James R. King, "Improvements in Photographic Processing Baths," Brit. Pat. 898,328 (1962); "Combined Developing and Stabilizing Solution," U. S. Pat. 2,875,048 (1959).

26. Wilbert J. Humphlett, Grant M. Haist, and James R. King, "Thiosugar Silver Halide Solubilizing Agents," U. S. Pat. 3,220,838 (1965).

27. A. A. Newman, "The Chemistry of Stabilisation Processing," *Brit. J. Phot.*, **114**: 1009 (1967).

28. J. Volhard, "Über einige Derivate des Sulfoharnstoffs," *J. Prakt. Chem.*, (2) **9**: 6 (1874). See pp. 14 and 15.

29. J. Waterhouse, "On the Reversal of the Negative Photographic Image by Thio-Carbamides," *Brit. J. Phot.*, **37**: 601 (1890).

30. S. O. Rawling, "Thiocarbamide Fog and a Suggested Explanation of Waterhouse Reversal," *Phot. J.*, **66**: 343 (1926).

31. T. H. James and W. Vanselow, "Relative Rates of Reaction of Silver Bromide with Adsorbed Monolayers of Derivatives of Thiourea," *J. Phot. Sci.*, **1**: 133 (1953).

32. T. H. James and W. Vanselow, "Kinetics of the Reaction Between Silver Bromide and an Adsorbed Layer of Allylthiourea," *J. Phys. Chem.*, **57**: 725 (1953).

33. T. H. James and W. Vanselow, "Thiourea as an Accelerator of the Solution and Development of Silver Halide Grains," *Phot. Sci. and Tech.*, (II) **3** (3): 69 (1956).

34. Shin Suzuki and Yasushi Oishi, "Effects of Some Organic Compounds on Zeta-Potential of Silver Bromide," *Phot. Sci. and Eng.*, **1**: 56 (1957).

35. Shin Suzuki and Tooru Kataoka, "Effect of Derivatives of Thiourea and Related Compounds on Zeta-Potential of Silver Bromide," *Phot. Sci. and Eng.*, **3**: 127 (1959).

36. James E. LuValle and Juanita M. Jackson, "The Zeta Potential of Silver Bromide in the Presence of Various Substances of Photographic Interest," *J. Phys. Chem.*, **61**: 1216 (1957).

37. V. N. Sintsov, "Application of Thiourea in Photographic Processes," *Zhur. Nauch. Prikl. Fot. Kinemat.*, **9**: 231 (1964) (in Russian).

38. *Beilsteins Handbuch der Org. Chem.*, "Thiocarbamid, Thioharnstoff, Sulfoharnstoff," 4th Edition, **3**: 186 (1921).

39. Rolf S. Bruenner, "Thiourea and Its Derivatives in Photographic Stabilization Processing," *Phot. Sci. and Eng.*, **4**: 186 (1960).

40. Steven Levinos and Willard C. Burner, "Stabilization Processing," *Phot. Eng.*, **2**: 148 (1951).

41. Steven Levinos and Willard C. Burner, "Photographic Stabilization Process," U. S. Pat. 2,696,439 (1954).

42. Willard C. Burner, "Stabilization Processing in Sea Water," *Phot. Eng.*, **4**: 27 (1953).

43. Christopher Lucas and Harvey Hodes, "Stabilization Processing with AFD-25, Acetic Acid, and Thiourea," *Phot. Sci. and Eng.*, **6**: 294 (1962).

44. K. I. Markhilevich, "The Reduction of Processing Time and Water Consumption Through Stabilization of Developed Images," *Zhur. Nauch. Prikl. Fot. Kinemat.*, **2**: 148 (1957) (in Russian).

45. Francis H. Gerhardt, John Proc, and Joseph Sottysiak, "Stabilization of Print-Out Emulsion Images," U. S. Pat. 2,930,692 (1960).

46. Kurt Wenske and Anna Warnke, "Improvements in or Relating to Simultaneously Developing and Fixing or Stabilizing Photographic Silver Halide Emulsions," Brit. Pat. 768,401 (1957).

47. Harold D. Russell, "Stabilization of Processed Photographic Emulsions to High Temperatures and Humidities," U. S. Pat. 2,453,346 (1948).

48. Harry Baines, "The Argentothiosulphuric Acids and Their Derivatives. Part I. The Preparation of the Sodium Salts and the Isolation of Monoargentomonothiosulphuric Acid," *J. Chem. Soc.*, p. 2763 (1929).

49. Henry Bassett and John T. Lemon, "The System $Na_2S_2O_3$-$Ag_2S_2O_3$-H_2O at 25°," *J. Chem. Soc.*, p. 1423 (1933).

50. L. F. A. Mason, *Photographic Processing Chemistry*, Focal Press, London and New York, 1966, p. 191.

51. H. D. Russell, "Procedures and Equipment for the Rapid Processing of Photographic Materials," *Phot. Eng.*, **2**: 136 (1951).

52. R. Gilliam Rudd, "A Porous-Platen Processor for Processing Photographic Materials in Room Light," *Phot. Sci. and Tech.*, (II) **1**: 9 (1954).

53. E. T. Smith, "Processing Systems for Autopositive Paper in Office Copying," *J. Phot. Sci.*, **10**: 43 (1962).

54. Geoffrey Broughton and Robert N. Woodward, "Rapid Processing of Photographic Materials," U. S. Pat. 2,614,927 (1952).

55. Ronald H. Miller and Martin A. Foos, "Photographic Processing Baths for Stabilization Processing," U. S. Pat. 3,271,153 (1966).

56. Kinji Ohkubo and Katsumi Hayashi, "Rapid Stabilization Process for Photographic Silver Halide Materials," U. S. Pat. 3,663,227 (1972).

57. M. Meynier, *Bull. soc. franc. phot.*, **9**: 13 (1863).

58. "A 'Fixing' Agent that Will Not Fix," *Brit. J. Phot.*, **22**: 277 (1875).

59. C. Welborne Piper, "Sulphocyanide Fixers and a New Observation on Fixing Baths," *Brit. J. Phot.*, **61**: 511 (1914).

60. Davanne and Girard, "On the Employment of Sulpho-cyanide of Ammonium," *Phot. News*, **7**: 210 (1863).

61. Vincent J. Occleshaw, "Phase-rule Studies of Metallic Thiocyanates. Part II. The Systems AgNCS-NaNCS-H_2O, AgNCS-KNCS-H_2O, and AgNCS-NH_4NCS-H_2O at 25°," *J. Chem. Soc.*, p. 2404 (1932).

62. "The Changing Stabilization Picture," *Photo Methods for Industry* (*PMI*), **10** (10): 60 (1967).

63. Herbert Müller, "Das Zweibadverfahren in der Praxis," *Photo-Tech. und Wirtschaft*, **18** (1): 17 (1967).

64. Établissements Bauchet, "Improvements in and relating to Process of Stabilizing Developed Photographic Materials with Silver Image Thereon," Brit. Pat. 936,117 (1963).

65. Fumihiko Nishio, Mitsunori Sugiyama, and Kintaro Nasu, "Method for Stabilizing Developed Photosensitive Materials," U. S. Pat. 3,326,684 (1967).

66. Andrew Witold Rak and Leslie Alfred Williams, "Improvements in Photographic Reproduction Processes," Brit. Pat. 1,139,063 (1969).

67. Agfa-Gevaert Aktiengesellschaft, "Stabilisation of Developed Photographic Silver Images," Brit. Pat. 1,249,277 (1971).

68. Fuji Sashin Film, "Photographic Stabilising Composition," Brit. Pat. 1,061,892 (1967).

69. William L. Brice, "Stabilization of Photographic Emulsions," U. S. Pat. 2,448,857 (1948).

70. John William Glasset and Frank Shirley Sutton, "Improvements relating to Photographic Processes and to Stabilising Solutions for Use in such Processes," Brit. Pat. 875,878 (1961).

71. Georges Bonjour, "Perfectionnements aux procédés de stabilisation des images photographiques," French Pat. 1,233,010 (1960).

72. David Harold Cole and Douglas James Fry, "Production of Photographic Prints," Brit. Pat. 1,004,301 (1965).

73. David Harold Cole and Douglas James Fry, "Photographic Emulsions," Brit. Pat. 1,004,302 (1965); "Photographic Material," Brit. Pat. 1,079,061 (1967); "Perfectionnements à la stabilisation d'images photographiques," French Pat. 1,373,500 (1964).

74. Anita von König, Werner Berthold, Armin Voigt, and Wolfgang Scharnke, "Process for Stabilising Developed Photographic Images," Brit. Pat. 1,186,441 (1970).

75. David Harold Cole and Douglas James Fry, "Production of Photographic Prints," Brit. Pat. 1,049,052 (1966).

76. David Harold Cole and Douglas James Fry, "Photographic Material," Brit. Pat. 1,049,054 (1966).

77. Eric Thomas Smith and Leslie Alfred Williams, "Stability of Rapid-Processed Photographic Prints," U. S. Pat. 3,137,574 (1964); "Nouveau procédé pour l'obtention d'une image argentique, composition de traitement utile pour la mise en oeuvre de ce procédé et images photographiques obtenues," French Pat. 1,273,601 (1961).

78. Fumihiko Nishio, Mitunori Sugiyama, and Kintaro Nasu, "Stabilizing Developed Silver Halide Emulsions with Heterocyclic Thiol Compounds," U. S. Pat. 3,627,531 (1971).

79. Jozef Frans Willems and Oskar Riester, "Stabilizing Silver Image in Presence of Heterocyclic Thioxo Compound Containing Sulphogroup," U. S. Pat. 3,645,738 (1972).

80. Werner Berthold and Anita von König, "Stabilisation of Developed Photographic Images," U. S. Pat. 3,623,872 (1971).

81. Jean Barbier and Jean-Pierre Fauchille, "Stability of Rapid-Processed Photographic Materials," U. S. Pat. 3,212,895 (1965).

82. Werner Berthold, Karl Frank, and Anita von König, "Process for the Stabilisation of Developed Photographic Images," Brit. Pat. 1,169,124 (1969); "A Thiocyanate Stabilizing Bath Containing Cyclohexanone Bisulfite," U. S. Pat. 3,615,514 (1971); "Procédé de production d'images photographiques stables," French Pat. 1,558,174 (1969).

83. Établissements Bauchet, "Procédé de stabilisation d'épreuves photographiques développées," French Pat. 1,239,429 (1960).

84. Kintaro Nasu and Katsumi Hayashi, "Method for Stabilizing Developed Photosensitive Materials," U. S. Pat. 3,239,340 (1966).

85. Nelson Seeley Case, "Silver Halide Stabilising Compositions," Brit. Pat. 1,255,750 (1971).

86. Kintaro Nasu, Tomiyasu Asai, Katsumi Hayashi, and Shunichirco Tsuchida, "Method for Stabilizing Developed Photosensitive Materials," U. S. Pat. 3,243,296 (1966).

87. Anthony Joseph Owen Axford and Frank Shirley Sutton, "Improvements in or relating to the Treatment of Photographic Emulsion Layers," Brit. Pat. 1,061,053 (1967).

88. David John Norman and Peter George Lungley, "Improvements relating to the Stabilisation of Developed Silver Halide Photographic Emulsions," Brit. Pat. 876,497 (1961).

89. Georges Schwienbacher and Klaus Pfister, "Process for the Rapid Stabilisation of Developed Photographic Layers," Brit. Pat. 867,242 (1961).

90. John William Glassett, Edward Whittaker, and Frederick Stanley Winter, "Improvements relating to Photographic Processes and Photographic Films," Brit. Pat. 1,138,087 (1968).

91. Theodore J. Kitze, Jr., and William J. Rosecrants, Jr., "Antistain Agents for Spectrally Sensitized Silver Halide Photographic Elements," U. S. Pat. 3,380,828 (1968); "Photographic Silver Halide Element for Use in Rapid Processing Systems," Brit. Pat. 1,149,493 (1969).

92. Theodore J. Kitze, Jr., "Optically Sensitized Photographic Element Containing a Developing Agent," U. S. Pat. 3,428,455 (1969); "Photographic Silver Halide Materials," Brit. Pat. 1,141,774 (1969).

93. Albert Edward Harris and Edward Cyril Dodd, "Photographic Silver Halide Emulsion Containing Finely Divided Inert Particles Dispersed in a Synthetic Colloid Medium

and a Silver Halide Developer," U. S. Pat. 3,352,682 (1967); "Nouveau produit photographique à développateur incorporé," French Pat. 1,551,591 (1968).

94. Henry Josef Fassbender, "Photographic Silver Halide Materials," Brit. Pat. 1,157,165 (1969).

95. Établissements Bauchet, "Procédé de reproduction photographique rapide," French Pat. 1,206,359 (1960).

96. Kenneth Charles Shipton, Richard Franklin Bulgin, Malcolm Smith, Anthony Malcolm Barnett, and Ilona Roza Dicker, "Photographic Silver Halide Materials," Brit. Pat. 1,258,906 (1971).

97. Wilhelm Kairies and Kurt Faber, "Photographic Silver Halide Stabiliser Bath," Brit. Pat. 1,293, 621 (1972).

98. Henry J. Fassbender and Nelson S. Case, "Photographic Stabilizing Baths Inhibited Against Corrosion with Polyalkylene Glycols," U. S. Pat. 3,667,951 (1972); "Photographic Processing Solution," Brit. Pat. 1,293,451 (1972).

99. Kintaro Nasu and Katsumi Hayashi, "Method for Stabilizing Developed Photosensitive Materials," U. S. Pat. 3,239,340 (1966).

100. Albert Edward Harris and Edward Cyril Dodd, "Process for Preventing Image Destruction in Thiocyanate-Stabilized Photographic Prints," U. S. Pat. 3,404,981 (1968).

101. Eric Thomas Smith and Guy William Willis Stevens, "Rapid Processing of Photographic Materials Including the Use of Phosphate Ions as Anti-Staining Agents," U. S. Pat. 3,132,943 (1964).

102. Kodak-Pathé, "Procédé pour l'obtention d'images argentiques, composition de stabilisation pour la mise en oeuvre de ce procédé et images photographiques obtenues," French Pat. 1,273,600 (1961).

103. Alan D. O'Neill and Edward A. Sutherns, "Photographic Compositions and Processes for Using Said Compositions," Can. Pat. 883,752 (1971).

104. Eric Thomas Smith and Edward Charles Timothy Samuel Glover, "Improvements in Photographic Processing Compositions," Brit. Pat. 1,030,495 (1966); "Nouvelle composition de traitement photographique et procédé de traitement des émulsions à noircissement direct," French Pat. 1,332,997 (1963).

105. A. R. Burkin, "Ultra-Rapid Processing of Photographic Materials," *Phot. J.*, **87B**: 108 (1947).

106. Kintaro Nasu, Tatsuya Tajima, and Takao Kano, "Ammonium or Alkali Metal Thiocyanate Rinse Solution for Stabilized Silver Photographic Images," U. S. Pat. 3,356,502 (1967); "Improvements in or relating to Photography," Brit. Pat. 1,061,606 (1967); "Traitement de produits photographiques," French Pat. 1,437,983 (1966).

107. Charles R. Dotson and Harold M. Campbell, "Rapid Access Photographic Process," U. S. Pat. 3,345,174 (1967).

108. Shunichiro Tsuchida, Tomiaki Miyata, and Michihiko Takahashi, "Water Wash for Stabilized Silver Halide Photographic Materials," U. S. Pat. 3,558,313 (1971); "Procédé pour stabiliser des matières photosensibles devéloppées," French Pat. 1,473,375 (1967); "Process for the Stabilization of Developed Light-Sensitive Materials," Brit. Pat. 1,103,806 (1968).

109. Henry J. Fassbender, "Stabilization of Photographic Prints with Thiocyanate," U. S. Pat. 3,615,489 (1971).

110. Harold D. Russell, "Stabilization of Photographic Prints with Thiophenols," U. S. Pat. 2,453,347 (1948).

111. Roman P. Dreywood, "Simultaneously Developing and Fixing Photographic Images," U. S. Pat. 2,525,532 (1950).

112. G. M. Haist, J. R. King A. A. Rasch, and J. I. Crabtree, "Photographic Processing in Metal-Ion–Chelate Systems," *Phot. Eng.*, **7**: 182 (1956).

113. Grant M. Haist and James R. King, "Combined Photographic Developing and Stabilizing Solution," U. S. Pat. 2,875,048 (1959).

114. Donald E. Sargent, "Process of Rendering Undevelopable the Silver Halides Present in an Outer Layer of Multilayer Color Film," U. S. Pat. 2,636,821 (1953).

115. Christopher Lucas, "Monobaths for Photographic Processing," U. S. Pat. 3,512,980 (1970).

116. Christopher Lucas, "A Four Second Monobath," *Phot. Sci. and Eng.*, **10**: 259 (1966).

117. Nederlandsche Fotografische Industrie N. V., "A Stabilizing Bath for Photographic Materials," Brit. Pat. 1,063,134 (1967).

118. Fritz Nittel, Hans Öhlschläger, and Karl-Wilhelm Schranz, "Photographic Stabilising or Fixing Bath," Can. Pat. 883,754 (1971).

119. Fritz Nittel, Hans Öhlschläger, and Karl-Wilhelm Schranz, "Bath for Stabilising or Fixing Photographic Images," Brit. Pat. 1,265,886 (1972).

120. Maria Scheibitz, Hans-Joachim Kabbe, Anita von König, Johannes Götze, and Edith Weyde," Process for Stabilizing Silver Images," Can. Pat. 905,191 (1972).

121. Scheuring S. Fierke and Cyril J. Staud, "Development of Photographic Emulsions," U. S. Pat. 2,410,644 (1946).

122. E. W. Jackson, "A Self-Processing Camera for the Rapid Production of Photographic Negatives," *Brit. J. Phot.*, **97**: 55 (1950).

123. Leonard R. Sainsbury, Francis J. Farren, and Alan S. Grant, "Processing Photographic Paper and Film," U. S. Pat. 2,706,157 (1955).

124. Marilyn Levy, "Rapid Photographic Processing System," Can. Pat. 764,918 (1967).

125. Arthur H. Herz and Norman W. Kalenda, "Photographic Silver Halide Emulsions Containing Thioether Derivatives as Antifoggants and Stabilizers," U. S. Pat. 3,140,178 (1964).

126. Ralph Connor, "Organic Sulfur Compounds," in *Organic Chemistry*, 2nd edition, edited by Henry Gilman, John Wiley & Sons, New York, 1945, Vol. I, p. 841.

127. M. Feroroňko and P. Zuman, "Polarography of Urea and Thiourea Derivatives. XIII. Kinetics of Base Catalysed Decomposition of S-Substituted Thioureas in Alkaline Solution," *Coll. Czeck. Chem. Comm.*, **29**: 2115 (1964).

128. D. G. Dickerson, Private Communication.

129. Arthur Herman Herz and Norman Wayne Kalenda, "Improvements in or relating to Silver Halide Photographic Materials," Brit. Pat. 1,019,222 (1966): "Photographic Emulsions Containing Isothiourea Derivatives," U. S. Pat. 3,220,839 (1965).

130. Arthur Herman Herz and Norman Wayne Kalenda, "Improvements in or relating to Silver Halide Photographic Materials," Brit. Pat. 1,019,223 (1966).

131. Richard Franklin Bulgin, "Photographic Silver Halide Materials," Brit. Pat. 1,255,655 (1971).

132. Grant M. Haist, James R. King, and David A. Pupo, "Stabilization of Silver Halide Emulsions with 1,1-Bis-Sulfonyl Alkanes," U. S. Pat. 3,647,453 (1972).

133. John V. Baccoli, Jr., "A Short History of Stabilization Processing," *SPSE News*, **8** (2): 9 (1965).

134. Paul Harold Stewart, George Earle Fallesen, and John Watson Reeves, Jr., "Improvements in Photographic Processes and in Photographic Sensitive Materials therefor," Brit. Pat. 930,572 (1963).

135. Wilbert J. Humphlett, Dee Lynn Johnson, and Grant M. Haist, "Process for Stabilizing Photographic Images with Heat," U. S. Pat. 3,301,678 (1967); "Stabilising Photographic Emulsions," Brit. Pat. 1,113,603 (1968); "Nouveau procédé pour stabiliser des images photographiques," French Pat. 1,443,441 (1966).

136. Grant Milford Haist, Wilbert Jeptha Humphlett, and Dee Lynn Johnson, "Activator Precursors for Stabilizers for Photographic Images," U. S. Pat. 3,531,285 (1970); "Nouvelles compositions de stabilisation utilisables en photographie," French Pat. 1,566,285 (1969).

137. Grant M. Haist and Donald M. Burness, "Dry Stabilization of Photographic Images," U. S. Pat. 3,506,444 (1970); "Dry Stabilization of Photographic Images," Can. Pat. 886,511 (1971).

138. Joseph Samuel Yudelson, "Method and Materials for Photographic Processes," Brit. Pat. 1,131,108 (1968); "Non-aqueous Silver Halide Photographic Process," U. S. Pat. 3,438,776 (1969).

139. Joseph Samuel Yudelson and Randall Edward Mack, "Photographic Process," Brit. Pat. 1,175,106 (1969).

140. David Alan Morgan, "Article photosensible notamment en ferme de feuille et son procédé de fabrication," Belg. Pat. 663,112 (1965).

141. David P. Sorensen and Joseph W. Shepard, "Print-Out Process and Image Reproduction Sheet Therefor," U. S. Pat. 3,152,904 (1964).

142. David A. Morgan and Benjamin L. Shely, "Sensitized Sheet Containing an Organic Silver Salt, a Reducing Agent and a Catalytic Proportion of Silver Halide," U. S. Pat. 3,457,075 (1969).

143. Wesley R. Workman, "Reactive Copying Sheet and Method of Using," U. S. Pat. 3,446,648 (1969).

144. Minnesota Mining and Manufacturing Company, "Transparent Heat-Developable Photosensitive Sheet Material," Brit. Pat. 1,261,102 (1972).

145. Edgar E. Renfrew, "Light-Sensitive, Heat Developable Copy-Sheets for Producing Color Images," U. S. Pat. 3,531,286 (1970).

146. Burt K. Sagawa, "Copy-Sheet," U. S. Pat. 3,547,648 (1970).

147. G. E. Chutka and J. B. Gergen, "New Dry Process Photographic Systems: Progress Report," *Unconventional Photographic Systems, Symposium III*, Society of Photographic Scientists and Engineers, Washington, 1971, p. 7.

148. Mary J. Youngquist, "Photosensitive and Thermosensitive Elements, Compositions, and Processes," U. S. Pat. 3,679,426 (1972).

149. Charles A. Goffe, "Element, Composition, and Process," U. S. Pat. 3,666,477 (1972).

150. Kinji Ohkubo, Takao Masuda, and Junpei Noguchi, "Thermally Developable Light-Sensitive Elements," U. S. Pat. 3,645,739 (1972); "Thermally Developable Light-Sensitive Elements," Brit. Pat. 1,161,777 (1969); "Improvements in or Relating to Thermally Developable Light-Sensitive Elements," Brit. Pat. 1,205,500 (1970).

151. Kinji Ohkubo and Takao Masuda, "Procédé de stabilisation des éléments photosensibles développables par la chaleur," French Pat. 1,567,962 (1969): "Stabilisation Processing of Light-Sensitive Elements," Brit. Pat. 1,191,919 (1970).

152. Fuji Shashin Film Kabushiki Kaisha, "Improvements in or relating to Light-Sensitive, Heat-Developable, Photographic Material," Brit. Pat. 1,163,187 (1969).

153. Lester Salerno, "Stabilizing Stabilization Prints," *Photo Method for Industry* (*PMI*), **11** (11): 55 (1968).

Chapter 6
Incorporated Processing Chemicals

The presence in the immediate neighborhood of the light-sensitive silver-halide microcrystals of the developing substances can promise certain practical advantages, among which are simplification and acceleration of the processing of the resulting photographic layers.

N. I. KIRILLOV[46]

H. T. Anthony has been credited[1,2,3,4] with being the first to use ammonia fumes to increase the sensitivity of early dry plates and photographic paper. Fuming with ammonia could be done either before or after exposure. The photographic materials of that photographic era often contained preservatives, such as tannin, gallic acid, pyrogallol, even honey, or other reducing substances.[5] When exposed dry plates containing this type of reducing agent were treated with ammonia fumes, the latent image on the plate became visible immediately. "Dry" development with ammonia fumes was studied extensively in the early 1860s but particularly by John Glover[6] and Alfred Verity.[7] The results given by the ammonia-vapor treatment were uncertain, depending upon the amount of moisture in the plate.[8] Thomas M. Leahy[9,10] proposed the use of an ammonia solution for dependable development, the

ammonia being considered the developing agent by Leahy[11] but not by others.

The presence of developing agents within the light-sensitive layer is really as old as photography, for both the Rev. J. B. Reade and W. H. Fox Talbot[12] had found gallic acid to be beneficial within the emulsion layer of the very first photographic materials. But the activation, either by gaseous or aqueous ammonia, of the developing agents in the dry plate materials of the 1860s pointed out the advantages of incorporated processing chemicals in the light-sensitive layer. By 1886 pyrogallol was being added as a developing agent directly to the emulsion layer, or the unexposed plate was bathed in a pyrogallol solution then dried before use.[13] Alkaline activation of the developing agent made photographic development faster, simpler, and more convenient. Yet, since that time, only a very, very few systematic, scientific articles have been published on the nature of incorporated chemical processing. Almost all of the available disclosures have been in the form of patents, indicating the commercial importance that has been attached to this field by the various investigators.

In 1895 M. Petzold[14] placed the developing agent and bisulfite on the back of the plate, then developed the exposed plate in an aqueous alkaline solution. In 1900 Otto Böhrer[15] put the developing agents, such as hydroquinone, pyrogallol, *p*-aminophenol, or Eikonigen, within the emulsion layer, then activated the exposed material with potassium carbonate–sodium sulfate solution. Plates containing developing substances were introduced commercially by Frederich Bayer and Co.[16,17] and by C. R. Bernauer[18] in 1903. Dry photographic emulsion layers were bathed in solutions of developing substances, then dried before use. This technique allowed acetone–sodium sulfite to be introduced into the emulsion layer without the crystallization of the sulfite. Kelly and Bentham secured Russian Patent 16,604 in 1905, covering the coating of the base of photographic plates with a layer containing the developing agents, potassium metabisulfite, and alkali. When such an exposed plate was immersed in only water, the latent image on the plate was developed because of the diffusion of the processing chemicals from the base to form an active developing solution.

These early attempts demonstrated that rapid and simple development were possible with photographic materials containing developing substances. Practical difficulties in this form of simplified processing were also evident. Developing agents were often unstable in the coated layer in the presence of the oxygen of the air. The considerable amount of sulfite as a necessary preservative often resulted in the crystallization of this compound within the emulsion layer, producing an increase in image fog. In 1924 Raphael Eduard Liesegang[19] avoided the use of sulfite by adding developing substances with organic or inorganic acids or acid salts (except sulfuric acid). Develop-

ment of such photographic materials was activated by alkaline baths or ammonia fumes. The silver halide coating containing the developing agent was said to be stable when the acids or acid salts were present. Freedom from sulfite in the emulsion layer permitted tanned images to be formed.

Treatment by ammonia fumes was also proposed[20] for a fine-grained emulsion, such as a modified Lippmann type, containing "any of the customary developing agents such as hydroquinone, Elon, Amidol, *p*-phenylenediamine, etc." As an example, 12 g of hydroquinone and 6 g of sodium sulfite were added to four liters of a 4% gelatin-water solution containing 220 g of silver bromoiodide. After coating and drying, the exposed sensitive material containing the developing agents was "subjected to the action of alkaline vapors for a sufficient length of time to produce a visible image in the sensitive layer. We prefer to use ammoniacal vapors for this purpose, such as the vapors produced by heating a solution of ammonium hydroxide. In using ammonia the exposed layer may be subjected to the action of the vapor of a 10% ammonia solution at 40°C for approximately one minute. A 33% solution of methylamine or a 25% solution of ethylamine in water may also be employed, these solutions also being heated to about 40°C and the vapor is allowed to act on the exposed emulsion for about one minute. The strength of the ammonia in the vapors should be such as is obtained by heating 10 cc. of the solutions to the temperatures indicated and confining the vapors to a volume of about 35 cu. inches." Development was stopped by the action of acid vapors, for example, hydrochloric acid vapors arising from a 37% solution at 20°C, for approximately 30 sec, preventing further development and completing the processing.

Activating emulsion layers containing developing agents with alkaline vapors requires a special closed container which may be inconvenient to use in practice. To eliminate the need of this special apparatus, S. S. Fierke and C. J. Staud[21] proposed and patented the incorporation of a nitrogen compound capable of generating an amine in the silver halide layer with the developing agent, then treating the exposed material with steam or water vapor. The nitrogen compound capable of yielding ammonia or an amine was claimed not to cause development in the dry state but to be activated in the presence of water. Water-insoluble amines were preferred, being dissolved in a water-insoluble but water-permeable organic solvent. The solvent was dispersed as very fine droplets in the emulsion layer. It was said that "When incorporated in this way, the water-insoluble amines do not react on the silver halide until they are released by the action of the steam and the emulsion may, therefore, have a greater speed than when the water-soluble amines are incorporated directly in the emulsion. When the emulsion is acted upon by steam, the amine is released from the solvent by what amounts to steam distillation, and thereby increases the

alkalinity of the emulsion to the point where development of the layer is produced."

Water-insoluble amines, including benzylamine, *n*-heptylamine, and di-isoamylamine, were dissolved in water-insoluble, water-permeable solvents such as butyl phthalate, butyl benzoate, ethyl sebacate or tri-*o*-cresyl phosphate. Water-soluble amines, such as ethanolamine, guanidine hydrochloride, formamide, urea, and others, were also used as alkali generators within the emulsion layer upon activation with steam. Ammonia or amines were generated according to the following reactions:

$$2 \underset{\underset{NH_2}{\diagdown}}{\overset{\overset{NH_2}{\diagup}}{C}{=}O} \xrightarrow{\text{steam}} NH_3 + \underset{\underset{\underset{\underset{NH_2}{\diagdown}}{C{=}O}}{\underset{NH}{\diagup}}}{\overset{\overset{NH_2}{\diagup}}{C}{=}O}$$

urea ammonia biuret

$$(CH_3)_4NI \xrightarrow{\text{steam}} (CH_3)_3N + CH_3I$$

tetramethyl ammonium trimethyl methyl
iodide amine iodide

To stop the continued development that would occur in the alkaline emulsion layer upon light exposure, the vapors of hydrochloric acid may be used, or the residual silver halide treated with a solution of 10% potassium iodide. Dispersal of organic iodides in the emulsion layer or the adjacent layers was also proposed. Upon heating with steam, the iodide was said to be driven out of the dispersed particles, reacting then with the undeveloped silver halide to form an image of silver iodide with low sensitivity to light exposure.

Other methods have been suggested for increasing the permanence of images produced by incorporated-developer emulsion layers. In a patent, I. G. Farbenindustrie[22] proposed putting the developing agent in the silver halide emulsion layer and then causing developing and fixing to occur in an alkaline fixing bath that may also contain neutral salts such as Glauber's salt. A more rapid and a more complete washing was said to be possible than when acid fixing baths were used. In another patent, Jakob Degenhart[23] made a light-sensitive material consisting of three layers: (1) near the base a layer containing a fixing substance, (2) an intermediate layer containing a development-inhibiting substance, such as potassium metabisulfite, and (3) on top a light-sensitive layer with developing substances present. Simultaneous development and fixation occurred when the exposed material was immersed in sodium hydroxide solution.

A proposal similar in result was suggested by Georges Barthelémy[24] in

1954. Any of the usual developing agents were incorporated in the emulsion layer, adjacent layers, or in the base, if absorbent. Sodium sulfite, potassium bromide or 6-nitrobenzimidazole was also added, but no alkali could be present because of the premature reduction of the silver salts that would occur. The exposed material was then processed in an aqueous solution of an alkali, such as 1% sodium hydroxide, and a fixing agent, such as 15% sodium thiosulfate pentahydrate. Ten to 30 sec, 20°C, was said to be sufficient to treat a chlorobromide paper containing hydroquinone and sodium sulfite in the emulsion layer. As early as 1938 Agfa manufactured a photographic recording paper (Copex-Autorapid) containing developing substances. Processing was carried out rapidly in sodium hydroxide–sodium sulfite solution.

A patent[25] in 1940 stated that the light-sensitive layers containing developing substances may deteriorate during storage, a situation that has limited the usefulness of such materials. An organic compound called an emulsion stabilizer which prevents fog was added to the light-sensitive layer containing the developing agents. Either 0.1 g of 2,6-dimercapto-4-keto-3,5-diphenylpenthiophene or 1 g of nitrobenzimidazole added to one liter of silver halide emulsion was said to prevent the general gray or dichroic fog that resulted when an emulsion layer containing developing substances was treated in highly caustic solutions such as 1% sodium hydroxide. This combination of light-sensitive material with caustic processing achieved "rapid development free from fog of layers which are stable in storage."

The incorporation of developing agents into photographic layers has exhibited certain disadvantages. Water-soluble developing agents are easily added to the emulsion composition, but these active reducing agents react during storage with the oxygen of the air, resulting in lessened activity and staining upon alkaline treatment. Soluble developing agents are free to migrate through the coated layer, often resulting in a nonuniform distribution. Less soluble developing agents are less likely to be as reactive or mobile, but difficulties are encountered in obtaining an even distribution of the developing agent in the emulsion layer. The particles of the developing agent may be sheared to a very small size in a colloid mill, then suspended in the emulsion composition. Alternatively, the compound of low water solubility may be dissolved in a water-insoluble crystalloidal solvent, then dispersed as extremely small droplets throughout the emulsion. The solvent has a high boiling point and is retained in the emulsion. Milled dispersions of developing agents often are not uniform and add to the graininess of the photographic image, and the developing substances may lose some of their developing activity during the milling and coating operations. Developing agents dispersed in oily solvents soften the emulsion layer and often exhibit low stability upon storage. (See Figure 1.)

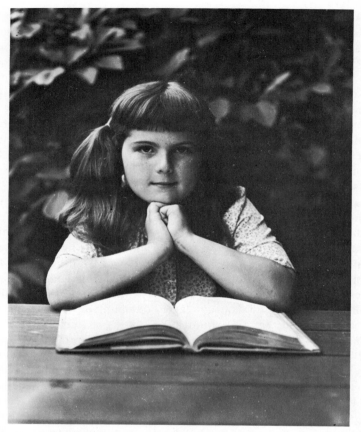

Figure 1. **Proof contact print of negative of Lynne Haist made on experimental photographic paper containing both developing and fixing compounds in the emulsion layer. The exposed paper was immersed for 10 sec in a simple alkaline activator at 75°C, then washed briefly in water. Print is 11 years old. (Grant Haist, Eastman Kodak Company)**

INCORPORATION OF DEVELOPING AGENTS

The introduction of 3-pyrazolidones, especially Phenidone, into emulsion layers has been the concern of a number of modern patents. Glay M. Hood and Paul R. Crookshank[26] added from 0.2 to 2.0 g of the 3-pyrazolidone per mole of silver nitrate used to make the silver halide. The developing agent was added, preferably, just after the final digestion and just before coating. When processed in the normal developing solution, the coated emulsion developed much more quickly, especially if the silver halide of the

emulsion was of a normally slow developing type. Enhanced developing action may be had by incorporating a development promoter, such as a tetronic acid, in the emulsion layer with the 1-phenyl-3-pyrazolidone.[27]

Much larger quantities of 3-pyrazolidones ranging from 7 to 80 g/mole of silver in the emulsion were proposed by Anthony J. Axford.[28] With ordinary exposure the photographic material with the incorporated developing agent could be processed in an aqueous solution of 2% sodium hydroxide and 5% sodium sulfite for 5 sec to yield a stainfree image. With a 10-sec ultraviolet exposure, a strong printout image is obtained directly, the density of the image being roughly proportional to the quantity of the 3-pyrazolidone present in the emulsion layer.

Hydroquinone, catechol, and pyrogallol were commonly used developing agents for incorporation in the emulsion layer, but fogged or stained images often resulted from their presence. Stainfree images could be obtained, according to Edward B. Knott,[29] if hydroquinone was incorporated in a photographic emulsion at a pH of 6.0 when a resin was dispersed in the emulsion. The substantially water-insoluble resins included hard and soft shellacs, glyptal resins, gum mastic, dammar, and others. Another approach was to increase the stability of the developing agent by making derivatives of the various phenolic developing substances.[30] Cyclohexyl, tertiary butyl, and dodecyl groups were added to the ring of di- or trihydroxy benzenes or to aminophenols. Increasing the molecular weight of the developing agent usually decreases water solubility of the compound which may require that the developing agent be dissolved in a solvent, then dispersed as tiny globules in the emulsion layer. This procedure has been used for incorporating derivatives of catechol and hydroquinone[31] or other substituted catechols and hydroquinones.[32] The water-insoluble developing agent may be mixed with a film-forming polymer in a common solvent, then this solution dispersed in the gelatin emulsion layer and the solvent removed.[33] The presence of a dispersion makes it difficult to obtain thin, hard layers, so Albert C. Smith, Jr.[34] avoided this difficulty through the use of gentisic acid and various 3-pyrazolidones as a water-soluble combination. From about 25 to 75 g of gentisic acid and from about 1 to 25 g of a 3-pyrazolidone were added per mole of silver in the emulsion composition.

Incorporation of Developing-Agent Precursors

The conventional methods of adding developing agents still have serious disadvantages. One modern approach has been to use a water-soluble developing agent but to chemically inactivate it to render it less susceptible of reaction while the photographic material is in storage. During processing of the photographic material, however, the developing agent is converted

into an active reducing agent for forming the silver image. The developing agent is rendered less active by chemically blocking or masking the active functional groups of the developing agent. These chemically modified developing agents are called developing-agent precursors. Developing-agent precursors are often water soluble, but the less soluble compounds may require dispersion in suitable solvents and colloidal milling. Usually, treatment of the developing-agent precursor, such as with an alkaline solution, results in the formation of the active developing agent.

Hydroquinone is the principal developing agent used to build contrast in the developed image. Along with catechol and pyrogallol, hydroquinone tans or hardens the gelatin in the areas of development. For these and other reasons, polyhydroxybenzenes would be desirable as incorporated developing agents in the emulsion layer or in layers contiguous to it. Blocking these compounds is necessary if oxidation is to be prevented while the developing agent is in the coated material. For hydroquinone, one method[35] involves forming "a hydroquinone silver halide developing agent precursor wherein at least one of the hydroxyl groups of said hydroquinone has been esterified to form a hydrolyzable, halogenated aliphatic acyloxy radical," to quote from U. S. Patent 3,246,988. For example, one or both of the —OH groups may be converted to $-O-C{\overset{O}{\underset{\|}{}}}-R$, where R may be methyl, ethyl, or propyl groups containing one, two, or three chloro, bromo, or fluoro substitutions.

hydroquinone precursor of hydroquinone
 hydroquinone

Some developing-agent precursors have sufficient solubility to be added in solution to the emulsion or the gelatin solution before coating. For example, *p*-chloroacetoxyphenol can be dissolved in a 1 : 1 solution of water and methanol. Many precursors, however, are not of sufficient solubility under aqueous conditions. In this case, according to U. S. Patent 3,246,988, "a developing agent precursor can be made up as an oil dispersion by stirring a solution of 10 grams of the developing agent precursor into 40 grams of warm tricresyl phosphate, and then mixing this solution with 100 grams of a 10 percent aqueous gelatin solution containing 10 cc. of a

5% aqueous solution of an alkylnaphthylene sodium sulfonate wetting agent. The resulting dispersion can then be homogenized by passing for 5 times through a colloid mill to produce a homogeneous colloid dispersion."

The photographic developing-agent precursor may be contained in the emulsion layer or in a contiguous layer, or both. After exposure the coated material may be developed by merely treating with an alkaline activator bath. For example, an aqueous solution of 1% sodium hydroxide and 5% sodium sulfite developed the exposed coating in 30 sec when the solution temperature was 68°F. The same time and temperature were sufficient when the aqueous solution contained 4% sodium carbonate and 5% sodium sulphite. Higher solution temperatures required only a few seconds for development.

Iodohydroquinones have been prepared that contain an "alkaline splittable protecting group" on each hydroxyl.[36] These protecting groups prevent undesirable effects upon storage of the emulsion containing the developing agent, and the groups split off in alkaline solution to yield free hydroquinone. Upon development in sulfite solution, it has been proposed that iodide ion is also released.

Reduced contrast and increased edge effects with little or no loss in effective emulsion speed are claimed from the release of the development inhibitor— that is, iodide ion. Among suitable alkaline splittable protecting groups are acetyl, mono-, di-, or trichloroacetyl and mono-, di-, or trifluoroacetyl. Other substituted hydroquinones have also been used as incorporated agents that release development inhibiting substances. In U. S. Patent 3,379,529 is a description of the chemical combination of a development inhibitor such as 1-phenyl-5-mercaptotetrazole, with a free or chemically blocked hydroquinone.[37]

Other methods[38] have also been used to form a development precursor from hydroquinone. One or both of the hydroxyl groups have been modified to include an ammonium group, as, for example,

Developing-agent precursors have also been formed from hydroquinone and catechol by the chelation of an atom of lead, calcium, or cadmium, with catechol or with hydroquinone having a group attached to the carbon adjacent to the hydroxyl group.[39]

Aminophenols may also be converted to developing-agent precursors. One method[40] has been to make the *N*-acyl derivative of aminophenol, such as

Metol precursor of Metol

The chemical modifications possible are essentially those previously de-scribed in U. S. Patent 3,246,988. Another chemical method[41] for providing *o*- and *p*-aminophenols or *p*-phenylenediamines with satisfactory stability to oxidation when incorporated in the emulsion layer has been to substitute at least one of the amino groups with a methane phosphonic acid group. An example of this method of forming developing-agent precursors may be represented by the following:

p-aminophenol precursor *p*-aminophenol

Improved storage life, less fog, and higher sensitivity were claimed[42] for light-sensitive silver halide layers that contained "ortho- or para-amino-phenol derivatives or ortho- or para-naphthol derivatives having a 2-carbon chain bridged between the amine groups of two such compounds and having a phosphonic acid group or an aryl-sulfonyl group substituted on each carbon of the branch." One developing-agent precursor of this type would have the structure

p-Phenylenediamines are the developing agents customarily used to form dyes in color film emulsion layers. Incorporation of a *p*-phenylenediamine within the photographic material would possess desirable advantages over the conventional use of this agent in the color developer solution. An emulsion layer having a *p*-phenylenediamine incorporated in it is unstable, owing to reaction with the silver halide. Certain indoaniline dyes of the general formula

may be dispersed in a solvent, such as diamylphenol, in the gelatin of the emulsion layers. Upon treatment with alkaline solution, the developing-agent precursor in the solvent cleaves to form an active *p*-phenylenediamine developing agent. The *p*-phenylenediamine is then free to react with color-forming compounds to form nondiffusible dyes.[43]

Developing-agent precursors of *p*-phenylenediamines or *p*-aminophenols can also be formed by reacting the developing agent with a salicylaldehyde

to form compounds called Schiff's bases.[44] Examples of such developing-agent precursors are

C_2H_5 C_2H_4OH
N

N
‖
CH— (ring)
O
H

H
O

N
‖
CH— (ring)
O
H

N-ethyl-N-(β-hydroxyethyl)- 4-salicylidene aminophenol
4-salicylidene amino aniline

The Schiff-base type of developing-agent precursor has been claimed to have a high resistance to oxidation and good stability in photographic layers, yet to cleave very rapidly in aqueous alkaline solution above pH 9 to yield active developing agents. The precursor form is said to have reduced allergenic and toxic properties. Color development may be activated by an alkaline activator solution consisting of 5 g sodium hydroxide, 10 g sodium carbonate monohydrate, and 10 g sodium sulfite (desiccated) in one liter of water.

PROPERTIES OF MATERIALS WITH INCORPORATED CHEMICALS

Very little has been published on any systematic investigation of the characteristics of emulsion layers containing developing substances. (See Figure 2.) However, the continued flow of patents since the turn of the century would indicate a widespread interest with an awareness of the commercial implications of photographic materials incorporating processing chemicals. The work of many investigators has been obscured by the cryptic legal language used to define the working of an invention for a patent without any elaboration on the special properties that are characteristic of incorporated chemical photographic layers.

Several Russian investigators have published their results of laboratory investigations of adding developing agents to the emulsion layer. One study was published in a Russian journal[45] and summarized by one of the authors in a book in English.[46] The developing agents were first dissolved in a solution containing sodium sulfite and lactic acid, citric acid, or tartaric acid. The solution containing the developing agents was either added directly

to the emulsion composition before coating or used to bathe the coated light-sensitive material. Both methods were reported to be satisfactory, but it was found more desirable and convenient to add the developing-agent solution to the emulsion before coating.

Hydroquinone was selected from a number of developing agents tested, including Amidol, p-aminophenol, Metol, pyrogallol, and others. Below pH values of about 8, hydroquinone is relatively inactive, thus avoiding any premature reduction of the silver during the heating of the emulsion before coating. Lower-than-normal coating temperatures were used. The presence of the developing agents in the emulsion composition lowered its normal viscosity, requiring the addition of more gelatin before coating. To the fine-grain, high-contrast ammoniacal emulsion of a positive film was added a solution of hydroquinone consisting of (calculated on the basis of 1 kg of emulsion):

Sodium sulfite (anhydrous)	3.6 g
Hydroquinone	11.5 g
Lactic acid (40%)	5.0 ml
Distilled water	100.0 ml

The emulsion layer containing the developing substances could be developed in sodium or potassium carbonate, sodium hydroxide, aluminate, or chromite solutions. When no sodium sulfite was present, the developed image had a brown color and the processing solution darkened rapidly. For developing the positive film containing hydroquinone in the emulsion layer, using machine development with continuous replenishment, the following aluminate activator was formulated:

	Activator Solution	Replenishing Solution (10 ml/m^2)
Potassium alum (crystalline)	40 g	40 g
Potassium hydroxide (or an equivalent amount of sodium hydroxide)	42 g	50 g
Sodium sulfite (anhydrous)	40 g	45 g
Hydroquinone	1 g	—
Potassium bromide	2 g	—
Water to make	1 liter	1 liter

Figure 2. The incorporated chemical film contained both the developing and stabilizing compounds in the silver chloride emulsion layer: (a) the shadowed replica of the emulsion grains (15,000 ×), (b) the form of the processed silver of a maximum density area (22,500 ×). Processing consisted of heating the back of the photographic material for 15 sec at 160°C, causing both development and stabilization to occur. (Grant Haist, Eastman Kodak Company)

(b)

Figure 2. (continued)

Both hydroquinone and oxidized hydroquinone are leached from the photographic layer and pass into the activator solution during processing. Sodium sulfite was necessary to react with the oxidized hydroquinone. A small amount of hydroquinone is present initially in the activator composition for machine processing in order to help establish an equilibrium solution from the very start of processing. The continued removal of some of the hydroquinone from the emulsion layer during the processing does not require that hydroquinone be present in the replenisher solution. For ordinary nonmachine activation, hydroquinone need not be present in the initial solution.

Incorporated developing agents are already on or very near the exposed silver halide crystals in the coated emulsion, thus minimizing the time needed for a developing solution to diffuse through the gelatin layer. N. I. Kirillov, M. Yu. Deberdeev, and N. E. Kirillova[45] concluded, "As compared with the development of ordinary light-sensitive materials, the materials developed in the aluminate solution quickly reached a certain optimum gamma. The gamma remained almost constant within a range of development times. The image density hardly increased at the same time even in the presence of hydroquinone in the aluminate solution. The optimum gamma reached at such 'primary' development, because of the developing agent included in the emulsion layer, was approximately one and one-half times smaller than the maximum gamma of the control starting emulsion (without developing agent) coated in ordinary thickness."

An increase in light sensitivity was noted for contrasty emulsions containing developing agents, but a negative emulsion with developing agents showed a decrease in light sensitivity as compared with the control emulsion coatings without developing agents. The resolving power and graininess of both positive and negative emulsions containing developing agents remained unchanged. No important differences were found between gold and spectral sensitization of the ordinary emulsion and the same emulsion containing developing agents.

The extensive study by the Russian investigators showed that "the effect of developer temperature on the results obtained during the development of film coated with emulsions containing the developing agent, was considerably smaller than the developer temperature effect on ordinary film. Such a condition is explained partially by a certain optimum degree of 'primary' development of films coated with emulsions including developing agents. The degree of development in an ordinary film does not appear to be optimum. In the latter case the gamma and, consequently, the density of the image obtained are increased considerably when the temperature is increased."

Selective hardening of the gelatin, especially with high silver coverage in

the emulsion layer, was observed after development of light-sensitive layers containing developing agents. Gelatin hardening occurred not only in alkaline solutions containing little or no sodium sulfite but also in alkaline solutions containing large quantities of sulfite, such as in the aluminate activator solution. These alkaline solutions are much more stable than the ordinary tanning developers used for hardening of gelatin. When the light-sensitive layer contained a large amount of silver halide, the relief image was easily observed and could be used either before or after the unhardened part of the emulsion layer had been removed with warm water.

An exposed film containing the developing agent in the emulsion was processed in a combined activator-fixer solution containing 10 g of potassium hydroxide, 1 g of potassium iodide, and 125 g of crystalline sodium thiosulfate per liter of aluminate working solution. Two minutes' immersion in the monobath in a processing machine was followed by two minutes' washing, then drying in the drying cabinet of the machine. Projection of the positive film after monobath processing showed that the image and sound track were almost the same as those of the same film processed in the aluminate solution by the ordinary method. The monobath dissolved silver halide from the film, and a precipitation of metallic silver occurred in the replenished monobath solution. This metallic silver was easily recovered during the filtering of the solution by the filters of the circulation system of the processing machine. Economical utilization of all the ingredients of the monobath was secured, including the developing agent that was contained in the emulsion layer.

Natural and artificial aging of photographic emulsions containing hydroquinone showed that no appreciable changes occurred during one-half year. Ten months of normal storage of a positive film containing hydroquinone caused almost no change in the sensitometric values of the coated material.

SYSTEMS USING EMULSION LAYERS CONTAINING DEVELOPING AGENTS

Systems Involving Tanning Development

Tanning developer solutions are highly unstable because preservatives cannot be used in ordinary quantities. The oxidized form of the developing agent must be allowed to react with the colloid of the emulsion layer to reduce the solubility of the layer. The presence of a preservative, such as sodium sulfite, would react with the oxidized developer and thus reduce the extent of the tanning action. Inclusion of tanning developing agents, such as hydroquinone, catechol, or pyrogallol, within the emulsion layer offers

an alternative approach to the use of the agents in alkaline solution. Activation of the tanning developing agent is made with alkaline solutions after the exposure of the light-sensitive material.

"I have found," said Edward C. Yackel[31] in U. S. Patent 2,592,368,

that it is possible to incorporate a tanning developing agent into a photographic emulsion on a support such as tracing cloth and after exposure and development to form relief images by washing the unexposed emulsion away with water. However, if a soluble tanning developing agent such as pyrocatechol or hydroquinone is used, because of solubility, vapor pressure, etc., the developing agent does not remain in the emulsion layer during long periods of keeping. Instead, it wanders throughout the gelatin and waterproofing layer of a material such as tracing cloth and from one piece of material to another when the two are in close contact. This wandering of the developing agent results in undesirable stain, poor developability, etc. However, if a substantially water-insoluble tanning developing agent is used in the emulsion layer, the objections to a more soluble type of developing agent are overcome.

Preferred developing agents had a solubility from about 0.01 to 0.2 g per 100 ml of a buffer solution consisting of 1.5 % solution of sodium dihydrogen phosphate and sufficient citric acid to bring the pH to 5.0. Developing agents satisfying these solubility requirements included 3,4-dihydroxy diphenyl, 2,5-dihydroxy diphenyl, 2,3-dihydroxy diphenyl, and 5,6,7,8-tetrahydro-naphthohydroquinone.

The working of the Yackel invention was described as follows:

Solutions are made of (a) 25 grams of gelatin in 1 liter of water at 40°C., (B) 100 grams of silver nitrate in 500 cc. water at 20°C. and (C) 35 grams of sodium chloride in 500 cc. of water. Solutions B and C are simultaneously run into Solution A at a uniform rate while stirring the latter over a period of about 10 minutes; Solution B preferably not being allowed to run in faster than C. Thereafter, 150 grams of gelatin in 1500 cc. of water at 40°C. are added. The emulsion is then adjusted to pH 5.0. If desired, the emulsion may then be chilled, set, and washed in the usual manner. It is then remelted and 25 grams of 3,4-dihydroxy diphenyl dissolved in 250 cc. of methyl alcohol is slowly added to the above emulsion with stirring. As a result the developing agent becomes dispersed in the emulsion in minute crystals. Preparatory to coating an emulsion layer, in case a gelatin having poor physical properties has been used, 2 cc. of 10 % formaldehyde may be added and this composition is coated on a prepared tracing cloth support over an area of about 500 square feet and dried. The dried product is exposed to a suitable negative and developed in a 4 percent sodium carbonate solution. The developed element is then washed with water at 35°C. to remove the unexposed, undeveloped and untanned emulsion, and is then rinsed and dried. A positive relief image in gelatin is thus obtained with no gelatin remaining in the unexposed area. Erasures and redrawing of lines were as satisfactory on the print as on the uncoated tracing cloth. Curl was greatly diminished and was approximately equivalent to that of the uncoated tracing cloth, after having been processed through the same baths."

This same method of preparation was also quoted, often word for word, as the first example in a U. S. patent by Henry C. Yutzy and Edward C. Yackel.[47] The object in this case was not the production of a tracing cloth but a photographic method of producing positive copies of two-tone, but not continuous-tone, subjects. The coated, substantially unhardened, light-sensitive gelatin-silver halide layer, preferably pigmented with carbon black or dyes such as copper phthalocyanine and containing the tanning developing agents, is exposed with the emulsion surface in contact with the front of a sheet containing printed matter. The exposed gelatin emulsion layer is then developed for about 15 sec in an alkaline solution of 2% sodium carbonate or sodium hydroxide that may also contain one or more of the following compounds:

Formamide	2 to 20%
Ethylene chlorohydrin	5 to 20%
Urea	2 to 20%
Sodium nitrate	5 to 20%
Glycerol	10 to 20%

Development causes the gelatin to be hardened in the exposed areas such as the white areas of a business letter, but not in the areas of little exposure such as the typewritten characters of the letter. Excess water is removed from the surface of the emulsion layer, which is then pressed in contact with an absorbent surface, such as a sheet of paper. The unhardened gelatin of the emulsion layer adheres to the sheet of absorbent paper. Upon separation of the emulsion layer from the paper sheet, the unhardened gelatin of the emulsion layer is stripped, either partially or totally, away by the paper sheet, yielding a positive copy of the original subject. If only a thin stratum is removed from the emulsion layer, several positive copies may be made from the same emulsion layer. Six to eight satisfactory copies were said to be possible, although the process could be adjusted to yield only a single, high-quality copy. This system was introduced commercially by Eastman Kodak Company under the Verifax trade name. This writer has used a trusty Verifax copier to copy many of the references for this book.

The thin stratum of the emulsion layer that is transferred to the receiving paper must be of sufficient density to be easily seen. Coloring matter was incorporated in the emulsion layer or was formed in the stratum of the transferred layer. Formation of the coloring matter in the transferred layer could be accelerated by heating the light-exposed transferred stratum. An improved process was proposed[48] that contained two different types of developing agents: (1) a gelatin-tanning silver halide developing agent and (2) a

nontanning or a feebly tanning developing agent. The exposed areas of the image were developed by the tanning developing agent and the gelatin insolubilized; in those areas of much less exposure, tanning development is very low and the gelatin is not tanned, but the silver halide is partly developed by the nontanning developing agent to produce a considerable image density. This density is sufficient so that any further treatment of the receiving sheet is not necessary.

The improved emulsion composition of

A substantially unhardened gelatino silver halide emulsion of the paper emulsion type containing one mol of silver halide, 340 grams of gelatin and 5700 grams of water was jelled, noodled and washed for one-half hour with water, then melted at 40°C. and the following additions made:

650 grams of 8 % aqueous saponin solution
680 grams of Dispersion A (a dispersion of 4-phenyl catechol prepared by dissolving 50 grams of 4-phenyl catechol in 75 grams of dibutyl phthalate at 80°C. and pouring it into a vigorously stirred solution of 50 grams of gelatin in 50 grams of 8 % aqueous saponin solution and in 500 cc. of water at 40°C.)
340 grams of a dispersion like A except substituting 4-methoxy-1-naphthol for 4-phenyl catechol

This emulsion was coated over 500 square feet of paper containing no ingredients tending to harden the emulsion.

Improved results were obtained from the colloid transfer when the surface of the absorbent receiving sheet contained a silver halide fogging agent, a compound that renders silver halide indiscriminately developable, such as thiourea or thiosemicarbazide.[49] A compound which retards gelatin tanning in the presence of fogged silver halide—for example, sodium formaldehyde bisulfite—was also added to the surface of the absorbent receiving paper. More than one transferred copy was possible because "when the developed emulsion layer is pressed against the receiving sheet, the unexposed or less exposed regions of the emulsion adhere to the receiving sheet and at the same time the fogging agent commences to fog the unexposed silver halide, and the gelatin tanning retarder, such as sodium formaldehyde bisulfite, tends to stop tanning development of the emulsion layer. Thus, the additional copies are readily obtainable from the same developed emulsion layer."

The colloid transfer process of Yutzy and Yackel was adapted to the making of lithographic printing plates by Walter Clark and Herbert B. Cowden.[50] A conventional method for preparing an offset printing plate

involves sensitizing a metal plate, such as a zinc plate which has been grained, with a light-sensitive coating such as bichromated albumin, following which the plate is exposed usually to a line or halftone negative and before developing the plate a coating of lithographic developing ink is applied. Subsequently the plate is developed in water to remove the albumin in the unexposed areas, leaving the hardened albumin covered with ink in the exposed regions. When the plate is moistened and then inked with a greasy printing ink in the lithographic printing press, the ink is taken up only in the areas occupied by the hardened albumin image. If it is necessary to reverse the image, actually this can be accomplished in the usual manner by first transferring the ink image to a rubber offset blanket and thence to the paper, otherwise the ink image can be transferred directly from the printing plate to the receiving paper.

For this usual method of lithographic printing plate preparation, Clark and Cowden proposed the use of the substantially unhardened silver halide emulsion layer, as was used in the Verifax copier process, followed after exposure by tanning development from the incorporated tanning developing agent. The unhardened, unexposed areas were then transferred to a suitably prepared absorbent surface that was water accepting (hydrophilic). To render the transferred areas more fully ink receptive by reducing their hydrophilic character, it was proposed to "subject the printing element to dry heat sufficient to improve ink-receptivity and preferably at a temperature below the charring point of the transferred colloid stratum; that is, a temperature of the order of 150 to 275°C for ten seconds to three minutes, depending upon the temperature used and the extent to which the element has been dried before heating. At 230 to 250°C, 20 seconds is satisfactory for a previously dried element or 30 seconds if the element is moist from the transfer operation. At 150°C, three minutes and at 275°C, 10 seconds heating are required."

A printing plate prepared in this fashion, according to Orson Warren Lake and Charles F. Amering,[51] was said to lack durability in the printing operation and to lack sufficient ink receptivity. They proposed to transfer the unhardened gelatin of the light-sensitive material to a lithographic printing plate, then swab the transferred image with a water solution of 4% tannic acid, 4% sodium bisulfite, and 4% thiourea. The thiourea was used to increase the ink receptivity of the transferred image but the usual gelatin hardening agents were not effective in the presence of the thiourea. Tannic acid, however, was an effective gelatin tanning agent when thiourea was present. The transfer of undesirable background gelatin from the light-sensitive layer may be prevented by treating with an alkaline solution and drying the plate before the transfer is made. Suitable alkaline solutions include a 2% solution of borax or a 3% solution of sodium carbonate, ammonium hydroxide, sodium hydroxide, ethanolamine, or methylamine. When run on an offset press, the treated plate produced at least 100 copies.

The many practical applications (silk-screen stencils, document copying, dye transfer matrices, lithographic printing, and others) of the colloid transfer process of Yutzy and Yackel were sufficient to stimulate extensive research that resulted in a considerable number of patented improvements. Developing-agent precursors, substantially inert to atmospheric oxygen even at elevated temperatures and humidities, were suggested for incorporation in the light-sensitive emulsion layer. An active tanning developing agent was liberated on treatment with an alkaline solution having a pH of at least 8.5. The developing-agent precursor can be in the form of diene adducts of para-quinones,[52] or the diene adducts of ortho-quinones,[53] and related compounds.[54] Various catechol derivatives,[55] chloromalealdehydic acids,[56] sulfur dioxide adducts of tanning developers,[57] and gentisic acid with a 3-pyrazolidone[58] have also been proposed for incorporation in the light-sensitive layer for use in the colloid transfer process. This emulsion layer may also contain nitro derivatives of N-oxides of heterocyclic compounds[59] or quaternized derivatives of 1,2-bis(4-pyridyl)ethylene[60] as desensitizers so that the light-sensitive material might have sufficient room-light tolerance.

Activator solutions may be as simple as 40 g of sodium carbonate monohydrate and 50 g of urea in a liter of water to be used at a temperature of 81°F. Usually, however, colloid transfer activator baths are more than just simple alkaline solutions. Sequestering agents may be present to deal with precipitation problems; gelatin hardeners may be present to give improved transferred-image characteristics; desensitizers are often added to the solution to give improved room-light handling characteristics of the light-sensitive material; and other compounds may be added to reduce the tendency for the salts of the activator to crystallize from solution.

A liquid activator having the following composition

Potassium carbonate	40.0 g
Ethylenediamine tetraacetic acid, sodium salt	4.5 g
Diethylene glycol	40.0 ml
p-Toluenesulfonic acid monohydrate	10.0 g
Water to make	1.0 liter
Potassium hydroxide, dilute solution to make pH 11.0	

was capable of being replenished by soaking in the activator for 60 sec, after every 16 letter-size matrices, a sheet of $8\frac{1}{2} \times 11$-in. paper containing 1 g of lithium hydroxide per square foot.[61] It has also been proposed[62] to add 2,2′-azopyridine to the solution to act as a desensitizer for room-light handling of the light-sensitive material. The presence of a formaldehyde

donor, such as sodium formaldehyde bisulfite, was also said to improve the transferred-image quality, especially for making improved lithographic printing plates.[63]

An activator for the colloid transfer process was said[64] to give very good transfers after the light-sensitive layer was treated for only 6 sec at 75°C:

Water	800 ml
Trisodium phosphate	80 g
Potassium salicylate	10 g
Ethylenediamine tetraacetic acid, tetrasodium salt	5 g
Tetraethylene glycol	40 ml
Water to make	1 liter

The useful temperature range was claimed to extend from 60 to 90°C, although the reception sheet for the transferred image was advantageously one containing on its surface a silver fogging agent (thiourea, thiosemicarbazide, and others) and a development-suppression agent, such as sodium formaldehyde bisulfite.[65]

Systems Involving Lith Development

Conventional lith developing solutions contain hydroquinone as the developing agent in the presence of the smallest possible concentration of free sulfite ions. Quantities of free sulfite ions greater than 5 g of sodium sulfite per liter may degrade the lith effect. The sulfite is usually present as a bisulfite addition product of an aldehyde or a ketone and usually as the formaldehyde sodium bisulfite addition product. An antifoggant, often potassium bromide, and an alkaline substance, such as sodium carbonate or sodium metaborate, are a part of lith developer compositions as well as other compounds, such as sequestering agents. Because the developer preservative must be maintained in a very low concentration, as in the case of tanning developing solutions, the lith developer is very susceptible to oxidation, even without use. This lack of stability makes machine processing of lith materials costly because of the need to replenish the impaired solution at a very rapid rate.

Some of the difficulties associated with unstable lith developing solutions may be obviated by incorporation of some of the processing chemicals within the light-sensitive layer. Lith emulsions usually contain silver chloride with not more than 40 mole percent silver bromide and not more than 5 mole percent silver iodide with gelatin usually present as the vehicle. The dried emulsion layer "should advantageously contain between 5 g. and 20 g. of

hydroquinone per square metre and at least the same quantity by weight of bisulphite compounds per square metre," according to British Patent 1,137,801.[66] The exposed material is then developed in a solution composed of hydroquinone (60 g/l) and sodium formaldehyde bisulfite (20 g/l) for 2 min before immersion in this solution:

Sodium carbonate	72.0 g
Potassium bromide	2.5 g
Ethylenediamine tetraacetic acid	1.2 g
Sodium formaldehyde bisulfite	62.0 g
Water to make	1.0 liter

The film is suspended vertically in the solution for 2 to 3 min and is not moved. From 150 to 200 ml of a replenisher (same solution except for 10 more g of sodium carbonate) per square meter of film was said to give "practically constant development" for 20 m² of lith film.

Water Processing

Emulsion layers containing developing agents can be activated in solutions containing alkaline substances. Such photographic solutions, upon standing in the air, evaporate and eventually cause crystallization of the chemicals from the solution. Crystals may creep up the sides of the retaining vessel.[67] Chemical crystallization problems can be minimized by the presence of glycols and amines in the solution. Another way is to place all the necessary chemicals in the photographic material and use only water, a readily available compound, as the activating medium. The photographic material must contain a developing agent or agents, a fixing agent, and an alkaline activator to promote the developing and fixing actions. Many attempts have been made to incorporate all of the needed chemicals, especially by using multiple layers to isolate the components,[68] but undesirable decreases in sensitivity of the photographic material have usually been obtained.

Such deficiencies have been said to be overcome by coating the processing chemicals in two layers over the silver halide layer.[69,70] The layer above the silver halide contains the developing agents, such as a 3-pyrazolidone and hydroquinone or ascorbic acid, and the alkaline substance, such as an amino pyridine or sodium metaborate. These two layers are dried. The silver complexing agent, such as sodium thiosulfate or 4,5-(2,3-*d*-fructopyrano)-oxazolidine-2-thione, is then applied in a water-permeable binder, such as cellulose derivatives, acrylamide derivatives, or polyvinyl compounds. The exposed photographic material is then processed from 30 sec to 2 min at

room temperature by immersion in water and dried. The resulting image is stable to light.

Another light-sensitive photographic material has been proposed[71] for water processing that depends upon a desensitizer to secure stability against continued light exposure. A fine-grain silver bromoiodide emulsion containing 95 mole percent silver bromide and 5 mole percent silver iodide was coated on paper base at a coverage of 1900 sq ft per mole of silver. The emulsion layer was then overcoated with a solution of 50 g sucrose, 48 g of 20% water solution of gelatin, and 500 ml of the following developing solution:

1-Phenyl-3-pyrazolidone	2.5 g
Sodium sulfite, desiccated	45.0 g
Sodium ascorbate	15.0 g
Potassium bromide	1.0 g
Sodium metaborate	45.0 g
5-Methylbenzotriazole	0.02 g
Water to make	1.0 liter

Nine grams of this solution was applied for each square foot of the emulsion surface. This layer was then overcoated with a 0.01% (by volume) solution of 6-chloro-4-nitrobenzo-1,2,3-triazole in isopropyl alcohol.

The exposed photographic material was processed by treatment with running water for 15 sec. After one week's exposure to north light, the print had zero minimum density; that is, it was resistant to printout. Even after 7 hr exposure to 50-fc illumination at 100% R.H. and 75°F, the print had a minimum density of only 0.05. Other desensitizers found effective included 1-methyl-2-(p-nitrostyryl)-6-ethoxyquinolinium-p-toluene sulfonate, 2-(p-diethylaminophenyliminomethyl)-1,6-dimethylquinolinium chloride, and 2-(p-dimethylaminophenyliminomethyl)-benzothiazole ethoethylsulfate.

Thermal Processing

The incorporation of processing chemicals within the light-sensitive material makes possible simple and rapid treatment by activating solutions. In many cases, however, this has not been the ultimate goal. The use of all solutions may be eliminated completely if the incorporated chemical layers are activated by the application of heat to trigger the chemical reactions. Dry processing of silver halide materials has been, and continues to be, the objective of many photographic scientists who wish to banish the delay and inconvenience of wet processing from the production of photographic images.

In a German patent of 1953, Edith Weyde[72] added processing chemicals to a silver halide emulsion layer to produce a recording paper whose latent image could be made visible by heat treatment. Hydroquinone (20 g), potassium metabisulfite (10 g), and urea (100 g) were first dissolved in 150 ml of water. This solution was added to a liter of an ordinary silver chloride emulsion. After coating, drying, and exposing, the light-sensitive material was developed by heating to 130°C. The urea, which forms an alkaline substance upon heating, was present to activate the hydroquinone at lower temperatures than if the urea was absent. Hydrazine, phenylhydrazine, acid hydrazides, semicarbazides, Metol, and catechol were also said to be effective heat-activated developing agents. After heat processing, the image continued to develop when exposed to light, but the image remained visible for interpretation. Agfa Recording Paper W (tried out near the end of World War II) was based on this invention.

The production of another thermally activated recording paper, Ikotherm by Zeiss Ikon, occurred about the same time. The details were later published by K. Meyer and F. Lühr.[73] After imbibition of Metol, hydroquinone, sodium sulfite (anhydrous), and potassium bromide by a dry coated emulsion, the photographic layer produced by heating at 80°C an image that was of low contrast and sensitivity. To supply needed moisture, compounds were used that decomposed upon heating to form water. Ammonium phthalate was found to be especially suitable, as it also produced ammonia and phthalimide after heating to 195°C:

Guanidine phthalate and the guanidine, methylamine, and dimethylamine salts of other organic acids were also effective promoters of development. Actually, the 14 to 18% water retained by the gelatin in the layer was found to be sufficient medium for the reactions to occur, but the alkaline substances generated upon heating the salts were necessary for rapid development.

A contrasty, fine-grain silver bromoiodide emulsion of the document-copying type was most suitable for making the incorporated-chemical paper. Results were less acceptable when the compounds were added to the liquid emulsion than when the solution of the compounds was added by bathing the dry coated emulsion layer. The emulsion layer for the Ikotherm paper was bathed in the following solution at a temperature of 32°C:

Water	1 liter
Gelatin	40 g
Hydroquinone	30 g
Sodium sulfite (anhydrous)	30 g
Guanidine phthalate	84 g
Sodium lauryl sulfate (2%)	12 ml

When the processing chemicals were added by imbibition, Ikotherm paper had good stability. The exposed paper was processed by contacting the paper base for 10 sec on a curved metal sheet heated to a temperature of 150°C, or dipping for 3 sec in a paraffin bath at 140°C. Images developed in the paraffin bath had the better light stability, due apparently to the protective action of a thin layer of paraffin retained on the emulsion surface. In bright daylight the developed image was obscured in 1 min, but in dim light it was retained for months. Because the short developing time does not allow for diffusion of the developing agent, only grains on the surface of the coating were said to be developed, resulting in only 10% of the silver in the image that would have been obtained in a wet process.

For promoting development in a photographic material during heat activation, compounds that are weakly alkaline or generate alkaline substances have often been found necessary. These compounds, sometimes called development-promoter precursors, usually release alkali but may promote image formation by other means, such as furnishing water for the medium for the necessary reactions. Suitable substances patented by G. M. Haist and J. R. King[74] were the sodium, potassium, or ammonium salts of organic carboxylic acids. Suitable compounds included sodium formate, acetate, propionate, or benzoate; disodium succinate or malonate; and dipotassium oxalate.

One example of the use of development-promoter precursors consisted of coating 20 ml gelatin (10%), 20 ml water, and sodium formate (3 g) at 0.005-in. wet thickness on paper base and then drying. Then a second layer containing the developing substances and the silver bromoiodide emulsion (pH 4.4) was coated. This emulsion composition consisted of the following ingredients:

Water	20.0 ml
1-Phenyl-3-pyrazolidone	0.2 g
L-Ascorbic acid	0.4 g
Sucrose	2.0 g
Gelatin (10% solution)	20.0 ml
High-speed bromoiodide emulsion	2.0 ml

After drying, the exposed coating was developed by heating the back of the paper for 10 sec on a metal surface heated to a temperature of 300°F. Images were also formed by applying steam for 10 sec or immersing in a hot paraffin bath for 10 sec.

To avoid the necessary source of external water, one patented system proposed[75] to find water in the pores of a porous solid compound that was incorporated in the emulsion layer. Subjecting the exposed recording paper to heating caused the porous, crystalline sodium or calcium alumino silicate (called a molecular sieve) to supply free water for the development of the image. The developing action was said to stop when the water was completely evaporated or, when the paper was cooled, the remaining water was taken up again by the porous silicates.

Heat development of a latent image usually requires the presence of an alkaline substance to accelerate image formation during the very short processing time. Alkaline compounds added directly to the emulsion layer containing a developing agent would produce fog. Sodium salts of acids, such as sodium acetate, are only weakly alkaline. Such a compound may produce tackiness when the gelatin layer containing it is heated, and the light-sensitive layer may fog during storage. These deficiencies of weakly alkaline substances have stimulated a search for more stable alkali-generating compounds that are suitable for use in dry-processed coatings containing developing agents.

Heat-sensitive salts of readily decarboxylated organic acids have been suggested[76] as activators for incorporated chemical coatings. These salts were composed of trichloroacetic or trifluoroacetic acid and an alkaline compound, such as piperidine, guanidine, or triethylenediamine. When a compound such as guanidine trichloroacetate is heated to the decomposition temperature, an acid gas (carbon dioxide) is driven off and an alkaline condition is produced in the coating.

$$
\begin{array}{c}
NH_2 \\
| \\
C=NH_2^{(+)} \cdot Cl_3CC \underset{O^{(-)}}{\overset{O}{\big\backslash\!\!/}}
\end{array}
\quad \xrightarrow{\text{heat}} \quad
\begin{array}{c}
NH_2 \\
| \\
C=NH + CO_2\uparrow + CHCl_3 \\
| \\
NH_2
\end{array}
$$

A readily decarboxylated acid, such as trichloroacetic acid, may also be combined with a developing agent of the p-aminophenol or p-phenylenediamine type.[77] Although these salts that give off acidic gases do provide an alkaline environment for image formation to occur, such salts usually do not have adequate stability in coatings that must be stored. This deficiency was also noted earlier when amine-trichloroacetic acid salts were tried for diazotype coatings that were designed for heat processing.[78]

Instead of reacting amines with trichloroacetic acid, the reaction of amines with oxalic acid has been proposed and patented.[79] When the amine oxalate salts are heated to their decomposition temperature, they evolve carbon dioxide and produce an amine suitable for activating development in an emulsion layer containing a developing agent. Decomposition temperatures of some amine oxalate salts are: dicyclohexylamine oxalate, about 120°C; benzylamine oxalate, about 125°C; piperidine oxalate, about 105°C; and morpholine oxalate, about 135°C. In addition, a substance containing water of crystallization releasable by heating was also present in the coating of silver halide with the developing agents (hydroquinone, catechol, pyrogallol, Phenidone). Magnesium acetate tetrahydrate, zinc acetate dihydrate, cadmium acetate dihydrate, lead acetate dihydrate, and manganese acetate tetrahydrate are compounds that lose part of their water of crystallization below 100°C and the rest at 100°C. Thirty seconds' heating at 140°C was sufficient to obtain development of the latent image. No data were given on the stability of the coated compositions. (See Figure 3.)

The storage stability of light-sensitive photographic materials containing developing agents and alkali generators has not been entirely satisfactory. This deficiency has delayed the appearance of a satisfactory, dry-processed, high-speed silver halide product. The alkali-generating compound has been the primary inadequacy. To avoid this pitfall, efforts have been directed to finding incorporated chemical systems that are heat activatable without requiring the presence of the precursor to produce alkali. One approach has been to use less acidic developing agents or compounds that are active at lower alkalinities, such as Phenidone or aminophenols. These agents are activated by heat alone. Phenidone ("advantageously 7–20 g. per mol of silver halide") and sucrose ("advantageously 200–400 g. per mol. of silver halide") have been incorporated in an unhardened light-sensitive material to produce heat-developable images without the need of alkalis.[80] Storage of the coated photographic material "for a relatively long period at fairly high temperatures (i.e., about 60°C) showed that the sensitivity was not changed, even under extreme conditions." Presumably, the sugar acts as an oxygen barrier and antifoggant, but the retention of moisture by high levels of sucrose is known to increase the tackiness of unhardened gelatin layers.

Associated developer salts offer another means to incorporate developing agents in the emulsion or nearby layers. The chemical association of an acidic developing agent, hydroquinone, with a developing agent with a basic function, such as monomethyl-para-aminophenol, was studied by A. and L. Lumiére and A. Seyewetz in 1903.[81] The combination of two molecules of the monomethyl-para-aminophenol with one molecule of hydroquinone, called Metoquinone, required only the presence of sodium sulfite to form an active developing solution. This developing action without the need of

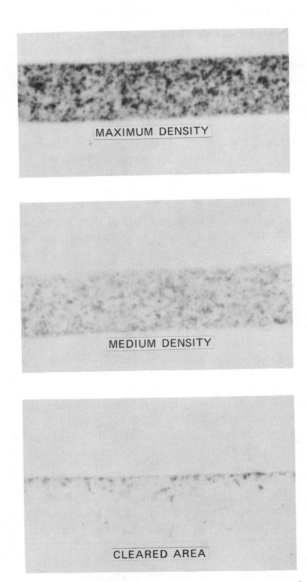

MAXIMUM DENSITY

MEDIUM DENSITY

CLEARED AREA

Figure 3. These cross-section photomicrographs (1750 ×) show various areas of a heat developed-and-stabilized photographic film. The silver chloride emulsion layer contained developing agents and an isothiuronium stabilizing agent. Image formation and stabilization occurred when the base of the photographic material was heated for 15 sec at 160°C. (Grant Haist, Eastman Kodak Company)

stronger alkalis was not a particularly valuable asset in solutions already containing alkaline substances, but for emulsion coatings where alkali is limited, associated developer salts offer advantages over the incorporation of the separate developing agents. Metol, for example, is a salt of sulfuric acid and not readily activatable with heat, but the combination of Metol free base with hydroquinone forms a salt that will develop when the emulsion layer is heated.

A developing agent, such as ascorbic acid, has been reacted with a basic developing agent (an aminophenol, for example) to form a reaction product that "can be employed in photographic systems, especially photographic coatings, and be easily activated by heat without the need of a separate alkali-generating compound or separate source of alkali."[82] A combination of ascorbic acid with N-methyl-p-aminophenol ("Ascorelon") was reported to produce a dark brown image of good density when this associated developer salt was incorporated in a silver halide coating that was heated on a metal block for 30 sec at 155°C.

A similar approach involves reacting an acidic developing agent, such as ascorbic acid or hydroquinone, with an alkaline substance, such as urea or guanidine. Such a developing-agent precursor, described by Grant Haist and James King,[83] was prepared from urea and ascorbic acid ("Urbic Acid"), yielding a semisolid white product. This compound was incorporated in a silver chloride emulsion layer coated on a baryta-coated paper. The exposed material produced a brown image when the uncoated side of the paper was contacted for 30 sec on a metal block heated to 160°C.

Improved storage stability was claimed[84] for photographic silver halide layers when β-nitroethanols were present with the developing agents. Images of good speed and density were obtained after exposure of the coated layers to light and heat. Alkaline compounds, alkali-generating compounds, or compounds that release water of crystallization were not needed when the β-nitroethanols were present. Suitable compounds included

α-phenyl-β-nitroethanol

α-4-tolyl-β-nitroethanol

α-4-pyridyl-β-nitroethanol

An example of a heat-activatable material containing a β-nitroethanol was the following:

<div align="center">Coating Composition</div>

Gelatin silver chloride emulsion (0.3 mole silver chloride/liter)	1.0 liter
1-Phenyl-5-mercaptotetrazole (1% in alcohol)	0.02 g
Saponin (5% in water)	20.0 ml
Formalin (30% in water)	3.0 ml
1-Phenyl-3-pyrazolidone	10.0 g
α-Phenyl-β-nitroethanol (in small amount of alcohol)	20.0 g

This preparation was coated on baryta-coated paper and dried. The exposed material was heated to about 120°C for 2 sec by contact with a heated metal plate. A brown-black image was obtained, suitable for a recording paper.

The β-nitroethanols are presumed to split off water upon heating and are particularly advantageous when used with developing agents containing amino groups, such as the aminophenols, aminonaphthols, and phenylenediamines. Improved developing agents for incorporation in photographic materials are said[85] to result when at least one amino group is substituted with a methane phosphonic acid group,

$$\begin{array}{c} \quad\quad O \\ H \quad \| \\ -C-P-OH \\ H \quad | \\ \quad\quad O \\ \quad\quad H \end{array}$$

Suitable developing agents include:

$$HO-\!\!\left\langle\bigcirc\right\rangle\!\!-\overset{H}{\underset{}{N}}-\overset{H}{\underset{H}{C}}-\overset{O}{\underset{\underset{H}{O}}{\overset{\|}{P}}}-OH$$

$$\begin{array}{c} C_2H_5 \\ | \\ N-\!\!\left\langle\bigcirc\right\rangle\!\!-\overset{H}{\underset{}{N}}-\overset{H}{\underset{H}{C}}-\overset{O}{\underset{\underset{H}{O}}{\overset{\|}{P}}}-OH \\ | \\ C_2H_5 \end{array}$$

$$\text{N}-\overset{\text{H}}{\underset{\text{H}}{\text{C}}}-\overset{\text{O}}{\underset{\overset{|}{\underset{\text{H}}{\text{O}}}}{\overset{||}{\text{P}}}}-\text{OH}$$

It was stated that "Compared with known developers such as hydroquinone, aminophenol, *p*-methylaminophenol, and other developers, the developers according to the invention, after they have been incorporated in the emulsion layer, are distinguished not only by better stability to oxidation but also increased utilisation of the sensitivity. The photographic elements of the present invention show practically no fogging, as compared with photographic materials which contain conventional developer compounds."

There actually is enough moisture in the coated layers and the paper base for rapid, dry development of a silver-sensitized paper to occur, providing the moisture is prevented from escaping. A recording paper, labeled "Kind 1549" by Eastman Kodak Company, was sold in the early 1960s.[86] This paper was processed in an entirely enclosed heating chamber, the moisture being driven from the coated layers and the base by the heat. This vaporized water then condensed on the cool surface of the emulsion layer as the exposed paper entered a slit in the heated chamber. Paper speeds up to 35 fpm produced satisfactory development, but, initially, 5 ft of paper had to be run before good image development could be achieved. Adding a few drops of water to the chamber at the start-up of the processor produced good results immediately without the passage of any paper. Once operating continuously, the processor did not require any external source of water.

Such a heat-processed paper was described in the patent literature.[87] The combination of a 3-pyrazolidone with ascorbic acid as developing agents was essential for producing a high-density silver image. Acyl derivatives of Phenidone, such as 1-phenyl-2-acetyl-3-pyrazolidone, were proposed as developing-agent precursors to improve emulsion stability. The active developing agent was not formed until the acyl group had split off in the presence of alkali. The presence of sucrose also improved the storage stability of the developing agents. In making the coating composition,

48 grams of a 20% gelatin solution were added to 500 cc. of the following solution:

Sodium sulfite (anhydrous)	45.0 grams
Ascorbic acid	13.5 grams
Potassium bromide	1.0 gram
Sodium metaborate, octahydrate	45.0 grams
5-Methylbenzotriazole	0.02 gram
Water to make	1.0 liter

The mixture was then coated upon a baryta-coated photographic paper base at a coverage of about 8 grams of solution per square foot. The alkaline layer was then overcoated with a gelatino-silver bromoiodide emulsion (94.5 mole percent silver bromide, 5.5 mole percent of silver iodide) containing 50 grams of 1-phenyl-3-pyr-azolidone and 320 grams of sucrose per mole of silver at a coverage of approximately 475 square feet per mole of silver.

After exposure, the paper was heated at 200°C at a rate of 20 fpm in the enclosed processor, producing an image with a maximum density of 1.65.

Developing-Agent Transfer Processes

Silver halide emulsion layers containing a developing agent can be developed by heat, consuming the developing agent in the exposed areas. In the un-exposed portions of the emulsion layer the developing agent is unused. This active developing agent can be made to migrate to a non-light-sensitive layer which is in intimate contact with the exposed emulsion layer during the application of heat. When the transferred developing agents reach the non-light-sensitive coating, they react with one or more colorless or nearly colorless substances to form colored compounds. The colored image formed is a right-reading positive image that corresponds to the original subject.

A silver halide photographic paper containing a 3-pyrazolidone was placed in contact, before heating, with a receiving layer that contained a colorless triazolium or tetrazolium compound.[88] When heated, the unused developing agent in the light-sensitive layer diffused to the non-light-sensitive material, converting the colorless triazolium or tetrazolium com-pounds to colored dyes. The fastness of this dye image to light and washing was said to be improved by the presence of salts of multivalent metals, such as copper, iron, zinc, and similar metallic elements.

A silver halide layer containing a 3-pyrazolidone at 0.1 to 2.0 g/m² of coating has also been used to transfer unused developing agent to a re-ceiving layer containing a colorless or nearly colorless leuco-phthalocyanine compound.[89] When the two layers were placed in contact and then heated to a temperature of 110 to 170°C for 1 to 30 sec, a deeply colored, positive phthalocyanine dye image was found to have been formed in the receiver when this material was separated from the light-sensitive layer. The dye image was said not to fade even if exposed to sunlight. The leuco-phthalocy-anines are preferably incorporated as complexes with metals, such as nickel, cobalt, copper, or zinc. A suitable leuco-phthalocyanine is Phthalogen Blue IB, a product of Farbenfabricken Bayer AG.

A number of other substances have been patented for use in developer transfer systems. Two developing agents—a 3-pyrazolidone and 8-hydroxy-1,2,3,4-tetrahydroquinoline—were included in the light-sensitive layer in

the presence of a substance that liberates water upon heating.[90] The 8-hydroxy-1,2,3,4-tetrahydroquinoline from the unexposed areas diffused to a contacted receiving layer to form a visible image by reacting with a metal salt. Salts of cobalt, copper, and chromium were suitable for use in the receiving layer. In another patent[91] the receiving layer contained a compound that split off sulfur at a temperature of 80 to 150°C. The color of the sulfur dyestuffs formed by the transferred developer depends upon the nature of the developing agent, but the depth and tone were influenced by adding heavy-metal salts, such as copper or zinc sulfate or ferric nitrate. The sulfur-forming compounds included ammonium sulfides or the sulfides of metals, or organic compounds such as thiourea and thioacetamide.

REFERENCES

1. "Ammonia as an Accelerator for Dry Plates," *Phot. J.*, **8**: 133 (1862).
2. "Development by Ammonia," *Brit. J. Phot.*, **10**: 45 (1863).
3. "Fuming with Ammonia," *Brit. J. Phot.*, **11**: 326 (1864).
4. "Fuming Paper," *Brit. J. Phot.*, **21**: 443 (1874).
5. "On Reducing Agents," *Brit. J. Phot.*, **22**: 374 (1875).
6. John Glover, "On Dry Development of Dry Plates," *Brit. J. Phot.*, **9**: 367 (1862).
7. Alfred Verity, "Development by the Fumes of Ammonia," *Brit. J. Phot.*, **10**: 26 (1863).
8. "The Development of Dry Plates by Means of Ammonia Vapour," *Brit. J. Phot.*, **22**: 433 (1875).
9. T. M. Leahy, "Ammonia as a Developing Agent," *Phot. News*, **6**: 540 (1862).
10. T. M. Leahy, "Ammonia Development," *Phot. News*, **6**: 589 (1862).
11. Thomas M. Leahy, "Development by Aid of Ammonia," *Brit. J. Phot.*, **10**: 66 (1863).
12. "The Late Rev. J. B. Reade, F.R.S.," *Brit. J. Phot.*, **17**: 588 (1870).
13. Angus Fraser, "Pyro in the Emulsion," *Phot. Times and Am. Phot.*, **16**: 18 (1886).
14. M. Petzold, "Verein zur Förderung der Photographie," *Phot. Mitt.*, **32**: 114 (1895).
15. Otto Böhrer, "Entwicklersubstanzen in Bromsilbergelatine-Platten," *Eder's Jahrbuch*, **14**: 749 (1900).
16. Friedr. Bayer and Co., "Verfahren zur Herstellung von in alkalischen Bädern selbstentwickelnden lichtempfindlichen Platten und Papieren," German Pat. 141,584 (1903).
17. Arthur Eichengrün and Julius Precht, "Photographic Plate and Process of Making Same," U. S. Pat. 742,405 (1903).
18. "Bernauers Gelatine-Emulsionsplatten, welche die Entwicklersubstanz in den Schichten enthalten und mit gewöhnlichem alkalihaltigen Wasser entwickelt werden," *Phot. Korr.*, **40**: 726 (1903).
19. Raphael Eduard Liesegang, "Verfahren zur Herstellung entwicklerhaltiger Silberhaloidschichten," German Pat. 403,585 (1924).
20. Edward C. Yackel, John A. Leermakers, and Cyril J. Staud, "Method of Developing Photographic Emulsions," U. S. Pat. 2,388,894 (1945).

21. Scheuring S. Fierke and Cyril J. Staud, "Development of Photographic Emulsions," U. S. Pat. 2,410,644 (1946).

22. I. G. Farbenindustrie Aktiengesellschaft, "Procédé de développement-fixage," French Pat. 870,764 (1942).

23. Jakob Degenhart, "Für Schnellentwicklung geeignete photographische Schicht sowie Verfahren und Vorrichtung zu ihrer Entwicklung," German Pat. 887,908 (1953).

24. Georges Barthélemy, "Procédé d'obtention d'images photographiques et produits utilisables dans ce procédé," French Pat. 1,108,059 (1956).

25. Fritz Albers, Hans Nitze, Gustav Schaum, and Edith Weyde, "Photographic Development of Silver Halide Layers," U. S. Pat. 2,214,446 (1940).

26. Glay M. Hood and Paul R. Crookshank, "Photographic Emulsion Layer Containing a 3-Pyrazolidone," U. S. Pat. 2,751,297 (1956); "Improvements in Photographic Emulsions," Brit. Pat. 767,704 (1957).

27. Dorothy Johnson Beavers and Norman Allentoff, "Processes of Photographic Development," U. S. Pat. 1,071,674 (1967).

28. Anthony Joseph Axford, "Improvements in or relating to Photographic Emulsions," Brit. Pat. 845,928 (1960).

29. Edward Bowes Knott, "Photographic Emulsion," U. S. Pat. 2,315,966 (1943).

30. Ernst Herdieckerhoff, Ilse-Dörte Meyer, and Edith Weyde, "Entwicklersubstanzen enthaltende Halogensilberschichten," German Pat. 954,391 (1956).

31. Edward C. Yackel, "Gelatine Silver Halide Emulsion Layer Containing a Dihydroxy Diphenyl Tanning Developing Agent," U. S. Pat. 2,592,368 (1952).

32. Ilmari Fritiof Salminen, James Albert van Allen, and Edward Carl Yackel, "Photographische Emulsion, die einen gerbenden Entwickler enthält," German Pat. 1,019,556 (1957).

33. Joseph Stanley Dunn and Albert Charles Smith, Jr., "Photographic Materials with Incorporated Developing Agents," U. S. Pat. 1,177,488 (1970).

34. Albert C. Smith, Jr., "Photographic Developer Composition," U. S. Pat. 3,300,307 (1967).

35. Ralph F. Porter and Thomas E. Gompf, "Halogenated Acyl Hydroquinone Derivative Developers," U. S. Pat. 3,246,988 (1966); "Sensitive Photographic Materials," Brit. Pat. 1,055,920 (1967).

36. Frederick Charles Duennebier and James Thomas Kofron, "Photographic Developing Agents," Brit. Pat. 1,066,991 (1967).

37. Ralph Frederick Porter, Judith A. Schwan, and John W. Gates, Jr., "Photographic Inhibitor-Releasing Developers," U. S. Pat. 3,379,529 (1968).

38. Jozef Frans Willems and Antoon Leon Vandenberghe, "Précurseurs de substance révélatrice dérivés d'hydroquinone," French Pat. 2,010,543 (1970).

39. Charles R. Barr, "Light-Sensitive Photographic Elements Containing Developing Agent Precursors," U. S. Pat. 3,295,978 (1967); "Light-sensitive Photographic Materials Containing Developing Agent Precursors," Brit. Pat. 1,068,555 (1967).

40. Ralph Frederick Porter and Thomas Edward Gompf, "Developer Incorporated Photographic Materials," U. S. Pat. 3,291,609 (1966); "Nouveau produit photographique à révélateur incorporé," French Pat. 1,359,923 (1964).

41. Anita von König, Helmut Mäder, Hans Ulrich, and Edith Weyde, "Light-Sensitive Material with Incorporated Developer," U. S. Pat. 3,419,395 (1968).

42. Anita von König, Helmut Mäder, and Edith Weyde, "Light-Sensitive Material with Incorporated Developer," U. S. Pat. 3,415,651 (1968).

43. Donald P. Harnish and Richard L. Reeves, "Color Developer Precursor," U. S. Pat. 3,342,597 (1967).

44. Richard L. Reeves, "Schiff Base Developing Agent Precursors," U. S. Pat. 3,342,599 (1967).

45. N. I. Kirillov, M. Yu. Deberdeev, and N. E. Kirillova, "Investigation of Light-Sensitive Materials Coated with Emulsion Containing Developing Agents," *Tekhnika Kino Televideniya*, 7: 38 (1963) (in Russian).

46. N. I. Kirillov, *Problems in Photographic Research and Technology*, Focal Press, London, 1967, pp. 140–147.

47. Henry C. Yutzy and Edward C. Yackel, "Photomechanical Copy Method," U. S. Pat. 2,596,756 (1952).

48. Henry C. Yutzy and Edward C. Yackel, "Photographic Transfer Process," U. S. Pat. 2,716,059 (1955).

49. Robert E. Chan, Herbert B. Cowden, and William B. Kendall, "Photographic Reproduction Process," U. S. Pat. 2,865,745 (1958).

50. Walter Clark and Herbert B. Cowden, "Lithographic Offset Printing Process," U. S. Pat. 2,763,553 (1956).

51. Orson Warren Lake and Charles F. Amering, "Method of Preparing Lithographic Printing Plate," U. S. Pat. 2,794,388 (1957).

52. William W. Rees, Elliott Frauenglass, and John W. Gates, Jr., "Light-Sensitive Photographic Elements Containing Developing Agent Precursors," U. S. Pat. 3,287,129 (1966).

53. Francis John Evans and John Warburton Gates, "Substituted Quinones and Sensitive Silver Halide Photographic Materials," Brit. Pat. 1,112,627 (1968); "Light-Sensitive Photographic Elements Containing Developing Agent Precursors," U. S. Pat. 3,345,170 (1967).

54. Clarence Edward McBride, David Frank O'Brien, and John Warburton Gates, Jr., "Silver Halide Developing Agents," Brit. Pat. 1,203,845 (1970); "Perfectionnement au développement des émulsions photographiques aux halogénures d'argent," French Pat. 1,479,090 (1967).

55. Ilmari F. Salminen, James A. van Allan, and Edward C. Yackel, "Photographic Emulsions Containing Tanning Developing Agents," U. S. Pat. 2,751,295 (1956).

56. René J. Dennilauler, Maurice E. Pfaff, and Pierre A. Roman, "Tanning of Gelatin and the like Colloid Layers and Compounds Useful as Tanning Agents," Can. Pat. 831,042 (1969).

57. Paul Brewster Gilman, Jr., and John Carleton Barnes, "Photographic Colloid Transfer Process with a Sulfur Dioxide Adduct Tanning Developer," U. S. Pat. 3,311,472 (1967); "Photographic Reproduction Processes and Sensitive Materials therefor," Brit. Pat. 1,084,631 (1967).

58. Albert C. Smith, Jr., "Photographic Developer Composition," U. S. Pat. 3,300,307 (1967); "Sensitive Photographic Material," Brit. Pat. 1,047,642 (1966).

59. Norman Wayne Kalenda, "Photographic Silver Halide Emulsions and Sensitive Materials prepared therefrom," Brit. Pat. 1,075,337 (1967); "Photographic Colloid Transfer System," U. S. Pat. 3,340,063 (1967).

60. Norman W. Kalenda, "Photographic Colloid Transfer System," U. S. Pat. 3,326,687 (1967).

61. Richard Winthrop Henn and Nancy Hilborn King, "Improvements in Photographic Processing," Brit. Pat. 1,114,576 (1968); "Activator Solution Rejuvenation," U. S. Pat. 3,379,528 (1968).

62. Herbert B. Cowden, "Desensitizer for Exposed Silver Halide Emulsions," U. S. Pat. 3,314,790 (1967).

63. Joseph Thomas Leone and James Francis McKague, "Photographic Processing Solution," Brit. Pat. 1,150,160 (1969).

64. Richard G. Yost, "Colloid Stratum Transfer Process," U. S. Pat. 3,189,449 (1965).

65. Robert Earl Chan, Herbert Bayley Cowden, and William Beveridge Kendall, "Improvements in Processes of Photographic Reproduction," Brit. Pat. 800,772 (1958).

66. Agfa-Gevaert Aktiengesellschaft, "Process for Litho Development," Brit. Pat. 1,137,801 (1968).

67. Gerald Druce, "The 'Creeping' of Solutions," Camera Craft, **39** (10): 418 (1932).

68. Max H. Goldschein, "Self-Processing Photostat Paper," U. S. Pat. 2,819,166 (1958).

69. Patrick Kunz, Maurice Edgar Pfaff, and Pierre Amédée Roman, "Nouveau révélateur photographique et nouveau produit photosensible le contenant," French Pat. 1,500,987 (1967).

70. Francois Bredoux and Maurice Pfaff, "Nouveau procédé de préparation d'un produit photographique pouvant être développé et fixé par un simple traitement à l'eau et procédé de traitement d'un tel produit," French Pat. 1,591,741 (1970); "Photographic Element and Process," U. S. Defensive Publication T870,007 (1969).

71. Paul H. Stewart and John W. Reeves, Jr., "Photographic Process for Producing Prints Stabilized Against Print-Out," U. S. Pat. 3,278,307 (1966).

72. Edith Weyde, "Method for Producing Photosensitive Layers in which the Latent Image can be Developed by the Operation of Heat," German Pat. 888,045 (1953) (in German).

73. Kurt Meyer and Franz Lühr, "Über thermische Entwicklung," *Bild und Ton*, **11**: 62 (1958).

74. Grant Milford Haist and James Reber King, "Nouveau produit photographique à développateur incorporé et procédé de développement à sec," French Pat. 1,272,332 (1961); "New Class of Development Promoter Precursors for Dry Processing Self-Developing Silver Halide Coatings," U. S. Pat. 3,041,170 (1962).

75. John Howard Jacobs, "Improvements in and relating to Photography," Brit. Pat. 898,964 (1962).

76. John Frank Tinker and John Joseph Sagura, "Couche thermographique et produits comprenant une telle couche," French Pat. 1,333,723 (1963); "Use of Salts of Readily Decarboxylated Acids in Thermography, Photography, Photothermography and Thermophotography," U. S. Pat. 3,220,846 (1965); "Thermographic and Heat Developable Photographic Copying Materials," Brit. Pat. 998,949 (1965).

77. John Frank Tinker and John Joseph Sagura, "Photographic Material," Brit. Pat. 998,950 (1965).

78. Harold G. Greig, "Photographic Diazotype Composition and Heat Development Thereof," U. S. Pat. 2,653,091 (1953).

79. Kinji Ohkubo and Takao Masuda, "Heat Developable Photographic Copying Materials," U. S. Pat. 3,523,795 (1970); "Heat Developable Photographic Copying Material," Brit. Pat. 1,086,279 (1967).

80. Anita von König, "Heat Developable Photographic Material," Brit. Pat. 1,053,539 (1967).

81. A. and L. Lumière and A. Seyewetz, "On the Preparation and Developing Properties of Metoquinone Combination of Methyl-Paramidophenol (Metol) and Hydroquinone," *Am. Amat. Phot.*, **15**: 552 (1903).

82. Grant M. Haist and David A. Pupo, "Photographic Elements, Compositions and Processes," U. S. Pat. 3,600,176 (1971).

83. Grant Milford Haist and James Reber King, "Produit photographique contenant de nouveaux précurseurs de développateurs et procédé de développement à sec de ce produit photographique," French Pat. 2,024,496 (1970).

84. Helmut Mäder, Hans Ulrich, Walter Püschel, and Anita von König, "Heat Developable Light-Sensitive Photographic Material," U. S. Pat. 3,348,945 (1967).

85. Anita von König, Helmut Mäder, Hans Ulrich, and Edith Weyde, "Light-Sensitive Material with Incorporated Developer," U. S. Pat. 3,419,395 (1968).

86. P. H. Stewart, W. Bornemann, and W. B. Kendall, "Rapid Dry Development of a Silver-Sensitized Recording Paper," *Phot. Sci. and Eng.*, 5: 113 (1961).

87. Paul H. Stewart, George E. Fallesen, and John W. Reeves, Jr., "Processing Photographic Elements Containing Developing Agent," U. S. Pat. 3,312,550 (1967); "Improvements in Photographic Processes and in Photographic Sensitive Materials therefor," Brit. Pat. 930,572 (1963); "Improvements in Photographic Sensitive Materials," Brit. Pat. 1,023,701 (1966).

88. Paul Maria Cassiers, Louis Maria De Haes, Gerard Laurens Vanreusel, and Josef Frans Willems, "Method for Heat Development," U. S. Pat. 3,257,205 (1966).

89. Anita von König, Walther Wolf, and Helmut Mäder, "Heated Diffusion Transfer Using Leucophthalocyanines," U. S. Pat. 3,335,006 (1967).

90. Gevaert Photo-Producten, "Production of Photographic Images," Brit. Pat. 1,001,662 (1965).

91. Hildegard Haydn and Anita von König, "Process for the Production of Laterally Non-Reversed Positive Copies by Heat Development," Brit. Pat. 801,053 (1958).

Chapter 7

Reversal Processing of Black-and-White Materials

By a modification of processing, called reversal processing, a normal emulsion can be made to give a positive instead of a negative result.

H. BAINES[12]

In the photographic processes described so far, the exposed silver halide is converted into the silver image that is used. The remaining silver halide is removed by a fixing bath. The silver image has reversed tones as compared with the original subject and must be used as the object for exposure of another silver halide coating, producing a developed positive image that has tones corresponding to the original subject. The two-step negative-to-positive photographic system has the advantage that corrections can be made to either the negative or positive images in order to achieve the desired subject rendition. The printing of the negative to form the positive image does involve some loss of image sharpness, however. Dust or dirt on the negative may be a problem, as such spots are present on the print as white areas that attract attention.

Many photographic uses require only a positive image. Amateur and other types of motion pictures, duplicate negatives, copies of X-rays, slides for projection, and certain graphic arts uses are examples where intermediate

negatives are not desired. Reversal processing is a procedure to produce a positive image on the same film or paper that was exposed. It was first suggested by C. Russell[1] in 1862, modified by R. Namias[2-4] in 1899, and used commercially at the beginning of the century for the early screen plate color processes, such as the Lumière Autochrome and later the Dufaycolour (Dufaycolor) materials.[5,6]

With reversal processing, the latent image formed by the exposure is first developed to form a negative silver image. This metallic negative image is then removed and the remaining silver halide is either exposed to light or chemically rendered developable. A second development forms the positive image. Forming the positive image in the same emulsion layer that received the original negative exposure results in an economy of photographic material as compared with the two steps of the negative-positive process. The positive image is formed by the silver halide that was not developed as a result of the initial light exposure. This first exposure is more critical than with photographic materials used in the negative-positive system. Over-exposure is a disaster, because not enough silver halide will remain to form an adequate positive image. Some compensation may be made for exposure deviations, provided the reversal processing steps can be modified, especially the variation of the composition or the conditions of use of the first developer.[7]

ADVANTAGES OF REVERSAL PROCESSING

Reversal processing does offer certain advantages over the negative-positive system of photography.[8]

Fineness of Grain

The large silver halide crystals in a photographic emulsion are often the most developable. These are exposed during the initial light exposure and form the silver image during the first development. The smaller silver halide crystals of less light sensitivity remain. These are then exposed and developed to form a fine-grained positive image, thus producing the fine-grained images often obtained by reversal processing. An excessively grainy negative image must be formed by the first developer, however, as the positive image is formed by the deposits of the remaining silver halide. A grainy negative image thus has some influence on the character of the positive image.

The composition and conditions of use of the first developer largely determine the characteristics of the positive image, as the second development has little effect on these characteristics. The finer grain of reversal

images is not only due to the development of smaller silver halide crystals but also has been attributed[8] to the fact that no printing of the negative is required to obtain the positive image. Printing of the negative image results in the positive copy's having a higher graininess than the negative, because the grain of the negative is imprinted upon the grain of the positive image material.

Sharpness of the Image

Improved image sharpness results from the development of the residual fine-grained silver halide by a contrasty developer often exhibiting beneficial edge effects. Elimination of the printing of the negative image, a necessary step with the negative-positive process, avoids degradation of the image characteristics. The improved edge sharpness, finer grain, and low fog given by reversal processing produces an image that has brilliance and plasticity when projected.

Absence of Fog

When properly compounded and applied, the chemical solutions of a reversal process are capable of producing an image that is almost free of image-obscuring fog; the result is a clarity of image that is apparent when the image is shown by projection.

Absence of White Dust Spots

Dust or dirt on the surface of a reversal film or paper shields the emulsion layer from exposure. This unexposed silver halide, after reversal processing, produces a black spot on the positive image, often unnoticed because of the unobtrusive nature of a very small black area. Dust or dirt on a negative used to make a positive print produces an eye-attracting white spot on the print, because the emulsion shielded by the dust is not developed. For this reason, dust spots are much less a problem with reversal processing than with the negative-positive process.

THE STEPS IN REVERSAL PROCESSING OF BLACK-AND-WHITE MATERIALS

Special photographic film and paper products are supplied for reversal processing. Such products often contain a considerable amount of silver halide coated in a thin emulsion layer. Some photographic films in general

use may be processed to give an acceptable positive image by the reversal procedures. Thick emulsion layers with high silver coverage, such as on Kodak Tri-X film, have been found to be difficult to reversal process, apparently because of the difficulty of securing exposure and development to penetrate through the emulsion layer to the film base. An extremely fine-grained thin emulsion layer, such as found on Kodak high-contrast copy film, may not have sufficient silver halide left for the second development to produce a satisfactory maximum density in the positive image.[9] A pictorial film such as Kodak Panatomic-X, 35mm, is said[10] to give "excellent black-and-white transparencies" with reversal processing even though this film has a gray dye in the film base. (Panatomic-X professional film in the 120 roll-film size is not recommended for reversal processing.) Other general-purpose films, such as Kodak Plus-X, 35mm, may be successfully reversal processed provided the chemicals and the conditions of processing are suitably modified.[11]

The chemical steps and their purposes can be briefly summarized as follows:

Step No.	Chemical Operation	Purpose
1	First development	Develop the negative silver image
2	Bleaching	Convert metallic silver image into a form that can be solubilized
3	Clearing	Remove silver compound formed during bleaching
4	Second development	Develop remaining silver halide to form the positive silver image
5	Fixing	Remove any remaining silver halide not used to form the positive silver image

Reversal processing of black-and-white films involves these five basic chemical operations, usually with water rinses between each step and a final water wash before the film is dried. An exposure to light may be given before the second development, or chemical compounds may be used to render the silver halide developable without light exposure. (See Figure 1.)

First Development

An exposed, developed, but unfixed emulsion layer consists of two kinds of images: one is the negative silver image; the other is the complementary

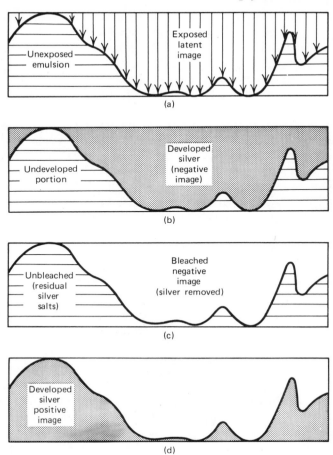

Figure 1. **The major steps in reversal processing. A schematic cross section of the photographic emulsion layer represents (a) the effect of exposure, (b) development of the negative silver image, (c) removal of the silver image, and (d) development of the positive silver image. [H. A. Miller, H. D. Russell, and J. I. Crabtree, *PSA J.* 15: 383 (1949)]**

positive image composed of silver halide. The first developer must be so constituted that the required amount of silver halide remains, because it is the positive image that is important. The maximum density of the positive silver image should be at least 2.0, transmitting only $\frac{1}{100}$ of the incident light, or, preferably, around 2.2 to greater than 2.4. High maximum densities are not needed because, as H. Verkinderen[8] has pointed out, "by normal pro-

jection all density-discrimination for densities exceeding from 2.2 to 2.4 is lost." The density of the clear parts of the image should not be much greater than the density of the base alone. The image should be free of fog so that a high degree of image brilliance is obtained during projection. A uniform gradation of the tones should extend from the black shadow to the clear highlight of the image.

Maximum highlight exposure of the negative image, followed by a vigorous first developer, would seem all that is necessary to produce a suitable positive image by reversal processing. In practice, the positive image is too dense, including too much silver in the highlights, so that the projected image lacks clarity. The first developer forms much of the silver image in the upper portions of the emulsion layer, leaving much silver halide at the lower regions. This silver halide is then available for development to form the positive image.

The amount of the first exposure could be increased, resulting in a lowering of the emulsion speed of the photographic material, but this procedure is not too practical or effective. If the positive image is to have clear highlights, the original light exposure must cause almost the entire silver halide of the layer to become developable in the highlight region. H. Baines[12] calculated that 300 times the minimum exposure to give a good negative would be required to accomplish this. A reversal material only one three-hundredth the speed of a negative film would severely limit the usefulness of the reversal film. Such an excessive exposure still might not give clear highlights in the positive image, however, because, as Lloyd E. Varden[13] has pointed out, "there will remain some exposed grains that will not develop because they have become solarized." Such nondevelopable grains of silver halide crystals will then form a considerable fog level in the positive image. Joseph S. Friedman[14] also concluded that "it was impossible to ever expose and develop an emulsion in such a manner that 100% of the silver halide grains become developed."

The dilemma of securing a satisfactory positive image by reversal processing has been overcome by a combination of the design of the photographic material and the chemistry of the first developer. Thin coatings of silver halide emulsions are used, but sufficient silver halide must be maintained so that the positive image will have adequate density in the shadow areas. The entire exposure latitude of the photographic emulsion is used: the minimum exposure that places the shadows at the foot of the characteristic curve of the emulsion also places the highlights on the shoulder of the curve. The exposed image extends from almost clear film base to the maximum density of the developed image. Only a limited variation in exposure is possible. Exposure less than recommended will give dense highlights; exposure more than the recommended will burn out the highlights so that

any detail will be missing. Only a limited tolerance of about one-half to double the recommended correct exposure is available to give tolerable positive images.

Considerable ingenuity has been applied to correct reversal exposures that may differ from the correct value for the optimum quality reversal image. Some silver halide may be dissolved in the clearing bath after bleaching.[15] Early patented methods[16–18] involved operator evaluation and later automatic evaluation (U. S. Pat. 1,908,610) of the opacity of the remaining silver halide in each frame or scene after the negative image had been developed and removed. A controlled light exposure varying in intensity, duration, or direction—that is, from emulsion or base side—dependent on the opacity of the remaining silver halide was then given to insure that the correct density was formed in the positive image during the second development. Any excess silver halide was fixed out, providing some correction for under-exposure or underdevelopment in the first developer. Controlling the time of the second development has been tried, but it is difficult to estimate when development should be stopped to provide the desired positive image. Prolonging first development, although allowing shorter-than-normal ex-posures to light, does increase graininess and contrast, which may produce a positive image with insufficient density in the shadow areas of the image.

Chemical means have provided the most satisfactory answer to the prob-lem of securing the desired balance between the negative silver image and the remaining silver halide so that a high-quality positive image can be obtained. An energetic, contrasty negative developer is combined with a silver halide solvent to produce vigorous development of the exposed silver halide and to insure clear highlights in the positive image. First developers in reversal processing are hydroquinone solutions that produce high-contrast images. Metol of Phenidone is usually also present in small quanti-ties in the developer. For rapid first development, sodium hydroxide is often present in the developing solution, but sodium carbonate is satisfactory when longer developing periods are possible. High sodium sulfite concentra-tions are often needed to preserve the highly alkaline developers.

Fog in the negative must be suppressed, as it lowers the possible maximum density of the positive image. Antifoggants are essential for development at higher-than-normal temperatures. Benzotriazole and 6-nitrobenzimidazole nitrate have been used for fog control at high temperatures. Such higher temperatures permit a shortening of the first developing period, a desirable and necessary situation for machine processing. As a general rule, the de-veloping time may be reduced by one-half for each 15°F increase up to 95°F.[19] The times in the other solutions are not as greatly affected by tem-perature, being only about one-half that with developing solutions.

The contrasty first developer is energetic enough to compete successfully

with the silver halide solvents that are present in the developing solution. Many silver halide solvents have been tried: sodium thiosulfate, potassium cyanide, ammonia, organic amines,[20-21] ammonium chloride or bromide, potassium iodide, and others. Potassium bromide is also added to the solution to suppress fog and slow the rate of developing, allowing sufficient time for the silver halide solvents to work, including the sodium sulfite also present. Presently, the preferred silver halide solvent in the first developer is potassium thiocyanate, although sodium thiocyanate or ammonium thiocyanate has also been used. The optimum level of potassium thiocyanate varies from photographic emulsion to emulsion, but for many materials about 5 g of the thiocyanate per liter of developer is most satisfactory. When the thiocyanate rises above 5 g/liter, the maximum density of the positive image may be sharply decreased; below 5 g/liter, the emulsion speed of the photographic material drops rapidly and long times of development are required.

The action of the silver halide solvent in the first developer effectively increases the speed of the reversal film or paper, because a shorter light exposure may be given and the solvent's action will insure that the highlights of the positive image will be clear. The fact that all grains in a photographic emulsion layer cannot be made developable by light exposure is thus circumvented by giving a less-than-total exposure for all the silver halide crystals, developing the exposed silver halide fully to form a high-contrast silver image, and removing some of the remaining silver halide by solvent action to insure a clear positive highlight. The solvent is particularly effective where most needed—that is, in the areas of maximum exposure, as these areas become the highlights of the positive image. Here, only small silver halide crystals of low light sensitivity, probably of high silver iodide content,[22-26] remain after chemical development of the negative image. It is much easier to remove these silver halide crystals by solvent action than by attempting to expose and develop them. The presence of the developed silver acts as a catalyst for the solvent action of the thiocyanate. Most silver is formed in the areas of maximum light exposure. Thus, the presence of the most silver filaments results in the maximum solvent action, which is needed to remove the less sensitive silver halide from the region that will be the highlights of the positive image.

The first developer in the reversal process is a combined chemical-and-physical developing solution. Kodak D-67 developer was used as the first developer in the reversal processing of Kodak Super-X blue base reversal film.[27] The D-67 developer is Kodak developer D-19 with 2 g of sodium thiocyanate added to each liter of the developing solution. Such a developer may unduly prolong development for satisfactory clean-out of the positive image highlights on some films. For these reversal films, a more energetic,

caustic developer, such as Kodak D-88, with or without added silver halide solvents, has been suggested for use for 10 min, 68°F.

Kodak Developer D-88[27]

Water (125°F)	750 ml
Sodium sulfite, desiccated	45.0 g
Hydroquinone	22.5 g
Boric acid, crystals	5.5 g
Potassium bromide	2.5 g
Sodium hydroxide	22.5 g
Cold water to make	1.0 liter

A first developer suitable for processing Gevaert 8 and 16mm motion picture films in 6 to 8 min, 68°F, had the following composition[28]:

Metol	2.0 g
Sodium sulfite, desiccated	50.0 g
Hydroquinone	8.0 g
Sodium carbonate	50.0 g
Potassium thiocyanate	4.0 g
Potassium bromide	4.0 g
Water to make	1.0 liter

Another proposed first developer[29] for the reversal processing of motion picture films contained:

Water	2839 ml
Calgon (Calgon Corporation)	1.4 g
Metol	2.3 g
Sodium sulfite, desiccated	191.4 g
Hydroquinone	75.5 g
Potassium bromide	30.3 g
Potassium thiocyanate	22.7 g
Sodium hydroxide	75.5 g
Water to make	3785 ml

First development, although not carried to completion, is usually sufficiently long so that the contrast of the image is no longer increasing rapidly with time. Film emulsion speed, as determined by the least exposure required

to give clean highlights in the positive image, does not change appreciably with small variations in developing time. Thus, there is some tolerance in the amount of first development caused by agitation, temperature, and solution-exhaustion variations, but such deviations from normal must be minimized. With a correctly exposed image, insufficient first development will produce excessively high densities in the positive image. If the shadow density of the positive is low, excessive first development may have occurred. Inadequate second development after reexposure can produce low contrast and low maximum image density. Reversal processing requires that exposure be correct and the processing be satisfactory if high-quality positive images are to be produced. There is no safety factor in exposing reversal materials that yield a contrasty image, unlike the lower-contrast negative materials that have a wide latitude for over- or underexposure. (See Figure 2.)

The high contrast of the image formed by the first development means that the positive image will be of high contrast, too. This is an unfortunate

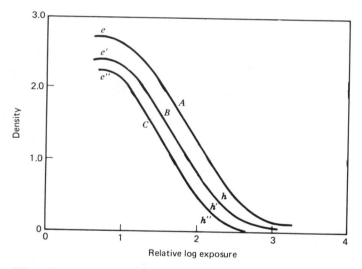

Figure 2. Effect of the time of first development upon "film speed." Small changes in the time of first development of a reversal process have only little effect upon contrast but do change "film speed." The curves represent time of development at 68°C in Kodak D-67 as follows: A, 9 min; B, 12 min; C, 15 min. The least exposure required to give detail in the shadows (emulsion speed), shown as e, e', and e'' on the curves, is not much influenced by variation in the first developer time. The least exposure required to give transparent highlights (highlight film speed), shown as h, h', and h'' on the curves, does vary considerably with the time of first development. Thus, increased time in the first developer (pushed development) can increase highlight film speed but with a reduction in the maximum density of the positive image. [H. A. Miller, H. D. Russell, and J. I. Crabtree, *PSA J.*, 15: 384 (1949)]

limitation of reversal processing. The presence of the solvent in the first developer makes the positive image fail to be the mirror image of the negative image formed by the first development. In practice, the positive image has a lower maximum density than the image formed by first development and may have an even higher contrast. The sum of the density of the negative image and the density of the positive image passes through a minimum value at intermediate exposure levels. J. C. Barnes[30] has also pointed out that the maximum density of the positive image contains considerably less silver than the minimum density, indicating a difference in the light-stopping power of the metallic silver in the different regions of the image.

The nature of the silver image formed on reversal development is explained on the basis that both chemical and physical development are occurring in the first developer. The thiocyanate dissolves some of the silver from the silver halide crystals and, in the presence of large amounts of sodium sulfite, releases the silver ions for reaction with the sulfite ions. The thiocyanate is available again for dissolving more silver halide. The silver sulfite and some silver thiocyanate, as well, are unstable in the presence of freshly developed silver filaments of the chemically formed photographic image. The silver from the complexes is deposited upon these silver filaments, thickening the filaments slightly but not materially increasing their light-stopping power (covering power). The deposition is accelerated by the presence of the silver particles of the image, and the most silver filaments occur in the high densities of the image formed in the first developer. Thus, unexposed or undevelopable silver halide crystals in this area are dissolved away, leaving almost no silver halide for subsequent development to form the positive image. In this way a combination of chemical and physical development in the first developer achieves a desired fogfree result that cannot be obtained by exposure alone.

The action of silver halide solvents upon the image obtained by reversal processing has been studied by E. Klein,[31–32] who used the electron microscope to observe the thickening of the filamentary silver in the thiocyanate-containing first developer. Klein concluded: "Physical development on chemically developed silver takes place most readily if on the one hand the largest possible surface of undeveloped silver halide is available for complex formation, and on the other hand a large surface of developed silver is available for the deposition of physically developed silver. This will probably occur in the middle range of the characteristic curve. A relatively large quantity of silver is here physically deposited without any contribution to the covering power. This silver can subsequently not be used for the chemical development of the reversal density." At the lower exposures there were only a few exposed silver halide crystals and very many unexposed crystals. Physical development was slowed because of the lack of the metallic silver

of the image that is needed to accelerate the solubilization of the unexposed silver halide. Much of the silver halide is unchanged. This silver halide is chemically developed to form the positive image. This metallic silver has great light-stopping action. The maximum density thus has lower silver than the minimum density, which has high silver and lower density where physical development had occurred.

The chemical development, being a fast process, provides the centers for silver deposition by physical development, the slower process. Near the surface of the emulsion layer, silver ions that have been solubilized pass into the solution of the developer. This solubilized silver is quickly deposited on the chemically developed silver filaments, leading to the accelerated solution of silver halide grains near the surface in the vicinity of the silver particles. Deeper in the emulsion layer this condition does not occur, as the physical development rate is slowed because silver ions soon saturate the space between silver halide crystals.

The difference in the rates of physical development at different levels in the emulsion layer has been reported to decrease the width of a line image nearer the surface. Retardation of the physical development in the top part of the emulsion layer was said[33] to result when 2-mercapto-5-sulfobenzimidazole was added to the first developer. The change in image detail dimensions was decreased and the sharpness of the image edges was increased when the film was treated with the developer containing the 2-mercapto-5-sulfobenzimidazole.

Rinse Bath

Water rinses usually follow each of the chemical steps of reversal processing to prevent contamination of the processing solution that is next in the cycle. After the first development the photographic film or paper is usually rinsed in running water or in a bath designed to stop development. This rinse is especially important because the active alkaline first developer continues to act for a short period in the rinse bath. This developing action influences the nature of the final developed image and may give rise to significant edge effects of a desirable nature. Uniformity of the image may also be influenced during the rinse or stop bath. The first development and the rinse bath following it are the two critical processing steps of reversal processing, determining the photographic quality of the positive. The rinse following first development is essential to prevent staining that results when the developer and bleach bath react. The other intermediate rinses may, of necessity, be omitted, although the succeeding baths may have less exhaustion life. A final water wash is essential to remove the thiosulfate and silver thiosulfates that may be present in the emulsion layer.

Bleaching

Treating the developed-and-rinsed photographic image with a bleach bath, sometimes called a reversal bath, converts the metallic silver of the image into a silver compound that can be removed from the emulsion layer, leaving a positive image composed of silver halide. This silver halide must not be deleteriously affected by the ingredients of the bleaching solution. Bleaching solutions may be considered to be the opposite in action to a fixing bath. The thiosulfate of a fixing solution solubilizes the silver halide but has little effect upon the metallic silver of the image. The bleach bath contains an oxidizing agent that converts the metallic silver image to silver ions for removal from the emulsion, leaving the silver halide substantially unchanged.

A bleaching bath such as Farmer's reducer containing potassium ferricyanide and sodium thiosulfate is not suitable for reversal processing, because both silver halide and metallic silver would be dissolved. Any bleach bath that converts the metallic silver to an insoluble silver salt, such as a silver halide, is also unsuitable. An acidic potassium permanganate solution containing hydrochloric acid would change the metallic silver into silver ions, but these would immediately be deposited as insoluble silver chloride. Bleach baths for reversal processing are specially compounded to oxidize the image silver to ionic condition while avoiding the formation of any silver compound that is not soluble in the bleach solution itself or following baths.

The oxidizing agent in the bleach bath is commonly either potassium dichromate or potassium permanganate in a water solution made acidic with sulfuric acid. The potassium dichromate–sulfuric acid bleach bath is commonly used today, although the pollution effect of dichromate may limit its future use. A representative dichromate bleach consists of 5 g of potassium dichromate dissolved in a liter of water, to which is then added, with care, 5 ml of concentrated sulfuric acid. No more than traces of chloride or bromide ions should be present in the solution. The dichromate bleach is rapid acting, the image usually disappearing in less than a minute. Immersion time should not exceed 2 or 3 min.

In a sulfuric acid solution the dichromate converts the metallic silver of the image to soluble silver sulfate, according to the reaction[34]

$$K_2Cr_2O_7 + 5H_2SO_4 + 2Ag \longrightarrow$$

Potassium sulfuric metallic
dichromate acid silver

$$Ag_2SO_4 + Cr_2(SO_4)_3 + K_2SO_4 + O_2 + 5H_2O$$

silver chromium potassium oxygen water
sulfate sulfate sulfate

The dichromate also reacts with the gelatin of the emulsion layer to form a small amount of chromium oxide (Cr_2O_3):

$$K_2Cr_2O_7 + H_2SO_4 \xrightarrow{\text{(gelatin)}} Cr_2O_3 + K_2SO_4 + H_2O + 3O$$

Potassium dichromate — sulfuric acid — chromium oxide — potassium sulfate — water — oxygen

Dichromate bleach is said[28] to harden physically the gelatin of the emulsion layer because of the formation of the chromium oxide, the reduction product of the dichromate.

Dichromate bleach baths are preferred, not only for their rapidity of action, but for their stability of solution and exhaustion characteristics. With some dichromate bleaches a residue of chromium and silver may be deposited in the areas of greatest negative silver image formation. This warm-colored stain or minimum density appears in the positive image in the highlights or lower image densities where such a stain is the most conspicuous. It has been said,[19]

The successful use of the dichromate bleach is dependent on the control of a series of steps, among which the rates of reaction and movement by diffusion of reactants and reaction products must be harmonized. The silver is first converted to silver ion which is in solution in the presence of the sulfate and dichromate ions. If the rate of formation of silver ion exceeds its rate of removal by diffusion from the gelatin emulsion layer into the bath, solubility limits are reached and solids are deposited which are not readily removable in the steps of the process preceding redevelopment. This imbalance occurs more readily in the bleaching of fine-grain images because the relatively great surface of small silver grains favors rapid reaction with the bath.

This chromium-and-silver deposit is capable of development in the second developer, producing a noticeable density in the highlights of the positive image. The deposit is light-sensitive but much less so than the silver halide for the positive image. If an excessive second exposure is avoided, the stain-forming residue will not develop but will be removed when the image is fixed near the end of the reversal processing cycle. It was found by H. A. Miller, H. D. Russell, and J. I. Crabtree[27] that "The extent of staining rises with the pH of the bleaching, and the pH increases with exhaustion. Therefore, frequent replacement of the bleach, or its revival by the addition of a little sulfuric acid, is helpful in lessening stain troubles." Obviously, an adequate rinse bath before the bleach would help maintain the bleach solution in trouble-free condition, but overuse of the bleach must be avoided. Excessively strong dichromate bleach solutions have been reported[19] to deposit insoluble residues in the emulsion layer when the bleach solution is restricted from movement from the film surface.

The interaction of the highly energetic first developer with the acidified dichromate bleach solution produces a complex chromic hydroxide sludge that may adhere to the film surface or the processing machine. The interaction between the two processing solutions generally may be avoided by a thorough wash in water between development and bleaching. In rapid machine processing, where the total processing time may be less than 60 sec, the formation of the undesired chromium hydroxides is more difficult to avoid. The addition of glacial acetic acid to the acidic dichromate bleach has been patented[35] as a means to minimize the sludge formation during rapid processing. A solution consisting of 1% potassium dichromate, 2% glacial acetic acid, and 3% sulfuric acid (concentrated), all by weight, was found to be optimum in a process that had an elapsed time of less than 30 sec from exposure to projection of the film. A listed example of such a bleaching solution consisted of

Potassium dichromate	10 g
Sulfuric acid (concentrated)	20 g
Glacial acetic acid	50 g
Water to make	1 liter

Potassium permanganate has been used as the oxidizing agent in bleach baths made acid with sulfuric acid. Permanganate bleaches were used some years ago when a controlled light exposure was made before the second development or in the process for screen color plates and films. Permanganate in sulfuric acid solution converts the metallic silver of the image to silver sulfate, the permanganate forming manganese sulfate as a result of the oxidation of the silver.

$$2\,KMnO_4 \;+\; 8\,H_2SO_4 \;+\; 10\,Ag \;\longrightarrow$$

Potassium sulfuric metallic
permanganate acid silver

$$5\,Ag_2SO_4 \;+\; K_2SO_4 \;+\; 2\,MnSO_4 \;+\; 8\,H_2O$$

silver potassium manganese water
sulfate sulfate sulfate

The gelatin of the emulsion layer also reduces a small quantity of permanganate, forming manganese dioxide that colors the emulsion brown.

$$2\,KMnO_4 \;+\; H_2SO_4 \;\xrightarrow{\text{(gelatin)}}\; 2\,MnO_2 \;+\; K_2SO_4 \;+\; H_2O \;+\; 1\tfrac{1}{2}O_2$$

Potassium sulfuric manganese potassium water oxygen
permanganate acid dioxide sulfate

Permanganate bleach baths are short-lived, usually being mixed just before use, and are not stable even if not used, precipitating brown manganese

dioxide. The permanganate bleach does not cause a residual stain on the positive image as dichromate sometimes does. The acid permanganate bath must be free of chloride or bromide ions, because the oxidized silver image will be partly reformed as a silver halide image, producing a weak negative image superimposed upon the positive image. Permanganate solutions soften the gelatin of the emulsion layer, sometimes allowing reticulation to occur during the processing cycle. Permanganate bleaching causes a graded sensitivity of the remaining silver halide, requiring a greater light reexposure and a more vigorous second developer. The residual silver halide, after the metallic silver has been dissolved by the acid permanganate bleach and washed away, has a very low sensitivity to light. H. Baines[12] mentioned that the silver halide could be resensitized after bleaching and a water rinse, by immersing the image for a short time in a solution of sodium sulfite.

One early commercially used permanganate bleaching bath[36] consisted of dissolving 3 g of potassium permanganate in a liter of warm water and then adding carefully 10 ml of concentrated sulfuric acid. (Do not add sulfuric acid to dry permanganate crystals or an explosion may occur.) At least 4 min will be required to bleach the metallic silver image. The dense parts of the image will be bleached more rapidly than the light areas. The reaction rate is higher deep within the emulsion layer, rather than at the surface as with dichromate bleach baths. Tone reproduction may be influenced by the reexposure sensitivity of the silver halide that has been in a permanganate bleaching solution, but, for some photographic emulsions, a blacker tone and better tone gradation may be given by the permanganate than by the dichromate bleach. Potassium permanganate is recommended[37] for the bleach bath when positive images are to be obtained by physical development after fixation, because potassium dichromate bleach partially destroys the latent image that is left after fixing.

Although dichromate and permanganate bleaches have been extensively used, many sulfuric acid solutions of metal-ion compounds are effective. Cerium sulfate can convert a metallic silver image into soluble silver sulfate[38]:

$$Ce_2(SO_4)_3 + 2Ag \longrightarrow 2CeSO_4 + Ag_2SO_4$$

Ceric sulfate · metallic silver · cerous sulfate · silver sulfate

The yellow ceric sulfate is converted into colorless cerous sulfate when the silver is oxidized. The cerium sulfate bleach acts throughout the emulsion layer uniformly. The cost of the cerium compound has been the major deterrent to its use. Pierre Glafkides[34] suggested a bath made by adding 4 ml of sulfuric acid to 1000 ml of water, then adding 10 g of ceric sulfate.

Clearing

When the photographic film or paper is removed from the bleach solution, the emulsion layer may be stained brown with manganese dioxide from the permanganate bleach or may be greenish from chromium oxide formed in the dichromate bath. Unreacted permanganate or dichromate may also be imbibed in the emulsion layer. The water rinse following the bleaching treatment does remove some of the water-soluble products from the emulsion layer, thus lengthening the active life of the clearing bath. This water rinse may be omitted if replenishment is increased to maintain the chemical balance of the clearing bath. If the water rinse is omitted between the dichromate bleach and the clearing treatments, the chromic ion in the emulsion layer will produce substantially more gelatin hardening than if the water rinse is used.[29] An active clearing bath is essential to convert any residual bleaching compound and the colored by-products of the bleaching reaction into soluble compounds that will migrate from the emulsion layer during the clearing period or in the water rinse that follows the clearing. All of the reactive oxidizing compounds from the bleaching solution must be removed before the photographic material is immersed in the second developer, or stained highlights will result.

Thorough washing in considerable quantities of agitated water could suffice for a clearing bath, but a chemical solution is simpler and safer. A 5% solution of sodium sulfite,[39] sodium bisulfite, or potassium metabisulfite is commonly used for clearing baths for moderate times of clearing, but the choice of a suitable compound depends upon the nature of the oxidizing agent present in the bleach. After acidic permanganate bleaching, a 5% solution of sodium bisulfite is preferable. An acidic solution is necessary to convert any remaining permanganate and other products of the bleaching reaction into water-soluble manganous ions that are readily removable. If the clearing bath were neutral or alkaline, permanganate would be converted to insoluble manganese dioxide. Sodium sulfite solution would not be suitable for a clearing bath following permanganate bleaching.

A solution of sodium sulfite is customarily used to remove dichromate and the products of dichromate bleaching, as these compounds are almost completely soluble in the sulfite solution. These compounds become less soluble as the pH of the clearing bath is lowered. A sodium bisulfite clearing bath is thus not a satisfactory clearing solution following a dichromate bleach. Kodak clearing bath CB-1 is a 9% sodium sulfite solution, but for machine processing the CB-2 clearing bath contains 21% sodium sulfite. Times of treatment longer than 1 min, 68°F, in the 21% sodium sulfite solution must be avoided, as a high sulfite concentration acts to solubilize silver halide, thus lowering the density of the image produced by second

development. The use of a sulfite-bisulfite solution produces a solution with a lower pH and less attack upon the silver halide. Potassium bromide is sometimes added to the clearing bath to reduce the attack of the sulfite upon the silver halide. If sufficient period of time is available for the clearing treatment, a weak sulfite solution should be used. For example, Kodak clearing bath CB-3 is only a 1 % solution of sodium sulfite.

The strong oxidizing compounds used in bleach baths attack the sites for latent image formation in the residual silver halide to be used for forming the positive image.[40-43] As a result, this silver halide is of very low light sensitivity. The presence of sulfite ions in the clearing bath restores some of the light sensitivity of the silver halide, apparently by etching away some of the surface silver halide to reveal subsurface sites for latent image formation. These internal sites were protected from the destructive action of the bleaching compound. Thus, sodium sulfite, as it usually does, exhibits a complex activity involving several actions.

Redevelopment

After a water rinse following clearing, the silver halide of the emulsion layer must be developed to form the silver positive image. This silver halide may be made developable by exposing the emulsion layer to light or by immersing in a fogging developer, without the need of the light exposure, to form the silver image. The fogging agent may be contained in a separate solution but the common practice is to incorporate the fogging agent in the second developer, thus obviating the need for another processing solution. Usually, a fogging developer is slower in action than the combination of light exposure and an active developer.[27] Although light exposure is a simple procedure for most processing, light exposure is difficult to apply for rewind processing, where the film is wound back and forth between two spools submerged under the surface of the developer. In place of a fogging developer, a toning bath, such as 2 % sodium sulfide (Kodak T-19 sulfide redeveloper) may be used to form a brown silver sulfide image if the silver image is not necessary.

Controlled light reexposure is generally not practical as an attempt to compensate for improper camera exposure. There is a broad plateau of correct reexposure that does not cause any variation in picture quality. Exposures of about 10 times the maximum can cause an unwanted increase in minimum density; decreased exposure by a factor of 100 times reduces the maximum picture density to an inadequate level. "Thus, the aim in reexposure," said C. E. Ives, J. W. Zuidema, N. A. Exley, and C. C. Wilt,[19] "is to operate on the plateau region so as to obtain the full maximum density

necessary for normal contrast and shadow quality without, however, bringing about complete development of the less sensitive and less readily developable material which would only raise minimum density to the detriment of highlight quality." The exposure to light may be made at any time during the latter part of the clearing period to the early part of the second development.

When properly exposed, the light-flashed film or paper emulsion may be developed in any energetic developer without considerable quantities of a silver halide solvent. A paper developer, such as Kodak D-72, or a film developer, such as Kodak D-8 or D-19, gives satisfactory results. Negative film developers, such as Kodak D-76 or DK-50 or warm-toned paper developers, are generally unsuitable. If a first developer was used that did not contain an excessive amount of silver halide solvent, such as Kodak D-88, then the same developing solution may be used for the second development. Many first developers do contain sodium thiosulfate or potassium thiocyanate, and such solutions are usually unsatisfactory, often depositing a silver scum (dichroic fog) on the emulsion surface. The silver solvent in the developer results in a loss in the maximum density obtained in the positive image. The addition of a small amount of antifoggant to the developer will help reduce the minimum density and prevent dichroic fog stains. Potassium iodide has been suggested[27] at a concentration of 0.25 g/liter of D-88 developer.

In many cases, because of the configuration of the processing equipment, a uniform reexposure to light is difficult to attain. It is feasible to fog chemically and then reduce all of the remaining silver halide without the need to expose the silver halide to light. This procedure has the disadvantage that even the small, less sensitive silver halide crystals, normally not developed when light exposure is used, will be reduced to silver, thus producing a minimum density that may cloud the highlights of the positive image. This led Ives, Zuidema, Exley, and Wilt in 1957 to state that "reliance must be placed on the re-exposure method for highest-quality results. Chemical fogging redevelopment methods are thus restricted to the cases where control of re-exposure is too difficult or where the disposition of the film in the equipment makes re-exposure impossible." The trend in modern reversal processing, however, is to fogging solutions for individual and machine processing because of the simplicity and convenience of operation.

Sulfide toners, nonselective inorganic reducing compounds, or developing solutions with a fogging agent are capable of redevelopment without the need of a light exposure. If a brown-toned image is acceptable, the residual positive silver halide image may be converted to a positive silver sulfide image through the use of a highly alkaline thiourea solution containing 1% thiourea in a 2% solution of sodium hydroxide or the Sulfide Redeveloper

T-19. Nonselective inorganic reducing agents tend to produce images of blacker tone composed primarily of metallic silver. In 1934 Edwin E. Jelley[44-45] proposed hydrogen peroxide, hydrazine, or sodium hydrosulfite (sodium dithionite) as well as methylene blue, an organic compound. Other hydrazine compounds, such as phenyl hydrazine, hydrazine benzoic acid, and semicarbazide, were patented by Joseph C. Ville.[46] The instability of certain compounds such as alkaline solutions of thiourea and derivatives produces silver sulfide which tints the image a brown color. The formation of the silver sulfide was claimed[47] to be prevented by the use of the acidic solutions of thiourea and its derivatives—for example, thiosinamine, also called N-allyl thiourea. Glacial acetic acid (5 ml) and thiosinamine (0.4 g) were present in a liter of solution used as an intermediate bath after first development. Stannous compounds are suitable as fogging agents for silver halide.[48] Silver halide that is not developed in the first developer may be made developable by treatment in acidic solutions of stannous chloride of rather high concentrations. Aerial oxidation of this solution eventually causes the deposition of stannic oxide as a dirt. Any of the stannous salt carried into the following second developer causes an insoluble precipitate to form immediately. These difficulties are claimed[49] to be overcome when the stannous salt is added to a water solution of a compound such as nitrilo-N,N,N-trimethylenephosphonic acid, with about a 10% excess of the acid, to form a combined compound. This solution is made acid with acetic acid if the solution is to be used as a stop bath after first development, or the solution without the acetic acid may be added to the second developer. Stannous compounds used in combined form are claimed to be superior to boron compounds such as potassium or sodium borohydride,[50] potassium boranocarbonate[51] or boranes,[52] phosphine, arsine, and stilbene compounds that have been patented and used. These compounds are relatively unstable in acid stop-bath solutions and are generally used in the alkaline developer solution, where the compounds are still decomposed by aerial oxidation. Borane compounds, such as tert-butylamine borane, are extremely toxic to handle.

The action of many of these nonselective compounds is essentially the same as that of light: the silver halide has a surface development center which will cause the reduction of the entire crystal when the silver halide is placed in a developing solution. The compounds that nucleate the reduction of unexposed silver halide are ideally placed in the second developer. This is why it is desirable to have the nucleating compounds as stable as possible in alkaline solution. A fogging compound such as sodium hydrosulfite, patented in 1927 by Georges Emmanuel Zelger,[53] both renders the silver halide developable and then reduces the silver halide to metallic silver. Such a fogging solution has a short life. Many other compounds, such as thioureas,

hydrazines, and boranes, are added directly to the second developer, where conventional developing agents reduce the silver halide to form the positive silver image. As little as 1 or 2 g/liter of hydrazine sulfate will convert a caustic developer such as D-8 or D-88 into a second developer that will reduce the residual silver halide image without the need for light exposure. A compound such as tertiary butylamine borane was effective at a concentration of 0.1 g/liter of developer. Alkaline solutions of the oxygenated reaction product of thiourea with hydrogen peroxide, called thiourea dioxide, may be used[54] to blacken the silver halide remaining after the bleaching step. Dioxindol or substituted benzoin have also been proposed[55] for use alone or in regular developers for transforming silver halide into silver without previous exposure to light.

Fixing

After redevelopment and a brief rinse in water or in an acid stop bath such as 3 % acetic acid, the emulsion layer must be immersed in a fixing bath. When reexposure by light is part of the reversal cycle, some of the small or inert silver halide crystals are still present and must be removed by the thiosulfate of the fixing bath. The fixing bath also removes silver and chromium compounds that may have formed during bleaching in the dichromate solution. Removal of these deposited residues helps reduce minimum density, cleans the highlights, and prevents later discoloration of the highlights. The hardening action of the fixing bath also helps reduce the swelling in the water wash that follows fixation, thus lowering the water uptake and speeding the drying of the processed film or paper.

REVERSAL SYSTEMS

Motion Picture Reversal Films

A positive image is needed for motion picture projection, and reversal processing was the method used so that the exposed film was converted to a positive image. Such films had to have thin emulsion layers, having little exposure latitude and little means for correcting exposure mistakes. Insufficient exposure gave a positive image that was too dense; overexposure produced a thin, washed-out image lacking in highlight details. Reversal motion pictures were based on the process of R. Namias[2] who, in 1900, removed the negative silver image with acidic potassium permanganate solution. In 1923 Eastman Kodak Company introduced 16mm safety reversal film[56] that was treated in an improved reversal process with controlled

second[57-58] exposure, said[59] to have been conceived in 1914 and then perfected by John Capstaff, who has been called the "Father of Home Movies."[60]

The basic reversal process has changed little since then, consisting of developing to form a contrasty negative silver image, oxidizing the silver with a bleaching solution so that the soluble silver and the bleach may be removed by a clearing bath, then exposing the remaining silver halide to light and redeveloping, or treating the silver halide with a fogging redeveloper without light exposure, forming a positive silver image. Immersion in a fixing bath to remove any remaining silver halide, followed by washing in water, completes the reversal processing cycle. The best image quality is obtained when the film is especially designed for reversal processing in solutions most suitable for it. For small-scale processing, motion picture film may be wound on a reel that dips into a tray or trough of solution, or the film may be threaded on a flat reel that is immersed in a tank of solution.[61] Modern motion picture films such as

- Kodak Plus-X reversal film 7276
- Kodak Tri-X reversal film 7278
- Kodak 4-X reversal film 7277

can be processed in reel-and-trough or reel-and-tank equipment with the cycle shown in Table 1 and the following formulations, as outlined in Kodak Pamphlet No. D-9.[62]

First Developer

Kodak Developer D-94

Water, about 21°C (70°F)	750.0 ml
Elon developing agent	0.6 g
Sodium sulfite, desiccated	50.0 g
Hydroquinone	20.0 g
Potassium bromide	8.0 g
Sodium thiocyanate	6.0 g
Sodium hydroxide (caustic soda)	20.0 g
Water to make	1.0 liter

Caution: Dissolve the sodium hydroxide in a small volume of water in a separate container before adding it to the solution of the other constituents.

Table 1. Reversal Process for Kodak Plus-X, Tri-X, and 4-X Reversal Films

Step	Operation	Treatment	Time (min at 20°C)
1	First development	D-94 developer	2 (reel-and-trough) $2\frac{1}{2}$ (reel-and-tank)
2	Rinse	Water only, not acid stop bath	2
3	Bleach	R-9 bleach bath	3
4	Rinse	Water	1
5	Clear	CB-3 clearing bath	3
6	Rinse	Water	1
7	Reexposure (light)	800 fc-sec[a]	
8	Redevelop	D-19 developer	3
9	Rinse	Water or SB-1a stop bath	1
10	Fix	F-6 fixing bath	5
11	Wash	Water	As required
12	Dry		

[a] This amount of reexposure can be obtained in 30 sec by using an opal-glass illuminator, fitted with 25-W tungsten lamps spaced 4 in. apart and located 7 in. from the nearest point of approach of the film.

Bleaching

Kodak Bleach Bath R-9

Water	1.0 liter
Potassium dichromate	9.5 g
Sulfuric acid (concentrated)	12.0 ml

Caution: Add the sulfuric acid to the solution, stirring constantly. Never add the solution to the acid, as this may cause the solution to boil, spattering the acid, which can cause serious burns.

Clearing

Kodak Clearing Bath CB-3

Water	750.0 ml
Sodium sulfite, desiccated	10.0 g
Water to make	1.0 liter

Redeveloper

Kodak Developer D-19

Water, about 50°C (125°F)	500.0 ml
Elon developing agent	2.0 g
Sodium sulfite, desiccated	90.0 g
Hydroquinone	8.0 g
Sodium carbonate, monohydrated	52.5 g
Potassium bromide	5.0 g
Cold water to make	1.0 liter

Stop Bath

Kodak Stop Bath SB-1a

Water	1.0 liter
Acetic acid, 28%	125.0 ml

Add three parts of glacial acetic acid to eight parts of water to make approximately 28% acetic acid from glacial acetic acid.

Fixing

Kodak Fixing Bath F-6

Water, about 50°C (125°F)	600.0 ml
Sodium thiosulfate (hypo)	240.0 g
Sodium sulfite, desiccated	15.0 g
Acetic acid, 28%	48.0 ml
Kodalk Balanced Alkali	15.0 g
Potassium alum	15.0 g
Cold water to make	1.0 liter

For continuous processing machines, the same Kodak reversal films may be treated as in Table 2.[63]

Table 2. Reversal Process for Continuous Processing Machines for Kodak Plus-X, Tri-X, and 4-X Reversal Films

Step	Processing Operation	Processing Time 20°C (68°F)	35°C (95°F)	43°C (110°F)
1	First developer (Kodak D-94)	2 min	40 sec	13 sec
2	Water rinse[a]	30 sec	20 sec	5 sec
3	Bleach (Kodak R-9)	50 sec	40 sec	10 sec
4	Water rinse	30 sec	20 sec	5 sec
5	Clearing bath (Kodak CB-2)	30 sec	20 sec	5 sec
6	Water rinse	30 sec	20 sec	5 sec
7	Reexposure	——800 fc-sec——		
8	Redeveloper (Kodak D-95)	30 sec	20 sec	5 sec
9	Water rinse[b]	30 sec	20 sec	5 sec
10	Fixer (Kodak F-10)	50 sec	30 sec	5 sec
11	Water wash[c]	——As required——		
12	Dry	——As required——		

[a] Use running water, not an acid stop bath, at this point.

[b] An acid stop bath, such as Kodak stop bath SB-1a, may be used in place of a water rinse after redevelopment.

[c] The degree of washing required is determined by the efficiency of the water wash and the permissible residual thiosulfate concentration for the intended use.

Formulas for Machine Reversal Processing

The formulas for the first developer and the bleaching bath are the same as given for the reel processes; the formulas for the other solutions are given below.

Kodak Clearing Bath CB-2

Water	750.0 ml
Sodium sulfite, desiccated	210.0 g
Water to make	1.0 liter

Kodak Redeveloper D-95

Water, about 21°C (70°F)	750.0 ml
Elon developing agent	1.0 g
Sodium sulfite, desiccated	50.0 g
Hydroquinone	20.0 g
Potassium or sodium bromide	5.0 g
Potassium iodide	0.25 g
Sodium hydroxide	15.0 g
Water to make	1.0 liter

Kodak Fixing Bath F-10

Water, about 50°C (125°F)	500.0 ml
Sodium thiosulfate (hypo)	330.0 g
Sodium sulfite, desiccated	7.5 g
Kodalk Balanced Alkali (sodium metaborate)	30.0 g
Acetic acid, 28%	72.0 ml
Potassium alum	22.5 g
Water to make	1.0 liter

Direct Positive Processing with Fogging Redeveloper

Photographic Films

Kodak Panatomic-X film in 135 size *only*[64] and Kodak direct positive panchromatic film 5246 (35mm) can be reversal processed without light reexposure by using Kodak fogging developer FD-70. The processing procedure in Table 3 is outlined in Kodak pamphlet No. J-6.[65]

First Development Table

Processing Method	Development Time (min) at 20°C (68°F)
1. Small spiral reels	8
2. Reel and trough	6
3. Small noninvertible tanks	8
4. Large spiral reels	6
5. Rack and tank	9

Table 3. Reversal Processing Procedure without Light Reexposure

Step	Operation	Treatment	Time of Treatment at 20°C (68°F)
1	First development[a]	Developer D-67	See accompanying table
2	Rinse	Water	2 to 5 min[b]
3	Bleach	Bleach bath R-9	1 min
4	Clear	Clearing bath CB-1	2 min[c]
5	Redevelopment	Fogging developer FD-70	8 min
6	Rinse	Water or stop bath SB-1	1 min
7	Fixing	Kodak fixing bath F-5 or F-6	5 min
8	Wash	Water	20 min

[a] Drain film 10 to 15 sec between successive baths.
[b] Two minutes is sufficient rinse with running water and agitation.
[c] Do not exceed 2 min in clearing bath or some silver halide may be dissolved, resulting in a loss of density of the positive image.

Kodak Developer D-67

Water, about 50°C (125°F)	500.0 ml
Elon developing agent	2.0 g
Sodium sulfite, desiccated	90.0 g
Hydroquinone	8.0 g
Sodium carbonate monohydrated	52.5 g
Potassium bromide	5.0 g
Sodium thiocyanate (liquid), 51 %	3.0 ml
Water to make	1.0 liter

This developer can also be made from a solution of Kodak developer D-19 as follows:

Developer D-19 solution	1.0 liter
Sodium thiocyanate (liquid), 51 %	3.0 ml

Kodak Bleach Bath R-9

Water	1.0 liter
Potassium dichromate (bichromate) (anhydrous)	9.5 g
Sulfuric acid (concentrated)	12.0 ml

Caution: Add the sulfuric acid to the solution, stirring constantly. Never add the solution to the acid, as this may cause the solution to boil, spattering the acid, which can cause serious burns.

Kodak Clearing Bath CB-1

Water	1.0 liter
Sodium sulfite, desiccated	90.0 g

Kodak Fogging Developer FD-70

Part A

Sodium dithionite (sodium hydrosulfite)	5.0 g

Part B

Water	900.0 ml
Kodalk Balanced Alkali (or sodium metaborate)	10.0 g
2-Thiobarbituric acid	0.5 g
Water to make	1.0 liter

Dissolve part A in part B not more than 2 hr before use, then discard after one use.

If 2-thiobarbituric acid is unavailable for use in part B, 2-thiohydantoin (0.3 g) may be used to replace the 0.5 g of the 2-thiobarbituric acid.

Kodak Stop Bath SB-1

Water	1.0 liter
Acetic acid, 28%	48.0 ml

Add three parts of glacial acetic acid to eight parts of water to make approximately 28 % acetic acid from glacial acetic acid.

Kodak Fixing Bath F-5

Water, about 50°C (125°F)	600.0 ml
Sodium thiosulfate (hypo)	240.0 g
Sodium sulfite, desiccated	15.0 g
Acetic acid, 28 %	48.0 ml
Boric acid, crystals	7.5 g
Potassium alum dodecahydrate (granular)	15.0 g
Cold water to make	1.0 liter

Add three parts of glacial acetic acid to eight parts of water to make approximately 28 % acetic acid from glacial acetic acid.

Crystalline boric acid should be used, as the powdered boric acid dissolves only with difficulty.

The odor of the sulfur dioxide given off from fixing bath F-5 may be objectionable, especially in warm weather or in poorly ventilated darkrooms. This odor may be almost eliminated by omitting the boric acid from the F-5 formula and substituting twice its weight of Kodalk Balanced Alkali (sodium metaborate).

The use of the D-67 first developer, a minor variation on the D-19 formulation, has been criticized by Phillip T. Jones[66,67] as producing transparencies that are too contrasty. A more suitable first developer, according to Jones, is a two-solution developer of the formula:

Developer D-67V

Solution A

Water	750.0 ml
Metol	2.0 g
Sodium sulfite, desiccated	90.0 g
Hydroquinone	16.0 g
Potassium bromide	7.0 g
Water to make	1.0 liter

Solution B

Water	750.0 ml
Sodium carbonate monohydrated	25.0 g
Sodium thiocyanate	1.7 g
Water to make	1.0 liter

Development times are approximately 5 min in solution A followed by 9 min in solution B at 21°C (70°F). Vigorous initial and subsequent agitation in solution B is needed to avoid uneven image development.

The Arneleon System of reversal processing "converts *all* black-and-white negative material into excellent direct positives."[68] Stock solutions of Metol (15%), hydroquinone (2%), potassium thiocyanate (10%), anhydrous sodium sulfite (10%), anhydrous sodium carbonate (10%), sodium thiosulfate (10%), and sodium hydroxide (10%) were used to prepare first developers that were most suitable for films that were divided into classes for processing. The Arneleon System represents an attempt to obtain the best image quality by modification of the first developer to suit the film type, because the character of the image is largely determined by the first development. The rest of the Arneleon reversal processing procedure is the same for the different films.

Photographic Paper

Kodak super speed direct positive paper has sufficient sensitivity for exposure as a camera material, or the paper may be used to make enlargements of positive transparencies, such as projector slides. The procedure consists of the following steps[69] (see Figure 3):

STEP 1 Develop exposed prints in full-strength Kodak developer D-88 for 45 sec at 20°C (68°F).

Kodak Developer D-88

Water, about 50°C (125°F)	750.0 ml
Sodium sulfite, desiccated	45.0 g
Hydroquinone	22.5 g
Boric acid, crystals	5.5 g
Potassium bromide	2.5 g
Sodium hydroxide (caustic soda)	22.5 g
Cold water to make	1.0 liter

Crystalline boric acid should be used, as the powdered boric acid dissolves with difficulty.

STEP 2 Rinse in running water for at least 15 sec. Stained prints will result if rinse is adequate.

STEP 3 Bleach in Kodak bleach bath R-9 for 30 sec or until image disappears.

Kodak Bleach Bath R-9

Water	1.0 liter
Potassium dichromate	9.5 g
Sulfuric acid (concentrated)	12.0 ml

Use full strength at 18 to 24°C (65 to 75°F) for about 30 sec.

STEP 4 Rinse in running water for at least 15 sec.

STEP 5 Clear for 30 sec in Kodak clearing bath CB-1.

Kodak Clearing Bath CB-1

Sodium sulfite, desiccated	90.0 g
Water to make	1.0 liter

Use full-strength for about 30 sec at 18 to 24°C (65 to 70°F).

STEP 6 Rinse in running water for at least 15 sec.

STEP 7 (Process 1) No light exposure of the bleached print is necessary. Redevelop the print in Kodak developer FD-70 for 60 sec at 20°C (68°F). Or, if a brown tone is desired, use Kodak sulfide redeveloper T-19 for the same time as FD-70.

Kodak Fogging Developer FD-70

Part A

Sodium dithionite, 90% (sodium hydrosulfite)	5.0 g

Part B

Water	900.0 ml
Kodalk Balanced alkali	10.0 g
2-Thiobarbituric acid	0.5 g
Water to make	1.0 liter

Dissolve the 5 g of part A in the one liter of part B not more than 2 hr before use. Discard after one use.

Kodak Sulfide Redeveloper T-19

Sodium sulfide (not sulfite)	20.0 g
Water to make	1.0 liter

Use either the fogging developer FD-70 or the sulfide redeveloper for about 1 min at 20°C (68°F).

STEP 7A (Process 2) If Kodak developer D-88 is used for redevelopment, reexpose the prints either by the light of a 40-W bulb at 8 in. distance for 3 sec or by turning on the white light as soon as the prints are in the clearing bath. After reexposure, redevelop the prints in D-88 for 30 sec at 20°C (78°F).

Note. Use either step 7 or step 7A, not both. Step 7 does not require light reexposure but requires a fogging developer; step 7A requires a light exposure but developer D-88 may be used.

STEP 8 After step 7 or 7A, wash the developed prints in running water for 30 sec before drying.

(a)

(b)

Figure 3. **Steps in making direct positive photographic prints with Kodak Super Speed Direct Positive Paper. After exposure, the print is (a) developed to form the negative silver image, (b) bleached and cleared to remove the silver image, then (c) the silver halide that remains is developed to form the positive silver image. Some printout has made the bleached-and-cleared print have a positive image that is more evident than normal. [The original is a lantern slide, one of a series of George Eastman's second African safari, from the author's collection]**

Lith Reversal by Etch Bleach

Lithographic films have a thin emulsion layer that is suitable for reversal processing. An etch bleach bath is used to treat the silver image formed by first development. The gelatin surrounding the metallic silver is dissolved away, removing the silver image and forming a relief image consisting of silver halide. This silver halide image is then exposed and redeveloped to form a silver image in gelatin surrounded by clear areas that consist of the clear base itself. The technique may be used to make line monochrome projection slides[70] or for various uses in the graphic arts field.[71]

Exposure of the lith film should be 10 to 15% greater than normal, as the image must be exposed through to the base of the emulsion layer. Development of $2\frac{1}{2}$ to $3\frac{1}{2}$ min, 68°F (20°C), is carried out in a lith developer. Inspection during development is recommended so that the developed image is visible from the base side of the film. After 30 sec in a stop bath of

2% acetic acid, the room lights may be turned on. The film is then placed in the etch bleach bath and agitated.

<div align="center">

EB-2 Etch Bath

Solution A

Water (125 to 150°F)	750.0 ml
Copper sulfate	120.0 g
Citric acid	150.0 g
Potassium bromide	7.5 g
Water to make	1.0 liter

Solution B

Hydrogen peroxide, 3% solution
(10-volume commercial hydrogen
peroxide)

</div>

For use: mix one part of solution A and one part of solution B.

After about 30 sec the exposed and developed part of the image will begin to separate from the base. A gentle swabbing with cotton will help the removal of all the original image. The film is then washed in water, and any remaining traces of gelatin are removed by swabbing. The swabbing and washing operations in normal room illumination should have provided sufficient reexposure for the remaining silver halide. The redevelopment may be in any rapid-acting developer, such as D-8, until the image is blackened through to the base of the film. A lith developer may be used, but about twice the normal processing time will be required. The image should be rinsed in the stop bath, hardened in a hardening fixing bath for 3 min, washed 5 min in running water, and dried.

Reversal Bleach Process for Phase Holograms

Transparent phase holograms, almost free of the flare light image, may be produced by a reversal bleach treatment of Kodak spectroscopic plates, type 649-F.[72] A relief image is formed by a tanning developer where the plate has been exposed. The silver image is then bleached and removed. The thickness of the emulsion layer is increased in the tanned areas by the gelatin's pulling together during drying. The original silver halide crystals remain in the areas of less exposure.

Exposed plates may be processed in a tray with continuous agitation of the solutions by the following procedure.

Reversal Bleach Processing: Kodak Spectroscopic Plates, Type 649-F

STEP 1 Develop in Kodak Special Developer SD-48 (mixed from two solutions just before use) for 5 to 8 min at 24°C (75°F).

Kodak Special Developer SD-48

Solution A

Water	750 ml
Sodium sulfite, desiccated	8 g
Pyrocatechol	40 g
Sodium sulfate, desiccated	100 g
Water to make	1 liter

Solution B

Water	750 ml
Sodium hydroxide, granular	20 g
Sodium sulfate, desiccated	100 g
Water to make	1 liter

Solution A and solution B may be kept separately in full, stoppered glass bottles for about one month. For use, mix equal parts of solution A and solution B. Use immediately as the mixed solution loses effectiveness after about 15 min.

STEP 2 Stop development in Kodak stop bath SB-1 for 15 sec at 21 to 27°C (70 to 80°F).

Kodak Stop Bath SB-1

Water	1 liter
Acetic acid, 28%	48 ml

Add three parts of glacial acetic acid to eight parts of water to make approximately 28% acetic acid.

STEP 3 Rinse in running water for 1 min, 21 to 27°C (70 to 80°F).

STEP 4 Bleach in Kodak bleach bath R-9 for 2 min at 21 to 27°C (70 to 80°F).

Kodak Bleach Bath R-9

Water	1.0 liter
Potassium dichromate	9.5 g
Sulfuric acid, concentrated	12.0 ml

STEP 5 Wash in running water for 5 minutes, 21 to 27°C (70 to 80°F). If the plate has an objectionable brown stain after washing, this stain can be removed by immersing the plate in a solution of Kodak stain remover S-13. After this treatment, the plate will be less sensitive to printout.

Kodak Stain Remover S-13

Solution A

Water	750.0 ml
Potassium permanganate	2.5 g
Sulfuric acid, concentrated	8.0 ml
Water to make	1.0 liter

Solution B

Water	750 ml
Sodium bisulfite, anhydrous	10 g
Water to make	1 liter

Bathe the plate in solution A for 1 min, then in solution B for 1 min before washing in water for 5 to 10 min. Use solutions only once.

STEP 6 Dry under room conditions. Drying is critical. For uniform drying, the plate may be rinsed in a solution of methanol, diluted with seven times its volume of water, followed by two washes in isopropyl alcohol.

PHOTOGRAPHIC REVERSAL EFFECTS

Photography normally produces a negative image composed of metallic silver formed primarily from those silver halide crystals that were exposed to light. An increase in the exposure results in an increase in the amount of silver in the image. In a conventional reversal process, such as already described in this chapter, the negative-forming image exposure and its chemical treatment are followed by a second positive-forming uniform exposure to light, followed by additional chemical treatment. The positive-forming exposure to light may be replaced by chemical action in the form of fogging developing agents or by nucleating compounds that render unexposed silver halide developable by conventional developing agents. When the negative-forming light exposure is extended to extremely long times, a positive image may be formed directly on some photographic material requiring only normal development and fixation.

A number of photographic reversal effects involve negative-working and positive-working exposures to radiation that produce a positive image without intermediate processing between the two exposures. The double-exposure sequence often involves high- or low-intensity light, long-wavelength radiation, or X-rays, used in various combinations for the two exposures. For producing the positive image, the negative-working exposure is usually uniform over the emulsion layer and the positive-working exposure is imagewise. In other cases, two different image exposures, one negative-working, the other positive-working, have been used. Chemical fogging may be used to replace the uniform negative-working exposure. A positive-working first exposure may interfere with the formation of a latent image — an action known as desensitization — or a positive-working second exposure may cause the destruction of an already-formed latent image.

Early latent-image destruction or desensitization effects were named after their discoverer; modern practice is to name the effect by the mechanism of its proposed action. Considerable confusion has arisen because the same effect may be called by more than one name, or different effects may be designated by the same name. This uncertainty has led to attempts to distinguish among photographic reversal effects.[73-74] A complete review of these effects has been given by P. J. Hillson and E. A. Sutherns.[75] Many of these double-exposure effects are outside the scope of this book because reversal is accomplished only through the radiation action, not by any special processing solution. When two exposures of a different character are given, competitive interaction between surface and internal latent images may produce effects that do not occur when only a single exposure is given. Such effects can be only briefly mentioned here, but some of them have been used to produce commercial products of unique characteristics.

Solarization

This is an effect encountered when printout paper or negative materials
are given extended exposure to light radiation, resulting in a decrease in
developed image density with gross exposure.[76–80] The destruction of the
latent image by light of the same kind and intensity produces a reversal.
Continued exposure, however, may cause the developed density to increase
again to form a second negative image. Although a vast amount of study
has been made of solarization, its exact mechanism remains undefined,
possibly because the nature of the photographic emulsion has influenced the
results obtained by various investigators. One current hypothesis proposes
that bromine is released during the formation of internal image with the
gross exposures needed to produce the effect. This bromine then destroys
the surface latent image, producing a reversal upon development. Solariza-
tion has been employed to produce direct positive images, using an easily
solarized emulsion that is completely fogged by light or chemical treatment
to the maximum developable density.[81] Additional exposure produces a
direct positive image upon development. A multitude of patents cover
numerous emulsion compositions that contain fogged silver halide crystals
that produce a positive image upon exposure.[82–105] Desensitizing dyes or
electron acceptors are combined with chemical fogging agents to produce
direct positive photographic materials. A few of these patents are listed below.

U. S. Patents	British Patents	Canadian Patents
2,005,837	443,248	872,180
2,126,516	1,151,782	872,181
2,184,013	1,155,404	
2,699,515	1,186,711	
3,361,564	1,201,792	
3,367,778		
3,455,235		
3,501,310		
3,519,428		
3,531,290		
3,560,213		
3,579,345		
3,650,758		
3,655,390		

Clayden Effect

A. W. Clayden, in 1899, observed that a high-intensity, short-duration exposure to light desensitized the emulsion to the effect of moderate- or low-light exposure. A lighting flash was rendered as "black lightning." One proposed mechanism involves the sensitization of the internal latent image with a desensitization of the surface latent image. The Clayden effect has been used commercially for oscillographic recording materials (high-intensity, short-duration trace images are subjected to low-level, long-duration light to print out lines of a higher density than the background) and for various photographic masking materials.[106-114] Prescreened photographic materials for making halftone records directly have been prepared using the Clayden effect.[115-118] Use of the Clayden effect to produce positive images was patented as a means of document copying by G. I. P. Levenson[119] in 1952.

Herschel Effect

John F. W. Herschel noticed that the red light of a spectrum bleached the printout silver being formed simultaneously by daylight. Today, the Herschel effect is the name given to the destruction of latent image by red light or longer-wavelength radiation (not necessarily capable of forming a latent image as with solarization). Absorption of the red or infrared radiation causes the ejection of an electron from a metallic silver atom of the latent image.[120] If enough of the freed electrons combine with silver ions at internal sites, rather than at image sites on the surface, photographic reversal results. One photographic application of the Herschel effect has involved a completely fogged silver chloride emulsion, often with added compounds to trap photoelectrons, that produced a direct positive image when exposed to yellow light.[121] Such emulsions usually require the presence of a desensitizer to insure the effectiveness of the yellow light.[122-126]

Villard Effect

P. Villard found in 1890 that the latent image from an X-ray exposure was partially destroyed by a moderate or long exposure to light. The Villard effect involves a destruction of latent image, not a desensitization as by the Clayden effect. The mechanism of the effect is unclear, although probably it depends upon the relative distribution of internal and surface latent images.[127-129]

Low-Intensity Desensitization Effect (LID Effect)

This effect was reported in 1952 by R. E. Maurer and J. A. C. Yule.[130-135] Image reversal resulted when a long exposure to low-intensity light was followed by a second short exposure to high-intensity light. The first low-intensity exposure desensitized the emulsion to the second flash exposure. The Villard effect involves the reverse order of these two exposures. The desensitization during the LID effect is thought[136] to be related to a competition between the internal and surface latent images.

PHOTOGRAPHIC REVERSAL EFFECTS INVOLVING INTERMEDIATE CHEMICAL TREATMENT

Albert Effect

E. Albert[137] in 1890 showed that when a collodion plate is first given a full imagewise exposure to light, then treated in nitric acid, then uniformly exposed to light, a direct-positive image is obtained. This observation was extended to silver halide emulsions in gelatin coatings by Lüppo-Cramer,[138-139] who used a solution of chromic acid or ammonium persulfate as the intermediate bath between the two exposures to light. Walter Clark[140-141] suggested that the first exposure facilitated the destruction of the sensitivity centers by the chromic acid treatment. G. W. W. Stevens[142-143] concluded that the desensitization of the Albert effect is due to the internal latent image.

Somewhat similar to the Clayden effect, the Albert effect is thought to result from a competition between internal and surface latent image sites for photoelectrons. The first image-forming exposure must be sufficient to form internal latent image sites as well as the surface latent image. This exposure may be short or long but must form the internal latent image. When the emulsion layer is treated in an oxidizing solution, such as chromic acid, all the surface latent image centers are destroyed but the internal sites are protected from attack. The emulsion will not develop in a surface developer but will form a metallic silver image that is negative if development is carried out in a solvent developer to reach the internal latent image. The bleached emulsion layer is then given a uniform light exposure. The internal latent image centers act as electron traps during this second exposure, forming almost entirely an internal image. Previously unexposed grains, not having the well-formed internal image sites, form surface latent image, which, when developed in a surface developer, will produce a positive image. The stronger

the internal image of the silver halide crystals, the less density produced by the surface developer.[144]

Attempts have been made recently to adapt the Albert effect for the duplication of aerial negatives.[145–147] One procedure for producing positive images on Kodak film, type 8430, required an exposure about 1000 times that normally given to the film. In this case the Albert exposure was 60 sec at 1 ft from a RFL-2 lamp. The basic formula of the oxidizing solution was the Kodak R-9 bleach containing 10 g of potassium dichromate and 12.5 ml of sulfuric acid per liter of solution. Doubling the bleach concentration reduced the bleach time by one-half. Six minutes, 68°F, were required. A 1-min clearing time in 10% potassium bicarbonate was followed by a 1- or 2-min wash in water. The second exposure is critical, with only 5% variation on each side of the optimum, which is related to the emulsion type. Maximum densities greater than two are produced by 4 min, 68°F, development in DK-50, or by 6 min development in D-11. Two-minute development in D-19 produced a maximum density of 1.97, but this developer may have too high a solvent action for some emulsion types. According to K. H. Day and R. J. Kohler, "The resolution obtainable with the Albert reversal is greater than that obtainable with conventional two-stage reversal techniques."

Sabattier Effect

In 1860 Armand Sabattier[148–149] observed that when an exposed collodion plate was partially developed and rinsed in water, then given a uniform exposure to light and developed again, a reversal of the original image was obtained. Reversal may be partial or complete. With partial reversal, the first exposure and development produces a negative silver image, the second exposure and development produces primarily a positive silver image. The final image consists of the sum of these two images, with a minimum density between the negative and positive images.[150] According to G. W. W. Stevens and R. G. W. Norrish,[151] "An effective local desensitization of the plate, proportional to the amount of development, seems to occur during the first development. The greater the amount of the first development, the greater is the desensitization and the less will be the effect of any diffuse second exposure."

When a negative consists of a fully exposed subject against a dark background, the positive image produced by the second light exposure does not touch the negative image but leaves a clear line between the two images.[152–156] The clear line lies outside the image of the subject and is, according to Stevens and Norrish,[151] "a reversed halation band." This partial reversal has been widely used for pictorial purposes since the early exploits of Man Ray and Somerset Murray.[157] The Sabattier technique has

often been called, erroneously, "solarization,"[158-161] and continues to be called by this name even today.[162-163] "Pseudo-solarization" is another name for the image that contains both the negative and positive images.[164-166] This reversal is also correctly called the "Sabattier effect" by other photographers.[167-168]

The Sabattier effect (or pseudo-solarization or "solarization") may be obtained with negatives or positives, on photographic film or photographic paper. Photographic film, especially sheet film, is to be preferred, because the Sabattier image need only be printed by contact or enlargement. Partially reversed photographic prints usually need to be rephotographed before the final print is made, although Farmer's reducer may be used to lighten the highlight and other areas of dark photographic prints. "The ideal negative," says Julio Cesar Genovese,[167] "for use in making a Sabattier photo is one with strong grays and pure translucent zones, obviously of higher than normal contrast index. Don't use soft-lighted scenes; use contrasty ones, instead. This master negative then permits printing as many Sabattier films as desired for experimental work without danger of destroying the original." Making a contact copy or enlargement from the master negative on a commercial, process, or lith film having only blue or ortho sensitivity will allow visual inspection under a safelight in the darkroom.

The film copy should be developed in a filtered developer of low fogging tendency. Genovese recommended AM-G-63, an Amidol formulation:

Developer AM-G-63

Warm water (30°C)	200.0 ml
Sodium sulfite (anhydrous)	25.0 g
Amidol	5.0 g
Potassium bromide	2.5 g
Cold water	250.0 ml

Practical conditions for producing the Sabattier reversal vary considerably between practitioners. The kind of photographic material, the length of the first development period, the extent of the second exposure, and the length of the second development influence the final image. The film is first developed about one-third to one-half the normal time of development of the photographic material, but usually this time of first development must be determined by controlled tests for the desired effect that is sought. The Sabattier exposure is given by some workers while the film is in filtered, bubble-free, still developing solution. Others prefer to rinse for 10 to 15 sec in running water to remove the surface developing solution, then expose

outside of any liquid. One photographer has suggested removing the film from the developer, placing it emulsion side up on a horizontal opal glass, and then squeegeeing the film to the glass before light exposure.

The other conditions for producing Sabattier reversal also vary with each worker. Hal Denstman,[165] for example, states that "a standard safelight can be used with a 7.5-watt frosted bulb. With a copy negative made on Kodak professional copy film (gravure copy film), re-exposed with a 7.5-watt bulb positioned about four feet away, an average re-exposure will range between two to four seconds, while a re-exposure on line film, such as Kodalith, could be as high as 30–40 seconds." The film is then immersed in the developing solution for a time sufficient to give the desired effect— usually, the remainder of the normal developing time for the photographic material used.

The technique of adhering the developer-soaked film to a glass plate permits visual observation during reexposure, but the technique is somewhat difficult. According to Genovese, "Place the film under an opal lamp of 60 to 100 watts, at a distance of about one meter. Switch on the lamp. You can see that slowly the unexposed zones fog to a density approaching that of the exposed ones. This fog continues but does not affect the heavily exposed areas. Between the printed and fogged parts you can see a clear, beautiful borderline. If now you put the opal glass in front of the light source in a vertical position, you can control the progress of the Sabattier development."[167] For this technique to work it is essential that the developer form a very thin, uniform layer on the emulsion surface.

The mechanism of Sabattier reversal has been widely studied,[169–173] but its complex nature has made characterization difficult. The presence of the developed silver from the first developing period screens out much of the light from the second exposure. This second light exposure has minimal effect on the remaining silver halide grains in the developed regions, as these silver halide grains are of low light sensitivity. Desensitization effects have been ascribed to the oxidation products of the developing agents as well as the restraining action of the bromide and iodide released during development. G. W. W. Stevens and R. G. W. Norrish[174] have shown that after eliminating the effects of the by-products of development, there remained a desensitization effect that was attributed to metallic silver from the first development that diffuses to the remaining silver halide crystals.

Internal Image Reversal

Although the Sabattier effect has been widely used for pictorial images, the image has too much negative development to provide a satisfactory positive image. This negative development may be minimized by the use of special

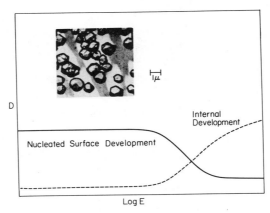

Figure 4. Development behavior of standard halide conversion emulsion. The typical halide conversion emulsion has almost no surface but good internal sensitivity. Light exposure results in the trapping of the photoelectrons by the internal image. A fogging or nucleating developer can only form fog nuclei on the unexposed grains, resulting in a positive image in the surface developer, but the negative image may be revealed by a solvent developer. [W. T. Hanson, Jr., *Phot. Sci. and Eng.*, 20: 158 (1976)]

photographic emulsions that contain silver halide crystals with well-formed sites for internal image in the interior of the crystal.[171,175–177] Such an emulsion has been called a Burton's emulsion.[178] Almost no negative silver image was formed after exposure and normal development of such an emulsion, as the internal image has effectively desensitized the exposed silver halide crystals. The competition for photoelectrons has been won by the internal latent image sites. When such an exposed photographic material was processed in a developer containing a silver halide solvent, such as sodium thiosulfate or potassium iodide, the internal image was made developable, forming a negative image of normal contrast and density. (See Figure 4.)

A positive image of low minimum density was obtained when the internal-image emulsion layer was given a negative light image exposure, then immersed in a low-solvent developer and given a uniform light flash. (See Figure 5.) The negative image does not need to develop, as necessary with Sabattier reversal, before the positive-forming light exposure is given. The second light exposure may be replaced by chemical treatment to render the unexposed silver halide developable to form the positive image. Nonselective reducing agents, such as hydrogen peroxide or other peroxides or hydrazines, have been used for this purpose. Oxygen of the air or various hydrazine derivatives[179–180] have been used as nucleating agents in active MQ developers to produce the positive image directly without the need of

DIRECT REVERSAL MECHANISM

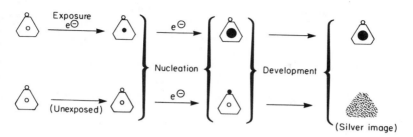

o = Sensitivity center
• = Latent image or fog center
● = Latensified latent image

Figure 5. A mechanism is shown for forming a direct positive image with silver halide grains having a good internal but almost no surface sensitivity. [W. T. Hanson, Jr., *Phot. Sci. and Eng.*, 20: 158 (1976)]

the second uniform light exposure. The hydrazine compounds have also been incorporated in the emulsion layer, permitting developers of normal composition to be used.[181]

Although oxygen from the air has proven sufficient in an active developer to replace the second light exposure for use with internal image emulsions,[182] such oxygen fogging developer (OFD) solutions are variable in action and are unstable after mixing. Hydrazines may be used for the nucleating agents in the reversal developer, producing a one-solution developer of improved stability. Such a developer has the following formulation:

Metol	5.0 g
Hydroquinone	10.0 g
Sodium sulfite (anhydrous)	75.0 g
Kodalk Balanced Alkali	45.0 g
Sodium hydroxide	10.0 g
5-Methylbenzotriazole	0.2 g
Phenylhydrazine	0.5 g
Water to make	1.0 liter

The presence of antifoggants (5-methylbenzotriazole),[183] the kind of hydrazine, and the nature of the photographic emulsion, especially the iodide content and the type of the sensitizing dye, are primary factors in determining the minimum and maximum densities of the positive image.

Phenylhydrazine is a toxic compound, and many other hydrazines have been patented as improvements. Phenylhydrazine with an alkylsulfonamido-alkyl group has reduced toxicity, according to the U. S. Patent 2,663,732 of A. Weissberger.[184] Such a compound is $p(\beta$-methylsulfonylamidoethyl)-phenylhydrazine hydrochloride. This compound was used by Grant M. Haist and Harold D. Russell[185] in a direct-positive photographic developer that contained certain quaternary ammonium compounds to produce accelerated development of internal latent image emulsions. The useful life of the developer was also extended, yielding a solution that had little coloration even after several days of intermittent use. An example of this improved developer is the following (pH = 11.5):

Metol	5.0 g
Hydroquinone	10.0 g
$p(\beta$-Methylsulfonamidoethyl)-phenylhydrazine hydrochloride	2.0 g
Sodium sulfite, desiccated	75.0 g
Trisodium phosphate, crystals	75.0 g
Diglycolic acid	13.4 g
5-Methylbenzotrizole	0.2 g
Sodium hydroxide	15.0 g
3-Methyl-2-β-phenethyl isoquinolinium bromide	0.4 g
Water to make	1.0 liter

Development time is 2 min at 75°F.

In a fogging developer of the type suitable for an internal latent image photographic paper, such as Photostat Photographic Positive Paper, the hydrazine itself or its oxidation product, phenyl diimide, is capable of forming surface sensitivity specks that can initiate reduction of the silver halide crystal by active developing agents. These sites are formed preferentially on those silver halide crystals that were not struck by light, as the light-struck crystals have been desensitized by the internal latent image. Phenyl diimide is thought to be the active nucleating agent, although intermediate phenylhydrazine radicals may also be involved to a lesser extent.

Phenyl diimide, ⟨benzene ring⟩—N=NH, is formed when phenylhydrazine loses two electrons. Phenyl diimide is a powerful reducing agent that is capable of fogging the surface of silver halide crystals and also injecting electrons into the crystals. The pH of the direct-positive developer and the oxidizing substances for the phenylhydrazine provide a supply of phenyl diimide which itself may react with other ingredients of the developer (oxygen, quinones, quinonediimines) to form nucleating agents.

SIMPLE REVERSAL PROCESSES

Most reversal processes require special photographic materials in a multi-step sequence involving special solutions or special processing procedures. In 1890 Colonel J. Waterhouse[186-187] added phenylthiourea as a preservative to an Eikonogen developing solution. Waterhouse reported that phenylthiourea, "added in a very minute quantity to the ordinary eikonogen developer, possessed the remarkable property of more or less completely transforming the negative photographic image into a positive, and that thus I was able to produce at will more or less perfect positive pictures in place of the negative ones, under otherwise normal conditions of exposure in the camera and of development." Thiosinamine (allyl thiourea) was even more effective than the phenylthiourea, but thiourea produced less satisfactory reversal. Urea did not produce a reversal when it was added to the developer.

Practical efforts[188-189] were made to use the Waterhouse reversal process, but results tended to be erratic unless the temperature, composition, and quantity of developing solution were closely regulated. The presence of a negative image and a yellowish fog detracted from the appearance of the positive image. S. O. Rawling[190] suggested an explanation for the Waterhouse reversal. The exposed silver halide grains develop rapidly in the developing solution, forming a metallic silver image and bromide ions. These bromide ions prevent the formation of fog in the region of the negative image. With the unexposed silver halide, the thiourea forms a silver complex which, in the alkaline solution, decomposes to silver sulfide. The silver sulfide is sufficient to cause the development of silver halide without the need for light exposure. A very high fog level results, and this is the positive image. The final photographic image consists of the negative image and the positive image, yielding a positive with a fairly high minimum density.

A monobath reversal process was proposed by Howard A. Miller,[191] who used Kodak D-19 developer with the addition of sodium hydroxide (5 g/liter) and sodium thiosulfate pentahydrate (25 g/liter). Exposed film was tray developed for 15 min at 68°F with agitation every 3 sec, or tank

developed with agitation every 2 min. After the development both sides of the film were held for a total of about 10 sec at a distance of 18 in. from a No. 2 Photoflood bulb operating at 105 V. A 10-sec immersion in the developing solution was sufficient to develop the positive image, followed by a 10-min wash in running water before the film was dried. A contrasty positive image with a high minimum density was obtained.

According to Miller's proposed mechanism for the monobath reversal process, the rate of solution of silver halide by the thiosulfate during processing varies directly with the quantity of image silver formed. In the region of the higher exposures of the negative image almost all of the remaining silver halide is removed. Only about one-third of the total undeveloped silver halide is solubilized in the area of the low negative exposure. Thus, after light flashing and development, the final image consists of a contrasty positive image and a low-contrast negative image. The contrast of the positive is so high that for most purposes it is unnecessary to remove the negative silver. Miller pointed out that the monobath reversal process, although using a light exposure between processing steps, is not similar to the Sabattier effect because the reexposure is not critical and a fogging developer (such as sodium sulfide) may be used in place of light exposure and redevelopment. The reversal depends upon a differential rate of silver halide solubilization during the first solution treatment, not upon the chemical desensitization or silver image screening actions that occur in the Sabattier reversal. Hermann Eggenschwiller and Walther Jaenicke[192] concurred that monobath reversal is different from the Sabattier effect. J. C. Barnes[30] pointed out that physical development played a primary role in monobath reversal.

In 1954 Hutson K. Howell used the reversal monobath to increase the film speed with most negative films. After being processed for the recommended time with continuous agitation, the film, saturated with developing solution, was exposed to a bright light (10 sec to a No. 1 Photoflood bulb at a distance of 1 ft), forming the positive image. An acid rinse or acid hardening bath completed the reversal processing. The composition of the monobath varied with each photographic material, but the following formula was successfully used with the higher-speed films:

Water	800 ml
Metol	5 g
Sodium sulfite, desiccated	50 g
Hydroquinone	20 g
Sodium hydroxide	20 g
Sodium thiosulfate (anhydrous)	54 g
Water to make	1 liter

Developing time was 3 to 5 min at 68°F.

The original camera exposure is critical, and Hutson K. Howell recommended that four times the normal exposure index be used. A positive that is too dense may be improved, according to Arthur Garza and Patrick D. Dignan,[193] by reducing for 3 or 4 min in

Water	400 ml
Ammonium thiosulfate	100 ml
Potassium ferricyanide	1 g

Mix just before using, then discard.

An energetic Phenidone-hydroquinone monobath containing sodium thiosulfate was used by A. P. Strel'nikova et al.[194] at a temperature of 60°C, but the reversal image was brownish in color, apparently owing to dichroic fog. This condition was eliminated by adding 1-phenyl-5-mercaptotetrazole to the solution. The mercaptotetrazole forms a difficultly soluble silver salt on the surface of the silver halide crystals, regulating the formation of the soluble silver thiosulfate complexes. This controls the rate of physical development. The Russian scientists concluded that "the threshold light sensitivity of the film obtained appeared to be higher when obtaining an optimum reversal image, as compared with the threshold light sensitivity of the same film obtained in ordinary negative development. As far as the image structure obtained in the negative arm of the characteristic curve is concerned, the silver structure in the investigated reversal image appears to be finer and has a characteristic property of a higher covering power, which also shows its relationship to formation by physical development."

The strong adsorption of 1-phenyl-5-mercaptotetrazole to developed silver was employed by R. W. Henn and Nancy H. King[195] to produce a simple reversal process consisting of three steps: (1) formation of the negative image by conventional development, (2) developing the remaining silver halide (positive image) in a developer containing the 1-phenyl-5-mercaptotetrazole, and (3) bleaching-and-fixing, removing the negative silver preferentially. The positive silver halide image may be exposed to uniform light exposure, or the light-exposure may be eliminated if potassium borohydride is added to the second developer. Very good positive images were reported to be obtained with Recordak Micro-File film, type 5455, and Kodalith ortho film, type 3. For the Micro-File film, the following solutions and conditions were used:

STEP 1 Negative silver development (1.5 min at 72°F).

First Developer, Kodak D-94

Elon developing agent	0.6 g
Sodium sulfite, desiccated	50.0 g
Hydroquinone	20.0 g
Potassium bromide	8.0 g
Sodium thiocyanate	6.0 g
Sodium hydroxide (caustic soda)	20.0 g
Water to make	1.0 liter

STEP 2 Uniform exposure to light (addition of 1 g of potassium borohydride to each liter of the second developer will eliminate this reexposure step).

STEP 3 Positive silver development (2.5 min at 72°F).

Second Developer, Kodak SD-47

Hydroquinone	10.0 g
Sodium sulfite, desiccated	31.25 g
Sodium hydroxide (caustic soda)	31.25 g
2-(2-Ethoxyethoxy)ethanol	200.0 ml
1-Phenyl-5-mercaptotetrazole	1.00 g
Water to make	1.0 liter

STEP 4 Bleaching and fixing

Bleach-and-Fix Solution, Kodak SRF-1

Ferric chloride	12.0 g
Ethylenediamine tetraacetic acid, tetrasodium salt	55.0 g
Sodium sulfite, desiccated	15.0 g
Sodium thiosulfate (hypo)	150.0 g
Sulfuric acid, concentrated	8.0 ml
Water to make	1.0 liter

Positive images of greater speed and improved gamma were said[196,197] to result when the 1-phenyl-5-mercaptotetrazole was present with an aminoalkanol (such as 1-amino-2-propanol) in the first developer of a three-step reversal process. An exposed fine-grained, low-speed silver bromo-

iodide film was processed for 5 sec at 55°C in each of the following three solutions, using continuous agitation:

First Developer

Metol	0.6 g
Sodium sulfite, desiccated	50.0 g
Hydroquinone	20.0 g
Potassium bromide	8.0 g
Sodium hydroxide	20.0 g
1-Amino-2-propanol	30.0 ml
1-Phenyl-5-mercaptotetrazole	0.1 g
Water to make	1.0 liter

Bleaching Solution

Potassium dichromate	25.0 g
Sulfuric acid, concentrated	32.0 ml
Water to make	1.0 liter

Fogging Developer

Thiourea	20.0 g
Sodium hydroxide	5.0 g
Sodium sulfate	50.0 g
Water to make	1.0 liter

A one-bath reversal process has been proposed by Nancy H. King.[198] The processing solution contained sodium or potassium selenocyanide, a poisonous compound. A photographic film described as having "a fine-grain, slow, cine-positive photographic gelatino-silver-bromoiodide emulsion" was processed for 20 sec at 95°F in

Phenidone	10.0 g
Sodium isoascorbate	40.0 g
Sodium hydroxide	30.0 g
Potassium selenocyanide	40.0 g
β,β'-Dithiasuberic acid	40.0 g
Monothioglycerol	5.0 ml
Water to make	1.0 liter

A positive image having a black or blue-black image tone was produced.

REFERENCES

1. C. Russell, in L. P. Clerc, *Photography, Theory and Practice*, 2nd Edition, Pitman Pub. Co., New York, 1946, p. 302.
2. R. Namias, "Sull'Impiego del Permanganato di Potassa in Fotografia," *Bull. della Soc. fot. italiana*, **12**: 313 (1900).
3. R. Namias, "Reversed Negatives," *Brit. J. Phot.*, **47**: 679 (1900).
4. R. Namias, "Übermangansaures Kali sur Abschwächung zu harter Negative und die Herstellung direkter Positive in der Camera," *Phot. Mitt.*, **36**: 366 (1899).
5. T. Thorne Baker, "The Spicer-Dufay Colour Film Process," *Phot J.*, **72**: 109 (1932).
6. F. F. Renwick, "The Dufaycolour Process," *Phot. J.*, **75**: 28 (1935).
7. P. K. Turner, "Reversal Processing," *Brit. J. Phot.*, **84**: 435 (1937).
8. H. Verkinderen, "Reversal Processing," *Brit. Kinemat.*, **13** (2): 37 (1948).
9. Kerwin Dunsmore, "A 3^3 Screening Experiment for Factors Affecting Contrast of Certain Reversal Processed Black and White Materials," *Photo Scientist*, **2** (3): 48 (1971).
10. "Black-and-White Transparencies with Kodak Panatomic-X Film (FX135)," Kodak Publication No. F-19 (14-2-72-F, Major Revision).
11. Arthur S. Beward, "Reversal Development of Black and White Negative Films," *Photo Scientist*, **2** (2): 24 (1971).
12. H. Baines, *The Science of Photography*, Fountain Press, London, 1960, p. 229.
13. Lloyd E. Varden, as quoted by Joseph S. Friedman, "Reversal Processing," *Am. Phot.*, **32** (4): 282 (1938).
14. Joseph S. Friedman, "Reversal Processing," *Am. Phot.*, **32** (4): 281 (1938).
15. John G. Capstaff, "Controlled Reversal Process," U. S. Pat. 1,552,791 (1925).
16. John G. Capstaff, "Photographic Reversal Process," U. S. Pat. 1,460,703 (1923).
17. John G. Capstaff, "Reversal Processes," *Brit. J. Phot.*, **70**: 409, 419 (1923).
18. Merrill W. Seymour, "Photographic Reversal Process," U. S. Pat. 1,939,231 (1933).
19. C. E. Ives, J. W. Zuidema, N. A. Exley, and C. C. Wilt, "Processing Methods for Use with Two New Black-and-White Reversal Films," *J. SMPTE*, **66** (1): 1 (1957).
20. Leroy Matthew Dearing and Charles Henry Guell, "Improvements in or relating to Photographic Developers and Methods of Producing Photographic Images by Development," Brit. Pat. 561,203 (1944).
21. Leroy Matthew Dearing and Charles Henry Guell, "Developers Containing Silver Halide Solvents," U. S. Pat. 2,371,740 (1945).
22. Raphael Ed. Liesegang, "Intermediäres bei der Emulsionsbildung," *Phot. Ind.*, p. 711 (1925).
23. R. B. Wilsey, "X-ray Analysis of Some Mixed Crystals of the Silver Halides," *J. Frank. Inst.*, **200**: 739 (1925).
24. F. F. Renwick and V. B. Sease, "Sedimentary Analysis of Photographic Emulsions," *Phot. J.*, **64**: 360 (1924).
25. W. D. Baldsiefen, V. B. Sease, and F. F. Renwick, "Silver Iodide in Photographic Emulsions," *Phot. J.*, **66**: 163 (1926).
26. Merle L. Dundon and A. E. Ballard, "The Fate of the Iodide in the Development of Bromo-Iodide Emulsions," *Brit. J. Phot.*, **77**: 90 (1930).

27. H. A. Miller, H. D. Russell, and J. I. Crabtree, "Direct-Positive Processing of the New Kodak Blue Base Reversal Films," *PSA J.*, **15**: 382 (1949).

28. Joseph H. Coenen, "Processing Reversal Films," *Phot. Technique*, **2** (12): 28 (1940).

29. Aubrey Malphurs, "The Function of Chemicals in Reversal Processing," *Am. Cinematog.*, **44**: 716 (1963).

30. J. C. Barnes, "Mechanism of Development in Monobaths Containing Thiosulfate Ion," *Phot. Sci. and Eng.*, **5** (4): 204 (1961).

31. E. Klein, "Die Form des entwickelten Silbers," *Z. Elektrochem.*, **62**: 505 (1958).

32. E. Klein, "The Influence of Silver Halide Solvents in the Developer on the Characteristic Curve in Negative and Reversal Development," *J. Phot. Sci.*, **8**: 178 (1960).

33. V. D. Rul and G. V. Derstuganov, "Investigation of Physical Development in Photographic Reversal Processes," *Uspekhi Nauch. Foto.*, **13**: 57 (1968) (in Russian).

34. Pierre Glafkides, *Photographic Chemistry*, Vol. One (English Edition), Fountain Press, London, 1958, pp. 173–174.

35. Robert Charles Morris Smith and Eustace Raymond Townley, "Bleach Solutions for Use in Photography," Brit. Pat. 879,443 (1961).

36. *The Dufaycolor Manual*, 1st Edition, Dufaycolor, Inc., New York, 1938, p. 13.

37. A. and L. Lumière and A. Seyewetz, "Reversed Negatives Direct by Development After Fixing," *Brit. J. Phot.*, **58**: 851 (1911).

38. A. Seyewetz, "Réactions produites dans les divers Procédés de Dissolution de l'Image Argentique," *Revue Franc. Phot.*, **10**: 365 (1929).

39. Verne H. Reckmeyer and H. Scott Baldwin, "Reversal Process," *The Complete Photographer*, **9** (49): 3145 (1943).

40. E. R. Bullock, "Réactifs attaquant l'Argent; leur Influence sur les Caractères de l'Image latente," *Sci. et Ind. Phot.*, **7** (5): 21 (1927).

41. E. R. Bullock, "On the Chemical Potential Necessary for the Destruction of the Latent Image," *Abridged Sci. Publ. Kodak Res. Labs.*, **11**: 210 (1927).

42. A. P. H. Trivelli and R. P. Loveland, "The Action of Chromic Acid on the Sensitivity of Solarized Silver Bromide Plates," *Abridged Sci. Publ. Kodak Res Labs.*, **13**: 259 (1929).

43. S. E. Sheppard, E. P. Wightman, and A. P. H. Trivelli, "Studies in Photographic Sensitivity. IV. Effect of Oxidizers on the Sensitivity and on the Latent Image," *J. Frank. Inst.*, **198**: 507 (1924).

44. Edwin Ernest Jelley, "Photographic Reversal Process," U. S. Pat. 1,962,348 (1934).

45. Edwin Ernest Jelley, "Improvements in or relating to Photographic Reversal Processes," Brit. Pat. 341,183 (1931).

46. Joseph C. Ville, "Photographic Reversal Process," U. S. Pat. 2,150,704 (1939).

47. Gustav Wilmanns, Wilhelm Schneider, and Richard Kethur, "Reversal Development of Light-Sensitive Silver Halide Emulsions," U. S. Pat. 2,159,466 (1939).

48. H. A. Miller, H. D. Russell, and J. I. Crabtree, "Direct-Positive Processing of the New Kodak Blue Base Reversal Films," *PSA J.*, **15**: 386 (1949).

49. Charleton C. Bard, Arthur D. Kuh, and Richard J. Malloy, "Nucleating Agents for Photographic Reversal Processes," U. S. Pat. 3,617,282 (1971).

50. Richard W. Henn, David K. Bulloch, and Charleton C. Bard, "Method for Elimination of Reversal Reexposure in Processing Photographic Films," U. S. Pat. 2,984,567 (1961).

51. Otto Ernst, Eberhard Gunther, Heinz Meckl, and Herbert Odenbach, "Photographic Reversal Process," Brit. Pat. 1,195,526 (1970).

52. Wesley T. Hanson, Jr., and Howard W. Vogt, "Method for Elimination of Reversal Re-Exposure in Processing Photographic Elements," U. S. Pat. 3,246,987 (1966).

53. Georges Emmanuel Zelger, "Process for Obtaining Direct Positives by Reversal," U. S. Pat. 1,628,445 (1927).

54. John Rau Weber and Lynn Barratt Morris, "Photographic Reducing Composition and Process," U. S. Pat. 2,339,309 (1944).

55. Gustav Wilmanns and Wilhelm Schneider, "Photographic Developers," U. S. Pat. 2,122,599 (1938).

56. Glenn E. Matthews and Raife G. Tarkington, "Early History of Amateur Motion-Picture Film," *J. SMPTE*, **64**: 105 (1955).

57. C. E. K. Mees, "A New Substandard Film for Amateur Cinematography," *Trans. SMPE*, No. 16: 252 (1923).

58. C. E. K. Mees, "Motion Picture Photography for the Amateur," *J. Frank Inst.*, **196**: 227 (1923).

59. C. E. K. Mees, "John George Capstaff," *J. SMPE*, **44**: 10 (1945).

60. Harris B. Tuttle and Glenn E. Matthews, "The Father of Home Movies," *PSA J.*, **18**: 418 (1952).

61. Frank E. Arland, "Sixteen mm. Film Reversal at Home," *The Camera*, **49**: 253 (1934).

62. "Processing Kodak Plus-X, Tri-X, and 4-X Reversal Films," Kodak Pamphlet No. D-9 (1-70 Minor Revision).

63. "Processing Official Formulas for Kodak Black-and-White Reversal Films," *Dignan Photographic Newsletter*, *B & W*, **5**: 5 (1972).

64. "Black-and-White Transparencies with Kodak Panatomic-X Film (FX135)," Kodak Publication No. F-19 (14-2-72-F Major Revision).

65. "Kodak Direct Positive Panchromatic Film 5246 (35mm), Formulas and Processing," Kodak Pamphlet No. J-6 (216-9-71-E Major Revision).

66. Phillip T. Jones, "Divided First Developer for B/W Direct Positive Processing," *Dignan Photographic Newsletter*, *B & W*, **5**: 5 (January 1972).

67. Phillip Jones, "Black-and-White Transparencies vs. Prints," *Photographic Mag.*, **1**: 68 (1972).

68. "Arneleon," *Brit. J. Phot.*, **107**: 597 (1960).

69. "Direct Positive Photography with Kodak Super Speed Direct Positive Paper," Kodak Pamphlet No. G-14 (63-4-71-F Major Revision).

70. Richard Morton and K. P. Duguid, "Rapid Reversal," *Brit. J. Phot.*, **115**: 417 (1968).

71. Kodak Ltd., "A New Method of Reversal Processing," *Process Engravers' Monthly*, **61**: 10 (1954).

72. "Reversal Bleach Process for Producing Phase Holograms," Kodak Pamphlet No. P-230 (10-70-E New Publication).

73. E. P. Wightman, "Photographic Reversal Effects," *PSA J.*, **14**: 107 (1948).

74. J. A. C. Yule and R. E. Maurer, "The Nomenclature of Photographic Reversal Effects," *Phot. Sci. and Eng.*, **8**: 289 (1964).

75. P. J. Hillson and E. A. Sutherns, "Latent-Image Effects Involving Reversal or Desensitization," Chap. 8 in *The Theory of the Photographic Process*, 3rd Edition, edited by T. H. James and C. E. K. Mees, Macmillan, New York, 1966.

76. A. P. H. Trivelli, "Beitrag zur Kenntnis des Solarisationsphänomens und weiterer Eigenschaften des latenten Bildes," *Z. wiss. Phot.*, **6**: 197 (1908).

77. G. A. Perley, "Experiments on Solarization," *J. Phys. Chem.*, **13**: 630 (1909).

78. G. A. Perley, "Experiments on Solarization. II," *J. Phys. Chem.*, **14**: 685 (1910).

79. Wilder D. Bancroft, "The Problem of Solarization," *J. Phys. Chem.*, **13**: 1, 181, 269 (1909); "The Theory of Solarization," **13**: 538 (1909).

80. A. P. H. Trivelli, "The Solarized Latent Image of Photographic Emulsions," *J. Frank. Inst.*, **209**: 373 (1930).

81. Lloyd E. Varden, "Direct Copy Film," *Am. Phot.*, **32**: 236 (1938).

82. Hans Arens, "Manufacture of Photographic Emulsions," U. S. Pat. 2,005,837 (1935).

83. Geza Szasz, "Photographic Process," U. S. Pat. 2,126,516 (1938).

84. John A. Leermakers, "Direct Positive Emulsion," U. S. Pat. 2,184,013 (1939).

85. John David Kendall, Henry Walter Wood, and Stanley Frederick William Welford, "Direct Positive Emulsions," U. S. Pat. 2,669,515 (1954).

86. John H. Bigelow and Cortland R. Burt, "Amine Borane as Fogging Agent in Direct Positive," U. S. Pat. 3,361,564 (1968).

87. Robert W. Berriman, "Silver Salt Direct Positive Emulsion," U. S. Pat. 3,367,778 (1968).

88. Cortland R. Burt, "Rhodium and Iridium Salts as Anti-Kinking Agent in Direct Positive Silver Halide Emulsions," U. S. Pat. 3,445,235 (1969).

89. Bernard D. Illingsworth and Harry E. Spencer, "Direct Positive Silver Halide Emulsions Containing Compounds which Accept Electrons and Spectrally Sensitize the Emulsion," U. S. Pat. 3,501,310 (1970).

90. Hidehiko Ishikawa, Mikio Sato, and Masaaki Yoshioka, "Direct-Positive Light-Sensitive Photographic Material," U. S. Pat. 3,519,428 (1970).

91. Roberta A. Litzerman, "Direct Positive Silver Halide Emulsions Containing Excess Halide," U. S. Pat. 3,531,290 (1970).

92. Heman Dowd Hunt, "Direct-Positive Silver Halide Emulsions Containing Silver Halide Reducing Agents in a Low pH Environment," U. S. Pat. 3,560,213 (1971).

93. Jean E. Jones, "Direct Positive Emulsions Sensitized with Pyrylium and/or Thiapyrylium Salts," U. S. Pat. 3,579,345 (1971).

94. Paul Brewster Gilman, Jr., "Direct-Positive Print-out Silver Halide Emulsion Fogged to Visible Density," U. S. Pat. 3,650,758 (1972).

95. Joseph De Witt Overman, "Direct Positive Emulsions Containing Amine Boranes and Bismuth Salts," U. S. Pat. 3,655,390 (1972).

96. I. G. Farbenindustrie, "Improvements in the Manufacture of Photographic Emulsions," Brit. Pat. 443,245 (1936).

97. Geza Szasz, "Improvements in or relating to a Process of Preparing Silver Halide Emulsions for the Production of Direct Positives," Brit. Pat. 462,730 (1937).

98. Robert William Berriman, "Photographic Direct Positive Emulsions and Sensitive Materials," Brit. Pat. 1,151,781 (1969).

99. Robert William Berriman, "Photographic Silver Halide Emulsions," Brit. Pat. 1,151,782 (1969).

100. Raymond Leopold Florens, Theofiel Hubert Ghys, Johannes Götze, and August Randolph, "Improved Direct Positive Emulsions," Brit. Pat. 1,155,404 (1969).

101. Bernard David Illingsworth, "Photographic Emulsions," Brit. Pat. 1,186,711 (1970).

102. Bernard David Illingsworth, "Photographic Emulsions," Brit. Pat. 1,186,713 (1970).

103. Bernard Leonard John Byerley and Thomas Reginald Maynard, "Direct-Positive Photographic Silver Halide Materials," Brit. Pat. 1,201,792 (1970).

104. John D. Mee and Donald W. Heseltine, "Direct Positive Emulsions," Can. Pat. 872,180 (1971).

105. Paul B. Gilman, Jr., Roberta A. Litzerman, and Bernard D. Illingsworth, "Direct Positive Emulsions," Can. Pat. 872,181 (1971).

106. Edith Weyde, "Über eine praktische Anwendung des Claydeneffektes," *Z. wiss. Phot.*, **48**: 45 (1953).

107. John H. Jacobs, "An Investigation of Print-Out Paper," *Phot. Sci. and Eng.*, **5**: 1 (1961).

108. Heman D. Hunt, "High-Speed Direct-Recording Papers," *Phot. Sci. and Eng.*, **5**: 104 (1961).

109. Delbert D. Fix and Jean E. Jones, "Direct-Print Photographic Silver Halide Emulsions," U. S. Pat. 3,367,780 (1968).

110. Delbert Dale Fix and Richard Warren Karlson, "Direct-Print Silver Halide Emulsions," U. S. Pat. 3,579,348 (1971).

111. John A. C. Yule, "Photographic Masking," U. S. Pat. 2,420,636 (1947).

112. John A. C. Yule, "Photographic Masking Using the Clayden Effect," U. S. Pat. 2,444,867 (1948).

113. John A. C. Yule and Richard E. Maurer, "Photographic Light-Sensitive Material for Making Halftones," U. S. Pat. 2,691,586 (1954).

114. H. Stabe, "Beitrag zur Entwicklung eines neuen photographischen Schreibverfahrens mit sofort sichtbaren und bleibenden Lichtspuren," *Z. wiss. Phot.*, **48**: 19 (1953).

115. Donald J. Howe, "Increasing Contrast of Halftone Emulsions," U. S. Pat. 2,691,580 (1954).

116. Richard E. Maurer, "Continuous Prescreening of Photographic Film and Paper," U. S. Pat. 2,925,339 (1960).

117. John A. C. Yule, "Low Temperature Clayden Prescreening," U. S. Pat. 3,110,593 (1963).

118. Donald Joseph Howe, "Nouveau film photographique prétramé et procédé pour sa préparation," French Pat. 1,305,210 (1962).

119. Gerald Isaac Pasternak Levenson, "Improvements in Photographic Processes," Brit. Pat. 665,682 (1952).

120. V. I. Saunders, R. W. Tyler, and W. West, "Herschel Effect in Single Crystals of Silver. Bromide," *J. Chem. Physics*, **46**: 206 (1967).

121. "How to Use Kodak Autopositive Materials," Kodak Pamphlet No. Q-23 (12-68 Minor Revision).

122. William B. Kendall and George D. Hill, "Direct Positive Emulsion Containing Desensitizing Dye," U. S. Pat. 2,541,472 (1951).

123. Hidehiko Ishikawa, Mikio Sato, and Kazuo Matusi, "Silver Halide Element Containing a Developer and Aromatic Sulfinic Acid Stabilizers," U. S. Pat. 3,466,173 (1969).

124. Yoshiyuki Nakazawa, Kintaro Nasu, and Fumihiko Nishio, "Direct Positive Silver Halide Photographic Materials," U. S. Pat. 3,367,779 (1968).

125. Marcel Adam Schouwenaars, "Improvement in or relating to the Manufacture of Photographic Material," Brit. Pat. 723,019 (1955).

126. Bernard David Illingsworth and Harry Edwin Spencer, "Photographic Emulsions," Brit. Pat. 1,186,714 (1970).

127. Hans Arens and John Eggert, "Die Schwärzungsfläche des Villardeffektes," *Z. wiss. Phot.*, **30**: 121 (1932).

128. Hans Arens, "Die Schwärzungsfläche des Villardeffektes II," *Z. wiss. Phot.*, **32**: 233 (1934); III, **34**: 125 (1935).

129. Hans Arens, "Uber den Villard-Effekt," *Z. wiss. Phot., II*, **50**: 392 (1955); II, **52**: 179 (1958); III, **53**: 157 (1959); IV, **54**: 121 (1960).

130. R. E. Maurer and J. A. C. Yule, "A Photographic Low Intensity Desensitization Effect," *J. Opt. Soc. Am.*, **42**: 402 (1952).

131. R. E. Maurer and J. A. C. Yule, "A Unique Film for Halftone Negative," *Mod. Litho.*, **21** (12): 53 (1953).

132. J. A. C. Yule, "Notes on 'Two-Stage Masking Simplified'," *Litho Printer*, **2** (9): 18 (1959).

133. Richard E. Maurer, "Direct Positive Prescreened Photographic Material," U. S. Pat. 2,912,326 (1959).

134. Richard E. Maurer, "Prescreened Negative Photographic Material," U. S. Pat. 2,912,327 (1959).

135. Richard E. Maurer, "Direct Positive Prescreened Photographic Material," U. S. Pat. 2,912,328 (1959).

136. Franz Tomamichel, "Der 'Intensitätsumkehreffekt' (latent image destruction; LID) and die ihm verwandten Effekte," *Phot. Korr.*, **99**: 197 (1963).

137. E. Albert, "Über das latente Bild," *Arch. wiss. Phot.*, **1**: 285 (1899).

138. Lüppo-Cramer, "Neue Untersuchungen zur Theorie der photographischen Vorgänge," *Phot. Korr.*, **46**: 493 (1909).

139. Lüppo-Cramer, "Zur Kenntnis der Albertschen Bildumkehrung," *Phot. Korr.*, **72**: 17 (1936).

140. Walter Clark, "On the Sensitivity of the Silver Halide Grains of a Photographic Emulsion," *Phot. J.*, **64**: 91 (1924).

141. Walter Clark, "The Reduction Centres of a Silver Bromide Emulsion," *Phot. J.*, **63**: 230 (1923).

142. G. W. W. Stevens, "The Mechanism of Photographic Reversal," *Phot. J.*, **79**: 27 (1939).

143. G. W. W. Stevens, "The Depth of Internal Latent Image," *J. Phot. Sci.*, **1**: 122 (1953).

144. F. Trautweiler, "Mechanismus einiger Umkehreffekte an Silberhalogenidschichten," *Reprographie*, **4** (1): 13 (1964).

145. J. R. Manhardt and D. J. Forst, "The Albert Effect: I. The Dual Mechanism," *Phot. Sci. and Eng.*, **8**: 265 (1964).

146. K. H. Day and R. J. Kohler, "The Albert Effect: II. Practical Application," *Phot. Sci. and Eng.*, **8**: 336 (1964).

147. D. J. Forst, C. Armstrong, and R. J. Kohler, "The Albert Effect. III. Operational Feasibility," *Phot. Sci. and Eng.*, **11**: 279 (1967).

148. Armand Sabattier, "Positifs Directs Sur Collodion," *Bull. soc. franc. phot.*, **6**: 306 (1860).

149. Armand Sabattier, *Bull. soc. franc. phot.*, **8**: 175, 289 (1862).

150. Erich Stenger, "Die Sabatiersche Bildumkehrung," *Z. wiss. Phot.*, **13**: 369 (1914).

151. G. W. W. Stevens and R. G. W. Norrish, "Border Effects Associated with Photographic Reversal Processes," *Phot. J.*, **77**: 20 (1937).

152. H. J. Channon, "Studies in Photographic Science," *Phot. J.*, **60**: 164 (1920).

153. Lüppo-Cramer, "Über Entwicklungshöfe," *Phot. Rund.*, **70**: 267 (1933).

154. Lüppo-Cramer, "Über die Sabatiersche Bildumkehrung," *Phot. Ind.*, **33**: 72 (1935).

155. Lüppo-Cramer, "Der Sabattier-Effekt als Grundlage praktisch brauchbarer Bildum-kehrungsverfahren," *Kinotechnik.*, **17**: 410 (1935).

156. Lüppo-Cramer, "Zur Bildumkehrung nach Sabattier," *Phot. Ind.*, **34**: 82 (1936).

157. Somerset Murray, "Making the Most of the Partial Reversal Process," *Photography*, **3** (31): 4 (1935).

158. Don Loving, "Solarized Negatives," *Am. Phot.*, **37** (4): 16 (1943).

159. Jack Emerald, "Solarisation with Miniature Negatives," *Amat. Phot.*, **95**: 631 (1945).

160. Willard R. Card, "Solarization," *Pop. Phot.*, **17** (4): 34 (1945).

161. Francois Dewitte, "Solarization," *Good Phot.*, **19** (2): 92 (1963).

162. Ken Palmer, "Solarisation is Easy," *Amat. Phot.*, **145** (1): 26 (1972).

163. Masaharu Sato, "Solarization Photographs," *Camerart*, **15** (3): 44 (1972).

164. E. Ch. Gehret, "Pseudo-Solarisation," *Brit. J. Phot.*, **114**: 318 (1967).

165. Hal Denstman, "Pseudo-Solarization," *Ind. Phot.*, **19** (10): 18 (1970).

166. Thomas D. Sharples, "Quasi-Solarization," *J. PSA*, **11**: 427 (1945).

167. Julio Cesar Genovese, "The Sabattier Effect," *PSA J.*, **34**: 39 (1968).

168. Chris Regas, "Sabattier Effect," *PSA J.*, **38** (6): 26 (1972).

169. H. Seemann, "Die Sabatiersche Bildumkehrung," *Phot. Rund.*, **51**: 212 (1914).

170. Anthony Marriage, "A Note on the Sabattier Effect," *Phot. J.*, **77**: 619 (1957).

171. Hans Arens and John Eggert, "Verfahren zur Herstellung direkter Positive mit Hilfe des Sabattier-Effektes," German Pat. 749,864 (1944).

172. Hans Arens, "Über die Theorie des Sabattiereffektes," *Z. wiss. Phot.*, **44**: 44, 51, 172 (1949); **45**: 1 (1950); **46**: 125 (1951).

173. Hans Arens, "Der Sabattier-Effekt," *Z. wiss. Phot.*, **48**: 48 (1953).

174. G. W. W. Stevens and R. G. W. Norrish, "The Mechanism of Photographic Reversal. Part 1. The Sabattier Effect and its Relation to the Other Reversal Processes," *Phot. J.*, **78**: 513 (1938).

175. Edward Philip Davey and Edward Bowes Knott, "Photographic Silver Bromide Emulsion Containing Some Silver Iodide," U. S. Pat. 2,592,250 (1952).

176. Edward Bowes Knott and Guy William Willis Stevens, "Improvements in Photographic Reversal Processes," Brit. Pat. 581,773 (1946).

177. Gerard Laurens Vanreusel, Paul Desire Van Pee, and Jules Maria de Laet, "A Method of Producing Photographic Images," Brit. Pat. 1,150,553 (1969).

178. E. J. Wall, *Photographic Emulsions*, Am. Phot. Pub. Co., Boston, 1929, pp. 52–53.

179. Charles E. Ives, "Direct Positive Photographs from Hydrazine-Containing Developers," U. S. Pat. 2,563,785 (1951).

180. Charles Ellis Ives, "Improvements in Photographic Reversal Processes," Brit. Pat. 702,162 (1954).

181. Charles E. Ives, "Direct Positive Photographs Using Hydrazine in the Emulsion," U. S. Pat. 2,588,982 (1952).

182. George Earle Fallesen, "Direct Positive Photographs Using Aerial Fogging Developer," U. S. Pat. 2,497,875 (1950).

183. Robert Eliot Stauffer, "Method of Producing Direct Positive Photographs Having Increased Density," U. S. Pat. 2,497,917 (1950).

184. Arnold Weissberger, "(Alkylsulfonamido) Arylhydrazines," U. S. Pat. 2,663,732 (1953).

185. Grant M. Haist and Harold D. Russell, "Direct Positive Photographic Development Process," U. S. Pat. 2,685,514 (1954).

186. J. Waterhouse, "On the Reversal of the Negative Photographic Image by Thio-Carbamides," *Brit. J. Phot.*, **37**: 601 (1890).

187. J. Waterhouse, "Elektro-chemische Umkehrungen mittels Thiocarbamide," *Eder's Jahrbuch*, **16**: 170 (1892).

188. Francis C. Frary, Ralph W. Mitchell, and Russell E. Baker, "The Direct Production of Positives in the Camera by Means of Thiourea and its Compounds," *Brit. J. Phot.*, **59**: 840 (1912).

189. G. A. Perley and Alan Leighton, "Preliminary Studies on Direct Photographic Positives," *Brit. J. Phot.*, **59**: 860 (1912).

190. S. O. Rawling, "Thiocarbamide Fog and a Suggested Explanation of Waterhouse Reversal," *Phot. J.*, **66**: 343 (1926).

191. Howard A. Miller, "A One-Bath Reversal Process," *PSA J.*, **14**: 103 (1948).

192. Hermann Eggenschwiller and Walther Jaenicke, "Bildumkehr bei Fixierentwicklung," *Phot. Korr.*, **95**: 165 (1959).

193. Arthur Garza and Patrick D. Dignan, "An Experimental Reversal Monobath," *Dignan Photographic Newsletter, B & W*, **6**: 4 (February 1972).

194. A. P. Strel'nikova, N. I. Kirillov, N. G. Maslenkova, and E. M. Fel'dsherov, "A Simple Method for Reversing the Image During the Development of a Film in a Developing-Fixing Solution," *Papers of International Congress of Photographic Science, Section C, Moscow, USSR, July 9–August 5, 1970*, pp. 92-95 (C-20).

195. R. W. Henn and Nancy H. King, "A Simple Reversal Process," *Phot. Sci. and Eng.*, **11**: 363 (1967).

196. Richard Winthrop Henn and Bernadette Daukintas Mack, "Photographic Compositions," Brit. Pat. 1,219,315 (1971).

197. Richard W. Henn and Bernadette D. Mack, "Photographic Processes and Compositions," Can. Pat. 837,527 (1970).

198. Nancy H. King, "Developers for Photographic Reversal Processes," U. S. Pat. 3,021,212 (1962).

Chapter 8
Diffusion Transfer

The diffusion-transfer process is one
of the few genuinely original inventions
in photography.

W. F. BERG[197]

The history of photography has been marked by continuous improvements. Many photographic concepts and proposals of the nineteenth century have been technologically refined in the twentieth. Reversal processing by diffusion transfer is one of the very few photographic advances of the present century. The impact of this concept will become more evident in the years just ahead, particularly in its adaptation to the diffusion of dyes to form color prints.

The principles of silver diffusion transfer were discovered independently by different routes by André Rott, of Gevaert (Belgium), and Edith Weyde, of Agfa (Germany), while these two companies were still competitors. Rott[1] has written, "On November 2, 1939, Gevaert Photo Producten N. V. of Antwerp, Belgium, filed in England the first application for a patent for this process, of which I am the inventor and which belongs to that company. It was the first application filed for this invention in any country." Rott also claimed, "In the course of my research I recognized the applicability of the new method to one-step processes (claim 4 of Netherlands Patent 59365,

filed October 23, 1941)." The one-step photographic process was later perfected by Edwin H. Land for use in instantaneous camera photography to produce silver-image prints. Still later, Land and the Polaroid Corporation pioneered in the introduction of in-camera color prints using dye diffusion transfer.

In their co-authored book[2] André Rott and Edith Weyde recount how they independently discovered the principles of the diffusion transfer process. Rott was seeking a means to duplicate business letters so that correspondence could be circulated to various locations of the Gevaert factory. Attempts were made to transfer a developed negative image using a stripping film so that the film emulsion layer could be applied to a sheet of paper, yielding a right-reading negative image with white letters on a black background. The transferred film emulsion had to be fixed to make the image permanent, but this step caused the thin film emulsion to lift from the paper support. It was noted that when the emulsion layer became unstuck after fixing, a faint positive image was present on the paper. The thiosulfate of the fixing bath had dissolved some of the undeveloped silver halide and transferred it to the paper, where it had been converted to metallic silver of a brownish tone. Considerable activity then ensued to increase the density of the positive transferred image and to change the tone of the image from brown to black.

In her account, Edith Weyde[3-4] said that a number of coincidences dealing with customer complaints led to the discovery of diffusion transfer. Some of these complaints concerned the formation of yellow fog, often at the unexposed borders of prints. It was discovered that the fog was formed not in the emulsion layer but in the underlying baryta layer, producing a weak but sharp negative image of the positive image of the print. The developer, contaminated with sodium thiosulfate, had dissolved some of the undeveloped silver halide and diffused to the baryta layer, where the silver was reduced. In another problem, unsharp negative images were found on the back of the paper prints. When the prints were fixed together in a thiosulfate bath that had become alkaline, or with minimum agitation, some of the silver salts from the positive image of one print had been deposited as the negative silver image in the fibers of the back of the adjacent print. In dealing with a yellow-fog difficulty in a color film, Dr. Weyde[5] found that the fog was formed on the very fine silver particles of a yellow filter layer. These colloidal silver particles greatly accelerated the transfer of silver halide from one layer to another. In these and other related problems, it became evident that sodium thiosulfate could dissolve silver halide and transfer it to an adjacent layer, where a sharp silver image was produced. The first application of this discovery was made in 1940 in a kind of instant photography rather than in the photocopy field, but it led to the Agfa Copyrapid process of document copying.[6-12]

Diffusion of photographic substances had been observed previously. In 1857 Belfield Lefevre[13] found that when a gelatin-coated paper was pressed against a developed Daguerreotype plate moistened with thiosulfate, all the particles of the image on the plate were transferred to the gelatin paper. Lefevre proposed to strengthen the transferred image by using the silver particles as catalytic centers for the deposition of more silver. R. Ed. Liesegang[14] reported in 1899 that when a silver chloride print (containing silver nitrate) was pressed against a sheet of glass coated with gelatin containing gallic acid, a negative image of the print was formed in the gelatin layer by the reduction of silver nitrate that had diffused from the print to the gelatin layer containing the developing agent. In 1898 Captain Colson[15] studied the diffusion of substances contained in the developing solution. Later, Erich Stenger and Alfred Hertz[16–17] pressed an exposed silver bromide layer, wetted with developer, in contact with a uniformly light-flashed layer of silver bromide. In the exposed layer with the image exposure, the developer was exhausted forming the negative image in the heavily exposed areas, but the unused developer in the other areas was transferred to the light-flashed silver bromide, where a positive image was developed. This was an example of imagewise chemical transfer (patented in German Patent 382,975 in 1922) rather than silver diffusion transfer.

In 1938 G. W. W. Stevens and R. G. W. Norrish,[18] while studying the mechanism of the Sabattier effect, immersed an exposed process plate and a plate coated only with gelatin in a Metol developing solution, then pressed the two plates into contact. After removal from the developer and after 2 min contact, the plates were separated. The process plate had a negative image; the gelatin plate, after treatment in an acid Metol physical developing solution, had an image exactly the reverse of the image on the process plate. Unexposed but slightly fogged silver salts had diffused from the undeveloped areas of the process plate to the gelatin plate, where silver nuclei were formed suitable for physical development.

The experiment by Stevens and Norrish was cited by the German Patent Office in rejecting Edith Weyde's first patent application, dated January 24, 1941. The Patent Office ruled that the concept of obtaining a positive image by diffusion transfer was thus known, and only improvements on the process could be protected by a patent. This arbitrary ruling has been questioned by both Rott and Weyde,[19] particularly because an external source of silver (a physical developing solution) was required to amplify the transferred nuclei to form the positive image. The work of Fritz Hausleiter has been suggested as a forerunner of the diffusion transfer technique.[20–23] Dry in-camera print processing was also known.[24–25] It is certain, however, that none of the early experimenters with the diffusion of photographic chemicals were able to match the practical elegance of the process as proposed by Rott[26]

or Weyde,[27-29] or the simplicity of the instant-picture camera system introduced by E. H. Land.[30-34]

THE DIFFUSION TRANSFER PROCESS

For the direct production of positive images, the diffusion transfer process requires three major components: (1) a light-sensitive silver halide emulsion layer, (2) a light-insensitive reception layer, and (3) a processing fluid which permeates both layers. After exposure the photographic layer is pressed into intimate contact with the light-insensitive layer with the processing fluid between them. A negative silver image of the original subject is formed in the photographic layer. Some of the unexposed silver halide is solubilized by the silver halide solvent of the monobath. The complexed silver ions diffuse from the photographic image layer to the light-insensitive layer, where they are reduced to metallic silver, forming a positive image depicting the original subject. The formation of the positive image is greatly accelerated if the receiver contains catalytic substances that aid in the reduction of the complexed silver ions to metallic silver. Just as silver particles can serve as centers for physical development, so finely divided silver, silver sulfide, or other metal sulfides can serve as centers for image formation in the diffusion transfer process, a type of physical development.

For office copying use, the common form of the diffusion transfer reversal process consists of two sheets: one is the light-sensitive photographic material, the other is the light-insensitive receiver sheet that will contain the positive image. The photographic sheet (the negative) and the receiver sheet (the positive) are wetted by a monobath that is essentially a rapid-acting developer containing a small amount of sodium thiosulfate which may also be contained in the receiver. These two sheets are then pressed together between rollers with the emulsion layer of the negative in contact with the coated side of the receiver. The negative silver image in the photographic sheet is formed rapidly by the reduction of the exposed silver halide, leaving less unreacted silver halide than in a region where no development had occurred. The thiosulfate reacts with any of the remaining silver halide to form soluble silver complexes that are relatively unstable in the alkaline solution. These complexes diffuse in all directions. Some of the silver thiosulfate complexes that are intimately close to the metallic silver of the negative image will physically deposit the silver on the silver filaments of the image. Other complexes formed in areas where there is no developed image will diffuse from the layer of the photographic material, pass through the liquid that holds the two sheets together, and enter the coated layer of the receiver sheet. Because the silver thiosulfate complex is unstable, it will tend to

precipitate silver metal in the presence of the developing agent, but this reaction is relatively slow.

The positive-image formation may be greatly accelerated if finely divided silver (colloidal silver), or other nucleating substances, are dispersed throughout the receiving layer. The colloidal silver particles act as catalytic sites for physical development to deposit metallic silver from the unstable silver thiosulfate complexes. A positive image is found on the receiver sheet when it is separated from the photographic sheet which contains a negative image. Unless special precautions are taken for the photographic material, the negative image will be darkened when exposed to the light. The positive image is light stable, but residual chemicals may cause staining or fading unless the processing fluid is especially compounded to minimize these problems.

In the two-sheet diffusion transfer reversal systems the negative and positive images are separated from each other by stripping the sheets apart. Both the negative and positive layers can be coated on the same base material to produce a one-sheet system.[35] When the negative layer is on top, this layer is removed after development by washing or stripping it away, revealing the positive image in the hardened underlayer.[36] The negative layer need not be removed, but the positive image is viewed through the transparent support with dyes or pigments, such as titanium dioxide, between the positive and negative images in order to mask the negative image.[37] This last arrangement can be used when the positive layer is coated on top of the negative or with separate negative and positive layers laminated together with the masking layer between the two layers to hide the negative image. The top positive image may also be transferred to a second sheet.

Another system combines the light-sensitive silver halide and the catalytic silver particles in a single layer. After treatment with a monobath containing sodium thiosulfate, the negative image (from exposed silver halide) consists of silver of low light-stopping power and the positive image of silver of high light-stopping power, yielding a useful positive image. A number of other variations have been proposed to simplify the process, such as incorporating the thiosulfate in the positive image-forming layer, adding the catalytic nuclei directly to the monobath so that normal paper can be used, or using dye-containing positive sheets that adhere to the areas of silver development in the negative but not to areas that do not have developed silver.

The Negative Material

The sensitivity of the negative material may range from low for some office copy uses to very high for camera use. High-speed negative sheets must be

protected from nonimage light exposure, but the slower-speed negative sheets are usually employed under normal room illumination. In addition, the slower-speed negative material is designed primarily for copying letters and similar documents which require a special exposing technique to produce right-reading copies. Reflex copying provides right-reading copies. This technique involves placing the light-sensitive layer of the negative in contact with the face of the sheet to be copied. Exposure is made by passing the light through the base of the negative, then through the light-sensitive layer to the face of the sheet to be copied (a letter, for example). The light is reflected back from the white areas but is absorbed by the dark areas, such as the typewritten characters. The reflected light exposes the negative photographic layer, resulting in a difference in developability of the negative between the dark and light image areas of the original letter.

Only about 75% of the light is reflected by the white areas of the image to be copied, and the black areas may reflect up to 10% of the incident light. To overcome this relatively small exposure difference, the negative material for reflex copying purposes must have a steep gradation to enhance the exposure difference so as to secure a black image on a white background without background fog. To obtain this objective, the silver halide of the negative is sensitized to yellow-green radiation, as the contrast of the emulsion is greater for yellow-green light exposure than for blue light exposure of an unsensitized silver halide layer. Yellow-green light is also scattered less during its passage through the negative material during reflex copying. Yellow-green sensitization of the negative requires that the exposing light have a high content of yellow-green wavelengths or a yellow filter should be used to exclude the blue of the exposing light. With the orthochromatic negative, business letters with yellow or yellowed backgrounds would be reproduced with white backgrounds on the copy, but other colors would be reproduced as black.

Hardening agents for the gelatin of the negative layer are essential to limit the swelling of the gelatin during processing. Limiting the swelling helps speed the development of the negative image and prevents the lengthening of the diffusion path to the positive material. The time of transfer is increased over a longer path because of excessive swelling. The emulsion should not be excessively hardened, because keeping properties of the negative may be impaired and the contact with the positive may be difficult to maintain uniformly.

It is essential that the negative image develop fully before solubilization of the silver halide begins. Photographic emulsions of essentially silver chloride are rapid to develop, and so fine-grained silver chloride, with small amounts of bromide or iodide, is used for the negative whenever the sensitivity is sufficient. According to W. Krafft,[38] a minimum silver content of 0.8 g/m^2

of an ordinary paper-base negative is sufficient to transfer between 0.4 and 0.5 g of silver per square meter of the paper positive. A considerable percentage of the silver of the negative diffuses to the paper base. This loss may be prevented by the use of a water-resistant base for the negative, which will require only about one-half the silver coverage of regular paper base.

In Rott's British patent[39] the processing solution was a thiosulfate monobath containing hydroquinone and Metol as developing agents. But the coated layer of the negative material may contain a number of chemical additions. Two developing agents, hydroquinone and Metol, were incorporated in the negative of the Agfa Copyrapid process in 1949. Hydroquinone and Phenidone were later used. Hydroquinone with potassium metabisulfite or sodium formaldehyde bisulfite as protectants may be used in the negative, but the Phenidone may be in the positive layer or in the monobath. Other developing agents, such as gallic acid, gentisic acid, or pyrogallol, have been added to the negative as secondary developing agents to act superadditively with the primary developing agent, such as Metol or Phenidone, that may be contained in the processing liquid or in the positive receiver. The negative layer may also contain antifoggants, such as benzotriazole, nitrobenzotriazole, or mercaptothiazole, since a high fog level in the negative limits the amount of silver available for transfer. Development accelerators, such as amines, hydrazines, guanidines, or thiocyanates, have also been proposed for incorporation in the negative.[40]

The Positive Material

The image-receiving layer of the positive material should be thin when dry, but swell rapidly when wet so that the diffusion of the silver complexes will occur rapidly. Rapid diffusion is essential if lateral spreading of the image is to be prevented and adequate image densities are to be obtained in a short transfer time of 10 sec duration. The binding agent in the receiver layer must not swell more than necessary to minimize the take-up of the monobath solution that may produce stains in the background of the transferred image. This binding agent must not stick to the negative emulsion layer during the necessary contact time for the silver diffusion to occur.

The choice of a colloid for coating the image-receiving layer is very important, because the rapidity of transfer, the quality and permanence of the image, and the release properties from the negative are related to the binding agent or agents in the layer. Gelatin, cellulose derivatives, starches, polyvinyl acetate or alcohol, and various other synthetic polymers have been commonly used alone or in combination for the image-receiving layer. Often a separate layer, sometimes referred to as a "slime coat," is applied as a top coat to the positive and negative to insure the complete release of

the positive material when it is stripped from the negative sheet. This top layer also insures good contact between the negative and positive, producing uniform images. Colloidal silica and silicate compounds are often added to this top layer to prevent silver mirror formation on the surface. Like every photographic top coat, this outer layer protects the silver image from abrasion.

The binding agents in the image-receiving layer must act as a vehicle for suspending and dispersing the two essential ingredients of the layer: the development nuclei and the toning compound. The development nuclei act as catalytic sites for the deposition of the silver from the transferred silver complexes. The substances used for the catalytic sites were first called "fogging agents" by André Rott[41] because these substances were "capable of promoting the reduction of silver halides without requiring for this the action of light. Of these substances there may be mentioned by way of example: colloidal silver, colloidal forms of sulfur, silver sulfites, hypophosphites, stannous chloride and organic sulfur compounds, which are capable of splitting off sulfur in the form of a bivalent ion. One of these latter compounds is thiosinamine." In British Patent 654,630, an addition to André Rott's first British patent, such agents were called development nuclei.[42] These agents either served as sites for the reduction of the silver ions from the transferred silver thiosulfate complexes or caused the formation of such nuclei. The activity of the nuclei depends primarily on their kind, their size, and their quantity in the receiver layer. The activity of such small particles may change with time. Because of their greater stability and high activity, the sulfides of silver, palladium, nickel, lead, and other metals are now commonly used.

The number of active silver nuclei in the positive layer determines the rate of silver deposition. Edith Weyde[9] has noted:

In the silver-salt diffusion method, if very many nuclei are now added to the positive emulsion then silver is provided there for precipitation and, in fact, the number must be very high for this since, to be sure, the negative also possesses such nuclei in the developed silver grains. The positive emulsion, however, should not be colored by the nuclei, that is, the smallest possible amount, by weight, of nuclei must be distributed over the largest possible area in the positive emulsion. The Copyrapid negative paper, for example, contains for the same area a maximum of 1000 times more silver in the form of silver halide than the Copyrapid positive paper contains in the form of nuclei! It has been determined experimentally, however, that the nuclei silver of the positive emulsion is around 10 million times more active; that is, is distributed more finely than the developed silver grains of the Copyrapid negative papers.

High-speed negative films, such as Kodak Verichrome pan film, contain higher percentages of silver iodide than do the negative-paper emulsion

layers. When bromoiodide negative layers are to be used for diffusion transfer reversal processing, the size, number, and activity of the nuclei must be carefully controlled to yield black positive images after transfer. According to E. H. Land,[43]

If more than about 10^{11} separate, ungrouped, precipitation nuclei per cc. are present, there will be so many places for the silver to start precipitation that the grains will not grow to full desired size (about 1/2 micron) using the amount of silver brought down by the solvent. As this amount of silver is increased it will darken the grains in the shadows, making them black or dark brown, will increase the size of the silver grains in the middle tones to change their color from light yellow to dark yellow and will yellow the highlights. When the size of the middle tone grains is enlarged to black by further growth, the highlights are further darkened and all detail is removed from the shadows.

In the present process [U. S. Patent 2,698,245], positive images of substantially uniform color for all tone gradations are achieved by (1) providing nuclei in no greater concentration than 10^{11} per cc. and (2) adjusting the effective size of such nuclei so that when silver aggregates appear visible on the nuclei they will be brownish or gray, this effective size being in the neighborhood of 1/2 micron. These two effects are achieved by employing precipitation nuclei comprising crystals, aggregates of crystals or aggregates of ions of such size as to be conveniently handled quantitatively.

Land further stated:

In general the size of the precipitant nuclei may be controlled in several ways. When the precipitant nucleus comprises a single crystal, its size may be controlled by precipitating the crystals under controlled conditions of temperature, of precipitation medium, of pH, reprecipitating the crystals from solution by sequential baths, or dissolving crystals of a size smaller than those desired. These procedures are particularly suitable for those single crystals which are smaller than 1/2 micron. Where the crystals are of a larger size, in the neighborhood of 1/2 micron or larger, they may be additionally subjected to mechanical treatment such as occurs in a colloid mill and it is sometimes practical to separate various desired sizes of crystals by selective filtration.

When galaxies of extremely small crystals are to be employed these galaxies may be aggregated to the proper size by concentrating them in the spaces between inert particles suspended in a liquid. Another way of forming a precipitant nucleus in the form of a galaxy, is to adsorb the precipitant anions to the surface of an inert adsorptive colloid. Still another method of forming such a galaxy is to impregnate minute plastic globules with precipitant anions which are only slowly released from the plastic globules.

The aggregation of the precipitated silver in the positive, so necessary for neutral image tones, is accomplished by the inclusion of a matrix of minute particles, colloidal in nature and invisible to the naked eye, in the same image-

receiving layer with the precipitation nuclei. Satisfactory chemically inert particles of this type are, according to U. S. Patent 2,765,240,[44] "colloidal silica, such as silica aerogel, fuller's earth, diatomaceous earth, kieselguhr, wood flour, infusorial earth, bentonite, filter aids such as Celite and Super-Floss, and finely powdered glass, talc, mica or zinc oxide." Silica aerogel, available under the trade name "Santocel C" (Monsanto Co.), or hydrated silica dispersions commercially available under the trade name "Ludox" (E. I. du Pont de Nemours and Company) are particularly useful for forming the dispersing medium or matrix for the precipitation nuclei.[45–46] Ludox is especially useful, forming silica micelles that have a particle size from 10 to 30 mμ with an average size of about 15 mμ.[47] Preferred silver precipitating nuclei are "sulfides of zinc, chromium, gallium, iron, cadmium, cobalt, nickel, lead, antimony, bismuth, silver, cerium, arsenic, copper, and rhodium and the selenides of lead, zinc, antimony and nickel."[44] The sulfides of nickel, zinc, cobalt, and lead are active silver precipitants, and it has been claimed[48] that mixing these nuclei with a silver salt produced improved maximum densities and more neutral tones in the transferred image. The nuclei may be coated in binders other than gelatin, such as the reaction product of bis-maleimide with gelatin,[49] on pigmented electron bombarded polyethylene layers,[50] or in the upper alkali-permeable surface formed by the hydrolysis of an alkali-impermeable polymer such as cellulose diacetate.[51–52]

The other primary ingredient of the positive layer is now a toning compound, although this agent was not present in early products. The first commercial diffusion transfer reversal process was Gevaert Transargo, marketed in 1940.[53] This copying process used sodium thiosulfate as the silver complexing agent and colloidal silver sulfide as the nuclei in the positive. The transferred image was yellow, requiring selenium toning to obtain adequate image tone. Selenium toning was also necessary for another early Gevaert product call Diaversal, which had both the light-sensitive and image-receiving layers on the same base.[54–55] The upper light-sensitive layer was washed away to produce a direct positive monochrome reproduction of color transparencies. The need for a separate treatment to produce acceptable image tone in the positive can be obviated by the inclusion of a suitable toning compound in the nucleated layer of the positive material. Most toning compounds are sulfur-containing organic compounds that influence the form of the silver deposited on the nuclei.

According to Edith Weyde,[9] heterocyclic mercapto compounds, which form silver compounds of low solubility, slow the rate of deposition of silver from the silver complexes being transferred by the diffusion of the monobath. More silver ions are available to be deposited on a few favored nuclei or on fewer active sites on each nuclei that have not been inhibited by the thiol compound. When the mercapto compound is absent from the monobath,

the image is yellowish- or reddish-brown; when the mercapto compound is present, the image is black. The toning of silver diffusion transfer images has been the subject of considerable investigation[56-66] and considerable difference in interpretation. One recent study, by E. H. Land, V. K. Walworth, and R. S. Corley,[67] attributed the difference in image color to the size and structure of the silver deposits, as determined by electron microscopy. According to this investigation, "The brown image deposit (a), is in the form of spheres and ellipsoids 50–100 nm in maximum dimension, with mean diameter 70 nm; many appear to be single crystals. The deposit in the black image, (b), comprises clusters 120–200 nm in maximum dimension with mean 146 nm; an estimated 50 or more particles 10–30 nm across are seen in a typical cluster. Stereoscopic comparison shows separation of the unit particles of the image deposit (a) to be of the order of their diameters (50–100 nm), whereas within the clusters of image (b) typical spacing between the small particles is 1/10 diameter or less (≤ 1 nm)."

Many, many thiol compounds have been found to be suitable for producing black diffusion transfer images. Edith Weyde[68] patented the 5-mercapto-1,2,3,4-tetrazoles, particularly the 1-phenyl-5-mercapto-1,2,3,4-tetrazole, of which 0.05 g was added to a liter of 5% gelatin solution containing 0.05 g of colloidal silver before a sheet of paper was coated to make the receiver material. Tetrahydro-2H-1,3-thiazine-2-thiones,[69] 1,3,4-triazol-4-in-2-thiones[70] or 1,3-oxazolidine-4-on-2-thione,[71] diphenyl iodonium-5-methyl benzotriazole or 5,5-dimethyl-4-thiohydantoin,[72] benzothiazole-2-thiol,[73] 5-chlorobenzotriazole,[74] 5-nitro- and 6-nitrobenzimidazole,[75] and cysteine[76] are only a few representative compounds that have been used as black toners in the diffusion transfer process. Many mercapto compounds, however, have no influence on image tone, and it is difficult to predict the effective agents.[77] A relatively complete listing is given in the book, *Photographic Silver Halide Diffusion Processes*, by André Rott and Edith Weyde, beginning on p. 61.

The usual brown transfer image can be converted into a black image by incorporation into the receiver of compounds such as benzotriazole or its derivatives, 5-nitrobenzimidazole, or 1-phenyl-5-mercaptotetrazole. These compounds form silver compounds of low solubility, decreasing both the rate of development in the negative and the rate of image formation in the receiver. Acceleration of the transfer process has been claimed for black toning agents such as 3-alkyl-benzoxazoline-2-thione, 5,5-dimethyl-4-thiohydantoin, or 5-methyl-3-mercapto-1,2,4-triazole. Black, or blue-black, toning and development acceleration has been claimed for such compounds as 4-amino-3-methyl-1,2,4-triazoline-5-thione or 4-acetamido-1,2,4-triazoline-5-thione.[78] Certain 1,2,4-triazine derivatives, such as 3-thio-1,2,4-triazaspiro[5,5]undecane-3,5-dione, have been patented for this purpose.[79]

An image-receiving layer may be coated from this composition containing this triazine:

Gelatin	40 g
Sodium thiosulfate, crystal	35 g
Colloidal nickel sulfide	1.28×10^{-3} mole
3-Thio-1,2,4-triazaspiro-[5,5]undecane-3,5-dione (0.7% in ethanol)	100 ml
Formaldehyde, 20%	5 ml
Sandozol (sulfonated organic oil) (Sandoz Chemical Works, Inc.)	1 ml
Water to make	1 liter

This suspension is sufficient to cover 13 m² of a paper support.

Developing agents are incorporated in the receiving layer as well as development nuclei and toning agents. A superadditive developing-agent combination has been proposed[80] such that the principal developing agent, hydroquinone, is incorporated in the receiver layer and the secondary developing agent, a 3-pyrazolidone, is incorporated in the light-sensitive material. In the light-sensitive material 1.3 g of silver chloride and 0.1 g of 1-phenyl-3-pyrazolidone are applied to cover 1 m². One liter of the following composition is coated on 12 m² of paper support:

Water	877.2 ml
Gelatin	40.0 g
Sodium sulfide (10% in water)	2.4 ml
Cobalt nitrate (10% in water)	13.2 ml
Potassium metabisulfite	12.8 g
Hydroquinone	6.4 g
Sodium thiosulfate	48.0 g

The light-sensitive material and the receiver paper are passed through a developing apparatus containing

Water	1 liter
Sodium phosphate	100 g
Sodium sulfite, anhydrous	20 g

The two sheets are laminated together in the machine. After 10 sec contact time, the two sheets are stripped apart to reveal a positive image of the original on the receiver.

The Processing Solution

The liquid used to bind the light-sensitive negative material in intimate contact with the light-insensitive positive material is an alkaline solution of processing chemicals whose number varies with the composition of the negative and positive layers. The developing agents may be coated in one of the layers of the negative or positive sheets. The silver complexing agent may be coated as part of the receiver. The image-forming nuclei may be part of the processing liquid but usually are coated in the receiving layer. Other variations are possible, but one common combination has the silver complexing agent and nuclei as part of the receiver and the developing agents contained in the liquid. Or the developing agent or agents may be present in the solution with the silver complexing agent to produce a true monobath.

The alkaline processing solution or monobath may contain a number of other compounds, such as sodium sulfite or potassium metabisulfite, to act as an auxiliary silver solvent and to minimize staining due to the oxidation products of the developing agents; restraining agents to minimize fog in the negative; toning compounds to produce a black-toned positive image; development accelerators to speed negative development; sequestering agents to prevent deposition of calcium compounds from hard water or leached from the coated layers; and thickening agents if the processing is carried out in a camera. Viscosity-increasing compounds, such as sodium carboxymethyl cellulose or hydroxyethyl cellulose, in the processing liquid insure even spreading of the thickened liquid and maintain uniform thickness between the negative and receiver sheets. If the processing liquid is subject to continued re-use, as in office copying machines, mercapto compounds to inhibit the sludging of silver from solution may be added to the processing liquid.[81–83]

The most commonly used silver halide solvent for the diffusion transfer process is sodium thiosulfate, sometimes with a small amount of ammonium thiosulfate added. Other solvents, such as calcium thioglycolate, have been[84] proposed for use in the solutions but are little used. The sodium thiosulfate may be present in either the processing solution or the positive material. In either case the quantity of thiosulfate must be maintained at a low level, so that the unstable silver thiosulfates are formed preferentially to the more stable complexes that contain a higher proportion of thiosulfate to silver. When the processing solution contains large amounts of thiosulfate, considerable silver ions are lost to the solution before the positive and negative

are brought together in some office copy machines. Excess thiosulfate coated in the positive material must also be avoided. According to W. Krafft,[85]

The optimum amount of sodium thiosulfate in the positive largely depends on the quantity of silver supplied by the negative, on the activity of the developer and of the nuclei as well as on the swelling properties and absorptivity of the positive. This concentration generally lies between 1 and 3 grams of sodium thiosulfate-5-water per square meter. A real disadvantage of this system is the increase which takes place in concentration of thiosulfate in the developing liquid, when the latter has been used repeatedly. This brings about a reduction in image density, on the one hand by the solution of the silver salts from the negative, which are thus lost to the transfer process, and on the other hand by the formation of stable silver thiosulphate complexes which are no longer capable of being reduced.

Other precautions when incorporating the thiosulfate in the positive involve maintaining the pH of the coated layer at 5.0, at least, to prevent decomposition of the thiosulfate during storage of the positive. The rapid drying of a processed positive that contained incorporated thiosulfate is essential so that silver thiosulfate complexes do not diffuse into the paper base, where later they may decompose and stain the positive image. Baryta underlayers on the positive or nonpermeable barrier layers help to limit the penetration of soluble silver thiosulfates. The use of sparingly soluble thiosulfate compounds was not as practical, because the contact time was greatly lengthened or the amount of image silver was reduced.

The amount of silver halide solvent in the processing solution is also of critical importance if more than one copy is to be obtained from a single negative. A. J. Sievers[86] found that "Silver analysis of the negative material, both before and after transfer, and analysis of the positive image showed that of all the possible limiting factors the action of the silver halide solvent was by far the greatest. While the processing solution was removing 52.1% of the available silver halide in the negative, only 26.8% was actually reduced on the positive sheet. That meant that 25.3% was lost to the processing solution; almost twice the amount required for formation of a positive image. Also 47.9% of the silver halide was left in the negative; enough to form another 3.4 copies." Increasing amounts of silver are transferred as the amount of silver halide solvent is increased. A reduction of 30% from a standard amount normally used in a processing solution removed less silver halide from the negative after forming three copies than solutions containing higher concentrations of sodium thiosulfate.

Multiple copies have been obtained by using the stepwise action of barium thiosulfate although the transfer time may be lengthened (30 sec).[87] Another proposal[88-89] for multiple copies involves the coating of an unhardened

positive layer containing development nuclei on top of a silver halide emulsion layer. After exposure this two-layer element was treated with a solution containing developing agents and a silver halide solvent (sodium thiosulfate). A positive image is formed in the top nucleated layer. This upper layer is then transferred to absorbent sheets to obtain several positive transfers. Water-soluble starch ethers or carboxymethyl cellulose have been suggested[90–91] as binding agents for the positive layer.

For in-camera use, according to E. H. Land in an early patent,[92] sodium thiosulfate, ammonium thiosulfate, sodium thiocyanate, ammonia, or sodium cyanide were suggested as suitable silver complexing agents. In the same patent Land suggested this simple example of the early preparation of a processing solution by taking

Water	1860 g
Sodium carboxymethyl cellulose	117 g
Sodium sulfite	78 g
Sodium hydroxide	74.6 g
Sodium thiosulfate	14.5 g
Citric acid	38.5 g
Hydroquinone	52.0 g

Land stated that the processing solution "is prepared by dissolving the carboxymethyl cellulose, for example the commercially available Hercules 1362 medium viscosity type, in the water in a mixer at room temperature, and the solution is mixed therein for approximately one hour. Thereafter, the sodium sulfite, sodium hydroxide, sodium thiosulfate and citric acid are added to the solution, the addition being effected in an inert atmosphere, for example of nitrogen. Upon dissolution of these materials, the hydroquinone is added and the solution is further mixed for an hour at approximately room temperature in a nonoxidizing atmosphere of nitrogen."

This processing solution was spread uniformly between an exposed negative, such as Kodak Verichrome film, and a receiver sheet having a thin coating of the following composition on a baryta-coated paper base:

Lead acetate, neutral (40% in water)	192 ml
Silica aerogel (Santocel C)	30 g
Sodium sulfide (1% in water)	60 ml
Copper acetate (1% in water)	66 ml
Ascorbic acid (15% in water)	36 ml

A finished positive image, presumably brown or brown-black in color, was said to have been obtained after 1-min contact time of the negative and positive materials.

This illustrative example of early in-camera processing used sodium thiosulfate as the silver complexing agent. The early processing solutions for office copying machines also were based on the use of sodium thiosulfate as the primary silver transfer agent. Some of this thiosulfate or its silver complexes, in addition to the other chemicals contained in the solution, was retained in the print materials. The presence of thiosulfates and oxidized developing agents has a deleterious effect on silver images; indeed, even thorough washing of conventionally processed photographic materials sometimes fails to insure image permanence. Diffusion transfer reversal prints, therefore, must receive special treatment if they are expected to have a long life. Office copies are for short-time use, but in-camera prints must last as permanent records of past events.

An in-camera print is subject to sulfiding due to the decomposition of the retained thiosulfate or due to atmospheric sulfides entering the image layer. The developing agents oxidize with time, staining the background of the print. Oxidized developing agents can cause fading of the silver image. To counteract these deleterious effects, the print has to be overcoated with a thin liquid layer that dries to a protective coating. The coating solution may consist of hydrolyzed gelatin,[93] hydrolyzed polyvinyl butyral,[94] or other acidic polymeric film former, a solvent, a volatile alkali, and certain heavy-metal salts. The substance to be used for the protective coating may be the result of the interaction of an acidic vinyl monomer and a lower alkyl acrylate,[95-96] or a vinylpyridine polymer and a hydantoin-formaldehyde condensation polymer.[97] The organic solvent may be water-miscible solvents such as alcohols (methanol, ethanol, and so on) and ketones (acetone or methylethyl ketone) to solubilize the polymer and to give the coating a quick-drying character.

According to a patent by Edwin H. Land and Meroe M. Morse,[98-99] the incorporation of a volatile alkaline material, preferably ammonia, in fairly substantial quantity in the coating composition provides a material having unexpectedly good stabilizing qualities and does not tend to distort or bleach developed photographic silver images. Although the precise quantity of alkali is not critical, where the developing agent used is acid-sensitive it has generally been found that compositions having a pH of at least about 8 and preferably 9 or higher provide optimum results. Further, although ammonia is the preferred alkaline material owing to its high degree of volatility, other bases which are volatile and which have little or no crystalline or opaque residue which might obscure or disfigure the image

also provide satisfactory ingredients, such as ethylamine, diethylamine, triethylamine, and butylamine.

It is desirable that the coating solution contain an agent capable of becoming dispersed in the protective coating and of protecting the image by reacting with atmospheric sulfides that may penetrate the protective coating. Preferred protective agents or salts, preferably water-soluble, are those containing heavy metal cations which form insoluble sulfides. These salts, for example, are composed of: cations such as zinc, cadmium, zirconium, and tin; and anions such as acetate, sulfate, nitrate, and formate. Since these salts in small quantity are substantially invisible and form invisible sulfides, they and their sulfides do not affect the optical clarity of the protective coating. A salt of zinc is preferred because zinc sulfide is white and does not tend to discolor the highlights of the image on which it is present.[98]

The patent also notes that when the protective coating contains both ammonia and zinc oxide as the salt of the heavy metal,

the zinc oxide and ammonia react to form a zinc ammonium complex which complex, in turn, enters a state of equilibrium with zinc oxide and ammonia. These reactions may be represented as follows:

$$ZnO + NH_3 \longrightarrow Zn(NH_3)_4^+ + OH^- \rightleftharpoons Zn(OH)_2 + NH_3$$

When the composition is applied as a coating to photographic images, ammonia evaporates, generating additional zinc hydroxide. As zinc hydroxide is formed, however, it reacts with the available acid groups on the chain of the acid film-forming polymer in such a way as to cross-link the polymer.

An example of a protective coating incorporating these chemical constituents has the following composition:

Phthalaldehydic acid partial acetal of polyvinyl alcohol	10 g
Dimethyl hydantoin formaldehyde condensation polymer	13.5 g
Zinc oxide	1.44 g
Water	50 ml
Isopropyl alcohol	30 ml
Ammonia (29.4% solution)	10 ml

The protective coating that had to be applied to freshly processed in-camera prints was essential if the prints were to be protected from rapid fading, but the coating operation required the presence of the applicator and

a smooth surface for the spreading of the liquid.[100-101] The operation was messy and almost impossible to do well under dusty field conditions. The coating of the prints could be avoided if a nonstaining developing agent was present in the developer as well as a nonsulfiding silver solvent. Most developing agents containing a benzenoid structure have staining oxidation products; sodium thiosulfate, with its labile sulfur, strongly attacks any silver image in its presence. In-camera prints of improved stability would then require a departure from conventional diffusion transfer solutions and materials that contain either type of developing agent or sodium thiosulfate or thiocyanate.

Optimistically, Edwin H. Land[92] in 1953 listed the following developing agents, alone or in combination, as being useful for in-camera processing: "hydroquinone, monomethyl-*p*-aminophenol sulfate (Elon, Metol), *p*-aminophenol hydrochloride (Kodelon), *p*-hydroxyphenylaminoacetic acid (Athenon, Glycin), *p*-phenylenediamine, *o*-phenylenediamine, pyrocatechin (pyrocatechol, catechol), diaminophenol dihydrochloride (Amidol), diaminophenol hydrochloride (Acrol), pyrogallol, chlorohydroquinone, dichlorohydroquinone, tetrachlorohydroquinone, bromohydroquinone, toluhydroquinone, xylohydroquinone, *o*-aminophenol, 2-amino-5-diethylaminotoluene hydrochloride, *p*-tertiary-butylcatechol, hydroquinone disulfonic acid (potassium salt), 2,5-ditertiary butyl hydroquinone, and *p*-aminodiethylaniline." The compound 4,6-diamino-ortho-cresol partially oxidized has been claimed to have high energy as a developing agent or auxiliary developing agent.[102,103]

In practice, however, hydroquinone was generally used in a caustic developing-and-silver-solubilizing solution. The hydroquinone was often combined with Phenidone because rapid and complete image development in the negative is essential in order to achieve clean white areas in the positive print. Catechol and pyrogallol developing agents have been suggested. The combination of ascorbic acid, in place of hydroquinone, with Phenidone or its derivatives would be presumed to have a lower staining propensity. One approach involves incorporating the developing agents in the negative layer. These compounds develop the exposed image, but they or their oxidized forms do not diffuse into the transfer solution or to the reception layer. Suitable nondiffusing developing agents include cyclohexyl derivatives of dihydroxybenzenes, such as 1,4-dihydroxy-2-cyclohexyl benzene, or weighted developing agents, such as 1,4-dihydroxy-2-tertiary-butyl benzene.[104] Ascorbic acid is incorporated in the receiver to reduce the transferred silver, the oxidized form of ascorbic acid having low staining tendency. Compounds such as 3,4-dihydroxy diphenyl or lauryl hydroquinone[105] were claimed to be nondiffusing developing agents. Other weighted hydroquinones, such as those containing alkylthio groups[106] or 2,5-bis-ethylenimino groups,[107]

and mono-*N*-benzyl-diamino-phenyl compounds,[108] have also been proposed for minimizing the stain of oxidized developer in the positive image. *p*-Aminophenoxyhydroquinone,[109] 1,5-bis(2',5'-dihydroxyphenyl)-3-pentylamine,[110] 2-γ-amino-propylamino-1,4-dimethoxy-benzene,[111] and 2-hydroquinone-amino-4-chloro-6-hydroxy-s-triazine[112] have been patented for diffusion transfer processes. A hydrazine derivative, bis-benzene-sulfonyl hydrazide, was patented[113] as early as 1954 as a colorfree developing agent but probably did not have sufficient activity for general use.

Ascorbic acid and isoascorbic acid have oxidation products of low color, but the compounds alone may not possess sufficient activity for a diffusion transfer system. The acid ketals and acetals of either ascorbic or isoascorbic acids may be used alone but are said[114-115] to be most effective when used with other developing agents—for example, a very small amount of an active developing agent such as 2,6-dimethoxy-4-aminophenol—or with ascorbic or isoascorbic acids. The use of large quantities of a weak developing agent such as ascorbic acid with extremely small quantities of a high-energy developing agent, such as 2,4-diamino-ortho-cresol, was claimed to form a combination that eliminated the need for overcoating the transferred image. An uncoated image was reported to have resisted silver image fading or background coloration for over two years standing at room temperature and humidity (actual conditions not stated). These results were achieved with a solution of the following composition that was spread between a silver iodobromide negative film and a "surface hydrolyzed cellulose acetate spreader sheet" for 40 sec:[116]

Water	902.0 ml
Hydroxyethyl cellulose	41.5 g
Sodium sulfite, desiccated	33.0 g
Potassium thiosulfate	14.0 g
Ascorbic acid	60.0 g
2,4-Diamino-ortho cresol	2.0 g
Cysteine	2.2 g
Diethylamine	50.0 ml
Sodium hydroxide	25.0 g

The diethylamine and the sodium hydroxide are the alkaline components of the solution. The diethylamine contributes a considerable amount of the alkalizing action. Diethylamine is a volatile alkalizing agent whose evaporation from the positive print will result in a reduction of the alkalinity of the print, so that overcoating of the print after processing is not needed.[117]

A nonvolatile salt of the amine, such as diethylamine sulfate, may be incorporated in the receiver, the hydroxide ions of the processing solution freeing the volatile amine, which is then free to evaporate and lower the alkalinity of the positive print.[118] The cysteine in the processing fluid is said[76] to provide "a considerably more neutral tone in the resulting print than would exist in its absence." Cysteine in combination with an amine such as diethylamine[119] has been claimed to prevent thiosulfate complexes from being reduced in the negative, providing a usable negative without washing.

The need for low-staining developing agents for reducing staining and fading of the positive print has resulted in the patenting of a number of potential compounds for this purpose.[120-121] Anhydro dihydro hexose reductones were said[122] to combine desired activity with improved stability and colorless or low-colored oxidation products. The incorporation of an aminomethyl hydroquinone developing agent, such as 2-methyl-5-morpholinomethyl hydroquinone, in the light-sensitive layer and the use of the anhydro dihydro hexose reductone in the processing fluid was claimed to be an especially suitable arrangement.[123-124]

In highly alkaline solution, hydroxylamine is an active developing agent with colorless oxidation products. N-Alkyl and N-alkoxyalkyl substituted hydroxylamines have been proposed[125-133] for diffusion transfer processes. These compounds, however, were reported to lose effectiveness after storage in the highly alkaline processing solution. The shelf life of such a solution containing a hydroxylamine developing agent, such as N,N-diethyl hydroxylamine, was said[134-135] to be substantially improved by the presence of certain amines containing the oxyethylamino grouping,

$$>N-CH_2CH_2-O-,$$

as in triethanolamine. The combination of a considerable quantity of a hydroxylamine such as N,N-diethylhydroxylamine, or an ascorbic acid, with a small amount of an aminophenol, for example, 2,6-dimethoxy-4-aminophenol hydrochloride, was said to give reduced developer stain in the positive image as well as improved image stability.[136] Another proposal[137] had a nondiffusing developing agent, for example, 4'-methylphenylhydroquinone, in the emulsion layer of the light-sensitive material and the N,N-diethylhydroxylamine in the processing solution. The N,N-diethylhydroxylamine volatilized from the receiver layer, yielding transferred images of less stain and better stability without after treatment.

In summary, the necessity of swabbing a freshly formed receiver image can be avoided if (1) a nondiffusing developing agent is coated in the light-sensitive layer and the low-staining or volatile auxiliary developing agent is contained in the processing fluid, or if (2) an extremely small amount of an

active developing agent is combined in the solution with a large quantity of a volatile, low-staining developing agent, such as N,N-diethylhydroxylamine. This latter compound is necessary to reduce the silver that is transferred to the nuclei of the receiver, but its oxidation products, or the unoxidized compound, volatilize from the layer, leaving the image free from stain or later attack on the silver image. The use of a volatile alkali as part of the alkali of the processing solution also helps lower the alkalinity of the transferred image layer.

The choice of the most suitable developing agent and alkali is essential for compounding a transfer fluid that makes aftertreatment of the transferred image unnecessary, but the image still may deteriorate because some of the usual silver solvent, sodium or potassium thiosulfate, would be contained in the positive image, resulting in sulfiding of the silver of the image. Obviously, thiosulfate should be replaced by a more stable silver solvent that does not attack silver images. A number of nonthiosulfate silver complexing agents have been proposed. Dicyanamide was found to be effective in diffusion transfer systems by Grant Haist, James King, and Lance Bassage.[138] Bis(methylsulfonyl)methane is an active silver halide solvent at high pH but is inactive when the pH of the print is reduced to a lower value.[139]

One particularly useful approach was suggested by a research team at the Polaroid Corporation.[125–127] Two associated complexing agents were found to be more effective together than each used alone, and the combination was suitable for the production of transferred images.[132–137] Cyclic imides characterized by the following general formula

$$O = C \cdots Z$$
$$HN - C$$
$$\|$$
$$O$$

where Z represents enough atoms to complete a ring of from five to six atoms, of which from one to three are nitrogen and the remainder carbon, were used in combination with nitrogenous bases. The cyclic imides could be, for example, compounds such as uracil or amino urazole, although triazines, barbiturates, hydantoins, glutarimides, glutaconimides, succinimides and maleimides were also suggested, The nitrogenous bases consisted of amines, hydroxylamines, or hydrazines, and their various derivatives. Such a suitable amine is aminoethylethanolamine.[140]

The selection of a cyclic imide-nitrogenous base as the silver complexing agent, and a suitable low- or no-staining development agent of the hydroxylamine type, provides a diffusion transfer system that avoids most of the chemical reasons that required aftertreatment of the transferred image. According to U. S. Patent 2,857,274, "If the associated complexing agents

and developer are judiciously chosen, the reaction product residue of the composition and silver halide will remain substantially colorless when present on the silver image either as a trace remaining after the processing composition layer has been separated from the silver image or within the protective coating formed when the processing composition has been permitted to remain upon the silver image." Thus, modern in-camera silver prints are able to avoid the chemical attack so common to the early instant prints when no aftertreatment of the freshly processed image was given. Various other chemical addition agents, such as sulfonamides,[141] imidazolidine-2-thiones,[142] and polyethyleneglycols,[143] are added to the processing fluid to increase the rate of silver transfer and image density so that high-quality transfer prints are available in seconds under a variety of environmental conditions.

VARIATIONS OF THE DIFFUSION TRANSFER PROCESS

The ease with which positive images are produced by the diffusion transfer technique has led to the investigation of various modifications of the basic process, including some which do not involve the transport of silver ions from the negative to the receiver. Some of these ingenious variations are well worthy of mention.

The Use of Water or an Alkaline Solution as the Transfer Fluid

Usually, the diffusion transfer reversal process has an alkaline, sometimes caustic, transfer solution with a silver complexing agent, often sodium thiosulfate, contained in the liquid or incorporated as part of the receiver layer. The thiosulfate or other silver solvent is necessary because the undeveloped silver halide of the negative image is insoluble in water or alkaline solution. The silver complexing agent makes possible the transfer of the silver ions from the negative to the positive layers. This silver solvent might not be needed if a light-sensitive silver salt of greater water solubility was used in place of the silver halide of the negative material.

Grant Haist[144] appears to have been the first to recognize that a separate silver solvent in the diffusion transfer system would be unnecessary if water-soluble, light-sensitive organic silver salts were used in the negative material to replace completely the silver halide. Earlier, Curt B. Roth[145] has used tap water to transfer the soluble silver salts normally present in very slow printout emulsions to a receiver, preferably with silver halide present. In one example, dark-brown letters on a dark background was obtained. Most light-sensitive inorganic silver salts are either insoluble or unsuitable, but silver-containing

organic compounds offer a wide choice of properties. Some organic compounds bind silver so tightly that it is not available for physical development, even though the complex may be readily soluble and diffusible. Sugars, such as fructose, glucose, or arabinose, containing an oxazolidine-thione nucleus combine with silver ions in equimolar proportions to form a light-sensitive silver compound that is water and alkali soluble. When a negative material containing silver-4,5(2,3-D-fructopyrano)-2-oxazolidine-thione is exposed and wetted with an alkaline developer, such as a 1 : 1 dilution of Kodak Dektol developer, then pressed in contact with a receiver containing nickel sulfide, a positive image of precipitated silver is found when the receiver is stripped from the negative sheet.[144]

Organic acids containing carboxyl (—COOH) groups react with silver ions to form light-sensitive salts. The light sensitivity of the silver salt of lactic acid was discovered as early as 1833 and later was used for making collodion emulsion and lantern plates.[146] Silver malate was investigated as early as 1875.[147] The silver salts of many carboxylic acids have been of interest for modern photographic processes, such as silver behenate[148] or silver perfluoro alkane sulfonate[149] for heat processing, or the silver salts of pyridine carboxylic acids for rapid processing.[150] Almost all of these compounds are unsuitable for use in diffusion transfer systems that do not contain silver halide complexing agents.

Gelatin or polyvinyl alcohol coatings of the light-sensitive silver salts of substituted carboxylic acids containing a thioether (—S—) or disulfide (—S—S—) group are particularly suitable for photographic purposes.[151] Precipitation or formation of the silver salt of thiacarboxylic acids is usually carried out by adding the sulfur-containing carboxylic acid and a silver compound, such as silver nitrate or silver p-toluenesulfonate, in one-to-one molar ratio in an aqueous solution or a protective colloid such as gelatin producing an emulsion composition suitable for coating after finishing and sensitizing. If the carboxylic acid contains two —COOH groups, then two moles of the silver salt should be used. In practice, the exact proportions of the organic acid to silver ions may vary from simple molecular ratios, however, and the most suitable emulsion composition is best determined by experimentation. The silver salt of the organic thiacarboxylic acid is not necessarily a simple salt of the acid, but the silver may be held in a complex that involves both the carboxyl group and the sulfur in the carbon chain of the compound. In any case, the acid compound should be in excess, so that no free silver ions are available for fog formation. The presence of a small amount of a silver halide such as AgI may improve the speed and other characteristics of the coated emulsion composition.

When the silver salts of organic carboxylic acids contain thioether groups, emulsions containing these compounds may be developed even under

neutral or acidic conditions, even with water.[152–154] The nature of the organic thioether carboxylic acid determines the nature of the coated silver salt. The silver complex of ethylenedithia-α,α'-dipropionic acid is very water soluble and produces a coated emulsion of speed about that of contact paper but low in contrast and maximum density. The silver butylene dithiadiacetic acid has low water solubility, and its coated emulsion is slower in speed but with an image of higher contrast and maximum density. The silver-butylenedithia-α,α'-dipropionic acid complex is intermediate in solubility between the two previously mentioned silver complexes. The coated emulsion with this silver compound yields good contrast and maximum density with good speed. In a pure silver-organic thioether carboxylic emulsion there do not appear to be any microcrystals such as are present in a silver halide emulsion.

The silver salt of carboxymethylthiomalic acid may be used as the light-sensitive negative and colloidal yellow silver as the nucleated layer of the receiver for diffusion transfer processing. Both the exposed negative and the transfer material are passed through 0.5 % aqueous solution of 1-phenyl-3-pyrazolidone before their coated surfaces are pressed into intimate contact. After 10 sec the layers are separated to reveal a "positive, nonreversed black silver image of the original" in the transfer layer. When the developing agent is coated upon the nucleated layer, the negative only needs to be wetted in water before being pressed in contact with the receiver. A positive image of the original is formed after about 5 sec contact time.

Formation of Electrically Conducting Photographic Images

Metallic silver is a good conductor of electricity, and the photographic image is composed of fine particles of metallic silver. The normal photographic image does not conduct electricity, however, because the fine silver particles are separated from each other by the gelatin of the coated emulsion layer. Long exposures of silver alginate with ultraviolet light,[155] or the use of a silver bromide–cadmium iodide emulsion followed by 200 to 450°C heating after development,[156–157] have been suggested as methods of securing silver images that conduct electricity. A method involving titanium dioxide, a copper plating bath, and a physical developer has also been proposed for this purpose.[158] These methods seek to form conducting images suitable for manufacturing printed circuits.

Electrically conducting photographic images may be secured more simply by using the diffusion transfer technique, forming the conducting image either on the same sheet that was exposed to light or by transferring the conducting image to a receiver. James R. King and Grant Haist[159] probably were the first to have used diffusion transfer for this purpose. In

U. S. Patent 3,033,765 they treated the light-sensitive negative in a monobath for 30 to 90 sec to develop the negative image and to solubilize some of the residual silver, removed, then blotted to remove surface liquid and allowed to dry. A silvery, electrically conducting image is formed in the unexposed areas and a normal black silver image in the exposed areas of the light-sensitive material. In the presence of air and the highly alkaline environment of the processed layer, the silver of the silver complex of β,β'-dithiasuberic acid is not tightly held, so that the silver ions may be reduced on the catalytic centers that are normally present or are introduced as physical development nuclei. The silver is deposited as plates near the surface of the coated layers. The silver plates grow until a continuous electrical circuit is formed. If desired, the conducting silver image may be reinforced by copper plating with a solution of copper sulfate and sulfuric acid, using a 1.5-V dry cell battery.

A similar diffusion transfer technique has also been patented[160] for forming electrically conducting photographic images. The image is produced by "treating the exposed layer with a high-energy developer containing a high concentration of silver halide solvent and a water-soluble nucleating agent capable of diffusing through the water-permeable organic colloid layer, which agent forms nuclei in and on the photographic element which grow to form, by silver diffusion transfer, in the unexposed areas of the water-permeable organic colloid layer, or the outer of such layers if there is more than one, an electrically conductive silver image having a resistivity not more than 50 ohms per square and at most 0.01 times that of the exposed regions."

A two-bath developer was used; the first bath was a caustic solution of Phenidone and ascorbic acid, the second a caustic hydroquinone-Phenidone monobath containing potassium thiocyanate as the silver halide solvent and with sodium sulfide as the nucleating substance. A related two-developer processing system has been proposed[161] with the first developer also containing salicylic acid. J. F. Strange and R. K. Blake[162] have studied the balancing of the developers so as to yield reliable printed circuits on litho film. The developing time, solution alkalinity, and the relative concentrations of the developing agent, silver halide solvent, and the nucleating agent were found to control the electrical conductivity of the images. Controlled nucleation near the surface with suitable silver solubilization and reduction rates are necessary for optimum image characteristics in order to avoid nucleation in the depths of the layer or loss of the solubilized silver to the solution. The Fuji Photo Film Co. patented (German Patent 2,161,183)[163] the use of 1 to 50 g of an imidazole in a liter of developing solution to produce electrically conducting silver images on the undeveloped areas of a photographic emulsion.

Negative and Positive Images by Web Processing

The conventional diffusion transfer process is designed to produce a positive image on a receiver, the negative being discarded. A usable film negative and a usable paper positive image can be obtained, however, if a fine-grained negative material of limited silver coverage, a carefully balanced transfer monobath, and a suitable receiver are used. A commercial product of this type is the Polaroid Black and White 4 × 5 Land Film Packets Positive/Negative Type 55P/N. In this type of closed system the processing is carried to completion. All of the silver of the negative is reduced to metallic silver in either the negative or positive images by the action of chemical, physical, or solution physical development. Because the process has gone to completion, a light-stable negative and a light-stable positive image are obtained when the negative and receiver sheets are separated, although some chemical treatment may be necessary to remove chemicals from the negative image.

A variation of this basic technique was devised for the processing of long lengths of exposed photographic materials. Leonard Tregillus, Arthur Rasch, and Edwin Wyand patented[164-166]

a method of simultaneously developing and fixing an exposed photographic silver halide emulsion which comprises: (A) bringing the exposed layer into intimate contact with a water-absorbent, organic colloid processing web under the following conditions: (i) either the exposed layer or the web has been preimbibed with aqueous liquid, (ii) a photographic silver halide developing agent has been incorporated either in the emulsion layer or in the web before contact, provided that where the developing agent has been incorporated in the emulsion layer, development is not allowed to commence before contact, (iii) the processing web has incorporated therein before contact an organic amine-sulphur dioxide addition product preservative, at least one silver halide solvent, and sufficient silver precipitating agent as herein defined to precipitate the whole of the silver halide complex which will diffuse into the web during step (B); (B) maintaining the emulsion layer and processing web in contact until development of a silver image in the emulsion layer is complete and substantially all the undeveloped silver halide has been removed from the emulsion layer and precipitated in the processing web; and (C) separating the emulsion layer from the processing web.

The processing web is a length of photographic film base coated with a water-absorbing polymeric layer that imbibes processing chemicals for transfer to the exposed negative layer.[167] Webs have been used to simplify photo processing before,[168] but the web of the patent also contains physical development nuclei. The web is then soaked in an aqueous processing solution containing developing agents, silver complexing agent or agents, and an amine-sulfur dioxide addition product that serves both as an alkali and as

a preservative. The following formulation is listed as particularly useful for imbibing into the absorbent layer of the web:

2,2'-Iminodiethanol–sulfur dioxide addition compound (20 mole percent SO_2)	190.0 g
Hydroquinone	11.6 g
4,4-Dimethyl-1-phenyl-3-pyrazolidone	1.0 g
Sodium thiosulfate, desiccated	5.4 g
Potassium iodide	0.42 g
Water to make	1.0 liter

This solution is imbibed into the absorbent layer of the processing web containing physical development nuclei. The moist layer is pressed against the exposed silver halide layer of the photographic material. The temperature of the processing is not critical, and it may be carried out at ambient or slightly elevated temperatures. Development of the negative image was essentially complete in 1 min, but transfer of the undeveloped silver halide from the silver halide emulsion to the web required at least 4 min. Longer contact times, even for hours, was not detrimental, provided the loss of moisture does not occur.

The webs or transfer films and the transfer imbibants were supplied by Eastman Kodak Company as part of a method employing Bimat Films and Chemicals.[169-170] This system was used in the Lunar Orbiter photographic missions.[171-172] The presoaked web was laminated to the exposed high-definition film, and after processing, the film was removed, dried, and the negative scanned by a flying spot scanner to provide the electronic signals for transmittal to Earth (the positive image was not used).

The granularity and other characteristics of images processed with Kodak Bimat transfer film were reported by L. W. Tregillus.[173] A moderately high-speed negative film had a granularity equal to or slightly greater than that of an image of equal contrast produced by conventional development. The silver filaments of the image were thickened by solution physical development, especially as the image density increased. The positive image formed in the Bimat transfer film has about one-half the granularity of the negative image, the silver particles being spherical in shape. Strong edge effects were present in the negative image; the positive image has soft edges. Tregillus found that the sharpness of the positive image could be increased by (1) maintaining the closest possible contact between the silver halide emulsion layer and the emulsion layer of the Bimat film, (2) increasing the transferral rate to promote deposition of the silver on the nuclei closest to the surface of the Bimat film, and (3) stopping the transfer of silver as soon as the positive image has reached an acceptable positive image density.

A positive image was obtained[174–175] that was equal in quality to that of a vacuum contact print from a conventional negative by using a 5-sec, 120°F, transfer between Kodak Plus-X Aerographic film 2402 and the Bimat film (soaked in the imbibant for 10 sec, 120°F, immediately before lamination to the Plus-X film). Continuous rolls of exposed conventional aerial film may be in-flight processed by a special processor called SPAN (Simultaneous Positive And Negative), manufactured by Mark Systems, Inc., by contacting the aerial negative and a presoaked Bimat film under pressure.[176] A cassette of imbibed Bimat film and exposed Kodak Pan-atomic-X film was used by Merrick Photo's Model 35-36 Processor to yield processed negative and positive images in 5 min. Other 35mm negative films, such as Kodak Plus-X pan and Tri-X pan, may not be cleared completely. Additional fixation may be necessary, or simply drying the film without washing may be sufficient, because the amine buffer of the imbibant acted as a silver halide solvent.[177]

Thermal Diffusion Transfer

The conventional diffusion transfer process consists of wetting an exposed light-sensitive layer with a liquid containing a silver halide solvent. This solvent transfers the nonexposed silver halide from the negative layer to a contacted receiver layer, where the silver ions are reduced to form a metallic silver positive image upon the catalytic nuclei contained in the receiver layer. Rudolf Wendt proposed[178] to avoid the use of the transfer liquid by heating the receiver in contact with the negative. The light-sensitive negative layer contained a developing agent. The positive or receiver layer was composed of polyvinyl alcohol, a bi- or trifunctional alcohol, such as glycerol as a humectant and reducing agent, a hydrated compound such as sodium acetate, an alkali such as sodium carbonate, a silver halide solvent such as sodium thiosulfate, a blackening agent (benzotriazole), sodium bicarbonate to minimize yellowing, and potassium metabisulfite to increase the dissolving action of the thiosulfate. Hydrated compounds (sodium acetate, sodium citrate, or sodium sulfate) give off water when heated, liberating a sufficient amount to allow the development and transfer reactions to occur. The presence of the glycerol also helps retain moisture. And the use of polyvinyl alcohol helps conserve the limited amount of moisture present, because this layer-forming substance does not take up water as gelatin would. Sodium acetate was present from 100 to 200%, by weight, of the polyvinyl alcohol, and the sodium carbonate and sodium thiosulfate were present in quantities of about one-tenth by weight of the sodium acetate. The negative and receiver materials were contacted under pressure and a temperature of 70 to 80°C to produce a positive image in the receiver layer.

Additional details of thermal diffusion transfer were given by Werner Zindler.[179] The light-sensitive layer contains a developing substance, and the positive layer is composed of

Polyvinyl alcohol (4% solution has viscosity of 28 cp at 20°C)	10.0 g
Water	50.0 ml
Glycerin	15.0 ml
Sodium carboxymethyl cellulose (57%)	1.0 g
Polyethylene glycol (mean molar weight of 13,000 to 17,000)	1.0 g
Sodium acetate, crystals	5.0 g
Dry soda	2.0 g
Aluminum hydroxide	0.2 g
Dry potassium metabisulfite	1.0 g
Hydroxylamine hydrochloride	1.0 g
p-Aminophenol hydrochloride	0.2 g
Dry sodium sulfite	0.5 g

The hydroxylamine and p-aminophenol serve as reducing agents, with the sodium sulfite present as a protective agent for these compounds. This composition is coated to form the receiver. The positive layer and the negative layer (containing developing agents, as well) are contacted and heated from 50 to 90°C "until the development of the picture in the reception emulsion is completed."

Although thermal diffusion transfer is an enticing prospect, the early attempts left much to be desired. A more recent patent[180] describes the preparation of the negative and positive materials as follows:

Light-Sensitive Material

To one liter of pure silver chloride gelatin emulsion was added

Benzotriazole (5% solution in ethanol)	0.1 g
Sodium acetate, crystal	150.0 g
Sodium formaldehyde bisulfite	12.0 g
Cyclopentanone bisulfite	5.0 g
N,N-Diethyl-p-phenylenediamine sulfate	20.0 g
Silicic acid hydrosol (15%)	200.0 ml
Polyethylene glycol (average molecular weight of 300)	3.0 ml
Saponin (30% in water)	5.0 ml

Adjust pH to 4.9 with citric acid.

Positive Transfer Material

Gelatin	75.0 g
Carboxymethyl cellulose	23.0 g
Colloidal silver sulfide	0.2 g
3-Mercapto-4-allyl-5-methyl-1,2,4-triazole	0.08 g
Polyethylene glycol (average molecular weight of 1500)	2.0 ml
Formalin (30% in water)	5.0 ml
Water to make	1.0 liter

Each composition was coated on baryta-coated paper. The exposed negative was pressed in contact with the receiver sheet, the back of either sheet was moistened with water, then heat-processed for 14 sec at 120°C. After an additional 10 sec of contact, the sheets were separated and a grayish-black positive image was obtained.

Developing agents for heat activation in the presence of low or no alkali must be carefully chosen if adequate image quality is to result. Developing agents with two hydroxy groups, such as hydroquinone, do not develop under low alkaline conditions, even if heated. Compounds containing amine ($-NH_2$) or substituted amino ($-NHR$) groups, such as *p*-aminophenol, Metol (free base), or *p*-phenylenediamine may be activated for development by heat alone, but these compounds may oxidize in the coated layers. The oxidation products desensitize the emulsion, so there may be a serious loss of emulsion speed.

Active compounds may cause spontaneous fogging of the silver halide. To overcome this problem of instability of heat-activatable developing agents in the light-sensitive layer of a diffusion transfer process, proposals have been patented to block chemically the $-NH_2$ groups of an *o*- or *p*-aminophenol to increase the stability of the compound in the coated layer. One method[181] joins the amino groups of two molecules of *p*-aminophenol together with a substituted two-carbon bridge, such as illustrated by the following structure of a suitable compound:

Another method[182] of modifying o- or p-aminophenol or o- or p-amino-naphthol involved the substitution of a methane phosphonic acid group on the $-NH_2$ of the developing agent, as in the compound

$$HO-C_6H_4-\underset{H}{\overset{H\quad H}{N-C-PO_3H_2}}$$

or

$$\underset{}{\overset{H}{N}}-CH_2PO_3H_2$$
naphthol-OH

The image produced by thermal diffusion transfer was said to be improved by the presence of a hygroscopic salt in the polyvinyl alcohol layer of the image-receiving material. Zinc chloride hemihydrate, lithium chloride monohydrate, potassium acetate (deliquescent), calcium chloride hexahydrate, zinc nitrate hexahydrate, or potassium carbonate dihydrate were claimed[183] to be particularly useful, especially in the presence of an amino acid such as glycine, leucine, or tyrosine.

The object of these patented approaches involves the thermal transfer of silver from the negative to the receiver. It is worthy of note that the unused developer from an exposed and developed negative layer may be heat-transferred to a receiver sheet to form a laterally nonreversed positive image.[184] Developing agents of the amino, hydroxy, or aminohydroxy types may be used, such that these transferred compounds may react with diazo compounds contained in the receiver layer, forming azo dyestuffs. The developer substances may be caused to react, at temperatures of about 80 to 150°C, with compounds that split off sulfur at these temperatures. The sulfur dyestuffs formed in the receiver form a positive, colored image.[185]

Dye Diffusion Transfer for Forming Photographic Images in Color

The various processes discussed in this chapter often involve the transfer of silver from the light-sensitive negative element to the light-insensitive layer, where the silver is reduced to the metallic form to produce the positive photographic image. Silver diffusion transfer reversal processes have achieved outstanding commercial success for office copying and in-camera print making. Beginning in the late 1950s, patents began to issue on diffusion transfer processes to form color dye images, rather than those of metallic silver. The color images do not involve the migration of silver from the

negative but rather the color-forming substances or dyes from the negative. In some cases developer transfer occurs, but the developer is already a dye molecule and need not react further. Color diffusion transfer reversal systems involve ingenious photographic chemical reactions of the utmost complexity. The issuing of patents on these processes has threatened to reach a flood stage, because the in-camera color print may be the dominant system for producing amateur prints within a few years. Polaroid's Polacolor[186-187] was the first entry in this field, but already there are sufficient competitive approaches so that a review article can be published just on the processes similar to Polacolor.[188] Polacolor was said to be "probably the most outstanding single advance in photographic science made during this century."[186] Describing the chemical complexity of these dye diffusion transfer processes is not practical, but brief mention must be made of a few aspects of this important new outpost of photographic processing, particularly with regard to the technology of the commercially available systems.

The well-established dye transfer process consists of developing an unhardened silver halide emulsion layer in a tanning developer, such as an alkaline solution of pyrogallol, washing off the unhardened layer where development did not occur, and imbibing a dye in the remaining relief image. With three filtered exposures to provide three gelatin matrix layers suitable for imbibing three dyes, it is possible to transfer the dye from each in register to a single receiver sheet, yielding a full-color print of high quality. It is also possible to incorporate the dye directly into the tanning developer solution. The tanning action of the developer in the exposed areas restricts or immobilizes the dye in the regions where the negative silver image is formed. The unreacted dye and developer are not restrained in the undeveloped areas, however, and these can be transferred to a contacted print receiver to form a positive dye image. When a one-step process is attempted with the print receiver in a superposed position on the light-sensitive element, the dye will start to transfer before the tanning action has proceded far enough in the exposed areas to restrain the dye migration. In addition, some of the tanning developing agent may transfer to the print, resulting in stain in the highlights and degradation of the dye colors of the positive image.

Although a considerable number of approaches for one-step color prints have been patented, a modification of the above dye-and-developing agent process appears to be the basis of the early Polaroid color print material introduced commercially in 1963. In U. S. Patent 2,983,606, issued in 1961 to Howard G. Rogers,[189] the tanning developing agent which forms quinonoid oxidation products is connected through an insulating group to the dye to form a large, single molecule of a dye developing agent. The yellow-, magenta-, and cyan-colored dye developing agents are coated in separate

layers beneath the blue-, green-, and red-sensitized silver halide layers, respectively. This arrangement is necessary because the colored developing agents would absorb the exposing light if the colored material were in the silver halide layer, thus causing an emulsion speed loss.

When the dye developing agent reacts with exposed silver halide, the oxidized dye developing agent is formed. The oxidized molecules are immobilized, forming an image in the areas of developed silver much in the manner of the stain image from low-sulfite pyrogallol development. The available dye developer is immobilized in proportion to the degree of exposure and development of the silver halide:

(Z is an insulating group that connects the dye with the developing agent.) The oxidized dye developer is immobilized in the areas of exposed silver halide. The unreacted dye developer is soluble and can diffuse from the negative layer (silver halide) to a receiving layer where the dye developer molecule is mordanted. A positive dye image is formed by the transfer of the unused dye developer from the negative silver halide layer. It is claimed that if the transferred dye developer is maintained in a neutral or acid environment in the print, both the unoxidized and oxidized forms of the developing agent will be the same color and will resist change due to aerial oxidation.

The dye developer molecule consists of an azo or anthraquinone dye attached to one or more hydroquinone, aminonaphthol, or *p*-methylaminophenols, usually with an insulating bridge of atoms to prevent the developing function from modifying the dye color. The developing function could be a part of the dye molecule, but in this case the developing function of the

molecule will alter the dye color. The insulation of the developing function, such as hydroquinone, from the conjugated system of bonds of the dye helps to reduce the pH sensitivity of the dye that can change the dye color from the desired hue.

The transfer liquid used to wet both the negative and positive elements is alkaline and not a desirable environment for the dye image formed in the receiver layer. If the alkali in the liquid is sodium hydroxide, the pH of the dye layer will be slowly lowered by the reaction of the hydroxide with the carbon dioxide of the air. The use of a volatile alkali, such as diethylamine or other amines, will result in the lowering of the pH in a much shorter time. The vehicle for the receiving layer may be selected to resist the penetration of the alkali, as, for example, a layer of N-methoxymethyl polyhexamethylene adipamide. The neutralization of absorbed alkali in the receiving layer can be accomplished by coating a layer beneath that contains difficultly soluble acids capable of reacting with alkali.

An example of the negative structure was given in U. S. Patent 2,983,606 as follows:

This photosensitive element comprises the following layers, laid down in the order recited, on a suitable support, e.g., a gelatin-coated film base:

1. A polymeric layer containing a cyan dye developer, i.e., 1,4-bis[β-(2′,5′-dihydroxy-phenyl)propylamino]-anthraquinone.
2. A red-sensitive silver halide emulsion layer.
3. A layer of polyvinyl alcohol as a spacer layer.
4. A polymeric layer containing a magenta dye developer, i.e., 2-[p-(2′,5′-dihydroxy-phenethyl)phenylazo]-4-n-propoxy-1-naphthol.
5. A green-sensitive silver halide emulsion layer.
6. A layer of polyvinyl alcohol as a spacer layer.
7. A polymeric layer containing a yellow dye developer; i.e., 1-phenyl-3-N-n-hexyl-carbamido-4-[p-(2″,5″-dihydroxyphenethyl)phenylazo]-5-pyrazolone.
8. A blue-sensitive silver halide emulsion layer.

An example of suitable processing composition for use with such a multilayer photosensitive element comprises an aqueous solution comprising:

	Percent
sodium carboxymethylcellulose	4.5
sodium hydroxide	3.0
1-phenyl-3-pyrazolidone	0.6
2,5-bis-ethyleneimino-hydroquinone	0.4
6-nitrobenzimidazole	0.12

In practice, the photosensitive element would probably contain a considerably greater number of coated layers than the eight listed in the example. The presence of the Phenidone in the processing liquid is for improving the contrast and speed of the transferred dye image. The 1-phenyl-3-pyrazolidone rapidly initiates development of the exposed silver halide, much faster than the large dye developing agent. The oxidized 1-phenyl-3-pyrazolidone then reacts with the dye developing agent. This cross-oxidation restores the 1-phenyl-3-pyrazolidone to the original reduced form, but the dye developing agent is oxidized. In this manner, the tanning action or other restraining reactions are made to occur more rapidly in the negative layers, resulting in a transferred dye image of less highlight stain and better contrast. An organic solvent miscible in water, such as methanol, ethanol, or dimethyl formamide, may also be added to the processing fluid to increase the solubility, and hence the transfer rate, of the unreacted dye developer molecules to the receiver.

The unreacted dye developing agent is diffusible and migrates to the receiver, which consists of at least three superposed layers.[190] One is the image-forming layer, where the dye developing agent molecule is anchored or mordanted; another is a polymeric acid layer; between these is an inert or spacer layer. The layer in which the color positive image is formed is very alkaline and must be maintained in this condition until the dye developing agent molecules are transferred and anchored in place. The pH of the dye layer must then be dropped from about 12 to 14 to about 9 to 10 before the dye image is exposed to the air. At the lower pH the dye image has increased stability, and the lower pH also terminates the dye transfer from the negative. Sodium, lithium, or potassium ions, or organic amines diffuse from the dye image, across the inert separating layer, and react with the acidic groups, particularly the $-COOH$ group of the acidic polymeric layer. The space between the image-forming layer and the acidic polymeric layer acts as a timing device, as the pH does not drop until the hydroxide ions or amines actually reach the polymeric layer. This allows sufficient time for the dye image to form a satisfactory density before the pH begins to fall, thus terminating the dye transfer. Polyvinylamides or polyacrylamides, alone or in combination with other polymers, are suitable for neutralizing the alkalinity of the dye image layer, preferably reducing the pH to about 5 to 8 after the dye transfer.

Making a color print by diffusion of dye developer molecules is a marvel of photographic chemistry. The in-camera processing of such a print usually involved sheet film units consisting of the light-sensitive and receiver sheets with a pod of processing solution to be spread between them. Each picture was a unit operation that had to be carried out and timed to the point where the positive print was stripped from the negative. The waste negative then

had to be disposed of. Picture-taking was suspended until each print was processed before another picture could be taken.

In 1972 Polaroid Corporation introduced an integral dye transfer color print material which consisted of a negative light-sensitive unit to be permanently bonded to a dye-receiving unit. After exposure, the bonded units were ejected from the camera, dry to the touch, and the processing continued for 8 to 10 min outside the camera. During this time, other pictures could be taken with the same camera. Polaroid SX-70 film was exposed and viewed from the same side, using a camera with an optical system to reverse the image so that it would be right-reading in the final color print unit. This unit had an opaque film base to prevent the light from entering. The processing solution, which was permanently spread between the negative and the dye-receiving units, had opacifying properties that protected the developing negative image from light entering from the image-viewing side. Thus, the developing negative was effectively enclosed in a darkroom of its own.

The technique of using a light-absorbing filter dye to protect the developing negative when the ejected film unit is in the light was described in a patent having 134 claims and 18 drawings.[191] The abstract of the patent stated:

Photographic films and particularly film units for performing diffusion transfer processes are disclosed which may be processed outside of a camera. A light-absorbing reagent is employed to prevent postexposure fogging by actinic light passing through a transparent face of the film unit. After a suitable period, the light-absorbing reagent is rendered ineffective to prevent viewing an image through said transparent face. In a preferred embodiment, the image is viewed against a light-reflecting material such as a white pigment, said light-reflecting material and said light-absorbing material being employed in combination to provide desired protection against said postexposure fogging. Particularly useful light-absorbing materials are dyes which are light absorbing at a pH at which image formation is effected and nonlight-absorbing at a subsequently attained pH. Other light-absorbing reagents include dyes which are selectively mordanted to render them ineffective to prevent viewing transfer images visible against a light-reflecting material. The final stage may be dye or silver. Suitable image-forming reagents include dye developers, color couplers, coupling dyes, etc.

Figures 1(a) and (b) show the exposure of SX-70 film to white, blue, green, and red light, followed by the changes that occur during processing of this film. The exposed negative, on an opaque support, is pressed into contact with the dye-receiving layer of the positive with a layer of processing fluid between them. In addition to the usual processing ingredients, the processing solution contains titanium dioxide and phthalein indicator dyes to provide the opacified medium to prevent light from reaching the developing negative image. Dye developers act as in Polaroid's previous color material, except

Figure 1. The various layers of Polaroid SX-70 film are depicted, showing (a) the exposure of the three light-sensitive layers and the (b) transfer of the dyes after development to an image-receiving layer. The SX-70 film is exposed and the image viewed from the same side. [From E. H. Land, *Phot. J.*, **114**: 342 (1974)]

that the development of the silver halide is accomplished not by the dye developer but by a mobile auxiliary developing agent, namely, methylphenylhydroquinone. The oxidized form of this compound oxidizes the dye developer, regenerating the reduced form of the methylphenylhydroquinone but immobilizing the dye developer.

The unoxidized dye developer molecules are mobile and can diffuse to the receiving layer, where the dye image can be viewed through the transparent face of the unit. The dye developer molecules that form the image consist of hydroquinone molecules connected to dye molecules. In the case of the SX-70 film, the dye part of the dye developer has been reacted to incorporate metal ions which are said to provide dye images of improved light stability.

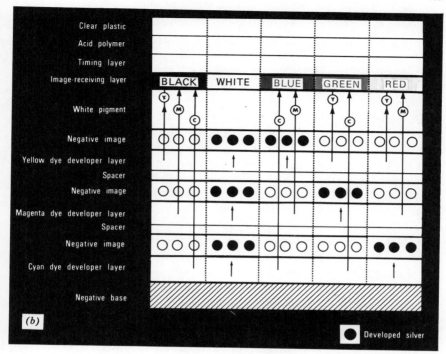

Figure 1 (*continued*)

The cyan dye developer contains a copper phthalocyanine attached to four hydroquinone groups. The magenta dye developer contains a chromium-metallized hydroxynaphthylazopyrazolone. A chromium complex of a dihydroxy-substituted anil serves as the yellow dye developer. Metallized dye developers were used in Polacolor 2, a peel-apart product that Polaroid introduced in 1975.

The Polaroid print has been described as "15 layers of chemicals bound between two sheets of plastic."[192] The penalty for this complex print structure and the need to move large dye molecule through the layers is paid in the time of processing. From 8 to 15 min may be required for the image to reach its final color saturation, although improvements have decreased this time. The dye image begins to appear shortly after the exposed print is ejected from the camera. With the compact Polaroid SX-70 single-lens reflex or similar Polaroid cameras that have followed it, the print material forms a system that Edwin H. Land[193,194] has called "Absolute One-Step Photography."

Kodak Instant Picture System

On April 20, 1976, Eastman Kodak Company introduced an instant photography system using a print film that W. T. Hanson, Jr., described as having "fundamentally new imaging technology."[195] Unlike the Polaroid print film, which had a negative silver halide emulsion layer, the Kodak print film was based on a positive-working emulsion of exposure index 150, a much higher rating than was said to have been achieved previously for a direct positive emulsion. The emulsion may be similar to the core-shell emulsion as described by Francis J. Evans in U. S. Patent 3,761,276 (1973).

In such positive-working emulsions, the silver halide grains have almost no surface sensitivity but considerable internal sensitivity. Light exposure results primarily in the capture of the photoelectrons by the internal latent image. Thus, the exposed silver halide grains have an intensified internal latent image; the unexposed grains do not. When such an exposed direct reversal emulsion is developed in a fogging or nucleating developer (such as one with a hydrazine present), the electrons are funneled to the interior latent image of the light-exposed grains. On the unexposed grains the electrons are trapped at surface sites to build fog nuclei that become developable by a surface developer. The exposed grains with the internal latent image do not develop. A direct positive image results.

The positive-working silver halide emulsion was used with negative-working sulfonamidophenol dye redox-releaser compounds. The developing fluid from the pod of the print film contained a derivative of 1-phenyl-3-pyrazolidone to reduce the silver in those grains with the nucleated surface image. This oxidized electron transfer agent then interacted with the dye releaser, oxidizing the dye releaser but regenerating the reduced form of .the electron transfer agent for further activity. (See Figure 2.)

Under the highly alkaline conditions provided by the activator fluid, the oxidized dye releaser is hydrolyzed to give a mobile dye and a residual by-product that is immobile.

Figure 2. Dye-release process. The electron transfer agent (ETA) is oxidized during the reduction of the exposed silver, and the oxidized form then reacts with the dye releaser molecule (DR) to produce a mobile dye. This dye then migrates to the image-receiving layer to form the dye image. [W. T. Hanson, Jr., *Phot. Sci. and Eng.*, **20**: 156 (1976)]

$$\text{Ballast} \overbrace{}^{\text{OH}}_{\text{NHSO}_2-\text{Dye}} R \xrightarrow[\text{ETA}]{\text{Ag}^+} \text{Ballast} \overbrace{}^{\text{O}}_{\text{NSO}_2-\text{Dye}} R \xrightarrow{\text{OH}^-}$$

$$\text{Ballast} \overbrace{}^{\text{O}}_{\text{O}} R + \text{H}\bar{\text{N}}\text{SO}_2-\text{Dye}$$

The reduced and oxidized forms of the electron transfer agent are the only mobile, photographically active species in the system. The dye is mobile but not photographically active. Thus, there is no danger of reaction as the dye migrates to the receiving layer. This differs from the Polaroid system, where active dye developer molecules must pass through silver halide layers containing exposed silver, particularly in regard to the magenta dye reproduction. The passage of the unoxidized dye developer molecules through the green sensitive layer has been recognized as a possible limitation of the Polaroid system, but this difficulty has been said to be minimized by the correct balancing of the activities of the dye developers and their rate of migration.

The dye image of the Kodak Instant Print film is produced on the side opposite to the exposing side. The complex nature of this material is illustrated by a schematic section during exposure and then during processing to show the migration of the dyes to the image-receiving layer. The dyes released as a result of the development are azo dyes. The yellow dye is an arylazo derivative of a 5-pyrazolone. Both the magenta and cyan dyes are 4-arylazo-1-naphthols. (See Figures 3 and 4.)

The Kodak instant print film has been described as "19 layers deep and incredibly complex."[196] After the three dyes have been released from their layers adjacent to the blue-, green-, and red-sensitive silver halide layers containing a nucleating agent, the dyes migrate to a mordanting layer where they are held. This migration may take from 8 to 15 min, although improvements have shortened this time. The mordanting layer is viewed through the film support. The emulsion layers beneath are protected from light fogging by an opaque white titanium dioxide layer and a carbon-containing layer. The TiO_2 layer also provides the white background for the

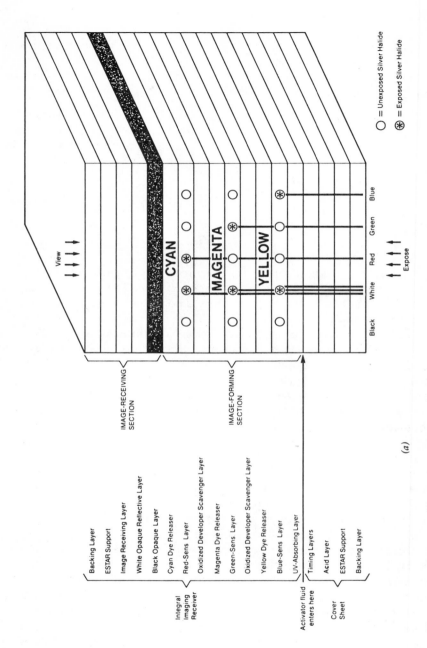

Figure 3. (a) Schematic section of integral imaging receiver, activator fluid, and cover sheet, showing the exposing light on the blue, green, and red sensitive layers.

412

Backing Layer
ESTAR Support
Image Receiving Layer
White Opaque Reflective Layer
Black Opaque Layer
Cyan Dye Releaser
Red-Sens Layer
Oxidized Developer Scavenger Layer
Magenta Dye Releaser
Green-Sens Layer
Oxidized Developer Scavenger Layer
Yellow Dye Releaser
Blue-Sens Layer
UV-Absorbing Layer
Activator fluid
Timing Layers
Acid Layer
ESTAR Support
Backing Layer

Integral Imaging Receiver

Cover Sheet

IMAGE-RECEIVING SECTION

IMAGE-FORMING SECTION

View

Black White Red Green Blue

○ = Undeveloped Silver Halide
● = Developed Silver

(b)

Figure 3. (b) Schematic section of the layers in Kodak instant print film, indicating the path of the diffusion of the dyes to the image receiving layer during processing. [From W. T. Hanson, *Phot. Sci, and Eng.*, **42**: 161 (1976)]

413

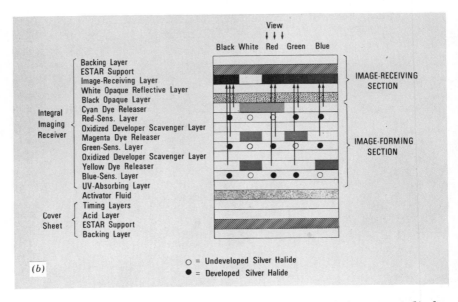

Figure 4. These schematic sections of Kodak Instant Print Film (a) during exposure, (b) after processing, illustrate the complexity of layers in such a product. Note that the film is exposed from one side and the transferred dye image is viewed from the other side of the film. [W. T. Hanson, Jr., *Phot. Sci. and Eng.*, 20: 161 (1976)]

print dye image. The activator fluid from the pod is introduced between the surface of the film and a cover sheet which is to be bonded permanently to the film surface. The fluid contains carbon, which prevents light from reaching the developing emulsion layers as well as providing a black color for the back of the print. Timing layers and acidic polymeric layers control the dye image transfer and provide a suitable environment for maintaining the image dyes after transfer to the mordanting layer. The mordant is a polymer with positively charged sites that form ionic bonds with the negatively charged dyes, anchoring the dyes together in the image-receiving layer.

The structural relationship of the image-forming and image-receiving layers as well as the cover sheet and activator fluid of the Kodak instant print is shown in the schematic illustration, Figure 5.

COMPOSITIONS OF INTEGRAL
IMAGING RECEIVER, ACTIVATOR FLUID, AND COVER SHEET

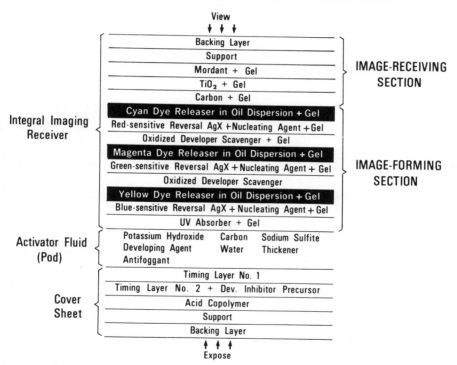

Figure 5. A schematic section of Kodak Instant Print film indicates the composition of the layers in the cover sheet and the image receiver as well as the activator fluid that is spread between them. [From W. T. Hanson, *Phot. Sci. and Eng.*, **20**: 159 (1976)]

REFERENCES

1. André Rott: "re:One-step Photographic Processes," *PSA J.*, **14**: 108 (1948).
2. André Rott and Edith Weyde, *Photographic Silver Halide Diffusion Processes*, Focal Press, London, 1972, pp. 15–19.
3. Edith Weyde, "Woher stammen die fotochemischen grundlagen für die Ein-Minuten-Kamera?," *Foto-Kino-Technik*, **2** (9): 229 (1948).
4. Lloyd E. Varden and Peter Krouse, "Chemical Background of One-Step Processes," *Phot. Age*, **4** (2): 45 (1949).
5. Edith Weyde, "The Diffusion of Dissolved Silver Salts in Photographic Emulsions," *Science and Applications of Photography*, Royal Photographic Society, London, 1955, pp. 47–48.
6. Edith Weyde, "Das Copyrapid-Verfahren der Agfa," *Phot. Tech. Wirt.*, **1** (1): 36 (1950).
7. B. Meerkämper, "The Copyrapid Process," *Camera* (*Luzern*), **29**: 376 (1950).
8. Edith Weyde, "Über die Silberausscheidung durch Keime beim Silbersalzdiffusionsverfahren (Agfa-Copyrapidprozess)," *Z. für Naturforsch.*, **6a**: 381 (1951).
9. Edith Weyde, "Über die Wiedergabe von Details in den nach den Silbersalz-Diffusionsverfahren hergestellten Positiven," *Phot. Korr.*, **88**: 203 (1952).
10. Walter Hornung, "The Image Diffusion Method of Document Copying," *Brit. J. Phot.*, **101**: 593 (1954).
11. K. Hultgren, "Two-minute Photocopying in Daylight—The Copyrapid Process," *Funct. Phot.*, **4** (5): 4 (1953).
12. Edith Weyde, "Das Copyrapid-Verfahren der AGFA," *Mitt. aus den Forschungslaboratorien der AGFA*, **1**: 262 (1955).
13. Belfield Lefevre, "A Mode of Transferring the Daguerrean Image to Paper," *Phot. Notes*, **2**: 343 (1857).
14. R. Ed. Liesegang, "Printing Out," *Brit. J. Phot.*, **46**: 54 (1899).
15. Captain Colson, "Le Développement Confiné," *Bull. soc. franc. phot.*, (2) **14**: 108 (1898).
16. Erich Stenger and Alfred Herz, "Photographische Bilderzeugung durch bildmässige Abstufung geeigneter chemischer Agentien," *Z. wiss. Phot.*, **22**: 195 (1923).
17. Erich Stenger and Alfred Herz, "Photographische Bilderzeugung durch Abstufung geeigneter chemischer Agenzien," *Phot. Rund.*, **61**: 5 (1924).
18. G. W. W. Stevens and R. G. W. Norrish, "The Mechanism of Photographic Reversal," *Phot. J.*, **78**: 513 (1938).
19. Edith Weyde, "Woher stammen die fotochemischen Grundlagen für die Ein-Minuten-Kamera?," *Foto-Kino-Technik*, **4** (1): 22 (1950).
20. Wilhelm Urban, "Die direkten Aufnahmeverfahren für Zwecke der Klischeefabrikation," *Phot. Korr.*, **47**: 219 (1910).
21. Willi Mutschlechner, "Diffusionserscheinungen bei photographischen Prozessen und Diffusionsverfahren," *Phot. Korr.*, **87**: 28 (1951).
22. Gevaert Photo-Producten, "Photographische Diffusionsverfahren," *Phot. Korr.*, **87**: 96 (1951).
23. J. Rzymkowski, "Geschichtliches zur Kontaktwirkung kolloiden Silbers beim fotografischen Entwicklungsprozess," *Foto-Kino-Technik*, **4** (7): 214 (1950).
24. J. Rzymkowski, "Die Kleinkamera mit 'eingebauter' Dunkelkammer," *Phot. Ind.*, **33**: 870 (1935).

25. "Kameras mit 'eingebauter' Dunkelkammer," *Foto-Kino-Technik*, **1** (6): 7 (1947).

26. André Rott, "Un Nouveau Principe de l'Inversion: l'Inversion-Transfert par Diffusion," *Sci. et Ind. Phot.*, (2) **13**: 151 (1942).

27. J. Eggert, "Zum 'One-Step'-Verfahren," *Camera (Luzern)*, **27**: 94 (1948).

28. Lloyd E. Varden, "Comments Regarding 'A New One-Step Photographic Process' by Edwin H. Land," *J. Opt. Soc. Am.*, **38**: 69 (1948).

29. Lloyd E. Varden, "One-Step Photographic Processes," *PSA J.*, **13**: 551 (1947).

30. Edwin H. Land, "A New One-Step Photographic Process," *J. Opt. Soc. Am.*, **37**: 61 (1947).

31. Edwin H. Land, "A New One-Step Photographic Process," *PSA J.*, **13**: 370 (1947).

32. "Die Ein-Minuten-Kamera," *Foto-Kino-Technik.*, **1** (3): 3 (1947).

33. E. H. Land, "Obtention rapide simultanée d'un négatif et d'un positif," *Sci. et Ind. Phot.*, (2) **18**: 206 (1947).

34. Edwin H. Land, "One-Step Photography," *Phot. J.*, **90**: 7 (1950).

35. Henry C. Yutzy and Leonard W. Tregillus, "Photographic Roll Film Transfer Process," U. S. Pat. 2,882,151 (1959).

36. Edward Carl Yackel, Henry Clay Yutzy, Donald Paul Foster, and Arthur Allyn Rasch, "Improvements in Photographic Sensitive Materials and in Photographic Reproduction methods Using the Same," Brit. Pat. 868,241 (1961).

37. Edwin Herbert Land and Leonard Clarence Farney, "Photographic Products and Processes," Brit. Pats. 1,182,306, 1,182,307, and 1,182,308 (1970).

38. W. Krafft, "The Office Copy-Materials," in *Photographic Silver Halide Diffusion Processes*, by André Rott and Edith Weyde, Focal Press, London, 1972, p. 45.

39. André Rott, "Improvements in or relating to Photographic Processes," Brit. Pat. 614,155 (1948).

40. Farbenfabriken Bayer, "Direct Production of Positive Photographic Images," Brit. Pat. 695,915 (1953).

41. André Rott, "Photomechanical Printing Process and Printing Material for Carrying Out The Same," U. S. Pat. 2,352,014 (1944).

42. Gevaert Photo-Producten, "Improvements in or relating to the Manufacture of Photographic Images," Brit. Pat. 654,630 (1951).

43. Edwin H. Land, "Photographic Product and Process for Making a Positive Transfer Image," U. S. Pat. 2,698,245 (1954).

44. Edwin H. Land, "Process for Forming Print-Receiving Elements," U. S. Pat. 2,765,240 (1956).

45. Edwin H. Land, "Photographic Silver Halide Transfer Product and Process," U. S. Pat. 2,698,236 (1954).

46. Edwin H. Land, "Photographic Silver Halide Transfer Product and Process," U. S. Pat. 2,698,237 (1954).

47. Edwin H. Land and Meroe M. Morse, "Photographic Silver Halide Transfer Process," U. S. Pat. 2,774,667 (1956).

48. Charles A. Goffe, "Nuclei for Use in Solvent Transfer Systems," U. S. Pat. 3,532,497 (1970).

49. William H. Ryan, "Novel Photographic Products and Processes," U. S. Pat. 3,313,625 (1967).

50. Michael John Alsup and William Joseph Venor, "Photographic Sheet Material for Diffusion Transfer," Brit. Pat. 1,148,174 (1969).

51. Richard W. Young, "Image-Receiving Elements and Photographic Processes Employing Same," U. S. Pat. 3,607,269 (1971).

52. International Polaroid, "Photographic Products and Processes," Brit. Pat. 1,149,921 (1969).

53. Lloyd E. Varden, "Diffusion-Transfer Reversal Materials," Chap. 28 in *Photography, Its Materials and Processes*, 6th Edition, by C. B. Neblette, Van Nostrand, New York, 1962.

54. B. Meerkämper, "Das Diaversal-Umkehr-Papier," *Camera (Luzern)*, **28**: 78 (1949).

55. W. K. Raxworthy, "The Gevaert Diaversal Process," *PSA J.*, **17**: 560 (1951).

56. P. M. Cassiers, "Der Farbton des Bildsilbers im Silbersalzdiffusionsverfahren," *Wissenschaftliche Photographie*, International Conference, Cologne, 1956, Helwich, Darmstadt, 1958, pp. 285–290.

57. P. M. Cassiers, "De Studie van het Zilverdiffusietransferprocede," *Industrie Chimique Belge*, **22**: 11 (1957).

58. Leonard W. Tregillus and Arthur Allyn Rasch, "Photographic Silver Halide Diffusion Transfer Process," U. S. Pat. 3,017,270 (1962).

59. Yasushi Ohyama, Kiyoshi Futaki, and Senji Tosa, "Diffusion Transfer Process," U. S. Pat. 3,702,246 (1972).

60. Thomas R. Thompson, "Action of Organic Stabilizers on a Photographic Emulsion," *Phot. Sci. and Eng.*, **3**: 272 (1959).

61. Kiyoshi Futaki, Yasushi Ohyama, and Toh-Ichi Iwasaki, "Influences of Some Addition Agents on the Color of Developed Silver from Liquid Photographic Emulsion," *Phot. Sci. and Eng.*, **4**: 97 (1960).

62. Hermann Eggenschwiller and Walther Jaenicke, "Catalytic Activity of Photographically Developed Silver for the Reduction of Silver Complexes," *Z. Elektrochem.*, **64**: 391 (1960) (in German).

63. R. J. Newmiller and R. B. Pontius, "The Adsorption of Development-Restrainers to Silver and Their Effects on Physical Development," *Phot. Sci. and Eng.*, **5**: 283 (1961).

64. E. Weyde, E. Klein, and H. J. Metz, "Silver Deposition in the Diffusion Process," *J. Phot. Sci.*, **10**: 110 (1962).

65. Yasushi Ohyama and Kiyoshi Futaki, "Observation on Fine Structure of Developed Silver in the Presence of Added Tone Modifiers," *Phot. Sci. and Eng.*, **7**: 84 (1963).

66. G. R. Bird, M. Morse, H. Rodriguez, P. E. Bastian, J. Johnson, and W. E. Gray, "Diffusion Transfer Images of Pure and Impure Silver in Model Systems," *Phot. Sci. and Eng.*, **15**: 356 (1971).

67. E. H. Land, V. K. Walworth, and R. S. Corley, *Phot. Sci. and Eng.*, **16**: 313 (1972).

68. Edith Weyde, "Photographic Process for the Direct Production of Positive Images," U. S. Pat. 2,699,393 (1955).

69. George Frans van Veelen, Eric Maria Brinckman, Jozef Frans Willems, and Gerard Michiel Sevens, "Silver Complex Diffusion Transfer Process," U. S. Pat. 3,360,368 (1957).

70. Fuji Sashin Film, "Improvements in or relating to Diffusion Transfer Photography," Brit. Pat. 1,096,784 (1967).

71. Jozef F. Willems, Eric M. Brinckman, and Louis M. De Haes, "Diffusion Transfer Materials and Processes," Can. Pat. 725,107 (1966).

72. Colin Holstead, "Improvements in processes of Photographic Reproduction," Brit. Pat. 972,064 (1964).

73. I. G. Farbenindustrie," Procédé pour la constitution d'images photographiques positives," French Pat. 879,995 (1943).

74. Henry Phillips and Frank Russell Tolhurst, "Improvements in or relating to the Production of Photographic Images by a Migratory Reversal Transfer Process," Brit. Pat. 706,333 (1954).

75. Edwin H. Land, "Photographic Diffusion Transfer Reversal Processes," U. S. Pat. 2,704,721 (1955).

76. Meroe M. Morse, "Photographic Process and Composition," U. S. Pat. 2,984,565 (1961).

77. G. F. van Veelen and E. Brinckman, "Influence of Mercapto Compounds on Grain Habit and Colour of Physically Developed Silver," *Phot. Korr.*, **99**: 139 (1963).

78. Mitsubishi Paper Mills, "Improved Photographic Silver Complex Diffusion Transfer Materials and Process," Brit. Pat. 1,204,931 (1970).

79. Jozef Frans Willems, George Frans van Veelen, and Louis Maria De Haes, "Silver Complex Diffusion Transfer Process," U. S. Pat. 3,431,108 (1969).

80. Louis Maria De Haes, "Silver Halide Diffusion Transfer Process," U. S. Pat. 3,335,007 (1967).

81. James R. King and James R. Moran, "Method and Composition for Inhibiting Silver Sludge in Thiosulfate Monobaths," U. S. Pat. 3,173,789 (1965).

82. Anita von König and Raymund Pfeiffenschneider, "Preventing Darkening and Formation of Precipitates in Solutions of Photographic Developers," U. S. Pat. 3,212,892 (1965).

83. Anita von König and Raymund Pfeiffenschneider, "Verfahren zur Verhinderung der Dunkelfärbung und Schlammbildung in photographischen Entwicklern," German Pat. 1,175,077 (1965).

84. Humphrey Desmond Murray, Richard Penn Royer, and George William Smith, "Improvements in or relating to Photographic Processes," Brit. Pat. 761,368 (1956).

85. W. Krafft, "Materials," in *Photographic Silver Halide Diffusion Processes*, by André Rott and Edith Weyde, Focal Press, London, 1972, p. 52.

86. A. J. Sievers, "Some Problems in the Production of Multiple Copies by the Diffusion Transfer Process," *PSA Technical Quarterly, Phot. Sci. and Tech.*, **2** (2): 75 (1955).

87. Edith Weyde, "Verfahren zur Herstellung mehrerer Positive von einem Negativ nach dem Silbersalzdiffusionsverfahren," German Pat. 1,062,545 (1959).

88. Henry C. Yutzy and Herbert B. Cowden, "Transfer Process of Photographic Printing," U. S. Pat. 2,725,298 (1955).

89. Henry C. Yutzy and Herbert B. Cowden, "Transfer Process of Photographic Printing," U. S. Pat. 2,843,485 (1958).

90. Edith Weyde, "Production of Transfer Images by the Silver Salt Diffusion Process," U. S. Pat. 3,067,033 (1962).

91. Edith Weyde, "Verfahren zur Herstellung direkter Positive nach dem Silbersalzdiffusionsverfahren," German Pat. 1,055,953 (1959).

92. Edwin H. Land, "One Step Photographic Transfer Process," U. S. Pat. 2,647,056 (1953).

93. Edwin H. Land and Milton Green, "Methods for Washing and Protecting Photographic Silver Images," U. S. Pat. 2,794,740 (1957).

94. Edwin H. Land and Meroe M. Morse, "Process of Washing and Protecting Photographic Silver Images," U. S. Pat. 2,866,705 (1958).

95. Edwin H. Land, Elkan R. Blout, and Howard C. Haas, "Process of Washing and Protecting Photographic Silver Images, and Photographic Products Thereof," U. S. Pat. 2,830,900 (1958).

96. Edwin H. Land, Elkan R. Blout, and Howard C. Haas, "Process of Washing and Protecting Photographic Silver Images, and Photographic Products Thereof," U. S. Pat. 2,956,877 (1960).

97. Edwin H. Land, "Composition Comprising a Vinylpyridine Polymer and a Hydantoin Formaldehyde Condensation Polymer," U. S. Pat. 2,979,477 (1961).

98. Edwin H. Land and Meroe M. Morse, "Process of Washing and Protecting a Diffusion Transfer Photographic Silver Print," U. S. Pat. 3,533,789 (1970).

99. Howard C. Haas, "Method for Washing and Protecting Photographic Silver Images," U. S. Pat. 3,533,790 (1970).

100. George Cohen, "Camera Accessory for Coating Prints," U. S. Pat. 3,132,049 (1964).

101. Joseph W. Distel, Maxfield Parrish, Jr., and Karl Maiershofer, "Flattening and Coating Device for Photographic Prints," U. S. Pat. 2,969,766 (1961).

102. Edwin H. Land, "Diffusion Transfer Process Using an Oxidized 4,6-Diamino-Ortho-Cresol Solution," U. S. Pat. 3,241,964 (1966).

103. Edwin H. Land, "Diffusion Transfer Photographic Process Using 4,6-Diamino-Ortho-Cresol," U. S. Pat. 3,326,683 (1967).

104. Agfa, "Improvements in or relating to the Production of Direct Positive Photographic Images by the Silver Salt Diffusion Process," Brit. Pat. 767,978 (1957).

105. Henry Clay Yutzy and Edward Carl Yackel, "Improvements in materials for and processes of photographic reproduction," Brit. Pat. 745,445 (1956).

106. Milton Green and Howard G. Rogers, "Novel Photographic Products, Compositions, and Processes," U. S. Pat. 3,043,690 (1962).

107. Elkan R. Blout, "Novel Photographic Developers," U. S. Pat. 2,939,788 (1960).

108. Milton Green, Meroe Morse, and Myron S. Simon, "Mono-N-Benzyl-Diamino-Phenyl Compounds," U. S. Pat. 3,235,599 (1966).

109. Milton Green and Warren E. Solodar, "Novel Substituted Silver Halide Developing Agents," U. S. Pat. 3,061,434 (1962).

110. Elkan R. Blout, Saul G. Cohen, and Myron S. Simon, "Photographic Process," U. S. Pat. 3,003,876 (1961).

111. Milton Green and Myron S. Simon, "Photographic Products, Processes and Compositions," U. S. Pat. 3,002,997 (1961).

112. Richard S. Corley, "Photographic Silver Halide Developers Containing Triazine Rings," U. S. Pat. 3,053,656 (1962).

113. Robert B. Woodward, "Compositions and Processes for the Development of Silver Halide Elements," U. S. Pat. 2,674,533 (1954).

114. International Polaroid, "Method of Developing Photosensitive Emulsions and Developer Compositions for use therein," Brit. Pat. 1,142,135 (1969).

115. Milton Green, "Photographic Developing Agents," U. S. Pat. 3,337,342 (1967).

116. Meroe M. Morse, "Photographic Compositions and Processes," Can. Pat. 865,659 (1971).

117. Edwin H. Land, "Photographic Processes for Producing Prints by Transfer," U. S. Pat. 2,702,244 (1955).

118. Edwin H. Land, "Photographic Processes for Producing Prints by Transfer and Products Useful in Connection Therewith," U. S. Pat. 2,740,715 (1956).

119. Meroe M. Morse, "Monobath Containing Cysteine-Nitrogenous Base Combination," U. S. Pat. 3,343,958 (1967).

120. Edwin H. Land, Milton Green, and Meroe M. Morse, "Photographic Processes," U. S. Pat. 3,256,091 (1966).

121. International Polaroid, "Method of Developing Photosensitive Emulsions and Developer Compositions for use therein," Brit. Pat. 1,142,135 (1969).

122. Rolf S. Gabrielsen and Ismael A. Olivares, "Photographic Composition, Element and Process," U. S. Pat. 3,672,896 (1972).

123. Mary J. Youngquist, "Photographic Product, Composition and Process Comprising an Anhydro Dihydro Amino Reductone Developing Agent," U. S. Pat. 3,664,835 (1972).

124. Mary J. Youngquist, "Photographic Product, Composition and Process," U. S. Pat. 3,666,457 (1972).

125. Edwin H. Land, Elkan R. Blout, Saul G. Cohen, Milton Green, Helen J. Tracy, and Robert B. Woodward, "Photographic Compositions and Processes," U. S. Pat. 2,857,274 (1958).

126. Edwin H. Land, Elkan R. Blout, Saul G. Cohen, Milton Green, Helen J. Tracy, and Robert B. Woodward, "Photographic Compositions and Processes," U. S. Pat. 2,857,275 (1958).

127. Edwin H. Land, Saul G. Cohen, and Helen J. Tracy, "Photographic Processes and Compositions Useful Therein," U. S. Pat. 2,857,276 (1958).

128. Milton Green, Adnan A. Sayigh, and Henri Ulrich, "Sulfone-Hydroxylamines as Photographic Developers," U. S. Pat. 3,287,124 (1966).

129. Milton Green, Adnan A. Sayigh, and Henri Ulrich, "Aminoalkyl Hydroxylamines as Photographic Developers," U. S. Pat. 3,287,125 (1966).

130. Milton Green, Adnan A. Sayigh, and Henri Ulrich, "Alkoxy Hydroxylamines as Photographic Developers," U. S. Pat. 3,293,034 (1966).

131. International Polaroid, "N-Substituted Hydroxylamine Silver Halide Developing Agents," Brit. Pat. 1,053,067 (1967).

132. International Polaroid, "Improvements relating to Photographic Processes and Solutions Therefor," Brit. Pat. 789,837 (1958).

133. Jozef Frans Willems, Robrecht Julius Thiers, and Roger Alois Spriet, "Silver Diffusion Transfer Process Having Hydroxylamine, Cyclic Imide and a Pyrazolidinone," U. S. Pat. 3,687,662 (1972).

134. Sidney Kasman, "Photographic Processing Composition and Processes Using Same," Can. Pat. 888,646 (1971).

135. Polaroid Corporation, "Compositions pour le développement photographique et procédés pour leur utilisation," Belgian Pat. 739,520 (1965).

136. International Polaroid, "Photographic Compositions and Processes," Brit. Pat. 1,142,134 (1969).

137. Edwin H. Land, "Diffusion Transfer with 4-Methylphenylhydroquinone in the Emulsion and N,N-Diethylhydroxylamine in the Processing Fluid," U. S. Pat. 3,406,064 (1968).

138. Grant Milford Haist, James Reber King, and Lance Harris Bassage, "Photographic Silver Materials and Processes," Brit. Pat. 1,183,907 (1970).

139. Grant Milford Haist, James Reber King, and David Alan Pupo, "Produit photographique aux halogénures d'argent comprenant un agent de stabilisation," French Pat. 2,095,613 (1972).

140. International Polaroid, "Improvements in Photographic Processing Compositions and in Photographic Silver Image Transfer Processes," Brit. Pat. 751,304 (1956).

141. Roger M. Cole, "Sulfonamides in Diffusion Transfer Systems," U. S. Pat. 3,600,171 (1971).

142. Edward J. Johnson, Jr., "Photographic Image Transfer Process Utilizing Imidazolidine-2-Thione," U. S. Pat. 3,565,619 (1971).

143. Meroe M. Morse, "Photographic Processes and Composition Useful Therein," U. S. Pat. 2,938,792 (1960).

144. Grant Milford Haist, "Silver Mercaptides and their use in Sensitive Photographic Materials," Brit. Pat. 1,070,183 (1967).

145. Curt B. Roth, "Diffusion-Transfer Reversal Process," U. S. Pat. 3,042,514 (1962).

146. "Lactate of Silver Plates," *Brit. J. Phot. Almanac*, 1897, p. 858.

147. L. T. Young, "Malate of Silver in Washed Emulsions," *Brit. J. Phot.*, 22: 287 (1875).

148. Thomas Toplica Bryan, "Preparation of Silver Salts of Organic Carboxylic Acids," U. S. Pat. 3,458,544 (1969).

149. James Salvatore Marchese, "Image-Yielding Elements and Processes," U. S. Pat. 3,529,963 (1970).

150. Simone L. Boyer and Lucienne S. Pichon, "Silver Salts of Pyridine Carboxylic Acids and Photographic Emulsions Containing the Same," U. S. Pat. 3,532,502 (1970).

151. Edith Weyde and Anita von König, "Photographic Material," Brit. Pat. 1,111,492 (1968).

152. Edith Weyde, Anita von König, Harald von Rintelen, and Siegfried Wagner, "Process for the Production of Direct Positive Images by the Silver Salt Diffusion Process," Brit. Pat. 1,112,355 (1968).

153. Edith Weyde, Anita von König, Harald von Rintelen, and Siegfried Wagner, "Process for the Production of Direct Positive Images by the Silver Salt Diffusion Process," Can. Pat. 832,385 (1970).

154. Edith Weyde, Anita von König, Harald von Rintelen, and Siegfried Wagner, "Process for the Production of Direct Positive Images by the Silver Salt Diffusion Process," U. S. Pat. 3,528,810 (1970).

155. Mikio Tamura, "Image of High Electrical Conductivity Produced by Photodecomposition of Organic Silver Salt," *The Photographic Image*, edited by S. Kikuchi, Focal Press, London, 1970, pp. 137–140.

156. Harold H. Herd and Theresa I. Sun, "Method of Making Conductive Silver Images and Emulsion Therefor," U. S. Pat. 3,647,456 (1972).

157. Harold Henry Herd and Theresa I. Sun, "Method of Making an Electrically Conductive Silver Image," Brit. Pat. 1,234,847 (1971).

158. Hendrik Jonker, Casper Johannes Gerardus Ferdinand Janssen, and Lambertus Postma, "Method of Manufacturing Electrically Conducting Metal Layers," U. S. Pat. 3,674,485 (1972).

159. James R. King and Grant M. Haist, "Photographic Production of Electrically Conducting Silver Images," U. S. Pat. 3,033,765 (1962).

160. E. I. du Pont de Nemours and Company, "Process for making Electrically Conductive Images," Brit. Pat. 1,136,225 (1968).

161. Jack F. Strange, "Process of Producing Conductive Images Including Addition of Salicylic Acid to Developing Solutions to Counteract Emulsion Ageing," U. S. Pat. 3,486,893 (1969).

162. J. F. Strange and R. K. Blake, "A Diffusion Transfer Development Process Yielding Conductive Silver Images," *Annual Conference Preprint Book*, Soc. Phot. Sci. and Eng., San Fransisco, May 9–13, 1966, p. 243.

163. Isao Shimamura and Haruhiko Iwano, "Verfahren zur Herstellung von elektrisch leitenden Silberbildern," German Pat. 2,161,183 (1972).

164. Leonard W. Tregillus, Arthur A. Rasch, and Edwin B. Wyand, Jr., "Web Processing Method and Composition," U. S. Pat. 3,179,517 (1965).

165. Leonard Warren Tregillus, Arthur Allyn Rasch, and Edwin Berton Wyand, "Improvements in the processing of Exposed Photographic Materials," Brit. Pat. 964,514 (1964).

166. L. W. Tregillus, A. A. Rasch, and E. B. Wyand, "Nouveau procédé de traitement des couches d'émulsion aux halogénures d'argent et solution de traitement photographique utile pour la mise en oeuvre de ce procédé," Belgian Pat. 594,237 (1960).

167. Billy K. Boller, Edward A. Smith, and Allan L. Sorem, "Photographic Web Processing," U. S. Pat. 3,573,048 (1971).

168. Bell and Howell Company, "Improvements in or relating to Producing Stable Photographic Images," Brit. Pat. 1,120,064 (1968).

169. Raife G. Tarkington, "The Kodak Bimat Process," *Photogramm. Eng.*, **31**: 126 (1965).

170. "An Introduction to the Kodak Bimat Transfer Processing System," Kodak Pamphlet No. P-65 (8-66-RPP-G Major Revision).

171. Geoffrey Crawley, "The Lunar Orbiter Photographic Mission," *Brit. J. Phot.*, **113**: 852 (1966).

172. "A Photographic Laboratory 232,000 Miles from Earth," *Phot. Proc.*, **2** (4): 26 (1967).

173. L. W. Tregillus, "Image Characteristics in Kodak Bimat Transfer Film Processing. I. Grain Structure," *J. Phot. Sci.*, **15**: 45; "Image Structure," **15**: 129 (1967).

174. R. L. White, R. J. Wilson, L. W. Tregillus, R. J. Hsu, S. L. Passarell, and R. C. Salsich, "A Five-Second Diffusion Transfer System," *Image Tech.*, **13** (2): 15 (1971).

175. "Breadboard for Better Bimat," *Photo Methods for Industry (PMI)*, **12** (10): 47 (1969).

176. "New Speed for High-Flying Photo Systems," *Chem. Week*, **97** (7): 96 (1965).

177. Wallace Hanson, "5-Min. Processing with a Film Positive, Too!," *35-MM Photography*, Spring: 12 (1971).

178. Rudolf Wendt, "Diffusion Transfer Process," U. S. Pat. 3,211,551 (1965).

179. Werner Zindler, "Improvements in or relating to Non-reversed Positive Photographic Prints," Brit. Pat. 984,635 (1965).

180. Anita von König, Hildegard Haydn, Ferdinand Grieb, and Harald von Rintelen, "A Process for the Production of Non-Laterally Reversed Positive Images," Brit. Pat. 1,028,199 (1966).

181. Anita von König, Helmut Mäder, and Edith Weyde, "Light-Sensitive Material with Incorporated Developer," U. S. Pat. 3,415,651 (1968).

182. Anita von König, Helmut Mäder, Hans Ulrich, and Edith Weyde, "Light-Sensitive Material with Incorporated Developer," U. S. Pat. 3,419,395 (1968).

183. Rudolf Wendt, "Image Receiving Sheet with a Double PVA-Hygroscopic Salt Layer Coating," U. S. Pat. 3,379,532 (1968).

184. Agfa, "Process for the Production of Laterally Non-Reversed Positive Copies by Heat Development," Brit. Pat. 790,811 (1958).

185. Hildegard Haydn and Anita von König, "Process for the Production of Non-Laterally Reversed Positive Copies by Heat Development," U. S. Pat. 2,971,840 (1961).

186. Geoffrey Crawley, "Polacolor," *Brit. J. Phot.*, **110**: 76 (1963).

187. Anthony A. Newman, "Colour Processes for the Land Camera," *Brit. J. Phot.*, **109**: 212 (1962).

188. Yasushi Ohyama, "Recent Progress in Diffusion-Transfer-Color Materials Similar to 'Polacolor' Process," *Nippon Shashin Gakkai Kaishi* (*J. Soc. Sci. Phot., Japan*), **32** (5): 243 (1970) (in Japanese).

189. Howard G. Rogers, "Processes and Products for Forming Photographic Images in Color," U. S. Pat. 2,983,606 (1961).

190. Lloyd D. Taylor, "Novel Photographic Products and Processes," U. S. Pat. 3,421,892 (1969).

191. Edwin H. Land, "Photographic Products, Processes and Compositions," U. S. Pat. 3,647,437 (1972).

192. *Rochester Democrat and Chronicle*, October 27, 1972, p. 8D.

193. "Absolute One-Step Photography," *Brit. J. Phot.*, **119**: 495 (1972).

194. Edwin H. Land, "Absolute one-step photography," *Phot. Sci. and Eng.*, **16**: 247 (1972).

195. W. T. Hanson, Jr., "A Fundamentally New Imaging Technology for Instant Photography," *Phot. Sci. and Eng.*, **20**: 155 (1976).

196. Kodak, "Now. Instant pictures with color by Kodak," *PSA J.*, **42** (8): 9 (1976).

197. André Rott and Edith Weyde, *Photographic Silver Halide Diffusion Processes*, Focal Press, London, 1972, p. 11.

Chapter 9
Color Photographic Systems

*The history of color photography makes depressing
reading. It is a story of processes born before
their time and processes that should never have
been born at all, of ships that stagger past in
the night, founder and rise again keel upwards
only to be remanned by optimistic crews.*

D. A. SPENCER[299]

The sun bathes the earth with a broad band of radiation. A small portion
of this radiation is perceived by the eye of the photographer and interpreted
by his mind, thus allowing him to "see" the colorful world around him.
Actually, the sun's direct or reflected light is not colored at all, but the sensa-
tion of color is the result of interpretive processes occurring in the viewer's
brain. The brain, conditioned by visual experiences since childhood, reacts
to signals resulting from the eye's stimulation by impinging light. The retina
of the human eye reproduces color sensations with the use of only three
color receptors—cones containing blue-absorbing, green-absorbing, and
red-absorbing pigments. The response of the three color-sensing cones is
only the first link of the wondrous chain that is called human vision.

This nature of human color vision was unknown to the early physicists
who were studying the properties of light. In 1611 Antonius de Dominis[1]

demonstrated that all colors of light could be synthesized by mixing just three: violet, green, and red. Isaac Newton, seeking to overcome the strange color fringing given by optical instruments, especially telescopes, discovered in 1666 that sunlight could be dispersed into a spectrum of colors and then reunited to produce white light again.[2] Newton felt that the spectrum consisted of seven principal colors and also that the complexity of white light was an insurmountable defect. He invented the reflecting telescope, which was free of the color fringing so common with uncorrected glass lenses.[3] Jakob Le Blon printed engravings in color using successive copper plates inked in the seven Newton colors (red, orange, yellow, green, blue, indigo, and violet). In 1722 Le Blon concluded that all color could be reproduced from three plates using red, yellow, and blue inks.[1]

Other sets of three primary colors were suggested by others. In 1792 Christian E. Wünsch, after considerable testing, proposed red, green, and violet-blue as the three primary colors.[4] These same three colors were proposed as primaries by Thomas Young in 1802, but Young advanced the idea that color was a sensation occurring within the eye and not an intrinsic property of the light waves. It was postulated that within the human eye there were three sets of nervous fibers corresponding to each of the primary colors. All colors could be matched by the stimulation of one or more of these visual sensors. These concepts were later extended by Hermann von Helmholtz in Germany and James Clerk Maxwell[5] in England.

Clerk Maxwell adopted Young's theory of color perception and in 1861 used photography to demonstrate publicly that a colored projected image could be formed using red, green, and blue as the primary colors.[6,7] The actual photographic work was performed by Thomas Sutton.[8–10] A tartan ribbon bow was pinned on black velvet. Sutton prepared negatives taken with a blue solution (ammoniacal copper sulfate), a green solution (copper chloride), or a red solution (sulphocyanide of iron) in front of the lens. A negative was also prepared with a yellow glass in front of the lens. Positive transparencies were prepared from the blue, green, yellow, and red negatives. Sutton states, "The picture taken through the red medium was at the lecture illuminated by red light,—that through the blue medium by blue light,—that through the yellow medium by yellow light,—and that through the green medium by green light;—and when these different coloured images were superposed upon the screen a sort of photograph of the striped ribbon was produced in the natural colors." The account of the lecture in the *British Journal of Photography* of August 1, 1861, however, states that only three transparencies from the red, green, and blue filter negatives and three projectors, with the respective chemical solutions in front of their lenses, were used. When the three images were superposed on the screen, "a coloured image was seen, which, if the red and green images had been as fully photo-

graphed as the blue, would have been a truly-coloured image of the ribbon." Other sources also indicate that the positive from the yellow filter exposure was not used at Maxwell's demonstration during his lecture.[11]

Maxwell's demonstration of three-color photography in 1861 has always posed a technical question: How could three color separation negatives be taken with a photographic material that was sensitive only to the blue end of the spectrum and totally insensitive to green, yellow, or red light? Sutton had used wet collodion plates containing silver iodide which had no sensitivity beyond the extreme blue. The color sensitization of photographic emulsions was not discovered until 12 years later, in 1873, when Hermann Vogel, found the effect of dyes upon the spectral sensitivity of silver halides.[12]

The baffling character of Maxwell's demonstration has been resolved by R. M. Evans,[13] who carefully reconstructed all the conditions of the making and showing of the three color separations. All of Maxwell's filter solutions were found to transmit light in the ultraviolet and blue region of the spectrum at wavelengths shorter than 430 nm, producing separations for short wavelengths rather than the entire spectrum. It is thought that the red of the striped ribbon had a high reflectance of ultraviolet, a common property of red dyes, producing an exposed negative entirely by this short-wavelength radiation. Evans concluded, "Maxwell's ingenuity in devising a proof by the new technique of photography for an old theory of Young's on the three-colour nature of vision, coupled with Sutton's knowledge of photography and lenses, led to the invention and demonstration of colour photography some 20 years before it was 'possible'."

Maxwell had used photography to substantiate Young's theory of human vision; Maxwell himself, and the others who saw or read of the demonstration, were oblivious that a method of color photography was now possible.[14,15] However, two Frenchmen, Louis Ducos du Hauron and Charles Cros, independently of each other, seized upon the idea of using three photographic images from blue, yellow, and red light to produce pictures in their natural colors, either by projection, by photographic prints, or by three-color printing.[16–20]

Ducos du Hauron, especially, was active throughout his life in outlining his concepts in patents and in books, now rare.[21–25] It is said[26] that "In these books du Hauron outlined not only the method of making records of scenes in colour by exposures through red, green and blue-violet filters, as had been done by Clerk Maxwell in 1861, but also the system of printing from such colour-sensation negatives in complementary colours, and, further, the whole system of distributing the colour-filters in the form of a mosaic of minute structure, such as afterwards formed the basis of the Joly process, the Autochrome and other methods of so-called 'screen-plate' photography."

Ducos du Hauron invented and patented a three-color camera by which a single exposure formed three color separations on three negatives behind complementary light filters. He used Vogel's sensitizing dyes to produce photographic materials sensitive to blue, yellow, or red light. Ducos du Hauron devised the "tripack," the placing of three color films sensitized to blue, yellow, and red light, one behind the other, to produce three color negatives with a single exposure. Because of inadequate spectral sensitizers, the processes of Ducos du Hauron were never commercially acceptable, but his contributions anticipitated today's color materials, which had to wait until photographic chemistry made them possible. The monumental works of Ducos du Hauron (and Cros) are described more fully in Eder's *History of Photography*[27] and E. J. Wall's *The History of Three-Color Photography.*[28]

The work of Ducos du Hauron and Cros was ignored just as had been the demonstration of Maxwell in producing a projected three-color image. Most photographers continued to seek a process by which a single exposure caused a reproduction in color on a single piece of film. A few tantalizing partial successes through the years nurtured the hope that photochromy, as this process was called, would make a practical system of color photography. Jean Senebier in 1782 had noticed that silver chloride appeared more blue in color when exposed to blue-violet light than when exposed to other colors. In 1810 Johann Seebeck was able to reproduce the solar spectrum on silver chloride paper in shades of color similar to the colors of the spectrum. After work by John Herschel in 1840 and Edmond Becquerel from 1847 to 1855, Niepce de Saint-Victor in 1862 exhibited chlorinated silver plates that were natural color photochromes. These pictures were stable as long as they were not exposed to light but turned gray rapidly in light. Fixation of the image was not possible, as the colors resulted from the interaction of light waves and pigments within the thin coated layer.

In 1891 Gabriel Lippmann, however, was able to produce fixed photochromes by using the interference of light waves within an extremely fine-grain silver halide layer.[29] Light waves, striking the glass side of the plate first, penetrated through the emulsion and were reflected off the emulsion surface coated with a mercury mirror. (See Figure 1.) The reflected and incident light waves interacted with themselves to form interference phenomena, producing microscopically fine laminae or divisions of latent image, each color having a characteristic division of latent image depending on the wavelength of its light. After development and fixation with potassium cyanide or sodium thiosulfate, a brilliantly colored image was seen when the plate was viewed in reflected light.[30] Lippmann color plates were made commercially by August and Louis Lumière in France, who took the first color portrait of a human being in 1893 using a Lippmann plate. Lippmann color plates were slow in speed and were inconvenient to use, resulting in their

Figure 1. The Lippmann process used a grainless emulsion that was exposed in contact with a layer of mercury, as shown at left. Light reflected from the mercury would meet incoming light in half phase and set up silver laminae in the emulsion layer after development. Developed plate was viewed by reflected light. Viewing angle was critical, making the process impractical for general use. (Norman Rothschild, *Color Photography 1973*, p. 10) Copyright © 1973 Ziff-Davis Publishing Co.

decline from use as soon as a more satisfactory color method became available.[31] Maxwell and Ducos du Hauron did not attempt to reproduce the original color but only the psychological equivalent that caused the eye and mind to perceive color in a photographic image. To many who believed in photochromy, this was faked color.

Beginning in the late 1880's, Frederic E. Ives[32,33] began to utilize Maxwell's concepts to practice trichromatic photography—that is, the formation of color images from three photographic images obtained through red, green or yellow, and blue filters. The need for three primary color images, however, posed serious technical problems, particularly for any other than stationary subjects. Parallax, lack of registration, increased exposure from loss of light due to the optical system, the color filters, and beam-splitting, lack of image sharpness, dimensional changes of the three sheets of film, and other difficulties limited the results given by the three-color process. Three cameras, one camera with three lenses, or a one-shot camera with a beam-splitting prism or reflecting and transmitting mirrors were used to obtain three separation negatives made through filters of the three primary colors.[34,35] (See Figure 2.)

(a)

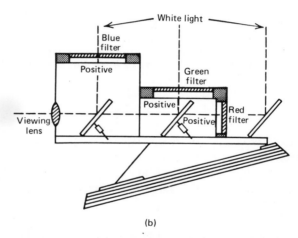

(b)

Figure 2. Ives chromoscope camera. This early "one-shot" apparatus allowed making three color-separation negatives with one click of the shutter. In the version shown here (a), three images of identical size are formed on glass plates, side by side. This design gave way to two-mirror beam-splitter cameras, a design often used for high-quality work. Ives photochromoscope. This device (b) was used to view the three positives made from three color-separation negatives. While results were sometimes beautiful, early quests were for paper color prints. "One-shot" camera. This was the type of camera (c) most often used in modern times to make three-color separations with one exposure. It used semisilvered mirrors, or pellicles, to cast three identically sized images. In front of each film was the appropriate red, green, or blue filter. (From Norman Rothschild, *Color Photography 1973*, p. 10) Copyright © 1973 Ziff–Davis Publishing Co.

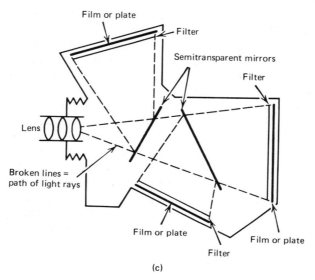

Film or plate
Filter
Semitransparent mirrors
Filter
Lens
Broken lines = path of light rays
Film or plate
Filter
Film or plate
Filter

(c)

Figure 2 (*continued*)

Many of the difficulties encountered with three individual separation negatives of trichromatic photography could be overcome if the images from the three color filters were made with a single exposure upon a single light-sensitive layer. A method to accomplish this had been suggested by Louis Ducos du Hauron, whom Joseph S. Friedman[36] has called "the real founder of modern color photography." Several years before photography had advanced to a stage where his suggestion could be tried, Ducos du Hauron proposed the screen plate process of color photography. The base of a transparent sheet was to be completely covered with a checkerboard of colors formed by alternating blue, yellow, and red lines of such fineness that the line pattern could not be individually resolved by the eye at a near distance. This screen was then coated with a single light-sensitive layer and exposed through the base so that the light had first to pass through the colored lines. Processing to give a positive image would yield a natural color transparency. Du Hauron also suggested that the colored filter lines could be separate from the light-sensitive material, the two being brought into contact just before light exposure.[37] Both integral and separated screen grid plates and film were to be sold commercially many years later.

Charles Cros also sought a solution to simplify trichromatic photography. His proposal involved the placement of a prism, either in front of or behind the camera lens, to form blue, yellow, and red components of the light for making simultaneously three separations on a single photographic material.

No filters were necessary. This diffraction method was later studied by others but never extensively used.

The screen grid plate consisted of the three primary color filters in the form of minute lines, dots, or other patterns in such a proportion that the overall appearance was gray by transmitted light. When the light-sensitive panchromatic emulsion coated upon the filter grid was exposed through the grid and developed, there would be a deposit of silver under the individual filter elements that transmitted the incident light. A developed silver image would be found only below a red filter element if the exposure was by red light. Light other than the primaries would cause image formation under more than one color of filter element but of a lesser amount. The developed silver was then removed by bleaching, the remaining silver halide either exposed to light or fogged chemically, then developed to form a silver image that partially or completely blocked the filter elements. The transparency of the gelatin passed incident light so that a color picture was formed that was similar to the original subject. The color reproduction was obtained by the use of the color filter grid and a panchromatic black-and-white photographic layer. The processing solutions were conventional monochrome reversal chemicals with an active first developer, sometimes containing a silver solvent such as potassium thiocyanate.

The pattern of the filter elements in the screen plates and films was important. The Lumière Autochrome plate was the first commercially successful photographic material to be marketed (1907) that followed the proposal of Ducos du Hauron,[37-39] although J. W. McDonough patented colored particles and John Joly the use of alternate red, green, and blue-violet lines for earlier screen grid processes.[40] Other screen plate materials were also produced.[41,42] The Autochrome plate, Lumière film color (1932), and the Agfacolor plate (1916) had screen elements consisting of a mixture of transparent particles stained with dyes of the three primary colors.[43] There were about 4,000,000 dyed and crushed potato starch grains per square inch in the Autochrome plate, with finely powdered charcoal filling the interstices between them. The final image has a granular character that was accentuated by the inevitable clumping of filter particles of the same color.[44] The Agfa color plate had droplets of varnish dyed in the three primary colors suspended in gum arabic which coalesced on the plate, eliminating the need for the carbon black.[45] Agfa granular-screen film, called Agfacolor, was introduced in 1932.

Dufaycolor film, resulting from the original work of Louis Dufay,[46] avoided the clumping of the particles by printing the color filter screen (reseau).[47-51] (See Figure 3.) The final reseau consisted of alternating blue and green lines with red lines overprinted at right angles. The entire surface of the film was divided into tiny areas of blue, green, and red, approximately

(a)

(b)

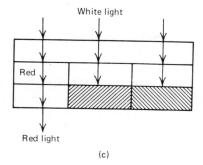

(c)

Figure 3. How a mosaic screen works. (*a*) A mosaic color plate or film has coated on its base transparent elements colored red, green, and blue. These may be particles of starch, tannin globules, or ruled lines or figures. Each colored particle serves as a color separation filter. On top of the screen, or reseau, is a waterproof layer and atop all of this is a panchromatic silver halide emulsion. In use, the emulsion is faced away from the lens, so that the light can go through the screen first. (*b*) Red light is passing through a red area in the mosaic screen. The blue and green particles block the passage of red light; thus only the area behind the red particles will be exposed. After exposure, the plate or film is placed in a black-and-white developer, producing silver density behind particles through which light has passed. After development, the unused silver halide is not fixed out; instead, the silver is bleached out, leaving clear areas in the appropriate places. (*c*) After the silver negative image has been bleached out, the plate or film is exposed to white light. The balance of the silver halide is now developed to form a positive image. In the illustration, silver now covers the green and blue particles, allowing only red light to pass. For green objects, the red and blue particles are covered; for blue objects, the red and green particles are covered; for yellow objects, the red and green particles are uncovered. For cyan objects, green and blue particles are uncovered; for magenta objects, red and blue particles are uncovered. The amount of transparency for each color will depend on the amount of that color reflected by the object. (From Norman Rothschild, *Color Photography 1973*, p. 13. Copyright © 1973 Ziff–Davis Publishing Co.)

1,000,000 of these microscopic filters per square inch of film area.[52] Exposing light went through the transparent base, through the filter elements, and exposed the silver halide emulsion. The exposed silver halide was developed and the silver removed, leaving clear gelatin in areas exposed by one of the filter colors. The remaining silver halide was then light-flashed, or fogged, and developed.

Light passed through those filter elements of the transparency where the exposing light had passed originally. Blue exposing light was reproduced in only that color because only the blue filter elements were not blocked with metallic silver. Part of the yellow exposing light passed through both the green and red filters but not the blue. Although some metallic silver was present under both these filter elements in the final transparency, some light would still pass through the red and green filters but not the opaque blue filter areas to create the sensation of yellow. A 16mm Dufaycolor motion picture film was introduced in 1934. Polaroid's Polavision instant movie film is a further refinement of the Dufay lined screen film.

In the Finlay color process the 175-line filter screen was separate from the light-sensitive plate. Separate screens were used for exposure and reproduction. The black-and-white negative could be used to produce as many color transparencies or black-and-white prints as desired.[53] A more complete review of screen plates and films is given in Chapters 17 through 20 of E. J. Wall's *The History of Three-Color Photography*. A summary of granular and regular line screen plates and films has also been given by Gert Koshofer.[54] The processing solutions used for the Agfacolor plate, the Lumière Autochrome plates and film color, and Dufaycolor film are summarized in the *Handbook of Photography*.[55]

A third screen process—the lenticular—was also practiced. In his description of the lenticular process Joseph S. Friedman[56] credits F. N. Lanchester (1895) with the germ of the idea; Gabriel Lippmann[57] as the one who first (1908) suggested the possibility of a lenticular film; and R. Berthon[58] (1909) as the one who showed how to make the film. A lenticular film was used commercially: an Eastman Kodak Company color film called Kodacolor for 16mm amateur movies.[59,60] A filter consisting of blue, red, and green bands was introduced in front of the lens. Exposure was through the back of the film support which was embossed with minute cylindrical lenses. By optical means the filter was imaged as parallel bands on the photographic emulsion, producing an effect similar to that of the line screen process. Kodacolor lenticular film was reversal processed to a positive transparency. When this film was projected through a lens with a similar three-banded filter, a colored image was formed on a white screen. The camera film was slow in speed but the projected color images were of acceptable quality.

Difficulties in making prints limited the theatrical uses of the film. A foreign review article stated that "the Kodacolor process is a step towards solving the problem of color movies, but still only for the amateurs (characteristic line of the capitalistic science where the interests of private consumers dominate the general public interests)."[61] Agfa color lenticular film in 1932 made 35mm color photography possible for the first time.

SUMMARY OF EARLY COLOR PROCESSES

The bleaching action of light,[62] or the interference[62,63] or diffraction properties of light,[62] have been used to make colored images. The most practical of the early color photographic systems, however, depend upon reproducing not the actual color of the subject but only its psychological equivalent. This approach is possible because the human eye and mind perceives color as a result of the stimulation of three receptors—for blue, green, and red light—in the retina of the eye. The mind synthesizes color from the sensations resulting from millions of these nerve receptors. Maxwell demonstrated that a color picture could be perceived from blue, green, and red photographic records projected in register on a white surface. This type of three-color photography reached its highest stage of perfection with the three-color camera, although motion picture photography by this means was difficult. Coating the three-color filters on a transparent material in the form of millions of microscopic lines, squares, patterns, or dyed particles, following the original suggestion of Ducos du Hauron, produced a more reliable and convenient photographic material—the screen plate or film. Dufaycolor film and the Finlay plate with their ruled lines in the primary colors were of good photographic sensitivity and were processed easily and rapidly with ordinary darkroom solutions and equipment.[64] (See Figure 4.)

The screen films and plates have good color rendition, as the filter elements do not overlap, but the saturation is somewhat lowered by the scattering of light from one minute filter area into an adjoining one. The color is formed by adding the sensations produced by the light that passes through each filter. These three-color methods are called additive color processes. The blue filter passes only blue light, from full intensity to zero, depending on the amount of metallic silver present, and absorbs the green and red light. The green filter passes only the incident green light, from full intensity to zero, and absorbs the blue and red light. The red filter passes the red light, from full intensity to zero, but absorbs the blue and the green portions of the incident white light. In each case, essentially two-thirds of the incident light

is lost and only one-third is passed to form the final color image. Only after passing through the separate filter elements can the transmitted light be added together to form the color image. Any additive color process has a great waste of the incident light: only one-third of it is usable, and, in practice, only about one-tenth is used effectively.[65] This loss of light, though serious, may not be of such great concern for home viewing of transparencies but becomes a serious obstacle for theater projection of motion pictures. Additive color systems are difficult to adapt to the production of color prints with an opaque paper base. These limitations of the additive color system indicated that a more effective color process was still needed—a process that was to come as a result of a better understanding of color analysis and synthesis together with a major contribution from photographic chemistry to make it possible. (See Figure 5.)

Figure 4. In these enlargements (negative) in black and white of Dufaycolor film (positive), the screen grid is not especially evident at small enlargement (*a*) but the nature of the image is revealed at greater enlargement (*b*). (From $2\frac{1}{4} \times 2\frac{1}{4}$ Dufaycolor film from the author's collection)

(b)

Figure 4 (*continued*)

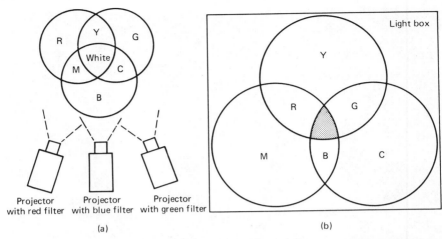

Figure 5. (*a*) Additive color. If three projectors are used to cast three beams of light across each other, one red (R), one green (G), and the other blue (B), white light will result where all beams intersect. In this method, the colors are being "added" together. Where the red and green beams intersect, yellow results. Where the red and blue intersect, magenta results. Where blue and green intersect, cyan results. Since yellow, magenta, and cyan are each a combination of two colors, with the third missing, they are also designated as minus-blue, minus-green, and minus-red, respectively. (*b*) Subtractive color. When a yellow (Y), magenta (M), and cyan (C) filter are laid atop each other on a light box, the point at which all overlap will be black, or pass no light, since all light has been absorbed, or "subtracted." Where the yellow and cyan filters overlap, green light passes. The yellow filter passes red and green light, but blocks or "absorbs" blue. The cyan filter passes blue and green but absorbs red. The only color passed by both filters is green, which reaches the viewer. Where yellow and magenta filters overlap, red light passes, the only color not blocked or absorbed by either filter. Where magenta and cyan filters overlap, blue light passes, the only color not blocked or absorbed by either filter. (From Norman Rothschild, *Color Photography 1973*, p. 6.) Copyright © 1973 Ziff–Davis Publishing Co.

SUBTRACTIVE COLOR PROCESSES

In the additive color processes the color image is formed by adding each of the three primary colors (blue, green, and red) in register to obtain the color reproduction of the subject photographed. White light is formed when suitable quantities of each of the three primaries are added together. This is not nature's method of producing color. When white light, such as sunlight, falls upon the subject, some of the light is absorbed or subtracted, the remainder being passed on to the retina. The eye perceives the subject to be of a color represented by the sensation produced by the remaining light after the subtraction of the absorbed radiation. If the subject subtracts blue from

the white light, the green and red components remain. The eye perceives the green plus red components as yellow, the complementary color to blue (yellow is sometimes called minus blue). Subtraction of green from white light leaves blue and red, a color seen as magenta (minus green). Subtraction of the red component from white light leaves the blue and green components, a color called cyan (minus red). In each case, only one-third of the light is subtracted and two-thirds is allowed to pass. Subtractive color formation is thus superior in light efficiency to the additive synthesis of color. Passing white light in succession through yellow (minus blue), magenta (minus green), and cyan (minus red) filters or dyes would subtract all of the visible spectrum of colors. The eye would experience the sensation of black, the lack of light.

Louis Ducos du Hauron, who seems to have anticipated almost every modern color photographic process, was the first to suggest the use of subtractive colors for the preparation of color photographs.[66] Three separation negatives were made by exposure through orange, green, and violet-blue filters. The negative taken through the violet-blue filter was converted to a yellow positive: that made with the green filter was used to make a red positive; and that made with the orange filter was used to make a blue positive on pigmented bichromated gelatin. Superposition of the three positives was said to yield a polychromic picture.

Each positive was clear where the original negative exposure had been made, and the background was colored where no exposure had originally occurred. The blue filter negative produced a yellow positive that was clear where the original blue exposure had been made. White light passed unchanged through this part of the yellow positive but had to pass through the superposed blue (red-absorbing) and the red or magenta (green-absorbing) positives. Blue light was the only light to be transmitted. This was the color of the original exposure. The green filter negative produced a magenta positive that was clear where the original exposure was made. Light passed through this clear area but also had to pass through the superposed yellow (minus blue) and the cyan (minus red), yielding green light. The red filter negative had produced a cyan image that was clear where the original red exposure had been. White light was unaffected in this area of the cyan positive but had to pass through the yellow (minus blue) and magenta (minus green) positives. The emerging light was red, as the remainder of the spectrum of colors had been absorbed, restoring the effect of the original red light exposure.

Subtractive color reproduction has substantial advantages when compared with additive color systems. White areas from additive color systems are formed by the blending of the three primary colors, limiting the brightness of a projected image. White is produced by the subtractive color reproduction

process by the absence of any dye deposit in each of the three primary dye layers; in other words, the incident light brightness is transmitted without any significant attenuation. Each additive filter element transmits less than one-third of incident light, absorbing more than two-thirds, and the transmitted light is modulated by an opaque silver deposit. The dyes of the subtractive color synthesis absorb only one-third, and pass two-thirds, of the incident light without the need for the silver image. The three filter elements of the additive system must be separate (not overlapping), the emergent light being combined after passing through the three color filters. With the subtractive system the three dye images can be placed one on top of each other, the incident light being modulated by each primary dye layer in turn. The emergent light need not be blended, or suffer from the granular or grid effect, that limits the degree of magnification of the additive synthesis of color. This is a significant advantage for motion picture exhibition in theaters. The early Kinemacolor process,[67] for example, was a two-color additive system that exhibited color fringing when there was rapid action, such as a horse having two tails, one red and the other green. The first Technicolor camera had a single lens with a beam splitter to expose, simultaneously, two images which were then used to project through two apertures, with different color filters on each, an image in register on a screen. According to H. T. Kalmus,[68] the "special attachments on the projector required an operator who was a cross between a college professor and an acrobat."

At first, the additive color system required three separation negatives made through the three primary color filters. Ducos du Hauron suggested and patented in 1895 the simultaneous exposure of the three records by placing the three photographic materials in contact as a single unit. This unit is called a tripack. Ducos du Hauron's tripack consisted of a blue-sensitive plate of high transparency and low sensitivity, the glass side of the plate toward the lens. A yellow filter was added to remove any blue light that passed through the plate, because any such light would expose the other silver halide emulsions that were also blue-sensitive. Next in the pack was a green-sensitive photographic material followed by a red filter to remove any transmitted green light. A red-sensitive or panchromatic plate completed the tripack. Images produced by such a material were subject to loss of sharpness because of diffusion through the photographic emulsions that were not transparent. The blue positive was the one with the most diffusion, and it is in the blue or cyan positive record that the eye is most critical in detecting the lack of sharpness. The sharpness contribution of the red positive is much less and the yellow has little effect. An improved tripack[69] was made in 1929 that had the sharpness-determining red-sensitive emulsion layer first, so that the cyan positive would have improved definition. Even Ducos du Hauron[70] in 1897 recognized the small contribution of the yellow positive

and suggested that it could be eliminated with surprisingly good color reproduction. The fact that the eye and brain respond so favorably to two-color (no yellow) reproduction made possible the early two-color motion pictures. Even so, parallax and registration of two (red and green) separate images was an almost insurmountable problem when scaled up to the dimensions of a theater motion picture screen.

Much human ingenuity has been devoted to simplifying the necessary procedures for forming the final colored image, particularly for photographic paper prints and motion picture prints. The Carbro Process[71] used the three separation negatives to produce three bromide prints. These prints were then contacted with three sensitized and pigmented but unhardened gelatin tissues, the gelatin being insolubilized in proportion to the amount of silver image of the print. Further processing involved the removal of the soluble gelatin with hot water, forming a colored relief image that was transferred in register to the final support. Imbibition methods were also used, such as the early Eastman Wash-Off Relief Process[72, 73] or the modern Kodak Dye Transfer Process,[74] which is used today to produce the highest-quality color prints.

The Dye Transfer Process involves the printing of each of the three separation negatives through the base of an unhardened photographic film. Each of these positives, called a matrix, is developed in a tanning developer, such as one containing pyrogallol as the developing agent in a low-sulfite formulation. Each matrix is then treated with hot water to remove the unhardened gelatin, forming a positive relief image in clear gelatin. Subtractive dyes (cyan, magenta, and yellow) are imbibed into the appropriate gelatin relief images, then the dyes are transferred in register to a support, such as a paper with a mordant to anchor the dyes. Early Technicolor motion pictures, consisting of thin gelatin relief images whose backs were welded together, had reliefs dyed in complementary colors. These two-color prints were later (1932) replaced by three-color imbibition prints for theater exhibition.[68]

The coating of more than one emulsion layer on top of another had been suggested by a number of persons,[75] including Ducos du Hauron, but Karl Schinzel[76,77] has been credited (by Joseph Friedman[78]) with being the first to described a multilayer material for color photography. Schinzel proposed to coat three silver bromide emulsions, sensitive to either blue, green, or red light, on top of each other on a single plate. This coating arrangement is called an integral tripack. Each sensitized emulsion layer was to contain a dye complementary to the spectral sensitivity, the dye to be destroyed in the image developed areas. At that early time Schinzel's dye bleach method of generating the subtractive positive dyes was more theoretical than practical. The integral tripack would form three separation negatives automatically in register, but the means to form the subtractive dye images was lacking.

It was well known that silver images formed by pyrogallol development in a low-sulfite solution were of a warmer color than images formed by other developing agents, such as ferrous oxalate. As shown by R. Ed. Liesegang,[79] the color was due to an insoluble deposit of oxidized pyrogallol with the metallic silver of the developed image. A pyro-developed negative was bleached by Alfred Watkins[80] to remove the metallic silver image, revealing a yellow-brown image that increased in intensity with the density of the original silver image. This colored image was very resistant to chemical treatment. Lüppo-Cramer also studied the nature of the developed silver.[81,82] In almost every case the presence of an insoluble dye image was considered to be a nuisance, and any import for the future of color photography was not recognized.

During a study of the latent image and the silver negative image, Benno Homolka[83] found that indoxyl or thioindoxyl could be used to develop a latent image to form metallic silver and an indigo dye.

two molecules of indoxyl one molecule of indigo
 (a blue dye)

two molecules of thioindoxyl one molecule of thioindigo
 (a red dye)

The blue indigo or the red thioindigo dye images were revealed when the metallic silver image was removed by potassium cyanide. Later, Homolka[84] found that the monomethylether of naphthohydroquinone or 4-oxyiso-carbostyril also yielded dye images when the compounds were used as developing agents. The developing agent *o*-aminopenol, for example, has been found to produce a yellowish-brown dye image:

This type of dye formation in which a developing agent reacts with itself, or with its oxidized form, has been called primary color development.

Primary color development has never achieved widespread application, but the observations of Homolka and the others about the colored oxidation substances of developing agents served a valuable purpose. Rudolf Fischer[85] patented the practical application of Homolka's work for making additive or subtractive photographs. For the first time the process of making photographs in natural colors was termed "color development," and the substances causing the color development were called "color formers." Fischer described a subtractive color process as follows:

Three emulsions are made, one being sensitive only to blue, another only to green and a third only to red. In these emulsions are incorporated the substances necessary for the formation of each color, i.e., the substances termed "color formers," the latter being so selected, for example, that color is formed at any time which is complementary to the corresponding selective color-sensitization of the halogen-silver. Now when these three emulsions are poured out in three layers one on another, there is formed, e.g. under the action of blue light, a yellow color, and at the places acted on by red or green light the corresponding complementary colors. When the colors are correctly chosen those places which white light strikes become nearly black, while at those whereon no light strikes, (i.e. under the covered parts of the negative), no coloration is formed at all, and consequently after fixing white results. By copying a complementary-colored negative on such a layer the correct colors and correct black-white values are obtained. As such superposed layers are very thin they will actually stop only light rays of their own color.

In an example, pyrogallol was used to produce a yellow image, thioindoxyl carboxylic acid a red image, and indoxyl carboxylic acid a blue image.

Fischer also patented[86] a process that formed the dyes by secondary color development; that is, the oxidized developing agent was caused to react not with itself but with a second compound that was added along with the developing agent. Fischer called this second compound a color coupler, because it combined or coupled with the oxidized developing agent to produce the dye image. p-Aminophenol or a p-phenylenediamine (for example, dimethyl-p-phenylenediamine) could be combined with phenolic compounds (phenol, α-naphthol, or xylenol) to produce blue or cyan dyes; these developing agents could be used to produce magenta or yellow dyes when used with coupling compounds containing an active methylene group. Rudolf Fischer and H. Siegrist[87] combined the multilayer coating of blue-, green-, and red-sensitive emulsions, each containing a coupler to produce the complementary dye, with development by p-aminophenols or p-phenylenediamines. Thus, at the beginning of the twentieth century Fischer and

Siegrist had described the foundations of modern color photography. Unfortunately, the dye couplers suggested diffused from one layer to another, causing dye contamination, and the proposed color systems were not satisfactory for commercial production at that early time. Two possible approaches were suggested—isolating the couplers in the film by means of barrier layers or using a developing solution containing the coupler—but neither was satisfactory for a successful color product at that time.

Kodachrome color film, the first modern integral tripack subtractive color material derived from the Fischer concepts, was introduced by Eastman Kodak Company in April, 1935, as 16mm movie film, the 35mm film not becoming available until August, 1936. (This film is not to be confused with an earlier, two-color Kodachrome process, the invention of John G. Capstaff,[88] used in 1914 for portraiture and in 1916 to make the very first two-color motion picture.) Two professional musicians, Leopold Mannes and Leopold Godowsky, Jr., had independently carried out their experiments on color film materials for about 10 years before joining Kodak in 1930.[89-94] Their patent rights were acquired by Kodak and served as the basis for Kodachrome film. However, the Mannes–Godowsky process was far from commercially acceptable, and many others of the Kodak Research Laboratory made valuable contributions.[95] Gert Koshofer[54] credits Merrill W. Seymour,[96,97] John G. Capstaff, and Leo T. Troland[98-100] of Technicolor as co-inventors along with Mannes and Godowsky,[101-109] but other unnamed scientists helped in the perfection of Kodachrome film.

Kodachrome was really a black-and-white film with separate layers sensitized to blue, green, and red light. There were no color components in the film layers. Both the color developing agents and color couplers were supplied from the processing solutions. A controlled diffusion method was used to introduce the dyes into the film layers, requiring continuous processing machines. More than 30 stages of development were said to be involved, requiring three separate developments on three machines with film drying between machines. The Kodachrome film process was described by E. R. Davies[110] and C. E. Kenneth Mees[111] but has been summarized elsewhere[112] as follows: "After negative development, the silver was bleached and the remaining silver bromide redeveloped as in the reversal process to give silver and cyan dye in all three layers. By a process of controlled diffusion, the dye in the two upper layers was destroyed, and the silver in these layers reconverted to silver halide. The two upper layers were then developed in a solution which produced black silver in association with a magenta dye. By a second bleach bath, the dye in the top layer was destroyed and the silver reconverted to silver halide. The top layer was then developed in a solution which produced black silver and a yellow dye. As a final step, the silver was removed from all three layers, leaving only the dye images." The

dyes, however, were reported to be unstable, especially the yellow and magenta, which faded to leave a blue monochrome image.

About 1938 the unwieldy processing of Kodachrome film was changed. The new processing method, involving differential reexposure, was described by C. E. K. Mees[113] as follows:

In this process, the exposed film is put through an ordinary developer to produce a silver image. Then the film is exposed through the base to red light, which makes developable the unexposed silver bromide in the bottom layer, and this is developed with a cyan coupler, so that in the bottom layer a positive image in cyan dye is associated with the development of the whole of the silver bromide originally present in the layer. Next, the top side of the film is exposed to blue light and is passed into a developer containing a yellow-forming coupler. Then all the silver bromide is exhausted except that corresponding to the positive image of the middle layer, which is developed with a coupler forming a magenta dye. There are then in the film three positive images in the appropriate colors and the whole of the silver bromide converted into silver by the two development operations which each layer has undergone. The silver is removed from all three layers, and the film is fixed, washed, and dried.

This method of Kodachrome film processing has undergone some evolutionary changes for the later Kodachrome II film (introduced in 1961) and Kodachrome-X film (1963) and the Kodachrome 25 and Kodachrome 64 films (1974). The use of chemical fogging rather than light exposure for reversal of the magenta layer and the use of three different p-phenylenediamines in the color developers for the cyan, magenta, and yellow layers, are examples of some of these changes.

Kodachrome film made possible a commercial color product, but the method to process this film did not really represent a chemical solution to Fischer's problem with wandering incorporated couplers. Agfa solved this problem first. Wilhelm Schneider and Gustav Wilmanns and an associated team of organic chemists[114-121] found that attaching long hydrocarbon chains to the molecules of known couplers would anchor the molecules in place and prevent their diffusion into adjacent layers. In order to make it possible to coat such large and insoluble molecules from an aqueous emulsion composition, acid groups were added to the long chain of carbon atoms, some chains having as many as 18 carbon atoms. Once coated in a gelatin layer, the large coupler molecule was immobilized by its size, preventing unwanted migration from the layer. The new reversal film, introduced on October 17, 1936, and marketed first as a 35mm daylight type in November of 1936, was called Agfacolor Neu.[122,123] This name served to distinguish the new film from an Agfacolor lenticular screen film and an Agfacolor granular screen film. Agfacolor Neu was also marketed in the United States

as Ansco Color film.[124] A similar photographic material coated on an opaque white base (Ansco Printon) was used to make photographic prints as early as 1942. Seizure and publication of the details of the manufacture of Agfacolor made this information available to competitors after World War II.[125,126]

Couplers that are made nondiffusing by anchoring the molecules with long fatty chains are generally known as Fischer couplers. Agfa patents claimed chains longer than five carbon atoms to produce nonwandering molecules. Examples of such Fischer couplers are:

$$C_{17}H_{35}CONH - \bigcirc - COCH_2CONH - \bigcirc \genfrac{}{}{0pt}{}{COOH}{COOH}$$

yellow

magenta

cyan

In Agfacolor Neu the red-sensitive silver halide layer containing the cyan coupler was coated next to the film base. On top of this layer was placed the green-sensitive emulsion with the magenta coupler. A yellow filter layer was was then added. On top of the yellow filter was coated the blue-sensitive emulsion layer containing the yellow coupler. When this exposed integral tripack (monopack) was developed in a solution containing a color developing agent, such as *N,N*-diethyl-*p*-phenylenediamine sulfate, a nondiffusing

yellow dye was formed in the top layer, a magenta dye in the middle layer, and a cyan dye in the bottom layer. Unlike the complex machine processing necessary for Kodachrome film, color development of Agfacolor was a simple processing procedure, capable of being carried out in any darkroom. The processing of Agfacolor film offered a distinct advantage for widespread use, particularly by amateur and professional photographers.

Eastman Kodak Company had other ideas about how to incorporate couplers that would not wander. Their approach was to isolate or protect the incorporated coupler in a protective shell or layer. As early as 1937 M. Martinez[127,128] of Kodak proposed that the coupler be wrapped in a resin and then dispersed in the emulsion layer. Cellulose esters were suggested as a dispersion medium by Mannes and Godowsky;[108,109] polymeric substances, such as polyvinyl acetate or polystyrene, were patented by S. S. Fierke.[129] Collodion was proposed by Fierke and David Bennett, Jr.[130] Alternatively, the coupler could be precipitated in gelatin, then added to a nongelatin emulsion (cellulose esters).[131,132] With Martinez, Edwin E. Jelley and Paul W. Vittum have been credited[54] with the perfection of the techniques that made possible Kodacolor film and later coupler-dispersed color films. In their patent, Jelley and Vittum[133] gave the following description of making a coupler dispersion:

The invention, therefore, includes a sensitive silver halide emulsion having a water-soluble binder such as gelatin in which are dispersed particles of oil-like consistency composed of coupler and a high-boiling water-insoluble crystalloidal organic compound. In carrying out the invention, the coupler which has been mixed with the high-boiling organic compound to produce an oil-like mixture may be dispersed in water or gelatin solution or in any aqueous binder of colloidal character which is miscible with the silver halide emulsion. The dispersion may be affected with the aid of homogenizer, colloid mill or the like and the dispersions may be stabilized by the addition of emulsifying agents such as those of the well known fatty alcohol sulfate type. The dispersion may also be formed by dispersing a solution of coupler, and crystalloidal material, in a solvent of low boiling point such as butyl acetate, with water or gelatin solution and subsequently removing the low boiling solvent by evaporation. Here also an emulsifying agent may be used.

A considerable number of ketones, amides, sulfonamides, and other high-boiling crystalloidal materials are given as oil formers in the patent, but the largest listings are of esters or phosphate esters. In British Patent 541,589 butyl phthalate and tricresyl phosphate are said to be good oil formers. Reduced amounts of coupler solvent may be used if an auxiliary solvent (ethyl acetate) is present during dispersion.[134]

C. E. Kenneth Mees[135] states that Kodacolor film was produced because of the needs of the U. S. Army in 1940:

In order to obtain a film that could be processed in the field, it was necessary to incorporate the couplers in the layers. To ensure freedom from wandering, the couplers are dissolved in organic solvents, which are then dispersed in the emulsions as very small oily globules, much as butter fat is dispersed in milk. When the film is developed, the oxidized developer diffuses into the globules and there reacts with the couplers to form dyes.

In the new film three types of coupler are dispersed in the globules, one in each emulsion layer, so that after development the bottom layer (which is red-sensitive) gives a cyan image, the middle (green-sensitive) layer a magenta image, and the top (blue-sensitive) layer a yellow image. If the film, therefore, is developed after exposure with a colour-forming developer, the oxidized form of which can unite with the couplers to form dyes, the three layers will be developed, and after removal of the silver by a bleaching bath a colour negative will be obtained in which not only are the tones reversed, so that black is represented as white and white as black, but the colours are reversed and are shown as complementaries.

When such a complementary colored negative is printed on a negative paper or film of similar type, a positive color print is obtained in natural colors. Kodacolor film,[136] first produced by Kodak in December, 1941, was used for the making of amateur color prints,[137] and has evolved into the current Kodacolor-II film with integral color masks for improved color rendition of the prints. The color masks also give the characteristic orange color to the background of the Kodacolor negative. The color print paper has evolved through several versions, such as Type C in 1955 and Ektacolor paper in 1959, into the present color print paper.

The first reversal film using dispersed couplers in the emulsion layers was Kodacolor Aero reversal film supplied for military use in 1943. A sheet film version, Ektachrome sheet film, was marketed in 1946 using Process E-1 chemicals, later (1959) replaced by Process E-3 chemicals. Other Ektachrome films have been processed by E-2, E-2 Improved, E-4, ME-4, and EA-5 chemicals. Many of these chemicals have now been superseded by Process E-6 chemicals.

Image quality in color prints from color originals was limited by the contrast of the image and the imperfect nature of the subtractive dyes formed in both the negative film and the positive print made from it. Duplication of color transparencies also suffered color losses. As early as 1897 E. Albert[138] found that binding a low-contrast negative in register with a color transparency resulted in better color reproduction than from the transparency alone. The negative silver image, called a mask, lowered the scale of the image of the transparency and thereby improved the color quality of the reproduced image. Kodacolor film from 1944 to 1949 was said to have a silver masking layer coated between the yellow filter layer and the green-sensitive layer.

Such a material was described in British Patent 541,298.[139] After color development, the film was exposed through the back to white light, printing the images of the cyan and magenta dyes upon the masking silver halide. The weak, low-contrast silver positive that was formed after development acted as an integral silver mask to reduce the printing contrast of the negative, producing color prints of enhanced quality. Development masks have been used in various commercial color films, such as those based on Agfa processes.

Silver masks help improve color saturation of the print, but they cannot completely compensate for the imperfect dyes in transparencies, negatives, and the prints. A perfect cyan dye should absorb red light and red light only. Even the very best cyan dyes absorb considerable amounts of blue and green light. The magenta dye should subtract only green light but, in practice, also subtracts some blue. The yellow dye is closer to perfection, and its unwanted absorptions of green and red light are small. As C. E. Kenneth Mees[135] has noted, "As a result of this absorption of green by the cyan dye and of blue by both the cyan and magenta dyes, a duplicate or print from the color transparency will show excessive brightness of the reds and yellows compared with the blues and greens, which are degraded by the unwanted absorptions. Some correction can be obtained by printing by red light the negative mask registered with the transparency. Although the correction obtained in this way is not perfect, it does much to mitigate the excessive brightness of the reds and yellows in the print." The integral mask in Kodacolor film was formed during the last stages of processing.

A more satisfactory method of masking color negatives was devised by Wesley T. Hanson, Jr.[140] By forming complementary color positives in the magenta and cyan dye layers formed by the negative exposure, color negatives could be produced that compensated automatically for the imperfect color absorptions of the color-developed cyan and magenta dyes. In most cases the couplers normally used in subtractive color materials are initially colorless. The couplers used for masking color negatives were not colorless but were yellow in the magenta and orange in the cyan layer. These colored couplers combine with oxidized developing agent, destroying their original color and forming a new one in the exposed areas. In the unexposed areas the original color of the coupler remained.

In the red-sensitive layer the cyan dye formed by development absorbed red light but also some green and blue light. The original coupler had been designed to absorb the same amount of green and blue so that the developed image consisted of cyan dye (where the original coupler color was destroyed) and an orange-colored coupler that had the same absorption of green and blue. The remaining yellow coupler in the magenta layer forms a positive mask that absorbed the same amount of blue light as does the magenta dye. When these colored couplers are used in a negative color film,

such a film does not suffer from the imperfect absorptions of the cyan and magenta dyes, and prints made from such a color negative are superior in color saturation. Ektacolor sheet film, introduced in 1948, was the world's first negative film using integral color masking for improved color print quality. Eastman color negative film, containing integral color masks, has been widely used as camera film for motion picture production.

In almost all modern color films, subtractive dyes are formed by the reaction of the oxidation product of the developing agent, resulting from the development of the latent image, and a coupler, either contained in the film or the developing solution. This process has been called chromogenic development. Since the introduction of Kodachrome film in April, 1935, a great number of chromogenic-processed color films have been marketed, as revealed by a 30-year survey.[141] In almost every case in which subtractive color rendition is used, R. W. G. Hunt[142] has noted that "On many occasions, subtractive color photographs produced by some of the modern commercial processes are so pleasing to the eye that the impression is made that almost perfect colour rendering has been achieved. In point of fact, however, as far as colour rendering is concerned, all subtractive processes suffer not only from the defects inherent in the additive method, but also from some further defects of their own."

Each subtractive dye should stimulate only its own sensing cone in the eye, but with chromogenically produced dyes each cone is not independently controlled by only one dye. Absorption characteristics of even the best cyan and magenta subtractive dyes reduce transmission in regions where such transmission should be 100%. Exact color reproduction is impossible, and blues and green may appear darker than the original subject because of such unwanted absorptions. Increasing the sensitivity separation of the blue-, green- and red-sensitive emulsions beyond the sensitivity separation of the three retinal cones has helped to improve the color saturation of the image dyes but has introduced other distortions of color reproduction, such as an increased response to ultraviolet light beyond that of the eye. Generally, color processes are operated to produce higher contrast than the original subject, as this gives the impression of more brilliant colors at the expense of tone reproduction. Hunt concludes, "What is claimed for modern subtractive processes is that they produce pleasing colour photographs, and that the inevitable inaccuracies are balanced in such a way as to be least noticeable."

THE SILVER DYE BLEACH PROCESS

This process provides dyes with characteristics superior to those produced by chromogenic color development. Color images produced by silver dye-

bleach are superior in brilliance and luminosity—and the dyes are far more stable to light and acid gases, such as SO_2 in the air—than the subtractive dyes produced by oxidized developer-coupler interaction. A color material for silver dye-bleach processing contains the conventional integral tripack arrangement of blue-, green- and red-sensitive emulsion layers, but each layer (or nearby layer) also contains a dye complementary in hue to the color sensitivity of the layer. The complementary dye, usually of an azo type, because it is already formed before being added to the layer, can be selected for correct spectral absorption and great stability to light. After exposure, this color film is developed in an ordinary black-and-white developer to produce a silver image. The developed image is then placed in a dye-bleach bath containing an accelerator. The metallic silver image causes the destruction of adjacent dye molecules in proportion to the amount of silver present in each layer. The remaining silver and silver salts are dissolved and removed. Washing and drying completes the simple processing cycle. Color images formed by the silver dye-bleach process have cleaner yellows and greens, and brighter reds, with improved sharpness of image detail.

The catalytic effect of the silver photographic image was used in 1899 by E. Howard Farmer[143] to tan the gelatin surrounding the silver particles and in 1897 by R. Ed. Liesegang[144] to soften the surrounding gelatin. Karl Schinzel[76,145] proposed a color print process in 1905 that consisted of an integral tripack in which the top blue-sensitive layer was dyed yellow, the middle red-sensitive layer cyan, and the bottom green-sensitive layer magenta. The final step of the processing involved immersing the developed silver images in a peroxide solution, resulting in the release of oxygen from the peroxide in the silver image areas. This oxygen then bleached the adjacent dye. A direct positive color print was produced, although, in practice, the dyes available at that time tended to decolorize in the nonimage areas as well. The destruction of the dyes near the silver image by reduction rather than oxidation was proposed by J. H. Christensen[146] in 1918. Others extended Christensen's work on the destruction of the dye in direct proportion to the amount of developed silver image. Suitable reducing agents included sodium hydrosulfite and stannous chloride.

Béla Gaspar[147] did much to make silver dye-bleach a practical process, as evidenced by the many patents issued to him. Gert Koshofer[54] has summarized Gaspar's struggles to market his film as an independent in the world of major film manufacturers and processors:

The Gasparcolor method was first introduced to the public in Germany in 1933. The colours of the film were remarkably luminous. In 1934 Gaspar founded Gasparcolor Ltd. in London and showed a few of his films to the Royal Photographic Society in 1935. Although Gaspar would have liked to produce feature films, he had to confine

himself to cartoon and advertising films as he could not obtain a beam-splitting camera. The Gasparcolor advertising films produced in various European countries were very successful. It is remarkable that Garparcolor was the world's first commercial multi-layer film. The Second World War destroyed many of Gaspar's plans for he had to emigrate from the U. K. to the U. S. Because of the very strong position of Technicolor and the other American cinefilm processes Gaspar, who had established a new firm in Hollywood, was unable to produce his Gasparcolor film in the U.S.A. He therefore concentrated on the manufacture of the Gasparcolor opaque printing material for colour paper prints. Gaspar introduced his first material for paper prints by the SDB (Silver Dye-Bleach) process in Paris in July, 1935.

Gasparcolor print material was used until 1952.

This Gasparcolor print material was the forerunner of a new color print material that Ciba in Switzerland decided to produce in 1958. Cibachrome paper for prints from transparencies and Cibacolor paper for prints from negatives were shown in March, 1963, resulting in much favorable comment and a revived interest in the potential of the silver dye-bleach process. These materials were later renamed Cilchrome and Cilcolor when Ciba and Ilford joined forces. These materials are now called Cibachrome again, and the greatly improved and simplified process has stimulated renewed interest among amateurs and professionals for making dye-bleach prints. Terry Scott in the May, 1976, issue of *Photography* (London), has said that "Cibachrome-A is probably the best colour print process on the market."

Because of the presence of the azo dyes in the coated layers, silver dye-bleach materials have always been slow in speed, thus preventing their use as camera films. As a print material, however, silver dye-bleach papers have distinct advantages in the saturation of their colors and the stability of their dyes. It has been wished that when major film manufacturers find only diminishing improvements at the end of their patented approaches to sub-tractive chromogenic films and papers, a major effort to apply modern chemical technology may be made to produce both color films and papers of truly lasting quality using the acknowledged advantages of images made by the silver-dye process.

Table 1, a chronology of color materials, is a slightly modified version of one that was originally published by Harvey V. Fondiller on p. 87 of *Color Photography 1973*, a copyright © 1973 publication of the Ziff–Davis Publishing Company.

THE NATURE OF COLOR DEVELOPMENT

Today, the predominant color photographic systems—negative or reversal— use chromogenic development to form the dye images. Exposed silver

Table 1. A Chronology of Color Films

Year	Process	Remarks

Transparency Films

Year	Process	Remarks
1906	Finlay color plate	Made in England; trade name: Thames
1907	Lumière Autochrome	Plates—made in France
1914	Kodachrome	Two-color subtractive process: produced black-and-white separation negatives
1916	Agfacolor Screen Plate	Made in Germany
1932	Agfa Lenticulated Film	Made in Germany
1933	Gasparcolor	Dye bleach film
1935	Dufaycolor	Roll and sheet film based on color screen process of Louis Dufay
1935	Kodachrome	Reversal three-color subtractive (16mm only)
1936	Agfacolor (Neu)	Reversal film made in Germany
	Kodachrome	Available in 35mm
1938	Kodachrome Professional Sheet Film	Available in sheets
1939	Kodak Ready-Mounts	Kodachrome (35mm) returned in 2 × 2 cardboard mounts
1943	Ansco Color Film	First available color roll film
1946	Ektachrome Transparency Sheet Film	First Kodak film that user could process
1953	Agfacolor Sheet Film	User-processed; made in Germany.
1955	Improved Ektachrome Professional Film	Processing kits available
	Anscochrome	ASA 32
1956	Agfacolor CT 18 and CK	CT 18: ASA 50 (daylight); CK: ASA 80 (tungsten)
1957	Super Anscochrome	ASA 100
1959	High Speed Ektachrome	Fastest color film then marketed (ASA 160, daylight; ASA 125, tungsten)
1960	Super Anscochrome 6500	ASA 100 sheet film, balanced specifically for electronic flash
1961	Kodachrome II	ASA 25 (daylight) or 40 (indoors); processed by Kodak or others
1962	Agfachrome CK 20	ASA 80 (tungsten); discontinued 1969
	Agfachrome CT 18	ASA 50 (daylight)

Table 1. (*continued*)

Year	Process	Remarks
1963	Kodachrome-X	ASA 64
	Ektachrome-X	ASA 64
	GAF Color Slide Film D/50, D/100, and D/200 (daylight); T/100 (tungsten)	Replaced Anscochrome and Super Anscochrome 35mm
1966	High Speed Ektachrome	ASA 160; E-4 process
1967	GAF Color Slide Film D/500	35mm (1968: 120 size)
1970	Fujichrome	Available in 135 and 126 sizes; processed by most photofinishers
1974	Kodachrome 25	Replaced Kodachrome II
	Kodachrome 64	Replaced Kodachrome X
	Agfachrome 64	Replaced Agfachrome CT 18
1976	Ektachrome 64 Professional	E-6 process
	Ektachrome 200 Professional	E-6 process
1977	Polavision instant movie film	Additive three-color lined screen film processed in cassette

Color Negative Films

Year	Process	Remarks
1942	Kodacolor	Available in six roll-film sizes (six-exposure rolls); speed rating: Weston 20 (daylight)
1948	Ektacolor Sheet Film	User processed; ASA 25 speed
1955	Kodacolor	ASA 32; processed by independent photofinishers
1956	Kodacolor (two types)	For either indoor or outdoor use
1957	Agfacolor Negative Film CN 17	
1958	Agfacolor CN 14	ASA 20
1961	Ektacolor Professional	Type L: ASA 50; Type S: ASA 80
1963	Kodacolor-X	ASA 64
1964	Agfacolor CN 17	ASA 40: clear base; discontinued 1968
1968	Agfacolor CNS	ASA 80: orange-mask base
1969	GAF Color Print Film	ASA 80

Table 1. *(continued)*

Year	Process	Remarks
1970	Fujicolor	Made in Japan: processed by independent photofinishers
1972	Kodacolor II	Improved color negative film; ASA 80
1973	3M Brand Color Print Film	ASA 80
1974	Fujicolor F-II	ASA 100
1976	Fujicolor 400	ASA 400
1977	Kodacolor 400	ASA 400

Color Print Materials

Year	Process	Remarks
1877	Carbon	Invented by Louis Ducos du Hauron
1930	Tri-color carbro	Pigment—no fugitive dyes
1935	Chromatone	Silver toning process marketed by Defender
1935	Gasparcolor	Dye bleach print material
1941	Kodachrome prints and enlargements (Minicolor)	From 35mm Kodachrome film on white-pigmented cellulose acetate base
1942	Ansco Printon	White opaque base
1946	Kodak Dye Transfer Process	Color prints from three color separation negatives
1955	Kodachrome prints	Made by independent photofinishers
1955	Kodak Type C paper	Later known as Ektacolor paper
	Kodak Type R paper	Later known as Ektachrome paper
	Anscochrome Printon	Improved process
1958	Agfacolor reversal paper	Available for user processing in 1962
1961	Kodak Ektacolor Professional Paper	Improved
1963	Polacolor	In-camera processed; equivalent speed: ASA 75
1969	Cibachrome	Dye bleach print material
	Agfacolor MCN 111	Primarily for photofinishers
1972	Polaroid SX-70	In-camera processed; integral unit with metallized dyes
1975	Polacolor 2	In-camera processed; peel-apart product with metallized dyes
1976	Kodak Instant Print Film	In-camera processed

halide is converted to metallic silver by an active developing agent, resulting in the formation of the oxidized form of the developing agent. In black-and-white photography, the silver image is utilized and the oxidized developing agent is removed. In color photography the reverse is true: the oxidized form of the developing agent is used to form a dye image and the silver image is removed.

In negative color systems, the oxidized developing agent from the first silver halide exposure is reacted further to form subtractive dyes. With most reversal color systems the silver halide that was exposed first is developed in a black-and-white developing solution to form a negative silver image; the remaining silver halide is then light-flashed or chemically fogged, followed by development in a color developer. The oxidized developing agent from this color development is then used to form a positive dye image by reacting with a different coupler in the blue-, green-, and red-sensitive layers to produce the yellow, magenta, and cyan subtractive dyes. All metallic silver is removed from the color materials. Negative color film exposed in the camera produces, after processing, a three-color image in colors complementary to the original subject. Reversal processing produces a color transparency, usually in pleasing colors resembling the original subject.

Color development has been described with the following word equations:

$$\text{exposed silver halide} + \text{color developing agent} \longrightarrow$$

$$\text{metallic silver} + \text{oxidized developing agent}$$

$$\text{oxidized developing agent} + \text{coupler} \longrightarrow \text{dye}$$

Such equations, however, do not reveal the nature of the dye-forming reaction. In his patents, Rudolf Fischer suggested the use of N,N-diethyl-p-phenylenediamine as the color developing agent and α-naphthol as the coupler to obtain a cyan dye from the development of silver. Writing this reaction in the light of present knowledge reveals more concerning the color-forming action. (See top of page 457.) In this case, dye formation involves the removal of four hydrogens (as $4\,H^+$) from the developing agent and coupler, forming four molecules of hydrobromic acid. To accomplish this conversion, four silver ions from exposed silver halide are reduced to four atoms of silver, forming one molecule of the dye. The coupler used to form a dye that requires the reduction of four silver ions is called a four-equivalent coupler. Other types of couplers may only require the reduction of two silver ions. Such couplers are called two-equivalent couplers.

A four-equivalent coupler requires the reduction of four silver ions in order to form the dye. Each N,N-diethyl-p-phenylenediamine molecule can only provide two electrons in going from the reduced to the fully oxidized

N,N-diethyl-p-phenylene diamine α-naphthol silver bromide (exposed)

cyan dye of indoaniline class metallic silver hydrobromic acid

form. Two molecules of the developing agent must be fully oxidized in order to form the single dye molecule, yet only one of the oxidized forms of the developing agent has been used in the structure of the dye. To explain this and other intriguing questions concerning color development has been the objective of many investigators for many years. Current knowledge about dye formation with p-phenylenediamine developing agents indicates that the mechanism is far more complicated than might be thought, involving a series of consecutive reactions, some of which cannot be adequately expressed as simple relationships on paper. The intermediate products of the oxidation of p-phenylenediamines are highly unstable, requiring a jet mixing instrument for their study.[148] Using this mixer and other analytical devices, L. K. J. Tong and M. Carolyn Glesmann[149] in the 1950s were able to elucidate the mechanism of dye formation during color development.

Each nitrogen of *N,N*-diethyl-*p*-phenylenediamine contains two free electrons. The unsubstituted amino group can lose one electron for the reduction of a silver ion, forming a semiquinone of the developing agent.

$$C_2H_5 - \overset{..}{N} - C_2H_5 \qquad + \quad Ag^+ \quad \longrightarrow \quad C_2H_5 - \overset{..}{N} - C_2H_5 \qquad + \quad Ag$$

| *N,N*-diethyl-*p*-phenylenediamine (free electrons represented by dots) | silver ion from exposed silver halide | semiquinone of the *N,N*-diethyl-*p*-phenylenediamine | metallic silver atom |

The positively charged semiquinone is a highly reactive, unstable species called a free radical because of its single unpaired electron. The semiquinone ion exists in several hybrid forms which are continuously being formed and unformed, a process called resonance. These resonating hybrids help prolong the existence of the semiquinone. Six of the principal resonating semiquinones have the structures[150]

For brevity, the first contributing form listed is used here to represent all the resonance structures of the semiquinone.

The semiquinone ion is highly reactive and may be in a number of equilibria, resulting from the loss of an H^+ (yielding a neutral radical), from formation by interaction of the reduced and fully oxidized forms of the developing agent, and dimerization reactions.[151] Some of these equilibria are shown in the following relationship:

$$2 \quad \xrightarrow{-2H^+} \quad 2 \quad \xrightleftharpoons{+H^+}$$

semiquinone ion semiquinone radical (neutral)

$$\quad + \quad \xleftarrow{\quad}$$

reduced form of developing agent fully oxidized form of developing agent fully oxidized form of developing agent

The fully oxidized form of the developing agent, the quinonediimine ion, is the reactive form that unites with the coupler.[149] Reduction of a silver ion removes an electron from the developing-agent molecule to form the semiquinone ion. In alkaline solution, the semiquinone ions are converted to neutral radicals. Two of the semiquinone radicals then react to form a quinonediimine ion and one molecule of reduced form of the original developing agent, or a quinonediimine and the developing-agent molecule may react to form two semiquinones. As the quinonediimine is removed by reaction, the equilibrium system supplies more quinonediimine. Quinonediimine, as does the semiquinone, exists in many resonance-stabilized hybrids.

The positively charged quinonediimine and the negatively charged coupler ion may unite to form, not the dye, but a molecular structure that is similar to the dye, called the leuco dye. The leuco dye is colorless or only weakly

colored. It is believed that the leuco dye then reacts with another quinone-diimine to form the dye, producing a reduced developing-agent molecule in the process. Two quinonediimines, one to unite with the coupler and the other to convert the leuco dye to the dye itself, have been used for each dye molecule. Four silver ions were required to produce the two quinonediimines that are required for the four-equivalent coupler to produce the dye.

quinonediimine α-naphthol ion ⟶

leuco dye ion hydrogen ion

leuco dye ion quinonediimine ⟶

cyan indoaniline dye *N,N*-diethyl-*p*-phenylene diamine

The structure of the leuco dye is the one given by P. W. Vittum,[152] or P. W. Vittum and A. Weissberger,[151] and others,[153] but more recently Fred Porter[154] has written this intermediate by the formula

If a displaceable substituent occupies the coupling position of the coupler, such as a chlorine atom in the 4 position of α-naphthol, the dye can be formed through the use of only one quinonediimine molecule. Only two silver ions are needed to produce this quinonediimine, and the coupler is a two-equivalent coupler. Fred Porter has summarized the chemical reactions with the following equations (using 4-chloro-α-naphthol as the two-equivalent coupler):

quinonediimine

4-chloro-
α-naphthol

leuco dye

leuco dye

cyan dye

$+ Cl^- + HOH$

Only one quinonediimine is needed, as the leuco dye is converted into the dye by the presence of the base used in the reaction.

The base that is present in the color developing solution may also interfere with the dye formation. The quinonediimine can be destroyed by the base in a reaction called deamination. The resulting quinonemonoimine

can no longer form the desired dye, but it may produce undesirable reactions.

$$CH_3CH_2 \quad CH_2CH_3$$

quinonediimine $\xrightarrow{OH^-}$ quinonemonoimine $+$ diethylamine

Quinone monoimine is a highly reactive species and may react with the ionized α-naphthol coupler to form a red dye:

quinonemonoimine $+$ α-naphthol ion \longrightarrow red indophenol dye

The quinonemonoimine may diffuse from the site of its formation and react with the reduced form of the *p*-phenylenediamine developing agent.

quinonemonoimine $+$ *N,N*-diethyl-*p*-phenylenediamine \rightleftharpoons

p-aminophenol ion $+$ quinonediimine

The quinonediimine formed by this reaction may unite with the coupler, forming dye at a distance away from the development site.

Sodium sulfite is the usual preservative in photographic developers, but only a small amount can be used in a color developing solution. Sulfite ion usually reacts with the quinonediimine to produce the 3-sulfo derivative of the developing agent.

$$\text{(quinonediimine)} + SO_3^{2-} \longrightarrow \text{(N,N-diethyl-3-sulfo-p-phenylenediamine)}$$

CH$_3$CH$_2$, CH$_3$CH$_2$ — $\overset{(+)}{N}$=⟨ ⟩=NH + SO$_3^{2-}$ ⟶ CH$_3$CH$_2$, CH$_3$CH$_2$ — N—⟨ ⟩—NH$_2$, SO$_3^{(-)}$

| quinonediimine | sulfite ion | N,N-diethyl-3-sulfo-p-phenylenediamine |

In compounding color developers, control of the basicity of the solution and the sulfite concentration are essential to prevent serious loss of the quinonediimine that might impair the quality of the final dye image.

Color Developing Agents

The subtractive dyes formed by most modern color photographic processes are the result of the union of the oxidized developing agent with an active reaction site on the organic molecules called couplers. The characteristics of the three subtractive dyes thus depend upon the chemical constitution of the developing agent as well as the structures of the three couplers. Much research has been devoted to the investigation of how structural modifications of the developing agent affect its developing activity and coupling efficiency.[155] Hydroquinone, p-aminophenol, and various p-phenylenediamines were suggested by Rudolf Fischer[86] in 1912. The N,N-dimethyl- or the N,N-diethyl-p-phenylenediamines were used at that time for forming subtractive dyes with suitable couplers. These N,N-dialkyl derivatives of p-phenylenediamine have continued to be of major interest because the resulting dyes have desirable characteristics and are reasonably stable after formation.

p-Phenylenediamine is a very slow-acting developing agent, exhibiting strong solvent action on silver halide.[156] In neutral solution this developing agent may appear to lack developing properties, because the oxidized form may partly or totally destroy the surface latent image. Removal of the oxidized form by a coupler accelerates the rate of development at least two-fold for most p-phenylenediamine derivatives.[157] T. H. James has written, however, "Of the group of ring-substituted 4-aminodiethylanilines containing substituents in the 3-position, the coupler did not increase the rate of development by the —OH, —NH$_2$, —NHC$_2$H$_5$, —N(CH$_3$)$_2$, and —NHSO$_2$CH$_3$ derivatives." Sodium sulfite also accelerates development by p-phenylenediamines, but the increase is generally less than that caused by the coupler. The symmetrical or N,N'-dimethyl-p-phenylenediamine is a much more active developing agent than the unsymmetrical or N,N-dimethyl-p-phenylenediamine, but substitutions on both of the —NH$_2$ groups of p-phenylenediamine cause it to fail to couple to form a dye. For color

photography one of the $-NH_2$ groups must remain unsubstituted, although both hydrogens on the other $-NH_2$ group may be replaced.

The substitution of any group on the one amino group or on the ring that increases the tendency of the *p*-phenylenediamine molecule to release electrons increases the activity of the developing agent; any *N*-substitution or ring substitution that is electron attracting decreases the activity of the *p*-phenylenediamine derivative. In general, these were the findings of a 13-man research team[150] studying the properties of the *N,N*-dialkyl-*p*-phenylenediamines. In most cases, bulky groups substituted ortho (2 or 6 positions) to the substituted amino group decreased developing activity. The resonance hybrids of the semiquinone of the substituted developing agent molecule require that the benzene ring and the substituents on the nitrogen of the substituted amino group must all lie in one plane. If the bulkiness of a ring substituent interferes with this required configuration, the formation of the semiquinone is hindered and the molecule will be less effective as a developing agent, because electron transfer has become more difficult.

The following general observations have been found for the *p*-phenylenediamines as color developing agents (the symbol " > " here means "is a better developing agent than"):

(1)

N,N-dimethyl-p-phenylenediamine > N-methyl-p-phenylenediamine > p-phenylenediamine

Substitution of one or more of the hydrogens on the amino group by methyl groups increases the electron transfer capability of the *p*-phenylenediamine molecule.

(2)

N,N-dipropyl-p-phenylenediamine > N,N-diethyl-p-phenylenediamine > N,N-dimethyl-p-phenylenediamine

Lengthening the alkyl groups symmetrically substituted on the one nitrogen increases the developing activity of the molecule. The chain lengths cannot be lengthened much beyond propyl, however, as compound solubility becomes a limiting factor.

(3)

$$C_2H_5 \backslash N / C_3H_7 \quad > \quad C_2H_5 \backslash N / C_2H_5 \quad > \quad C_2H_5 \backslash N / CH_3$$

N-ethyl-N-propyl-
p-phenylenediamine

N,N-diethyl-
p-phenylene-
diamine

N-ethyl-N-
methyl-p-
phenylenediamine

Increasing the chain length of one group on the N,N-disubstituted nitrogen, the other group remaining at the same length, does cause developing activity to increase through propyl.

(4)

$$C_2H_5 \backslash N / CH_2CH_2NH_2 \quad > \quad C_2H_5 \backslash N / CH_2CH_2OH \quad >$$

N-ethyl-N-(β-amino-
ethyl)-p-phenylene-
diamine

N-ethyl-N-(β-
hydroxyethyl)-
p-phenylenedi-
amine

$$C_2H_5 \backslash N / CH_2CH_2NHSO_2CH_3 \quad > \quad C_2H_5 \backslash N / C_2H_5$$

N-ethyl-N-(β-methyl-
sulfonamidoethyl)-p-
phenylenediamine

N,N-diethyl-
p-phenylenedi-
amine

Substitution in one of the alkyl chains attached to nitrogen can increase the activity of a p-phenylenediamine, but the order applies to black-and-white development only. The first is a poor color developer.

(5)

N,N-diethyl-p-phenylenediamine	>	2-amino-N,N-diethyl-p-phenylenediamine

2-methyl-N,N-diethyl-p-phenylenediamine	>	2-acetamido-N,N-diethyl-p-phenylenediamine

Bulky groups in the 2 position hinder formation of the quinoneimine, lessening developing activity.

(6)

3-hydroxy-N,N-diethyl-p-phenylenediamine	>	3-amino-N,N-diethyl-p-phenylenediamine	>

3-(methylsulfonamido)-N,N-diethyl-p-phenylenediamine	>	3-methyl-N,N-diethyl-p-phenylenediamine

The order in (6) applies to black-and-white development only and it is essentially reversed for efficient color development. The first compound listed is a good black-and-white developing agent but a very poor color developing agent.

>

N,N-diethyl-*p*-phenylenediamine

3-chloro-*N,N*-diethyl-*p*-phenylenediamine

Substitutions in the 3 position of the benzene ring of *N,N*-diethyl-*p*-phenylenediamine cause major increases in the development activities of such derivatives. Ionization of

$$-OH \longrightarrow O^-$$

and

$$-NHSO_2CH_3 \longrightarrow \overset{(+)}{-N}-SO_2CH_3$$

increases the developing activity of those compounds containing these groups. Hindrance by most groups in the 3 position with the $-NH_2$ in the 4 position is not a serious factor.[158] The tertiary-butyl group, however, does exhibit steric hindrance.

In a 1972 patent Richard L. Bent and Rowland G. Mowrey[159] claimed certain *p*-phenylenediamine derivatives produced image dyes of superior stability to prolonged exposure to light, heat, or humidity. The color developing agents were either 3-alkyl-*N*-alkyl-*N*-alkoxyalkyl-*p*-phenylenediamines or 3-alkoxy-*N*-alkyl-*N*-alkoxyalkyl-*p*-phenylenediamines. A specific example of such a compound, which is claimed to produce a higher developed dye-to-silver ratio, is

N-ethyl-*N*-methoxyethyl-3-methyl-*p*-phenylenediamine

The coupling efficiency and the developing activity of most of the substituted *N*,*N*-diethyl-*p*-phenylenediamines are quite closely related. Electron-donating substituents in the 3 position usually enhance both developing activity and the coupling reactivity, the amino and hydroxyl groups being exceptions to the general rule. Some very powerful electron-donating groups increase the developing activity but decrease the coupling reactivity.

Allergenic Toxicity

p-Phenylenediamine may cause skin dermatitis that resembles the disorder resulting from contact with poison ivy. The allergenic toxicity of *N*,*N*-dialkyl-*p*-phenylenediamines generally increases with increasing developing activity. This increased toxicity has been attributed[150] "to their reducing action, or, rather, to their oxidation to semiquinones and quinones which, by condensation with body proteins, may form antigens." It has been proposed to introduce water-soluble groups into the *p*-phenylenediamine molecule, thereby limiting the penetration through the human skin by the decreased lipoid solubility or possibly increasing the affinity of the compound for the keratin of the upper skin layers. The true nature of the allergenic activity of *p*-phenylenediamines is undoubtedly more complex than is known, but increased water solubility of the molecule does appear to have some beneficial effect.

Increased water solubility can be given to the *p*-phenylenediamine derivative by the introduction of acidic groups such as —COOH and —SO$_3$H and their salts. Such groups, however, are electron attracting. The unshared pair of electrons on the unsubstituted amino group is made less available for release, such as required for the reduction of silver ions of exposed silver halide. The presence of the water-solubilizing groups may thus cause a serious loss of developing activity by the *p*-phenylenediamine compound. This loss can be minimized, according to Maynard S. Raasch[160]; "If an acid group is to be attached to the nitrogen atom, the group must be separated from the nitrogen atom by a number of carbon atoms in order not to diminish the basicity of the nitrogen atom and the developer activity." Raasch studied a series of *p*-phenylenediamines that had the general formula *p*-H$_2$N—C$_6$H$_4$—N—(C$_2$H$_5$)(CH$_2$)$_n$COOH, where *n* was equal to 3, 4, 5, 7, and 10—that is, carbon chain lengths of three, four, five, seven, and ten —CH$_2$— groups between the nitrogen atom and the —COOH group. The activity of the compounds as developing agents was found to increase when the chain length increased from three to four or five carbon atoms, but the activity then decreased for the longer chain lengths.

To minimize the electron-attracting power of the —COOH used as a

water-solubilizing group, a carbon chain of five carbon atoms is necessary to insulate the effect of the —COOH from the nitrogen of the substituted amino group. The U. S. Patent of Raasch,[161] however, claimed an alkylene group of one to six carbon atoms between the benzene ring and the —COOH group. Other research has indicated that the electron-attracting effect of the sulfonic acid (—SO_3H) groups extend through at least six carbon atoms in a chain.[162] Sulfonic acid groups and their salts have been patented[163] to produce *p*-phenylenediamines having properties that are "but little or not at all allergic to the skin." Examples of such compounds are

$$C_2H_5 \diagdown N \text{—} \bigcirc \text{—} NH \text{—} \underset{\underset{CH_3}{|}}{CH} \text{—} SO_3H$$
$$C_2H_5 \diagup$$

and

$$C_2H_5 \diagdown N \text{—} \bigcirc \text{—} NH \text{—} \underset{\underset{CH_3}{|}}{\overset{\overset{CH_3}{|}}{C}} \text{—} SO_3Na$$
$$C_2H_5 \diagup$$

This type of developing agent was prepared by the reaction of the *N,N*-diethyl-*p*-phenylenediamine with sodium bisulfite and an aldehyde. The claimed reduction in allergenic properties of such compounds has been questioned by P. W. Vittum and A. Weissberger[151]: "The compounds appear to be largely hydrolyzed in the developer solution, and it is difficult to understand why solutions of the patented developing agents should be less allergenic or more stable toward aerial oxidation than the *p*-phenylenediamine from which they are derived in sulphite-containing solutions."

In 1938 Bruno Wendt[164] was granted a U. S. patent for *N*-hydroxy-alkylated-*p*-phenylenediamines. The *N,N*-di(hydroxyethyl)-*p*-phenylenedi-amine was said to develop about three times more quickly than the non-substituted *p*-phenylenediamine and to form purer and brighter colors when used for color development. A developer containing 2-amino-5-(*N*-hydroxyethyl-*N*-butyl)-amino-toluene dihydrochloride was also men-tioned. The introduction of one or more hydroxyethyl groups did increase the solubility of the *p*-phenylenediamine compound in the alkaline develop-ing solution, but the water solubility was not sufficiently increased to de-crease the "malignant eczema and like troubles" of compounds that are freely absorbed by the human skin. Another patent[165] in 1939 proposed

to substitute for the —CH$_2$CH$_2$OH a radical containing several oxy groups, such as —(CH$_2$CH$_2$O)$_n$—CH$_2$CH$_2$OH, where n is a small whole number. Examples of such compounds are

$$C_2H_5-N-CH_2CH_2-O-CH_2CH_2OH$$

NH$_2$·HCl

$$CH_3-N-CH_2CH_2-O-CH_2CH_2OH$$

CH$_3$

NH$_2$·HCl

The U. S. patent states that "their superior solubility and physiological harmlessness distinguish them from known phenylenediamines."

In a 1940 U. S. patent of Arnold Weissberger[166] the allergenic properties of *p*-phenylenediamine developing agents were said to be overcome when a sulfonamide group or an aminosulfonyl group was substituted on the alkyl group on the nitrogen atom of a *p*-phenylenediamine, such as on one ethyl group of *N,N*-diethyl-*p*-phenylenediamine. Such substituted *p*-phenylenediamine developing agents have been said to be low in developing activity. Examples of developing agents[167–171] of improved characteristics have the structures

C$_2$H$_5$ C$_2$H$_4$NHCOCH$_3$
N

NH$_2$

4-amino-*N*-ethyl-*N*-
(*β*-acetamidoethyl)
aniline

C$_2$H$_5$ C$_2$H$_4$NHCOCH$_3$
N

CH$_3$

NH$_2$

4-amino-*N*-ethyl-*N*-
(*β*-acetamidoethyl)-
m-toluidine

4-amino-*N*-ethyl-*N*-(β-
methylsulfonamidoethyl)-
m-anisidine

4-amino-*N*-ethyl-*N*-(*N'*-
methyl-β-methyl-sulfon-
amidoethyl)-3-methyl
aniline

4-amino-*N,N*-diethyl-3-
(β-methylsulfonamido-
ethyl) aniline

Wesley T. Hanson, Jr.,[172] patented the substitution of the acetylamino group in the 3 position of the *p*-phenylenediamine ring. Such compounds were reported to be of low solubility in the developing solution. Substitution of water-solubilizing groups in the 3 position was claimed by Willard D. Peterson[173] to produce developing agents that "are more active as color developers than the unsubstituted *p*-aminodialkylaniline and are more soluble in water. They are also less toxic than the unsubstituted *p*-amino-dialkylanilines." Examples of the compounds in Peterson's patent included

3-(β-hydroxy ethoxy)-
4-aminodiethylaniline

3-(ω-hydroxy diethylene
glycol)-4-amino-dimethylaniline

Arnold Weissberger[174] patented color developing agents of increased solubility that contained a 3-methyl sulfonamido group on an N,N-dimethyl-p-phenylenediamine.

Many attempts have been made to use sulfonic acid groups, that is, —SO$_3$H, to increase the needed water solubility of the p-phenylenediamine derivative and thus decrease the toxicity of the developing agent at the same time. The —SO$_3$H group, like the —COOH group, has a deactivating effect on the developing action. If the —SO$_3$H is substituted on the ethyl group attached to the tertiary nitrogen, forming —CH$_2$CH$_2$SO$_3$H, a low-contrast image is obtained with normal development times. Substitution of a —CH$_3$ or —OCH$_3$ on the carbon adjacent to the primary amino group (the 3 position) does increase the developing activity somewhat but there is a shift of dye coloration to longer wavelengths with the conventional couplers. Oxygen or nitrogen atoms have been added between the alkylene group and the sulfonic acid group, as in —CH$_2$CH$_2$NHSO$_3$H or —CH$_2$CH$_2$OSO$_2$OH, in an effort to weaken the deactivating effect of the acid group.[175] Such compounds are not too stable. The stability can be improved by forming the —CH$_2$CH$_2$NHSO$_2$CH$_3$, as in the many Weissberger patents, but this group resulted in decreased activity.

Other possibilities have been patented. "Very soluble, substantially non-irritant, active developers" are claimed to result when

$$-(CH_2)_n-\!\!\left\langle\!\!\bigcirc\!\!\right\rangle\!\!-SO_3H,$$

$n = 2$ to 6, is attached to the tertiary nitrogen.[176] A claim of "free from toxic effects" has been made for the grouping

$$-(CH_2)_n-O-\!\!\left\langle\!\!\bigcirc\!\!\right\rangle\!\!-SO_3H,$$

$n = 2$ to 10, attached to the tertiary nitrogen.[177] In both cases the other substitution on the nitrogen has from one to six carbon atoms. Such p-phenylenediamine derivatives diffuse slowly through gelatin layers and are difficult to remove by washing. In practice, the developing agent must be soluble—to decrease toxicity and insure diffusion into and out of the layers—but not so soluble so that the oxidized developing agent can migrate to an adjacent layer and cause undesired dye formation that falsifies the color rendition. The deficiencies of sulfonated p-phenylenediamines were claimed

to be overcome, according to an Agfa patent,[178] when the developing agent had the following structure:

$$R_1 - N - R_2$$

$$NH_2$$

where X = hydrogen atom, or an alkyl or alkoxy group having one to four carbon atoms

R_1 = alkyl radical with three to four carbon atoms

R_2 = ω-sulpho-n-propyl- or n-butyl radical (the n-propyl group may be substituted by a methyl group).

The developing agents are claimed to be "completely non-toxic," yet having the same developing properties as *N,N*-diethylaminoaniline. This suggests the tray use of the developing agents in making photographic prints. In addition, "Images produced with the new developers are faster to light than those produced, for example, with diethyl-*p*-phenylenediamine."

Phosphorus-containing groups have been proposed[179] as replacements for either the —COOH or —SO_3H groups. The disubstituted tertiary nitrogen of *p*-phenylenediamine may have an alkyl group of two or more carbon atoms, one hydrogen of which is replaced by

a phosphate group a phosphite group a phosphonic acid group a phosphinic acid group

Other Color Developing Agents

N,N-Dialkyl-*p*-phenylenediamines as color developing agents in the formation of subtractive dyes have been used universally in commercial color processes. A great number of other potential developing agents have been studied, however, but none has yet achieved usage. Rudolf Fischer originally suggested *p*-aminophenol, which yields the quinone monoimine,

after the loss of two electrons. After coupling to form the dye, the hydroxyl group is reformed. The hydrogen of the —OH group is ionizable, resulting in an undesirable shift in the color of the dye. Although this may be overcome by treating the dye image with a ballasted mordant ion to replace the easily lost hydrogen ion, such as with polymeric mordants,[180] *p*-aminophenols have not found use in commercial processes of the past. Some question also has been raised concerning the comparative stability of the subtractive dyes formed with the *p*-aminophenols. P. Martinelli and L. Del Bo[181] concluded that the *p*-aminophenols and the aminonaphthols as well did not produce results of commercial value when used with diffusible or with nondiffusing couplers. *o*-Aminophenol, or substituted derivatives, were patented in 1936.[182] 2,6-Diiodo-4-aminophenol

has been patented[183] as a nontoxic color developing agent. It is claimed to be superior to 2-halogenated or 2,5-dihalogenated *p*-aminophenols.[184] Substituted *p*-aminophenols have been suggested[185] for use with *p*-phenylenediamines in color developing solutions. *p*-Aminophenols are capable of forming stable dyes, however.

Brilliant dyes are said to be formed with couplers when the 1-(*p*-aminophenyl)-3-aminopyrazolines were used[186,187] as color developing agents, although the dyes were shifted about 100 nm to longer wavelengths than when the developer contained a *p*-phenylenediamine. The compound, 1-(*p*-aminophenyl)-3-aminopyrazoline, has the structure

Many derivatives are active color developers, but both amino groups must remain unsubstituted. The 1-(*p*-aminophenyl)-4-aminopyrazolone is not a color developing agent. The following developer

1-(*p*-Aminophenyl)-3-aminopyrazoline	0.9 g
Potassium carbonate	70.0 g
Potassium bromide	2.0 g
Sodium sulfite, anhydrous	3.0 g
Water to make	1.0 liter

produced a required gamma of 0.7 in 3 min, 18°C, but 7 min were required by the following *p*-phenylenediamine developer to accomplish the same result.

4-Amino-*N*-ethyl-*N*-(β-hydroxyethyl)-aniline	5.0 g
Potassium carbonate	70.0 g
Potassium bromide	2.0 g
Sodium sulfite, anhydrous	3.0 g
Water to make	1.0 liter

Compounds of an aliphatic or heterocyclic structure that contain the grouping $-CO-CHNH_2-$ or $-C(OH)=CNH_2-$ have been claimed[188] in color developers for treatment of color materials containing color couplers. These compounds, the 4-amino-5-pyrazolones, correspond in structure to the ortho-aminophenols. The 4-amino-5-pyrazolones are said to permit shorter development times, give improved emulsion speed, and permit a level of several times the sodium sulfite concentration that is permissible with *p*-phenylenediamine developers. The dyes formed are more pure and more stable to light and are more resistant to the action of acids than are dyes formed by *p*-phenylenediamine development. A pure yellow was said to be obtained when 1-(2′-benzthiazolyl)-3-methyl-4-amino-5-pyrazolone was the color developing agent. (4-Amino-5-pyrazolones have also been used as primary developing agents—that is, without the presence of a coupler.[189])

Many compounds have been investigated as color developers. Heterocyclic hydrazones—compounds having an $=N-NH_2$ group—will react with couplers to give very stable azo dyes[190]:

If the $=N-NH_2$ is converted to $=N-NHSO_2R$, only two AgBr are necessary to form the azo dye, as the sulfinic acid is eliminated during the coupling reaction.[191-193] Arylsulfonylhydrazides[194] or *N*-acyl-*N*-aryl-hydrazine[195] may be used as color developing agents with conventional couplers.

Azine dyes may be formed[196,197] when a 1,2,4-triaminobenzene derivative is used as the developing agent, permitting ring closure with suitable couplers:

coupler developing agent

bluish-green dye

The production of azine dye photographic images has been the subject of a number of patents since 1947[198-205] but has not become a commercial process for color photography.

The 5-amino-2-dimethylaminopyrimidines have been reported to be weak color developers.[206]

Most *p*-phenylenediamine color developing agents possess an unsubstituted amino group, which is highly reactive. The incorporation of the developing agent in the emulsion layer is not possible because the silver halide will suffer desensitization. The free amino group will react readily with an aldehyde, as found by Hugo Schiff in 1881.[207] The condensation product

of the amine and the aldehyde is now called a Schiff base. The Schiff base of p-aminophenol is more soluble in sodium carbonate solution than the p-aminophenol itself, according to David Malcolm McQueen.[208] McQueen prepared Schiff base color developing agents by the classic Schiff condensation reaction, as represented by this specific example:

o-carboxy-
benzalde-
hyde p-aminophenol

p-(benzylideneamino-2-
carboxy)-phenol

In developer solutions, the Schiff bases of color developing agents were said to possess improved solubility and greater stability against aerial oxidation, and to produce colored images with considerably less highlight stain. Schiff bases with alkyl chains longer than 12 carbon atoms were suggested for emulsion incorporation as nonmigratory developing agents.

Color developing-agent precursors were prepared by Richard Lewis Reeves[209] by reacting salicylaldehyde with p-aminophenols and N,N-disubstituted-p-phenylenediamines. Such Schiff base developing agent precursors could be incorporated in a photographic silver halide material, the precursor being "capable of splitting at a pH above 9 to release a primary amino silver halide developing agent."

Reeves stated further, "The developing agent precursors are found to be photographically compatible when incorporated into a silver halide emulsion or adjacent layers. They are also found to be more rapidly soluble in aqueous liquids than the parent developing agent in many cases. Further they have a high resistance to oxidation in solution or in photographic layers, and resist hydrolysis in aqueous medium at moderate pH's up to about pH 9, but hydrolyze very rapidly to yield active developing agents at higher pH's." The yellow color of many Schiff bases may affect the blue speed of silver halide emulsions, however.

The Schiff bases formed by the condensation of an aldehyde and a phenylenediamine have been reacted with metal ions by Edward E. Jaffe[210] to form colored pigments of excellent lightfastness. The reaction of a nickel salt with a Schiff base produced a highly insoluble yellow compound of excellent pigmentary properties.

Color Couplers

The early dye chemists found that when an oxidizing compound, such as potassium ferricyanide or potassium dichromate, was added to a solution of a *p*-phenylenediamine and a compound with an activated group, such as a methylene group, various dyes were produced. Rudolf Fischer was astute enough to recognize that if the silver ions from exposed silver halide were used as the oxidizing substance, a color photographic system could be devised using *p*-phenylenediamines or *p*-aminophenols as developing agents for the latent image. The oxidized developing agent could then be reacted with different compounds containing an activated group to form the desired cyan, magenta, and yellow subtractive dyes in the three separate layers of the photographic material. The compounds with the activated \diagdownCH$_2$ (a methylene group) are color-forming substances called couplers. Most couplers may be represented by the general formula

$$\begin{array}{c} X \diagdown \quad \diagup H \\ C \\ \diagup \quad \diagdown \\ Y \qquad H \end{array}$$

where X and Y are parts of a chain or ring structure that causes an attraction for electrons—that is, resulting in a loosening of the binding of the hydrogens to the carbon atom. In alkaline solution the coupler becomes negatively charged because of the loss of one of the hydrogens, which leaves its binding pair of electrons behind.

coupler · alkali · negatively charged coupler ion · water

N,N-Di-alkyl-*p*-phenylenediamine, as the result of the conversion of two silver ions into silver atoms, is oxidized to the quinonediimine. Quinonediimine may exist in a number of resonating structures, but the following are believed to be the preferred ones for coupling:

The positively charged amino group of the quinonediimine and the negatively charged coupler ion are electrostatically attracted, condensing to form a leuco dye.

quinonediimine ion · coupler ion · a leuco dye

Both the imino nitrogen and the coupling carbon have an octet of electrons, and the molecule is uncharged. The leuco dye may be oxidized to the dye by the oxygen of the air or directly by silver ions, but it is believed that the reaction of another molecule of quinonediimine actually oxidizes the leuco dye into the dye. This quinonediimine also required two silver ions to be reduced to metallic silver, making a total of four silver ions converted to four silver atoms for each molecule of the dye.

leuco dye · quinonediimine

dye · *N,N*-dialkyl-*p*-phenylenediamine · hydrogen ion

The fundamental equation summarizing color development and coupling may be expressed as

$$2 \; \underset{R}{\overset{R}{\diagdown}} N - \hspace{-4pt}\langle\!\!\!\!\bigcirc\!\!\!\!\rangle\hspace{-4pt} - N \underset{H}{\overset{H}{\diagup}} \; + \; \underset{H}{\overset{H}{\diagdown}} C \underset{Y}{\overset{X}{\diagup}} \; + \; 4\,Ag^{+} \; \longrightarrow$$

two molecules of *N,N*- coupler silver ions
dialkyl-*p*-phenylene (exposed
diamine silver
halide)

$$\underset{R}{\overset{R}{\diagdown}} N - \hspace{-4pt}\langle\!\!\!\!\bigcirc\!\!\!\!\rangle\hspace{-4pt} - N = C \underset{Y}{\overset{X}{\diagup}} \; + \; \underset{R}{\overset{R}{\diagdown}} N - \hspace{-4pt}\langle\!\!\!\!\bigcirc\!\!\!\!\rangle\hspace{-4pt} - N \underset{H}{\overset{H}{\diagup}}$$

dye one molecule of *N,N*-
 dialkyl-*p*-phenylene
 diamine

$$+ \quad 4\,Ag \quad + \quad 4\,H^{+}$$

four silver four hydrogen
atoms ions

Actually, only one molecule of the developing agent is consumed, although two molecules are involved in the total reaction.

Dye formation involves both the characteristics of the developing agent and those of the coupler. A satisfactory developing agent should be soluble in alkali, as nontoxic as possible, and able to penetrate rapidly the gelatin of the multilayer materials, A high rate of reaction of the oxidized form with the coupler is essential, otherwise dye formation may occur at a distance from the site of the silver reduction. Couplers that are part of the developer solution should be of small molecular size, as such compounds must be readily soluble in the alkaline solution as well as able to penetrate rapidly into the layers of the color material. Couplers contained in the emulsion layers must be nondiffusing and be free from adverse effect on the silver halide. Couplers that are to remain in the emulsion layers after processing should be colorless, unless designed for color masking purposes. Couplers should be highly reactive to form dyes of the desired color and stability. The structural characteristics of the developing agent and coupler should be such as to produce a dye that is stable to the various environmental conditions the dye will encounter. Ideally, the subtractive dyes should absorb light only in their one-third of the spectrum and none in the other two-thirds.

Classes of Subtractive Dyes

The major classes of subtractive dyes that are generally available from chromogenic development are:

1. *Indoaniline dyes* formed from a phenol and a *p*-phenylenediamine.

In actual practice phenol itself would not be used, as the dye would be soluble in the processing solutions and would fade in the light. A more realistic representation of the formation of a modern indoaniline dye is the following:

2. *Indophenol dyes* formed from a phenol and *p*-aminophenol.

α-naphthol *p*-aminophenol

indophenol dye

Indophenol dyes, even when made from complex coupler structures, have not been extensively used, possibly because the dye color is more sensitive to color change when the pH changes. If the coupler contains an —SH instead of the —OH, an indothiophenol dye results.

3. *Indamine dyes* formed from an amine and a *p*-phenylenediamine.

N,N-diethylaniline *N,N*-diethyl-*p*-phenylenediamine

indamine dye

Indamine dyes have been said to be sluggish in forming, limiting their practical usefulness.[211]

4. *Azomethine dyes* formed from a *p*-phenylenediamine and a coupler containing a reactive methylene group. The general representation of a compound with an activated methylene group is

where R_1 and R_2 contain electron-attracting groups that may exist in straight chain or ring structures. A general designation of the formation of an azomethine dye is given by

azomethine dye

Couplers with activated methylene groups are of major importance to color photography, as both the magenta and yellow subtractive dyes may be generated with these compounds.

benzoylacetanilide

yellow azomethine dye

A 5-pyrazolone may be used to form a magenta dye.

a 5-pyrazolone
coupler

N,N-diethyl-*p*-
phenylene
diamine

AgBr | (exposed)

magenta azomethine dye

Modern color photography is primarily the result of the chemistry of reacting a *p*-phenylenediamine developing agent with suitable couplers to form

indoaniline and azomethine dyes. The current practical color developing agents are all *p*-phenylenediamine derivatives, often 3-alkyl-*N*,*N*-dialkyl-*p*-phenylenediamines; however, the useful couplers comprise a much wider range of chemical structures. A veritable host of chemical color-forming substances have been patented, although a much smaller number have been thoroughly studied.

Yellow Couplers

These couplers should produce minus-blue subtractive dyes with maximum absorption between 400 and 500 mμ. Typical yellow couplers contain a methylene group in a chain of atoms, the methylene activated by a carbonyl,

$-\overset{\overset{\displaystyle O}{\|}}{C}-$, on one or both sides. A general example of this yellow coupler would be the 1,3-diketones,

$$R_1-\overset{\overset{\displaystyle O}{\|}}{C}-CH_2-\overset{\overset{\displaystyle O}{\|}}{C}-R$$

such as benzoyl acetic ester,

$$\langle\!\!\!\bigcirc\!\!\!\rangle-\overset{\overset{\displaystyle O}{\|}}{C}-CH_2-\overset{\overset{\displaystyle O}{\|}}{C}-O-C_2H_5.$$

One carbonyl group is sometimes replaced by a $-\overset{\underset{\displaystyle O}{\|}}{C}-NH-$ group, forming

N-substituted-2-acylacetamides,

$$R_1-\overset{\overset{\displaystyle O}{\|}}{C}-CH_2-\overset{\overset{\displaystyle O}{\|}}{C}-NHR.$$

Much attention has been devoted to the benzoylacetanilides,[212]

particularly to the nature of the R_1 and R_2 substituents that may be present at any of the possible ring locations. Electron-withdrawing substituents cause the dye to shift its absorption maximum to shorter wavelengths, and electron-donating groups on the phenyl groups cause a shift in the absorption maxima to longer wavelengths.[213] If R_1 is an ortho-alkoxy and R_2 is an ortho-chlorine group, a dye of improved absorption characteristics is claimed.[214] An ortho-alkoxy group as the R_2 substituent is said to improve the purity of the yellow dye produced.[215] When R_2 is 5-butylsulfonamido and 2-methoxy (R_1 = hydrogen), the coupler molecule has good solubility in the developer but forms nondiffusing dyes of superior characteristics.[216] For nondiffusing couplers that are to be incorporated in the emulsion layer (Agfacolor type), long carbon chains and acid groups are attached to the phenyl groups as in

Various other couplers have been proposed to produce yellow dyes, such as in compounds that replace one of the carbonyl groups with a heterocyclic ring or a —CN replacing one —C— group. Various other possible modifications are described by Glafkides,[217] J. Bailey and L. A. Williams,[218] J. R. Thirtle and D. M. Zwick,[153] and others.

Magenta Couplers

These couplers should produce minus-green subtractive dyes with maximum absorption between 500 and 600 mμ, but most magenta dyes have undesirable absorption in the blue. Much research has been done to find coupler structures and substituents that will minimize this undesired absorption.

Some magenta couplers may have a methylene coupling group adjacent to one one carbonyl if the structure is in the form of a ring. Two activating groups, for example, a carbonyl and a cyano, —CN, group, are usually present when the methylene is in a chain structure, although ring structures on the ends of the chain have a pronounced effect upon the deepening of the color. Magenta couplers incorporating —CN groups are cyanacetylureas,

$$R-NH-\underset{\underset{O}{\|}}{C}-NH-\underset{\underset{O}{\|}}{C}-CH_2-CN$$

cyanacetylhydrazones,

$$R{=}N-NH-\underset{\underset{O}{\|}}{C}-CH_2-CN$$

and substituted acetonitriles,

$$R-\underset{\underset{O}{\|}}{C}-CH_2-CN$$

Phenylacetonitrile,

for example, forms a dye with oxidized 4-amino-*N*,*N*-diethyl-3-methyl-aniline that has an absorption maximum at 516 mμ, but the dye absorption may be shifted to 526 mμ by replacing the phenyl with a *p*-nitrophenyl group.[211] Other substituents or other ring structures on the coupler modify the hue of the dye that is produced.

The most important class of magenta couplers is the 5-pyrazolones with the structure

1-Phenyl-3-methyl-5-pyrazolone was one of the first pyrazolone couplers, reacting in the following manner with N,N-diethyl-p-phenylenediamine:

magenta azomethine dye

This dye has undesirable absorption in the blue, so a wide range of substituents on the benzene ring or at the 3 position of the coupler have been used to obtain improved dyes. The 3-hydroxy has about the same absorption as the 3-methyl. The 3-methoxy substitution is an improvement over the 3-methyl, but the 3-amino, especially the acylamino, has been claimed to improve the absorption of the dye formed.[219,220] Introducing electron-attracting substituents, such as $-NO_2$, $-CN$, or $-SO_3H$, in the benzene ring can also reduce undesirable blue absorption. The solubility of the molecule may be increased by the introduction of the $-SO_3H$ group on the benzene ring in the 1 position. Large ballasting groups needed to immobilize the coupler in the emulsion may also be introduced in the 1 or 3 position. An example is the following Agfacolor magenta coupler:

Bis-pyrazolones, formed by the joining of two pyrazolones by a methylene ($-CH_2-$) or substituted methylene bridge in the 4 position of both molecules, have also been suggested as magenta couplers. Couplers involving ring formation between the 1-phenyl and the 5 position on the pyrazolone have been reported. Indazolones have been suggested for magenta couplers.[221,222] These couplers are of interest because the oxidized *p*-phenylenediamine links through an $-NH-$ rather than a $-CH_2-$ group, forming dyes with low blue absorption. Dye formation occurs according to the following reaction:

Cyan Couplers

A cyan coupler should produce minus-red subtractive dyes—that is, dyes that have a maximum absorption between 600 and 700 mμ—but actually

most cyan indoaniline dyes absorb on both sides of this range, particularly
blue light. Cyan couplers are usually derivatives of phenol,

or of naphthol,

Both these couplers are acids, and it is the ion that is the reactive coupling
form:

phenol naphthol

The cyan coupler must be a weak acid to form the negatively charged ion
that is the coupling form, but the coupler must not be such a weak acid that
it will not ionize, as no coupling will then take place. Coupling takes place
in the 4 position. The dyes formed with the simple phenols or naphthols do
not have sufficient insolubility or stability to be of practical value. Sub-
stitutions on the ring are made to achieve the desired characteristics in the
resulting dye, but such substitutions must not inhibit the ionization of the
hydrogen to form the active coupling ion.

The effect of the substituents in the phenol ring upon the cyan dye char-
racteristics has been exhaustively studied.[223] In 1912 Rudolf Fischer[86]

proposed phenol, cresol, ortho-aminophenol, and thiophenol $\left(HS\!-\!\!\!\left\langle\!\!\!\bigcirc\!\!\!\right\rangle\right)$

as color-forming substances for use with *p*-phenylenediamine and *p*-amino-
phenol developing agents. The resulting dyes were not sufficiently stable to
the effects of heat and light. Couplers in which the 2-amino group had been
converted to the 2-acetylamino group and with a substituent also present in

the 5 position were patented[224–226] for improvements of the dye stability. The simplest of these couplers was

2-acetylamino-5-methylphenol

but other compounds included

2-[α-(4′-tert.-amylphenoxy)-butyrylamino]-
5-methyl-1-phenol

Additional substitutions, such as 6-chloro, were said to improve further the desirable characteristics of the dyes formed. Many other 2-substituents have been patented,[227–230] including

$$-NH-\overset{\overset{\displaystyle O}{\|}}{C}-CH_2CN \quad \text{and} \quad -CH=N-CH_2-CH_2-O-\overset{\overset{\displaystyle O}{\|}}{C}-C_{17}H_{35}$$

or, for nondiffusing couplers,

$$-OCH_2(CH_2)_{16}CH_3 \quad \text{and} \quad -CH=CH-NH-COCH_3$$

or $-CH=N-COC_6H_5$. A coupler with an acylamido group in the 5 position to improve the heat stability and a perfluoroacylamido group in the 2 position

to deepen the dye hue has been patented.[231] Two phenol molecules have been joined by long chains to form couplers.[232,233]

Many useful cyan couplers have been prepared from napthols.[234–237]

Numerous compounds have a 2 $-\overset{\overset{\displaystyle O}{\|}}{C}-NH-R$, where R may be a variety

of chain or ring structures, such as a carbon chain of from 8 to 24 carbon atoms to make an oil-soluble dispersible coupler with nondiffusing characteristics.

Nonwandering cyan couplers that were used in the Agfachrome material were of the structure

Two naphthols joined by long chains have also been patented for cyan couplers.[238]

Many of the cyan dyes are derived from 1-hydroxy-2-naphthamide.

a 1-hydroxy-2-naphthamide

3-methyl-N,N-diethyl-
p-phenylenediamine

cyan dye (uncharged form) cyan dye (charged form)

The effect of various substituents on the nitrogen of the $2 -\overset{\displaystyle O}{\overset{\displaystyle \|}{C}}-NR_1R_2$ amide group upon the dye after oxidative coupling with 3-methyl-N,N-diethyl-p-phenylenediamine has been studied by C. R. Barr, G. H. Brown, J. R. Thirtle, and A. Weissberger.[239] Any substituent that favors the charged form of the dye causes the dye to absorb at longer wavelengths; inhibition of the charged form by a substituent on the amine produces a shift in the dye absorption to shorter wavelengths. The effect of ring substituents in other than the 2 or 3 positions of naphthol has also been reported.[240] Electron-attracting groups in the 5 ring position, such as nitro or chloro, shift the dye absorption to longer wavelengths; amide groups are more effective in a shift in this same direction than are acetyl groups. It was concluded that, with the exception of the amino group, the 5 substituents affect the hue of the dye by a withdrawal of the electrons from the system.

Couplers Containing Replaceable Substituents at the Coupling Site

The couplers discussed so far contain a reactive methylene ($-CH_2-$) group that has replaceable hydrogens. To replace the hydrogens and form one dye molecule by chromogenic development requires the conversion of four silver ions to four atoms of silver. Most of the couplers discussed may have a substituent other than hydrogen at the coupling site. Paul W. Vittum and Gordon H. Brown[241] studied the coupling of para-substituted phenols. They reported that "all of the phenols having coupling reactivity couple by elimination of the substituent para to the $-OH$ group."

$$(CH_3)_2N-\!\!\!\bigcirc\!\!\!-NH_2 + X-\!\!\!\overset{Z}{\bigcirc}\!\!\!-OH + \xrightarrow{\;2\,Ag^+\;}$$

$$(CH_3)_2N-\!\!\!\bigcirc\!\!\!-N=\!\!\!\overset{Z}{\bigcirc}\!\!\!=O + 2Ag + HX + 2H^+$$

where $X = -Cl, -Br, -CO_2H, -SO_3H, -OR, -\underset{H}{\overset{R}{C}}-OH, -\underset{R}{\overset{R}{C}}-OH.$

Substituents (represented by Z) in the phenol molecule influence the rate of the coupling reaction. All substituents in the para position are not eliminated, however. Phenolic couplers having certain 4-substituted groups showed little or no coupling. These inhibiting groups included methyl

$(-CH_3)$ or benzyl $\left(-\overset{H}{\underset{H}{C}}-\bigcirc\right)$, methylcarboxyl $(-CH_2COOH)$, alde-

hyde $(-CHO)$, hydroxy $(-OH)$, esters $\left(-\overset{O}{\overset{\|}{C}}-OCH_2CH_3\right)$, and others.

Note that the formation of the dye with the para-substituted coupler required only one molecule of the developing agent and two silver ions. The leuco dye is formed with a coupler with no para substitution, but the para-substituent is eliminated as a negatively charged ion, removing the two bonding electrons with it, essentially oxidizing the leuco dye to the dye. Only the loss of a proton (H^+) is needed to form the indoaniline dye.

leuco dye elimination of dye
 negative ion

Only the two electrons supplied by the one molecule of the developing agent are needed for the final formation of the dye. This is an example of two-equivalent dye formation, and the coupler is usually referred to as a two-equivalent coupler. If the substituent in the para position of the coupler had been eliminated as a positive ion, such as hydrogen which is displaced as the H^+, the electron bonding pair is left behind. These two electrons must be removed by a second quinonediimine formed by the reduction of two more silver ions. This is an example of four-equivalent dye formation, and this type of coupler is referred to as a four-equivalent coupler. The coupling step

is generally rate determining in phenol couplers, but in some naphthols the elimination step may be rate determining. The same coupling-off group may thus act differently when attached to a phenol or to a naphthol.

A considerable number of modern couplers derived from various chemical structures containing reactive methylene or methine groups now contain coupling-off groups such as fluorine, chlorine, sulfonic acid, acetyloxy, methoxy and phenoxy, and other suitable groups. Such couplers have the valuable property of requiring only two equivalents of silver to produce one molecule of dye, thus permitting lower silver coverages in the photographic material. Thinner emulsion layers may be used, increasing image definition and permitting more exposing light to penetrate to the lower emulsion layers of a color photographic material.

Colored Couplers for Color Correction

The hydrogen, chlorine, or groups of atoms displaced from the coupling site by the quinonediimine have generally not been used photographically. Increasingly, however, valuable photographic use is being made of the displaced substituents. One of the early applications for these coupled-off groups was for color correction of the yellow, magenta, and cyan image dyes. The need for color correction arises because of the inadequacies of these subtractive dyes. Cyan dye should absorb red light and red light only. In photographic materials the cyan dye image produced by chromogenic development absorbs not only red but also some green and blue light. In a negative color material, such as a film designed for making color prints, this unwanted blue and green light absorption subtracts some of the light that should have been used for the print image. In order to obtain a neutral scale under these imperfect conditions, the contrast of the yellow and magenta dye images must be reduced by the amount of the contrast of the images produced by the unwanted absorptions. This may be obtained by the addition of a like amount of the dye images produced from the blue and green exposures used to make the print. The magenta dye, besides having the desired absorption of green light, has some absorption to blue light, yielding an unwanted yellow dye image. This unwanted image must be compensated for by the reduction of the contrast of the yellow dye image formed by the blue light exposure. The yellow dye image has a minimum of unwanted light absorption in regions other than the blue, so a correction is not as necessary for this dye.

The net effect of the imperfection of chromogenically produced subtractive dyes has been summarized by W. T. Hanson, Jr., and P. W. Vittum

as follows: "The over-all effect of these unwanted absorptions of the cyan and magenta dyes is the subtraction of yellow from the reproduction of yellows, the subtraction of magenta and the addition of yellow to the reproduction of magentas, the subtraction of yellow and magenta from the reproduction of reds, and the addition of yellow or magneta or both to the reproduction of blues, greens, and cyans. The effects just cancel in neutrals."

The deficiencies of dyes and the difficulties of obtaining neutral dye images has long been recognized. Correction was first attempted by E. Albert[138] in 1897 for subtractive color printing, and a multitude of ingenious methods have been employed since then for photography. An admirable review of these various methods has been made by M. de Ramaix.[242] "Masking," according to T. H. Miller,[243] "is a technique, used in making color reproductions, either to correct fully or to minimize the reproduction deficiencies resulting from the high photographic contrast or the optical characteristics of the dyes in the original photograph or both." At first, the auxiliary correction image—the mask—was separate and had to be bound in register with the original photographic image.[244–246] Then, techniques were devised to use the silver, silver halide, or unused coupler of the integral tripack, often requiring an additional exposure and processing step, to form an integral mask for color correction of the dye images.[247–251]

Because unused oil-dispersed or substantive couplers remain in the emulsion layers of a processed color material, these couplers are usually colorless. A color negative film, however, is not viewed directly but is the basis of producing color prints on paper or film base. In 1948 Wesley T. Hanson, Jr.,[252] patented a method of using colored couplers for color correction of reproductions from the photographic color negative. The couplers were colored by the presence of azo dye substituents attached to the coupling site of the coupler. The light absorption of the colored coupler with its azo dye substituent can be selected to match the unwanted absorptions of the cyan and magenta dyes so that these undesired absorptions are canceled. The net result of having a yellow-colored coupler for forming a magenta dye is to cancel the undesired blue absorption of the magenta dye. Because cyan dyes have undesired green and blue absorptions, an orange-colored coupler is required to remove these absorptions. The result of the use of the colored couplers is an effect equal to a magenta dye without blue absorption, and a cyan dye without any green and blue absorptions.[253,254] The combination of the yellow- and orange-colored couplers produces a color negative with an overall orange cast. This color cast requires an increase in the blue and green exposures when the color negative is printed. Mixtures of colored and uncolored couplers may be used.[255] Examples of suitable colored couplers have the following structures[256–258]:

Coupler Structure	Color of	
	Coupled Dyes	Coupler

1.

$$CH_3-C \quad C-N=N-\text{⟨benzene⟩}-OH$$

1-phenyl-3-methyl-4-(4-hydroxy
phenyl-azo)-5-pyrazolone

Magenta Yellow

2.

4-(4-methoxyphenyl-azo)-
1-naphthol

Blue Red

3.

5-(5'-carboxy-2'-isopropyl-
phenyl-azo)-8-hydroxyquinoline

Cyan Red

497

The dispersed colored couplers with the azo dye substituent in the coupling position react with the color developing agent to produce the indoaniline or azomethine dye, resulting in the elimination of the azo dye substituent, which then reacts with the developing agent to destroy its color.

$$CH_3-C \quad C-N=N-\bigcirc-OH$$
$$\|N \quad C=O$$
$$N-\bigcirc$$

$$+ \ \overset{(+)}{HN}-\bigcirc-N\overset{C_2H_5}{\underset{C_2H_5}{\diagdown}}$$

$$\downarrow$$

$$CH_3-C \quad C-N=N-\bigcirc-OH$$
$$\|N \quad C=O \quad \underset{H}{N}-\bigcirc-N\overset{C_2H_5}{\underset{C_2H_5}{\diagdown}}$$
$$N-\bigcirc$$

$$\downarrow$$

$$CH_3-C \quad C=N-\bigcirc-N\overset{C_2H_5}{\underset{C_2H_5}{\diagdown}}$$
$$\|N \quad C=O$$
$$N-\bigcirc$$

$$+ \ \overset{(+)}{N_2}-\bigcirc-OH$$

The production of a molecule of dye required one quinonediimine to form the leuco dye and one quinonediimine to oxidize this to the dye. These two

quinonediimines would require the reduction of four silver ions, but the net reaction requires only one quinonediimine. The other quinonediimine is generated by reaction of the coupled-off diazonium ion with the developing agent:

$$\overset{(+)}{N_2}-\!\!\!\left\langle\!\!\!\bigcirc\!\!\!\right\rangle\!\!\!-OH \ + \ H_2N-\!\!\!\left\langle\!\!\!\bigcirc\!\!\!\right\rangle\!\!\!-N\!\!\begin{smallmatrix}C_2H_5\\ \\C_2H_5\end{smallmatrix} \ \longrightarrow$$

$$H-\overset{(+)}{N}-\!\!\!\left\langle\!\!\!\bigcirc\!\!\!\right\rangle\!\!\!-N\!\!\begin{smallmatrix}C_2H_5\\ \\C_2H_5\end{smallmatrix} \ + \ \left\langle\!\!\!\bigcirc\!\!\!\right\rangle\!\!\!-OH \ + \ N_2\!\uparrow$$

The colored coupler is thus a two-equivalent coupler, and its color is destroyed where the dye is formed. In this case, colorless and soluble phenol and nitrogen gas result from the reaction of the coupled-off diazonium group with the developing agent. In the areas where no dye is formed, the colored coupler is retained as a color mask for color correction of the imperfect subtractive dyes. The magenta dye formed from the 5-pyrazolone has an unwanted blue absorption. The colored coupler in all the areas where the dye was not formed has as close as possible to the same unwanted blue absorption. There is a uniform density to blue light in both the dye image and nonimage areas. The magenta image dye appears to have no blue absorption, so only a blue-light exposure adjustment need be made for the overall blue absorption of the magenta dye layer.

Mixing the masking coupler with a colorless coupler attempts to overcome the overmasking effect that results from the higher light-absorption properties of the masking coupler color and the slow reaction rate of the masking coupler. One patented method[257] to overcome these difficulties involved "a colour photographic multi-layer material which comprises at least one emulsion layer having incorporated therein at least one silver halide and a mixture containing only one diffusion-resistant colourless coupler and only one diffusion-resistant azo-dyestuff automatic-masking coupler, the colorless coupler having a reactivity or coupling speed differing from that of the masking coupler by not more than 50 per cent of that of the masking coupler."

The colorless color former and the colored azo-substituted coupler may be contained in separate but contiguous layers in the photographic material.[258] The colored and colorless couplers may be in the same layer, but the colored coupler may form a soluble dye that is removed by washing.[259] Another proposal[260] utilizes a light-colored, non-image-forming colored

coupler whose color is then shifted to the desired characteristics for masking, thus avoiding any light filtration effects during exposure. Colored couplers (2-azo-1-naphthol dyes) can be used with the colorless couplers. According to Keith E. Whitmore and Edward T. Pesch,[261] these colored couplers "will couple to substantially colorless or neutrally colored products which will not adversely affect dye images produced in the same region from colorless couplers." It has been suggested[262] that the colored couplers having an azo-substituted reactive coupling site can be reacted with an oxidized developing agent to form a colored photographic image. The azo group is eliminated during coupling, and an azomethine or indophenol dye image is produced. This is not a method of masking but a process to form the primary color image.

Other masking methods have been described. The color coupling process can be separated from the masking process.[263] For example, for masking the secondary absorption of the magenta dye, "A diffusion resisting yellow dye is incorporated into a layer disposed adjacent to a green-sensitized silver halide layer which contains a diffusion-resisting magenta coupler, the said yellow dye being bleached by the oxidized color developer. The color development then produces the dye image in one layer and the masking image separately in the other layer."

Photographic images may be masked without using colored couplers.[264] A multilayer photographic material containing color couplers is color developed and then subjected to an oxidizing substance usually present in the bleach bath. After oxidation a color coupler is reacted with a mask-forming compound, either present in the photographic material or in a bath between the color developer and the bleach bath. Substituted 4-amino-5-pyrazolones are used as the mask-forming compounds.

The dye substituent that is eliminated from the reaction site of the coupler can be utilized for photographic purposes. If the substituent is a fluorescent dye, the nondeveloped areas will fluoresce after development has destroyed the dye in the image areas.[265] A nondiffusing coupler can have a ballasting substituent in the coupling position. When this substituent is eliminated by the reaction of the coupler with the quinonediimine, a diffusing dye can be formed. This dye then can be diffused to a separate layer, where it is mordanted.[266,267] In other cases, the substituent in the coupling position is not eliminated but the oxidized developer still couples with the coupler, forming a colorless product. This reaction takes up excess quinonediimine that might react with itself to yield unwanted colored products.[268] Substituents eliminated from the coupling site may also react with the quinonediimine to produce soluble dyes that are removed from the emulsion layers. These competitive coupling reactions with the quinonediimine help produce dye images of improved rendition.

Development-Inhibitor-Releasing Couplers

If the substituent in the coupling position of the coupler is a development restrainer, then the elimination of this substituent during dye formation has been claimed to reduce graininess, enhance image sharpness, and, by means of interlayer interimage effects, achieve color correction.[269] Developer-inhibitor-releasing (DIR) couplers can be formed from any of the well-known classes of couplers; phenolic or naphtholic, 5-pyrazolones, and straight chain compounds with reactive methylene groups. Examples of such couplers, which have been patented,[270,271] are used in the following reactions to illustrate the formation of the development inhibitor:

5-pyrazolone DIR coupler

quinonediimine

dye

benzotriazole
(a development restrainer)

One of the most effective development inhibitors is 1-phenyl-5-mercapto-tetrazole. This compound can be generated imagewise when it is eliminated from the coupling position during dye formation.

$O-C_{14}H_{29}$ +

DIR coupler

quinonediimine

$O-C_{14}H_{29}$ +

dye

1-phenyl-5-mercapto-
tetrazole (a
development
restrainer)

The imagewise release of a development restrainer provides a means of modifying the image development within the coating of a color material, either in the layer in which the restrainer was released or in one or more of the other layers of the material. The DIR coupler may be used as the sole coupler, but its use with other conventional couplers provides an elegant means to achieve desirable changes in any of the coated layers. According to C. R. Barr, J. R. Thirtle, and P. W. Vittum,[269] release of development restrainers from DIR couplers provide finer grain, increased sharpness, and improved color quality. The development of grains is restrained, so dye clouds will be of smaller size. Sharpness is improved because of increased edge effects caused by the released restrainer, which is more effective than halide ions. The released restrainers also produce much greater desirable interimage effects than normally produced by bromide and iodide ions. The retarding effects have been found[272] to depend on the solubility of restrainer-silver salt and the exposure.

Interimage effects have been of especial interest to those who design color photographic materials and systems. Gelatin interlayers have been found to be effective barriers to prevent the migration of oxidized developing agent from one emulsion layer to another.[273] One of the products of development is the release of bromide or iodide ions as a result of the reduction of silver ions by the developing agent. In a multilayer color photographic material these halide ions may restrain development in the layer in which they are formed, but the halide ions, particularly the iodide, may diffuse to nearby silver halide layers. Development in these adjacent layers may be restrained as a result of the migration of the iodide. These interlayer effects may be used to correct the unwanted light absorption of the image dyes.[274]

DIR couplers releasing strong restrainers such as 1-phenyl-5-mercapto-tetrazole are much more effective than iodide ions in restraining development in nearby emulsion layers. A cyan-dye forming DIR coupler in the red-sensitive layer, for example, can cause the magenta dye formed in the green-sensitive layer to be formed in the inverse proportion to the amount of development taking place in the red-sensitive layer. This proportional reduction in the amount of magenta dye formed helps compensate for the undesired green absorption of the cyan dye. Thus, improved color quality is obtained, a particularly desirable goal for reversal-processed color images where colored color couplers cannot be used for color correction of the imperfect subtractive dyes.

DYE BLEACH COLOR MATERIALS

Most of today's color processes are based on Rudolf Fischer's concept of condensing the oxidized developing agent with color couplers, forming indoaniline and azomethine dyes within the photographic material. The limitations of forming the dyes during processing have resulted in dye characteristics that have unwanted light absorptions or are not stable to the effect of light and heat. Even before Fischer's proposals, another color system involving subtractive dyes had been proposed: destruction of pre-formed dyes in proportion to the amount of exposure in each of the three color layers of the photographic material. The dye destruction method of forming color images has the advantage of the use of dyes of superior color qualities and of great stability to light and heat. The presence of yellow, magenta, and cyan dyes in their separate layers has a very serious effect on the light sensitivity of the dye bleach material, reducing its speed so that it is not generally satisfactory for camera use. The speed is sufficient, however, for making paper prints or release prints from motion picture originals.

A cyan dye is incorporated in the red-sensitive silver halide layer; a magenta dye is incorporated in the green-sensitive layer; a yellow dye is incorporated in the blue-sensitive layer. According to N. Deuschel,[275] in relation to the gelatin present, from 1.5 to 10% dye must be present to obtain a maximum dye density of from 2.6 to 3.0 for a transparent image. This much dye absorbs a considerable amount of the exposing light in the very spectral region where the silver halide has its maximum light sensitivity, so that the sensitivity of the material is reduced. Some of this disadvantage may be overcome by having the maximum sensitivity of the silver halide displaced from the maximum absorption of the incorporated dye, thus providing a "window" through which the silver halide may be exposed more effectively. Such false sensitization has not been entirely satisfactory. Coating the dyes in layers adjacent to the silver halide layer has given some increase in effective sensitivity but usually with a loss of image sharpness. Dyes sensitive to color changes due to the pH of their environment permit the shifting of their absorption so that light may be transmitted in the layer containing the dye or to layers below. Such pH-sensitive dyes must then be shifted to their desired color by an additional processing step, but the final dyes are not as satisfactory as dyes that are not sensitive to pH changes. Colorless precursors of the dyes have been used to secure improved light transmission, but usually additional processing steps are required.[276] Colorless tetrazolium salts have been patented for this purpose.[277] Colored formazan dyes are formed in the developer used to form the silver image. This dye is then bleached imagewise in the areas of the metallic silver image. Formazan dye images are probably not as stable as other classes of dyes suitable for the dye bleach process.

An integral tripack silver dye bleach material has layers sensitive to blue light, containing the preformed yellow dye, to green light with magenta dye present, and to red light with cyan dye present. A yellow filter layer is necessary below the top blue-sensitive layer, as the yellow dye present does not absorb all of the blue light. To the eye, a dye bleach material is black in the unexposed areas, as each dye absorbs one-third of the light. The color material must be highly hardened, as it must pass through very acidic processing solutions. The silver image of the exposed silver dye bleach film or paper is developed in a conventional black-and-white developer. This imagewise silver is used proportionally to destroy the dye, so that a positive dye image is finally obtained.

The chemical nature of the incorporated dyes is important. A number of classes of dyes, such as anthraquinones, indigos, or triphenylmethanes, might satisfy the spectral and light-fastness requirements, but the dye must be readily degradable. The dye must not form leuco derivatives but must be split into colorless or soluble fragments. The azo dyes appear to satisfy

most of the requirements, especially destructability under processing conditions.[275] Azo dyes feature an —N=N— linkage which can be cleaved through the double bond to yield two colorless amines. If X—N=N—Y represents a suitable azo dye, then the reaction of the dye destruction may be expressed as

$$\underset{\text{azo dye}}{\text{X—N=N—Y}} + \underset{\substack{\text{metallic} \\ \text{silver}}}{4\,\text{Ag}^0} + \underset{\substack{\text{hydrogen ions} \\ \text{(strong acidic} \\ \text{medium)}}}{4\,\text{H}^+} \longrightarrow$$

$$\underset{\text{colorless amines}}{\text{X—NH}_2 + \text{H}_2\text{N—Y}} + \underset{\text{silver ions}}{4\,\text{Ag}^+}$$

Such an equation does not reveal, however, the mechanism involved in the in situ destruction of the dye by the image silver. Béla Gaspar, whose work in the dye bleach field produced many patents,[278–284] felt that the reaction mechanism involved the reaction

$$\underset{\substack{\text{metallic} \\ \text{image} \\ \text{silver}}}{2\,\text{Ag}^0} + \underset{\substack{\text{hydrogen} \\ \text{ions (acid} \\ \text{medium)}}}{2\,\text{H}^+} \rightleftharpoons \underset{\text{silver ions}}{2\,\text{Ag}^+} + \underset{\substack{\text{hydrogen} \\ \text{(nascent)}}}{\text{H}_2}$$

This equilibrium reaction is such that only a few silver ions and hydrogen are formed, leaving almost all the reactants in the form of metallic silver and hydrogen ions.[285] The reaction may be shifted to the right, however, by removing one of the products—that is, silver ion or hydrogen. Removal of the silver ion is accomplished by using a silver complexing agent, often thiourea. As the silver ions are complexed, more are formed from the metallic silver of the image. Eventually all the metallic silver is oxidized to silver ions, which are then complexed by the thiourea in the acid solution. Meanwhile, nascent hydrogen is being released. Nascent hydrogen is a powerful reducing agent that attacks the azo group, —N=N—, in acid solution, cleaving the molecule at the double bond to form two amines. The dye molecule is destroyed imagewise in proportion to the original metallic silver image.

In the dye bleach process it is essential that the dye destruction occur rapidly in order to avoid attack upon nonimage dye located away from the metallic silver. The speed of dye bleaching was found to be accelerated when a compound such as phenazine was present.[286] This compound acted as a

catalyst or electron-transfer compound, the phenazine being unchanged at
the end of the reaction. Compounds having at least one ring of the structure,

particularly with other condensed rings, have been found to be effective as
dye bleach catalysts. If R_1, R_2, R_3, and/or R_4 are hydrogen or other sub-
stituents, the compounds are the pyrazines. If R_1 and R_2 are joined to form
a fused aromatic ring, the quinoxalines are formed. If two fused aromatic
rings are formed from R_1, R_2, R_3, or R_4, the phenazines are produced. All
of these compounds are 1,4-diazines and all are effective as catalysts for the
dye bleach system. These compounds are often used as substituted deriva-
tives, containing solubilizing groups, such as —SO_3H.

pyrazine quinoxaline

phenazine

The 1,4-diazines are believed[287-288] to act as mobile electron carriers
between the silver image and the immobile azo dye. Only a small amount
of the carrier is needed, because each molecule completes many cycles of
electron transfer. The 1,4-diazine may be incorporated in the photographic
material or may be present in the developer or in the processing solution
that also contains the silver complexing agent and a strong acid. During
its recycling the oxidized form of the 1,4-diazine takes electrons from the

metallic silver of the image, producing the reduced form. The reduced form then transfers the electrons to the azo dye, regenerating the original oxidized form of the 1,4-diazine. The addition of the electrons results in the reduction of the azo dye linkage to cleave the dye molecule into two colorless or soluble amines. Because the electron transfer results in the formation of the original form of the 1,4-diazine, this compound acts as a true catalyst by increasing the rate of reaction without itself being changed by the reaction.

Under acidic conditions the 1,4-diazines, such as represented below by phenazine, change from their original oxidized to the reduced form in one-electron steps.[289] A stable semiquinone is formed upon the addition of one electron, and the second electron produces a 1,4-dihydrophenazine.

phenazine
(in oxidized form)

phenazine
semiquinone

1,4-dihydrophenazine
(reduced form)

There is some dispute about which form, the semiquinone or the dihydro species, is the more effective transfer agent for electrons. L. F. A. Mason[290] felt the dihydro form was not an active reducing agent for azo dyes. Others point out that the dihydrophenazine can transfer two electrons with one encounter with the azo dye to form stable products. The semiquinone would be available to transfer one electron, producing an intermediate azo dye radical that would then require an encounter with another semiquinone to form stable products. M. Schellenberg and R. Steinmetz[291] have proposed a mechanism of azo dye cleavage that requires two molecules of 1,4-dihydro-diazines to form the two amines from the dye.

A great number of 1,4-diazines have been proposed for dye bleach cata-lysts[292-294] or, in the reduced form, as black-and-white developing agents in acid solution.[295] Quinoline-quinaldine mixtures have been proposed as superadditive bleaching agents.[296] Azo dyes with one or more —N=N— linkages are used, but generally the mono- or dis-azo dyes are the most suitable.[297-298] Monoazo dyes are preferred, preferably for yellow and magenta, but it is difficult to find easily oxidizable monoazo dyes that resist diffusion and have the desired color intensity. A myriad of complex mole-cules for azo dyes have been proposed through the years. Some recent examples, all dis-azo dyes, taken from U. S. Patent 3,443,947 are given here.

cyan dye (red-sensitive layer)

magenta dye (green-sensitive layer)

yellow dye (blue-sensitive layer)

REFERENCES

1. Josef Maria Eder, *History of Photography*, translated by Edward Epstean, Columbia University Press, New York, 1945, p. 639.
2. Joseph S. Friedman, "Light and Color," *Am. Phot.*, **33**: 465 (1939).
3. Pierre Connes, "How Light is Analyzed," *Sci. Am.*, **219** (3): 72 (1968).
4. J. Waterhouse, "Wünsch's Researches on the Primary Components of White Light," *Brit. J. Phot.*, **56** (1909), *Colour Photography Supplement*, **3**: 34.
5. James Clerk Maxwell, "On Color Vision," in *Sources of Color Science*, edited by David L. MacAdam, MIT Press, Cambridge, Mass., 1970, pp. 75–83.
6. J. Clerk Maxwell, "On the Theory of Three Primary Colours," *Brit. J. Phot.*, **8**: 270 (1861).
7. "The Theory of the Primary Colours," *Phot. News*, **5**: 375 (1861).
8. Thomas Sutton, "Photographic Notes," *Phot. Notes*, **6**: 169 (1861).
9. Joseph S. Friedman, "Color Photography," *Am. Phot.*, **41** (1): 40 (1947).
10. E. J. Wall, "Clerk Maxwell's Theory and His Practice," *Brit. J. Phot.*, **68** (1921), *Colour Photography Supplement*, **15**: 47.
11. D. A. Spencer, "The First Colour Photograph," *Penrose Annual*, **42**: 99 (1940).
12. Joseph Maria Eder, *History of Photography*, translated by Edward Epstean, Columbia University Press, New York, 1945, pp. 457–464.
13. R. M. Evans, "Some Notes on Maxwell's Colour Photograph," *J. Phot. Sci.*, **9**: 243 (1961).
14. E. Howard Farmer, "Clerk Maxwell's Gifts to Photography: or, The Red, Green and Blue," *Brit. J. Phot.*, **49**: 566 (1902).
15. Joseph S. Friedman, "The Evolution of Modern Taking Methods in Color Photography," *Am. Phot.*, **40** (11): 44 (1946).
16. "M. Cros's Solution of the Problem of Photography in Colours," *Phot. News*, **13**: 483 (1869).
17. *Brit. J. Phot.*, **16**: 283 (1869).
18. "Lecture by M. Cros on Colour in Photography," *Phot. News*, **23**: 367 (1879).
19. "Photography in Natural Colours," *Phot. News*, **24**: 577 (1880).
20. E. J. Wall, "Photography in Colours," *Phot. J.*, **35**: 170 (1895).
21. Ducos du Hauron, "Ein neuer heliochromischer Process," *Phot. Korr.*, **5**: 197 (1869).
22. Louis Ducos du Hauron, "Sur la photographie des couleurs," *Photo Revue*, No. 24: 188 (1905).
23. "M. Ducos du Hauron's Heliochromic Process," *Brit. J. Phot.*, **22**: 235 (1875).
24. "Photochromie," *Brit. J. Phot.*, **23**: 377 (1876).
25. "Photography in Colours," *Brit. J. Phot.*, **24**: 152 (1877).
26. "Louis Ducos du Hauron," *Brit. J. Phot.*, **67** (1920), *Colour Photography Supplement*, **14**: 38.
27. Josef Maria Eder, *History of Photography*, translated by Edward Epstean, Columbia University Press, New York, 1945, pp. 642–653.
28. E. J. Wall, *The History of Three-Color Photography*, Am. Phot. Pub. Co., Boston, 1925, pp. 4–9, 105–119.

29. "Photographie in natürlichen Farben," *Eder's Jahrbuch*, **8**: 446 (1894).

30. Paul N. Hasluck, *The Book of Photography*, Cassell and Co., London, 1907, pp. 421–423.

31. Joseph Maria Eder, *History of Photography*, translated by Edward Epstean, Columbia University Press, New York, 1945, pp. 664–675.

32. Frederic Eugene Ives, "Composite Heliochromy," U. S. Pat. 432,530 (1890).

33. Frederic E. Ives, "The Optics of Trichromatic Photography," *Phot. J.*, **41**: 99 (1900).

34. J. H. Coote, "A Survey of Available 'One Shot' Colour Cameras," *Brit. J. Phot.*, **85**: 659 (1938).

35. R. C. Smith, "The History of Colour Photography. 2—The Edwardian Era," *Photography (London)*, **16** (6): 71 (1961).

36. Joseph S. Friedman, "Color Photography," *Am. Phot.*, **41** (3): 41 (1947).

37. Arthur von Hübl, "The Theory of the Autochrome Plate," *Brit. J. Phot.*, **55**, (1908), *Colour Photography Supplement*, **2**: 5.

38. E. Trutat, "La Photographie des couleurs par les Plaques à réseaux polychromes," *Photo-Revue*, No. 32: 41 (1907).

39. E. J. Wall, "Screen Plate Color Photography," *Phot. Annual*, **6**: 9 (1910).

40. H. Snowden Ward, "The McDonough-Joly Process of Colour Photography," *Phot. J.*, **41**: 141 (1900).

41. E. Stenger, "Zur Kenntnis der Autochromplatte und ähnlich gearteter Erzeugnisse," *Phot. Chronik*, **17**: 331 (1910).

42. C. E. Kenneth Mees and J. H. Pledge, "On Some Experimental Methods Employed in the Examination of Screenplates," *Phot. J.*, **50**: 197 (1910); *Brit. J. Phot.*, **57** (1910), *Colour Photography Supplement*, **4**: 45.

43. Keith Henny and Beverly Dudley, *Handbook of Photography*, McGraw-Hill Book Co., New York, 1939, pp. 654–656.

44. Carl W. Miller, *Principles of Photographic Reproduction*, Macmillan, New York, 1942, p. 254.

45. H. C. Colton, "Color Processes—Additive," *The Complete Photographer*, **3** (14): 914 (1942).

46. Louis Dufay, "Color Photography," U. S. Pat. 1,805,361 (1931); "Method of Manufacturing Polychrome Screens for Color Photography and Cinematography," U. S. Pat. 1,552,126 (1925).

47. John Naish Goldsmith, Thomas Thorne Baker, and Charles Bonamico, "Improvements in or relating to Colour Photography," Brit. Pat. 334,265 (1930).

48. Thomas Thorne Baker, Charles Bonamico, and Ralph Alfred Sidney Grist, "Improvements in or relating to Films for Colour Photography," Brit. Pat. 401,719 (1933).

49. Thomas Thorne Baker, "Improvements in or relating to Colour Photography," Brit. Pat. 420,824 (1934).

50. T. Thorne Baker, "The Spicer-Dufay Colour Film Process," *Phot. J.*, **72**: 109 (1932).

51. F. F. Renwick, "The Dufaycolour Process," *Phot. J.*, **75**: 28 (1935).

52. *The Dufaycolor Manual*, Dufaycolor, Inc., New York, 1938.

53. *Practical Color Photography with the Finlay Natural-Color Process*, Finlay Color Limited, New York, 1936.

54. Gert Koshofer, "30 years of Modern Colour Photography, 1935–1965," *Brit. J. Phot.*, **113**: 562, 738, 824, 920 (1966).

55. Keith Henney and Beverly Dudley, *Handbook of Photography*, McGraw-Hill Book Co., New York, 1939, pp. 654–660.

56. Joseph S. Friedman, *History of Color Photography*, Am. Phot. Pub. Co., Boston, 1945, pp. 211–232.

57. G. Lippmann, "Reversible Prints. Integral Photographs," *Compt. rend.*, **146**: 446 (1908).

58. Rodolphe Berthon, "Apparatus for Color Photography," U. S. Pat. 992,151 (1911).

59. J. G. Capstaff and M. W. Seymour, "The Kodacolor Process for Amateur Color Cinematography," *Trans. SMPE*, **12** (36): 940 (1928).

60. C. E. Kenneth Mees, "Amateur Cinematography and the Kodacolor Process," *J. Frank. Inst.*, **207**: 1 (1929).

61. M. Johanson, "Color Movies—Kodacolor," *Foto. Dlya Vsikh Ukrainian SSR*, **2** (2): 64 (1929) (in Russian).

62. E. J. Wall, *Practical Color Photography*, Am. Phot. Pub. Co., Boston, 1922, Chap. 13 ("The Bleach-Out Process,"), Chapter 14 ("The Lippmann Process or Interference Heliochromy"), and Chapter 16 ("The Diffusion Process").

63. "Photography in Colors," *Am. J. Phot.*, **12**: 180 (1891).

64. Carleton E. Dunn, *Natural Color Processes*, Am. Phot. Pub. Co., Boston, 1945, pp. 211–232 ("The Finlay Process").

65. E. R. Davies, "The Kodachrome Process of 16mm. Colour Kinematography," *Phot. J.*, **76**: 248 (1936).

66. Louis Ducos du Hauron, "A New Heliochromic Process," *Phot. News*, **13**: 319 (1869).

67. Adrian Cornwell-Clyne, *Color Cinematography*, 3rd Edition, Chapman and Hall London, 1951, p. 6.

68. H. T. Kalmus, "Technicolor Adventures in Cinemaland," *J. SMPE*, **31**: 564 (1938).

69. F. J. Tritton, "A Talk on the Processes of Colour Snapshots (1928) Ltd.," *Phot. J.*, **69**: 362 (1929).

70. E. J. Wall, *The History of Three-Color Photography*, Am. Phot. Pub. Co., Boston, 1925, p. 152.

71. Olindo O. Ceccarini, Chap. 22, "Color Photography," in Keith Henney and Beverly Dudley, *Handbook of Photography*, McGraw-Hill Book Co., New York, 1939, pp. 629–640 ("Carbro Process") and pp. 640–643 ("Eastman Wash-Off Relief Process").

72. Merrill W. Seymour and Alexander Clair, "Color Printing with Eastman Wash-Off Relief Film," *Am. Phot.*, **30**: 208 (1936).

73. Fred A. Smyth, "Exposure and Quality on Wash-Off Relief from Kodachrome," *Am. Phot.*, **36** (6): 12 (1942).

74. "Kodak Dye Transfer Process," Kodak Pamphlet No. E-80 (1-72 Major Revision).

75. "Dr. Smith's New Three-Colour Plates," *Brit. J. Phot.*, **52**: 355 (1905).

76. Karl Schinzel, "One-Plate Colour Photography," *Brit. J. Phot.*, **52**: 608 (1905).

77. R. Neuhauss, "Katachromie," *Phot. Rund.*, **19**: 239 (1905).

78. Joseph S. Friedman, *History of Color Photography*, Am. Phot. Pub. Co., Boston, 1947, p. 94.

79. R. Ed. Liesegang, "Die Farbe der Silberbilder," *Phot. Archiv*, **36**: 115 (1895); "Über den Farbstoffgehalt des Negativs," *Phot. Korr.*, **33**: 6 (1896).

80. Alfred Watkins, "Notes on the Pyro Developed Image," *Phot. J.*, **36**: 245 (1896).

81. Lüppo-Cramer, "Neue Untersuchungen zur Theorie der photographischen Vorgänge," *Phot. Korr.*, **42**: 319 (1905).

82. Lüppo-Cramer, "Neue Untersuchungen zur Theorie der photographischen Vorgänge," *Phot. Korr.*, **43**: 241 (1906).

83. B. Homolka, "Untersuchungen über die Natur des latenten und des negativen photographischen Bildes," *Phot. Korr.*, **44**: 55, 115 (1907); "Experiments on the Nature of the Latent Image and of the Negative Image," *Brit. J. Phot.*, **54**: 136 (1907).

84. B. Homolka, "Beitrag zur Theorie der organischen Entwickler," *Phot. Korr.*, **51**: 256, 471 (1914); **53**: 201 (1916).

85. Rudolf Fischer, "Process of Making Photographs in Natural Colors," U. S. Pat. 1,055,155 (1913); Neue Photographische Gesellschaft Akt.-Ges., "Verfahren zur Herstellung von Farbenphotographien," German Pat. 257,160 (1911).

86. Rudolf Fischer, "Verfahren zur Herstellung farbiger photographischer Bilder," German Pat. 253,335 (1912); "Process of Making Colored Photographs," U. S. Pat. 1,102,028 (1914).

87. R. Fischer and H. Siegrist, "Über die Bildung von Farbstoffen durch Oxydation mittels belichteten Halogensilbers," *Phot. Korr.*, **51**: 18, 208 (1914).

88. John G. Capstaff, "Photographs in Color and Method of Making the Same," U. S. Pat. 1,196,080 (1916).

89. Leopold D. Mannes and Leopold Godowsky, Jr., "Color Photography," U. S. Pat. 1,516,824 (1924).

90. Leopold D. Mannes and Leopold Godowsky, Jr., "Color Photograph and Method for Producing Same," U. S. Pat. 1,659,148 (1928).

91. Leopold D. Mannes and Leopold Godowsky, Jr., "Method of Making Color Photographs," U. S. Pat. 1,954,452 (1934); "Improvements in and relating to Colour Photography," Brit. Pat. 376,795 (1932); "Improvements in Processes for the Production of Colour Photographs," Brit. Pat. 376,838 (1932).

92. Leopold D. Mannes and Leopold Godowsky, Jr., "Color Photography," U. S. Pat. 1,980,941 (1934).

93. Leopold D. Mannes and Leopold Godowsky, Jr., "Sensitized Photographic Element and Process of Making Same," U. S. Pat. 1,996,928 (1935); "Process for Colour Photography," Brit. Pat. 376,794 (1932).

94. Leopold D. Mannes and Leopold Godowsky, Jr., "Color Photography," U. S. Pat. 1,997,493 (1935).

95. Joseph Wechsberg, "Whistling in the Darkroom," *The New Yorker*, p. 61 (November 10, 1956).

96. Merrill W. Seymour, "Photographic Reversal Process," U. S. Pat. 1,939,231 (1933).

97. Merrill W. Seymour, "Method of Producing Color Photographic Images by Development," U. S. Pat. 1,969,479 (1934).

98. Leonard T. Troland, "Color Photography," U. S. Pat. Re. 18,680 (1932).

99. Leonard T. Troland, "Multicolor Film and Method," U. S. Pat. 1,928,709 (1933).

100. Leonard T. Troland, "Monopack Process," U. S. Pat. 1,993,576 (1935).

101. Leopold D. Mannes and Leopold Godowsky, Jr., "Color Photography," U. S. Pat. 2,059,884 (1936); "Improvements in Colour Photography," Brit. Pat. 427,472 (1935); "Improvements in Colour Photography," Brit. Pat. 427,518 (1935); "Improvements in Colour Photography," Brit. Pat. 454,498 (1936); "Improvements in Colour Photography" Brit. Pat. 454,622 (1936).

102. Leopold D. Mannes and Leopold Godowsky, Jr., "Photographic Color-Forming Compounds," U. S. Pat. 2,108,602 (1938).

103. Leopold D. Mannes, Leopold Godowsky, Jr., and Willard D. Peterson, "Photographic Color-Forming Compounds," U. S. Pat. 2,115,394 (1938).

104. Leopold D. Mannes, Leopold Godowsky, Jr., and Willard D. Peterson, "Photographic Color-Forming Compounds," U. S. Pat. 2,126,337 (1938).

105. Leopold D. Mannes and Leopold Godowsky, Jr., "Color Forming Developer Containing Amines," U. S. Pat. 2,191,037 (1940).

106. Leopold D. Mannes and Leopold Godowsky, Jr., "Method of Color Photography," U. S. Pat. 2,238,495 (1941).

107. Leopold D. Mannes, Leopold Godowsky, Jr., and Lot S. Wilder, "Reversal Process of Color Photography," U. S. Pat. 2,252,718 (1941); "Process of Producing Coloured Images in Multilayer Photographic Elements," Brit. Pat. 507,841 (1939).

108. Leopold D. Mannes and Leopold Godowsky, Jr., "Multilayer Photographic Material Containing Color Formers," U. S. Pat. 2,304,939 (1942).

109. Leopold D. Mannes and Leopold Godowsky, Jr., "Color Photography," U. S. Pat. 2,304,940 (1942).

110. E. R. Davies, "The Kodachrome Process of 16 mm. Colour Kinematography," *Phot. J.*, **76**: 248 (1936).

111. C. E. Kenneth Mees, "Kodachrome—A New 16mm. Color Process," *Camera Craft*, **42**: 237 (1935).

112. "Kodachrome Now Processed by New Method," *Phot. Technique*, **3** (3): 74 (1941).

113. C. E. Kenneth Mees, "Direct Processes for Making Photographic Prints in Color," *J. Frank. Inst.*, **233**: 41 (1942); *Am. Phot.*, **36**: 8 (March 1942); *Phot. J.*, **82**: 300 (1942); *J. PSA*, **8** (2): 67 (1942).

114. Wilhelm Schneider, "Manufacture of Multicolor Photographs," U. S. Pat. 2,179,234 (1939); "Procédé pour la production d'images en plusieurs couleurs," French Pat. 811,541 (1937).

115. Gustav Wilmanns, Wilhelm Schneider, and Ernst Bauer, "Manufacture of Polychrome Pictures," U. S. Pat. 2,179,238 (1939); "Procédé de production d'images en plusieurs couleurs," French Pat. 803,566 (1936).

116. Gustav Wilmanns, Wilhelm Schneider, and Ernst Bauer, "Verfahren zur Herstellung farbiger Bilder in Halogensilberemulsionsschichten durch Farbentwicklung," German Pat. 746,135 (1935); "Color Photography," U. S. Pat. 2,179,239 (1939).

117. Gustav Wilmanns, Karl Kumetat, Wilhelm Schneider, Alfred Fröhlich, and Richard Brodersen, "Verfahren zur Herstellung von Halogensilberemulsionsschichten für farbenphotographisches Ein- oder Mehrschichtenmaterial," German Pat. 725,872 (1935); "Manufacture of Photographic Silver Halide Emulsions," U. S. Pat. 2,186,849 (1940); "Verfahren zur Herstellung von Halogensilberemulsionsschichten für Farbenphotographie," German Pat. 733,407 (1935).

118. Wilhelm Schneider and Max Hagedorn, "Photographic Silver Halide Emulsion Layers," U. S. Pat. 2,178,612 (1939).

119. Wilhelm Schneider and Alfred Fröhlich, "Color Photography," U. S. Pat. 2,280,722 (1942).

120. Alfred Fröhlich, Wilhelm Schneider, and Adolf Sieglitz, "Process for the Production of Photographic Color Images," U. S. Pat. 2,303,928 (1942).

121. Alfred Fröhlich and Wilhelm Schneider, "Process for the Production of Colored Photographic Images with Dyestuff Formers Fast to Diffusion," U. S. Pat. 2,307,399 (1943).

122. Wilhelm Schneider and Gustav Wilmanns, "Agfacolor-Neu," Agfa Veröffentlichungen des Wissenschaftlichen Zentral-Laboratoriums der Photographischen Abteilung, **5**: 29 (1937).

123. J. L. Forrest and F. M. Wing, "The New Agfacolor Process," *J. SMPE*, **29**: 248 (1937).

124. Stanley L. Judkins and Lloyd E. Varden, "The Ansco Color Process," *J. PSA*, **10**: 553 (1944).

125. "U. S. Government Report on Agfa Color Process," *Am. Cinematog.*, **26**: 416 (1945).

126. Wilhelm Schneider, "The Agfacolor Process," FIAT Final Report 976, Office of Military Government for Germany (US).

127. Michele Martinez, "Color Photography," U. S. Pat. 2,269,158 (1942); "Improvements in or relating to Colour Photography," Brit. Pat. 505,834 (1939).

128. Michele Martinez, "Light Sensitive Color Element," U. S. Pat. 2,284,877 (1942); "Improvements in Color Photography," Brit. Pat. 543,606 (1942).

129. Scheuring S. Fierke, "Dispersing Mixtures of Resins and Coloring Materials in Gelatin," U. S. Pat. 2,272,191 (1942).

130. David E. Bennett, Jr., and Scheuring S. Fierke, "Method of Dispersing Coloring Materials in Water Swellable Colloids," U. S. Pat. 2,311,020 (1943).

131. John A. Leermakers and Scheuring S. Fierke, "Color Process Using Cellulose Ester Emulsions," U. S. Pat. 2,279,406 (1942).

132. John A. Leermakers and Scheuring S. Fierke, "Incorporation of Couplers in Nongelatin Emulsions," U. S. Pat. 2,318,788 (1943).

133. Edwin E. Jelley and Paul W. Vittum, "Color Photography," U. S. Pat. 2,322,027 (1943); "Improvements in and relating to Light-Sensitive Photographic Emulsions," Brit. Pat. 541,589 (1941).

134. Scheuring S. Fierke and Jonas John Chechak, "Photographic Color Former Dispersions," U. S. Pat. 2,801,171 (1957).

135. C. E. Kenneth Mees, "Modern Colour Photography," *Endeavor*, **7**: 131 (1948).

136. Joseph S. Friedman, "The New Kodacolor," *Am. Phot.*, **36** (6): 40 (1942).

137. "The Full-Color Snapshot has Arrived," *Am. Phot.*, **36** (3): 50, back cover (1942).

138. E. Albert, "Photographisches Farbendruck-Verfahren," German Pat. 101,379 (1897)

139. Kodak Limited, "Improvements in Methods of Producing Colour Photographs Employing Colour Correction and Colour Photographic Materials therefor," Brit. Pat. 541,298 (1941).

140. Wesley T. Hanson, Jr., "Integral Mask for Color Film," U. S. Pat. 2,449,966 (1948); "Improvements in Colour Photographic Processes," Brit. Pat. 599,377 (1948).

141. Gert Koshofer and Klaus Hübner, "A Historical List of the World's Chromogenic Processed Colour Films," *Brit. J. Phot.*, **112**: 780 (1965).

142. R. W. G. Hunt, *The Reproduction of Colour*, Revised Edition, Fountain Press, London, 1961, p. 39.

143. E. Howard Farmer, "Preliminary Note on Some Remarkable Properties of Silver and Gelatine," *Phot. J.*, **32**: 30 (1892); "A Photographic Wedding," *Brit. J. Phot.*, **41**: 742 (1894).

144. R. Ed. Liesegang, "A New Basis for Photo-Mechanical Processes," *Brit. J. Phot.*, **44**: 774 (1897); *Photography Annual*, p. 315. (1898).

145. E. J. Wall, *The History of Three-Color Photography*, Am. Phot. Pub. Co., Boston, 1925, pp. 432–434.

146. Jens Herman Christensen, "Improved Manufacture of Coloured Photographic Pictures," Brit. Pat. 133,034 (1920); "Film and Method for the Production of Colored Pictures," U. S. Pat. 1,517,049 (1924).

147. Béla Gaspar, "Neuere Verfahren zur Herstellung von subtraktiven Mehrfarbenbildern (Gasparcolor-Verfahren)," *Z. wiss. Phot.*, **34**: 119 (1935).

148. W. R. Ruby, "Mixing Machine of High Precision for Study of Rapid Reactions," *Rev. Sci. Instrum.*, **26**: 460 (1955).

149. L. K. J. Tong, "Kinetics of Deamination of Oxidized N,N-Disubstituted p-Phenylenediamines," *J. Phys. Chem.*, **58**: 1090 (1954); L. K. J. Tong and M. Carolyn Glesmann, "The Mechanism of Dye Formation in Color Photography. II. Salt Effects on Deamination Rate of Oxidized p-Phenylenediamines," *J. Am. Chem. Soc.*, **78**: 5827 (1956); "The Mechanism of Dye Formation in Color Photography. III. Oxidative Condensation with p-Phenylenediamines in Aqueous Alkaline Solutions," *J. Am. Chem. Soc.*, **79**: 583 (1957); "The Mechanism of Dye Formation in Color Photography. V. The Effect of a Non-ionic Surfactant on the Ionization of Couplers," *J. Am. Chem. Soc.*, **79**: 4305 (1957); "The Mechanism of Dye Formation in Color Photography. VI. The Effect of a Non-ionic Surfactant on the Rate of Coupling," *J. Am. Chem. Soc.*, **79**: 4310 (1957); "The Mechanism of Dye Formation in Color Photography. VII. Intermediate Bases in the Deamination of Quinonediimines," *J. Am. Chem. Soc.*, **82**: 1988 (1960).

150. R. L. Bent, J. C. Dessloch, F. C. Duennebier, D. W. Fassett, D. B. Glass, T. H. James, D. B. Julian, W. R. Ruby, J. M. Snell, J. H. Sterner, J. R. Thirtle, P. W. Vittum, and A. Weissberger, "Chemical Constitution, Electrochemical, Photographic and Allergenic Properties of p-Amino-N-dialkylanilines," *J. Am. Chem. Soc.*, **73**: 3100 (1951).

151. P. W. Vittum and A. Weissberger, "Recent Advances in the Chemistry of Dye-Forming Development," *J. Phot. Sci.*, **6**: 157 (1958).

152. P. W. Vittum, "Chemistry and Color Photography," *J. SMPTE*, **71**: 937 (1962).

153. J. R. Thirtle and D. M. Zwick, "Color Photography," a section in *Encyclopedia of Chemical Technology*, **5**: 812 (1964).

154. Fred Porter, "Photographic Processing Chemistry," in *Technologies in the Laboratory Handling of Motion Picture and Other Long Films*, edited by Frank P. Clark, SMPTE and SPSE, 1971, pp. 35–48.

155. A. G. Tull, "Colour Development: Its History, Chemistry, and Characteristics," *Phot. J.*, **85B**: 13 (1945).

156. T. H. James, "Kinetics of Development by p-Phenylenediamine in Neutral and Moderately Alkaline Solutions," *J. Phot. Sci.*, **6**: 49 (1958).

157. T. H. James, "Silver Image Development by Derivatives of p-Phenylenediamine. II. Dependence of Rate on Structure," *PSA J.*, **17B**: 27 (1951).

158. John R. Thirtle, "Properties of p-Phenylenediamine Color-Developing Agents," *Phot. Sci. and Tech.*, *PSA Tech. Quarterly*, Series II, **3** (2): 66 (1956).

159. Richard L. Bent and Rowland G. Mowrey, "Color Photographic Processes," U. S. Pat. 3,656,950 (1972).

160. Maynard S. Raasch, "ω-(p-Amino-N-ethylanilino)-alkanoic Acids as Photographic Developers," *J. Am. Chem. Soc.*, **75**: 2956 (1953).

161. Maynard S. Raasch, "Photographic Developers," U. S. Pat. 2,603,659 (1952).

162. P. Rumpf, "Préparation d'acides aminoalcoylsulfoniques en vue d'une étude physico-chimique comparative," *Bull. Soc. Chim.* (France), (5) **5**: 871 (1938).

163. Gevaert Photo-Producten, "Improvements in or relating to Photographic Development," Brit. Pat. 691,815 (1953); "Procédé pour le développement d'images photographiques," French Pat. 1,049,864 (1954); "Photographic Development," U. S. Pat. 2,695,234 (1954).

164. Bruno Wendt, "Photographic Developer," U. S. Pat. 2,108,243 (1938).

165. Gustav Wilmanns, Wilhelm Schneider, and Bruno Wendt, "Photographic Developer," U. S. Pat. 2,163,166 (1939); "Improvements relating to Photographic Developers," Brit. Pat. 481,275 (1938).

166. Arnold Weissberger, "Developer Containing Sulphonamide Groups," U. S. Pat. 2,193,015 (1940); "Improvements in Photographic Developers," Brit. Pat. 536,577 (1941).

167. Arnold Weissberger, Dudley B. Glass, and Paul W. Vittum, "Sulfonamide Substituted *p*-Phenylenediamines Containing *o*-Alkoxy Groups as Silver Halide Photographic Developers," U. S. Pat. 2,548,574 (1951).

168. Arnold Weissberger, Dudley B. Glass, and Paul W. Vittum, "*p*-Phenylenediamines Containing *N*-Alkylacetamido Ethyl Substituent," U. S. Pat. 2,552,242 (1951).

169. Arnold Weissberger, Dudley B. Glass, and Paul W. Vittum, "*p*-Phenylenediamine Developer Containing *N*-Alkylacetamido Ethyl Substituent," U. S. Pat. 2,592,363 (1952).

170. Arnold Weissberger and Dudley Brewer Glass, "Photographic Developers," Brit. Pat. 651,909 (1951).

171. Arnold Weissberger, Dudley Brewer Glass, and Paul Wendell Vittum, "Photographic Developers," Brit. Pat. 653,284 (1951).

172. Wesley T. Hanson, Jr., "Photographic Developers Containing Acylamino Groups," U. S. Pat. 2,350,109 (1944).

173. Willard D. Peterson, "Photographic Developer," U. S. Pat. 2,304,953 (1942).

174. Arnold Weissberger, "3-Methylsulfonamido-4-Amino Dimethyl Aniline Photographic Developer," U. S. Pat. 2,449,919 (1948).

175. David William Crichton Ramsay, "New Photographic Developers," Brit. Pat. 895,422 (1962).

176. E. I. du Pont de Nemours and Company, "Photographic Developers," Brit. Pat. 691,234 (1953).

177. Elmore Louis Martin, "Photographic Developing Agents," U. S. Pat. 2,603,656 (1952).

178. Agfa Aktiengesellschaft, "Process for the Development of Photographic Images, especially Colour Images," Brit. Pat. 811,679 (1959).

179. Kodak Limited, "Improvements in the Use of Aryl Compounds in Photography," Brit. Pat. 539,395 (1941).

180. Daniel Maurice Timmerman, Walter Frans de Winter, and Albert Emiel van Hoof, "Polymere Beizmittel," German Pat. 2,200,063 (1972).

181. P. Martinelli and L. Del Bo, "Sulle Sostanze Rivelatrici Cromogene," *Il prog. fot.*, **62**: 266 (1955).

182. I. G. Farbenindustrie Aktiengesellschaft, "Development of Silver Halide Emulsions in Colour," Brit. Pat. 457,326 (1936).

183. Kodak Limited, "Improvements in Photographic Colour Development," Brit. Pat. 515,971 (1939); Kodak-Pathé, "Perfectionnements aux procédés de développement photographique en couleurs," French Pat. 856,392 (1940).

184. I. G. Farbenindustrie Aktiengesellschaft, "Improvements in Photographic Colour Development and Developers therefor," Brit. Pat. 467,087 (1937).

185. Tadashi Nagae and Haruhiko Iwano, "Color Developing Process Utilizing Pyridinium Salts," U. S. Pat. 3,520,689 (1970).

186. Rudolf Mersch and Detlef Delfs, "1-(*p*-Aminophenyl)-3-aminopyrazolines and Process," U. S. Pat. 2,840,567 (1958); "1-(*p*-Aminophenyl)-3-Aminopyrazolines and their Production," Brit. Pat. 776,322 (1957).

187. Agfa Aktiengesellschaft für Photofabrikation, "Process for the Production of Photographic Colour Images by Colour Development," Brit. Pat. 795,476 (1958).

188. Ottmar Wahl, Rudolf Mersch, and Walter Püschel, "Verfahren zur Herstellung von farbigen Bildern durch Farbentwicklung," German Pat. 955,026 (1956); Willibald Pelz, Lothar Burgardt, and Ottmar Wahl, Agfa Aktiengesellschaft für Photofabrikation, "A Photographic Colour Developer, the Production of Coloured Photographic Images by means of Colour-Forming Development, and Coloured Images so Produced," Brit. Pat. 778,657 (1957).

189. I. G. Farbenindustrie Aktiengesellschaft, "Improvements in Photographic Developers," Brit. Pat. 459,665 (1937); "Photographischer Entwickler, insbesondere für Direktfarbenentwicklung," German Pat. 646,516 (1937).

190. S. Hünig, "Azofarbstoffe durch oxydative Kupplung," *Angew. Chem.*, **68**: 383 (1956).

191. Siegfried Hünig and Friedhelm Müller, "Azofarbstoffe Durch Oxydative Kupplung. XXI. Kupplung nicht-aromatischer Amidrazone und ω-Benzolsulfonyl-amidrazone; XXII. Synthese einfacher Amidrazone und Benzolsulfonylamidrazone," *Annalen*, **651**: 73, 89 (1962).

192. S. Hünig, "Ein weiterer neuer Weg in die Azochemie," *Angew. Chem.*, **71**: 379 (1959).

193. Jan Jaeken, "Color Photographic Process," U. S. Pat. 3,447,923 (1969).

194. Willy A. Schmidt and Joseph A. Sprung, "Color Developers Comprising Aryl-Sulfonhydrazides and Methods of Developing with Same," U. S. Pat. 2,424,256 (1947).

195. William E. Hanford, "Production of Azo Dyestuff Images from *N*-Acyl-*N*-Aryl Hydrazine Developers," U. S. Pat. 2,495,000 (1950).

196. W. A. Schmidt, Vsevolod Tulagin, J. A. Sprung, R. C. Gunther, R. F. Coles, and D. E. Sargent, "Photographic Color-Forming Development Reaction," *Ind. Eng. Chem.*, **45**: 1726 (1953).

197. Willy A. Schmidt, "Farbentwicklung in Photographischen Schichten," *Wissenschaftliche Photographie*, Othmar Helwich, Darmstadt, 1958, pp. 456–458.

198. Vsevolod Tulagin, "Photographic Developer," U. S. Pat. 2,414,491 (1947).

199. Willy A. Schmidt and Vsevolod Tulagin, "Production of Phenazonium Dyestuff Images," U. S. Pat. 2,486,440 (1949).

200. Willy A. Schmidt and Robert C. Gunther, "Silver Halide Developers for the Production of Azine Dyestuff Images," U. S. Pat. 2,527,379 (1950).

201. Robert C. Gunther, "Color Developers for the Production of Azine Dye Images," U. S. Pat. 2,570,116 (1951).

202. Robert C. Gunther, "Production of Azine Dyestuff Images," U. S. Pat. 2,555,127 (1951).

203. Robert C. Gunther, "Color Developers for the Production of Azine Dye Images," U. S. Pat. 2,570,116 (1951).

204. Willy A. Schmidt and Vsevolod Tulagin, "*N*-Substituted 4,6-Diamino Metanilic Acids," U. S. Pat. 2,575,027 (1951).

205. Robert C. Gunther and Vsevolod Tulagin, "Preparation of Azine Dye Images," U. S. Pat. 2,596,926 (1952).

206. D. G. Saunders, "Preparation of 4-Substituted 2-Dimethylamino-5-nitro- and -5-amino-pyrimidine," *J. Chem. Soc.*, p. 3232 (1956).

207. Hugo Schiff, "Über alkylensubstituirte Amidosäuren," *Annalen*, **210**: 114 (1881).

208. David Malcolm McQueen, "Aryl Azo Methine Sulfonic Acids," U. S. Pat. 2,507,114 (1950).

209. Richard Lewis Reeves, "Photographic Silver Halide Development," Brit. Pat. 1,138,762 (1969).

210. Edward E. Jaffe, "Schiff Bases and Metal Chelate Pigments Made Therefrom," U. S. Pat. 3,132,140 (1964).

211. P. W. Vittum and A. Weissberger, "The Chemistry of Dye-Forming Development," *J. Phot. Sci.*, **2**: 81 (1954).

212. Fred C. McCrossen, Stanley M. Parmerter, and Arnold Weissberger, "Color Couplers Containing Isophthalic Acid Radicals," U. S. Pat. 2,652,329 (1953).

213. G. H. Brown, J. Figueras, R. J. Gledhill, C. J. Kibler, F. C. McCrossen, S. M. Parmerter, P. W. Vittum, and A. Weissberger, "Azomethine Dyes. II. Color and Constitution of Acylacetamide Azomethine Dyes," *J. Am. Chem. Soc.*, **79**: 2919 (1957).

214. Arnold Weissberger, Charles J. Kibler, and Paul W. Vittum, "Color Couplers," U. S. Pat. 2,407,210 (1946).

215. Fred Carlin McCrossen, Paul Wendell Vittum, and Arnold Weissberger, "Improved Colour Couplers for use in Colour Photography," Brit. Pat. 800,108 (1958).

216. Bernard Hippoliet Tavernier, Marcel Leon Desmit, and Arthur De Cat, "Improvements in or relating to the Production of Coloured Photographic Images," Brit. Pat. 848,558 (1960).

217. Pierre Glafkides, *Photographic Chemistry*, Vol. Two, English Edition, Fountain Press, London, 1960, pp. 597–600.

218. J. Bailey and L. A. Williams, "The Photographic Color Development Process," Chap. VI of *The Chemistry of Synthetic Dyes*, Vol. IV, edited by K. Venkataraman, Academic Press, New York, 1971, pp. 356–362.

219. A. Weissberger and H. D. Porter, "Investigation of Pyrazole Compounds. I. The Reaction Product of Phenylhydrazine and Ethyl Cyanoacetate," *J. Am. Chem. Soc.*, **64**: 2133 (1942).

220. A. Weissberger and H. D. Porter, "Investigation of Pyrazole Compounds. IV. The Acylation of 3-Phenyl-5-pyrazolone and 3-Anilino-5-pyrazolone," *J. Am. Chem. Soc.*, **65**: 1495 (1943).

221. J. Jennen, "Een nieuwe klasse van magenta-kleurstofvormers," *L'Industrie Chimique Belge*, **16**: 472 (1951).

222. Wilson Baker, W. D. Ollis, and V. D. Poole, "Cyclic Meso-ionic Compounds. Part I. The Structure of the Sydnones and Related Compounds," *J. Chem. Soc.*, p. 307 (1949).

223. Paul W. Vittum and Gordon H. Brown, "Indoaniline Dyes. I. Some Phenol Blue Derivatives with Substituents in the Phenol Ring," *J. Am. Chem. Soc.*, **68**: 2235 (1946); "II. The Effect of Multiple Substitution on the Absorption of Phenol Blue," *J. Am. Chem. Soc.*, **69**: 152 (1947).

224. Paul W. Vittum and Willard D. Peterson, "Acylamino Phenol Couplers," U. S. Pat. 2,369,929 (1945).

225. Ilmari F. Salminen, Paul W. Vittum, and Arnold Weissberger, "Acylaminophenol Photographic Couplers," U. S. Pat. 2,367,531 (1945).

226. Ilmari F. Salminen and Arnold Weissberger, "Acylamino Phenols," U. S. Pat. 2,423,730 (1947).

227. Abraham Bavley, "Nondiffusing Phenolic Color Couplers," U. S. Pat. 2,418,747 (1947).

228. John David Kendall and Douglas James Fry, "Cyanacetylamino Phenol Color Formers for Color Photography," U. S. Pat. 2,441,491 (1948).

229. Du Pont Film Manufacturing Corporation, "Improvements in and relating to the Use of Colour-formers in Colour Photography," Brit. Pat. 512,542 (1939).

230. Kodak Limited, "Improvements in Colour Development and Colour Forming Developers," Brit. Pat. 496,195 (1938).

231. Ilmari F. Salminen, Charles R. Barr, and Anthony Loria, "Photographic Color Couplers Containing Fluoroalkylcarbonamido Groups," U. S. Pat. 2,895,826 (1959).

232. Kodak Limited, "Improvements in Colour Development and Colour Forming Developers," Brit. Pat. 496,245 (1938).

233. James Emory Kirby, "Dye Intermediate," U. S. Pat. 2,330,291 (1943).

234. Vsevolod Tulagin, "Photographic Elements Containing Urethanes of N-Substituted J Acids as Color Formers," U. S. Pat. 2,445,252 (1948).

235. Vsevolod Tulagin and Robert F. Coles, "Nondiffusing Color Formers Comprising Aryl J-Acids in which the Aryl Radical is Provided with a Nondiffusing Group," U. S. Pat. 2,591,642 (1952).

236. Richard V. Young and Arnold Weissberger, "Aromatic Color Couplers Containing Mercaptan and Hydroxyl Groups," U. S. Pat. 2,596,755 (1952).

237. Robert F. Coles, "Photographic Couplers Containing Acylamino Groups," U. S. Pat. 3,005,709 (1961).

238. Andrew B. Jennings, "Bis Sulphonamides of Naphthol Sulphonyl Chlorides with Aromatic Diamines," U. S. Pat. 2,395,484 (1946).

239. C. R. Barr, G. H. Brown, J. R. Thirtle, and A. Weissberger, "Indoaniline Dyes: IV. Some Dyes Derived from 1-Hydroxy-2-Naphthamides," *Phot. Sci. and Eng.*, **5**: 195 (1961).

240. A. P. Lurie, G. H. Brown, J. R. Thirtle, and A. Weissberger, "Indoaniline Dyes. V. Some Dyes Derived from Substituted α-Naphthols," *J. Am. Chem. Soc.*, **83**: 5015 (1961).

241. Paul W. Vittum and Gordon H. Brown, "Indoaniline Dyes. III. Coupling of para-Substituted Phenols with Oxidized p-Aminodimethylaniline," *J. Am. Chem. Soc.*, **71**: 2287 (1949).

242. M. de Ramaix, "Major Trends in Masking for Color Improvement: A Review," *Phot. Sci. and Eng.*, **15**: 262 (1971).

243. T. H. Miller, "Masking: A Technique for Improving the Quality of Color Reproductions," *J. SMPE*, **52**: 133 (1949).

244. John A. C. Yule, "Color Correction," U. S. Pat. 2,268,791 (1942).

245. Merrill W. Seymour, "Color Correction," U. S. Pat. 2,289,738 (1942).

246. Wesley T. Hanson, Jr., "Color Correction," U. S. Pat. 2,294,981 (1942).

247. Ralph M. Evans, "Integral Mask for Color Film," U. S. Pat. 2,203,653 (1940).

248. Ralph M. Evans, "Color Correction in Printing Multilayer Film," U. S. Pat. 2,253,070 (1941).

249. Leopold D. Mannes, Leopold Godowsky, Jr., and Lot S. Wilder, "Integral Mask for Multicolor Film," U. S. Pat. 2,258,187 (1941).

250. Ralph M. Evans, "Colored Photographic Mask," U. S. Pat. 2,376,132 (1945).

251. Wesley T. Hanson, Jr., "Color Correction Mask," U. S. Pat. 2,336,243 (1943).

252. Wesley T. Hanson, Jr., "Integral Mask for Color Film," U. S. Pat. 2,449,966 (1948).

253. W. T. Hanson, Jr., "Color Correction with Colored Couplers," *J. Opt. Soc. Am.*, **40**: 166 (1950).

254. W. T. Hanson, Jr., and P. W. Vittum, "Colored Dye-Forming Couplers in Subtractive Color Photography," *PSA J.*, **13**: 94 (1947).

255. Paul W. Vittum and Rebecca J. Arnold, "Photographic Color Correction Using Colored Couplers," U. S. Pat. 2,428,054 (1947).

256. Dudley B. Glass, Paul W. Vittum, and Arnold Weissberger, "Colored Couplers," U. S. Pat. 2,453,661 (1948); U. S. Pat. 2,455,169 (1948); U. S. Pat. 2,455,170 (1948).

257. VEB Filmfabrik Wolfen, "Colour Photographic Multi-Layer Materials for Colour Development with Automatic Masking," Brit. Pat. 1,309,952 (1973).

258. Newton Heimbach and Herbert Morreall, Jr., "Integral Masking of Photographic Silver Halide Emulsions Arranged in Contiguous Layers and Containing Colorless Color Formers and Azo Substituted Coupling Components," U. S. Pat. 2,688,539 (1954).

259. Keith E. Whitmore, "Photographic Color Correction Using Colored and Uncolored Couplers," U. S. Pat. 2,808,329 (1957).

260. John Williams, "Photographic Color Correction Process," U. S. Pat. 2,860,974 (1958).

261. Keith E. Whitmore and Edward T. Pesch, "Photographic Color Correction Process Using 2-Azo-1-Naphthol Dyes," U. S. Pat. 2,860,975 (1958).

262. Edwin E. Jelley and Paul W. Vittum, "Color Photography with Azo-Substituted Couplers," U. S. Pat. 2,434,272 (1948).

263. Walter Püschel, Ottmar Wahl, Willibald Pelz, and Hans Schellenberger, "Color Photography," U. S. Pat. 3,028,238 (1962).

264. Maurice Antoine de Ramaix and Jan Jaeken, "Production of Colored Photographic Images," U. S. Pat. 3,012,884 (1961).

265. James Anthony Carter, Hans Max Wagner, and Miroslav Vasa Mijovic, "Improvements in Colour Photography," Brit. Pat. 945,542 (1964).

266. Keith Elden Whitmore and Paul Miller Mader, "Improvements in Photographic processes," Brit. Pat. 904,364 (1962).

267. Anthony Loria, John Williams, and Charles Robert Barr, "Processes of Colour Photographic Reproduction," Brit. Pat. 1,038,331 (1966).

268. Walter Püschel, "Colour Photography," Brit. Pat. 914,145 (1962).

269. C. R. Barr, J. R. Thirtle, and P. W. Vittum, "Development-Inhibitor-Releasing (DIR) Couplers in Color Photography," *Phot. Sci. and Eng.*, **13**: 74, 214 (1969).

270. Keith E. Whitmore, Cyril J. Staud, Charles R. Barr, and John Williams, "Photographic Elements and Processes Using Splittable Couplers," U. S. Pat. 3,148,062 (1964).

271. Charles R. Barr, John Williams, and Keith E. Whitmore, "Photographic Elements and Processes Utilizing Mercaptan-Forming Couplers," U. S. Pat. 3,227,554 (1966).

272. H. D. Meissner, "Influence of Development Retarders on the Colour Reversal Process," *J. Phot. Sci.*, **19**: 83 (1971).

273. J. E. Bates and F. H. Gerhardt, "Problems of Multi-Layer Film Construction," *Phot. Eng.*, **4**: 197 (1953).

274. W. T. Hanson, Jr., and C. A. Horton, "Subtractive Color Reproduction: Interimage Effects," *J. Opt. Soc. Am.*, **42**: 663 (1952).

275. W. Deuschel, "Color Photography and Its Chemical Problems," *Chimia* (*Aarau*), **23** (11): 381 (1969) (translation).

276. Béla Gaspar, "Colored Light-Sensitive Material and Process of Producing Color Pictures Therewith," U. S. Pat. 2,041,827 (1936).

277. Ransford B. Wilson and John V. Williams, "Silver-Dye-Bleach Process Utilizing Formazan Dyes," U. S. Pat. 3,503,741 (1970).

278. Béla Gaspar, "Method of Producing Photographic Dyestuff Images," U. S. Pat. 2,004,625 (1935); "An Improved Method of Producing Photographic Dyestuff Images," Brit. Pat. 419,810 (1934).

279. Béla Gaspar, "Method of Producing Photographic Pictures in Colors," U. S. Pat. 2,020,775 (1935); "An Improved Method of Producing Coloured Photographic Images and Kinematograph Films," Brit. Pat. 395,718 (1933); "An Improved Method of Producing Multi-colour Photographic Images and Kinematograph Films," Brit. Pat. 397,188 (1933).

280. Béla Gaspar, "Method of Producing Photographic Dyestuff Images," U. S. Pat. 2,071,688 (1937).

281. Béla Gaspar, "Process for the Manufacture of Colored Photographic Materials and Material Therefor," U. S. Pat. 2,172,307 (1939).

282. Béla Gaspar, "Process for the Production of Light-Sensitive Materials for Color Photographic Purposes," U. S. Pat. 2,172,308 (1939).

283. Béla Gaspar, "Process for Producing Photographic Dyestuff Images," U. S. Pat. 2,178,167 (1939).

284. Béla Gaspar, "Production of Colored Photographic Pictures," U. S. Pat. 2,410,025 (1946).

285. Joseph S. Friedman, "Silver-Dye Bleach Processes. Part II," *Am. Phot.*, **36** (2): 38 (1942); "Gasparcolor III," *Am. Phot.*, **36** (3): 30 (1942).

286. Béla Gaspar, "Improvements in the Production of Coloured Photographic Pictures," Brit. Pat. 490,451 (1938).

287. A. Meyer, "Some Features of the Silver-Dye Bleach Process," *J. Phot. Sci.*, **13**: 90 (1965).

288. A. Meyer, "Practical Aspects of Silver Dye-Bleach Processing," *J. Phot. Sci.*, **20**: 81 (1972).

289. Leonor Michaelis and Edgar S. Hill, "Potentiometric Studies on Semiquinones," *J. Am. Chem. Soc.*, **55**: 1481 (1933).

290. L. F. A. Mason, *Photographic Processing Chemistry*, Focal Press, London, 1966, pp. 277–279.

291. M. Schellenberg and R. Steinmetz, "Die reduktive Spalting von Azofarbstoffen durch Dihydrochinoxaline," *Helv. chim. acta*, **52**: 431 (1969).

292. Rudolf Mory and Alfred Oetiker, "Colour Bleaching Catalysts for the Silver Dyestuff Bleaching Process," U. S. Pat. 3,443,947 (1969).

293. Alfred Oetiker and Rudolf Mory, "Dyestuff Bleaching Catalysts for the Silver Dyestuff Bleaching Process," U. S. Pat. 3,443,949 (1969).

294. Heinrich Schaller, Ernst Schumacher, Matthias Schellenberg, Rolf Steiger, and Reinhard Steinmetz, "Process for the Development of Photographic Silver Images," Can. Pat. 893,635 (1972).

295. Ciba Limited, "Process for the Development of Photographic Silver Images," Brit. Pat. 1,183,176 (1970).

296. Agfa Gevaert Aktiengesellschaft, "Dye-Bleaching Bath for the Silver-Dye-Bleach Process," Brit. Pat. 1,176,530 (1970).

297. Bernhard Piller, "Photographic Materials for the Silver Dyestuff Bleaching Process," U. S. Pat. 3,455,695 (1969).

298. Thomas E. Gompf and Philip T. S. Lau, "Photographic Materials and Processes," U. S. Pat. 3,493,372 (1970).

299. D. A. Spencer, *Colour Photography in Practice*, Pitman Pub. Corp., New York, 1938, p. ix.

Chapter 10
Color Processing

The common black silver picture image rather seems
to be nearing that age when it is only a by-product
in the formation of a colored image.

HOWARD C. COLTON [236]

Today's color films are almost universally chromogenically processed; that is, color formation results from the reaction of the oxidized color developing agent and a coupler to form a dye. The color developing agent is present in the color developer, but the coupler may be present in this solution or may be imbedded in the gelatin emulsion layers. If the silver halide that is exposed in the camera is color developed, a color negative results. If the exposed silver halide is developed first to form only a silver image, and then light flashing or fogging of the remaining silver halide takes place, a dye positive image is produced after color development. The metallic silver image from either the first development or color development is then converted to a silver compound that is solubilized by the fixing bath. After washing in water, the film may be treated in a stabilizing bath to improve the stability of the dyes. Some color processes require a hardening bath before development, particularly for higher-temperature processing. The modern trend, however, is to make the emulsion layer sufficiently hard so that a separate hardening solution is not needed.

Film
surface *(a)* Film
base *(b)*

Figure 1. This photomicrograph (2500 ×) shows a cross section of a piece of unprocessed color film (*a*) and the same film after processing (*b*). (Eastman Kodak Company)

524

COLOR PROCESSING CYCLES

Processing cycles for color film have a considerable similarity after the color development step. The side-by-side comparison of Kodak Reversal Processes E-3, E-4, and E-6, and Negative Process C-22 is outlined below:

Process E-3 (75°F)	Process E-4 (85°F)	Process E-6 (100°F)	Process C-22 (75°F)
	Prehardener		
	Neutralizer		
First developer	First developer	First developer	
Rinse	First stop bath	First wash	
Hardener			
Wash	Wash		
(Light exposure)		Reversal bath	
Color developer	Color developer	Color developer	Color developer
	Second stop bath		Stop bath
Wash	Wash		Wash
Clear		Conditioner	
Bleach	Bleach	Bleach	Bleach
Rinse			Wash
Fixing bath	Fixing bath	Fixing bath	Fixing bath
Wash	Wash	Wash	Wash
Stabilizer	Stabilizer	Stabilizer	Stabilizer

For reversal color films, a first developer is needed to form a silver image. Films made for Process E-6 do not need a hardening solution, but other films often need one, especially at temperatures above 75°F. For color materials such as Kodachrome film, a different coupler is present in each of the three color developers. First developers and color developers have important differences in formulation for products made by different film manufacturers, but there is some interchangeability of the other solutions in the cycle, particularly between similar processes of the same manufacturer.

With some films, especially some of those designed for machine processing, the very first processing solution is a prebath for the removal of the jet backing on the film. Jet backing is an efficient absorber of light, one of the very best, and helps avoid image degradation due to halation effects. Because of the difficulty of removal, such a backing is not used with user-processed

films, but occasionally some jet-backed products are offered in repackaged form for darkroom processing. The jet backing should be removed before the film reaches an alkaline developing solution. A suitable prebath for the removal of the jet backing is Kodak PB-1[1] (pH $= 9.25 \pm 0.05$ at 70°F):

Kodak PB-1: Prebath for Jet Backing Removal

Borax (sodium tetraborate) ($Na_2B_4O_7 \cdot 10H_2O$)	20.0 g
Sodium sulfate, desiccated	100.0 g
Kodalk Balanced Alkali (sodium metaborate)	6.5 g
Water to make	1.0 liter

Fifteen grams of borax having 5 moles of water of crystallization may be used to replace the 20 g of the 10 mole borax, but the Kodalk Balanced Alkali must be increased to 10 g/liter to maintain the necessary pH value.

A 10-sec immersion in the above prebath is sufficient; long times of immersion should be avoided. On processing machines the base side of the film is then gently buffed with a buffer wheel rotating counter to the direction of the film at about one-quarter the peripheral speed of the film. A brief spray rinse is usually necessary to insure that all the particles have been removed from both sides of the film. Improvised darkroom techniques can be devised for jet backing removal although with considerably less efficiency.

Prehardening Solutions

The trend in modern processing is to use higher temperatures to shorten the time required. Ernest Ch. Gehret[2] reported that the development time can be decreased by a factor of 2.4 for a 10°C temperature increase. The temperature increase also speeds up the chemical reactions of other processing solutions. At elevated solution temperatures, however, gelatin layers that have been normally hardened during manufacture still tend to soften. Excessive swelling may cause reticulation and greatly increase the drying time. The layers of multilayer film and paper products may separate from each other, especially if the layers contain color couplers. Ideally, it would be desirable to increase the hardening of the emulsion layers during manufacture, a type of hardening called forehardening, but increasing the hardening in this fashion often has detrimental effects. Large amounts of hardener in the emulsion may produce a continued action during storage after coating. Afterhardening gradually increases the difficulty of the penetration of the

processing solutions, resulting in an apparent loss of emulsion sensitivity and a lessening of the image contrast. New, vastly superior gelatin hardeners for forehardening may eventually eliminate the need for additional solution hardeners,[3,4] such as in Process E-6 or Process C-41.

To prevent excessive emulsion swelling during processing at elevated temperatures with normally hardened emulsion layers, additional gelatin hardening is given during the early stages of processing. The first processing solution may be the prehardening bath, although gelatin hardening has been used at later stages as well. The ingredients of a prehardening bath must be selected with care, however, as the gelatin-hardening substances may cause fog if they contaminate the developing solution. Color couplers may also be adversely affected by many gelatin hardening compounds, especially aldehydes. In acidic solution, however, aldehydes do not interact with the couplers in the coated layers. The couplers are not ionized at low pH values, but the dyes may be unstable. If aldehydes are used as the gelatin hardeners, then a neutralizing solution to inactivate the aldehydes usually follows the prehardening solution.

Formaldehyde has long been used as a gelatin hardener,[5,6] but a high concentration of formaldehyde must be present in prehardening solutions that are to work rapidly. The fumes from concentrated solutions of formaldehyde cause irritation of human eyes and nasal passages. Formaldehyde may also cause overhardening of the uppermost surface of the gelatin layers (case hardening) which can cause reticulation. Succinaldehyde has been proposed[7] for alkaline prehardening solutions. Harry C. Baden and Charleton C. Bard[8,9] combined an aqueous solution of succinaldehyde with formaldehyde at lower concentrations of each to produce a photographic prehardening bath. Purification of succinaldehyde is expensive, so it was proposed to add this compound in a precursor form. 2,5-Dimethoxy-

DMTF

tetrahydrofuran (DMTF) or 2,5-diethoxytetrahydrofuran decompose in the acidic prehardening solution to form succinaldehyde. Succinaldehyde-formaldehyde prehardening solutions, especially those prepared from the

furan precursor compounds, were reported to precipitate a polymeric dirt which could spot photographic surfaces.

An improved succinaldehyde-formaldehyde prehardening solution, containing a dirt-inhibiting compound, was claimed in U. S. 3,294,536.[10,11] Example 1 from that patent describes the preparation of such a prehardening solution:

800 ml. of water at 90°F was used to dissolve 4.30 ml. of dimethoxytetrahydrofuran, 5.41 ml. of 18 Normal sulfuric acid and 0.5 gram of the sodium salt of paratoluenesulfinic acid. This solution was stirred for 10 minutes at 90°F whereby the DMTF became hydrolyzed to succinaldehyde. 153 grams of sodium sulfate and 2 grams of sodium bromide were then added and the composition was mixed for 20 minutes. There was then added 20 grams of sodium acetate and 27 ml. of formalin. The volume is then brought to one liter with water and the pH was adjusted to 4.8 at 80°F. The composition prepared was employed as a prehardener for photographic films containing gelatin–silver halide photographic emulsions thereon and was found to be an effective prehardener prior to the processing of the film in the developing baths. This prehardener composition had the unique property of hardening the gelatin emulsion at a low pH and was very effective within the pH range of 4–5.

During storage the furan compounds, such as the 2,5-dimethoxytetrahydrofuran, may form deleterious peroxides. The formation of these peroxides can be greatly reduced or eliminated if a butylated phenol compound is present.[12] A small amount of the stabilizer, for example, 0.01 % of 2,6-ditertiary-butyl-*p*-cresol in a solvent, such as propylene glycol, was mixed or milled with the furan compound.

The formation of succinaldehyde from 2,5-dimethoxytetrahydrofuran or 2,5-diethoxytetrahydrofuran in highly acidic solution is a slow reaction, requiring about 1 hr before the other ingredients of the prehardener composition can be added to complete the solution. The solution of succinaldehyde has an objectionable pungent odor. These and other shortcomings, such as separate packaging of liquid furan compounds, have motivated a search for improved prehardeners. Succinaldehyde bis-(sodium bisulfite) has much more desirable characteristics but is not an effective hardening agent at pH 7 or lower. Inadequate hardening was also secured from formaldehyde, even in concentrations as high as 18.8 g/liter in a prehardening solution at 100°F. Charleton C. Bard and Howard W. Vogt[13] found, however, that satisfactory hardening could be secured when formaldehyde and a bis bisulfite adduct of a dialdehyde such as succinaldehyde, glutaraldehyde, or their derivatives were combined in the same hardening solution. Less odor, less dirt, and less time of mixing were claimed as advantages. One such prehardening solution had the following composition (pH = 4.8):

Water	500.0 ml
Succinaldehyde bis-(sodium bisulfite)	6.5 g
Formaldehyde (37.5%)	27.0 ml
Sodium sulfate	75.0 g
Sodium bromide	2.0 g
Sodium diacetate	7.8 g
Sodium acetate	15.0 g
Water to make	1.0 liter

A negative color film was immersed in this prehardener for 2 min, 35 sec, at 100°F. The combination of 9.4 g/liter of formaldehyde with 6.25 g/liter of succinaldehyde bis-(sodium bisulfite) were reported to give "ideal hardening."

When color film is developed at high temperature, the top emulsion layer, usually the blue-sensitive, yellow dye image layer, may be overdeveloped before the bottom layer is completely developed. It has been proposed[14] to incorporate a compound such as 1-(3-acetamidophenyl)-5-mercaptotetra-zole in formalin-succinaldehyde prehardening baths to reduce the over-development of the top layers.

Pyruvic aldehyde, alone or in combination with formaldehyde, has been reported[15] to be satisfactory in prehardening solutions for color materials. Less fogging action and no interaction with couplers were claimed. A reversal color film with incorporated couplers was hardened in (pH = 4.8):

Sodium sulfate	200 g
Sodium acetate	20 g
Potassium iodide	0.020 g
Potassium bromide	23 g
Formalin (37%)	5 ml
Pyruvic aldehyde (30%)	15 ml
Water to make	1 liter

Processing was for 1 min at 30°C.

A two-solution hardening bath has also been proposed.[16] In the first solution, the hardener is imbibed in the gelatin layers but does not harden because of the acidic pH (from 3 to 7) of the solution. Hardening occurs in the second solution, which has a pH between 11 and 14. Separating the diffusion of the hardener from the actual hardening step avoids a difficulty encountered with single-solution hardening bath: the overhardening of the uppermost gelatin layers of the color material. Such overhardening usually

causes the blue-sensitive, yellow-dye-forming layer to exhibit less than its normal development, upsetting the color balance of the image. For two-solution hardening, the hardening agent must be inactive at low pH values but rapid acting when the pH is raised. Compounds such as N,N'-methylene-bis-acrylamide or 1,3,5-N,N',N''-tris-acryloyl hexahydrotriazine are said to satisfy the requirements. Other compounds which inhibit swelling, such as sodium sulfate, are added to both of the prehardening baths.

An example of a two-bath prehardener is given in U. S. Patent 3,676,143:

Bath 1 (pH = 4.8)

Water	800.0 ml
Sulfuric acid (50%)	5.4 ml
Sodium sulfate	154.0 g
Sodium bromide	2.0 g
Sodium acetate	20.0 g
1,3,5-N,N',N''-tris-acryloyl hexahydrotriazine	5.0 g
Water to make	1.0 liter

Treatment: 60 sec, 20°C.

Bath 2 (pH = 12.9)

Water	800.0 ml
Sodium hydroxide	4.0 g
Sodium sulfate	154.0 g
Water to make	1.0 liter

Treatment: 60 sec, 20°C

The remaining steps of the negative color development can now be carried out at 40°C.

Other dialdehydes have been suggested for use in prehardening solutions. Glutaric aldehyde, β-methylglutaric aldehyde, and other glutaric aldehydes have been patented.[17] Aromatic dialdehydes, such as 5-methylisophthalde-hyde

may be used alone or with formaldehyde.[18,19] Aldehyde hardening solutions may be used before development, and an acidic solution of a zirconium salt may be used for further hardening after development.[20] Aldehyde-type hardening solutions tend to increase the fog formed during development. Such fog has been said to be minimized when a phenazine and a heterocyclic mercapto compound are present in glutaraldehyde prehardening solutions.[21]

A developing agent, active in acidic solution at pH about 4 to about 5.5, has been added to aldehyde hardening solutions to form a hardener-developer.[22] The following preferred composition is used in place of the prehardener, first developer and acid stop bath of the Kodak Process ECO-2 for Ektachrome commercial film (pH = 3.8):

Titanium trichloride	26 g
Ethylenediamine tetraacetic acid, tetrasodium salt	88 g
Formaldehyde (37%)	14 ml
Succinaldehyde	5 g
Water to make	1 liter

Neutralizing Solutions

A number of aldehydes such as formaldehyde, glyoxal, succinaldehyde, and glutaraldehyde have been proposed as hardeners for use in acidic prehardening solutions. The color developing solution that follows the prehardener is alkaline. Even trace quantities of aldehydes under these alkaline conditions can upset the color balance of the image by reaction with the couplers that are either in the developing solution or contained in the color film or paper. Development fog can also form. Sludge and scums may form in the developers if aldehydes are carried into the solution. These difficulties are avoided by using a neutralizing solution after the hardening bath. John Blackmer and Howard W. Vogt[23] patented a neutralizing solution "containing at least one primary amine compound containing in addition to the —NH₂ group a hydroxyl group, a carbonyl group, or an amino group, which may have a substituent thereon." Useful amine compounds included, among others,

H_2NOH hydroxylamine

$H_2NNHCNH_2$ (O) semicarbazide

H_2NNH_2 hydrazine

$H_2NHNCNH_2$ (NH) aminoguanidine

These amine compounds react with the aldehyde contaminants more rapidly at a pH below 8.0, so the neutralizing solutions were adjusted so that the pH was between 4.5 and 8.0. Sodium sulfate was added to control gelatin swelling, and a bromide, such as sodium bromide, to maintain the desired bromide level in the coated layers.

The Blackmer–Vogt neutralizing solution was illustrated as follows. An exposed, incorporated-coupler, reversal color film is first treated in this prehardening bath for 2 min at 100°F.

Succinaldehyde	10 g
Sodium acetate	10 g
Water to make	1 liter

The hardened film, without washing or rinsing in water, is immersed for 30 sec at 100°F in this neutralizing solution.

Sodium hexametaphosphate	0.5 g
Hydroxylamine	25.0 g
Sodium bromide	1.0 g
Sodium sulfate	50.0 g
Water to make	1.0 liter

The film is then placed directly into the black-and-white developer.

Later, Richard J. Malloy[24] pointed out that the aldehyde-neutralizing solution is unstable because of the decomposition of the hydroxylamine. Hydroxylamine decomposes to form nitrogen or nitrogen oxide gases, making it impractical to store concentrated liquid neutralizing solutions containing the hydroxylamine or its acid salts. The buildup of the gases eventually damages the container. This undesirable condition may be prevented, according to Malloy, by adding a hydroxyalkylidene diphosphonic acid of the type

$$\begin{array}{c} PO_3H_2 \\ | \\ R-C-OH \\ | \\ PO_3H_2 \end{array}$$

where R is a carbon chain of from one to five carbon atoms, or a water-soluble salt of the acid. A suitable aldehyde-neutralizing solution had the formula (pH = 5.0; 80°F):

Water	700.0 ml
Hydroxylamine sulfate	82.5 g
Glacial acetic acid	22.5 ml
Sodium sulfate (anhydrous)	125.0 g
Sodium hydroxide (50% solution)	20.7 ml
Sodium bromide	50.0 g
1-Hydroxyethylidene-1,1-diphosphonic acid (60% by weight in water)	6.0 ml
Water to make	1.0 liter

This solution is diluted with about five times its volume with water before use.

Fuji Shashin Film Kabushiki Kaisha[25] have proposed to treat photographic materials, between the prehardening and development steps, with an aqueous solution containing a heterocyclic compound having a ring composed of at least two of the following groups

$$-\overset{\displaystyle H}{\underset{\displaystyle |}{N}}-, \quad -\overset{\displaystyle O}{\underset{\displaystyle \|}{C}}-, \quad -\overset{\displaystyle R}{\underset{\displaystyle |}{C}}=, \quad \text{and} \quad -\overset{\displaystyle R}{\underset{\displaystyle \underset{\displaystyle R}{|}}{\underset{\displaystyle |}{C}}}-, \quad \text{one of them being}$$

$$-\overset{\displaystyle H}{\underset{\displaystyle |}{N}}- \quad \text{or} \quad -\overset{\displaystyle O}{\underset{\displaystyle \|}{C}}-$$

where R is a hydrogen, methyl, or ethyl group. Suitable compounds and their concentrations include barbituric acid (2 g/liter), cyanuric acid (5 g/liter), dimedone (2 g/liter), flavanic acid (5 g/liter), maleic hydrazide (2 g/liter), succinimide (5 g/liter), or uracil (3 g/liter). A prehardening composition

Sodium bisulfite	1 g
Formalin (37%)	15 ml
Borax	5 g
Sodium sulfate	50 g
Potassium bromide	2 g
Water to make	1 liter

was used for 1 min, 24°C, to treat a reversal color film that is to be developed with coupler-containing developing solutions. After a 1-min wash, the film was immersed in one liter of aqueous solution containing 8 g of boric acid, 0.8 g of potassium bromide, 0.3 ml of sulfuric acid, and one of the heterocyclic compounds and quantity listed before, for example, 2 g of maleic hydrazide. After a 1-min immersion followed by a 1-min water wash, the film is given the first development of the processing cycle. Fuji[26] has also patented the use of resorcinol (5 or 10 g/liter) or 4-chlororesorcinol (5 or 10 g/liter) for use under similar processing conditions.

High-temperature development of coupler-containing color materials may cause overdevelopment of the upper layer, usually the blue-sensitive, yellow-dye-forming layer, before the bottom layers are fully developed. An undesirable amount of image density is thus produced in the first dye layer. Development inhibitors have been previously used, but such compounds, although diffusing more slowly than the developing agents, may penetrate beyond the top emulsion layer and inhibit the image density produced in the lower emulsion layers. It has been proposed[14,27] to include a substituted 1-phenyl-5-mercaptotetrazole in the prehardener, the neutralizing, or the negative developing solution, or in a combination of these, to inhibit the high-temperature development of the top layer of the multilayer color material without affecting the other layers of the material. A compound such as 1-(3-caproamidophenyl)-5-mercaptotetrazole at 0.02 g/liter was added to a formalin-succinaldehyde prehardener for a 6-sec, 160°F, treatment of the film. Alternatively, the compound may be added to the hydroxylamine-sodium sulfate neutralizing bath used for 15 sec at 160°F. It is claimed that the negative development in the top yellow-dye-forming layer is beneficially inhibited with virtually no effect on the development of the other two dye-forming layers.

Overdevelopment of the top layer can be controlled by incorporating a benzothiazolium salt in the emulsion layer or having the benzothiazolium salt, such as *N*-methyl benzothiazolium-*p*-toluene sulfonate, in a bath prior to development.[28] 2-Thiobarbituric acid and its derivatives, or thiouriedonaphthols, have also been used in a solution before color development to slow development of the upper layers of a color material.[29]

First Developing Solutions

In a reversal color process, the first developer produces a silver image without dye formation much in the fashion of the developer used for a black-and-white film. The first developing solution usually contains Metol-hydro-

quinone or Phenidone-hydroquinone as the primary developing agents, but other combinations of developing agents have been suggested. An example[30] of a first developer is the Kodachrome film First MQ Tank Developer (Process K-12) (pH = 10.40; 80°F):

Water	800.0 ml
Quadrafos (Rumford Chemical Works)	0.6 g
Sodium sulfite, desiccated	79.0 g
Kodak Elon developing agent	5.0 g
Sodium hydroxide	1.0 g
Hydroquinone	2.0 g
Sodium carbonate (anhydrous)	35.0 g
Potassium iodide (0.1 % solution)	12.5 ml
Sodium bromide	3.0 g
Sodium thiocyanate	1.65 g
Hydroquinone monosulfonate	4.0 g
Water to make	1.0 liter

Most modern developers contain polyphosphate salts,[31] such as Quadrafos here, but Calgon (Calgon Corporation) is also widely used, to sequester calcium and magnesium ions present in the water to make the developing solution. Soluble complexes of calcium and magnesium are formed, preventing the immediate precipitation of the calcium and magnesium as sludges when the developer is made. Eventually, however, the phosphates of calcium and magnesium will precipitate, sometimes coating processing equipment. Ethylenediamine tetraacetic acid is a well-known sequestering agent[32-34] but may not be used, because this compound causes an increase in the rate of the air oxidation of the hydroquinone in the developing solution.

The first developer is a buffered alkaline solution of the developing agents with sodium sulfite as the preservative to prevent the buildup of the oxidized forms of the developing agents. Hydroquinone is commonly used as one of the developing agents, but bromohydroquinone, chlorohydroquinone, dichlorohydroquinone, phenylhydroquinone, hydroquinone monosulfonate, and other hydroquinones have been proposed. For rapid reversal processing, methylhydroquinone was suggested by Donald J. Forst[35-37] as a replacement for hydroquinone for use with Metol or Phenidone. An incorporated coupler reversal film (Kodak Ektachrome film 2448) was processed for 70 sec, 75°F, in the following formulation.

Quadrafos (sodium tetraphosphate)	2.0 g
Phenidone	1.0 g
Sodium sulfite, anhydrous	50.0 g
Methylhydroquinone	7.0 g
Ethylenediamine (93%)	26.0 ml
Sodium thiocyanate	1.0 g
Boric acid	12.0 g
Potassium iodide (0.1% solution)	13.0 ml
1-Phenyl-2-tetrazoline-5-thione (0.5% solution)	5.0 ml
Water to make	1.0 liter

For color reversal papers, hydroquinone was said to be disadvantageous because of the nonuniform color formation in large areas of the same color. Heinz Meckl, Helmut Häseler, and Bernhardt Morcher[38] found that this unwanted effect could be avoided when the hydroquinone was replaced by ortho-phenylenediamine (but not meta- or para-phenylenediamine) when used with 1-phenyl- or 5-phenyl-3-pyrazolidones. Alone, o-phenylenediamine at a pH about 10 was said not to develop silver halide but enhanced the development of 1-phenyl-3-pyrazolidone. According to Example 1 of U. S. Patent 3,295,975:

A multi-layer material on a paper support, containing a silver bromide layer with 3-(p-stearoylamino-benzoylacetamino)-isophthalic acid as yellow coupler, as well as two silver chloride layers with 1-(3-sulpho-4-phenoxy)-phenyl-3-heptadecyl-5-pyrazolone as magenta coupler and N-octadecyl-1-hydroxy-4-sulpho-2-naphthamide as cyan coupler, is exposed and developed at a pH value of 10.0 for 4 to 5 min at 20°C in a first reversal developer having the following composition:

Sodium hexametaphosphate	3 g
Anhydrous sodium sulphite	15 g
o-Phenylenediamine	5 g
Anhydrous sodium carbonate	60 g
Potassium bromide	5 g
1-Phenyl-3-pyrazolidone	5 g
Benzotriazole	0.05 g

Make up with water to 1 liter.

Color photographic materials that have aged produce fog in the first developer, particularly when the processing is carried out at high tem-

peratures. Fog production in the first developer causes a lowering of the saturation of the color in the final dye image as well as a loss of detail in areas of low exposure. A first developer has been devised[39] which is claimed to provide substantially the same color image from fresh or aged color materials. The developer contains a 3-pyrazolidone and hydroquinone at a relatively low pH. Such a developing solution as follows was suitable for machine processing for 60 sec at 52°C (pH = 9.25; 27°C):

Water	800.0 ml
Quadrafos (sodium tetraphosphate)	2.0 g
Sodium sulfite, anhydrous	44.0 g
1-Phenyl-3-pyrazolidone	0.6 g
Hydroquinone	5.5 g
Sodium thiocyanate	1.38 g
Sodium bromide, anhydrous	1.30 g
Potassium iodide (0.1 % solution)	13.0 ml
Potassium hydroxide (45 % by weight solution)	8.8 ml
Boric acid	10.2 g
Water to make	1.0 liter

The loss of silver halide as a result of fog formation must be minimized in the first developer in order that sufficient silver halide be available for the production of the dye image and to maintain the desired color balance of the final dye image. Most first developers contain sodium or potassium bromides or iodides to inhibit fog formation. Organic compounds are used as fog inhibitors, often in addition to the iodides and bromides. 4-Carboxythiazolidine and its substituted 2-phenyl derivatives have been found[40] useful in first developers for reversal color processing. 4-Carboxy-2-(p-chlorophenyl)-thiazolidine, for example, was added at 0.15 g/liter to a hydroquinone-Metol developing solution containing potassium bromide (1.0 g/liter) and potassium iodide (2.0 ml of 0.1 % solution).

First developers for reversal color processing contain a silver halide solvent, just as does the first developing solution used in black-and-white reversal processing. The primary purpose of the silver halide solvent is to clean out the reversal highlights but not to produce fog or remove silver halide from the unexposed areas. The effective reversal speed of the silver halide material is increased, the image definition is improved, and, with color materials, the color saturation of the dye image is promoted. Sodium thiocyanate is often used, the quantity sometimes specified to the hundredths of a gram. Vincent J. Miceli[41,42] patented the use of high concentrations of

of an alkali metal bromide, such as sodium bromide or chloride, at many times their normal concentration, thus replacing the sodium thiocyanate in the first developing solution. Higher maximum dye densities were said to be obtained in all layers, producing deeper colors and a better black. A reversal color film (GAF Anscochrome Film) was exposed and developed for 23 min, 68°F, in a developer of the following composition:

Ethylenediamine tetraacetic acid	0.8 g
Sodium sulfite, desiccated	20.0 g
Metol	3.0 g
Hydroquinone	6.0 g
Sodium bromide	2.0 g
Sodium carbonate	45.0 g
Potassium iodide	0.010 g
Sodium chloride	100.0 g
Water to make	1.0 liter

Organic amines have been used as silver halide solvents for the first developer of the reversal processing cycle. These compounds clear out the reversal highlights and provide the other benefits of the solvent action, such as improved color saturation and color balance of the dye images. n-Propylamine, isopropylamine, propylenediamine, n-butylamine, and other amines have been patented for solvents in first developers.[43] Organic amines often have objectionable odor and are volatile, so that their effect is variable as the amine escapes from the developing solution. Heman Dowd Hunt[44] overcame these objectionable properties of amines through the use of imidazoles as the silver halide solvent. The relative speed and the maximum dye densities were substantially increased when 1.4 g of imidazole was added to a liter of a conventional Metol-hydroquinone first developer containing potassium bromide at 5 g/liter but no sodium thiocyanate.

Improved first developers and color developers have been claimed[45,46] when 0.01 to 0.10 g of a thallium compound, such as thallous or thallic nitrate or sulfate, is present in a liter of a conventional developing solution. Thallium salts, it should be mentioned, are highly toxic compounds.

Color Developing Solutions

A color developing solution is an aqueous, alkaline bath of the color developing agent in the presence of a minimum of preservative with sufficient restrainers or antifoggants to prevent fog development. Special additives, such as solvents, development accelerators, and competing developing agents and coupling compounds are often added to achieve the desired dye

image characteristics. Primary, soluble couplers are included in those developers for color materials that do not have incorporated couplers. In a reversal color process, color development is essentially carried to completion so that temperature control is not so critical as with first development. Control in most first developers is usually specified to the minute with specific agitation conditions. Temperature limits of $\pm 0.5°C$ or to even a quarter of one degree are commonly specified. With color negative processing, the color developer is a critical step early in the processing cycle with restrictions similar to that of the first developer of the reversal color process.

Typical Color Developing Solution

Water	800 ml
Sequestering agent	
(1) Sodium tripolyphosphate, sodium hexametaphosphate or sodium tetraphosphate, or	
(2) Ethylenediamine tetraacetic acid derivative	0.6 to 5.0 g
Benzyl alcohol	2 to 14 ml
Sodium bromide (potassium bromide)	0.5 to 2 g
Potassium iodide	0.001 to 0.010 g
Sodium sulfite, desiccated	2 to 10 g
Organic antifogging agent (6-nitrobenzimidazole nitrate, benzotriazole)	0.001 to 0.050 g
Hydroxylamine sulfate	1 to 10 g
Alkaline buffer	
(1) Sodium metaborate, or	
(2) Sodium carbonate, or	
(3) Trisodium phosphate	40 to 80 g
Color developing agents	2 to 15 g
Secondary developing compounds	
(1) Balancing developing agents	0.1 to 3.0 g
(2) Cross-oxidizing agents	0.05 to 0.5 g
Coupling agent (if present)	
(1) Primary coupler	2 to 3 g
(2) Secondary coupler	2 to 3 g
Ethylenediamine or sodium thiocyanate	2.5 g
Glycol, such as hexylene glycol	15 ml
Water to make	1 liter

All color developers have a similarity in their constitution. Reversal color developing solutions tend to contain more additives to insure that the color image has the desired characteristics. The reversal color image is viewed directly and critically. The color negative, on the other hand, is an intermediate, often with masking dye layers, with possibilities of further color corrections during the making of the color print. Color developers for color negative materials tend to be somewhat less complex chemically although having much in common with the reversal color developer. The possible ingredients of a typical color developing solution are listed on page 539 (pH = 10.0 to 12.5).

The functions of these ingredients are discussed briefly here to help the reader understand the formulation of the color developing solution.

Water

Water is the necessary solvent to ionize the chemicals so that reactions may occur. Tap water, filtered free of sand, rust, and other particles, is sufficient for making a color developer, provided that the water does not contain copper or iron contaminants. Chlorination of the water is not detrimental. Distilled water is ideal if it is free of metal ions, such as copper, that might result from the use of a copper still or copper piping from the still to the faucet. The presence of copper ions is particularly a danger with color photographic processing.

Sequestering Agents

Tap water may contain a considerable number of naturally occurring salts, the exact water composition varying with the locality. The chlorides of sodium or potassium, or the sulfates and carbonates of calcium or magnesium, are the most common salts found in water. Their presence is actually beneficial, as the salt content of water restrains the swelling of gelatin. The low solubility of the calcium and magnesium salts may cause turbidity or precipitation in the color developing solution, or a calcium scum may form on the surface of the photographic material. Even if the water is free of calcium salts, they may be introduced by the photographic material itself. To inhibit the deposition of calcium or magnesium compounds, a sequestering agent is added to the developing solution to combine the calcium and magnesium into water-soluble complexes. Quadrafos (the trademarked name of Rumford Chemical Works for sodium tetraphosphate), Calgon (the trademarked name of the Calgon Corporation for sodium hexametaphosphate), and ethylenediamine tetraacetic acid (EDTA) have been used as calcium sequestering agents in color developing solutions. The water-

soluble calcium complexes formed by Calgon may slowly decompose to precipitate calcium ortho phosphate. EDTA as a sequestrant has less tendency to form precipitates. The combination of sodium hexametaphosphate and EDTA was patented[47] as a means to prevent the formation of the decomposition products of the metaphosphate or pyrophosphate and still prevent the precipitation of lime salts. Acylation products of phosphorous acid,

$$\begin{array}{ccc} O & R & O \\ \| & | & \| \\ HO-P-C-P-OH \\ | & | & | \\ O & O & O \\ H & H & H \end{array}$$

where R is an alkyl radical having one to five carbon atoms, bind calcium ions strongly and complex with metal ions. Superiority in sequestering power was claimed[48] over pentasodium tripolyphosphate and ethylenediamine tetraacetic acid.

Ethylenediamine tetraacetic acid must be used with care for sequestration. In the presence of ferric ion (Fe^{3+}), according to Paul M. Mader,[49] EDTA forms a complex with the iron that accelerates the oxidation of the developing agent in solution. The iron may have been introduced as an impurity in the water or in the chemicals used to compound the developing solution. Other ions, such as Ni^{2+}, Cr^{3+}, Co^{2+}, and Mn^{2+}, tend to act with EDTA in the same manner as Fe^{3+} but to a lesser degree. Copper (Cu^{2+}) caused a more severe loss of the developing agent and sodium sulfite in the absence of the EDTA than when it was sequestered by the EDTA.

In the presence of sodium sulfite, the color developing agent is oxidized by the oxygen of the air so that two molecules of the sulfite are consumed for each molecule of the developing agent that is lost.[50]

$$+ 2Na_2SO_3 + O_2 \longrightarrow$$

$$+ Na_2SO_4 + NaOH$$

The oxidation of the developing agent, according to Kurt Meyer and Lieselotte Roth,[51] was said to occur by a different route when the ethylene-diamine tetraacetic acid was present.

In this case, one molecule of sulfite is used up for each molecule of the developing agent.[52] Mader proposed that iron (Fe^{3+}) impurity combined with EDTA to form a complex that catalyzed the reaction of the developing agent with hydrogen peroxide that is formed during aeration.

Preservatives

Sodium sulfite is added to the alkaline solution of the color developing agent to minimize the air oxidation of the developing agent. The amount of sulfite that can be present, however, must be only a few grams per liter, because the oxidized form of the developing agent is utilized for dye production. The loss of the oxidized developing agent by reaction with sulfite can seriously reduce dye formation. The amount of sulfite that can be tolerated is insufficient to maintain protection against aerial oxidation. A 1937 patent of Edwin Ernest Jelley[53] proposed adding a hydroxylamine, a hydrazine, or sodium formaldehyde sulfoxalate to increase the stability of the developer solution. In 1938 Edith Weyde and Erwin Trabert[54] proposed to add to the

developer or incorporate within the photographic material a substance that is more reactive toward oxygen than the color developing agent. Hydroxylamine and its derivatives as well as organic hydrazines were patented for minimizing color fog formed during development. According to Mutter,[30] 1 g of hydroxylamine sulfate in one liter of color developer containing 2 g of sodium sulfite lost only 14% of the developing agent during exposure to air in four weeks. Without the hydroxylamine, 70% of the developing agent was oxidized.

A few grams of hydroxylamine sulfate, $(NH_2OH)_2 \cdot H_2SO_4$, is present in most of today's color developers. In alkaline solution hydroxylamine is unstable, decomposing according to

$$3\,NH_2OH \longrightarrow N_2 + NH_3 + 3\,H_2O$$

This deterioration becomes even more rapid if an ethylenediamine tetraacetic acid compound is present in the absence of metal-ion impurities.[55] In the presence of an impurity, such as ferric ion, the EDTA complex with the metal ion catalyzes the loss of the developing agent. Copper is a known catalyst for the autoxidation of hydroxylamine solutions by atmospheric oxygen.[56] EDTA combines with the copper to inhibit this reaction. Other compounds, such as 8-hydroxyquinoline, also deactivate copper ions. Kurt Meyer and Wolfgang Brune[55] concluded, "The use of Trilon B [the sodium salt of ethylenediamine tetraacetic acid] is indicated only when the color developer is contaminated with copper ions. It appears more sensible, however, to prevent the contamination of the color developer by copper and to use Calgon as the water softener instead of Trilon B. We are convinced that this has no catalytic effect on the decomposition of hydroxylamines, neither has the ability to render copper ions harmless." The combined use of Calgon and Trilon B has also been proposed.[31]

Storage of hydroxylamine-containing color developers without substantial loss of the essential ingredients was claimed by Donald J. Kridel[57] when the EDTA was replaced by 0.5 to 1.0 g/liter of 1,3-diamino-2-propanol tetraacetic acid (DPTA):

$$\begin{array}{ccc}
HOOC-CH_2 & & \overset{\displaystyle \overset{H}{\underset{|}{O}}}{} \quad CH_2COOH \\
\diagdown & & \diagup \\
& N-CH_2\overset{|}{C}HCH_2-N & \\
\diagup & & \diagdown \\
HOOC-CH_2 & & CH_2COOH
\end{array}$$

Diethylenetriamine pentaacetic acid (DTPA)

$$\begin{array}{ccc}
HOOC-CH_2 & & CH_2COOH \\
\diagdown & & \diagup \\
& NCH_2CH_2NCH_2CH_2N & \\
\diagup & | & \diagdown \\
HOOC-CH_2 & CH_2COOH & CH_2COOH
\end{array}$$

has been said[58] to stabilize color developers containing hydroxylamine while providing effective sequestration of calcium and iron to prevent the formation of scums and sludges. The presence of DTPA in a color developer had "a dramatic effect on the stability of the stored solutions," markedly stabilizing the hydroxylamine against loss during the 10-day, 75°F, test of open and closed containers. The color developer had the composition

Kodak color developing agent, CD-3 (4-amino-*N*-ethyl-*N*-(beta-methanesulfonamidoethyl)-*m*-toluidine sesquisulfate monohydrate)	4.50 g
Sodium metaborate · $4H_2O$	36.00 g
Sodium sulfite, desiccated	2.60 g
Hydroxylamine sulfate	3.60 g
Potassium bromide	0.30 g
Diethylenetriamine pentaacetic acid	0.80 g
Water to make	1.0 liter

An exposed multilayer positive color photographic film was processed for 5 min in the above solution (no solution temperature listed).

Considerable quantities of air are introduced into color developing solutions that are used in processing machines. According to Ralph M. Evans and Wesley T. Hanson, Jr.,[59] "This aeration sometimes oxidizes more of the developing agent than the actual development process itself and thus causes additional expense due to the exhaustion of the developer, as well as some difficulty in controlling the developing action of the solution." With color developers containing both the color developing agent and the coupler, premature oxidation of the developing agent can result in the formation of the dyestuff. The low solubility of the dye usually produces a scum on the surface of the solution and interferes with the photographic material. To inhibit the aerial oxidation of color-forming developing solutions, Evans and Hanson proposed "the addition of small amounts of hydroquinones to developing solutions containing aromatic amino developing agents, or in general the addition of reducing agents having a higher solution reduction potential than the developer in question but which are not strongly adsorbed to the grains in the emulsion and, therefore, take only a very small part in the actual development process." Hydroquinone (0.3 g), hydroquinone monosulfonate (1.0 g), or toluhydroquinone (0.2 g) were added to a liter of coupler-containing color developer.

Other hydroxyl-containing developing agents have been patented for inhibiting the aerial oxidation of color developing solutions that contain a primary amino aromatic developing agent and color coupler. A small

quantity of a 4-aryl-2-oxytetronic acid or 4-aryl-2-oxytetronimide is said[60] to be effective for this purpose:

where R is phenyl, naphthyl, or substituted derivatives and X is oxygen or an imino group.

Quantities of the oxytetronic acid or oxytetronimide as small as 0.1 g/liter were said to prevent oxidation of the developing solution when it is mixed and to delay the oxidation for 2 to 3 hr. At most, a reduction of 5% in the photographic activity of the developer took place.

Improved effectiveness against aeration was found by Leslie Frederick Alfred Mason[61] when the 4-aryl-2-oxytetronic acid, 4-aryl-2-oxytetronimide, or ascorbic acid, was present with hydroxylamine in the color developing solution. Normally, hydroxylamine requires a solution pH of at least 11.25 to be effective.[62] When the hydroxylamine was used with the ascorbic acid in solutions of the pH range of 9 to 11.25, the synergistic effect delayed scum formation for 12 hr or longer. Generally, hydroxylamine in quantities of 0.5 to 1.5 g/liter is combined with 0.1 to 0.5 g of ascorbic acid or the tetronic compound, or a mixture of the two compounds.

Color Developing Agents

p-Phenylenediamine developing agents are organic bases that are unstable in air. They are reacted with inorganic acids, such as hydrochloric or sulfuric, or with organic acids, such as p-toluenesulfonic acid, to form salts that are easier to purify and are more stable during storage. Commercially available color developing agents are invariably in the salt form. The free base, however, is the active developing form, and this base is formed when the salt is dissolved in an alkaline solution. Too strong an alkali should not be added in a concentrated form, as the free base, which has limited solubility, may be precipitated as an insoluble oil from the aqueous solution. Any form of the color developing agent should be kept from contacting the human skin, as a severe allergenic reaction may result.

A great number of potential color developing agents have been patented; a much smaller number have been thoroughly studied. A very few, probably fewer than the fingers of both hands, are used in all the commercial color

processes of today. These few *p*-phenylenediamines give acceptable results in a wide variety of color negative and color reversal processes. These commercially available photographic developing agents include

C₂H₅ ... C₂H₅ [chemical structure]

NH₂·HCl

Chemical name: *N,N*-diethyl-*p*-phenylene-diamine monohydrochloride

Trade names: Kodak Color Developing Agent, CD-1 (Eastman Kodak Co.); Activol No. 6 (Johnsons) (formerly Activol H)

C₂H₅ ... C₂H₅ [chemical structure]

NH₂·SO₂·½H₂O

Chemical name: *N,N*-diethyl-*p*-phenylene-diamine sulfur dioxide complex

Trade names: Activol (formerly Activol No. 1) (Johnsons); Genochrome (May and Baker[63,64])

This sulfurous acid salt of *N,N*-diethyl-*p*-phenylenediamine is a 1:1 addition compound. In alkaline solution there is formed the free base of the developing agent and sodium (or potassium) sulfite. Genochrome (114 parts) yields the equivalent of 100 parts of *N,N*-diethyl-*p*-phenylenediamine hydrochloride or 107 parts of the sulfate salt and 63 parts of sodium sulfite.[65] The presence of the sulfite must be reckoned with during the formulation of the color developer.

C₂H₅ ... C₂H₅ [chemical structure]

NH₂·½H₂SO₄

Chemical name: *N,N*-diethyl-*p*-phenylene-diamine sulfate

Trade name: Activol No. 7 (formerly Activol S) (Johnsons); Ferrania S-28

C₂H₅ ... C₂H₅ [chemical structure]

CH₃
NH₂·HCl

Chemical name: *N,N*-diethyl-3-methyl-*p*-phenylenediamine hydrochloride; or 2-amino-5-diethylaminotoluene hydrochloride

Trade names: Kodak Color Developing Agent, CD-2 (Eastman Kodak Co.); Tolochrome (May and Baker); Activol No. 2 (Johnsons)

C_2H_5 C_2H_4OH
N
(benzene ring)
$NH_2 \cdot H_2SO_4$

Chemical name: *N*-ethyl-*N*-(β-hydroxyethyl)-*p*-phenylenediamine sulfate

Trade names: Activol No. 8 (formerly Activol-X) (Johnsons); Droxychrome (May and Baker); Dicolamine (Ansco)

C_2H_5 C_2H_4OH
N
(benzene ring)
CH_3
$NH_2 \cdot H_2SO_4$

Chemical names: *N*-ethyl-*N*-(β-hydroxyethyl)-3-methyl-*p*-phenylenediamine sulfate; or 4-amino-3-methyl-*N*-ethyl-*N*-(β-hydroxyethyl)-aniline sulfate

Trade name: Kodak Color Developing Agent, CD-4

C_2H_5 $C_2H_4NHSO_2CH_3$
N
(benzene ring)
CH_3
$NH_2 \cdot \frac{1}{2}H_2SO_4 \cdot H_2O$

Chemical names: *N*-ethyl-*N*-(β-methylsulfonamidoethyl)-3-methyl-*p*-phenylenediamine sesquisulfate monohydrate; or 4-amino-*N*-ethyl-*N*-(β-methanesulfonamidoethyl)-*m*-toluidine sesquisulfate monohydrate

Trade names: Kodak Color Developing Agent, CD-3; Activol No. 3 (Johnsons); Mydochrome (May and Baker)

CH_3CH_2 $CH_2CH_2OCH_3$
N
(benzene ring)
CH_3
$NH_2 \cdot 2\ CH_3C_6H_4SO_3H$

Chemical name: 4-Amino-*N*-ethyl-*N*-(2-methoxyethyl)-*m*-toluidine di-*p*-toluenesulfonate

Trade name: Kodak Color Developing Agent, CD-6

Alkaline Buffering Compounds

Alkaline compounds are needed to ionize both the developing agent and the coupler before dye formation can result. In color developers, sodium metaborate, sodium or potassium carbonate, trisodium phosphate or other phosphates, or sodium or potassium hydroxide are commonly used as

alkalis. The pH of the developing solution may change because of several reactions, the most important of which are

1. Oxidation of the developing agent (pH increase):

$$+ \, 2\,Na_2SO_3 + O_2 \longrightarrow$$

$$+ \, Na_2SO_4 + NaOH$$

2. Oxidation of sulfite ion (pH decrease):

$$2\,SO_3^{2-} + O_2 \longrightarrow 2\,SO_4^{2-}$$

3. Carbon dioxide absorption from air (pH decrease):

$$CO_2 + OH^- \longrightarrow HCO_3^-$$

The effect of the aerial carbon dioxide is the major cause of pH change.

In the region of pH 9 to 13, phosphate ions are good buffering alkalis, but calcium phosphate may precipitate when calcium ions are present (from the water, from other chemicals, or from the photographic material). Inorganic carbonates may evolve bubbles of carbon dioxide if the alkaline photographic material is transferred to an acidic stop or fixing bath. Attempts have been made to find a substitute for the inorganic alkalis. Hydroxyalkylamines, such as triethanolamine, have been proposed as a substitute. Sugar amides such as methylglucamine, mannamine, and arabinamine have been patented for color developers.[66] None of the proposed substitutes has replaced completely the inorganic alkalis, although amines are often present in color developing solutions for their accelerating effect on development.

Buffering compounds that resist pH change are often added to present-day color developing solutions. Sulfonamide compounds that do not reduce

silver halide have been patented[67] as buffers for developing solutions having a pH in the range of about 9 to 13. Examples of such compounds are

$$CH_3SO_2NH_2$$

methanesulfonamide

$$CH_3SO_2NHCH_2CH_2OH$$

N-(β-hydroxyethyl)-methanesulfonamide

$$HO_3S-\langle\ \rangle-SO_2NH_2$$

para-sulfobenzenesulfonamide

In U. S. Patent 3,305,364 a comparative example is given of a conventional color film developer and one modified by the use of N-ethylmethanesulfonamide as the buffer (pH = 11.57 at 75°F):

Ingredients	Conventional Color Developer	Modified Color Developer
Water	1.0 liter	1.0 liter
Benzyl alcohol	6.0 ml	6.0 ml
Ethylenediamine tetraacetic acid	4.0 g	4.0 g
Sodium sulfite, desiccated	5.0 g	5.0 g
Trisodium phosphate, $12 H_2O$	40.0 g	0 g
Ethylenediamine	2.86 g	0 g
N-Ethylmethanesulfonamide	0 g	40.0 g
Potassium bromide	0.25 g	0.25 g
Citrazinic acid	1.4 g	1.4 g
Kodak color developing agent, CD-3	11.3 g	11.3 g

The N-ethylmethanesulfonamide replaced both the buffering compound (trisodium phosphate) and the development accelerator (ethylenediamine), yet the critical yellow dye yield was slightly greater for the modified color developer. The sulfonamide compound is as good a buffer as the phosphate ion, and the calcium salt of the sulfonamide is water soluble.

An example of a modified color developer for color print papers was

claimed to give a fourfold (two f/stops) increase in speed without any increase in fog as compared with a developing solution containing the normal carbonate buffer (pH = 10.0 at 70°F):

Ingredients	Normal Color Print Developer	Modified Color Print Developer
Water	1.0 liter	1.0 liter
Benzyl alcohol	12.64 ml	12.64 ml
Sodium bromide	0.417 g	0.417 g
Sodium chloride	0.730 g	0.730 g
Sodium sulfite, desiccated	2.08 g	2.08 g
Kodak color developing agent, CD-3	4.17 g	4.17 g
Hydroxylamine sulfate	2.08 g	2.08 g
Methanesulfonamide	0 g	40.0 g
Sodium carbonate	22.52 g	0 g
Sodium sesquicarbonate	7.92 g	0 g

A developer replenisher for machine processing of an incorporated coupler, negative color film has been formulated so that the potassium and sodium ions are in a weight ratio of at least 2.5 to 1.0.[68] This developer replenisher consists of three parts:

Part A

Benzyl alcohol	6.3 ml

Part B (Concentrated Buffer Solution)

Dissolve	
Sodium hydroxide	3.4 g
Potassium hydroxide	22.8 g
Water	63.0 g
Then add, slowly	
Boric acid	29.0 g

Potassium hydroxide (45% solution) sufficient to make pH 10.75 at 27°C.

Part C

Sodium sulfite, desiccated	2.0 g
Water	11.0 g

Then add and stir in

4-Amino-*N*-ethyl-*N*-(*β*-methane-sulphonamidoethyl)-*m*-toluidine sesquisulphate monohydrate	6.4 g

The replenisher is made by adding part A to 800 ml of water with vigorous stirring; part B is then added and stirred. Part C is added after part B is dissolved, and water is added to make one liter of solution. The replenisher for the equilibrium color developer is used for machine processing a color negative film for 14 min at 24 ± 0.03°C. The replenishment rate is 163 ml/sq ft of film processed.

Development Restrainers and Antifoggants

In color development, fog formation produces color fog that degrades the color rendition. Color fog is readily apparent in reversal-process color transparencies or in color prints on a white base. The prevention of color fog starts with the manufacture of the photographic emulsion layers and is maintained by antifog compounds in the developing solution. Reducing agents, such as hydroquinone or ascorbic acid, were incorporated early for antistain purposes, but such developing agents can decrease the amount of dye formed. Isoascorbic acid and hydroquinone help to decrease spotting due to metallic iron.[69] Derivatives of hydroquinone substituted in the 2 position, such as gentisamide or methyl gentisate, were claimed[70] for use for incorporation in the coated layers or in the developing solution at 0.5 to 1.0 g/liter of solution. Another proposal[71] was to incorporate in the emulsion compounds such as semicarbazides for removing traces of formaldehyde that might be present in the photographic material. Formaldehyde reacts with couplers to form color fog. Pyrazolones were said to give yellow-colored compounds when formaldehyde was present in the emulsion layers or base. The presence of the formaldehyde scavengers in the emulsion layer may in themselves contribute instability of the photographic film or paper. Modern coating technology makes use of hardening agents that do not interact with the couplers.

A variety of development restrainers or organic antifoggants have been incorporated in the color developing solution. Sodium or potassium bromide and potassium iodide are usually present in the solution. Other organic

compounds, such as 6-nitrobenzimidazole or benzotriazole, may be present in very small quantities, but such compounds may restrain development or require an increase in the developing time in order to obtain the desired image density.[72] 1-Phenyl-5-mercaptotetrazole, for example, at 0.01 g/liter causes serious reduction in dye density, although lowering the color fog. A recent patent[73] has proposed to add short-chain mercapto acids, for example, mercaptoacetic or mercaptopropionic acids, at 0.01 to 0.5 g/liter, to coupler-containing color developers.

During the first development of color reversal materials, fog centers are enhanced to such an extent that, after reversal exposure and subsequent color development with coupler-containing solutions, color images are formed in areas that have been unexposed. In processing color film such as Kodachrome film, development of the red-sensitive layer produces not only cyan dye in that layer but also cyan fog in the blue and green sensitive layers. The tendency to form color fog is especially severe in modern emulsions sensitized with sulfur-gold and the oleyl ether of polyethylene glycol. From 0.25 to 1.0 g of benzothiazolium or naphthothiazolium compounds in a liter of aqueous solution has been proposed[74] as a prebath just before color development to inhibit color fog in the unexposed layers. The same objective is said[75] to be achieved by adding to one or more of the color developers a heterocyclic compound containing a mercapto group. Such compounds are used at a concentration of 0.005 to 0.030 g/liter of color developer. Tetrazaindenes, such as

6-hydroxy-3-mercapto-4-methyl-
1,2,3a,7-tetrazaindene

are claimed to be effective as well for coupler-containing color photographic materials.

Catherine Spath[76] has also patented formamidinothiomethyl compounds, for example, 2-S-thiuroniumethanesulfonate, for the control of color fog produced by coupler-containing color developing solutions.

Secondary Developing Agents

Primary developing agents, such as the *p*-phenylenediamine derivatives, are carefully selected to couple rapidly to form nondiffusing dyes. Karl Schinzel,[77]

as early as 1936, proposed adding a noncoupling, non-color-forming developing agent to the color developing solution for the purpose of reducing the intensity of a dye image in relation to the other colored images of the material and improving the image gradation. Mono-*p*-benzyl-*p*-aminophenol is such a balancing agent, acting as a surface developing agent in hydroxide solution.[78] This compound (Kodak balancing developing agent, BD-80) was used in the cyan developer in Process K-12 for Kodachrome film. G. F. van Veelen found that this compound at 0.236 g/liter produced higher contrast and a shorter toe when used to develop the yellow layer of a color reversal film. A lower concentration of hydroquinone accomplished essentially the same result. Hydroquinone monosulfonate had a lesser effect than hydroquinone.[79] Many alkylated hydroquinones have been proposed as balancing developing agents. Eastman Kodak Company also lists sodium hydroquinone monosulfonate (BD-82), *p*-aminophenol hydrochloride (BD-86), and *N,N*-diethylhydroxylamine (BD-89) as balancing developing agents.

It has been proposed[80] to use mono-benzyl-*p*-aminophenol in combination with hydroquinone monosulfonate or 2,5-dialkyl hydroquinones. A study indicates, however, that a balancing developing agent such as mono-benzyl-*p*-aminophenol hydrochloride is oxidized by air at the usual pH of the color developer to form *p*-aminophenol (BD-86). As Paul Mutter[30] has stated, "The formation of *p*-aminophenol is very detrimental because it acts as a developing agent in competition with the primary developing agents and may couple to give unwanted dyes." The other product of the oxidation of mono-benzyl-*p*-aminophenol is benzaldehyde. This compound reacts with the *p*-phenylenediamine developing agent to form an oily substance that adheres to the surface of the photographic material. The ideal balancing or competing developing agent in coupler-containing color developers should avoid the formation of oxidation products that form unwanted dyes that degrade color quality or undesirable products that stick to the photographic surfaces. The maximum dye density should not change, but the highlight stain should be reduced, an effect called "toe chopping."

Such improved balancing developing agents, according to a recent patent by Charleton C. Bard,[81] are derivatives of phenol or naphthol, for example, 2,4-bis(benzenesulfonamido)phenol. A concentration of 0.5 g/liter of the balancing developing agent is used with about 0.25 g/liter of hydroxylamine sulfate, or 1 g/liter of the balancing developing agent may be used alone. The increased green absorption of the cyan image resulting from the use of mono-benzyl-*p*-aminophenol is said[82] to be avoided also by the use of other *N*-substituted-*p*-aminophenols. The amino group was blocked so that an oxidized form could not couple.

$$\text{H}$$
$$\text{O}$$

(structure) —CH$_3$

·H$_2$SO$_4$

H—N—CH$_3$

4-methylamino-2-
methylphenol sulfate

$$\text{H}$$
$$\text{O}$$

(structure)

CH$_3$—N—CH$_2$SO$_3$Na

4-(N-methyl-N-sulfomethyl
amino) phenol, sodium salt

N,N-Diethylhydroxylamine has been used as a balancing developing agent for the improvement of the quality of dye images. This compound has no detrimental effect on the solutions of the cyan and yellow color developers, but it has reacted with the magenta coupler in the magenta color developer. This loss has required that the magenta coupler and the developing agent concentrations have had to be increased. The stability of the magenta coupler and the developing agent in the magenta developing solution containing N,N-dialkylhydroxylamine has been reported to be increased by adding a small amount of hydroxylamine or a mono-substituted hydroxylamine.[83] About 0.5 g/liter of the hydroxylamine was used with about 3.0 g/liter of N,N-diethylhydroxylamine in a color developing solution containing a magenta coupler.

Cross-Oxidizing Developing Agents

These compounds are added to a color developer to increase the contrast or the maximum density of the dye image or to achieve a normal dye image with materials containing a reduced silver coverage. These agents are also balancing developing agents, but, unlike those previously discussed, their effect concerns the maximum dye densities rather than the minimum densities. Image-enhancing compounds are usually the conventional black-and-white developing agents that often exhibit superadditive activity. H. T. Neumann[84] was the first (1940) to patent the beneficial effect of including Metol in a coupler-containing color developer. Other developing agents, such as Glycin, Amidol, p-aminophenols, catechol, and hydroquinones, have been suggested. Metol has been found to have a strong activating effect, much better than Glycin, but hydroquinone itself has a deactivating effect. Amidol may also decrease dye formation. Substituted p-aminophenols have been proposed as accelerators for image dye formation.

John David Kendall[85] was the first to discover the developing action of the 1-phenyl-3-pyrazolidones in photographic developing solutions. When these compounds were coated in emulsion layers, Glay M. Hood and Paul R. Crookshank[86] found development to be accelerated. But L. F. A. Mason[87]

was the first to observe and patent the beneficial superadditivity of 1-phenyl-3-pyrazolidone with color developing agents. In British Patent 811,185 Mason[88] claimed a 3-pyrazolidone, preferably 1-phenyl-3-pyrazolidone (Phenidone), up to 0.5 g/liter (but preferably 0.1 to 0.2 g/liter) in coupler-containing color developing solutions. The density of the dye image in the yellow and cyan layers was said to have increased, and unwanted development of the middle magenta layer was inhibited by the presence of the 1-phenyl-3-pyrazolidone. The degree of activation varied roughly with the type of coupler: cyan couplers were affected strongly, yellow couplers to a lesser degree, and the magenta coupler not at all. Subsequent study has indicated that an incorporated magenta coupler does not necessarily inhibit activation, but the effect is usually less. The grain of the final dye image was said to be more even and smooth in appearance. An improvement in the hue of the dye, particularly the magenta, was also claimed.

Mason concluded "that the addition of a colour coupler to a developer containing either Phenidone or Metol together with a colour developing agent, results in a superadditive system with respect to the silver image, of similar magnitude to that of the Phenidone/hydroquinone or metol/hydroquinone systems in black-and-white developers." It was proposed that the Phenidone adsorbs to the silver halide and causes the reduction of the exposed silver halide. The free radical oxidation product of the Phenidone remains adsorbed, and the Phenidone is regenerated from it by the action of the color developing agent at the grain surface. The oxidized color developing agent then diffuses away from the grain surface and reacts with a color coupler to form the dye near the grain. The coupler originally may be present in the developing solution or in the color film or paper.[89] Other explanations of the function of Phenidone in a color developing solution are possible,[90] but Mason's concept is currently accepted. Absolute proof of the regeneration of Phenidone is difficult to obtain. There is some evidence that an oxidized form of the Phenidone may act as a mobile electron-transfer agent, shuttling between the exposed silver halide and the coupler and color developing agent.

1-(*p*-Aminophenyl)-3-aminopyrazoline

and its derivatives have been proposed[91] as activators for color developing solutions. The sensitivity of the photographic material was increased or the contrast of the dye image was raised when the substituted 3-aminopyrazoline was present. Alternatively, the same color dye intensity and image contrast could be obtained with reduced amounts of the developing substances. As an example, an exposed subtractive multilayer color negative film having incorporated color couplers (Agfacolor) was developed for 6 min, 18°C, in a solution of the following composition.

4-Aminodiethylaniline	2 g
Potassium carbonate	70 g
Sodium sulfite, anhydrous	3 g
Potassium bromide	2 g
Water to make	1 liter

A gamma of 0.7 and a "relative sensitivity" of 1 were obtained. When 0.25 g of 1-(p-methylaminophenyl)-3-aminopyrazoline dihydrochloride was added to the above developer, only 3.5 min development time were required to obtain the same results. Russian scientists[92–94] have found the 1-(p-amino-phenyl)-3-aminopyrazoline (about 0.1 g/liter) beneficial for processing color negative films. The mechanism of action has been said to be based in part on the ability of the compound to replace bromide ions adsorbed on the emulsion grain surface.

Tetraalkyl-p-phenylenediamines in the color developer containing a primary amino color developing agent have been reported (Belgian Patent 774,949) to activate color development without increasing the fog or reducing the gradation of the color image.

Coupling Agents

A coupler is included in each of the three color developing solutions for a photographic material such as Kodachrome film. These compounds must be soluble in the alkaline solution and be able to penetrate gelatin rapidly, but must react to form dyes that are nondiffusing. The coupling agents in solution tend to be unstable, forming products that interfere with dye formation, cause staining, or precipitate insoluble substances. Much research has been done to modify the existing types of couplers for improved characteristics for solution use. Because there are separate cyan, yellow, and magenta developing solutions, a different color developing agent can be utilized with each of the three couplers to form the most acceptable dye in each layer. In replenished processes, from about 1 to 3 g of each coupler are present in a

liter of the developing solution. The following compounds are typical examples of commercial couplers.

- Cyan Coupler (Kodak coupling agent, C-16):
 N-(o-acetamidophenethyl)-1-hydroxy-2-naphthamide
- Magenta Coupler (Kodak coupling agent, M-38):
 1-(2,4,6-trichlorophenyl)-3-p-nitroanilino-5-pyrazolone
- Yellow Coupler (Kodak coupling agent, Y-54):
 α-benzoyl-o-methoxyacetanilide

As an illustration of the processing treatment and the composition of the solutions needed for processing unincorporated-coupler color films, Example 1 of U. S. Patent 3,658,525 is given here.[95]

EXAMPLE 1

Two samples of a multilayer color film having a cellulose acetate film support coated in succession with a red-sensitive gelatino silver bromoiodide emulsion layer, a green-sensitive gelatino silver bromoiodide emulsion layer, a gelatin layer containing bleachable yellow colored Carey Lea silver and a blue-sensitive gelatino silver bromoiodide emulsion layer are sensitometrically exposed to a step tablet and processed at 27°C through the following process sequence:

Treatment Step	Time
Prehardener	2 min.
Water wash	30 sec.
MQ developing composition	3 min. 40 sec.
Water wash	1 min.
Red light exposed through support	
Cyan developing composition	4 min. 30 sec.
Water wash	2 min.
Blue light exposed through emulsion	
Yellow developing composition	4 min.
Water wash	2 min.
Borohydride bath	1 min.
Water wash	30 sec.
Magenta developing composition	5 min. 30 sec.
Water wash	4 min.
Ferricyanide bleach	2 min.
Hypo fix bath	2 min.
Water wash	2 min.
Dry	4 min.

The solutions used have the compositions given below:

Prehardener

Sodium hexametaphosphate	0.5 gram
Sulfuric acid	1.7 ml
Sodium tetraborate \cdot 5 H$_2$O	15.0 grams
Sodium bromide	2.0 grams
Sodium sulfate	200.0 grams
Formalin (37.5%)	20.0 ml
Sodium bisulfite	1.0 gram
Water to make	1 liter

MQ Negative Developing Composition

Sodium hexametaphosphate	0.6 gram
Sodium sulfite, desiccated	79.0 grams
Monomethyl-*p*-aminophenol sulfate	5.0 grams
Sodium hydroxide	1.0 gram
Hydroquinone	2.0 grams
Sodium carbonate	35.0 grams
Potassium iodide (0.1%)	12.5 ml
Sodium bromide	3.0 grams
Sodium thiocyanate	1.7 grams
Hydroquinone monosulfate	4.0 grams
Water to make	1 liter

Cyan Developing Composition

Sodium hexametaphosphate	0.6 gram
Sodium bromide	2.5 grams
5-Nitrobenzimidazole nitrate (1% in 0.1% NaOH)	3.0 ml
Potassium iodide (0.1%)	11.0 ml
Sodium sulfite, desiccated	10.0 grams
Sodium sulfate	60.0 grams
Sodium hydroxide	3.8 grams
Sodium thiocyanate	1.0 gram

Hydroxylamine sulfate	0.65 gram
4-Amino-*N*-ethyl-*N*-(β-hydroxyethyl)-3-methyl aniline sulfate	2.05 grams
1-Hydroxy-*N*-(2-acetamidophenethyl)-2-naphthamide	1.65 grams
Hexylene glycol	5.0 ml
Polyoxyethylene (mol. wt. 1540)	1.0 gram
N-Benzyl-*p*-aminophenol	0.45 gram
Methanol	2.0 ml
p-Aminophenol	0.16 gram
Water to make	1 liter

Yellow Developing Composition

Sodium hexametaphosphate	0.6 gram
Sodium sulfite, desiccated	10.0 grams
Sodium bromide	0.55 gram
Polyoxyethylene (mol. wt. 4000)	1.00 gram
Potassium iodide (0.1 % solution)	26.0 ml
N-Ethyl-*N*-methoxyethyl-3-methyl-*p*-phenylenediamine di-*p*-toluene sulfonate	2.0 grams
5-Nitrobenzimidazole (1 % solution)	10.0 ml
Sodium hydroxide	2.1 grams
Sodium sulfate	64.0 grams
Hexylene glycol	10.0 ml
An α-pivalyl-acetanilide yellow dye-forming coupler	2.0 grams
Diethylhydroxylamine	1.38 ml
1-Phenyl-3-pyrazolidone	0.5 gram
Water to make	1 liter

pH at 27°C = 12.0

Borohydride Bath

Sodium hexametaphosphate	0.6 gram
Sodium hydroxide	2.16 grams
Potassium borohydride	0.10 gram
Water to make	1 liter

Magenta Developing Composition

Sodium hexametaphosphate	4.0	grams
Sulfuric acid	2.1	ml
Sodium phosphate $12 H_2O$	40.0	grams
Sodium sulfite, desiccated	5.0	grams
Sodium thiocyanate	1.0	gram
Potassium iodide (0.1%)	7.5	ml
Sodium bromide	0.5	gram
Sodium sulfate	60.0	grams
4-Amino-*N*-ethyl-*N*-(*β*-methylsulfonamidoethyl)-*m*-toluidine sesquisulfate hydrate	2.9	grams
Citrazinic acid	0.72	gram
Ethylenediamine	3.0	ml
Polyoxyethylene (mol. wt. 4000)	1.0	gram
Hexylene glycol	10.0	ml
A 5-pyrazolone coupler of U. S. Patent No. 3,152,896	1.67	grams
Sodium hydroxide	0.32	gram
Water to make	1	liter

The bleach solution is a conventional alkali metal bromide and alkali metal ferricyanide bleach, and the hypo-fix a conventional alkali metal thiosulfate fixing bath.

The primary couplers present in the developing solutions or incorporated in the photographic material produce dye images that have a very high covering power. The dye image has a much higher density to light in the region corresponding to its maximum absorption than does the silver image. This intensification effect of color development produces a dye image that has excessive contrast and maximum density. Reducing the silver halide coverage of the photographic material would produce less dye, but these dye images are grainy and lack sharpness. For obtaining dye images of normal contrast, and improved sharpness and graininess, William R. Weller and Nicholas H. Groet[96] proposed to add another coupler, often called a competing coupler. This second coupler competes with the primary image-forming coupler for the oxidized form of the developing agent. The competing coupler, however, forms a soluble dye that is easily removed by washing. Competing couplers may be added to either color developers for incorporated-coupler photographic materials or for those materials that require a primary image dye-forming coupler in the solution. Two examples of competing couplers yielding soluble dyes were listed as

1. 1-Amino-8-naphthol-3,6-disulfonic acid (known as H-acid).
2. 2-Amino-5-naphthol-7-sulfonic acid (known as J-acid).

Competing couplers of the sulfonated naphthol type have been reported to be more reactive than is desired, necessitating that only a very small quantity of the coupler be present in the developing solution. Because of the required low concentration, the competing coupler may be exhausted in areas of considerable development. This may lead to undesired variations in image contrast. Ilmari Salminen[97] proposed competing couplers of lowered reactivity so that greater concentrations could be present in the color developing solution. Suitable competing couplers are the following two compounds and their derivatives:

3,5-dihydroxy-
benzoic acid

2,6-dihydroxy
isonicotinic acid

Another name for 2,6-dihydroxyisonicotinic acid is citrazinic acid. Citrazinic acid is used today in the developers for film materials such as Ektachrome film. Quantities added range from 0 to about 5 g/liter of developing solution.

The oxidized form of the color developing agent can migrate from the layer in which it was formed to an adjacent coupler-containing layer to produce unwanted dye as color fog. This situation may be avoided by incorporating a competing coupler in the coated layers or using a diffusible competing coupler in the color developing solution. This coupler reacts with the oxidized developer to form colorless products. The active methylene group of such a coupler usually has a substituent, replacing one of the two hydrogens, that is not eliminated from the coupling site. Such a substituent can be a hydrocarbon chain or group.[98] When the substituent is strongly electron attracting, as the —CN group, the competitive coupler is more reactive than when the substituent is a hydrocarbon.[99] Such a coupler is 1-*m*-sulfophenyl-3-methyl-4-cyano-5-pyrazolone:

562

Color Processing

The addition of 2 g to each 100 ml of color developing solution was said to reduce "very considerably the color fog produced in the green-sensitive layer."

Development Accelerators

Various short-chain organic amines and diamines, such as ethanolamine or ethylenediamine,[100,101] for example, have long been known to accelerate both black-and-white[102] and color developing agents so that the image is formed in less time than that required by the developing agent alone. Heterocyclic nitrogen compounds such as piperidine, piperazine, or morpholine have been patented[103] for good utilization of the emulsion speed while producing a dye image of moderate gradation. Such heterocyclic bases are said to be toxic and fail to accelerate the development process to a sufficient degree. Phenoxyalkylamines,[104] aralkylamines,[105,106] alkyl ethers of polyhydroxyaralkylamines,[107] and heterocyclic alkylamines[108] have been claimed for their superior properties. Compounds such as m-xylylenediamine or p-xylylenediamine were proposed[109] for use in either the photographic material or the color developer.

Most organic amines are reactive, bad smelling, volatile, and poisonous to human beings. For example, ethylenediamine in a color developer will react with carbonate ions to produce the photographically inactive N-(β-aminoethyl)-carbamic acid. The source of the carbonate ion may be the alkali or absorbed carbon dioxide from the air. The volatility of amines makes it difficult to maintain a constant concentration in a solution, particularly at elevated temperatures. Acceleration of the development is often accompanied by increased fog and an increase in the graininess of the image. Imidazole has been claimed to overcome most of these deficiencies, but apparently it is not suitable for photographic silver halide grains of around $1\ \mu$ dimension. Imidazole has been used for first developers for color reversal[110] and for hydroquinone-containing black-and-white developers for silver halide crystals of around 0.2 micron.[111] Development acceleration without increased fog for coupler-containing color developers, particularly the developer containing the cyan coupler, was claimed[112] when a polyethylene glycol was present in the solution. A polyethylene glycol with a molecular weight of about 1500, $HO(CH_2CH_2O)_{35}CH_2CH_2OH$, was used, such as Carbowax 1540, a product of Carbide and Carbon Chemicals Corporation.

Benzyl Alcohol

Most color developers for incorporated-coupler photographic materials contain benzyl alcohol as a substituent. Edwin E. Jelley[113] in 1940 patented the addition of

$$\text{benzyl alcohol} \qquad \text{CH}_2\text{OH}$$

benzyl alcohol

$$\text{CH}_2\text{CH}_2\text{OH}$$

β-phenethyl alcohol

$$\text{CH}_2\text{CH}_2\text{CH}_2\text{OH}$$

γ-phenylpropyl alcohol

to a chromogenic developer for increasing the "dye density particularly in the denser regions of the scale." According to Jelley, benzyl alcohol is soluble in water to about 40 g/liter but the β-phenethyl alcohol only to the extent of 16 g/liter. Because of its higher solubility, benzyl alcohol is commonly used, but this liquid must be separately packed in developer kits. Such a color developer for photographic color print material can consist of four parts[114]:

Part A

Benzyl alcohol	12.6 ml

Part B

Sodium sulfite (anhydrous)		1.9 g
Sodium hexametaphosphate		2.0 g
Sodium carbonate monohydrate		26.8 g
Sodium bicarbonate		2.9 g
Potassium bromide		0.48 g
Sodium chloride		0.7 g
Water	about	60.0 ml

Part C

Hydroxylamine sulfate	2.1 g
Water	6.0 ml

Part D

Sodium sulfite (anhydrous)		0.2 g
2-Amino-5-diethylaminotoluene monohydrochloride		3.0 g
Water	about	13.0 ml

According to British Patent 1,254,726,[115] however, "Even at the relatively low concentration in which benzyl alcohol is employed in conventional photographic processing solutions, e.g., colour developers, the benzyl alcohol has such low solubility as to cause unnecessary time delays in mixing the components to form the developer." It was proposed to mix benzyl alcohol and water in the presence of an emulsifying agent to form a stable mixture that could be packaged as part of a developer kit. A stable emulsion of benzyl alcohol in water was prepared as follows: "50 g of 'Natrosol' (trademark registered in the U.S.A.) 250 H (a high viscosity hydroxyethyl cellulose marketed by Hercules Chemical Company) is added to 20 ml of water. The mixture is stirred for about one hour. To this solution 12.6 ml of benzyl alcohol is added with stirring. After the addition is completed the mixture is vigorously stirred. The resulting emulsion appears stable at room temperature." This preparation may be used as part A of a four-part liquid color developer such as that given immediately above.

The most common method of dissolving and holding the benzyl alcohol in the color developer has been to add a solvent that is soluble both in water and in benzyl alcohol. Among such compounds are diethylene glycol or polyethylene glycols and methoxy polyethylene glycols of molecular weights ranging from 200 to about 20,000. The benzyl alcohol and the diethylene glycol are usually present in about equal volume, but not more than 15 ml of each per liter of developing solution.[116]

The effect of the benzyl alcohol—increased dye yield—is easy to observe, but the precise explanation has been a subject of considerable study. According to Charleton C. Bard,[117] "One effect is to enlarge the oil droplet size by extraction of benzyl alcohol into the oil phase. This increases the surface area of the droplet and allows more coupling sites to be formed. The benzyl alcohol-oil phase is also lower in viscosity which allows the coupler to diffuse more readily to the surface of the droplet. And finally, benzyl alcohol makes the oil phase more polar and thereby enhances the ionization of the coupler. All these effects combine to enhance dye formation."

Fogging Agents

After first development, a color reversal photographic material must be exposed to light or chemically fogged before color development produces the desired dye images. In black-and-white reversal systems, fogging developing agents, such as sodium hydrosulfite,[118] dioxindol,[119] or nucleating baths with hydrazine or methylene blue prior to redevelopment,[120] have been used. Thiourea dioxide, a compound which may exist in the following two forms,

$$
\begin{array}{c}
NH_2 \\
| \\
C\!=\!S \\
| \\
NH_2
\end{array}
\!\!
\begin{array}{c}
O \\
\diagup \\
\diagdown \\
O
\end{array}
\qquad \text{or} \qquad
\begin{array}{c}
NH_2 \\
| \\
C\!-\!S \\
\| \\
NH
\end{array}
\!\!
\begin{array}{c}
OH \\
\diagup \\
\diagdown \\
O
\end{array}
$$

thiourea dioxide formamidine sulfinic acid

has also been used as a fogging redeveloping agent without the need of light exposure for the silver halide.[121] These compounds, however, produce metallic silver images and have not proven suitable for color reversal photographic materials.

Thiourea and its derivatives, for example, *N*-allylthiourea (thiosinamine) or *N,N*-diethyl-*N'*-allylthiourea, were proposed as early as 1936 for producing silver nuclei capable of undergoing color development to produce a positive dye image.[122] The thiourea had to be used in an acetic, oxalic, citric, sulfuric, or phosphoric acid solution just before the color developing solution. As indicated in U. S. Patent 2,159,466, "The reversal development with the aid of sulfur compounds in neutral or alkaline solution is in particular little suitable for use in making multi-color pictures because in consequence of the strong blackening of the picture by the separation of black silver sulfide no useful result can be attained."

Sodium or potassium borohydride ($NaBH_4$ or KBH_4) can be used to nucleate silver halide, thereby eliminating the need of light reexposure.[123] After first development and hardening of a coupler-incorporated photographic film, the remaining silver halide can be made developable by treating the film for 30 sec in one liter of water containing 0.25 g of borohydride and 4.0 g of sodium hydroxide. Borohydrides, however, are not stable when present in color developing solutions. These compounds do form ring structures, containing two or more borohydride units, that are more stable in the alkaline developing solution and make the processing easier to control.[124] One such compound is

$$
\left[
\begin{array}{c}
CH_3 \\
| \\
CH_3\!-\!N\!-\!CH_3 \\
| \\
CH_3
\end{array}
\right]^{+}
\left[
\begin{array}{c}
BH_3 \\
\diagup \quad \diagdown \\
H_2B\!-\!\!-\!\!-\!\!-\!\!-\!BH_3
\end{array}
\right]^{-}
$$

tetramethylammonium octahydrotriborate

The preferred range of concentration is from 70 to 400 mg of the ionic boron compound per liter of color developing solution. A suitable composition containing an ionic boron compound for color development is the following:

Tetramethylammonium octahydrotriborate	0.10 g
Sodium hexametaphosphate	5.0 g
Trisodium phosphate ($12\,H_2O$)	36.0 g
4-Amino-N-ethyl-N-(β-methanesulfonamido-ethyl)-m-toluidine sesquisulfate monohydrate	10.5 g
Benzyl alcohol	3.1 ml
Ethylenediamine	3.0 g
Citrazinic acid	1.35 g
Sodium sulfite, desiccated	7.6 g
Sodium bromide	0.8 g
Potassium iodide	0.028 g
Sodium hydroxide	2.05 g
Water to make	1.0 liter

Amine boranes or borazines have been used as nucleating agents in color developers to render silver halide developable without the reversal exposure to light. One of the preferred compounds, patented by Wesley T. Hanson, Jr., and Howard W. Vogt,[125] is tertiary-butylamine borane

$$CH_3-\underset{\underset{CH_3}{|}}{\overset{\overset{CH_3}{|}}{C}}-NH_2 \cdot BH_3$$

which is used at about 0.01 to 0.10 g/liter of color developing solution. An example of a color developer containing t-butylamine borane was listed as

Benzyl alcohol	6.0 ml
Sodium hexametaphosphate	2.0 g
Sodium sulfite, anhydrous	5.0 g
Trisodium phosphate	40.0 g
Potassium bromide	0.25 g
Potassium iodide (0.1 % by weight solution)	10.0 ml
Sodium hydroxide	6.5 g
4-Amino-N-ethyl-N-(β-methanesulfonamidoethyl)-m-toluidine sesquisulfate monohydrate	11.33 g
Ethylenediamine sulfate	7.8 g
Citrazinic acid	1.5 g
Tertiary-butylamine borane	0.1 g
Water to make	1.0 liter

Tertiary-butylamine borane is commercially available as Kodak reversal agent, RA1, sometimes called TBAB. The label states: "DANGER. POISON. Hazardous Solid. Do not breathe dust. Handle only under exhaust ventilation. Absorbed through skin. When handling, wear protective clothing, rubber gloves, goggles, and face shield. Use a full-face respirator if likelihood of *any* dust exposure. In case of contact, immediately flush skin or eyes with plenty of water for at least 15 minutes."

Boron hydride nucleating agents have been used in practice, despite their toxicity, because they possess the desirable property of nucleating each layer of a multilayer color material to an equal extent. Many nucleating agents affect the top layer to a greater extent than the bottom layer. The boron compounds are also reasonably stable in the alkaline developer solution and resist aerial oxidation. The boranes and borohydrides do decompose if present in the acid stop bath just before color development. Chelated stannous salts have been claimed to be suitable for an acid stop bath or the alkaline color developer.[126] Stannous chloride may be used in acid stop baths, but the stannous ion is oxidized to the stannic ion, forming a scum. The use of a chelating agent, such as ethylenediamine tetraacetic acid or an organo phosphonic acid, eliminates the scum problem. Chelated stannous chloride can be added as a nucleating agent to the color developer without the scum formation. Improved color image quality, as well as less troublesome handling, are improvements claimed for chelated stannous-ion nucleating agents.

For use in the cycle for Kodak Process E-4, an incorporated-coupler reversal color film may be treated, after the usual processing steps, in a color developer of the following composition:

Benzyl alcohol	4.71 g
Ethylenediamine, 100%	3.0 g
Potassium iodide	0.047 g
Sodium bromide	0.80 g
Sodium hydroxide	2.05 g
Sodium sulfite, desiccated	7.60 g
Trisodium phosphate ($12 H_2O$)	36.0 g
Citrazinic acid	1.35 g
4-Amino-N-ethyl-N-(β-methanesulfonamidoethyl)-*m*-toluidine sesquisulfate monohydrate	10.50 g
Solution containing 500 g 1-hydroxyethylidene-1,1-diphosphonic acid and 100 g stannous chloride ($2 H_2O$) in a liter of water	30.0 ml
Water to make	1.0 liter

A first stop bath that is a nucleating solution may be made with the following formulation

Sodium acetate, anhydrous	3.58 g
1-Hydroxyethylidene-1,1-diphosphonic acid	1.5 g
Glacial acetic acid	28.85 g
Stannous chloride ($2\,H_2O$)	0.3 g
Water to make	1.0 liter

Hardening Solutions

Color films usually require additional hardening during the processing cycle. Hardening has been proposed to take place in a prehardening solution, in the first developer, in a separate hardening bath or a stop bath between the first developer and the color developer, and even during the color development.[127] In color negative or color reversal processing cycles operating at or near room temperature, the hardening of the color material has often been delayed until after the color development in color negative or the first development in color reversal processing. Alum hardening has often been used for this purpose. Potassium chrome alum,

$$K[Cr(H_2O)_6](SO_4)_2 \cdot 6H_2O,$$

slowly changes from a violet to a green form upon standing.[30] The green form is the result of the replacement of one of the coordinated water molecules of the violet form.

$$K[Cr(H_2O)_6]^{4+} \xrightarrow{\ H_2O\ } K[Cr(OH)(H_2O)_5]^{3+} + H_3O^{1+}$$

violet green

A 3% potassium chrome alum solution is a commonly used hardening bath. Potassium alum, $K_2SO_4 \cdot Al_2(SO_4)_3 \cdot 24H_2O$, is also used for hardening solutions, and this compound is quite stable in solution.

Alum hardening is not a rapid process, so that hardening with aldehydes is often used when rapid photographic processing is desired. In many cases, the hardening is first carried out before any development, such as with the use of prehardening and neutralizing solutions, as already described. Aldehyde hardening is sometimes employed after first development in reversal processing or after color development in negative color development. In these cases the first development steps of the process may be carried out at 75°F and the hardening and other processing steps at much higher tem-

peratures. One example of such a processing cycle is given in U. S. Patent 3,634,081 of Donald J. Forst.[35] Kodak Ektachrome film 2448 is processed for 2 min, 75°F, in the first developer and for 30 sec, 75°F, in an acetic acid stop bath. This is followed by 30-sec, 100°F, in a hardening solution of the following formulation (pH = 4.0):

Glutaraldehyde (25% solution)	80 ml
Sodium sulfate, anhydrous	100 g
Water to make	1 liter

The excess aldehydes are then removed by a 1 min, 100°F, immersion in a 1% sodium bisulfite solution. The bisulfite neutralizing solution also acts as a chemical fogging agent, eliminating the need for a chemical fogging agent in the color developing solution that follow the neutralizing solution. Neutralizing solutions consisting of hydroxylamine sulfate (20 g), anhydrous sodium sulfate (50 g), and glacial acetic acid (10 ml) in a liter of water may be used after the glutaraldehyde hardener, but the color developer must then contain a fogging agent, such as *t*-butylamine borane, a toxic compound. Glutaraldehyde may have a detrimental effect on certain incorporated couplers.

Bleaching Solutions

Metallic silver is formed during first development or color development. This silver must be removed in order not to degrade the hue of the dye image. Converting silver metal to silver ions is the reverse of development, and this conversion is accomplished by an oxidizing compound contained in the bleach bath.

$$Ag^+ \underset{\underset{\text{bleaching (oxidation)}}{-1e}}{\overset{\overset{\text{development (reduction)}}{+1e}}{\rightleftharpoons}} Ag$$

Potassium ferricyanide is the commonly used bleaching agent in a solution containing potassium bromide and a buffer to maintain the pH. The bleaching of the metallic silver is a concerted process: the ferricyanide oxidizes the silver atoms to ionic silver, which is precipitated by the bromide ions. In the process, the ferricyanide ions are converted to ferrocyanide ions, which accumulate and lower the efficiency of the bleaching reaction. The silver bromide formed during bleaching is subsequently removed in a

separate solution—the fixing bath that is present in most color film process-
ing cycles.

The ferricyanide bleaching of silver images may be represented by the
following equation[128]:

$$Fe(CN)_6^{3-} + Ag^0 + Br^- \longrightarrow AgBr + Fe(CN)_6^{4-}$$

Bleaching is a diffusion-controlled process, limited by the penetration rate
of the reactants and not by the rate of the chemical reactions. In fact, the
first Kodachrome reversal film was processed using the controlled rate of
diffusion of the bleach.

The buffering of a bleach bath is very important. With ferricyanide bleach-
ing solutions the pH must be maintained in the range of from about 6 to
about 7. Silver retention is said to occur if the pH rises much above 7. At
solution pH's above 7 or below 6, stains may be produced in the emulsion
layers. Prussian blue may form at pH values below 6. Borax, carbonates,
or phosphates are the common buffers in ferricyanide bleaching solutions.
For example, Ansco color bleach A-713 had the following composition[129]:

Potassium ferricyanide	100 g
Potassium bromide	15 g
Dibasic sodium phosphate	40 g
Sodium bisulfate	25 g
Water to make	1 liter

In practice, according to Lawrence G. Welliver,[130] ferricyanide bleaches
(packaged and sold as dry powders) may contain potassium ferrocyanide
to temper the action of a freshly used bleach solution to maintain uniform
activity over considerable use. This compound is used in addition to the
usual buffering ingredients: monosodium and disodium phosphate, citric
acid or sodium citrate, sodium bisulfate, or phthalic acid. The buffering
ingredients also tend to inhibit the corrosive action of the ferricyanide bleach
on the metallic containers for the bleaching solution. In such a bleaching
powder mixture, caking of the ingredients or a buildup of the toxic gas,
hydrogen cyanide, may occur. The presence of potassium dichromate at
3 to 5 g/liter can also lead to caking, discoloration, and gas formation of the
packaged bleach. Up to 50 g/liter of sodium nitrate may be added as a
corrosion inhibitor. Welliver proposed adding boric anhydride to the bleach
powders to prevent the undesired reactions. The following powder mixture
did not deteriorate during incubation of seven days at 110°F or after storage
for six months at room temperature.

Potassium ferricyanide	50.0 g
Potassium ferrocyanide	5.0 g
Sodium bromide	15.0 g
Monosodium phosphate	10.0 g
Phthalic acid	2.0 g
Boric anhydride	10.0 g
Water to make	1.0 liter

Charleton C. Bard[131] claimed that phosphorous and maleic acids, or their water-soluble salts, would strongly buffer bleach baths from about pH 6 to about pH 7. A suitable bleach bath for reversal color films had the formulation (pH = 7.0):

Sodium ferricyanide	85.0 g
Sodium bromide	38.0 g
Phosphorous acid	30.0 g
Water to make	1.0 liter

The continuously replenished bleach bath never dropped below pH 6.3 in use. The processed film was said to be free of retained silver or Prussian blue. Maleic acid at 10 g/liter may replace the phosphorous acid with similar results. A buffered bleach bath suitable for reversal paper had the formula:

Trisodium phosphate ($12 H_2O$)	45.0 g
Phosphorous acid	10.0 g
Sodium hydroxide	3.35 g
Potassium ferricyanide	40.0 g
Sodium bromide	13.0 g
Water to make	1.0 liter

The pH was adjusted to 6.9.

The overflow containing ferricyanide and ferrocyanide from bleach baths has often been dumped into the sewer as a means of disposal. In water, in the presence of sunlight and oxygen, the ferrocyanide may slowly undergo conversion to free cyanide:

(1) $Fe(CN)_6^{4-} + H_2O \xrightarrow{\text{light}} Fe(CN)_5(H_2O)^{3-} + CN^-$

$CN^- + H_2O \longrightarrow HCN + OH^-$

(2) $4 Fe(CN)_6^{4-} + O_2 + 2 H_2O \xrightarrow{\text{sunlight}} 4 Fe(CN)_6^{3-} + 4 OH^-$

$Fe(CN)_6^{3-} + 3 H_2O \longrightarrow Fe(OH)_3 + 3 HCN + 3 CN^-$

Efforts have been made to avoid discarding the used ferricyanide bleach bath by regenerating and reusing the solution indefinitely. The conversion of $Fe(CN)_6^{4-}$ to $Fe(CN)_6^{3-}$ has been attempted by a variety of methods:

1. Bromination (or chlorination)[132-135]:

$$2\,Fe(CN)_6^{4-} + Br_2 \longrightarrow 2\,Fe(CN)_6^{3-} + 2\,Br^-$$

2. Electrolytic regeneration[136]:

$$Fe(CN)_6^{4-} \xrightarrow{\text{electrolysis}} Fe(CN)_6^{3-} + e^-$$

3. Persulfate (peroxydisulfate)[137-138]:

$$2\,Fe(CN)_6^{4-} + S_2O_8^{2-} \longrightarrow 2\,Fe(CN)_6^{3-} + 2\,SO_4^{2-}$$

4. Ozonation[139]:

$$2\,Fe(CN)_6^{4-} + O_3 + H_2O \longrightarrow 2\,Fe(CN)_6^{3-} + O_2 + 2\,OH^-$$

5. Peroxide or alkylperacids[140]:

$$2\,Fe(CN)_6^{4-} + H_2O_2 + H_2SO_4 \longrightarrow 2\,Fe(CN)_6^{3-} + 2\,H_2O + SO_4^{2-}$$

Bromination involves the use of corrosive and hazardous liquid bromine. Electrolytic treatment and ozonation require a substantial capital expenditure as well as maintenance. The use of persulfate is simple and inexpensive, but the formation of sulfate ions reduces the swelling of the emulsion layers, decreasing the rate of bleaching of the silver image. Peroxide is an unstable compound that must be used at low pH (2 or 3), requiring an adjustment of the acidified bath to a pH of about 7 after regeneration. A discarded bleach solution can be treated with ferrous sulfate to precipitate iron ferrocyanide (Prussian blue), which then must be removed by filtration.

Much has been done to investigate other possible bleaching agents. Almost any of the oxidizing agents used as a photographic reducer has a potential for becoming a bleaching agent. Other iron salts, particularly ferric chloride, are efficient silver oxidants but must operate under very acidic conditions, such that stainless steel tanks would be ruined. Potassium dichromate, a toxic compound, is in commercial use in bleach baths but is not satisfactory for some chromogenic dyes. Cobalt and copper make effective bleaching solutions, but problems of suitable buffering, dye destruction, emulsion staining, and potential pollution problems detract from their possible use. Sodium or potassium bromates are effective oxidizing agents for silver,[141] but under suitable conditions these compounds may engage in explosive reactions. Iodine has been used for bleaching silver images.[142]

Organic compounds, such as quinone, have long been known for their silver bleaching action. In U. S. Patent 3,671,259 Bernard C. Cossar and

Delbert D. Reynolds[143] point out, "A bleach bath containing quinone, acid and an organic solvent has been used to convert silver images to a silver salt in the presence of a developed dye image. However, this bath cannot be used in the final stages of a color process because it destroys dyes, as well as converts the silver to a silver salt. In addition, while compounds such as quinone are known to bleach silver in acidic solution, such compounds suffer from the fact that they are water-insoluble and also insoluble in dilute mineral acids. Prior art acid quinone bleach solutions release toxic vapors." Cossar and Reynolds proposed aminomethylquinones as silver-bleaching agents that do not destroy dye images. Bleaching times were lengthy.

Bleaching Accelerators

Bleaching, like fixation, is usually considered a diffusion-controlled process. Bleaching is affected by the negative charge barrier that surrounds each developed silver particle.[144-146] This negatively charged electric double layer does not interfere with positively charged oxidizing agents. For positively charged oxidants, diffusion is probably the controlling factor in the bleaching of metallic silver. Persulfate ions, however, are double negatively charged, and persulfate, with or without bromide ions present, is a slow bleaching agent for silver images. J. F. Willems[147] found that persulfate bleaches could be highly activated by a superadditivity effect with positively charged ions of onium compounds. N,N,N',N'-Tetraethyl-p-phenylene-diamine hydrochloride was found to be the most active accelerator with persulfate, producing a superadditive combination that formed a practical bleach for silver halide films.

Willems proposed that the quinone diimmonium ion, the double positively charged form of the N,N,N',N'-tetramethyl-p-phenylenediamine formed in the persulfate solution, is adsorbed to the metallic silver. This ion, represented by Q^{2+}, starts the oxidation of the silver, forming silver ions and a stable semiquinone (S^+).

$$Q^{2+} + Ag \longrightarrow Ag^+ + S^+$$

The positively charged semiquinone helps the adsorption of the persulfate ion.

$$2S^+ + S_2O_8^{2-} \rightarrow 2Q^{2+} + 2SO_4^{2-}$$

The persulfate regenerates the quinonediimine, which continues the oxidation of the metallic silver image. The similarity between development acceleration and bleach acceleration suggests that many strongly adsorbed development accelerators would also be bleach accelerators, probably resulting from improved electron transfer from silver surface to the bleaching agent.

Fixing Baths

A bleaching solution, such as one containing potassium ferricyanide–potassium bromide, converts metallic silver to silver bromide. This silver compound is almost insoluble in water but can be solubilized by the thiosulfate in a standard fixing bath. For many years the fixing baths for color photographic processing contained sodium thiosulfate in a conventional formulation. The use of ammonium thiosulfate in place of the sodium thiosulfate will permit shorter fixing times, an important asset for rapid machine processing. Ammonium thiosulfate fixing solutions have other advantages: lower stain level on the photographic material and efficient silver recovery from the solution.

Ammonium thiosulfate, commonly supplied as a 58 to 60% solution containing sodium sulfite to increase stability,[148] is an economical source of thiosulfate. The total sulfite content of the fixing bath, however, must be carefully controlled. Too low a sulfite concentration can cause sulfiding during electrolytic silver recovery; too high a sulfite concentration can cause an increase in the stain level of the photographic material. Ammonium thiosulfate fixing baths have long been suspected of increasing the reticulation tendency of color films, particularly with some color processing cycles that operate above 80°F. Careful control of the temperature of the fixing bath will minimize the risk. Improved hardening of the color films and efficient prehardening baths have also limited the danger of reticulation, so that ammonium thiosulfate fixing baths are becoming more common in color film and paper processing cycles. Inadequate washing out of ammonium or sodium thiosulfate will cause dye fading, which is greater with the excessive amount of ammonium thiosulfate than with the sodium thiosulfate.

Fixing baths can vary widely in composition, depending on the color photographic material and the color processing cycle. Edwin Mutter[149] listed the fixing bath (FC 200) for 3M Ferrania color reversal films as a 20% sodium thiosulfate (crystal) solution. The hardener fixer for Orwocolor had the following composition (pH = 4.6 to 5.0):

Water	800.0 ml
Boric acid	2.0 g
Sodium benzyl sulfinate	2.0 g
Sodium acetate, anhydrous	20.0 g
Potassium alum	30.0 g
Ammonium thiosulfate 80/20	100.0 g
Water to make	1.0 liter

For Kodacolor negative processing the following fixing formulation has been suggested (pH = 4.4 to 4.8):

Water	800.0 ml
Ammonium thiosulfate 98/100	100.0 g
Potassium metabisulfite	20.0 g
Water to make	1.0 liter

In the processing of a color reversal film with a silver sound track record,[150,151] the film is bleached in 90 sec at 35°C, then fixed for the same time in

Water	800.0 ml
Ethylenediamine tetraacetic acid, disodium salt	0.5 g
Sodium thiosulfate pentahydrate	204.0 g
Sodium sulfite, desiccated	10.0 g
Disodium phosphate	15.0 g
Water to make	1.0 liter

A hardener-fixing bath for paper coatings used for 2 min at 73 to 77°F has the following composition[152]:

Water	1.0 liter
Glacial acetic acid	15.0 ml
Sodium zirconyl sulfate (Zircontan-N) (Rohm & Haas Co.)	0.46 g
Sodium bisulfite	17.9 g
Sodium thiosulfate	167.7 g
Sodium citrate	2.5 g
Boric acid	7.2 g
Potassium alum, granular	35.5 g
Sodium hydroxide, granular	10.4 g
Zinc sulfate monohydrate	7.5 g

A stop-fix bath, following color development of a negative incorporated-coupler color material and before the bleach-fix bath, was proposed in U. S. Patent 3,619,188 that contained a water-soluble selenocyanate or

selenourea. This bath was used for 4 min at 24°C and had the following composition (pH = 4.3):

Sodium thiosulfate pentahydrate	171.0 g
Sodium acetate, anhydrous	31.4 g
Sodium sulfite, anhydrous	4.3 g
Acetic acid, glacial	35.0 ml
Potassium alum	17.0 g
Ammonium chloride	43.0 g
N-Methyl-selenourea	0.3 g
Water to make	1.0 liter

Combined Bleaching-and-Fixing Solutions

The removal of the metallic silver from the image requires two solutions: a bleaching solution and a fixing solution, often with a water rinse between the two baths. The removal of the silver image could be greatly simplified if the bleaching and the fixing occurred in the same solution. This simplification would seem to be chemically impossible. The bleaching agent is strongly oxidizing, and most fixing baths are reducing in action. These two antagonistic actions would appear to preclude the coexistence of the bleaching and fixing actions in the same solution for any length of time. Indeed, Farmer's reducer combines ferricyanide and thiosulfate to bleach-and-fix, but the useful life of the solution is very short. Belitski's reducer containing ferric potassium oxalate and sodium thiosulfate is more stable but affects dye images adversely.

It was a considerable achievement, therefore, when Wilhelm Schneider and Richard Brodersen[153] of Agfa patented (November 28, 1944) a combined bleach-fix solution, now commonly called a blix bath, for chromogenic images. Simultaneous bleaching-and-fixing baths for the dye bleach process were patented in 1943.[154] This feat was accomplished by lowering the oxidizing action of the bleaching agent [iron(III)] by complexing it with an organic acid of at least two carboxyl groups. Suitable acids included fumaric acid, malic acid, malonic acid, diglycolic acid, aminotriacetic acid, ethylenediamine tetraacetic acid, and others. The pH of the blix bath should be around pH 7, although a pH of 9 does not interfere. Lower pH values around 5 may affect some dyes. The fixing action is stable in neutral to alkaline solution, but the decomposition of the thiosulfate increases with increasing

acidity. The bleaching-and-fixing action was relatively slow, requiring a longer time than the use of separate bleaching and fixing solutions. An example from the 1944 German patent had the following composition:

Ethylenediamine tetraacetic acid, tetrasodium salt	2.6 g
Sodium carbonate	2.4 g
Ferric chloride, crystals	1.5 g
Sodium sulfite, desiccated	1.3 g
Sodium thiosulfate	20.0 g
Water	50.0 g

Later, Max Heilmann[155] patented the cobalt(III) complexes of the same acids for use in combined bleaching-fixing baths. Heilmann has described the use of a blix bath in the Agfacolor process.[156,157]

The bleaching power of the ferric(III)-EDTA complex in the blix bath is considerably less than that of a ferricyanide bleaching solution. In addition, a grey to brown coloration may be present in the nondye areas of the color image, particularly with multilayer incorporated-coupler color reversal papers. Various alcohols have been proposed to aid in the oxidation of the metallic silver.[158,159] Improved results can be obtained by adding accelerators to the solution to increase the effectiveness of both the bleaching and fixing actions. These accelerators do not increase the bleaching power of the bath, so that the stability of the solution is not decreased. Many accelerators have been suggested. For example, polyethylene oxides have been proposed[160] as well as polyethylene oxides that have part of the oxygen atoms replaced by sulfur.[161] The effect of these agents is comparatively small, however, and bleaching times are slow.

The addition of iodide ions to a blix bath has been recommended for decreasing the background discoloration on color reversal papers.[162,163] Further improvement can be obtained if the iodide ions are present in a separate bath used after color development but before the bleaching-fixing solution.[164] If this intermediate bath is buffered at an acid pH value, the solution can be used as an acid stop bath after color development. After color development, the reversal color paper is treated for 3 min in (pH = 5.2)

Sodium acetate	30 g
Glacial acetic acid	5 ml
Potassium iodide	1 g
Water to make	1 liter

followed by removal of the image silver in the following blix bath (pH = 6.2):

Sodium salt of the iron complex of ethylenediamine tetraacetic acid	40 g
Ethylenediamine tetraacetic acid	3.78 g
Sodium sulfite, anhydrous	10 g
Sodium thiosulfate, crystalline	200 g
Water to make	1 liter

According to U. S. Patent 3,352,676, "there is not a simple entrainment of iodide into the bleach-fixing bath by a pretreatment with an iodide-containing bath, but that, surprisingly, a reaction takes place with the iodide-containing intermediate bath, which fixes the iodide, so that the effect of these iodide ions, which only becomes operative in the bleach-fixing bath, is not prevented by an intense intermediate rinsing lasting 24 hours."

The accelerating effect of iodides; however, has been observed only with silver halide emulsions that have been stabilized during manufacture with bleach-inhibiting sulfur compounds such as 2-phenyl-5-mercaptothiadiazole-3-thione. The bleach-inhibiting stabilizer is replaced by the iodide, which has a smaller bleach-inhibiting action. This is seen as an acceleration, but the use of iodide on other emulsions without bleach inhibitors causes an inhibition of the bleaching.

Compounds containing a thione group, $\diagdown C=S$, according to Swiss

Patent 336,257,[165] accelerate the action of blix baths. Thiourea and allyl thiourea have been used, but color fog can result if the color developer becomes contaminated with the blix solution, or if color developer is carried into the blix solution. Certain derivatives of thiourea, such as

$$\begin{array}{c} H_2C-NH \\ | \qquad \diagdown \\ \qquad \qquad C=S \\ | \qquad \diagup \\ H_2C-NH \end{array} \qquad \qquad \begin{array}{c} CH_2-NH \\ H_2C \diagup \qquad \diagdown \\ \qquad \qquad C=S \\ \diagdown \qquad \diagup \\ CH_2-NH \end{array}$$

ethylene thiourea propylene thiourea

are said to be free of the color fogging tendency when used in a blix bath of the following composition[166] (pH = 6.8):

Iron salt of EDTA	34 g
Sodium carbonate monohydrate	11 g
Boric acid	45 g
Sodium thiosulfate	140 g
Ethylene thiourea	2 g
Water to make	1 liter

Mercapto compounds having a five-membered heterocyclic ring with at least two nitrogen atoms have been added as accelerators to bleaching-fixing solutions without causing increased color fog in color prints.[167] A multilayer color photographic material, the silver halide emulsions of which had been stabilized with 2-phenyl-5-mercaptothiazole-3-thione, was developed in

Sodium hexametaphosphate	2 g
Hydroxylamine sulfate	4 g
Sodium sulfate, anhydrous	4 g
Potassium bromide	1 g
Potassium carbonate, anhydrous	100 g
N-Butyl-N-(4-sulfobutyl)-p-phenylenediamine	6 g
Water to make	1 liter

then treated 3 min in a stop-fixing bath

Sodium hexametaphosphate	2 g
Potassium dihydrogen phosphate	30 g
Sodium sulfite, anhydrous	4 g
Sodium thiosulfate, anhydrous	100 g
Potassium carbonate to make pH = 7.2	
Water to make	1 liter

followed by a 5-min treatment in a blix bath

Trisodium ethylenediamine tetraacetic acid	30 g
Trisodium phosphate, anhydrous	25 g
Iron salt of ethylenediamine tetraacetic acid	30 g
Sodium sulfite, anhydrous	2 g
Sodium thiosulfate, anhydrous	120 g
3-Mercapto-1,2,4-triazole	2 g
Potassium dihydrogen phosphate to pH 7.5	
Water to make	1 liter

The nitrogen-containing, heterocyclic thiol compounds compare as follows with previously proposed bleaching-fixing accelerators:

Additive	Quantity (g/liter)	Bleaching Time (min)
Without additive		17
Conventional substances		
Polyethylene oxide	5	13
Potassium iodide	2	7
Thiourea	2	3.75
Mercapto compounds		
2-Mercapto-1,3,4-triazole	2	3
1-Amino-2-mercapto-1,3,4-triazole	2	3
2-Mercapto-5-amino-thia-3,4-diazole	2	3
2-Mercaptoimidazole	2	3.5

Stable, rapid-acting blix compositions have been claimed when water-soluble organic diol fixing agents are combined with thiocyanate fixing agents and silver bleaching agents. The organic diol fixing agents, such as 3-thia-1,5-pentanediol ($HOCH_2CH_2$—S—CH_2CH_2OH) or 3,6-dithia-1,8-octanediol ($HOCH_2CH_2$—S—CH_2CH_2—S—CH_2CH_2OH), are said to exhibit an unexpected synergistic action with the thiocyanate fixing agent.[168] An incorporated-coupler, multilayer material was developed for 2 min, 85°C, as follows (pH = 12.0):

4-Amino-3-methyl-*N*-ethyl-*N*-(β-hydroxyethyl)-aniline sulfate	8.0 g
Sodium sulfite, desiccated	5.0 g
Benzyl alcohol	6.0 ml
Sodium phosphate ($12\,H_2O$)	40.0 g
Potassium bromide	0.5 g
Water to make	1.0 liter

then blixed for 1 min in

Sulfuric acid, concentrated	7.5 g
Ferric chloride · $6\,H_2O$	12.0 g
Ethylenediamine tetraacetic acid, tetrasodium salt	55.0 g
Sodium sulfite, desiccated	50.0 g
Ammonium thiocyanate	10.0 g
3,6-Dithia-1,8-octanediol	10.0 g
Water	1.0 liter

(adjust pH = 5.5) followed by a water wash of 1 to 3 min. The amount of silver remaining in the D-max area was slightly over 12 mg/sq ft, a quantity said to be acceptable.

Thia dicarboxylic acids were used in combined bleach-fix solutions by Paul Mader in 1954 as silver halide solvents.[169] Ethylene-bis(thioglycolic acid)

$$HOOC—CH_2—S—CH_2CH_2—S—CH_2—COOH$$

and 3,6,9-trithiahendecanedioic acid

$$HOOC—CH_2—S—CH_2CH_2—S—CH_2CH_2—S—CH_2—COOH$$

formed stable solutions with potassium ferricyanide or quinone. One bath consisted of 16 g of ethylene-bis(thioglycolic acid) and 3.5 g of quinone in a liter of water.

A bleach-fix solution containing an iron(III), a cobalt(III), or a copper(II) complex, and a fixing agent, such as thiosulfate or thiocyanate, can be accelerated in action by the presence of selenium-containing compounds. Sodium selenosulfate at 10 g/liter,[170] selenosemicarbazides, 1,2,4-triazole-3-selenols, and related compounds[171] have been used as bleach-fix additives to shorten the processing time of incorporated-coupler or dye-bleach color materials.

Organic amines have been patented for accelerating the bleach-fix action on photographic papers and for reducing the cyan, magenta, and yellow stain levels. Ethyl amine, ethylenediamine, and other amines and imines were added to a solution containing a water-soluble iron complex salt and a thiosulfate.[172] Such a blix bath may be used immediately after color development without an intermediate treatment. The composition of one bath (pH = 6.8 ± 0.2) included

Iron ethylenediamine tetraacetate	34 g
Sodium carbonate monohydrate	4 g
Boric acid	45 g
Sodium thiosulfate	140 g
Ethylamine	10 g
Water to make	1 liter

Processing time was 3 min, 24°C, as compared with 6 min for a control solution of the same pH but without the amine.

Omission of the stop bath between color development and the bleaching-fixing bath is highly desirable for rapid color print processes with as few solutions as possible. In the above example, the ethylamine in the blix bath was said to minimize color fog formation. Semicarbazide or carbohydrazide in the blix solution was patented for the same purpose, although a brief water rinse was still required.[173] A 5-min bleach/fixing bath had the following formulation.

Ethylenediamine tetraacetic acid, disodium salt	2.0 g
Boric acid	22.5 g
Borax	12.5 g
Sodium sulfite, anhydrous	3.75 g
Sodium thiosulfate	95.0 g
Ethylenediamine tetraacetic acid, iron salt	18.5 g
Magnesium sulfate · $7H_2O$	10.0 g
Carbohydrazide	2.5 g
Water to make	1.0 liter

An ammonium or amine salt of the Fe^{3+}, Co^{3+}, or Cu^{2+} complexes combined with an ammonium or amine sulfite, and an ammonium or amine thiosulfate, have been proposed as a rapid-acting blix.[174] A suitable solution which included ammonium ethylenedinitrilotetraacetate ferrate(III) (0.1 mole), ammonium thiosulfate (1.0 mole), and ammonium sulfite (0.1 mole) in one liter of water was 78% shorter in processing time than a similar solution containing equimolar quantities of the sodium salts of the three compounds.

The color fog that results from the elimination of the stop bath in simplified color print processing is the result of the reaction of color developing agent with the oxidizing agent of the bleach-fix solution. The color developing agent is oxidized, and this oxidized form reacts with the incorporated-color coupler in the emulsion layers, forming nonimage dye. Very little color fog was present in the color print if, after color development and a brief water rinse, the multilayer color photographic paper was processed in a bleach-fix bath that contained a 3-pyrazolidone[175] or a *p*-aminophenol.[176] Examples of such blix solutions are

Ethylenediamine tetraacetic acid, disodium salt	2.0 g	2.0 g	2.0 g
Boric acid	22.5 g	22.5 g	22.5 g
Borax	12.5 g	12.5 g	12.5 g
Sodium sulfite, anhydrous	3.75 g	3.75 g	3.75 g
Sodium thiosulfate	95.0 g	95.0 g	95.0 g
Ethylenediamine tetraacetic acid, iron salt	18.5 g	18.5 g	18.5 g
Magnesium sulfate · $7H_2O$	10.0 g	10.0 g	10.0 g
1-Phenyl-3-pyrazolidone	1.0 g	—	—
4,4-Dimethyl-1-phenyl-3-pyrazolidone	—	1.0 g	—
p-Aminophenol	—	—	2.5 g
Water to make	1.0 liter	1.0 liter	1.0 liter

Another formulation containing an *N,N*-disubstituted *p*-aminophenol had the following composition.

Boric acid	22.5 g
Borax · $10H_2O$	12.5 g
Sodium hydroxide	10.0 g
Ethylenediamine tetraacetic acid	16.2 g
Ethylenediamine tetraacetic acid, disodium salt	3.5 g
Ferric chloride · $6H_2O$	15.0 g
Sodium sulfite, anhydrous	4.0 g
Sodium thiosulfate · $5H_2O$	95.0 g
Magnesium sulfate · $7H_2O$	12.5 g
4-Hydroxy-3-methyl-*N*-ethyl-*N*-(β-hydroxyethyl)aniline, naphthalene-1,5-disulfonic acid salt	2.5 g
	2.5 g
Water to make	1.0 liter

An acidic bleach-fix solution would be especially desirable for its development-stopping action in those cases where the photographic print was not treated in a stop bath between development and blixing. Suitable bleach-fix solutions, stable under moderate acidic conditions, were said by Kurt Israel Jacobson[177] to result when the ethylenediamine tetraacetic acid was present in 1 : 3 proportions (by weight) with the iron chelate of that acid. Such a solution contained (pH = 6.5)

Ammonium thiosulfate	100 g
Ammonium thiocyanate	20 g
Ethylenediamine tetraacetic acid, disodium salt	12 g
Sodium ferric ethylenediamine tetraacetate	35 g
Thiourea	3 g
Water to make	1 liter

At about 80°F this solution bleached color film in 5 min and color paper in 1 or 2 min. The same results were obtained[178] when "600 gm. of an 18.5 w/w solution of the trisodium salt of *N*-(β-hydroxyethyl)-ethylenediamine triacetic acid is added to a solution of 58 gm. hydrated ferric chloride in 150 ml. of 3 *N* hydrochloric acid and 75 ml. water. To this solution is then added a solution in 350 ml of water of 15.5 gms. anhydrous sodium sulphite,

10 gms. ammonium thiocyanate and 62.5 gms. ammonium thiosulphate. The pH is adjusted to 6.7 using dilute hydrochloric acid, or dilute sodium hydroxide solution, and the volume of the bleach-fix bath is made up to 1 liter. The bleach-fix bath contains about a 50% excess of N-(β-hydroxyethyl)-ethylene diamine triacetic acid (and/or its ions) over and above the amount required to form the ferric chelate complex." The tribasic hydroxy acids were found (British Patent 774,545) to form stable ferric chelate salts in the pH range 5.5 to 6.5, making possible stop-bleach-fix baths.

As pointed out by Rowland G. Mowrey, Keith H. Stephen, and Eugene F. Wolfarth,[179]

The usual blix solutions for removing silver and silver halide from processed color photographic elements consist of from 20 to 60 g./l. of ferric ion complexed by a multidentate ligand and a simple silver halide solvent such as hypo in the range of from 50 to 150 g./l. The pH range is usually between pH 4.0 and 8.0. At the acid end of the pH scale, the oxidant powers of the blix are highest, but the oxidant attacks the silver halide solvent; also, the ferric ion complex is least soluble, being limited to about .25 mole/l or about 90 g./l. At the most alkaline pH value, a blix is least reactive, is more stable, and the solubility of the complex is about .45 mole/l. or about 150 g./l. These blixes having a pH about 8 are so slow that prohibitive time is required by these blixes to remove developed silver and residual silver halide even at the maximum concentration disclosed in the prior art.

Because of the low solubility of the ferric ion complex, bleach-fix solutions require a complicated method of mixing. The ferric ion complexes are often prepared during the mixing, requiring several separate solutions to prepare the working solution. Liquid blix concentrates were prepared by Mowrey, Stephens and Wolfarth, by using increased concentration of the fixing component, which permitted increased solubility of the ferric ion chelate. The ferric ion complex was said to be doubled over previous compositions when the liquid concentrate contained

Sodium ethylenedinitrilotetraacetato ferrate III hydrate	300 g
Ammonium thiocyanate	600 g
Water	1 liter

The pH was adjusted to 6.7 by adding ammonium hydroxide or sulfuric acid as required.

Photographic color films, unlike color papers, contain much higher coverage of silver halides. For color materials with a silver coverage greater than 200 mg/sq ft, Charleton C. Bard and George P. Varlan[180] worked out

a rapid processing cycle that included (after color development, a water rinse, and an acid stop) a bleach-fix bath followed by a bleach bath. Both solutions were used for 4 min, 70°F, without an intermediate treatment. The bleach-fix had the composition (pH = 7.0 at 70°F)

Ferric chloride · $6 H_2O$	24.0 g
Ethylenediamine tetraacetic acid, tetrasodium salt	40.0 g
Sodium thiosulfate · $5 H_2O$	150.0 g
Sodium sulfite, desiccated	15.0 g
Water to make	1.0 liter

and was followed by a bleach bath of the formulation (pH = 6.5 at 70°F)

Water	800.0 ml
Potassium ferricyanide	50.0 g
Potassium bromide	20.0 g
Water to make	1.0 liter

Hiroyuki Amano, Haruhiko Iwano, and Kazuo Shirasu[181] have summarized the state of the bleaching and fixing as follows:

Typical bleaching solutions for color photographic materials are a bleaching solution in which a water-soluble iron complex salt of ethylenediamine tetraacetic acid is used as the oxidizing agent and a bleaching solution in which a ferricyanide is used as the oxidizing agent. The former case is advantageous in that bleach-fixing can be done easily with a single solution which combines the bleaching and fixing since the oxidizing agent is stable with a thiosulfate but the employment of the former type bleaching solution is accompanied by disadvantages due to the weak oxidizing power of the oxidizing agent such that when a type of coupler is used, the leuco compound formed by the color forming development can not be oxidized into the dye. It is known to use an additional oxidizing bath after applying such a bleach-fixing procedure for improving these disadvantages (see, for example, the specification of British Pat. 1,026,496), but such an approach necessitates the use of a number of processing baths complicating the processing. Also, various attempts are known in which various types of accelerators are added in the case of using the water-soluble iron complex salt of ethylenediamine tetraacetic acid (see, for example, the specification of British Pat. Nos. 1,150,466 and 926,569), but such approaches are inferior in bleaching speed to the process in which a ferricyanide is used.

A combined bleaching-fixing-hardening bath was proposed by Amano, Iwano, and Shirasu that "has the same bleaching power and bleaching

speed as those of a conventional ferricyanide-type bleaching bath and in addition, the solution has the same hardening power and hardening speed of a conventional hardening bath. Also, the stability of the processing solution per se is better than the conventional bleaching bath, fixing bath and hardening bath." An example of such a solution used for an incorporated-coupler multilayer color film (49 sec at 30°C) contained

Potassium ferricyanide	125 g
Phosphorus acid	30 g
Sodium thiocyanate	100 g
Formalin (35 to 40%)	30 ml
Water to make	1 liter

pH was adjusted to 7.0 with aqueous sodium hydroxide.

Hardening bleach-fixing baths were found by Max Heilmann and Wolfgang Himmelmann[182] to be extremely stable, maintaining their activity during storage of several months. Formaldehyde or, preferably, dialdehydes were used as the gelatin-hardening agents in a bath containing the iron(III) or cobalt(III) complexes of ethylenediamine tetraacetic acid, or similar complex-forming compounds. Sodium thiosulfate was the silver-complexing agent in the bath. Sodium sulfite, or an organic sulfinic acid, was found to increase the stability of the bath. From 5 to 10 g/liter of benzene-sulfinic acid, sodium salt, was preferred. In such a solution as the following example, hardening, bleaching, and fixing were said to occur in 5 min for commercial chromogenic color materials.

Tetrasodium salt of ethylenediamine tetraacetic acid (30% active acid)	10 g
Sodium salt of iron(III) complex of ethylenediamine tetraacetic acid	30 g
Sodium benzenesulfinate	10 g
Sodium thiosulfate, anhydrous	100 g
2-Mercapto-1,3,4 triazol	5 g
Formalin, 30%	45 ml
Water to make	1 liter

Another example of a hardening blix bath as prepared by Heilmann and Himmelmann had the following method of preparation:

Consecutively, 0.5 g of sodium *p*-toluenesulfinate and 5.4 ml of concentrated sulfuric acid are dissolved in 800 ml of water while stirring is applied. Then, 4.0 ml of dimethoxy-

tetrahydrofuran is caused to flow in and stirring is applied for 15 minutes. Subsequently, one neutralizes with concentrated sodium hydroxide. By the addition of

10 g of ethylenediaminetetraacetic acid in the form of the tetrasodium salt (technical product with about 30 % of active ethylenediaminetetraacetic acid)
10 g of sodium benzenesulfinate
30 g of the sodium salt of the iron(III) complex of the ethylenediaminetetraacetic acid, and
100 g of sodium thiosulfate, anhydrous,

and by filling up to water to 1000 ml, one obtains a very active, hardening and bleaching fixing bath. It is able to harden unhardened gelatin layers thoroughly within 5 minutes.

Solutions for Increasing the Stability of Dye Images

Bleaching and fixing removes the metallic silver and residual silver halide of the color photographic material. A short wash in water is sufficient to remove most of the residual chemicals from the previous processing steps. Dye images and coupler solvent are embedded in the gelatin layers along with unused coupler in a coupler solvent dispersion. Other organic compounds may also have penetrated the coupler droplets and are retained there, unable to be removed by the water wash. Most dye images produced by chromogenic development have poor light fastness. Many different approaches have been used to improve the light fastness of the color images. One continuing method has been the search for a colorless, nondiffusing ultraviolet absorbing compound that can be incorporated into the photographic material at the time of manufacture.[183-192] Another proposal involves incorporating the ultraviolet-absorbing, fluorescent-whitening compound in an alkaline aqueous thiosulfate solution. Dye fading and color stains were said to be reduced.[193] Such fluorescent brightening agents, however, have offered only slight improvement in the light fastness of textile dyes.[194] Hydroquinone antistain agents, such as gentisaldoxime, have been added to the color developer.[195]

Chromogenic images have been treated in a variety of chemical baths in an effort to increase the long-term stability of the dyes. Stabilizing solutions, as these baths are called, are usually the final treatment of the color processing cycle before the color material is dried. Decolorization of dye images or the discoloration of residual couplers in photographic layers was said to be effectively inhibited by bathing the photographic material in a rinse bath containing an antioxidant or reducing agent. Paul W. Vittum[196] suggested hydroquinone at 5 g/liter of water with 0.5 g of sodium sulfite, or hydroquinone derivatives, ascorbic acid at 2.5 g/liter of water, p-benzylaminophenol, phenylhydrazine, or 1-phenyl semicarbazide. Pyrogallol and gallic

acid[197] have been patented, but these compounds may cause brown stains. The combination of urea or one of its derivatives with hydroquinone or a derivative of hydroquinone has been claimed[198] in a rinse bath to increase the light-fastness of cyan, magenta, and yellow chromogenically formed dyes. A 2-min immersion in a solution of urea (40 g) and hydroquinone (4 g) in a liter of water, following the final wash, inhibited the fading of the dyes in a photographic paper print. A 5% urea rinse bath, according to data supplied by George W. Larson,[199] is a relatively weak stabilizing agent, but 5% carbohydrazide, according to Larson, was more effective.

A considerable number of agents have been included in a patent for use as rinse baths to prevent dye fading or residual coupler discoloration. Some of the preferred compounds include sugars such as glucose or sucrose; hexitol compounds such as sorbitol or mannitol; amino acids, such as glycine or α-alanine; or guanidine or guanidine derivatives.[200] Mannitol, for example, was most effective between 5 to 10% in solution for both transparencies and prints. For inhibiting mold growth in such solutions 0.5% zinc fluorosilicate or 1% sodium pentachlorophenate may be added to the rinse bath.

Sodium sulfite has often been an ingredient of a stabilizing rinse bath. A 2-min treatment in a 0.1% sodium sulfite solution was said by Harold C. Harsh and James E. Bates[201] to improve dye stability. A buffered sulfite solution with a citrate antisludging agent was patented by Ronald H. Miller and Martin A. Foos.[202] An example of such a bath is

Dipotassium acid phosphate (K_2HPO_4) 16.8% and potassium diacid phosphate (KH_2PO_4) 13.2%	500 ml
Potassium sulfite, 30%	500 ml
Sodium citrate	20 g

Often the sulfite has been in the form of sodium formaldehyde bisulfite, such as a solution containing 2% sodium formaldehyde bisulfite and 1% borax, as proposed by Eugene Seary and Anthony Salerno.[203] Sulfite or bisulfite ions may have a detrimental effect on some cyan dyes, so aldehyde bisulfite addition products have been found beneficial. Rowland G. Mowrey[204] found that a 1-min, 29°C, treatment in a 1% sodium formaldehyde bisulfite rinse bath, with enough sulfuric acid or sodium hydroxide to adjust the solution pH to 7.0, reduced stain increase due to coupler decomposition.

Boric acid in a concentration range of 0.01 to 1.0% has been said to improve photographic prints by avoiding the formation of stain.[205] Formic, acetic, citric, maleic, oxalic, tartaric and other organic acids have been used in rinse baths.[206] A stabilizing bath for improving the physical properties of

color prints has included a water-soluble aluminum salt, a polycarboxylic buffer, and benzoic acid, or one of its salts, as a mold inhibitor.[207] Such a stabilizing bath (for use at 30°C for 2 min) contained (pH = 3.3)

Potassium alum	30 g
Sodium citrate	5 g
Sodium benzoate	0.5 g
Boric acid	5 g
Sodium metaborate	4.3 g
Water to make	1.0 liter

Various water-soluble carboxylic acids, such as acetic, propionic, itaconic, and citraconic, have been employed as water-washing accelerators.[208] Such compounds may also be added to a stabilizing solution. British Patent 736,881 described polycarboxylic acids in the rinse bath to prevent stain due to iron contamination. Imbibing compounds containing one or more tri(hydroxymethyl)methyl groups have been found to minimize dye fading and discoloration or color photographic materials.[209] Typical stabilizing compounds included 3-hydroxy-2,2-dihydroxymethylpropionic acid and 2-amino-2-hydroxymethylpropane-1,3-diol.

Thiourea (0.5 %) or ethylthiourea (1 %) have been used in stabilizing baths to inhibit the discoloration of color prints.[210] A 5 % solution of cysteine hydrochloride was patented as a stabilizing solution to minimize discoloration and dye fading.[211] Image stabilizing agents, such as formaldehyde or acetaldehyde, may be combined with a surfactant of the polyethoxy ethanol type, for example, octyloxy polyethoxy ethanol, to form stabilizing baths.[212] Formaldehyde has also been combined with p-alkylphenoxy poly(hydroxy-alkylene oxide) surfactant to form a rinse bath that does not have adverse effects on dye images.[213]

In U. S. Patent 2,788,274 Hubert O. Ranger states that

Various treatments have been proposed to prevent the dye fading of color images formed by color forming development, but these treatments are largely ineffective in preventing the discoloration of the white areas when exposed to heat, high humidity, sunlight or ultraviolet light. In spite of the ordinary precautions which are taken in storing photographs, the whites will turn yellow when the color pictures are kept near windows, in billfolds or even in storage cabinets where they are subjected to heat or high humidity. This yellowing which affects not only the whites but also the pastel shades becomes even more pronounced when the color pictures are exposed to direct sunlight or to the limited amount of ultraviolet light which is given off by fluorescent lamps. Prints processed without the use of color forming development do not exhibit this stain.

A final rinse bath was proposed by Ranger, who claimed that the yellowing would be prevented by using an aqueous solution containing a water-soluble zinc salt. Color prints were treated for 3 min in a final rinse bath containing 4 % zinc sulfate in water solution buffered to a pH of 5.5. According to Ranger, "The treated and the untreated prints were placed in a high humidity oven having a temperature of 50°C and a relative humidity of 80 percent. After 5 days, the prints were removed from the oven. The print which had received a final rinse in the zinc sulfate solution did not show any yellowing of the white areas while the untreated print was badly yellowed."

Stop-bleach-fix-stabilizer solution has been proposed as part of a two-solution rapid color process for thin, concentrated emulsion layers of photographic films or papers.[214] After color development, the photographic material is immersed immediately in a bath of the following composition:

Ammonium thiosulfate (60%)	150 ml
Water	300 ml
Sodium sulfite, anhydrous	10 g
Sodium hydroxide	5 g
Ethylenediamine tetraacetic acid	10 g
Ammonium thiocyanate	10 g
Thiourea	2.5 g
Sodium ferric ethylenediamine tetraacetate	20 g
Disodium hydrogen phosphate	20 g
Dihydrogen sodium phosphate	20 g

Film treatment is complete in 5 min or less at 27°C, but paper requires only 1 to 2 min. The photographic material is washed for a few minutes and then dried.

LIGHT FASTNESS OF COLOR PHOTOGRAPHIC IMAGES

Stabilizing final rinse baths do help to improve the stability of dye images, but the total effect is relatively small. According to Karl H. Landes of Agfa–Gevaert, Inc.,[215] "The commercially available stabilizing final baths are only applied to compensate for the normally too short washing time of several minutes." "Dye fading for all dyes begins the instant they are formed," said Richard K. Schafer, Motion Picture and Audiovisual Markets Division of Eastman Kodak Company.[216] "The use of black-and-white separations is the most reliable way known at the present time to store the photographic information in a color original negative or color original reversal [motion

picture film]," concluded Peter Z. Adelstein, C. Loren Graham, and Lloyd E. West of the same company.[217]

This concern for the persistence of dye images was borne out in 1973 by an evaluation of the light fastness of color prints or transparencies by C. H. Giles, S. D. Forrester, R. Haslam, and R. Horn, all of the University of Strathclyde, Glasgow.[218] The following is part of the abstract of the publication of their findings in the *Journal of Photographic Science*:

In transparencies from reversal films there appears to be a correlation between emulsion speed and speed of fading: the slowest film gives the best fastness, its colours are graded about 4 (on the B.S. scale of 1 to 8) in medium shade depths. This is probably adequate for occasional projection, though poor by textile standards, corresponding with a possible useful life of about 4 hours under continuous exposure in a modern projector. The fastest reversal films (100 ASA and above) are very poor indeed and are graded about 1 on the scale, corresponding with a possible useful life of only about 0.5 hours in a projector.

Colour-developed paper prints are graded between 1 and 2, and estimated to have a useful life of between 4 and 12 months under continuous exposure in an average room in daylight.

[It should be noted that some color paper products have dyes that are as stable, or even more so, than color film materials.]

Transparencies and prints made by the silver-dye bleach process have good fastness, between 5 and 6 on the B.S. scale, representing a possible useful life of about 8 hours in a projector or 70 months in an average room.

Detailed examination of the three individual colours of one reversal film show that cyan is the most resistant to fading and magenta the least; in deep shades cyan has the highest possible fastness on the B.S. scale whereas in pale shades magenta has extremely poor fastness.

COMMERCIAL COLOR PROCESSES

Each manufacturer of a color film or paper provides a color process to obtain the optimum quality of the photographic material. All manufacturers specify the processing procedure and conditions of the processing. Some manufacturers make available the chemical formulation of each of the needed solutions; other manufacturers do not disclose publicly the composition of each solution but sell packaged chemicals. The selling of proprietary chemicals of undisclosed composition has challenged knowledgeable photographic chemists to devise and publish the composition of substitute formulations. Unofficial formulas have been published for every process with the possible exception of that for Kodachrome film or other films not

incorporating couplers, although "Home-Processing Kodachrome" was discussed in the May 1939 issue of *Better Photography Magazine*. A universal developing method was suggested by H. Gordon in 1954 for color negative films and color papers.[219,220] Sometimes formulations have been proposed as a substitute for the official formulas that have been furnished by the manufacturer. Most unofficial formulations provide results that differ in quality from recommended processing.

The manufacturer of Ansco color films has released the formulas for the color processing solutions "in line with its policy of placing as much as possible of the color process in the hands of the photographer himself." This philosophy was expressed by James E. Bates in 1945[221] with the publication of the formulas and processing cycle for the Ansco Color Reversible film available at that time. An improved first developer, with Phenidone replacing Metol, was published independently in 1957.[222] Anscochrome 64, D/200, D/500, and T/100 reversal films were designed to be processed by the AR-1 process, introduced in 1961. In 1968 an accelerated process, the AR-2, cut the processing time to 20 min at 80°F, the only difference in solution formulations being in the composition of the developers. The official formulas for most of the processing solutions for these now discontinued films were published by William L. Wike.[223,225] Other substitute formulations, using the same official processing procedure, have been devised by Ernest Ch. Gehret.[224] Gehret's formulas were claimed to give "results of excellent quality compared with that obtained with the official kits."

The lifetime of a color process is short. Generally, each new generation of a commercial color film or paper requires a new set of chemical solutions and a new cycle of processing steps and conditions. The photographic chemisty of color processing, however, is not obsoleted by such periodic changes but has been modified only slightly to provide optimum qualities to the new film or paper. In this section it is proposed to list representative processing cycles and chemicals. By the time these words are read, some of these processes will have been supplanted by new processes for new products. Even so, the listing of the chemical compositions should continue to be of value to those who formulate official or unofficial formulas for the latest color films or papers. This listing is provided for reference purposes and should not be used for the processing of valuable color materials without previous experimentation to determine the applicability of the process to current color photographic film or paper.

Color Reversal Film Processing

The widespread distribution and use of Kodak color films has, from the very first, inspired the formulation and publication of suitable substitute

formulas for the processing solutions. H. Gordon[226] and William J. Pilkington[227] listed the composition of processing solutions for Ektachrome film as early as 1948. Substitute formulas were also given in 1950 by C. Leslie Thomson,[228] who provided experimental formulations for Process E-2 (1957) as well. In 1958 Ernest Gehret[229] formulated solutions for Ektachrome sheet film (Process E-1) and Ektachrome 35mm and roll films (Process E-2). A modified stock solution process has been proposed.[230]

Process E-3 was used primarily for Kodak Ektachrome professional sheet and roll films; Process E-4 was for processing such films as Ektachrome-X or High Speed Ektachrome. The E-3 process has been suggested for use with E-4 process films,[231] but caution should be exercised. Some Ektachrome films, such as Kodak Ektachrome infrared film, may reticulate when processed in E-3 chemicals. Ernest Gehret[232,233] has proposed substitute formulations for both the E-3 and E-4 processes. Gehret's unofficial E-4 procedure and formulas are listed here as an example of a color reversal process, although now replaced by Process E-6 and a new family of Ektachrome films.

E-4 Processing Procedure

Step	Operation	Time (min)	Temperature
1	Preliminary hardener	3	$29.5 \pm 0.5°C$ ($85 \pm 0.5°F$)
2	Neutralizer	1	28 to 31°C
3	First developer	$6\frac{1}{4}$	$29.5 \pm 0.25°C$
4	First stop bath	$1\frac{3}{4}$	28 to 31°C
Normal room lighting may be resumed			
5	Wash, running water	4	27 to 32°C
6	Color developer	9	27 to 32°C
7	Second stop bath	3	27 to 32°C
8	Wash, running water	3	27 to 32°C
9	Bleach	5	27 to 32°C
10	Fixer	4	27 to 32°C
11	Wash, running water	6	27 to 32°C
12	Stabilizer	1	27 to 32°C
13	Dry	—	43°C max
	Total processing time	47	

Recommended agitation is continuous for the first 15 sec, then 5 sec every minute.

Prehardener

Sodium or potassium bisulfate	0.8 g
2,5-dimethoxytetrahydrofuran	5.0 ml
Sodium sulfate, anhydrous	136.0 g
Formaldehyde, 35 to 40%, formalin	30.0 ml
Potassium bromide	16.0 g
Water to	1000.0 ml
pH	4.9 to 5.0

Neutralizer

Acetic acid, 100%	1.5 ml
Sodium acetate, crystalline	24.0 g
Potassium bromide	17.0 g
Sodium sulfate, anhydrous	25.0 g
Potassium metabisulfite, crystalline	30.0 g
Water to	1000.0 ml
pH	5.1 to 5.2

First Developer

Calgon, sodium hexametaphosphate or tripolyphosphate	2.0 g
Metol	6.0 g
Sodium sulfite, anhydrous	50.0 g
Sodium carbonate, anhydrous	30.0 g
Hydroquinone	6.0 g
Potassium bromide	2.0 g
Sodium thiocyanate	1.3 g
Sodium hydroxide, pellets	2.0 g
Potassium iodide, 0.1% solution	6.0 ml
Water to	1000.0 ml
pH	10.1 to 10.3

Stop Baths

Sodium acetate, crystalline	5.3 g
Acetic acid, 98 to 100% (glacial)	32.0 ml
Water to	1000.0 ml
pH	3.4 to 3.6

Two stop baths are needed—do not interchange.

Color Developer

Trisodium phosphate, crystalline (12 H_2O)	40.0 g
Sodium hydroxide, pellets	8.0 g
Ethylenediamine, 80% solution	3.8 ml
or Ethylenediamine sulfate, crystalline	7.6 g
Benzyl alcohol, 35% solution (see below)	10.0 ml
Tertiary-butylamine borane (TBAB)	0.1 g
Citrazinic acid	1.3 g
EDTA Na4, Celon E, EDTA tetra-sodium salt	3.0 g
Sodium sulfite, anhydrous	5.0 g
Potassium bromide	0.2 g
Potassium iodide, 0.1% solution	10.0 ml
Add before use:	
Kodak CD3 (M and B Mydochrome: Activol No. 3)	12.0 g
Water to	1000.0 ml
pH	11.8 to 12.0

Benzyl Alcohol, 35% Solution

Benzyl alcohol	35.0 ml
Diethylene glycol	45.0 ml
Water	20.0 ml
	100.0 ml

Bleach

Potassium ferricyanide	112.0 g
Potassium bromide	24.0 g
Disodium phosphate, crystalline (7 H_2O)	45.0 g
Monosodium phosphate, anhydrous	12.0 g
Sodium thiocyanate	10.0 g
Water to	1000.0 ml
pH	6.6 to 7.0

Fixer

Ammonium thiosulfate, crystalline	120.0 g
Potassium metabisulfite, crystalline	20.0 g
Water to	1000.0 ml
pH	4.5 to 4.9

Stabilizer

Formaldehyde, 35 to 40% solution	3.0 ml
Wetting agent, 10% solution	10.0 ml
Water to	1000.0 ml

Color Negative Film Processing

Process C-22 was used for processing Kodacolor and Kodak Ektacolor negative color films. Because of the extensive use of Process C-22 by photofinishing plants, other color negative film manufacturers provided films that could be processed by the procedure and chemicals of Process C-22. Ernest Ch. Gehret[234] has proposed a procedure and substitute processing solutions for C-22 processing. Process C-41 has now replaced C-22 and can be used to process Kodacolor II and Kodak Vericolor II as well as other compatible color negative films. These same films can be processed in Process C-42, an official Kodak recommended process for Kodacolor II and Kodak Vericolor II films. Note that in the procedure of the C-42 process that follows that the first two steps are done in total darkness but the remaining steps may be done in normal room light.

Processing Procedure for Process C-42

Step	Operation	Time (min)	Temperature
1	Developer	$3\frac{1}{4}$	$100 \pm 0.25°F$ ($37.8 \pm 0.15°C$
2	Bleach	$6\frac{1}{2}$	75 to 105°F (24 to 40°C)

Remaining steps can be done in normal room light.

3	Running water wash	$3\frac{1}{4}$	75 to 105°F (24 to 40°C)
4	Fixer	$6\frac{1}{2}$	75 to 105°F (24 to 40°C)
5	Running water wash	$3\frac{1}{4}$	75 to 105°F) (24 to 40°C)
6	Stabilizer	$1\frac{1}{2}$	75 to 105°F (24 to 40°C)
7	Dry	10 to 20	75 to 110°F (24 to 43°C)

A 10-sec drain time should be included in each step. Agitation is continuous for the first 30 sec in each processing solution, with two sec agitation in every 15 sec for the developer, and 5 sec in every 30 sec for the other solutions.

Processing Solution Formulas for Process C-42

Color Developer	
Water (70 to 80.6°F; 21 to 27°C)	800.0 ml
Potassium carbonate, anhydrous	37.5 g
Sodium sulfite, anhydrous	4.25 g
Potassium iodide	0.002 g
Sodium bromide	1.3 g
Hydroxylamine sulfate	2.0 g
Kodak Anti-Calcium, No. 3	2.5 g
Color developing agent, CD-4	4.75 g
Water to make	1.0 liter

pH at 80.6°F (27°C) should be 10.00 ± 0.03. If necessary, add potassium hydroxide (10% solution) to raise the pH or sulfuric acid (10% solution) to lower the pH to this value.

Bleach

Water (70 to 80.6°F; 21 to 27°C)	600.0 ml
Ammonium bromide	150.0 g
Kodak bleaching agent, BL-1	175.0 ml
Glacial acetic acid	10.5 ml
Potassium nitrate	41.2 g
Water to make	1.0 liter

pH at 80.6°F (27°C) should be 6.0 ± 0.2. To raise the pH add ammonium hydroxide (28% solution) or add glacial acetic acid to lower the pH.

Fixer

Water (70 to 80.6°F; 21 to 27°C)	800.0 ml
Ammonium thiosulfate, 58.6% solution	162.0 ml
(Ethylenedinitrilo)-tetraacetic acid, disodium salt	1.25 g
Sodium bisulfite, anhydrous	12.4 g
Sodium hydroxide	2.4 g
Water to make	1.0 liter

pH at 80.6°F (27°C) should be 6.5 ± 0.2. Add sodium hydroxide (2.5 Normal) to raise the pH or sulfuric acid (7 Normal) to lower the pH.

Stabilizer

Water (70 to 80.6°F; 21 to 27°C)	800.0 ml
Formalin, 37% solution	5.0 ml
Kodak rinse additive, MX812	0.8 ml
Water to make	1.0 liter

Processing of Ektacolor 30 and 37 RC Color Papers

The processing procedure and solution formulas for Kodak Ektacolor 30 and 37 RC papers have been published by Patrick Dignan in the *Dignan Newsletter*.[235] Process P-125 is a three-solution color print process using

Kodak Ektaprint 3 chemicals, later simplified to a two-solution process with Ektaprint 2 chemicals. The official P-125 procedure and processing solutions are as follows:

Step	Operation	Time (min)	Temperature
1	Developer	$3\frac{1}{2}$	$88 \pm 0.5°F$
			$(31 \pm 0.3°C)$
2	Bleach-fix	$1\frac{1}{2}$	$88 \pm 2°F$
			$(31 \pm 1.2°F)$

A safelight with a 15-watt bulb (Kodak safelight filter No. 13) or with a $7\frac{1}{2}$ watt bulb (Kodak safelight filter No. 10) may used during first two steps. Room lights may be turned on after one-half of the bleach-fix time.

3	Running water wash	2	$88 \pm 2°F$ $(31 \pm 1.2°C)$
4	Stabilizer	1	$88 \pm 2°F$ $(31 \pm 1.2°C)$
5	Dry		Not over 225°F (107°C)

Include a 20-sec drain time in the time for each processing step.

Kodak Process P-125 Developer

Water (70 to 80.6°F; 21 to 27°C)	800.0 ml
Benzyl alcohol	14.5 ml
(Stir at least 5 min after adding to water. Complete uniformity of the solution is necessary before adding the other chemicals.)	
Potassium carbonate, anhydrous	32.0 g
Potassium sulfite, anhydrous	2.0 g
Potassium bromide	0.335 g
Hydroxylamine sulfate	3.4 g
Kodak anti-calcium, No. 5	0.8 ml
Kodak color developing agent, CD-3	4.3 g
Kodak Ektaprint 3 stain-reducing agent, Type 2	1.0 g
Kodak Ektaprint 3 solubilizing agent	1.78 g
Potassium hydroxide (45 % solution)	1.76 ml
Water to make	1.0 liter

pH at 80.6°F (27°C) should be 10.08 \pm 0.05. To increase pH, use potassium hydroxide, 10% solution; to decrease pH, use sulfuric acid, 10% solution.

Kodak Process P-125 Bleach-Fix Solution

Water (70 to 80.6°F)	600.0 ml
Kodak bleaching agent, BL-1	115.0 ml
Ammonium thiosulfate (60% solution)	172.5 ml
Sodium bisulfite, anhydrous	13.0 g
Water to make	1.0 liter

pH at 80.6°F should be 6.45 \pm 0.15. To increase pH add ammonium hydroxide, 28% solution; to lower the pH add sulfuric acid, 10% solution.

Kodak Process P-125 Stabilizer

Water (70 to 80.6°F)	800.0 ml
Citric acid, monohydrated	6.8 g
Glacial acetic acid	12.5 ml
Potassium hydroxide, 45% solution	4.1 ml
Sodium benzoate	0.34 g
Water to make	1.0 liter

pH at 80.6°F (27°C) should be 3.6 \pm 0.1. To increase the pH add potassium hydroxide (45% solution); to decrease the pH add glacial acetic acid.

REFERENCES

1. W. T. Hanson, Jr., and W. I. Kisner, "Improved Color Films for Color Motion-Picture Production," *J. SMPTE*, **61**: 667 (1953).
2. Ernest Ch. Gehret, "The Effect of Temperature on Colour Development," *Brit. J. Phot.*, **116**: 959 (1969).
3. Bruno Mücke, Karl Lohmer, and Heinrich Gold, "Process for Hardening Protein Layers," Can. Pat. 913,975 (1972).
4. Donald M. Burness, Stanley W. Cowan, and Charles J. Wright, "Hardeners for Photographic Gelatin," U. S. Pat. 3,490,911 (1970).
5. H. A. Miller, J. I. Crabtree, and H. D. Russell, "A Prehardening Bath for High-Temperature Processing," *J. PSA.*, **10**: 397 (1944).
6. Philip A. Friedell, "Hardeners and Hardening," *Am. Phot.*, **41** (6): 18 (1947).
7. Charles F. H. Allen and Donald M. Burness, "Hardening of Photographic Gelatin Layers," U. S. Pat. 3,232,761 (1966).

8. Harry C. Baden and Charleton Cordery Bard, "Formaldehyde and Succinaldehyde Gelatin Hardening Composition and Method of Hardening Therewith," U. S. Pat. 3,220,849 (1965).

9. Bryan Ernest Tabor, Harry Christian Baden, and Charleton Cordery Bard, "Improvements in or relating to the Chemical Modification and Hardening of Gelatin," Brit. Pat. 1,071,783 (1967).

10. Harry C. Baden, Charleton C. Bard, and James Marvin Seemann, "Photographic Prehardener Compositions," U. S. Pat. 3,294,536 (1966).

11. Harry Christian Baden, Charleton Cordery Bard, and James Marvin Seemann, "Photographic Gelatin Hardening Baths," Brit. Pat. 1,079,934 (1967).

12. Howard E. Munro, "Stabilized Photographic Prehardener Compositions," U. S. Pat. 3,345,173 (1967); "Photographic Prehardener Compositions," Brit. Pat. 1,112,040 (1968).

13. Charleton C. Bard and Howard W. Vogt, "Hardening Compositions for Photography," Can. Pat. 854,131 (1970).

14. John R. Abbott and Ilmari F. Salminen, "Novel Inhibitors for Use in the Black and White Development of Color Reversal Film," U. S. Pat. 3,295,976 (1967).

15. Fuji Photo Film Co., "Hardening of Photographic Silver Halide Materials," Brit. Pat. 1,293,038 (1972); Nobuo Yamamoto, Tadao Hatano, Isao Shimamura, and Haruhiko Iwano, "Imagewise Exposed Gelatino Silver Halide Emulsion Treated with Pyruvic Aldehyde Hardener," U. S. Pat. 3,695,883 (1972).

16. Wolfgang Himmelmann, Karl-Wilhelm Schranz, Johannes Sobel, and George Frans van Veelen, "Treatment of Exposed Silver Halide Emulsion with Acidic Hardening Bath Following by Alkaline Activating Bath," U. S. Pat. 3,676,143 (1972).

17. Donald J. Forst, "Verfahren zum Verarbeiten von Farbfilmen," German Pat. 1,903,097 (1969); "Rapid Color Processing," U. S. Pat. 3,719,493 (1973).

18. Fuji Shashin Film Kabushiki Kaisha, "Process for Hardening Photographic Silver Halide Light-Sensitive Elements," Brit. Pat. 1,238,572 (1971).

19. Fuji Shashin Film Kabushiki Kaisha, "Process for Hardening Photographic Silver Halide Light-Sensitive Elements," Brit. Pat. 1,238,573 (1971).

20. Fred Richard Holly, Jr., Norville Bruce Williams, and Gareth Neal Wall, "Photographic Hardening Baths," Brit. Pat. 1,271,025 (1972).

21. Fuji Photo Film Co., "Method of Processing Silver Halide Colour Photographic Materials," Brit. Pat. 1,297,473 (1972).

22. Howard W. Vogt, "Photographer Hardener-Developer Compositions," U. S. Pat. 3,567,441 (1971).

23. John Blackmer and Howard W. Vogt, "Rapid Processing of Photographic Color Materials," U. S. Pat. 3,168,400 (1965).

24. Richard J. Malloy, "Neutralizing Bath for Use in Photographic Processing," U. S. Pat. 3,647,449 (1972).

25. Fuji Shashin Film Kabushiki Kaisha, "A Process for the Development of Photographic Silver Halide Light-Sensitive Elements," Brit. Pat. 1,203,318 (1970).

26. Fuji Shashin Film Kabushiki Kaisha, "Processing Photographic Silver Halide Light-Sensitive Elements," Brit. Pat. 1,205,824 (1970).

27. John Richards Abbott and Ilmari Fritiof Salminen, "Substituted Mercapto-Tetrazoles and their use in Photographic Processing Methods," Brit. Pat. 1,119,799 (1968).

28. James L. Graham, "Benzothiazolium Compounds for Controlling Overdevelopment," U. S. Pat. 3,342,596 (1967).

29. Donald E. Sargent, "Process of Rendering Undevelopable the Silver Halides Present in an Outer Layer of Multilayer Color Film," U. S. Pat. 2,636,821 (1953).

30. Paul J. Mutter, "Chemical Stability of Photographic Processing Solutions," *Phot. Sci. and Eng.*, **8**: 49 (1964).

31. Alfred Miller, "Fotografische Entwickler," Ger. Pat. 720,630 (1942).

32. Ferdinand Münz, "Polyamino Carboxylic Acids and Process of Making Same," U. S. Pat. 2,130,505 (1938).

33. Heinrich Ulrich, Karl Saurwein, Paul Goldacker, and Georg L. Maiser, "Photographic Treating Bath," U. S. Pat. 2,168,181 (1939); "Improvements relating to Photographic Treating Solutions," Brit. Pat. 496,252 (1938).

34. Heinrich Ulrich and Karl Saurwein, "Photographische Behandlungsbäder," German Pat. 705,772 (1941).

35. Donald J. Forst, "Method for Removing Excess Aldehydes," U. S. Pat. 3,634,081 (1972).

36. Itek Corporation, "Improvements in or relating to Photographic Colour Processing," Brit. Pat. 1,260,382 (1972).

37. Donald J. Forst, "Rapid Reversal Color Processing," Can. Pat. 895,807 (1972).

38. Heinz Meckl, Helmut Häseler, and Bernhard Morcher, "Black-and-White Developer for Photographic Reversal Process," U. S. Pat. 3,295,975 (1967).

39. Julius Caesar Battaglini, John Howard Goselin, and Walter Peter Horylev, "Photographic Processing," Brit. Pat. 1,281,131 (1972).

40. Catherine M. Spath, "Antifoggants for Photographic Developers," U. S. Pat. 2,860,976 (1958).

41. Vincent J. Miceli, "Developers Containing Silver Halide Solvents," U. S. Pat. 3,523,793 (1970).

42. Vincent J. Miceli, "Developers Containing Silver Halide Solvents," U. S. Pat. 3,523,794 (1970).

43. Le Roy M. Dearing and Charles Henry Guell, "Developers Containing Silver Halide Solvents," U. S. Pat. 2,371,740 (1945).

44. Heman Dowd Hunt, "Reversal Process of Photography," U. S. Pat. 3,126,282 (1964).

45. James E. Bates, "Photographic Developer Containing Thallium Salts," U. S. Pat. 2,572,903 (1951).

46. James E. Bates, "Thallium Salts in Photographic Color Developers," U. S. Pat. 2,561,166 (1951).

47. Alfred Miller, "Photographic Developer," U. S. Pat. 2,172,216 (1939).

48. Bruno Blaser and Karl-Heinz Worms, "Process of Forming Metal Ion Complexes," U. S. Pat. 3,214,454 (1965).

49. Paul M. Mader, "The Chemistry of Color Developers: Effect of Ethylenediaminetetraacetic Acid and Iron on the Loss of Developing Agent and Sulfite from Aerated Solutions," *Phot. Sci. and Eng.*, **3**: 49 (1959).

50. Kurt Meyer and Wolfgang Brune, "Beiträge zur Farbentwicklung. II. Mitteilung: Über das Verhalten sulfithaltiger Farbentwickler gegenüber Luftsauerstoff," *Z. wiss. Phot.*, **46**: 135 (1951).

51. Kurt Meyer and Lieselotte Roth, "Beiträge zur Farbentwicklung. XII. Mitteilung: Über den Einfluss von Kupfer-Spuren auf die Autoxydation sulfithaltiger Farbentwickler- und Hydrochinon-Lösungen," *Z. wiss. Phot.*, **49**: 10 (1954).

52. Kurt Meyer, "Zur Kenntnis der Farbentwicklung," *Bild und Ton*, **7**: 69 (1954).

53. Edwin Ernest Jelley, "Improvements in Photographic Developing Solutions for Colour Photography," Brit. Pat. 462,140 (1937).

54. Edith Weyde and Erwin Trabert, "Color Photography," U. S. Pat. 2,286,662 (1942); "Procédé pour éviter des voiles de couleurs dans le développement chromogène," French Pat. 860,020 (1941).

55. Kurt Meyer and Wolfgang Brune, "Beiträge zur Farbentwicklung. III. Mitteilung: Über das Verhalten hydroxylaminhaltiger Farbentwickler gegenüber Luftsauerstoff," *Z. wiss. Phot.*, **46**: 169 (1951); "IV. Mitteilung: Über den Einfluss von Kupferionen und Kalkschutzmitteln auf die Oxydation hydroxylaminhaltiger Farbentwickler durch Luftsauerstoff," *Z. wiss. Phot.*, **46**: 174 (1951).

56. P. C. Moews, Jr., and L. F. Audrieth, "The Autoxidation of Hydroxylamine," *J. Inorg. Nucl. Chem.*, **11**: 242 (1959).

57. Donald J. Kridel, "Stabilized Photographic Developers for Color Photography," U. S. Pat. 2,875,049 (1959).

58. Vincent Anthony Tassone, "Stabilized Color Developing Solution Containing Diethylenetriamine Pentaacetic Acid," U. S. Pat. 3,462,269 (1969); "Photographic Developer Compositions," Brit. Pat. 1,192,454 (1970).

59. Ralph M. Evans and Wesley T. Hanson, Jr., "Reducing Aerial Oxidation of Photographic Developers," U. S. Pat. 2,301,387 (1942).

60. Harald Muhr and Anthony Joseph Axford, "Improvements in or relating to the Stabilisation of Photographic Developers," Brit. Pat. 782,304 (1957).

61. Leslie Frederick Alfred Mason, "Improvements in or relating to Colour Photography," Brit. Pat. 830,625 (1960); "Photographischer Entwickler für die Farbentwicklung," German Pat. 1,057,875 (1959).

62. Leslie Frederick Alfred Mason, "Photographic Colour Developing Composition," Brit. Pat. 805,174 (1958).

63. May and Baker Limited, "Improvements in or relating to Photographic Processes," Brit. Pat. 626,958 (1949).

64. David Hugh Oakley John, "Improvements in or relating to the Manufacture of Photographic Developing Agents," Brit. Pat. 658,010 (1951).

65. "'Genochrome' Colour Developing Agent," *Brit. J. Phot.*, **95**: 492 (1948).

66. Paul Goldacker, Georg Maiser, and Ernst Schmitz-Hillebrecht, "Photographic Developer," U. S. Pat. 2,181,941 (1939).

67. Charleton C. Bard and Judith A. Larkin, "Non-Silver Halide Reducing Sulfonamide Buffers for Photographic Developing Solutions," U. S. Pat. 3,305,364 (1967).

68. John Joseph Surash, Edward Joseph Giorgianni, and Lynn Russell Hotter, "Photographic Silver Halide Colour Processing," Brit. Pat. 1,293,654 (1972).

69. Albert Edward Harris and John Gough, "Antifogging Combination of Iso-Ascorbic Acid and 2 to 15 G. of Hydroquinone," U. S. Pat. 3,383,215 (1968).

70. Paul W. Vittum, Arnold Weissberger, and John R. Thirtle, "Antistain Agents for Photographic Color Materials," U. S. Pat. 2,675,314 (1954).

71. Fritz Albers, Alfred Fröhlich, Wilhelm Schneider, and Erwin Trabert, "Process for Avoiding Color Fog on Photographic Color Material," U. S. Pat. 2,309,492 (1943).

72. M. R. V. Sahyun, "Effect of Benzotriazole on Color Development Kinetics," *Phot. Sci. and Eng.*, **14**: 192 (1970).

73. Tadashi Nagae, Haruhiko Iwano, and Isao Shimamura, "Process for Development of Photographic Silver Halide Color Materials," U. S. Pat. 3,512,979 (1970).

74. Barbara C. Yager, Catherine M. Spath, and Judith A. Schwan, "Reducing Fog in Reversal Color Films Processed in Developers Containing Couplers," U. S. Pat. 3,113,864 (1963).

75. Catherine Marilyn Spath, "Mercapto Heterocyclic Addenda for Reversal Color Development," U. S. Pat. 2,956,876 (1960); "Improvements in Photographic Colour Development," Brit. Pat. 898,005 (1962).

76. Catherine Marilyn Spath, "Antifoggants for Reversal Color Development," U. S. Pat. 2,899,306 (1959); "Photographic Colour Developers and processes of Colour Development," Brit. Pat. 886,722 (1962).

77. Karl Schinzel, "Improvements in Colour Developers and Colour Development," Brit. Pat. 500,613 (1939).

78. J. R. Alburger, "Mathematical Expression of Developer Behavior," *J. SMPE*, **35**: 282 (1940).

79. G. van Veelan, "Gegenseitiges Verhalten von Schwarzweiss und Farbentwicklungssubstanzen, welche in Schichten die Farbkuppler enthalten," *Wissenschaftliche Photographie* (Internationalen Konferenz, Köln, 1956), Helwich, Darmstadt, 1958, pp. 498–503.

80. Yoshio Yamamuro, "Color-Developing Solution," Japanese Patent Publication 1970–23518 (1970) (in Japanese).

81. Charleton C. Bard, "Photographic Silver Halide Developer Compositions and Novel Developing Agents," U. S. Pat. 3,592,652 (1971); "Photographic Developer Compositions," Brit. Pat. 1,235,157 (1971).

82. Edward T. Pesch and Remsen S. Vaughn, "Color Developers Containing Competing Developing Agents," U. S. Pat. 3,300,305 (1967); "Photographic Colour Development and Colour Developing Solutions therefor," Brit. Pat. 1,066,967 (1967).

83. Courtenay D. Anselm, "Magenta Color Developer Solutions," U. S. Pat. 3,489,566 (1970).

84. Henry T. Neumann, "Method and Means for Producing Colored Photographic Images," U. S. Pat. 2,417,514 (1947).

85. John David Kendall, "Improvements in or relating to Photographic Development Processes," Brit. Pat. 542,502 (1942); "Photographic Developer," U. S. Pat. 2,289,367 (1942).

86. Glay M. Hood and Paul R. Crookshank, "Photographic Emulsion Layer Containing a 3-Pyrazolidone," U. S. Pat. 2,751,297 (1956).

87. L. F. A. Mason, "The Superadditivity of Phenidone and Metol with Colour Developing Agents," *J. Phot. Sci.*, **11**: 136 (1963).

88. Leslie Fredrick Alfred Mason, "Improvements in or relating to Colour Photography," Brit. Pat. 811,185 (1959).

89. Paul Miller Mader and Keith Elden Whitmore, "Procédé de développement chromogène d'images photographiques," French Pat. 1,268,712 (1961).

90. G. F. van Veelen, "Superadditivity in Colour Development," *J. Phot. Sci.*, **20**: 94 (1972).

91. Agfa Aktiengesellschaft, "Process for the production of Photographic Colour Images by Colour Development," Brit. Pat. 796,020 (1958).

92. Ts. A. Arnol'd, "Activation of Color Development," *Zhur. Nauch. Prikl. Fot. Kinemat.*, **11** (5): 378 (1966) (in Russian).

93. Ts. S. Arnol'd, R. B. Zhurin, and V. N. Ivina, "Activating Effect of 1-(*p*-Aminophenyl)-3-Aminopyrazoline During the Development of Color Negative Films," *Usp. Nauch. Fot.*, **13**: 100 (1968) (in Russian).

94. Ts. S. Arnol'd, R. A. Borisova, R. B. Zhurin, and O. E. Shul'gina, "Activation of Color Development by Phenylaminopyrazolines," *Int. Congress of Photographic Science, Section C, Moscow, USSR, 1970*, pp. 84–87.

95. Richard L. Bent and Rowland G. Mowrey, "Reversal Color Photographic Processes," U. S. Pat. 3,658,525 (1972).

96. William R. Weller and Nicholas H. Groet, "Controlling Grain and Contrast in Color Photography," U. S. Pat. 2,689,793 (1954).

97. Ilmari Salminen, "Controlling Grain and Contrast in Color Photography," U. S. Pat. 2,742,832 (1956).

98. Agfa Aktiengesellschaft, "Colour Photography," Brit. Pat. 861,138 (1961).

99. Societa Per Azioni Ferrania, "Process for the production of Colour Photographic Images and of Photographic Material therefor," Brit. Pat. 979,654 (1965).

100. Edwin Ernest Jelley, "Improvements in Colour Photographic Developers and Colour Photographic Development Processes," Brit. Pat. 520,528 (1940); "Procédé de photographie en couleurs," French Pat. 858,210 (1940).

101. Leopold D. Mannes and Leopold Godowsky, Jr., "Color Forming Developer Containing Amines," U. S. Pat. 2,191,037 (1940).

102. I. G. Farbenindustrie Aktiengesellschaft, "Improvements relating to Photographic Development," Brit. Pat. 512,060 (1939).

103. Wilhelm Schneider and Gustav Wilmanns, "Process for Color Development of Photographic Materials," U. S. Pat. 2,304,025 (1942).

104. Frank J. Kaszuba, "Phenoxyalkylamines as Accelerators for Photographic Developers," U. S. Pat. 2,482,546 (1949).

105. William L. Wasley, "Photographic Developer Containing a Negatively Substituted Aralkylamine and Process of Development," U. S. Pat. 2,496,903 (1950).

106. William L. Wasley, "Photographic Developer Containing an Aralkylamine and Process of Development," U. S. Pat. 2,515,147 (1950).

107. Ivy V. Runyan, "Alkyl Ethers of Polyhydroxyaralkylamines as Accelerators," U. S. Pat. 2,541,889 (1951).

108. Ivy V. Runyan, "Heterocyclic Alkylamines as Accelerators for Photographic Developers," U. S. Pat. 2,605,183 (1952).

109. Boris Peter Brand and John Mathers Woolley, "Photographic Silver Halide Materials and the Development thereof," Brit. Pat. 1,086,618 (1967).

110. Heman Dowd Hunt, "Reversal Process of Photography," U. S. Pat. 3,126,282 (1964).

111. Fuji Photo Film Co., "Photographic Silver Halide Development," Brit. Pat. 1,275,375 (1972).

112. Judith A. Schwan and Catherine Marilyn Spath, "Color Developers Containing Polyethylene Glycols," U. S. Pat. 2,950,970 (1960).

113. Edwin E. Jelley, "Photographic Developer," U. S. Pat. 2,304,925 (1942).

114. Robert L. Bimmler and Roy J. Kanous, "Photographic Developer Compositions," Can. Pat. 888,645 (1971); "Photographic Developer Compositions and Solutions for Use in the Preparation Thereof," Brit. Pat. 1,244,623 (1971).

115. Roy James Kanous and Henry Josef Fassbender, "Benzyl Alcohol Emulsions and Their Use in Making Photographic Developers," Brit. Pat. 1,254,726 (1971).

116. George Luther Nearhoof, "Method for Developing Exposed Color Photographic Emulsions," Brit. Pat. 1,286,111 (1972).

117. Charleton C. Bard, "The Whys and Wherefores of Today's Color Processing Chemistry," presented at the SPSE Symposium on Photographic Processing, May 7–9, 1973, Rochester, N.Y.

118. Georges Emmanuel Zelger, "Process for Obtaining Direct Positives by Reversal," U. S. Pat. 1,628,445 (1927).

119. Gustav Wilmanns and Wilhelm Schneider, "Photographic Developers," U. S. Pat. 2,122,599 (1938).

120. Edwin Ernest Jelley, "Photographic Reversal Process," U. S. Pat. 1,962,348 (1934).

121. John Rau Weber and Lynn Barratt Morris, "Photographic Reducing Composition and Process," U. S. Pat. 2,339,309 (1944).

122. Gustav Wilmanns, Wilhelm Schneider, and Richard Kethur, "Reversal Development of Light-Sensitive Silver Halide Emulsions," U. S. Pat. 2,159,466 (1939); "Improvements in the Reversal Development of Light-Sensitive Silver Halide Emulsions," Brit. Pat. 489,845 (1938).

123. Richard W. Henn, David K. Bulloch, and Charleton C. Bard, "Method for Elimination of Reversal Re-Exposure in Processing Photographic Films," U. S. Pat. 2,984,567 (1961); "Improved Photographic Processes," Brit. Pat. 904,462 (1962).

124. Charleton Cordery Bard and Howard Walter Vogt, "Photographic Processing Materials," Brit. Pat. 1,213,809 (1970); "Photographic Processes," Brit. Pat. 1,213,810 (1970).

125. Wesley T. Hanson, Jr., and Howard W. Vogt, "Method for Elimination of Reversal Re-Exposure in Processing Photographic Elements," U. S. Pat. 3,246,987 (1966); "Improved Photographic Reversal Processes," Brit. Pat. 1,056,454 (1967); "Photographic Processing Compositions Containing Boron Compounds," Brit. Pat. 1,056,455 (1967).

126. Charleton Cordery Bard, Arthur David Kuh, and Richard Joseph Malloy, "Photographic Processing Method," Brit. Pat. 1,298,752 (1972).

127. Cyril J. Staud and Catherine Salo Popper, "Hardeners for Photographic Processing Solutions," U. S. Pat. 2,356,477 (1944).

128. L. E. Varden and E. G. Seary, "Rapid Test for Ferricyanide Bleach Exhaustion," *J. SMPE*, **47**: 450 (1946).

129. A. H. Brunner, Jr., P. B. Means, Jr., and R. H. Zappert, "Analysis of Developers and Bleach for Ansco Color Film," *J. SMPE.*, **53**: 25 (1949).

130. Lawrence G. Welliver, "Stabilization of Photographic Bleach Powders Containing an Alkali Metal Ferricyanide," U. S. Pat. 2,943,935 (1960).

131. Charleton C. Bard, "Phosphorous and Maleic Acid Buffers for Ferricyanide Photographic Bleaches," U. S. Pat. 3,342,598 (1967); "Photographic Processing," Brit. Pat. 1,146,478 (1969).

132. Eugene G. Seary, "Regeneration of Photographic Silver Bleach Solution," U. S. Pat. 2,515,930 (1950).

133. F. E. Flannery, "The Regeneration of Ferricyanide-Bromide Bleach," *Phot. J.*, **91B**: 121 (1951).

134. Robert H. Zappert, "Regeneration of Exhausted Silver Bleaching Solutions," U. S. Pat. 2,611,699 (1952); Brit. Pat. 673,058 (1952).

135. August H. Brunner, Jr., and Robert H. Zappert, "Regeneration of Exhausted Silver Bleach Solutions by Means of *N*-Bromo Compounds," U. S. Pat. 2,611,700 (1952).

136. Gerald Russell, "Improvements in or relating to the Regeneration of Photographic Processing Baths," Brit. Pat. 801,106 (1958).

137. Lloyd Ellis West and Bernard Arthur Hutchins, "Improvement in Production and Regeneration of Photographic Silver Bleach Solutions," Brit. Pat. 778,559 (1957); "Regeneration of Photographic Silver Bleach Solutions," U. S. Pat. 2,944,895 (1960).

138. Bernard A. Hutchins and Lloyd E. West, "The Preparation or Regeneration of a Silver Bleach Solution by Oxidizing Ferrocyanide with Persulfate," *J. SMPTE*, **66**: 764 (1957).

139. Thomas W. Bober and Thomas J. Dagon, "The Regeneration of Ferricyanide Bleach Using Ozone," *Image Technology*, **14**(4): 13; **14**(5): 19 (1972). (See also Kodak Publication J-42, 3-73-AX New Publication.)

140. Charleton Cordery Bard and Julius Caesar Battaglini, "Photographic Processing," Brit. Pat. 1,247,741 (1971).

141. Georges Pascal Joseph Schweitzer, "Improved Method for Obtaining Photographic Prints in Colours," Brit. Pat. 249,530 (1927).

142. Cinecolor, "Improvements in or relating to Photographic Bleaches," Brit. Pat. 506,450 (1939).

143. Bernard C. Cossar and Delbert D. Reynolds, "Photographic Bleaching and Antifogging Agents," U. S. Pat. 3,671,259 (1972).

144. Ray M. Hurd and Norman Hackerman, "Electrokinetic Potentials on Bulk Metals by Streaming Current Measurements," *J. Electrochem. Soc.*, **103** (6): 316 (1956).

145. J. T. Harrison and G. A. H. Elton, "Electrophoresis of Gold and Silver Particles," *J. Chem. Soc.*, p. 3838 (1959).

146. J. Barr and H. O. Dickinson, "Electrokinetic Measurements on Silver, Silver Bromide and Silver Sulphide," *J. Phot. Sci.*, **9**: 222 (1961).

147. J. F. Willems, "Superadditivity Effects in the Photographic Bleaching Process," *J. Phot. Sci.*, **19**: 113 (1971).

148. Farbwerke Hoechst Aktiengesellschaft, "Improvements in and Relating to Ammonium Thiosulphate," Brit. Pat. 1,310,242 (1973).

149. Edwin Mutter, "The Chemistry and Technology of Colour Photography," *Leica Fotographie*, English Edition, **20** (6): 244 (1971).

150. Hobson J. Bello and Carl F. Holtz, "Film and Process Using Bleach Inhibitor for Producing Color Film with Silver Sound Record," U. S. Pat. 3,705,799 (1972).

151. William S. Lane, "Novel Photographic Processing Compositions and Improved Processing Using Such Compositions for Preparing Silver Sound Tracks," U. S. Pat. 3,705,800 (1972).

152. John H. Van Campen, "Filter and Absorbing Dyes for Use in Photographic Emulsions," U. S. Pat. 2,956,879 (1960).

153. Wilhelm Schneider and Richard Brodersen, "Verfahren zur Herstellung photographischer Abschwächer und Bleichfixierbäder," German Pat. 866,605 (1944).

154. Richard V. Young and Merrill W. Seymour, "Simultaneous Bleaching and Fixing Bath," U. S. Pat. 2,322,084 (1943).

155. Max Heilmann, "Verfahren zur Herstellung photographischer Abschwächer und Bleichfixierbäder," German Pat. 954,475 (1956).

156. M. Heilmann, "Über das Agfacolor-Bleichfixierbäd," *Mitt. Forsch. Agfa*, **1**: 256 (1955).

157. M. Heilmann, "Dissolution simultanée de l'argent et du bromure d'argent dans le procédé Agfacolor," *Sci. et Ind. Phot.*, **27**: 210 (1956).

158. Paul W. Vittum and Edwin E. Jelley, "Color Photography," U. S. Pat. 2,378,265 (1945).

159. Frank J. Kaszuba, "Bleaching Bath and Process for Bleaching Color Film," U. S. Pat. 2,419,900 (1947).

160. Max Heilmann, "Verfahren zum Bleichfixieren von photographischen Silberbildern," German Pat. 966,410 (1957); "Colour Photographic Processing," Brit. Pat. 746,567 (1956).

161. Max Heilmann, Hanswilli von Brachel, and Hans Holtschmidt, "Verfahren zum Bleichfixieren von photographischen Silberbildern," German Pat. 1,146,363 (1963).

162. Agfa Aktiengesellschaft, "A process for the Simultaneous Bleaching and Fixing of Photographic Color Images," Brit. Pat. 926,569 (1963).

163. Bernhard Morcher, Karl Frank, and Max Heilmann, "Verfahren zum gleichzeitigen Bleichen und Fixieren von photographischen Farbbildern," German Pat. 1,127,715 (1962).

164. Bernhard Morcher, Heinz Meckl, and Helmut Häseler, "Processing of Color Photographic Materials," U. S. Pat. 3,352,676 (1967); "Traitement de matériel photographique en couleurs," French Pat. 1,373,498 (1964).

165. Max Heilmann, "Verfahren zum Bleichfixieren von photographischen Bildern," Swiss Pat. 336,257 (1959).

166. Fuji Shashin Film Kabushiki Kaisha, "Improvements in Colour Photography Processes," Brit. Pat. 1,150,466 (1969).

167. Heinz Meckel, Helmut Häseler, and Wolfgang Lassig, "Bleach-Fixing for Photographic Silver Images," Brit. Pat. 1,138,842 (1969).

168. Henry J. Fassbender, Kenneth L. Wrisley, and Dee L. Johnson, "Blix Compositions for Photographic Processing," Can. Pat. 827,076 (1969).

169. Paul M. Mader, "Removing Silver and Silver Halide from Photographic Elements," U. S. Pat. 2,748,000 (1956); "Improvements in Photographic Processing," Brit. Pat. 765,053 (1957).

170. Alun Trefor Rhys Williams and David Gerald Alcock, "Color Photographic Process Using a Bleach-Fix Solution Containing a Selenosulfate," U. S. Pat. 3,702,247 (1972); "Photographic Silver Halide Bleach-Fix Accelerators," Brit. Pat. 1,297,905 (1972).

171. David Gerald Alcock, John Colin Brown, Enzo Piccotti, and Norman John Iungius, "Bleach-Fix Additives," U. S. Pat. 3,702,248 (1972); "Photographic Silver-Halide Bleach-Fix Accelerators," Brit. Pat. 1,297,653 (1972).

172. Hiroyuki Amano, Reiichi Ohi, Haruhiko Iwano, and Kazuo Shirasu, "Color Photographic Processing," U. S. Patents 3,578,453 and 3,578,454 (1971); Brit. Pat. 1,192,481 (1970); Can. Pat. 910,108 (1972).

173. David Lionel Cohen and Arthur McCauley, "Photographic Color Processing," Brit. Pat. 1,170,973 (1969).

174. Keith H. Stephen and John J. Surash, "Photographic Blixes and Blixing," U. S. Pat. 3,615,508 (1971).

175. David Lionel Cohen and Arthur McCauley, "Photographic Colour Processing," Brit. Pat. 1,132,399 (1968).

176. David Lionel Cohen and Arthur McCauley, "Photographic Colour Processing," Brit. Pat. 1,133,500 (1968).

177. Kurt Israel Jacobson, "Chemical Compositions," Brit. Pat. 991,412 (1965).

178. Kurt Israel Jacobson, "Photographic Bleach-Fix Baths," Brit. Pat. 1,014,396 (1965).

179. Rowland G. Mowrey, Keith H. Stephen, and Eugene F. Wolfarth, "Compositions for Making Blixes," U. S. Pat. 3,706,561 (1972).

180. Charleton C. Bard and George P. Varlan, "Color-Forming Photographic Process Utilizing a Bleach-Fix Followed by a Bleach," U. S. Pat. 3,189,452 (1965); "Method of Photographic Processing," Brit. Pat. 1,026,496 (1966).

181. Hiroyuki Amano, Haruhiko Iwano, and Kazuo Shirasu, "Bleach-Fixing Solution for Color Photography," U. S. Pat. 3,667,950 (1972).

182. Max Heilmann and Wolfgang Himmelmann, "Härtende Bleichfixierbäder," German Pat. 2,102,713 (1972); "Photographic Hardening, Bleaching and Fixing Bath," French Pat. 2,120,187 (1972) (in French).

183. Willard Roland Ruby and Paul Wendell Vittum, "Improvements in the Production of Coloured Photographs," Brit. Pat. 565,929 (1944).

184. Ilmari F. Salminen and Charles F. H. Allen, "Ultraviolet Filter on Photographic Layers," U. S. Pat. 2,632,701 (1953).

185. Richard O. Edgerton and Cyril J. Staud, "Photographic Element Protected Against Action of Ultraviolet Radiation," U. S. Pat. 2,747,996 (1956).

186. George W. Sawdey, "Photographic Elements Containing Thiazolidine Derivatives," U. S. Pat. 2,739,888 (1956).

187. George W. Sawdey, "Photographic Elements Protected Against Ultraviolet Radiation," U. S. Pat. 3,250,617 (1966).

188. Charleton Cordery Bard and Neil Allan Weiser, "Processing Photographic Silver Halide Colour Materials," Brit. Pat. 1,280,191 (1972).

189. James J. Hartigan and Robert J. Clementi, "Ultraviolet Protection of Photographic Materials," U. S. Pat. 3,692,525 (1972).

190. Shui Sato, Sadao Sugita, Tomio Nakajima, and Keiji Kasai, "Light-Sensitive Silver Halide Color Photographic Material," U. S. Pat. 3,698,907 (1972).

191. Fuji Photo Film Co., "Colour Photographic Light-Sensitive Materials Having Improved Light Fastness," Brit. Pat. 1,293,982 (1972).

192. Fritz Nittel, Johannes Sobel, and Wolfgang Himmelmann, "Photographic Layers Containing Compounds Which Absorb Ultraviolet Light," U. S. Pat. 3,705,805 (1972).

193. Hiroyuki Amano, Reiichi Ohi, and Kazuo Shirasu, "Color Photographic Process to Prevent Discoloration by Ultraviolet Light," U. S. Pat. 3,705,036 (1972).

194. C. H. Giles and S. M. K. Rahman, "Effect of Fluorescent Brightening Agents on the Light Fastness of Dyed Cellulose," *J. Soc. Dyers and Colourists*, **76**: 681 (1960).

195. Paul W. Vittum, Arnold Weissberger, and John R. Thirtle, "Antistain Agents for Photographic Color Materials," U. S. Pat. 2,675,314 (1954).

196. Paul W. Vittum, "Color Photography," U. S. Pat. 3,384,658 (1945).

197. Howard C. Haas, "Processes for Forming Dye Developer Images Having Stability in Sunlight," U. S. Pat. 3,069,262 (1962).

198. Fuji Photo Film Co., "The Stabilising of Colour Photographic Materials," Brit. Pat. 1,293,715 (1972).

199. George W. Larson, "Method of Inhibiting Discoloration of Color Photographic Layers Containing Dye Images and Resulting Photographic Products," U. S. Pat. 3,201,244 (1965).

200. Roy Arthur Jeffreys, Arthur Neil Davenport, and David George Saunders, "Method of Inhibiting Discoloration of Color Photographic Layers Containing Dye Images and Resulting Photographic Products," U. S. Pat. 3,095,302 (1963).

201. Harold C. Harsh and James E. Bates, "Sulfite Antistain Bath for Multilayer Color Film," U. S. Pat. 2,475,134 (1949).

202. Ronald H. Miller and Martin A. Foos, "Photographic Processing Baths for Stabilization Processing," U. S. Pat. 3,271,153 (1966).

203. Eugene Seary and Anthony Salerno, "Protecting Color Pictures Exposed to High Humidities Against Fading and Staining," U. S. Pat. 2,647,057 (1953).

204. Rowland G. Mowrey, "Photographic Stabilizer Compositions," U. S. Pat. 3,676,136 (1972).

205. Harold C. Harsh and James E. Bates, "Antistain Baths for Sensitive Color Photographic Material," U. S. Pat. 2,483,971 (1949).

206. Harold C. Harsh and James E. Bates, "Process for Preventing Stains in Photographic Color Material by Treatment with Basic Acids Immediately Prior to Drying," U. S. Pat. 2,515,121 (1950).

207. Hiroyuki Amano and Kazuo Shirasu, "Process of Color Photographic Printing Paper," U. S. Pat. 3,666,468 (1972).

208. Haruo Shibaoka and Shunichiro Tsuchida, "Water-Washing Accelerating Composition for Silver Halide Color Photographic Light Sensitive Elements," U. S. Pat. 3,649,277 (1972); "Improved Water Washing Processing of Silver Halide Colour Photographic Light-Sensitive Elements," Brit. Pat. 1,230,435 (1971).

209. Roy A. Jeffreys and Leslie A. Williams, "Method of Inhibiting Discoloration of Color Photographs," U. S. Pat. 3,473,929 (1969).

210. Henry B. Kellog. "Process for Preventing Stains on Photographic Color Material During Drying Following Exposure, Bleaching, and Fixing Treatment," U. S. Pat. 2,487,446 (1949).

211. George W. Larson, "Method of Inhibiting Discoloration of Color Photographic Layers Containing Dye Images and Resulting Photographic Products," U. S. Pat. 3,201,243 (1965).

212. James Marvin Seemann and Howard Walter Vogt, "Photographic Processing Compositions," Brit. Pat. 1,111,428 (1968); "Final Rinse Bath for Color Process," U. S. Pat. 3,369,896 (1968).

213. Charleton Cordery Bard and Harry Christian Baden, "Photographic Colour Processing," Brit. Pat. 1,281,619 (1972).

214. Kurt Israel Jacobson, "Method of Shortening the Processing Time of Color Photography," U. S. Pat. 3,372,030 (1968).

215. Karl H. Landes in Bob Nadler, "Old Color Prints Never Die, They Just . . ," *Camera 35*, **17** (3): 26 (1973).

216. Richard K. Schafer, "Dye Stability of Motion Picture Film," *Brit. Kinemat.*, **54** (10): 286 (1972).

217. Peter Z. Adelstein, C. Loren Graham, and Lloyd E. West, "Preservation of Motion-Picture Color Films Having Permanent Value," *J. SMPTE*, **79**: 1011 (1970).

218. C. H. Giles, S. D. Forrester, R. Haslam, and R. Horn, "Light Fastness Evaluation of Colour Photographs," *J. Phot. Sci.*, **21**: 19 (1973).

219. H. Gordon, "A Universal Developing Method for European Colour Negative Films," *Brit. J. Phot.*, **101**: 558 (1954).

220. H. Gordon, "A Universal System for Colour Printing," *Brit. J. Phot.*, **102**: 440 (1955).

221. James E. Bates, "Processing Ansco Color Reversible Film," *Am. Phot.*, **39** (7): 8 (1945).

222. "P.Q. for Reversal Colour Materials," *Brit. J. Phot.*, **104**: 398 (1957).

223. William L. Wike, "Chemistry and Processing of Aerial Color Films. Chemistry and Processing of Anscochrome Aerial Films," in *Manual of Color Aerial Photography*, John T. Smith, Jr., Editor, American Society of Photogrammetry, Falls Church, Va., 1968, pp. 209–223.

224. Ernest Ch. Gehret, "Processing Anscochrome Reversal Colour Films D/50, D/100, D/200, T/100," *Brit. J. Phot.*, **113**: 212 (1966).

225. William L. Wike, "An Accelerated Process for Anscochrome Color Films," *J. SMPTE*, **77**: 1142 (1968).

226. H. Gordon, "Ektachrome," *Camera*, **27**: 178, 209 (1948).

227. William J. Pilkington, "A Processing Formula for Ektachrome Colour Film," *Brit. J. Phot.*, **95**: 487 (1948).

228. C. Leslie Thomson, "Substitute Formulae for Ektachrome Processing," *Min. Camera Mag.*, **14** (11): 596 (1950); C. Leslie Thomson, "Experimental Formulae for E-2 Processing of Ektachrome," *Brit. J. Phot.*, **104**: 724 (1957).

229. Ernest Gehret, "The Processing of Kodak Ektachrome E.1 and E.2 Reversal Films," *Brit. J. Phot.*, **105**: 148, 178 (1958).

230. J. L. Linsley Hood and H. Francis, "Ektachrome Processing," *Amat. Phot.*, **129**: 641 (1965).

231. W. Ford Lehman, "Experimental E3/E4," *Dignan Newsletter*, II: 107 (July 1971).

232. Ernest Ch. Gehret, "Processing Ektachrome E-4," *Brit. J. Phot.*, **116**: 396 (1969).

233. Ernest Gehret, "Processing Ektachrome E-2, EH, and E-3," *Brit. J. Phot.*, **107**: 2 (1960); "Ektachrome E-3," *The British Journal of Photography Annual 1971*, Henry Greenwood and Co., London, 1970, p. 213.

234. Ernest Ch. Gehret, "The C22 Colour Negative Process and Its Application," *Brit. J. Phot.*, **119**: 820 (1972).

235. Patrick Dignan, "Kodak Official Process P-125," *Dignan Photographic Newsletter*, **1** (6): 4 (June, 1973).

236. Howard C. Colton, *Photo Technique*, **1** (4): 16 (1939).

Author Index

613

Subject Index